Henry M. Sayre
Oregon State University

The Humanities

Culture, Continuity & Change

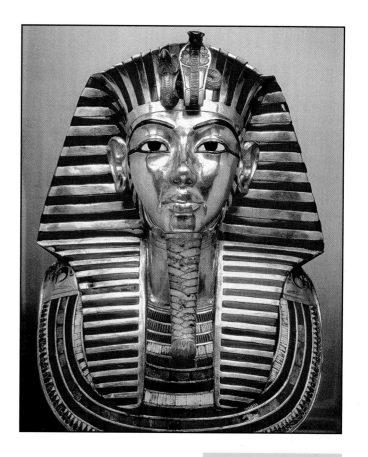

BOOK 1

THE ANCIENT WORLD AND THE CLASSICAL PAST:
PREHISTORY TO 200 CE

PEARSON

Prentice
Hall

Upper Saddle River, New Jersey 07458

Library of Congress Cataloging-in-Publication Data

Sayre, Henry M.

The humanities : culture, continuity & change / Henry M. Sayre.

 p. cm.

 Includes index.

ISBN 0-205-63826-0

 1. Civilization—History. 2. Humanities—History. 3. Social change—History. I. Title.

CB69.S29 2008

909—dc22 2007016065

For Bud Therien, art publisher and editor par excellence, and a good friend

Editor-in-Chief: Sarah Touborg
Senior Editor: Amber Mackey
Editor-in-Chief Development: Rochelle Diogenes
Senior Development Editor: Roberta Meyer
Development Editor: Karen Dubno
Assistant Editor: Alexandra Huggins
Editorial Assistant: Carla Worner
Media Editor: Alison Lorber
Director of Marketing: Brandy Dawson
Executive Marketing Manager: Marissa Feliberty
Senior Managing Editor: Mary Rottino
Project Manager: Harriet Tellem
Production Editor: Assunta Petrone
Production Assistant: Marlene Gassler
Senior Operations Specialists: Sherry Lewis and Brian Mackey
Senior Art Director: Nancy Wells
Interior and Cover Design: Ximena Tamvakopoulos
Layout Specialists: Gail Cocker-Bogusz and Wanda España
Line Art and Map Program Management: Gail Cocker-Bogusz
 and Mirella Signoretto
Fine Line Art: Peter Bull Art Studio
Cartographer: Peter Bull Art Studio

Line Art Studio: Precision Graphics
Pearson Imaging Center
 Site Supervisor: Joe Conti
 Project Coordinator: Corin Skidds
 Scanner Operators: Corin Skidds, Robert Uibelhoer, Ron Walko
Photo Research: Image Research Editorial Services/Francelle
 Carapetyan and Rebecca Harris
Director, Image Resource Center: Melinda Reo
Manager, Rights and Permissions: Zina Arabia
Manager, Visual Research: Beth Brenzel
Manager, Cover Visual Research and Permissions:
 Karen Sanatar
Image Permissions Coordinator: Debbie Latronica
Text Permissions: Warren Drabek, ExpressPermissions
Text Research: John Sisson
Copy Editor: Karen Verde
Proofreaders: Barbara DeVries and Nancy Stevenson
Composition: Preparé, Inc.
Cover Printer: Phoenix Color Corp.
Printer/Binder: Courier Kendallville
Cover Photo: Funerary Mask of Tutankhamun.
 c. 1327 BCE. Height 21 $^{1}/_{4}$ inches Egyptian Museum, Cairo.

Credits and acknowledgments borrowed from other sources and reproduced, with permission, in this textbook appear on appropriate pages within text and beginning on page Credits-1.

Pearson Education LTD.
Pearson Education Singapore, Pte. Ltd.
Pearson Education, Canada, Ltd.
Pearson Education–Japan
Pearson Education, Upper Saddle River, New Jersey

Pearson Education Australia PTY, Limited
Pearson Education North Asia Ltd
Pearson Educación de Mexico, S.A. de C.V.
Pearson Education Malaysia, Pte. Ltd

10 9 8 7 6 5 4 3 2
ISBN 10: 0-205-63826-0
ISBN 13: 978-0-205-63826-0

Series Contents

Contents

7 Golden Age Athens
The School of Hellas 187

8 Rome
Urban Life and Imperial Majesty 233

Dear Reader,

You might be asking yourself, why should I be interested in the Humanities? Why do I care about ancient Egypt, medieval France, or the Qing Dynasty of China?

I asked myself the same question when I was a sophomore in college. I was required to take a year long survey of the Humanities, and I soon realized that I was beginning an extraordinary journey. That course taught me where it was that I stood in the world, and why and how I had come to find myself there. My goal in this book is to help you take the same journey of discovery. Exploring the humanities will help you develop your abilities to look, listen, and read closely; and to analyze, connect, and question. In the end, this will help you navigate your world and come to a better understanding of your place in it.

What we see reflected in different cultures is something of ourselves, the objects of beauty and delight, the weapons and wars, the melodies and harmonies, the sometimes troubling but always penetrating thought from which we spring. To explore the humanities is to explore ourselves, to understand how and why we have changed over time, even as we have, in so many ways, remained the same.

About the Author

Henry M. Sayre is Distinguished Professor of Art History at Oregon State University–Cascades Campus in Bend, Oregon. He earned his Ph.D. in American Literature from the University of Washington. He is producer and creator of the 10-part television series, *A World of Art: Works in Progress*, aired on PBS in the fall of 1997; and author of seven books, including *A World of Art, The Visual Text of William Carlos Williams, The Object of Performance: The American Avant-Garde since 1970*; and an art history book for children, *Cave Paintings to Picasso*.

See Context and Make Connections...

The Humanities: *Culture, Continuity, and Change* shows the humanities in context and helps readers make connections—among disciplines, cultures, and time periods. Each chapter centers on a specific geographic location and time period and includes integrated coverage of all disciplines of the humanities. Using an engaging storytelling approach, author Henry Sayre clearly explains the influence of time and place upon the humanities.

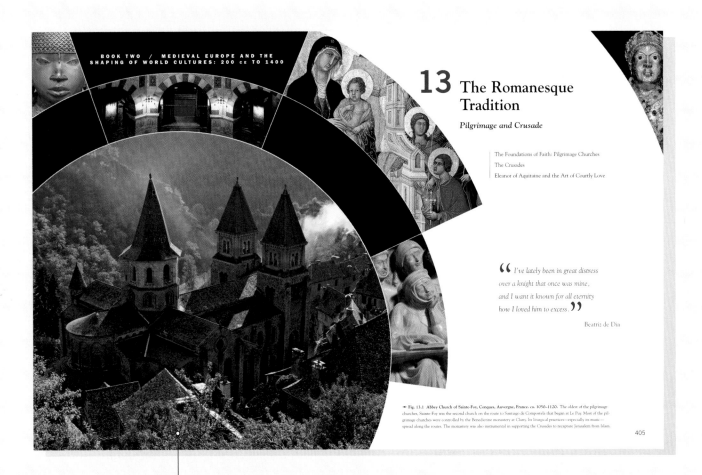

BOOK TWO / MEDIEVAL EUROPE AND THE
SHAPING OF WORLD CULTURES: 200 CE TO 1400

13 The Romanesque Tradition

Pilgrimage and Crusade

The Foundations of Faith: Pilgrimage Churches
The Crusades
Eleanor of Aquitaine and the Art of Courtly Love

*I've lately been in great distress
over a knight that once was mine,
and I want it known for all eternity
how I loved him to excess.*

Beatriz de Dia

◄ **Fig. 13.1 Abbey Church of Sainte-Foy, Conques, Auvergne, France. ca. 1050–1120.** The oldest of the pilgrimage churches, Sainte-Foy was the second church on the route to Santiago de Compostela that began at Le Puy. Most of the pilgrimage churches were controlled by the Benedictine monastery at Cluny. Its liturgical practices—especially its music—spread along the routes. The monastery was also instrumental in supporting the Crusades to recapture Jerusalem from Islam.

405

CHAPTER OPENERS Each chapter begins with a compelling chapter opener that serves as a snapshot of the chapter. These visual introductions feature a central image from the location covered in the chapter. Several smaller images represent the breadth of disciplines and cultures covered throughout the book. An engaging quote drawn from one of the chapter's readings and a brief list of the chapter's major topics are also included.

Across the Humanities

Egyptian and Greek Sculpture

Continuity & Change

Freestanding Greek sculpture of the Archaic period—that is, sculpture dating from about 600–480 BCE—is notable for its stylistic connections to 2,000 years of Egyptian tradition. The Late Period statue of *Mentuemhet* [men-too-em-het] (Fig. 6.18), from Thebes, dating from around 2500 BCE, differs hardly at all from Old Kingdom sculpture at Giza (see Figs. 3.8–3.9), and even though the *Anavysos* [ah-NAH-vee-sus] *Kouros* (Fig. 6.19), from a cemetery near Athens, represents a significant advance in relative naturalism over the Greek sculpture of just a few years before, it still resembles its Egyptian ancestors. Remarkably, since it follows upon the *Anavysos Kouros* by only 75 years, the *Doryphoros* [dor-IF-uh-ros] (*Spear Bearer*) (Fig. 6.20) is significantly more naturalistic. Although this is a

Roman copy of a lost fifth-century BCE bronze Greek statue, we can assume it reflects the original's naturalism, since the original's sculptor, Polyclitus [pol-ih-KLY-tus], was renowned for his ability to render the human body realistically. But this advance, characteristic of Golden Age Athens, represents more than just a cultural taste for naturalism. As we will see in the next chapter, it also represents a heightened cultural sensitivity to the worth of the individual, a belief that as much as we value what we have in common with one another—the bond that creates the city-state—our *individual* contributions are at least of equal value. By the fifth century BCE, the Greeks clearly understood that individual genius and achievement could be a matter of civic pride. ■

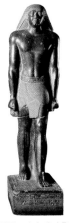 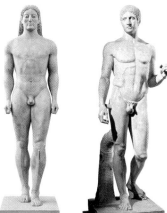

Fig. 6.18 *Montuemhet*, from Karnak, Thebes. ca. 660 BCE. Granite, height 54″. Egyptian Museum, Cairo.

Fig. 6.19 *Anavysos Kouros*, perhaps young Kroisos, from a cemetery at Anavysos [ah-NAH-vee-sus], near Athens. ca. 525 BCE. Marble with remnants of paint, height 6′ 4″. National Archaeological Museum, Athens; Fig. 6.20 *Doryphoros* (*Spear Bearer*), Roman copy after the original bronze by Polyclitus of ca. 450–440 BCE. Marble, height 6′ 6″. Museo Archeologico Nazionale, Naples.

185

CONTINUITY & CHANGE
Full-page essays at the end of each chapter illustrate the influence of one culture upon another and show cultural changes over time.

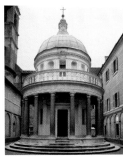

Fig. 18.6 **Donato Bramante, Tempietto. 1502.** San Pietro in Montorio, Rome. This chapel was certainly modeled after a classical temple. It was commissioned by King Ferdinand and Queen Isabella of Spain, financiers of Christopher Columbus's voyages to America. It was undertaken in support of Pope Alexander VI, who was himself Spanish.

In his plan for a new Saint Peter's (Fig. 18.7a), Bramante adopted the Vitruvian square, as illustrated in Leonardo's drawing, p. 260 placing inside it a **Greek cross** (a cross in which the upright and transverse shafts are of equal length and intersect at their middles) topped by a central dome purposely reminiscent of the giant dome of the Pantheon (see Fig. 8.25). The resultant central plan is essentially a circle inscribed within a square. In Renaissance thinking, the central plan and dome symbolized the perfection of God. Construction began in 1506.

Julius II financed the project through the sale of **indulgences**, dispensations granted by the Church to shorten an individual's stay in purgatory. This was the place where, in Catholic belief, individuals temporarily reside after death as punishment for their sins. Those wanting to enter heaven faster than they otherwise might could shorten their stay in purgatory by purchasing an indulgence. The Church had been selling these documents since the twelfth century, and Julius's building campaign intensified the practice (see *Voices*, page 588). (In protest against the sale of indulgences, Martin Luther would launch the Protestant Reformation in Germany in 1517; see chapter 21.) The New Saint Peter's would be a very expensive project, but there were also very many sinners willing to help pay for it. With the deaths of both pope and architect, in 1513 and 1514 respectively, the project came to a temporary halt. Its final plan would be developed in 1546 by Michelangelo (Fig. 18.7b).

Continuity & Change

The Pantheon

CONTINUITY & CHANGE references provide a window into the past. These eye-catching icons enable students to refer to material in other chapters that is relevant to the topic at hand.

CRITICAL THINKING questions at the end of each chapter prompt readers to synthesize material from the chapter.

Critical Thinking Questions

1. What was the relationship of the Anglo-Saxon lord or chief to his followers and subjects?

2. How does the *Song of Roland* reflect feudal values? How do these values differ from those found in *Beowulf*?

3. What is the Rule of St. Benedict and how did it affect monastic life?

4. What role did music play in Charlemagne's drive to standardize the liturgy?

See Context and Make Connections...

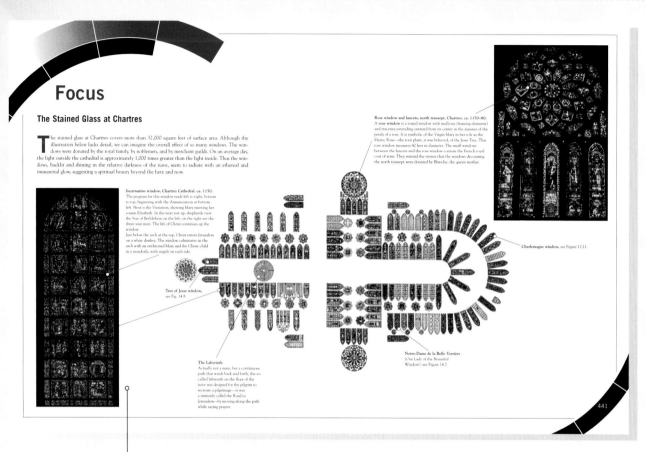

Focus

The Stained Glass at Chartres

The stained glass at Chartres covers more than 32,000 square feet of surface area. Although the illustration below lacks detail, we can imagine the overall effect of so many windows. The windows were donated by the royal family, by noblemen, and by merchant guilds. On an average day, the light outside the cathedral is approximately 1,000 times greater than the light inside. Thus the windows, backlit and shining in the relative darkness of the nave, seem to radiate with an ethereal and immaterial glow, suggesting a spiritual beauty beyond the here and now.

Incarnation window, Chartres Cathedral. ca. 1150.
The program for this window reads left to right, bottom to top, beginning with the Annunciation at bottom left. Next is the Visitation, showing Mary meeting her cousin Elizabeth. In the next row up, shepherds view the Star of Bethlehem on the left; on the right are the three wise men. The life of Christ continues up the window.
Just below the arch at the top, Christ enters Jerusalem on a white donkey. The window culminates in the arch with an enthroned Mary and the Christ child in a mandorla, with angels on each side.

Tree of Jesse window, see Fig. 14.8.

The Labyrinth
Actually not a maze, but a continuous path that winds back and forth, the so-called labyrinth on the floor of the nave was designed for the pilgrim to recreate a pilgrimage—it was commonly called the Road to Jerusalem—by moving along the path while saying prayers.

Rose window and lancets, north transept, Chartres. ca. 1150–80.
A rose window is a round window with mullions (framing elements) and traceries extending outward from its center in the manner of the petals of a rose. It is symbolic of the Virgin Mary in her role as the Mystic Rose—the root plant, it was believed, of the Jesse Tree. This rose window measures 42 feet in diameter. The small windows between the lancets and the rose window contain the French royal coat of arms. They remind the viewer that the windows decorating the north transept were donated by Blanche, the queen mother.

Charlemagne window, see Figure 12.11.

Notre-Dame de la Belle Verrière (Our Lady of the Beautiful Window), see Figure 14.7.

441

FOCUS Highly visual Focus features offer an in-depth look at a particular work from one of the disciplines of the humanities. These annotated discussions give students a personal tour of the work—with informative captions and labels—to help students understand its meaning.

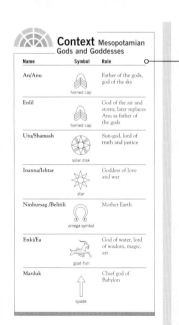

Context Mesopotamian Gods and Goddesses

Name	Symbol	Role
An/Anu	horned cap	Father of the gods, god of the sky
Enlil	horned cap	God of the air and storm; later replaces Anu as father of the gods
Utu/Shamash	solar disk	Sun-god, lord of truth and justice
Inanna/Ishtar	star	Goddess of love and war
Ninhursag/Belitili	omega symbol	Mother Earth
Enki/Ea	goat-fish	God of water, lord of wisdom, magic, art
Marduk	spade	Chief god of Babylon

CONTEXT boxes summarize important background information in an easy-to-read format.

MATERIALS AND TECHNIQUES boxes explain and illustrate the methods artists and architects use to produce their work.

Materials & Techniques
Tapestry

Tapestries are heavy textiles hand-woven on looms. The looms range in size from small, hand-held models to large, freestanding structures. They serve as frames, holding in tension supporting threads, called the **warp**, so that striking threads, called the **weft**, can be interwoven between them. Warp threads are made of strong fibers, usually wool or linen, while weft threads are brightly colored strands of silk or wool, spun gold, or spun silver. Once the warp threads are stretched on the loom, the weaver places a **cartoon**, or full-scale drawing, below or behind the loom. The weaver then works on the back side of the tapestry, pushing the weft threads under and over the warp threads, knotting alternating colors together in a single strand, to match the cartoon's design. So the front side of the tapestry reproduces the design in reverse. The design can approach painting in its compositional complexity, refinement, and the three-dimensional rendering of forms.

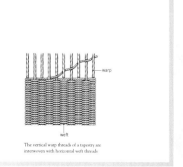

The vertical warp threads of a tapestry are interwoven with horizontal weft threads

Through Special Features and Primary Sources

Each chapter of *The Humanities* includes **PRIMARY SOURCE READINGS** in two formats. Brief readings from important works are included within the body of the text. Longer readings located at the end of each chapter allow for a more in-depth study of particular works. This organization offers great flexibility in teaching the course.

END-OF-CHAPTER READINGS

BRIEF READINGS

626 ━ BOOK THREE THE RENAISSANCE AND THE AGE OF ENCOUNTER

READINGS

READING 17.4

from Baldassare Castiglione, *The Book of the Courtier*,
Book 1 (1513–18; published 1528)

Castiglione spent his life in the service of princes, first in the courts of Mantua and Urbino, and then in Rome, where he served the papacy. His Book of the Courtier was translated into most European languages and remained popular for two centuries. It takes the form of a series of fictional conversations between the courtiers of the duke of Urbino in 1507 and included the duchess. In the excerpt below, the separate speakers have not been identified to facilitate ease of reading. The work is a celebration of the ideal character of the Renaissance humanist and the ethical behavior associated with that ideal.

[The Perfect Courtier]

Within myself I have long doubted, dearest messer Alfonso, which of two things were the harder for me: to deny you what you have often begged of me so urgently, or to do it. For while it seemed to me very hard to deny anything (and especially a thing in the highest degree laudable) to one whom I love most dearly and by whom I feel myself to be most dearly loved, yet to set about an enterprise that I am not sure of being able to finish, seemed to me ill befitting a man who esteems just censure as it ought to be esteemed. . . .

You ask me then to write what is to my thinking the form of Courtiership most befitting a gentleman who lives at the court of princes, by which he may have the ability and knowledge perfectly to serve them in every reasonable thing, winning from them favor, and praise from other men; in short, what manner of man he ought to be who may deserve to be called a perfect Courtier without flaw. . . .

So now let us make a beginning of our subject, and if possible let us form such a Courtier that any prince worthy to be served by him, although of but small estate, might still be called a very great lord.

I wish then, that this Courtier of ours should be nobly born and of gentle race; . . . for noble birth is like a bright lamp that manifests and makes visible good and evil deeds, and kindles and stimulates to virtue both by fear of shame and by hope of praise. . . . And thus it nearly always happens that both in the profession of arms and in other worthy pursuits the most famous men have been of noble birth, because nature has implanted in everything that hidden seed which gives a certain force and quality of its own essence to all things that are derived from it, and makes them like itself: as we see not only in the breeds of horses and other animals, but also in trees, the shoots of which nearly always resemble the trunk; and if they sometimes degenerate, it arises from poor cultivation. And so it is with men, who if rightly trained are nearly always those from whom they spring, and often

It is true that, by favor of the stars or of nature, some men are endowed at birth with such graces that they seem not to have been born, but rather as if some god had formed them with his very hands and adorned them with every excellence of mind and body. So too there are many men so foolish and rude that one cannot but think that nature brought them into the world out of contempt or mockery. Just as these can usually accomplish little even with constant diligence and good training, so with slight pains those others reach the highest summit of excellence. . . .

Besides this noble birth, then, I would have the Courtier favored in this regard also, and endowed by nature not only with talent and beauty of person and feature, but with a certain grace and (as we say) air that shall make him at first sight pleasing and agreeable to all who see him; and I would have this an ornament that should dispose and unite all his actions, and in his outward aspect give promise of whatever is worthy the society and favor of every great lord.

But to come to some details, I am of opinion that the principal and true profession of the Courtier ought to be that of arms; which I would have him follow actively above all else, and be known among others as bold and strong, and loyal to whomsoever he serves. And he will win a reputation for these good qualities by exercising them at all times and in all places, since one may never fail in this without severest censure. And just as among women, their fair fame once sullied never recovers its first lustre, so the reputation of a gentleman who bears arms, if once it be in the least blemished with cowardice or other disgrace, remains forever infamous before the world and full of ignominy. Therefore the more our Courtier excels in this art, the more he will be worthy of praise . . .

. . . And of such sort I would have our Courtier's aspect; not so soft and effeminate as is sought by many, who not only curl their hair and pluck their brows, but gloss their faces with all those arts employed by the most wanton and unchaste women in the world; and in their walk, posture and every act, they seem so limp and languid that their limbs are like to fall apart; and they pronounce their words so mourn-

THE VENETIAN RENAISSANCE CHAPTER 19 ━ 627

The poem, in short, demonstrates that traditional chivalric virtues—those that Castiglione was outlining in *The Book of the Courtier* (see chapter 17) even as Ariosto was writing his poem—had little or no relevance to the modern Italian court, just as armor, swords, and lances had been made irrelevant by the invention of gunpowder. On the subject of gunpowder, the poem makes the following lament (Reading 19.2b):

READING 19.2b from Ludovico Ariosto,
** *Orlando Furioso*, Canto XI**

XXVI

How, foul and pestilent discovery,
Didst thou find place within the human heart?
Through thee is martial glory lost, through thee
The trade of arms become a worthless art:
And at such ebb are worth and chivalry,
That the base often plays the better part.
Through thee no more shall gallantry, no more
Shall valour prove their prowess as of yore.

Love is never ennobling in the poem—and rarely chivalric—but leads only to insult, rejection, madness, and death. The only way to save oneself is not to love at all. But however unsympathetic the poem is to the chivalric code, Ariosto's ability to create an exciting narrative of nonstop action that moves across the globe in large part accounts for his poem's extraordinary success. Throughout the sixteenth century, new readers discovered the poem as the printing press (see chapter 21) made it more widely available, especially to a popular audience that had little use for the conventions of chivalry.

Lucretia Marinella's *The Nobility and Excellence of Women*

Not surprisingly, Renaissance women also attacked the chivalric, or rather pseudo-chivalric, attitudes and behavior of Renaissance women. One such attack was *The Nobility and Excellence of Women and the Defects and Vices of Men* by the Venetian writer Lucretia Marinella [loo-CREE-sha mah-ree-NEL-lah] (1571–1653), published in Venice around 1600 and widely circulated. (See **Reading 19.3a**.) Marinella was one of the most prolific writers of her day. She published many works, including a pastoral drama, musical compositions, religious verse, and an epic poem celebrating Venice's role in the Fourth Crusade, but her sometimes vitriolic polemic against men is unique in the literature of the time. *The Nobility and Excellence of Women* is a response to a contemporary diatribe, *The Defects of Women*, written by her Venetian contemporary, Giuseppe Passi [PAHS-see].

It is clear enough to Marinella, who had received a humanistic education, that any man who denigrates women

is motivated by such reasons as anger and envy (see Reading 19.3, pages 631–632, for an extended excerpt).

READING 19.3a from Lucretia Marinella,
** *The Nobility and Excellence*
** *of Women***

When a man wishes to fulfill his unbridled desires and is unable to because of the temperance and continence of a woman, he immediately becomes angry and disdainful, and in his rage says every bad thing he can think of, as if the woman were something evil and hateful. . . . When a man sees that a woman is superior to him, both in virtue and in beauty, and that she is justly honored and loved even by him, he tortures himself and is consumed with envy. Not being able to give vent to his emotions in any other way, he resorts with sharp and biting tongue to false and specious vituperation and reproof. . . . But if with a subtle intelligence, men should consider their own imperfections, oh how lamentable and low they would become! Perhaps one day, God willing, they will perceive it.

From Marinella's point of view, Renaissance women possess the fullest measure of Castiglione's moral virtue and humanist individualism, not the courtiers themselves. The second part of the book, on the defects and vices of men, is a stunning and sometimes amusing reversal of Passi's arguments, crediting men with all the vices he attributes to women.

For Marinella, Ariosto's *Orlando Furioso*, with its many exemplary female characters, was a rich mine of opinions, episodes, and characters that suggest women's moral and intellectual eminence. She makes use of the Neoplatonic argument that beauty is a reflection of goodness, arguing that women's souls must be preeminent because of "the beauty of their bodies." But perhaps Marinella's most important distinction is her insistence that women are autonomous beings, who should not be defined only in relation to men. (See *Voices*, page 627.)

Music of the Venetian High Renaissance

Almost without exception, women of literary accomplishment in the Renaissance were musically accomplished as well. As we have seen, Isabella d'Este played both the lute and the *lira da braccio*, the precursor to the modern violin (see Fig. 18.18). Through her patronage, she and her sister-in-law Lucrezia Borgia, duchess of Ferrara, competed for musicians and encouraged the cultivation of the *frottola*, (see chapter 17). Courtesans such as Veronica Franco could both sing and play. And both Isabella and Elisabetta Gon-

Voices

A Young Woman's Perspective on Venetian Society

Against her will, the parents of Arcangela Tarabotti (1604–1652) sent her to a Benedictine convent near Venice for her education. Here she expresses her passionate anger at her family, the convent system, and the hierarchy of Venetian society. This excerpt is from her first work, Parental Tyranny. Her next work was an even more searing indictment (never published) entitled Convent Hell.

"As soon as you men catch sight of a woman with pen in hand, you start ranting and raving; you order them under penalty of death to put aside their scribbling and attend to "feminine" tasks like needlework and spinning. . . ."

Compares the plight of young girls in the convent to captured birds:

Whenever I see one of these hapless young girls, betrayed by their very own parents, I am reminded of what happens to a pretty little bird from within the tree's foliage or along riverbanks, it delights the ear with sweet chirping and charming song, soothing the hearts of its audience—when suddenly it's trapped in a treacherous net, robbed of precious liberty.

Discussing education, Tarabotti focuses on her own experiences:

So shameless are you that while reproaching women for stupidity you strive with all your power to bring

them up and educate them as if they were witless and insensitive. You give them such a governess another woman, also unlettered, who can barely instruct them in the rudiments of reading, to say nothing of anything to do with philosophy, law, and theology. In short, they learn nothing but the ABC, and even that is poorly taught. (I know from experience, so I can bear witness at length.)

As soon as you men catch sight of a woman with pen in hand, you start ranting and raving; you order them under penalty of death to put aside their scribbling and attend to "feminine" tasks like needlework and spinning. . . . (As if our intellects could find no more appropriate occupation than spinning!)

Included in every chapter, **VOICES** features offer vivid first person accounts of the experiences of ordinary people during the period covered in the chapter. These primary source readings offer a glimpse of what life was like in the past and help students understand the social context of a particular culture.

A **CD ICON** calls out musical selections discussed in the text that are found on the supplemental CDs available for use with *The Humanities*.

zaga, duchess of Urbino, were well known for their ability to improvise songs. By the last decades of the sixteenth century, we know that women were composing music as well. The most famous of these was the Venetian Madalena Casulana [mah-dah-LAY-nah kah-soo-LAH-nah].

Madalena Casulana's Madrigals

Madalena Casulana was the first professional woman composer to see her own compositions in print. In 1566, her anthology entitled *The Desire* was published in Venice. Two years later, she dedicated her first book of songs to Isabella

chapter 17), the madrigal is **through-composed**—that is, each line of text is set to new music. This allows for word painting, where the musical elements imitate the meaning of the text in mood or action. Anguish, for example, is conveyed with an unusually low pitch, as in Casulana's *Morir non può il mio cuore* [moh-REER nohn pwo eel MEE-oh KWOR-eh] ("My Heart Cannot Die") (**CD-Track 19.1**). The song laments a relationship gone bad, and the narrator contemplates driving a stake through her heart because it is in so much pain. When she says that her suicide might kill her beloved—*so che morreste toi* [so keh mor-EH-stay VOY] ("I know that you would die")—

See Context and Make Connections...
Across Cultures

The Humanities: Culture, Continuity, and Change provides the most comprehensive coverage of various cultures including Asia, Africa, the Americas, and Europe.

Included in every chapter, **CULTURAL PARALLELS** highlight historical and artistic developments occurring in different locations during the period covered in the chapter. This feature helps students understand parallel developments in the humanities across the globe.

Detailed **MAPS** in each chapter orient the reader to the locations discussed in the chapter.

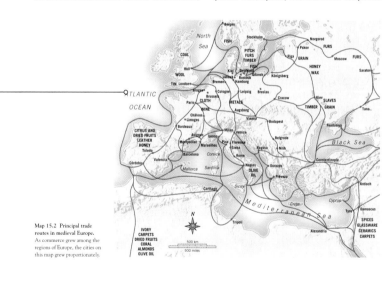

464 ⌒ **BOOK TWO** MEDIEVAL EUROPE AND THE SHAPING OF WORLD CULTURES

CULTURAL PARALLELS

Textiles in Florence and Peru

Florence was the center of textile production in the West, but 7,000 miles farther west, the Inca culture of the Peruvian highlands also produced abundant supplies of high-quality textiles. The Inca valued these woolen products even more than gold, and weavers encoded complex symbolism into the fabric (see chapter 16).

The Guilds and Florentine Politics Only two other cities in all of Italy—Lucca and Venice—could boast that they were republics like Siena and Florence, and governing a republic was no easy task. As in Siena, in Florence the guilds controlled the commune. By the end of the twelfth century there were seven major guilds and fourteen minor ones. The most prestigious was the lawyers' guild (the Arte dei Giudici), followed closely by the wool guild (the Arte della Lana), the silk guild (the Arte di Seta), and the cloth merchants' guild (the Arte di Calimala). Also among the major guilds were the bankers, the doctors, and other merchant classes. Butchers,

bakers, carpenters, and masons composed the bulk of the minor guilds.

As in Siena, too, the merchants, especially the Arte della Lana, controlled the government. They were known as the *Popolo Grasso* (literally, "the fat people"), as opposed to *Popolo Minuto*, the ordinary workers, who comprised probably 75 percent of the population and had no voice in government. Only guild members could serve in the government. Their names were written down, the writing was placed in leather bags (*borse*) in the Church of Santa Croce, and nine names were drawn every two months in a public ceremony. (The period of service was short to reduce the chance of corruption.) Those *signori* selected were known as the *Priori*, and their government was known as the *Signoria*—hence the name of the Piazza della Signoria, the plaza in front of the Palazzo Vecchio. There were generally nine Priori—six from the major guilds, two from the minor guilds, and one standard-bearer.

The Florentine republic might have resembled a true democracy except for two details: First, the guilds were very close-knit so that, in general, selecting one or the other of their membership made little or no political difference; and second, the available names in the *borse* could be easily manipulated. However, conflict inevitably arose, and throughout the thirteenth century other tensions made the problem worse, especially feuds between the Guelphs and

Map 15.2 Principal trade routes in medieval Europe. As commerce grew among the regions of Europe, the cities on this map grew proportionately.

See Context and Make Connections... with Teaching and Learning Resources

Title: *The Libyan Sibyl*
Artist: Michelangelo Buonarroti
Date: 1511-1512
Source/Museum: Detail of the Sistine Ceiling, Sistine Chapel, Vatican, Rome, Italy.
Medium: Fresco
Size: n/a

THE PRENTICE HALL DIGITAL ARTS LIBRARY contains every image in *The Humanities* in the highest resolution and pixellation possible for optimal projection. Each image is available in jpeg format and as a customizable PowerPoint® slide with an instant download function. Available to instructors upon adoption of *The Humanities*, the Digital Arts Library also includes video and audio clips for use in classroom presentations.
DVD Set: 978-0-13-615298-9
CD Set: 978-0-13-615299-6

myhumanitieslab

MYHUMANITIESLAB is a dynamic online resource that provides opportunities for practice, assessment, and instruction—including digital flashcards of every image in the text. Easy to use and easy to integrate into the classroom, it engages students as it builds confidence and enhances students' learning experience.
Visit **www.myhumanitieslab.com** to begin.

Instructor's Manual and Test Item File
978-0-113-18272-5

Test Generator
978-0-13-182730-1
www.prenhall.com/irc

Companion Website
www.prenhall.com/sayre

Student Study Guide
Volume I: 978-0-13-615316-0
Volume II: 978-0-13-615317-7

VangoNotes Audio Study Guides
www.vangonotes.com

Music CDs
Music CD to Accompany Volume I: 978-0-13-601736-3
Music CD to Accompany Volume II: 978-0-13-601737-0

The Prentice Hall Atlas of the Humanities
978-0-13-238628-9

Package Penguin titles at a significant discount
Visit **www.prenhall.com/art** for information.

Developing *The Humanities*

The Humanities: Culture, Continuity, and Change is the result of an extensive development process involving the contributions of over one hundred instructors and their students. We are grateful to all who participated in shaping the content, clarity, and design of this text. Manuscript reviewers and focus group participants include:

Kathryn S. Amerson, *Craven Community College*

Helen Barnes, *Butler County Community College*

Bryan H. Barrows III, *North Harris College*

Amanda Bell, *University of North Carolina, Asheville*

Sherry R. Blum, *Austin Community College*

Edward T. Bonahue, *Santa Fe Community College*

James Boswell Jr., *Harrisburg Area Community College–Wildwood*

Diane Boze, *Northeastern State University*

Robert E. Brill, *Santa Fe Community College*

Daniel J. Brooks, *Aquinas College*

Farrel R. Broslawsky, *Los Angeles Valley College*

Benjamin Brotemarkle, *Brevard Community College–Titusville*

Peggy A. Brown, *Collin County Community College*

Robert W. Brown, *University of North Carolina –Pembroke*

David J. Califf, *The Academy of Notre Dame*

Gricelle E. Cano, *Houston Community College–Southeast*

Martha Carreon, *Rio Hondo College*

Charles E. Carroll, *Lake City Community College*

Margaret Carroll, *Albany College of Pharmacy of Union University*

Beverly H. Carter, *Grove City College*

Michael Channing, *Saddleback Community College*

Patricia J. Chauvin, *St. Petersburg College*

Cyndia Clegg, *Pepperdine University*

Jennie Congleton, *College Misericordia*

Ron L. Cooper, *Central Florida Community College*

Similih M. Cordor, *Florida Community College*

Laurel Corona, *San Diego City College*

Michael W. Coste, *Front Range Community College–Westminster*

Harry S. Coverston, *University of Central Florida*

David H. Darst, *Florida State University*

Gareth Davies-Morris, *Grossmont College*

James Doan, *Nova Southeastern University*

Jeffery R. W. Donley, *Valencia Community College*

William G. Doty, *University of Alabama*

Scott Douglass, *Chattanooga State Technical Community College*

May Du Bois, *West Los Angeles College*

Tiffany Engel, *Tulsa Community College*

Walter Evans, *Augusta State University*

Douglas K. Evans, *University of Central Florida*

Arthur Feinsod, *Indiana State University*

Kimberly Felos, *St. Petersburg College–Tarpon Springs*

Jane Fiske, *Fitchburg College*

Brian Fitzpatrick, *Endicott College*

Lindy Forrester, *Southern New Hampshire University*

Barbara Gallardo, *Los Angeles Harbor College*

Cynthia D. Gobatie, *Riverside Community College*

Blue Greenberg, *Meredith College*

Richard Grego, *Daytona Beach Community College–Daytona*

Linda Hasley, *Redlands Community College*

Dawn Marie Hayes, *Montclair State University*

Arlene C. Hilfer, *Ursuline College*

Clayton G. Holloway, *Hampton University*

Marion S. Jacobson, *Albany College of Pharmacy of Union University*

Bruce Janz, *University of Central Florida*

Steve Jones, *Bethune-Cookman College*

Charlene Kalinoski, *Roanoke College*

Robert S. Katz, *Tulsa Community College*

Alice Kingsnorth, *American River College*

Connie LaMarca-Frankel, *Pasco-Hernando Community College*

Leslie A. Lambert, *Santa Fe Community College*

Sandi Landis, *St. Johns River Community College–Orange Park*

Vonya Lewis, *Sinclair Community College*

David Luther, *Edison Community College, Collier*

Michael Mackey, *Community College of Denver*

Janet Madden, *El Camino College*

Ann Marie Malloy, *Tulsa Community College–Southeast*

James Massey, *Polk Community College*

John Mathews, *Central Florida Community College*

Susan McClung, *Hillsborough Community College–Ybor City*

Joseph McDade, *Houston Community College, Northeast*

Brian E. Michaels, *St. Johns River Community College*

Maureen Moore, *Cosumnes River College*

Nan Morelli-White, *St. Petersburg College–Clearwater*

Jenny W. Ohayon, *Florida Community College*

Beth Ann O'Rourke, *University of Central Florida*

Elizabeth Pennington, *St. Petersburg College–Gibbs*

Nathan M. Poage, *Houston Community College–Central*

Norman Prinsky, *Augusta State University*

Jay D. Raskin, *University of Central Florida*

Sharon Rooks, *Edison Community College*

Douglas B. Rosentrater, *Bucks County Community College*

Grant Shafer, *Washtenaw Community College*

Mary Beth Schillaci, *Houston Community College–Southeast*

Tom Shields, *Bucks County Community College*

Frederick Smith, *Lake City Community College*

Sonia Sorrell, *Pepperdine University*

Jonathan Steele, *St. Petersburg Junior College*

Elisabeth Stein, *Tallahassee Community College*

Lisa Odham Stokes, *Seminole Community College*

Alice Taylor, *West Los Angeles College*

Trent Tomengo, *Seminole Community College*

Cordell M. Waldron, *University of Northern Iowa*

Robin Wallace, *Baylor University*

Daniel R. White, *Florida Atlantic University*

Naomi Yavneh, *University of South Florida*

John M. Yozzo, *East Central University*

James Zaharek, *Rio Hondo College*

Kenneth Zimmerman, *Tallahassee Community College*

Acknowledgments

No project of this scope could ever come into being without the hard work and perseverance of many more people than its author. In fact, this author has been humbled by a team at Pearson Prentice Hall that never wavered in its confidence in my ability to finish this enormous undertaking (or if they did, they had the good sense not to let me know); never hesitated to cajole, prod, and massage me to complete the project in something close to on time; and always gave me the freedom to explore new approaches to the materials at hand. At the down-and-dirty level, I am especially grateful to fact checker, George Kosar; to historian Frank Karpiel, who helped develop the timelines, the Cultural Parallels, and the Voices features of the book; to Mary Ellen Wilson for the pronunciation guides; as well as the more specialized pronunciations offered by David Atwill (Chinese and Japanese); Jonathan Reynolds (African); Nayla Muntasser (Greek and Latin); and Mark Watson (Native American); to John Sisson for tracking down the readings; to Laurel Corona for her extraordinary help with Africa; to Arnold Bradford for help with critical thinking questions; and to Francelle Carapetyan and her assistant Rebecca Harris for their remarkable photo research. The maps and some of the line art are the work of cartographer and artist, Peter Bull, with Precision Graphic drafting a large portion of the line art for the book. I find both in every way extraordinary.

In fact, I couldn't be more pleased with the look of the book, which is the work of Leslie Osher, associate director of design, Nancy Wells, senior art director, and Ximena Tamvakopoulos, designer. The artistic layout of the book was created by Gail Cocker-Bogusz and Wanda España. Gail Cocker-Bogusz coordinated the map and line art program with the help of Mirella Signoretto. The production of the book was coordinated by Barbara Kittle, director of operations; Lisa Iarkowski, associate director of team-based project management; Mary Rottino, senior managing editor; and by Harriet Tellem, project manager; who oversaw with good humor and patience the day-to-day, hour-to-hour crises that arose. Sherry Lewis, operations manager, ensured that this project progressed smoothly through its production route.

The marketing and editorial teams at Prentice Hall are beyond compare. On the marketing side, Brandy Dawson, director of marketing; Marissa Feliberty, executive marketing manager; and Irene Fraga, marketing assistant; helped us all to understand just what students want and need. On the editorial side, my thanks to Yolanda de Rooy, president of the Humanities and Social Science division; to Sarah Touborg, editor-in-chief; Amber Mackey, senior editor; Bud Therien, special projects manager; Alex Huggins, assistant editor; and Carla Worner, editorial assistant. The combined human hours that this group has put into this project are staggering. Deserving of special mention is my development team, Rochelle Diogenes, editor-in-chief of development; Roberta Meyer, senior development editor; Karen Dubno; and Elaine Silverstein. Roberta may be the best in the business, and I feel extremely fortunate to have worked with her.

Finally, I want to thank, with all my love, my beautiful wife, Sandy Brooke, who has supported this project in every way. She continued to teach, paint, and write, while urging me on, listening to my struggles, humoring me when I didn't deserve it, and being a far better wife than I was the husband. I was often oblivious, and might at any moment disappear into the massive pile of books beside my desk that she never made me pick up. To say the least, I promise to pick up.

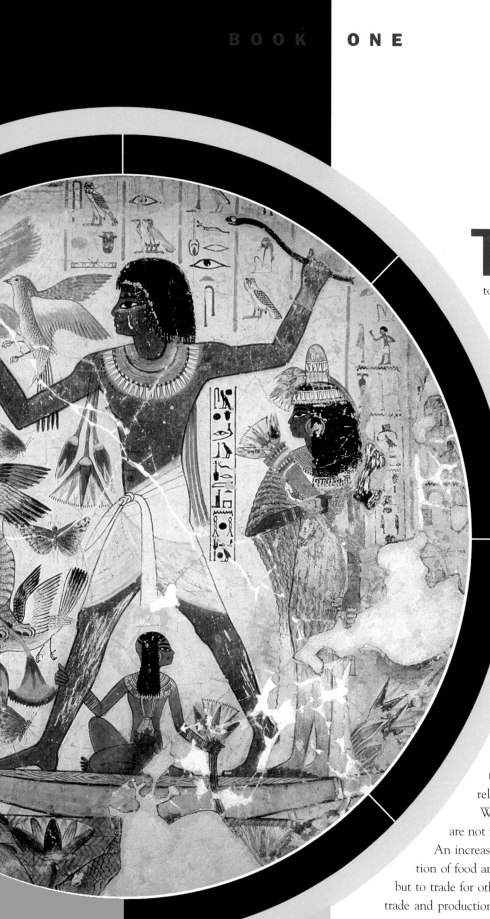

The history of human beings on this planet is, geologically speaking, very short. The history of their coming together in groups for their common good is even shorter, covering a span of perhaps 25,000–50,000 years on a planet that scientists estimate to be between 4 and 5 billion years old. We call these groups, as they become more and more sophisticated, civilizations. A **civilization** is a social, economic, and political entity distinguished by the ability to express itself through images and written language. Civilizations develop when the environment of a region can support a large and productive population. It is no accident that the first civilizations arose in fertile river valleys, where agriculture could take hold: the Tigris and the Euphrates in Mesopotamia, the Nile in Egypt, the Indus on the Indian subcontinent, and the Yellow in China. Civilizations require technologies capable of supporting the principal economy. In the ancient world, agriculture was supported by the technologies related to irrigation.

When the need arises for raw materials that are not native to a particular region, trade results. An increasing population requires increased production of food and other goods, not only to support itself, but to trade for other commodities. Organizing this level of trade and production, also requires an administrative elite to

Detail from *Nebamun Hunting Birds,* from the tomb of Nebamun, Thebes. ca. 1400 BCE, (see Fig 3.2).

The Ancient World and the Classical Past: Prehistory to 200 CE

form and to establish priorities. The existence of such an elite is another characteristic of civilization. Finally, as the history of cultures around the world makes abundantly clear, one of the major ways that societies have acquired the goods they want and simultaneously organized themselves is by means of war.

If a civilization is a system of organization, a **culture** is the set of common values—religious, social, and/or political—that governs that system. We generally judge a culture's relative success by the quality of the science and art that it creates. While science plays a crucial role in the development of new technologies, the arts appear as part of the general specialization of craft industries, closely connected to trade. Art, music, and literature are also closely tied to the increased concentration of wealth among the society's elite. To a certain degree, they come to signify power and social status, because only the wealthy can afford them. Furthermore, they play an important role in religion, one of civilization's most powerful instruments of social organization and unity and, paradoxically, one of its greatest sources of misunderstanding and conflict. The arts represent the visible sign of the nonvisible world, the world of the gods, the afterlife, and the imagination. They embody, in word, sound, and image, our ability to make and understand the symbolic—our ability, in short, to communicate.

We begin this book, then, with the first inklings of civilized cultures in prehistoric times, evidence of which survives in wall paintings in caves and small sculptures dating back more than 25,000 years. Before the invention of writing sometime after 10,000 BCE, these cultures created myths and legends that explained their origins and relation to the world. As we do today, ancient peoples experienced the great, uncontrollable, and sometimes violent forces of nature—floods, droughts, earthquakes, and hurricanes. Prehistoric cultures understood these forces as the work of the invisible gods, who could not be approached directly but only through the mediating agency of shamans and priests, or kings and heroes. As predictable as the natural world could sometimes be—in the daily cycle of day and night and the annual changing of the seasons—the forces that governed it represented the unknown, the mysteries of life and death, origin and eternal destiny.

Sometime between 1000 and 500 BCE, human nature began to assert itself over and against nature as a whole. In the islands between mainland Greece and Asia Minor, in Egypt, in China, on the Indian subcontinent, and on the Greek mainland, people increasingly thought of themselves as masters of their own destiny. This is reflected in their art: Although the gods still embodied the forces of nature, they began to look more human and to act in ways consistent with human foibles, ambiguities, and ills. The gods could still intervene in human affairs, but now they did so in ways that were recognizable. It was suddenly possible to believe that if people could come to understand themselves, they might also understand the gods. The study of the natural world might well shed light on the unknown, on the truth of things.

It is to this moment—it was a long "moment," extending for centuries—that the beginnings of scientific inquiry can be traced. Humanism, the study of the human mind and its moral and ethical dimensions, was born. In China, the formalities of social interaction—moderation, personal integrity, self-control, loyalty, altruism, and justice—were codified in the writings of Confucius. In Greece, especially fifth-century BCE Athens, the presentation of a human character working things out (or not) in the face of adversity was the subject of dramatic literature. It was also the subject of philosophy—literally, "love of wisdom"—the practice of reasoning that followed from the Greek philosopher Socrates' famous dictum, "Know thyself." Visual artists strove to perfect the human form through art, just as the philosopher Plato argued for the more mental Ideal Forms of the Good and the Beautiful.

Several centuries later, these traditions were carried on in more practical ways. The Romans attempted to *engineer* a society embodying the values of Greek art and culture.

Timeline Book One: Prehistory to 200 CE

	2.5 MILLION YEARS–10,000 BCE	10,000 BCE–3000 BCE	3000 BCE–1100 BCE
HISTORY AND CULTURE	**120,000–40,000 BCE:** development of *Homo neandertalensis*, later *Homo sapiens*; nomadic hunter-gatherers spread throughout Africa, Asia, Europe **30,000 BCE:** Ice Age **9,000–8,000 BCE:** ice recedes from Northern Hemisphere	**10,000–3000 BCE:** growth of large-scale agricultural societies in Mesopotamia, Indus River valley, Egypt, China **4000–3000 BCE:** earliest large cities emerge in southern Mesopotamia and control neighboring regions	**3000 BCE:** reign of Narmer; unifies upper/lower Egypt **3000–2000 BCE:** Aegean region Bronze Age, Cycladic culture **2700–2500 BCE:** reign of Gilgamesh, in Uruk, Mesopotamia **2700–1500 BCE:** Indus Valley civilization **2647–2124 BCE:** Old Kingdom era (Egypt) **2200–1766 BCE:** Xia dynasty in China; early efforts at organizing public life **2040–1648 BCE:** Middle Kingdom (Egypt) **1800–1375 BCE:** Minoan era, Greek culture centered in Crete **1792–1750 BCE:** Hammurabi's Law code **1700–1045 BCE:** Shang dynasty era (China); King Tang establishes dynasty, first large armies **1648 BCE:** Hyksos nomads invade Egypt from Aegean Sea **1623 BCE:** volcanic eruption destroys Thera (Santorini) **1540–1069 BCE:** New Kingdom (Egypt) **1500–322 BCE:** Vedic period (India and Indus Valley)
RELIGION AND PHILOSOPHY		**10,000–8000 BCE:** emergence of religious elites; priests, shamans in Mesopotamia, Egypt, China **4,000–2,000 BCE:** first city-state governments form in Sumeria ruled by priest-kings	**2040–1648 BCE:** Middle Kingdom: Theban deity Amun becomes main Egyptian deity **1500-322 BCE:** Vedic period and origins of Hinduism
TECHNOLOGY AND SCIENCE	**2.5 million years ago:** hominids in Africa develop first stone tools **800,000–100,000 BCE:** Lower Paleolithic, expanding use of stone tools **100,000–40,000 BCE:** Middle Paleolithic, development of sophisticated tools—cleavers, chisels, axes	**8000–3000 BCE:** development of ornate pottery for food and water storage **3500 BCE:** beginning of Bronze Age in Asia Minor	**2000 BCE:** beginning of iron technology in Asia Minor **1648–1540 BCE:** Egypt: Hyksos introduce horse-drawn chariot, transforms warfare **1500–1200 BCE:** development of Linear A, Linear B writing system in Aegean region
ART AND ARCHITECTURE	**30,000 BCE:** skilled art created in caves at Chauvet and Lascaux in France; Altimira, Spain **22,000 BCE:** creation of female sculptures, including *Venus of Willendorf* Bison, Chauvet Cave		**3000 BCE:** Egypt: *Palette of Narmer*—early hieroglyphic inscription depicting unification of Egypt **2650 BCE:** Egypt: Stepped Pyramid of Djoser, world's first pyramid **2500 BCE:** building of Giza pyramids
LITERATURE AND MUSIC		**3200–2000 BCE:** Mesopotamia: development of first writing system—cuneiform script	**2600 BCE:** first Chinese writing **1766–1122 BCE:** first written records of Shang dynasty, origins of the *I Ching* or *Book of Changes* (China) **1500 BCE:** creation of *Vedas*, sacred hymns written in Sanskrit (India) **1347–1323 BCE:** *Great Hymn to Aten* (Egypt) **ca. 1,200 BCE:** *Epic of Gilgamesh* written–world's first epic story **1200 BCE:** earliest use of Phoenician alphabet

1100 BCE–500 BCE	500 BCE–200 CE	
1300 BCE: Olmec culture develops–Mesoamerica **1100–800 BCE:** "Dark Ages" in Greece **1027–256 BCE:** Zhou dynasty era (China); development of written laws **1000–961 BCE:** reign of King David in Israel **883–600 BCE:** Ashurnasirpal II begins Assyrian empire **800 BCE:** development of Greek city-states—the *polis* **800–600 BCE:** origins of Roman culture, Etruscan story of *Romulus and Remus* **721 BCE:** Israelites exiled from homeland by Assyrians **715 BCE:** Kushites invade Egypt from Ethiopia **656 BCE:** Assyrians invade Egypt **559 BCE:** statesman and poet Solon rules Athens **538 BCE:** Hebrews return to Jerusalem **525 BCE:** Persians invade Egypt, incorporate into their empire **510 BCE:** Rome inaugurates self-rule, expels Etruscan kings **508 BCE:** Kleisthenes, ruler of Athens, institutes first democracy Ritual disc (Zhou dynasty)	**490 BCE:** Greeks defeat Persians at Marathon **461–429 BCE:** "Golden Age" of Pericles—Athens **450 BCE:** revolt of Sparta **431–404 BCE:** Peloponnesian Wars (Greece); Sparta dedeats Athens **356–323 BCE:** lifetime of Alexander the Great **273–232 BCE:** reign of King Ashoka in India **264–146 BCE:** the Punic Wars. Rome battles Carthage in North Africa. Carthage is defeated. Rome annexes Spain and dominates Asia Minor, Syria, Egypt, and Greece. **221–206 BCE:** Qin dynasty era (China) led by emperor Shi Huang Ti **206 BCE–220 CE:** Han dynasty (China); expansion of trade to/from China via Silk Road **100–44 BCE:** lifetime of Julius Caesar **73–71 BCE:** Roman slave revolt led by Spartacus **44 BCE:** Caesar assumes dictatorial power and is assassinated **27 BCE:** end of Roman Republic, Octavian becomes Emperor Augustus **27 BCE–68 CE:** rule of Julio-Claudian dynasty—Rome **69–96 CE:** rule of Flavian dynasty—Rome **96–180 CE:** rule of "Five Good Emperors"	**HISTORY AND CULTURE**
1000 BCE: Lao Zi develops Taoist philosophy **ca 800 BCE:** Hesiod composes *Works and Days* and *Theogeny* **563–483 BCE:** lifetime of Siddhartha Gautama (Buddha) in India **551–479 BCE:** lifetime of Confucius, philosopher and writer	**469–399 BCE:** lifetime of Socrates, Greek philosopher **461–429 BCE:** Sophist philosophers including Protagoras teach humanism, politics, rhetoric **384–322 BCE:** lifetime of Aristotle **280–233 BCE:** lifetime of Han-Fei-Tzu, philosopher of Legalism **273–232 BCE:** Buddhism becomes official state religion of India	**RELIGION AND PHILOSOPHY**
ca. 600 BCE: earliest Latin inscriptions	**221–206 BCE:** Qin dynasty standardizes Chinese written language, coins, roads, weights and measures **206 BCE–220 CE:** development of maps, invention of paper (China) **27 BCE–68 CE:** Roman emperors accelerate public works including Aqua Claudia aqueduct, using concrete	**TECHNOLOGY AND SCIENCE**
970–933 BCE: Solomon's temple built **850 BCE:** Ashurnasirpal II's palace complex and capital city built **800 BCE:** development of *acropolis* (citadel) and *agora* (market) in Greek city-states **800–600 BCE:** Etruscan temples constructed of mudbrick and wood, adapted Greek Doric order of columns, creating Tuscan order **600–400 BCE:** development of three orders of Greek architecture: Doric, Ionic, Corinthian	**500 BCE:** *Dying Warrior* sculpture highlights Mycenaean military prowess **461–429 BCE:** "Golden Age" Athens rebuilds Acropolis, constructs Parthenon **273 BCE:** spread of Buddhist architecture and art throughout Indian subcontinent and nearby regions **69–79 CE:** Emperor Vespasian builds Roman Colosseum Recumbent God (Parthenon)	**ART AND ARCHITECTURE**
1000 BCE: *Dao de jing* composed by Lao Zi **800 BCE:** earliest written Homeric epics, *Illiad* and *Odyssey* (Greece) **610–580 BCE:** lifetime of Sappho, female poet—Greece **ca. 600 BCE:** *Book of Songs* includes 305 poems (China) **525–456 BCE:** lifetime of Aeschylus, author of 97 plays **500 BCE:** *Epic of Ramayana* written by Valmiki (India)	**496–406 BCE:** lifetime of Sophocles, playwright, civic leader **480–406 BCE:** lifetime of Euripides (*Medea, The Trojan Women*)—Greece **445–388 BCE:** lifetime of Aristophanes (*Lysistrata*)—Greece **400 BCE:** *Mahabharata* composed (India) **431 BCE:** Thucydides writes *History of the Peloponnesian Wars* **300 BCE:** Ptolemies create world's largest library at Alexandria, Egypt, holding 700,000 volumes **106–43 BCE:** lifetime of Cicero, Roman statesman, political theorist **99–55 BCE:** lifetime of Lucretius, Roman poet, author of *De Rerum Natura* **8 BCE–65 CE:** lifetime of Seneca, Roman writer	**LITERATURE AND MUSIC**

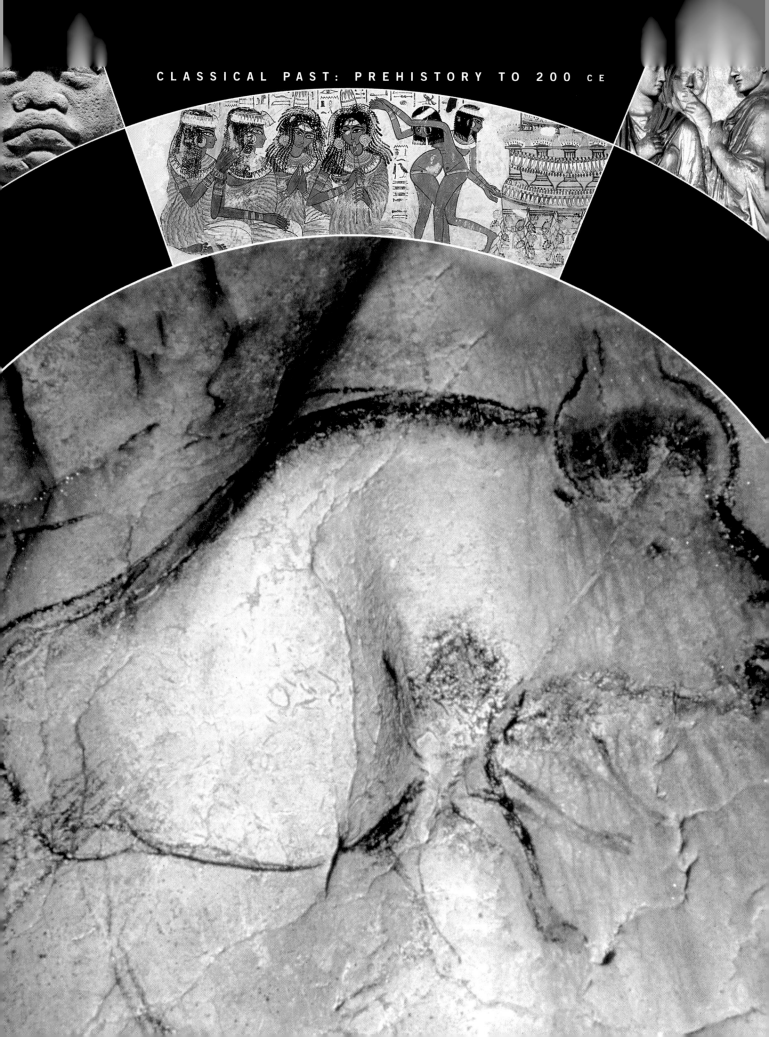

1 From Forest to Farm

The Rise of Culture

The Beginnings of Culture

The Rise of Agriculture

The Neolithic Megaliths of Northern Europe

Neolithic Cultures of the Americas

❝ *Yes, indeed. In this world there was no one at all. Always the sun came up; always he went in. No one in the morning gave him sacred meal; no one gave him prayer sticks; it was very lonely.* **❞**

A Zuni Emergence Tale

◄ **Fig. 1.1 Wall painting of a bison, Chauvet Cave, Vallon-Pont-dArc, Ardèche Gorge, France. ca. 30,000 BCE.** An artist painted this bison over 20,000 years ago on the wall of a cave in the Ardèche River gorge in southern France. Its eight legs may have been meant to depict running. Now known as Chauvet Cave, the skillful drawings found there have changed the way we think about prehistoric people.

O **N A COLD DECEMBER AFTERNOON IN 1994, JEAN-MARIE** Chauvet and two friends were exploring the caves in the steep cliffs along the Ardèche River gorge in southern France. After descending into a series of narrow passages, they entered a large chamber. There, beams from their headlamps lit up a

group of drawings that would astonish the three explorers—and the world. Since the late nineteenth century we've known that prehistoric people drew on the walls of caves. Twenty-seven such caves had already been discovered in the cliffs along the 17 miles of the Ardèche gorge (Map **1.1**). But the cave found by Chauvet [shoh-veh] and his friends transformed our thinking about **prehistoric** peoples, peoples who lived before the time of writing and so of recorded history. This cave contains by far the most accomplished prehistoric cave drawings ever discovered. We can only speculate that other great artworks were produced in prehistoric times but have not survived, perhaps because they were made of wood or other perishable materials. It is even possible that art may have been made earlier than 30,000 years ago, perhaps as people began to inhabit the Near East, between 90,000 and 100,000 years ago. This chapter will survey the art and cultures, of prehistoric peoples as they developed into increasingly sophisticated civilizations in the era before the invention of writing.

At first, during the Paleolithic [PAY-lee-uh-LITH-ik] era, or "Old Stone Age," the cultures of Europe sustained themselves on game and wild plants. The cultures themselves were small, scattered, and nomadic, though evidence suggests some interaction among the various groups. As the ice covering the Northern Hemisphere began to recede around 10,000 BCE, agriculture began to replace hunting and gathering, and with it, a nomadic lifestyle gave way to a more sedentary way of life. The consequences of this shift were enormous, and ushered in the Neolithic [nee-uh-LITH-ik] era, or "New Stone Age."

In the great river valleys of the Middle East and Asia, distinct centers of people involved in a common pursuit began to form. At Jericho [JER-ih-koe], for instance, on the Jordan River near present-day Jerusalem, in the Indus River valley of modern-day India, and at Jiangzhai [jee-ahng-zhye] in the Yellow (Shang) River valley of China, people sought to harness nature to suit their own needs. They began to domesticate animals, to grow foodstuffs, and to control water for irrigation and their own consumption. People also began to decorate their pots with unique, visually pleasing forms and designs.

In Northern Europe, where the ice receded more slowly, civilization developed more slowly as well, but by 4000 BCE, people began to construct giant stone architectural monuments around which their cultures were organized in some

ritualistic or spiritual way. Finally, in the Americas, the peoples who migrated across the land bridge from Asia around 15,000 BCE in pursuit of game gradually became sophisticated agricultural societies, especially in Mexico, Peru, and the Ohio and Mississippi river valleys.

The Beginnings of Culture

A culture encompasses the values and behaviors shared by a group of people, developed over time, and passed down from one generation to the next. Culture manifests itself in the laws, customs, ritual behavior, and artistic production common to the group. The cave paintings at Chauvet suggest that, as early as 30,000 years ago, the Ardèche gorge was a *center of culture*, a focal point of group living in which the values of a community find expression. There were others like it: In northern Spain, the first decorated cave was discovered in 1879 at Altamira [al-tuh-MIR-uh]. In the Dordogne [dor-DOHN] region of southern France to the west of the Ardèche, schoolchildren discovered the famous Lascaux cave in 1940 when their dog disappeared down a hole. And in 1991, along the French Mediterranean coast, a diver discovered the entrance to the beautifully decorated Cosquer [kos-KAIR] cave below the waterline near Marseille [mar-SAY].

Agency and Ritual: Cave Art

Since 1879, when cave paintings were first discovered at Altamira, Spain, scholars have been marveling at the skill of the people who produced them, but we have been equally fascinated by their very existence. Why were these paintings made? Until recently, it was generally accepted that such works were associated with the hunt. Perhaps the hunter, seeking game in times of scarcity, hoped to conjure it up by depicting it on cave walls. Or perhaps such drawings were magic charms meant to ensure a successful hunt. But at Chauvet, fully 60 percent of the animals painted on its walls were never, or rarely, hunted—such animals as lions, rhinoceroses, bears, panthers, and woolly mammoths. One drawing even depicts a buffalo, perhaps running (Fig. **1.1**), while another shows two rhinoceroses fighting horn to horn (Fig. **1.2**). (See *Voices*, page 8.)

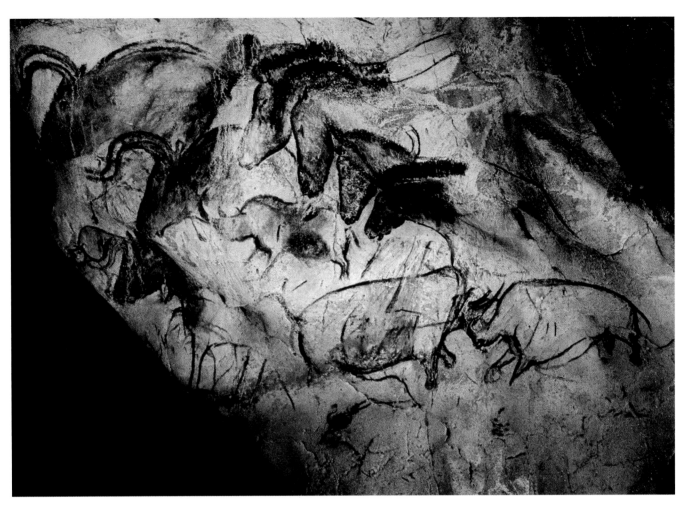

Fig. 1.2 Wall painting with horses, Chauvet Cave, Vallon-Pont-d'Arc, Ardèche gorge, France. ca. 30,000 BCE. Ministère de la Culture et de la Communication. Direction Regionale des affaires Culturelles de Rhone-Alpes. Service Regional de l'Archeologie. Paint on limestone, approx. height 6′. In the center of this wall are four horses, each behind the other in a startlingly realistic space. In front of the horses is a herd of aurochs, extinct ancestors of oxen. Below them two rhinoceroses fight.

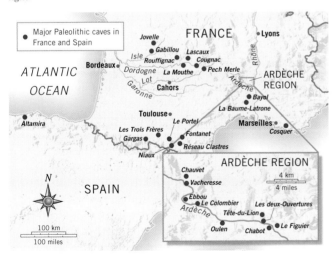

Map 1.1 Major Paleolithic Caves in France and Spain.

What role, then, did these drawings play in the daily lives of the people who created them? The caves may have been understood as gateways to the underworld and death, as symbols of the womb and birth, or as pathways to the world of dreams experienced in the dark of night. The general arrangement of the animals in the paintings by species or gender, often in distinct chambers of the caves, suggests to some that the paintings may have served as lunar calendars for predicting the seasonal migration of the animals. Whatever the case, surviving human footprints indicate that these caves were ritual gathering places and in some way served to further the common good.

At Chauvet, the use of color suggests that the paintings served some sacred or symbolic function. For instance, almost all of the paintings near the entrance to the cave are painted with natural red pigments derived from ores rich in iron oxide. Deeper in the cave, in areas more difficult to reach, the vast majority of the animals are painted in black pigments derived from ores rich in manganese dioxide. This shift in color appears to be intentional, but we can only guess its meaning.

VOICES

The Discovery of Chauvet Cave

The 1994 discovery of Chauvet Cave in southern France is one of the richest archeological finds in recent history, containing fossilized remains of animals as well as a lavish display of Paleolithic art. Three friends who were dedicated cave explorers stumbled upon the cave unexpectedly as they came to the end of an outing on a winter day.

> "...Everything was so beautiful, so fresh, almost too much so. Time was abolished, as if the tens of thousands of years that separated us from the producers of these paintings no longer existed."

From November [1994] onward, we decided to visit the most sheltered and sunniest parts of the gorges of the Ardeche. On 18 December, we had only a few hours in the afternoon, and we opted for . . . the entrances of the gorges, which in the cold weather is very pleasant in full sunlight. We decided to see the caves that we had not bothered with so far, since they had seemed to be of secondary interest. It was a fine and cold winter Sunday. The cliff overhangs the ancient bed of the Ardeche [River] which now flows a few hundred meters further away. We took an ancient mule path which came out onto a narrow ledge . . . Then we advanced into denser vegetation and arrived at the entrance of a little cavity. Once we had passed this narrow opening we found ourselves in a small sloping vestibule, several meters long, pierced by numerous passages cut by the waters. The ceiling was low, and we could only just stand up.

At the end, the ceiling became rounded, the slope of the floor led us toward . . . a spot where a slight draft was perceptible. The duct descended vertically, made a turn then ascended again. After about 10 feet it opened out. With head first, and arms outstretched in front of her, Eliette wriggled into the clayey narrowness, using the light from her helmet lamp. It was six-thirty in the evening. Triumphant, she could see the floor 30 feet below her: so there was a continuation! We joined her. To measure the resonance of the echo we shouted. The noise carried far and seemed to get lost in the immensity of the cave. We were certainly above a big gallery. We returned to the van, parked at the foot of the cliff [to get a ladder] . . .

After crawling through a narrow passage a second time we arrived at the edge of the shaft, unrolled our ladder, and one after the other climbed down into the profound darkness of the cave. Jean-Marie [Chauvet] was first to reach the floor. Our hearts were thumping: a magnificent cave network was opening up before us. The gallery that the beams from our helmet lamps were lighting so feebly was immense. About 50 feet high, surely more in places and almost 50 in length. The silence was total. . . . we were fascinated to discover some monumental columns of white calcite . . . [they] took the form of gigantic jellyfish, others were liked carved mother-of-pearl pillars. . . crys-

tals shining with a thousand fires. Everything was too beautiful, the spectacle was unreal.

A new chamber, far larger than the preceding one, now met our gaze. It seemed to stretch for dozens and dozens of meters. Our lamps did not enable us to see the end and we could scarcely see the walls. Darkness dominated all around us. Our excitement grew, since caves this large were totally unknown in the gorges. It was at this moment that we discovered multitudes of bear bones and teeth strewn over the floor. . . . Advancing slowly, we redoubled our precautions to avoid crushing them. All around us were dozens of depressions dug into the earth, as if the ground had been bombed. We recognized them as the "nests" in which bears must have hibernated.

We then took a narrower gallery to our right, still in a single file by the light of our headlamps and stepped over a rock covered by a shining film of calcite. Suddenly as Eliette's gaze swept the wall, she gave a cry: in the beam of her lamp she had just made out two lines of red ochre, a few centimeters long. We joined her with beating hearts. On turning round, we immediately spotted the drawing of a little red mammoth on a rocky spur hanging down from the ceiling. We were overwhelmed. Henceforth our view of the cave would never be the same. Prehistoric people had been here before us.

. . . To the right, we found more paintings in red ochre: a complex sign and then what seemed to us to be a big butterfly or a bird of prey with outspread wings. . . . A little further, on the white rock, there appeared the front of an immense red rhinoceros, endowed with an impressive curved horn. This was a real shock . . .

On bending down, we discovered [drawings of] a mammoth, then a bear or lion, and other rhinoceroses. To the right, we could make out three lion heads. . . . During those moments there were only shouts and exclamations; the emotion that gripped us made us incapable of uttering a single word. Alone in that vastness, lit by the feeble beam of our lamps, we were seized by a strange feeling. Everything was so beautiful, so fresh, almost too much so. Time was abolished, as if the tens of thousands of years that separated us from the producers of these paintings no longer existed. . . .

The skillfully drawn images at Chauvet raise even more important questions. The artists seem to have understood and practiced a kind of **perspectival drawing**—that is, they were able to convey a sense of three-dimensional space on a two-dimensional surface. In one painting, several horses appear to stand one behind the other (see Fig. 1.2). The head of another horse overlaps a black line, as if peering over a branch or the back of another animal (Fig. **1.3**). In several instances a whole herd of animals can be seen one behind the other. In no other cave yet discovered do drawings show the use of shading, or **modeling**, so that the horses' heads seem to have volume and dimension. And yet these cave paintings, rendered over 30,000 years ago, predate other cave paintings by at least 10,000 years, and in some cases by as much as 20,000 years.

Until now, historians divided the history of cave painting into a series of successive styles, each progressively more realistic. But Chauvet's paintings, by far the oldest known, are also the most advanced in their realism, suggesting the artists' conscious quest for visual **naturalism**, that is, for representations that imitate the actual appearance of the animals. Although both red and black animals are outlined, their modeling—extremely rare or unknown elsewhere—was achieved by spreading paint, either with the hand or a tool, to obtain gradual gradations of color. In addition, the artists further defined many of the animals' contours by scraping the wall behind so that the beasts seem to stand out against a deeper white ground. Three handprints in the cave were evidently made by spitting paint at a hand placed on the cave wall, resulting in a stenciled image.

Art, the Chauvet drawings suggest, does not evolve in a linear progression from awkward beginnings to more sophisticated representations. People have been capable of representing their world quite accurately from the very beginning and with a very high degree of sophistication. Apparently, from the earliest times, human beings could choose to represent the world naturalistically or not, and the choice *not* to represent the world in naturalistic terms should not necessarily be attributed to lack of skill or sophistication but to other, more culturally driven factors.

One of the few cave paintings that depict a human figure is found at Lascaux. What appears to be a male wearing a bird's-head mask lies in front of a disemboweled bison (Fig. **1.4**). Below him is a bird-headed spear thrower, a device that enabled hunters to throw a spear farther and with greater force.

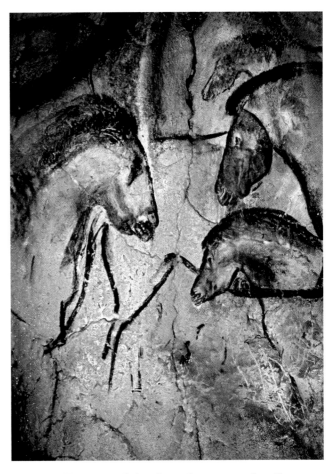

Fig. 1.3 **Wall painting with three horses facing one another, Chauvet Cave. ca. 30,000 BCE.** Each horse head is realistically rendered, using shading, or modeling, to give it a sense of roundness and volume.

Fig. 1.4 **Wall painting with bird-headed man, bison, and rhinoceros, Lascaux Cave, Dordogne, France. ca. 15,000–13,000 BCE.** Paint on limestone, length approx. 9′. In 1963 Lascaux was closed to the public so that conservators could fight a fungus attacking the paintings. Most likely, the fungus was caused by carbon dioxide exhaled by visitors. An exact replica called Lascaux II was built and can be visited.

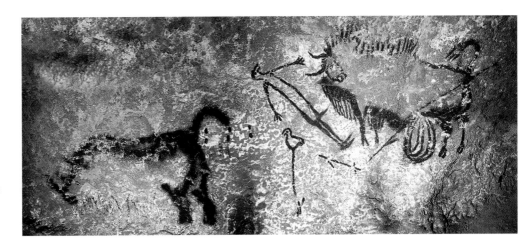

(Several examples of spear throwers have survived.) In the Lascaux painting, the hunter's spear has pierced the bison's hindquarters, and a rhinoceros charges off to the left. We have no way of knowing whether this was an actual event or an imagined scene. One of the painting's most interesting and inexplicable features is the discrepancy between the relatively naturalistic representation of the animals and the highly stylized, almost abstract realization of the human figure. Was the sticklike man added later by a different, less talented artist? Or does this image suggest that man and beast are different orders of being?

It is unlikely that the work was meant to be purely decorative or ornamental. It almost certainly possessed some form of *agency*—that is, it was created to exert some power or authority over those who came into contact with it. And footprints indicate it was almost certainly part of some larger ritual activity that took place in the cave itself. Many modern African cultures also invest works, such as their sculptural masks, with their own distinct forms of agency. Consider, for instance, a helmet mask carved some time in the last two centuries by a Baule [bah-oo-lay] carver from the Yamoussoukro [yah-moo-SOO-kroh] area of the Ivory Coast (Fig. 1.5). Commenting on just such a mask to anthropologist Susan Vogel for the 1987 exhibition *Perspectives: Angles on African Art* at New York's Museum for African Art, the Baule carvers explained:

> This is the Dye sacred mask. The Dye god is a dance of rejoicing for us men. So when I see the mask, my heart is filled with joy. I like it because of the horns and eyes. The horns curve nicely, and I like the placement of the eyes and ears. In addition, it executes very interesting and graceful dance steps. I never saw one with those things beside the nose. This is a sacred mask danced in our village. It makes us happy when we see it. There are days when we want to look at it. At that time, we take it out and contemplate it awhile.

The Baule carvers pay attention to elements that we normally associate with the mask's "art"—the curve of its horns, the placement of its eyes and ears—but to the Baule people the mask is not merely an object but part of a larger process, the dance. To the Baule eye, the mask projects its performance. In fact, it *is* the dance itself, as it executes "interesting and graceful dance steps."

Fig. 1.5 Helmet Mask, from Ivory Coast. Baule culture, 19th–20th century. Wood, coloring, length 34¼". The Metropolitan Museum of Art, The Michael C. Rockefeller Memorial Collection. Gift of Adrian Pascal LaGamma, 1973. (1978.412.664). Many people in the Western world value African masks for their abstract forms and emotional expressiveness, but these features are not necessarily those most valued by their makers.

Culture, Continuity, and Change

Like the Baule carvers, artists in the prehistoric era—and well into ancient times as well—worked within a larger ritual process in which drawing, painting, sculpture, dance, and music were a single whole. In prehistoric times—and even today—these ritual celebrations were usually orchestrated by a **shaman** [shah-mun], a person thought to have special ability to communicate with the spirit world. In fact, the bird-mask worn by the stick figure at Lascaux suggests a shamanistic ritual reunification of the animal and human worlds.

In the many caves of the Ardèche gorge, northern Spain, the Dordogne, and along the Mediterranean coast, people met, talked, and may have seen each other's drawings on the cave walls. They probably shared knowledge about the movement of herds, the best way to take down a bison, and how to make a spear. In short, they took in each other's thoughts. They conveyed this knowledge—their culture—from generation to generation, establishing a certain continuity of habits and traditions. As their needs and aspirations changed, certain aspects of their tradition continued, while others were discarded, even forgotten. This pattern of continuity and change, evident from the earliest times, is one of the hallmarks of culture itself and is a major theme of this text.

It would take thousands of years for the earliest rudimentary cultures to develop into full-blown civilizations. When anthropologists, historians and other academicians use the term "civilization," they are making a distinction between societies comprised of nomadic bands or small decentralized villages and those centered around cities. By this definition, some human societies can be called civilizations and some cannot. Unfortunately, the use of the word "uncivilized," to mean crude or barbaric, has affected how the word "civilization" is perceived. It might seem as if civilizations would be more refined, humane, or otherwise superior to other societies, and indeed throughout history civilizations have often seen themselves that way.

For a student of the humanities, such a view is inappropriate. Much of what we know about early civilizations is the result of the fact that cities, or more precisely, the elite within cities, had the materials and means to create objects that could survive long after the civilizations themselves had disappeared. Though the artifacts found in ancient ruins—as well as the ruins themselves—are impressive, many other cultures were not in a position to leave such a

Materials & Techniques Methods of Carving

Carving is the act of cutting or incising stone, bone, wood, or another material into a desired form. Surviving artifacts of the Paleolithic era were carved from stone or bone. The artist probably held a sharp instrument, such as a stone knife or a chisel, in one hand and drove it into the stone or bone with another stone held in the other hand to remove excess material and realize the figure. Finer details could be scratched into the material with a pointed stone instrument. Artists can carve into any material softer than the instrument they are using. Harder varieties of stone can cut into softer stone as well as bone. The work was probably painstakingly slow.

There are basically two types of sculpture: sculpture in the round and relief sculpture. **Sculpture in the round** is fully three-dimensional; it occupies 360 degrees of space. The Willendorf statuette (see Fig. 1.6) was carved from stone and is an example of sculp-

ture in the round. **Relief sculpture** is carved out of a flat background surface; it has a distinct front and no back. Not all relief sculptures are alike. In *high relief* sculpture, the figure extends more that 180 degrees from the background surface. *Woman Holding an Animal Horn*, found at Laussel, in the Dordogne region of France, is carved in high relief and is one of the earliest relief sculptures known. This sculpture was originally part of a great stone block that stood in front of a Paleolithic rock shelter. In *low* or *bas relief*, the figure extends less than 180 degrees from the surface. In *sunken relief*, the image is carved, or incised, into the surface, so that the image recedes below it. When a light falls on relief sculptures at an angle, the relief casts a shadow. The higher the relief, the larger the shadows and the greater the sense of the figure's three-dimensionality.

Woman Holding an Animal Horn, from Laussel (Dordogne), France. 30,000–15,000 BCE. Limestone, height 17 3/8″. Musée des Antiquites Nationales, St. Germain-en-Laye, France.

record. Where people live dictates to a large degree *how* they live and what they create. For example, people who live in arid regions and survive by moving their herds from place to place are unlikely to make much of an investment in permanent structures or art objects that cannot be easily moved with them. In these cultures, we might expect to find an emphasis on textiles, jewelry, and other small objects, rather than large sculptures or buildings. People who live in equatorial climates are likely to use materials close at hand for buildings and art objects. Wood is plentiful, but it rarely endures for more than a century or two. These cultures should be evaluated on their own merits, not by how well they measure up to any other human population or set of standards.

A civilization, as the term is used by modern scholars, is a culture that possesses the ability to organize itself thoroughly. It is a social, economic, and political entity, distinguished by its ability to express itself well, not only through images but through written language, which is in many ways the means by which people are best able to organize themselves. Civilizations with written language, however, did not come into being until about 3000 BCE, in the Near East. It is these cultures that we are able to study today. How many others vanished without a trace, we will never know.

Paleolithic Culture and Its Artifacts

Footprints discovered in South Africa in 2000 and fossilized remains uncovered in the forest of Ethiopia in 2001 suggest that, about 5.7 million years ago, the earliest upright humans, or hominins (as distinct from the larger classification of hominids, which includes great apes and chimpanzees as well as humans), roamed the continent of Africa. Ethiopian excavations further indicate that some time around 2.5 or 2.6 million years ago hominid populations began to make rudimentary stone tools, though long before, between 14 million and 19 million years ago, the *Kenyapithecus* [ken-yuh-PITH-i-kus] ("Kenyan ape"), a hominin, made stone tools in east central Africa. Nevertheless, the earliest evidence of a culture coming into being are the stone artifacts of *Homo sapiens* [ho-moh SAY-pee-uhnz] (Latin for "one who knows"). *Homo sapiens* evolved about 100,000–120,000 years ago and can be distinguished from earlier hominids by the lighter build of their skeletal structure and larger brain. This species gradually spread out of Africa, across Asia, into Europe, and finally to Australia and the Americas.

Homo sapiens were **hunter-gatherers**, whose survival depended on the animals they could kill and the foods they

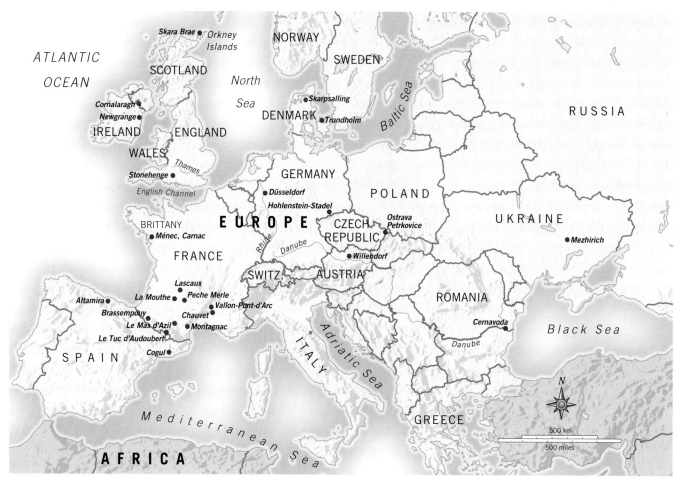

Map 1.2 Major Paleolithic Archeological Sites in Europe.

could gather, primarily nuts, berries, and other edible plants. The tools they developed were far more sophisticated than those of their ancestors. They included cleavers, chisels, grinders, handaxes, and arrow- and spearheads made of flint, a material that also provided the spark to create an equally important tool—fire. In 2004, Israeli archeologists working at a site on the banks of the Jordan River reported the earliest evidence yet found of controlled fire created by hominids—cracked and blackened flint chips, presumably used to light a fire, and bits of charcoal dating from 790,000 years ago. Also at the campsite were the bones of elephant, rhino, hippo, and small species, demonstrating that these early hominids cut their meat with flint tools and ate steaks and marrow. *Homo sapiens* cooked with fire, wore animal skins as clothing, and used tools as a matter of course. They buried their dead in ritual ceremonies, often laying them to rest accompanied by stone tools and weapons.

The Paleolithic era, or "Old Stone Age," from the Greek *palaios*, "old," and *lithos*, "stone," was so named because of the widespread use of stone tools and weapons in this early era of human development. Archeologists divide the Paleolithic era into three periods: Lower, Middle, and Upper. This reflects the relative position of each in the strata of archeol-

ogists' excavations, with Upper being the most recent and most near the surface. Lower Paleolithic extends from about 800,000 to 100,000 BCE, at which point *Homo sapiens* began to spread across the world. Middle Paleolithic extends from 100,000 to around 40,000 BCE. Upper Paleolithic extends from 40,000 BCE to the end of the so-called Ice Age, around 9000–8000 BCE, when the glaciers covering most of the Northern Hemisphere gradually receded. This is the period of *Homo sapiens'* ascendancy. These Upper Paleolithic people carved stone tools and weapons that helped them survive in an inhospitable climate. They carved small sculptural objects as well, which, along with the cave paintings we have already seen, appear to be the first instances of what we have come to call "art" (see *Materials and Techniques*, page 11). Among the most remarkable of these sculptural artifacts are a large number of female figures, found at various archeological sites across Europe (Map **1.2**). The most famous of these is the limestone statuette of a *Woman* found at Willendorf [VIL-un-dorf], in modern Austria (Fig. **1.6**), dating from about 22,000 to 21,000 BCE and often called the *Willendorf Venus*. Markings on the *Woman* and other similar figures indicate that they were originally colored, but what these small sculptures meant and what they were used for remains unclear.

Most are 4 to 5 inches high and fit neatly into a person's hand. This suggests that they may have had a ritual purpose. Their exaggerated breasts and bellies and their clearly delineated genitals support a connection to fertility and child-bearing. We know, too, that the *Woman* from Willendorf was originally painted in red ochre, suggestive of menses. And, her navel is not carved; rather, it is a natural indentation in the stone. Whoever carved her seems to have recognized, in the raw stone, a connection to the origins of life. But such figures may have served other purposes as well. Perhaps they were dolls, guardian figures, or images of beauty in a cold, hostile world where having body fat might have made the difference between survival and death.

Female figurines vastly outnumber representations of males in the Paleolithic era, which suggests that women played a central role in Paleolithic culture. Most likely, they had considerable religious and spiritual influence, and their preponderance in the imagery of the era suggests that Paleolithic culture may have been *matrilineal* [mat-rih-LIN-ee-ul] (in which descent is determined through the female line) and *matrilocal* (in which residence is in the female's tribe or household). Such traditions exist in many primal societies today.

The peoples of the Upper Paleolithic period followed herds northward in summer, though temperatures during the Ice Age rarely exceeded 60 degrees Fahrenheit (16 degrees Centigrade). Then, as winter approached, they retreated southward into the cave regions of northern Spain and southern France. But caves were not their only shelter. At about the same latitude as the Ardèche gorge but eastward, in present-day Ukraine, north of the Black Sea, archeologists have discovered a village with houses built from mammoth bone, dating from 16,000 to 10,000 BCE (Fig. **1.7**). Using long curving tusks as roof supports, constructing walls with pelvis bones, shoulder blades, jawbones, and skulls, and probably covering the structure with hides, the Paleolithic peoples of the region built houses that ranged from 13 to 26 feet in diameter, with the largest measuring 24 by 33 feet. Here we see one of the earliest examples of architecture—the construction of living space with at least some artistic intent. The remains of these

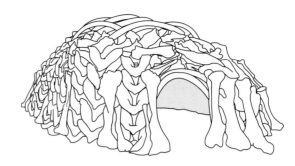

Fig. 1.7 Reconstruction drawing of a mammoth-bone house, Mezhirich, Ukraine. ca. 16,000–10,000 BCE.

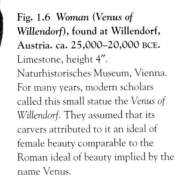

Fig. 1.6 *Woman (Venus of Willendorf)*, found at Willendorf, Austria. ca. 25,000–20,000 BCE. Limestone, height 4″. Naturhistorisches Museum, Vienna. For many years, modern scholars called this small statue the *Venus of Willendorf*. They assumed that its carvers attributed to it an ideal of female beauty comparable to the Roman ideal of beauty implied by the name Venus.

structures suggest that those who built them gathered together in a village of like dwellings, the fact that most underscores their common culture. They must have shared resources, cooperated in daily tasks, intermarried, and raised their children by teaching them the techniques necessary for survival in the harsh climate of the Ukraine.

The Rise of Agriculture

For 2,000 years, from 10,000 to 8000 BCE, the ice covering the Northern Hemisphere receded farther and farther northward. As temperatures warmed, life gradually changed. During this period of transition, known as the Mesolithic era, or "Middle Stone Age," areas once covered by vast regions of ice and snow developed into grassy plains and abundant forests. (The ice and snow melted at different times in different parts of the world, so the terms *Paleolithic*, *Mesolithic*, and *Neolithic* do not describe time periods that were uniform across the globe.) As the ice melted, the seas rose, covering, for instance, the cave entrance at Cosquer, filling what is now the North Sea and English Channel with water, and inundating the land bridge that had connected Asia and North America. Hunters developed the bow and arrow, which were easier to use at longer range on the open plains. They fashioned dugout boats out of logs to facilitate fishing, which became a major food source. They domesticated dogs to help with the hunt as early as 11,000 BCE, and soon other animals as well—goats and cattle particularly. Perhaps most important, people began to cultivate the more edible grasses. Along the eastern shore of the Mediterranean they harvested wheat, in Asia they cultivated millet and rice, and in the Americas they grew squash, beans, and corn. Gradually, farming replaced hunting as the primary means of sustaining life. A culture of the fields developed—an *agri*-culture, from the Latin *ager*, "farm," "field," or "productive land."

The rise of agricultural society defines the Neolithic era, or "New Stone Age." Beginning in about 8000 BCE, Neolithic culture concentrated in the great river valleys of the Middle East and Asia: the valleys of the Nile, Tigris [TYE-griss],

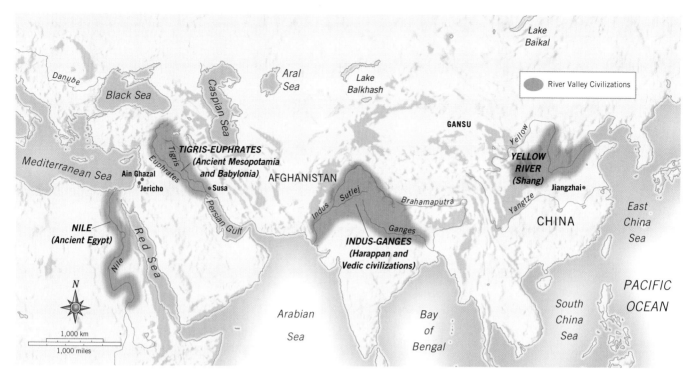

Map 1.3 The Great River Valley Civilizations, ca. 2000 BCE. Agriculture thrived in the great river valleys throughout the Neolithic era, but by the end of the period, urban life had developed there as well, and civilization as we know it had emerged.

Euphrates [yu-FRAY-teez], Indus [IN-duhs], Ganges [GAN-jeez], and Yellow rivers (Map **1.3**). Gradually, as the climate warmed, Neolithic culture spread across Europe. By about 5000 BCE, the valleys of Spain and southern France supported agriculture, but not until about 4000 BCE is there evidence of farming in the northern reaches of the European continent and England. The Neolithic era does not end in these colder climates until about 2000 BCE.

Meanwhile, the great rivers of the Middle East and Asia provided a consistent and predictable source of water, and people soon developed irrigation techniques that fostered organized agriculture and animal husbandry. As production outgrew necessity, members of the community were freed to occupy themselves in other endeavors—complex food preparation (bread, cheese, and so on), construction, religion, even military affairs. (Depictions of human conflict are first found in Mesolithic rock painting.) Soon permanent villages began to appear, and villages began to look more and more like cities.

Neolithic Jericho

Jericho is one of the oldest known settlements of the Neolithic era. It is located in the Middle East some 15 miles east of modern Jerusalem, on the west bank of the Jordan River (Fig. **1.8**). Although not in one of the great river valleys, Jericho was the site of a large oasis, and by 7000 BCE a city had developed around the water source. The homes were made of mud brick on stone foundations and had plaster floors and walls. Many of the walls were decorated with patterned designs. Mud bricks

were a construction material found particularly in hot, arid regions of the Neolithic Middle East, where stone and wood were in scarce supply. The city was strongly fortified, indicating that all was not peaceful even in the earliest Neolithic times. It was surrounded by a ditch, probably not filled with water, but dug out in order to increase the height of the walls behind. The walls themselves were between 5 and 12 feet thick, and the towers rose to a height of 30 feet. What particular troubles necessitated these fortifications is debatable, but Jericho's most precious resource was without doubt its water, and others probably coveted the site.

The most startling discovery at Jericho is the burial of ten headless corpses under the floors of the city's houses. The skulls of the dead were preserved and buried separately, the features rebuilt in plaster and painted to look like the living ancestor (Fig. **1.9**). Each is unique and highly realistic, possessing the distinct characteristics of the ancestor. The purpose of the skull portraits is unknown to us. Perhaps the people of Jericho believed that the spirit of the dead lived on in the likeness. Whatever the case, the existence of the skulls indicates the growing stability of the culture, its sense of permanence and continuity.

Neolithic Pottery Across Cultures

The transition from cultures based on hunting and fishing to cultures based on agriculture led to the increased use of pottery vessels. Ceramic vessels are fragile, so hunter-gatherers would not have found them practical for carrying food, but

Fig. 1.8 **Aerial view of Jericho, Jordan. ca. 7000 BCE.** Largely unexcavated, like most ancient sites in the Middle East, Jericho supported a surprisingly complex community as the mounds and existing excavations indicate.
Z. Radovan/www.BibleLand Pictures.com

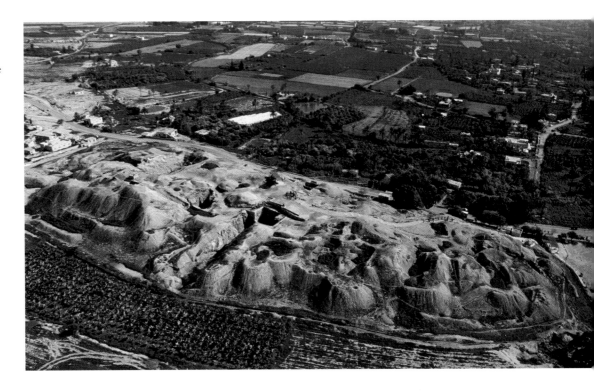

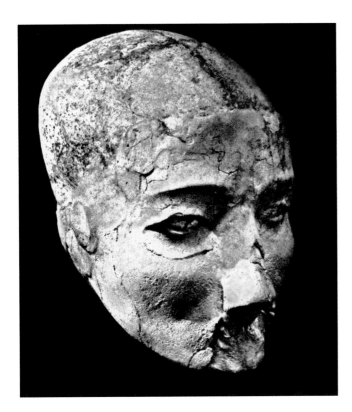

Fig. 1.9 **Neolithic human skull with restored features, from Jericho, Jordan. ca. 7000 BCE.** Life-size, features molded in plaster, painted, and inlaid with shell. Archaeological Museum, Amman, Jordan. Hair was originally painted onto the head, and the eye sockets were filled with cowrie shell to give the "portrait" realism.

people living in the more permanent Neolithic settlements could have used them to carry and store water and to prepare and store certain types of food.

There is no evidence of pottery at the Jericho site. But, as early as 10,000 BCE, Japanese artisans were making clay pots capable of storing, transporting, and cooking food and water. Over the course of the Neolithic era, called the Jomon [joe-mon] period in Japan (12,000–300 BCE), their work became increasingly decorative. *Jomon* means "cord markings" and refers to the fact that potters decorated many of their wares by pressing cord into the damp clay. As in most Neolithic societies, women made Jomon pottery; their connection to fertility and the life cycle may have become even more important to Neolithic cultures in the transition from hunting and gathering to agricultural food production. Jomon women built their pots up from the bottom with coil upon coil of soft clay. They mixed the clay with a variety of adhesive materials, including mica, lead, fibers, and crushed shells. After forming the vessel, they employed tools to smooth both the outer and interior surfaces. Finally, they decorated the outside with cord markings and fired the pot in an outdoor bonfire at a temperature of about 1650 degrees Fahrenheit (900 degrees Centigrade). By the middle Jomon period, potters had begun to decorate the normal flat-bottomed, straight-sided jars with elaborately ornate and flamelike rims (Fig. **1.10**), distinguished by their asymmetry and their unique characteristics. These rims suggest animal forms, but their significance remains a mystery.

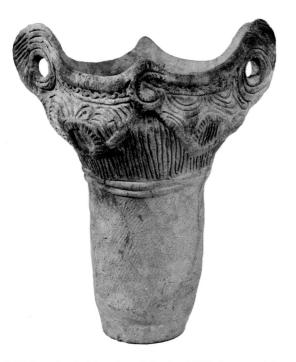

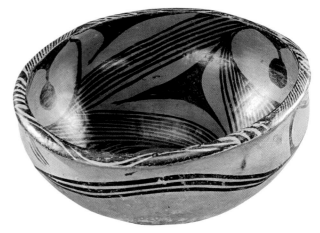

Fig. 1.11 Basin (pen), Majiayao culture, Majiayao phase, Gansu Province, China. ca. 3200–2700 BCE. Earthenware with painted decoration, diameter 11″. The Metropolitan Museum of Art, New York. Anonymous Loan (L.1996.55.6). The designs on this bowl are examples of the kind of markings that would eventually develop into writing.

Fig. 1.10 Deep bowl with sculptural rim, late Middle Jomon period (ca. 2500–1600 BCE), Japan. ca. 2000 BCE. Terracotta, 14 1/2″ × 12 1/3″. Musée des Arts Asiatiques-Guimet, Paris, France. The motifs incised on this pot may have had some meaning, but most interesting is the potter's freedom of expression. The design of the pot's flamelike rim is anything but practical.

The Neolithic cultures that flourished along the banks of the Yellow River in China beginning in about 5000 BCE also produced pottery. These cultures were based on growing rice and millet (grains from the Near East would not be introduced for another 3,000 years), and this agricultural emphasis spawned towns and villages, such as Jiangzhai, the largest Neolithic site that has been excavated in China. The Jiangzhai community, near modern Xi'an [she-an], in Shaanxi [shahn-shee] province, dates to about 4000 BCE and consisted of about 100 dwellings. At its center was a communal gathering place, a cemetery, and, most important, a *kiln,* an oven specifically designed to achieve the high temperatures necessary for firing clay. Indeed, the site yielded many pottery fragments. Farther to the east, in Gansu [gan-soo] province, Neolithic potters began to add painted decoration to their work (Fig. **1.11**). The flowing, curvilinear forms painted on the shallow basin illustrated here include "hand" motifs on the outside and round, almost eyelike forms that flow into each other on the inside.

Some of the most remarkable Neolithic painted pottery comes from Susa [soo-suh], on the Iranian plateau. The patterns on one particular beaker (Fig. **1.12**) from around 5000–4000 BCE are highly stylized animals. The largest of these is an ibex, a popular decorative feature of prehistoric ceramics from Iran. Associated with the hunt, the ibex may have been a symbol of plenty. The front and hind legs of the

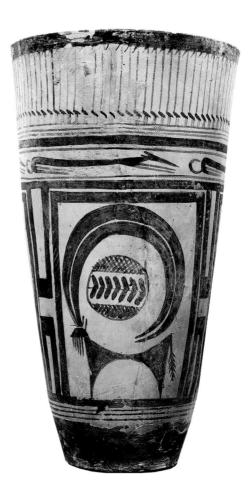

Fig. 1.12 Beaker with ibex, dogs, and long-necked birds, from Susa, southwest Iran. ca. 5000–4000 BCE. Baked clay with painted decoration, height 11 1/4″. Musée du Louvre, Paris. The ibex was the most widely hunted game in the ancient Middle East, which probably accounts for its centrality in this design.

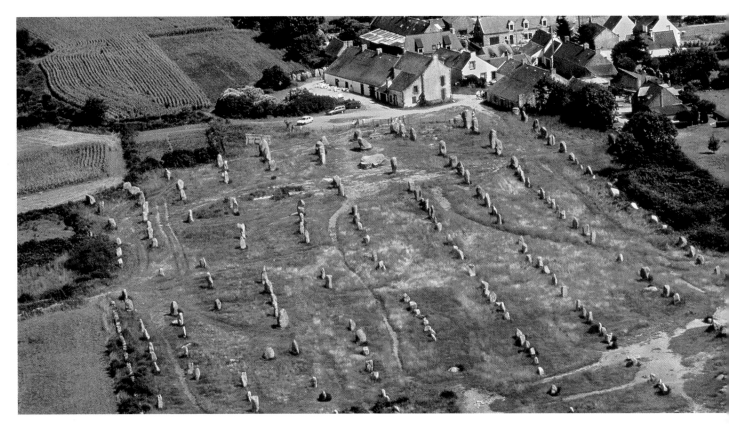

Fig. 1.13 Neolithic menhir alignments at Ménec, Carnac, Brittany, France. ca. 4250–3750 BCE. According to an ancient legend, the Carnac menhirs came into being when a retreating army was driven to the sea. Finding no ships to aid their escape, they turned to face their enemy and were transformed into stone.

ibex are rendered by two triangles, the tail hangs behind it like a feather, the head is oddly disconnected from the body, and the horns rise in a large, exaggerated arc to encircle a decorative circular form. Hounds race around the band above the ibex, and wading birds form a decorative band across the beaker's top.

In Europe, the production of pottery apparently developed some time later, around 3000 BCE. Early pots were made either by molding clay over a round stone or by coiling long ropes of clay on top of one another and then smoothing the seams between them. Then the pots were fired at temperatures high enough to make them watertight—above 700 degrees Fahrenheit (370 degrees Centigrade).

By this time, however, artisans in Egypt had begun using the potter's wheel, a revolving platter for forming vessels from clay with the fingers. It allowed artisans to produce a uniformly shaped vessel in a very short time. By 3000 BCE, the potter's wheel was in use in the Middle East as well as China. Because it is a machine created expressly to produce goods, it is in many ways the first mechanical and technological breakthrough in history. As skilled individuals specialized in making and decorating pottery, and traded their wares for other goods and services, the first elemental forms of manufacturing began to take shape.

The Neolithic Megaliths of Northern Europe

A distinctive kind of monumental stone architecture appears late in the Neolithic period, particularly in what is now Britain and France. Known as **megaliths** [MEG-uh-liths], or "big stones," these works were constructed without the use of mortar and represent the most basic form of architectural construction. Sometimes they consisted merely of posts—upright stones stuck into the ground—called **menhirs** [MEN-hir], from the Celtic words *men*, "stone," and *hir*, "long." These single stones occur in isolation or in groups. The largest of the groups is at Carnac [kahr-nak], in Brittany (Fig. **1.13**), where some 3,000 menhirs arranged east to west in 13 straight rows, called *alignments*, cover a 2-mile stretch of plain. At the east end, the stones stand about 3 feet tall and gradually get larger and larger until, at the west end, they attain a height of 13 feet. This east–west alignment suggests a connection to the rise and set of the sun and to fertility rites. Although scholars disagree about their significance, some speculate that the stones may have marked out a ritual procession route, while others think they symbolized the body and the process of growth and

maturation. But there can be no doubt that megaliths were designed to be permanent structures, where domestic architecture was not. Quite possibly the megaliths stood in tribute to the strength of the leaders responsible for assembling and maintaining the considerable labor force required to construct them.

Another megalithic structure, the **dolmen** [DOLE-muhn], consists of two posts roofed with a capstone, or **lintel**. Because it is composed of three stones, the dolmen is a **trilithon** [try-LITH-un], from Greek *tri*, "three," and *lithos*, "rock," and it formed the basic unit of architectural structure for thousands of years. Today we call this kind of construction **post-and-lintel** (see *Materials and Techniques*, page 19). Megaliths such as the Dolmen of Galitorte, near Buzeins, France (Figure **1.14**), were probably once covered with earth to form a fully enclosed burial chamber, or **cairn** [karn].

A third type of megalithic structure is the **cromlech** [krahm-lek], from the Celtic *crom*, "circle," and *lech*, "place." Without doubt the most famous megalithic structure in the world is the cromlech known as Stonehenge (Fig. **1.15**), on Salisbury Plain, about 100 miles west of modern London. A henge is a special type of cromlech, a circle surrounded by a ditch with built-up embankments, presumably for fortification.

The site at Stonehenge reflects four major building periods, extending from about 2750 to 1500 BCE. During the first phase, the circular ditch visible in the aerial photograph (see Fig. 1.15) was dug around the site. At a depth of about 6 feet, the chalk substratum beneath the surface was exposed. So, in its earliest stage, Stonehenge consisted of a giant white circle some 330 feet in diameter. An avenue leading toward the northeast was also constructed at this time, and in its middle, about 100 feet from the henge's edge, the builders placed a giant gray sandstone megalith with a tapered top. Called the Heel Stone, it stands 16 feet high and weighs 35 tons. It was brought from a quarry 23 miles away.

By about 2100 BCE, most of the elements visible today were in place. In the middle was a U-shaped arrangement of five post-and-lintel trilithons. The one at the bottom of the U stands taller than the rest, rising to a height of 24 feet, with a 15-foot lintel 3 feet thick. A continuous circle of sandstone posts, each weighing up to 50 tons and all standing 20 feet high, surrounded the five trilithons. Across their top was a continuous lintel 106 feet in diameter. This is the Sarsen Cir-

cle. Just inside the Sarsen Circle was once another circle, made of bluestone—a bluish-colored dolorite—found only in the mountains of southern Wales, some 120 miles away. (See *Focus*, pages 20–21.)

Why Stonehenge was constructed remains a mystery, although it seems clear that orientation toward the rising sun at the summer solstice connects it to planting and the harvest. Stonehenge embodies, in fact, the growing importance of agricultural production in the northern reaches of Europe. Perhaps great rituals celebrating the earth's plenty took place here. Together with other megalithic structures of the era, it suggests that the late Neolithic peoples who built it were extremely social beings, capable of great cooperation. They worked together not only to find the giant stones that rise at the site, but also to quarry, transport, and raise them. In other words, theirs was a culture of some magnitude and no small skill. It was a culture capable of both solving great problems and organizing itself in the name of creating a great social center. For Stonehenge is, above all, a center of culture. Its fascination for us today lies in the fact that we know so little of the culture that left it behind.

Neolithic Cultures of the Americas

Seventeen thousand years ago, about the time that the hunter-gatherers at Lascaux painted its caves, the Atlantic and Pacific oceans were more than 300 feet below modern levels, exposing a low-lying continental shelf that extended from northeastern Asia to North America. It was a landscape of grasslands and marshes, home to the woolly mammoth, the

Fig. 1.14 Neolithic dolmen, Galitorte, near Buzeins, France. ca. 2500–1500 BCE. A mound of earth once covered this structure, an ancient burial chamber.

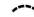

Materials & Techniques Post-and-Lintel Construction

Post-and-lintel is the most basic technique for spanning space. In this form of construction two **posts**, or pieces fixed firmly in an upright position, support a **lintel**, or horizontal span. Two posts and a single lintel, as seen at Carnac and Stonehenge (see Figs. 1.13, 1.15), constitute a **trilithon** (from the Greek *tri*, "three," and *lithos*, "rock").

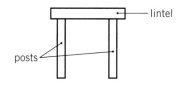

steppe bison, wild horses, caribou, and antelope. At some point around 15,000 BCE, bands of hunter-gatherers in northeastern Asia followed these animals across the grasslands land bridge into the Americas. By 12,000 BCE, prehistoric hunters had settled across North America and begun to move farther south, through Mesoamerica (the region extending from central Mexico to northern Central America), and on into South America, reaching the southern end of Chile no later than 11,000 BCE.

Around 9000 BCE, for reasons that are still hotly debated—perhaps a combination of over-hunting and climatic change—the big game that had attracted hunters to the Americas vanished there and around the world within a few centuries. Only the bison, or buffalo, survived, so an additional source of sustenance was needed. Like prehistoric peoples elsewhere, the peoples of the Americas developed agricultural societies. They domesticated animals—turkeys, guinea pigs, dogs, and llamas, though never a beast of burden

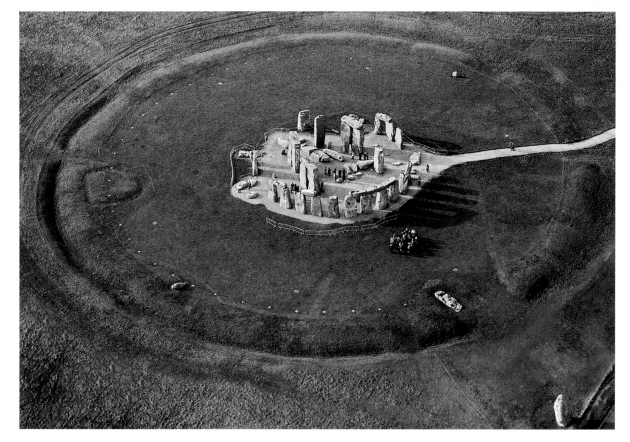

Fig. 1.15 Stonehenge, Salisbury Plain, Wiltshire, England. ca. 2750–1500 BCE. Like most Neolithic sites, Stonehenge invites speculation about its significance. Of this, however, we are certain: At the summer solstice, the longest day of the year, the sun rises directly over the Heal Stone. This suggests that the site was intimately connected to the movement of the sun.

Focus

The Design and Making of Stonehenge

How the Neolithic peoples of Britain constructed Stonehenge is uncertain. Scholars believe that the giant stones of the Sarsen Circle, which weigh up to 50 tons, were transported from the Marlborough Downs, roughly 20 miles to the north, by rolling them on logs. Most of the way, the going is relatively easy, but at the steepest part of the route, at Redhorn Hill, modern work studies estimate that it would have taken at least 600 men to push the stones up the hill. A relatively sophisticated understanding of basic physics—the operation of levers and pulleys—was needed to lift the stones, and their lintels, into place.

The Avenue.
The shadow cast by the Heel Stone on Midsummer's Eve would extend directly down this ceremonial approach.

The Slaughter Stone.
It was once believed that humans were sacrificed on this stone, which now lies flat on the ground, but it was originally part of a great portal.

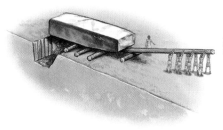

The sarsen stone is raised with a long lever. Logs are placed under the stone, and then it is rolled into place.

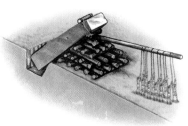

One by one, layers of timber are placed under the lever, both raising the stone and dropping it into the prepared pit.

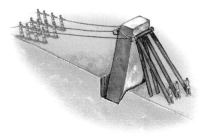

As many as 200 men pull the stone upright on ropes, as timbers support it from behind.

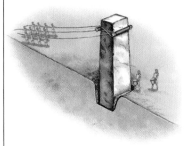

The pit around the stone is filled with stones and chalks to pack it into place.

The lintel is raised on successive layers of a timber platform.

Once the platform reaches the top of the posts, the lintel is levered onto the posts.

Finally, the platform is removed, and the trilithon is complete.

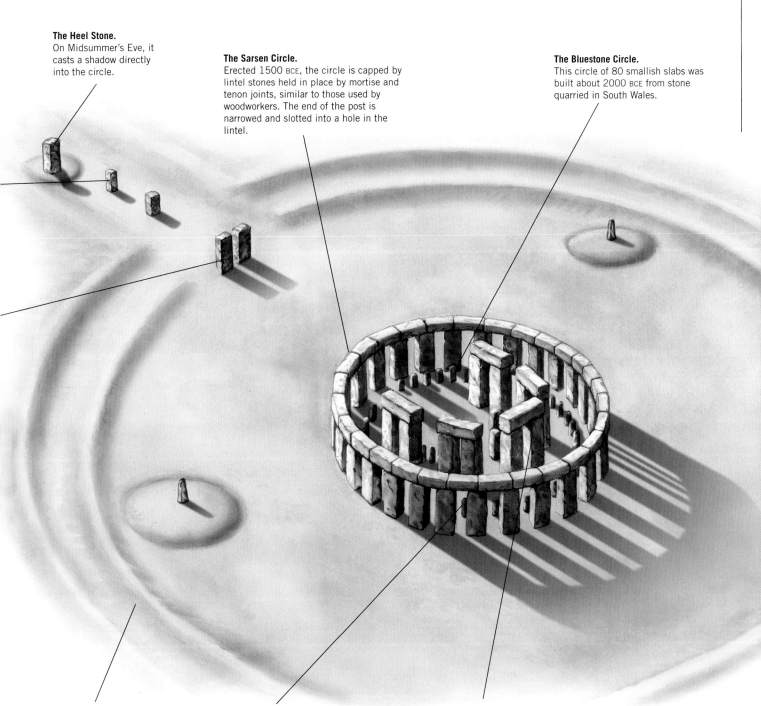

The Heel Stone.
On Midsummer's Eve, it casts a shadow directly into the circle.

The Sarsen Circle.
Erected 1500 BCE, the circle is capped by lintel stones held in place by mortise and tenon joints, similar to those used by woodworkers. The end of the post is narrowed and slotted into a hole in the lintel.

The Bluestone Circle.
This circle of 80 smallish slabs was built about 2000 BCE from stone quarried in South Wales.

The Outer Bank.
This ditch, 330 feet in diameter, is the oldest construction at the site, originally exposing the white limestone beneath the surface soil to form a giant circle.

The Altar Stone.
One of the most unique stones in Stonehenge, the so-called altar stone, 16-foot block of smoothed green sandstone located near the center of the complex.

Five Massive Trilithons.
Inside the outer circle stood a horseshoe of trilithons, two on each side and the largest at the closed end at the southwest. Only one of the largest trilithons still stands. It rises 22 feet above ground with 8 feet more below ground level. The stone weighs about 50 tons.

as in the rest of the world—and they cultivated a whole new range of plants, including corn, beans, squash, tomatoes, avocados, potatoes, tobacco, and cacao, the source of chocolate. The wheel remained unknown to them, though they learned to adapt to almost every conceivable climate and landscape. A **creation myth**, or story of a people's origin, told by the Maidu [MY-doo] tribe of California, characterizes this early time: "For a long time everyone spoke the same language, but suddenly people began to speak in different tongues. Kulsu (the Creator), however, could speak all languages, so he called his people together and told them the names of the animals in their own language, taught them to get food, and gave them their laws and rituals. Then he sent each tribe to a different place to live."

The Anasazi and the Role of Myth

A **myth** is a story that a culture assumes is true. It also embodies the culture's views and beliefs about its world, often serving to explain otherwise mysterious natural phenomena. Myths stand apart from scientific explanations of the nature of reality, but as a mode of understanding and explanation,

myth has been one of the most important forces driving the development of culture. Although myths are speculative, they are not pure fantasy. They are grounded in observed experience. They serve to rationalize the unknown and to explain to people the nature of the universe and their place within it.

Much of our understanding of the role of myth in prehistoric cultures comes from stories that have survived in cultures around the world that developed without writing—that is, **oral cultures**—such as the Oceanic [oh-shee-AN-ik] peoples of Tahiti in the South Pacific. These cultures have passed down their myths and histories over the centuries, from generation to generation, by word of mouth. Although, chronologically speaking, many of these cultures are contemporaneous with the medieval, Renaissance, and even modern cultures of the West, they are actually closer to the Neolithic cultures in terms of social practice and organization. Oceanic cultures are a case in point. Another is the Anasazi [ah-nuh-SAH-zee] culture of North America.

The Anasazi people thrived in the American Southwest from about 900 to 1300 CE, a time roughly contemporaneous with the late Middle Ages in Europe. They left us no written record of their culture, only ruins and artifacts. At Mesa

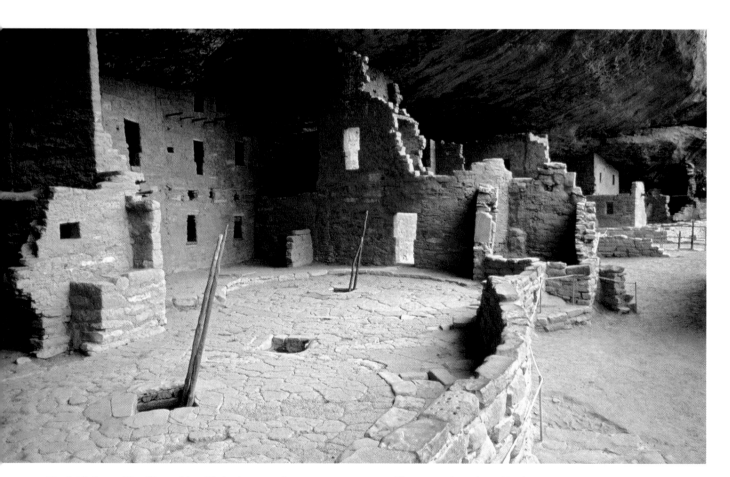

Fig. 1.16 Spruce Tree House, Mesa Verde. Anasazi culture. ca. 1200–1300 CE. The courtyard was formed by the restoration of the roofs over two underground kivas.

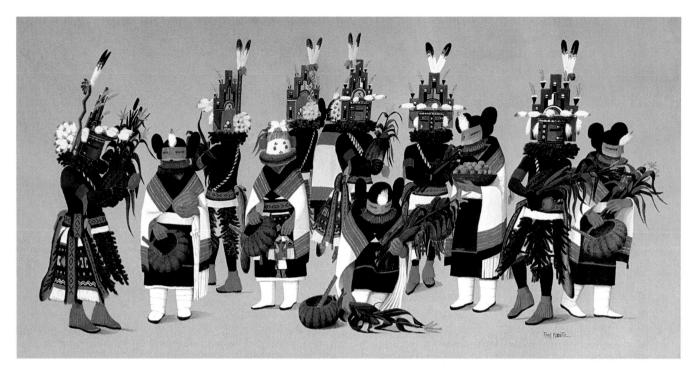

Fig. 1.17 Fred Kabotie. *Zuni Corn Dance*. 1920s. Watercolor and tempera. Peabody Museum, Harvard University.
© 2006 Peabody Museum, Harvard University 64-19-10/42483 T180. The Zuni corn dance, which takes place in late
June, is meant to promote fertility and rains to aid the maize, bean, and squash crops. Prayer sticks are planted in the fields.

Verde [may-suh vurd-ee], in what is today southwestern Col-orado, their cliff dwellings (Fig. **1.16**) resemble many of the Neolithic cities of the Middle East, such as Ain Ghazal [ine gah-zahl] ("spring of the gazelles"), just outside what is now Amman, Jordan. Though Ain Ghazal flourished from about 7200 to 5000 BCE, thousands of years before the Mesa Verde community, both complexes were constructed with stone walls sealed with a layer of mud plaster. Their roofs were made of wooden beams cross-layered with smaller twigs and branches and sealed with mud. Like other Neolithic cultures, the Anasazi were accomplished in pottery making, decorat-ing their creations with elaborately abstract, largely geomet-ric shapes and patterns. As William M. Ferguson and Arthur H. Rohn, two prominent scholars of the Anasazi, have described them: "They were a Neolithic people without a beast of burden, the wheel, metal, or a written language, yet they constructed magnificent masonry housing and ceremo-nial structures, irrigation works, and water impoundments."

The Anasazi abandoned their communities in the late thirteenth century, perhaps because of a great drought that lasted from about 1276 to 1299. Their descendents are the Pueblo [PWEB-loh] peoples of the Southwest today, includ-ing the Hopi [HO-pee] and the Zuni [ZOO-nee]. (*Anasazi* is in fact a Navajo word meaning "enemy ancestors"—we do not know what the Anasazi called themselves.) What is remarkable about the Pueblo peoples, who despite the fact that they speak several different languages share a remarkably

common culture, is that many aspects of their culture have survived and are practiced today much as they were in ancient times. For all Pueblo peoples, the village is not just the center of culture but the very center of the world. And at the center of the village is the **kiva** [KEE-vuh], a partly underground ceremonial enclosure that dates back to Anasazi times, with a hole in the floor that symbolizes the emergence of the people from the underworld.

Zuni Pueblo Emergence Tales The Pueblos have main-tained the active practice of their ancient Anasazi religious rites and ceremonies, which they have chosen not to share with outsiders. Most do not allow their ceremonial dances to be photographed. However, the Hopi painter Frank Kabotie depicted many of them in the 1820s (Fig. **1.17**). These dance performances tell stories that relate to the experiences of the Pueblo peoples, from planting, hunting, and fishing in daily life, to the larger experiences of birth, puberty, maturity, and death. Still other stories explain the origin of the world, the emergence of a particular Pueblo people into the world, and their history. Most Pueblo people believe that they originat-ed in the womb of Mother Earth and, like seeds sprouting from the soil in the springtime, were called out into the day-light by their Sun Father. This belief about origins is embod-ied in a type of narrative known as an **emergence tale**, a form of creation myth. **Reading 1.1**, written down in 1930, begins the Zuni Pueblo emergence tale.

Zuni Emergence Tale, *Talk Concerning the First Beginning*

Yes, indeed. In this world there was no one at all. Always the sun came up; always he went in. No one in the morning gave him sacred meal; no one gave him prayer sticks; it was very lonely.[1] He said to his two children:[2] "You will go into the fourth womb. Your fathers, your mothers, kä-eto·we, tcu-eto·we, mu-eto·we, le-eto·we, all the society priests, society pekwins, society bow priests, you will bring out yonder into the light of your sun father."[3] Thus he said to them. They said, "But how shall we go in?" "That will be all right." Laying their lightning arrow across their rainbow bow, they drew it. Drawing it and shooting down, they entered.

When they entered the fourth womb it was dark inside. They could not distinguish anything. They said, "Which way will it be best to go?" They went toward the west. They met someone face to face. They said, "Whence come you?" "I come from over this way to the west." "What are you doing going around?" "I am going around to look at my crops. Where do you live?" "No, we do not live any place. There above our father the Sun, priest, made us come in. We have come in," they said. "Indeed," the younger brother said. "Come, let us see," he said. They laid down their bow. Putting underneath some dry brush and some dry grass that was lying about, and putting the bow on top, they kindled fire by hand. When they had kindled the fire, light came out from the coals. As it came out, they blew on it and it caught fire. Aglow! It is growing light. "Ouch! What have you there?" he said. He fell down crouching. He had a slimy horn, slimy tail, he was slimy all over, with webbed hands. The elder brother said, "Poor thing! Put out the light." Saying thus, he put out the light. The youth said, "Oh dear, what have you there?" "Why, we have fire," they said. "Well, what (crops) do you have coming up?" "Yes, here are our things coming up." Thus he said. He was going around looking after wild grasses.

He said to them, "Well, now, let us go." They went toward the west, the two leading. There the people were sitting close together. They questioned one another. Thus they said, "Well, now, you two, speak. I think there is something to say. It will not be too long a talk. If you let us know that we shall always remember it." "That is so, that is so," they said. "Yes, indeed, it is true. There above is our father, Sun. No one ever gives him prayer sticks; no one ever gives him sacred meal; no one ever gives him shells. Because it is thus we have come to you, in order that you may go out standing yonder into the daylight of your sun father. Now you will say which way (you decide)." Thus the two said. "Hayi! Yes, indeed. Because it is thus you have passed us on our roads.[4] Now that you have passed us on our roads here where we stay miserably, far be it from us to speak against it. We cannot see one another. Here inside where we just trample on one

another, where we just spit on one another, where we just urinate on one another, where we just befoul one another, where we just follow one another about, you have passed us on our roads. None of us can speak against it. But rather, as the priest of the north says, so let it be. Now you two call him." Thus they said to the two, and they came up close toward the north side. . . .

[1]There is a reciprocal gift-giving relationship between the Sun Father and all creatures, including people. According to Zuni tradition, the Sun Father gives corn and breath, the gifts of life. In return, the Zuni offer corn meal and downy feathers, symbolizing clouds and breath, which are attached to ritually painted sticks. Both are deposited at shrines near Zuni.
[2]The two children are the Ahaiyute, the War God Hero Twins.
[3]Zuni people are organized into religious societies, each responsible for a different aspect of the community's welfare. The *-eto.we* are fetishes, each representing that spirit, originating deep within the womb of the earth, which is the foundational force of each society. The pekwin is the sun priest who keeps the ritual calendar; the bow priests govern warfare and regulate social behavior. In bringing all these from the earth's fourth womb onto the earth's surface, the War God Twins are assisting at the birth of the Zuni tribe, the "daylight people."
[4]A formulaic phrase, suggesting something like destiny: Everyone's life, and indeed the life of the community, can be imagined as a "road" to "pass another on the road" is to acknowledge converging destinies.

This brief passage from the Zuni emergence tale captures the fundamental principles of Zuni religious society. The Zuni, or "Sun People," are organized into groups, each responsible for a particular aspect of the community's well-being, and each group is represented by a particular *-eto·we*, or fetish, connecting it to its spiritual foundation in the Earth's womb. The pekwins mentioned here are sun priests, who control the ritual calendar. Bow priests oversee warfare and social behavior. In return for corn and breath given them by the Sun Father, the Zuni offer him cornmeal and downy feathers attached to painted prayer sticks symbolizing both clouds—the source of rain—and breath itself. Later in the tale the two children of the Sun Father bring everyone out into the daylight for the first time:

Into the daylight of their sun father they came forth standing. Just as early dawn they came forth. After they came forth there they set down their sacred possessions in a row. The two said, "Now after a little while when your sun father comes forth standing to his sacred place you will see him face to face. Do not close your eyes." Thus he said to them. After a little while the sun came out. When he came out they looked at him. From their eyes the tears rolled down. After they had looked at him, in a little while their eyes became strong. "Alas!" Thus they said. They were covered all over with slime. With slimy tails and slimy horns, with webbed fingers, they saw one another. "Oh dear! is this what we look like? Thus they said.

Then they could not tell which was which of their sacred possessions.

From this point on in the tale, the people and priests, led by the two children, seek to find the sacred "middle place," where things are balanced and orderly. Halona-Itiwana [ha-LOH-nah it-ee-WAH-nah] it is called, the sacred name of the Zuni Pueblo, "the Middle Ant Hill of the World." In the process they are transformed from indeterminate, salamander-like creatures into their ultimate human form, and their world is transformed from chaos to order.

At the heart of the Zuni emergence tale is a moment when, to the dismay of their parents, many children are transformed into water-creatures—turtles, frogs, and the like—and the Hero Twins instruct the parents to throw these children back into the river. Here they become *kachinas* [kuh-CHEE-nuhs] or *katcinas*, deified spirits, who tell the War God Hero Twins:

> May you go happily. You will tell our parents, "Do not worry." We have not perished. In order to remain thus forever we stay here. To Itiwana but one day's travel remains. Therefore we stay nearby. . . . Whenever the waters are exhausted and the seeds are exhausted you will send us prayer sticks. Yonder at the place of our first beginning with them we shall bend over to speak to them. Thus there will not fail to be waters. Therefore we shall stay quietly nearby.

The Pueblo believe that kachina spirits, not unlike the spirits evoked by the African Baule mask discussed earlier (see Fig. 1.5), manifest themselves in performance and dance. Masked male dancers impersonate the kachinas, taking on their likeness as well as their supernatural character. Through these dance visits the kachinas, although always "nearby," can exercise their powers for the good of the people. The nearly 250 kachina personalities embody clouds, rain, crops, animals, and even ideas such as growth and fertility. Although kachina figurines (Fig. **1.18**) are made for sale as art objects, particularly by the Hopi, the actual masks worn in ceremonies are not considered art objects by the Pueblo people. Rather, they are thought of as active agents in the transfer of power and knowledge between the gods and the men who wear them in dance, just like the African Baule mask. In fact, kachina dolls made for sale are considered empty of any ritual power or significance.

Pueblo emergence tales, and the ritual practices that accompany them, reflect the general beliefs of most Neolithic peoples. These include the following:

- belief that the forces of nature are inhabited by living spirits, which we call **animism**
- belief that nature's behavior can be compared to human behavior (we call the practice of investing plants, animals, and natural phenomena with human form or attributes **anthropomorphism**), thus explaining what otherwise would remain inexplicable

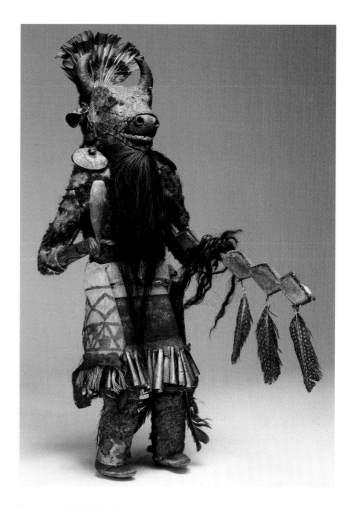

Fig. 1.18 Buffalo Kachina. Zuni culture. ca. 1875. Wood, cloth, hide, fur, shell, feathers, horse hair, tin cones. © Millicent Rogers Museum, Taos, New Mexico. The Buffalo Kachina is designed to increase the population of fur-bearing animals in the arid environment of the Southwest. Derived from a Plains Indian ritual dance, it was first danced by the Zuni near the end of the last century as the region's wildlife was becoming increasingly threatened.

- belief that humans can communicate with the spirits of nature, and that, in return for a sacrificial offering or a prayer, the gods might intercede on their behalf.

A culture's religion—that is, its understanding of the divine—is thus closely tied to and penetrated by mythical elements. Its beliefs, as embodied in its religion, stories, and myths, were closely tied to seasonal celebrations and agricultural production—planting and harvest in particular, as well as rain—the success of which was understood to be inextricably linked to the well-being of the community. In a fundamental sense, myths reflect the community's ideals, its history (hence, the preponderance of creation myths among ancient societies), and its aspirations. Myths also tend to mirror the culture's moral and political systems, its social

organization, and its most fundamental beliefs. They are not fanciful misconceptions about the nature of things; rather, they are reasonably accurate reflections of what a culture believes itself to be. (See **Reading 1.2**, page 30.)

The Olmec

In some prehistoric cultures, priests or priestesses were principally responsible for mediating between the human and the divine. In others, the ruler was the representative of the divine world on Earth. But in almost all prehistoric cultures, communication with the spiritual world was conducted in special precincts or places. Many scholars believe that caves served this purpose in Paleolithic times. In Neolithic culture, sites such as Stonehenge and the Anasazi kiva served this function. As early as 1300 BCE, a preliterate group known as the Olmec [OHL-mek] came to inhabit the area between Veracruz and Tabasco on the southern coast of the Gulf of Mexico (see Map 1.4), where they built huge ceremonial precincts in the middle of their communities. Many of the characteristic features of later Mesoamerican culture, such as pyramids, ball courts, mirror-making, and the calendar system, originated in the lowland agricultural zones that the Olmec inhabited.

The Olmec built their cities on great earthen platforms, probably designed to protect their ceremonial centers from rain and flood. On these platforms, they erected giant pyramidal mounds, where an elite group of ruler-priests lived, supported by the general population that farmed the rich, sometimes swampy land that surrounded them. These pyramids may have been an architectural reference to the volcanoes that dominate Mexico, or they may have been tombs. Excavations may eventually tell us. At La Venta [luh VEN-tuh], very near the present-day city of Villahermosa [vee-yuh-er-MOH-suh], three colossal stone heads stood guard over the ceremonial center on the south end of the platform (Fig. 1.19), and a fourth guarded the north end by itself. Each head weighs between 11 and 24 tons, and each bears a unique emblem on its headgear, which is similar to old-style American leather football helmets. At other Olmec sites—San Lorenzo, for instance—as many as eight of these heads have been found, some up to 12 feet high. They are carved of basalt, although the nearest basalt quarry is 50 miles to the south in the Tuxtla [toost-luh] Mountains. They were evidently at least partially carved at the quarry, then loaded onto rafts and floated downriver to the Gulf of Mexico before going back upriver to their final resting places. The stone heads are

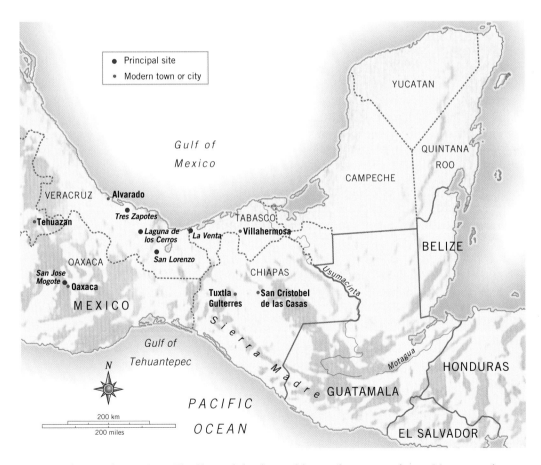

Map 1.4 Olmec Civilization Sites. The Olmec inhabited most of the area that we now refer to as Mesoamerica from 1300 to 400 BCE.

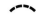

Map 1.5 Archeological Sites of the Anasazi and the Mound Builders' Archeological Sites in North America.

generally believed to be portraits of Olmec rulers, and they all share the same facial features, including wide, flat noses and thick lips. They suggest that the ruler was the culture's principal mediator with the gods, literally larger than life.

The Mound Builders

Sometime between 1800 and 500 BCE, at about the same time as the Olmec were building the La Venta mound cluster in Mexico, Neolithic hunter-gatherers in eastern North America began building huge ceremonial centers of their own, consisting of large-scale embankments and burial mounds (Map 1.5). These people, who probably had arrived in North America sometime between 14,000 and 10,000 BCE, are known as the Woodlands peoples because the area where they lived, from the Mississippi River basin in the West to the Atlantic Ocean in the East, was originally forested.

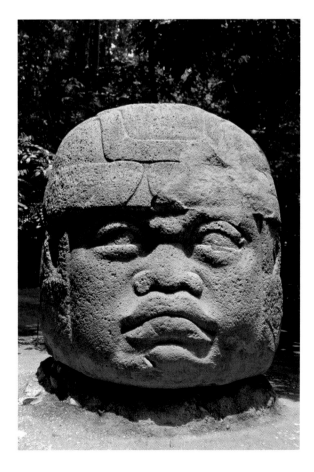

Fig. 1.19 Colossal head, from La Venta, Mexico. Olmec culture. ca. 900–500 BCE. Basalt, height 7′5″. La Venta Park, Villahermosa, Tabasco, Mexico. Giant heads such as this one faced out from the ceremonial center and evidently served to guard it.

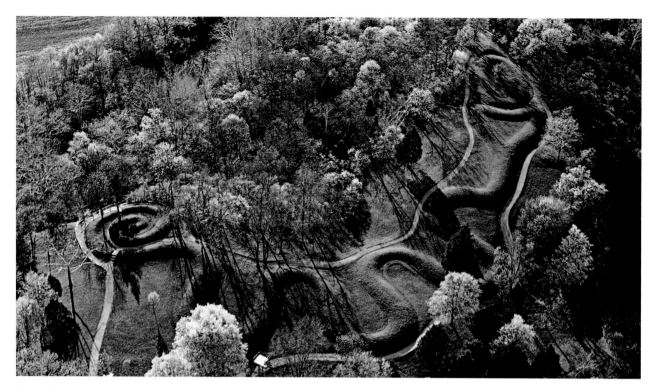

Fig. 1.20 Great Serpent Mound, Adams County, Ohio. Hopewell culture. ca. 600 BCE–200 CE. Length approx. 1,254′.
Recently, archeologists have carbon-dated an artifact found at the Great Serpent Mound as late as 1070 CE. As a result,
some now think that the mound may be related to Halley's comet, which passed by the earth in 1066.

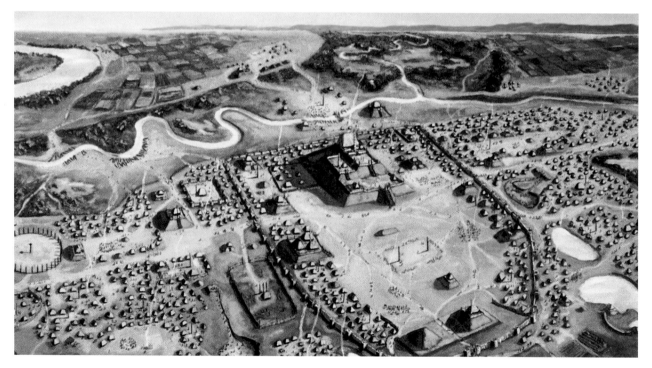

Fig. 1.21 Reconstruction of central Cahokia, East St. Louis, Illinois. Mississippian culture. ca. 1150 CE. East–west
length approx. 3 mi.; north–south length approx. 2 $\frac{1}{4}$ mi.; base of great mound, 1,037′ × 790′; height approx. 100′.
Painting by William R. Iseminger, "Reconstruction of Central Cahokia Mounds." Courtesy of Cahokia Mounds State
Historic Site. The stockade, or fence, surrounding the central area, indicates that warfare probably played an important
role in Mississippian life.

One of these Woodlands peoples, the Hopewell culture in southern Ohio, enveloped the corpses of what we presume were their highest-ranking leaders from head to toe in freshwater pearls, weighted them down with plates of beaten copper, and then surrounded them with jewelry, sculpture, and pottery. These burials give us a fair idea of the extent of Woodlands trade. Their copper came from the Great Lakes, decorative shell from the Gulf Coast, alligator and shark teeth from Florida, and mica from the Appalachian Mountains. There are even examples of obsidian that can be traced to what is now Yellowstone National Park, and grizzly bear teeth from the Rocky Mountains.

The most intriguing of the Hopewell mounds is the Great Serpent Mound, near Locust Grove, Ohio (Fig. **1.20**). Nearly a quarter of a mile long, it contains no burial sites. Its "head" consists of an oval enclosure that may have served some ceremonial purpose, and its tail is a spiral. The spiral would, in fact, become a favorite decorative form of the Mississippian culture, which developed out of the Woodland era cultures and raised ritual mound building to a new level of achievement. The great mound at Cahokia [kuh-HO-kee-uh] (Fig. **1.21**), near the juncture of the Illinois, Missouri, and Mississippi rivers at modern East St. Louis, Illinois, required the moving of over 22 million cubic feet of earth and probably three centuries to construct, beginning about 900 CE. It was the focal point of a ritual center that contained as many as 120 mounds, some of which were aligned with the position of the sun at the equinoxes, as well as nearly 400 other platforms, wooden enclosures, and houses. Evidence suggests that the Mississippians worshiped the sun: The Natchez people, one of the Mississippian peoples who survived contact with European culture, called their chief the Great Sun, and their highest social class the Suns.

The Mississippian culture sustained itself primarily by the cultivation of corn, suggesting close connections to Mexico, where cultivation of corn was originally perfected. As many as 4 million people may have lived in the Mississippi Valley. Cahokia itself thrived, with a population of 20,000 people within its six-square-mile area, until just before 1500 when the site was mysteriously abandoned.

READINGS

The Japanese Creation Myth: The *Kojiki*

The following is a beginning of a modern retelling of the "Kojiki" or "Records of Ancient Matters" the oldest surviving account of ancient Japanese history. This creation myth, which details the origins of Japan and the sacred spirits or "kami" which are objects of worship for the indigenous religion of Japan, Shintoism.

Before the heavens and the earth came into existence, all was a chaos, unimaginably limitless and without definite shape or form. Eon followed eon: then, lo! out of this boundless, shapeless mass something light and transparent rose up and formed the heaven. This was the Plain of High Heaven, in which materialized a deity called Ame-no-Minaka-Nushi-no-Mikoto (the Deity-of-the-August-Center-of-Heaven). Next the heavens gave birth to a deity named Takami-Musubi-no-Mikoto (the High-August-Producing-Wondrous-Deity), followed by a third called Kammi-Musubi-no-Mikoto (the Divine-Producing-Wondrous-Deity). These three divine beings are called the Three Creating Deities.

In the meantime what was heavy and opaque in the void gradually precipitated and became the earth, but it had taken an immeasurably long time before it condensed sufficiently to form solid ground. In its earliest stages, for millions and millions of years, the earth may be said to have resembled oil floating, medusa-like, upon the face of the waters. Suddenly like the sprouting up of a reed, a pair of immortals were born from its bosom. . . . Many gods were thus born in succession, and so they increased in number, but as long as the world remained in a chaotic state, there was nothing for them to do. Whereupon, all the Heavenly deities summoned the two divine beings, Izanagi and Izanami, and bade them descend to the nebulous place, and by helping each other, to consolidate it into terra firma. [The heavenly deities] handed them a spear called Ama-no-Nuboko, embellished with costly gems. The divine couple received respectfully and ceremoniously the sacred weapon and then withdrew from the presence of the deities, ready to perform their august commission. Proceeding forthwith to the Floating Bridge of Heaven, which lay between the heaven and the earth, they stood awhile to gaze on that which lay below. What they beheld was a world not yet condensed, but looking like a sea of filmy fog floating to and fro in the air, exhaling the while an inexpressibly fragrant odor. They were, at first, perplexed just how and where to start, but at length Izanagi suggested to his companion that they should try the effect of stirring up the brine with their spear. So saying he pushed down the jeweled shaft and found that it touched something. Then drawing it up, he examined it and observed that the great drops which fell from it almost immediately coagulated into an island, which is, to this day, the Island of Onokoro. Delighted at the result, the two deities descended forthwith from the Floating Bridge to reach the miraculously created island. In this island they thenceforth dwelt and made it the basis of their subsequent task of creating a country. . . . First, the island of Awaji was born, next, Shikoku, then, the island of Oki, followed by Kyushu; after that, the island Tsushima came into being, and lastly, Honshu, the main island of Japan. The name of Oyashi- ma-kuni (the Country of the Eight Great Islands) was given to these eight islands. . . . ■

Reading Question

One of the key moments in this creation myth is when the Heavenly deities order Izanagi and Izanami to "descend to the nebulous place, and by helping each other, to consolidate it into terra firma." What does this tell us about Japanese culture?

Summary

■ **The Beginnings of Culture** Culture can be defined as a way of living—religious, social, and/or political—formed by a group of people and passed on from one generation to the next. It took thousands of years for cultures to develop into full-blown civilizations. A civilization is distinct from a culture in its ability to organize itself thoroughly as a social, economic, and political entity by means, especially, of written language, which did not come into being until about 3000 BCE. Early culture manifests itself in Paleolithic times particularly in cave paintings, such as those discovered at Chauvet Cave, where the artists' great skill in rendering animals helps us to understand that the ability to represent the world with naturalistic fidelity is an inherent human skill, unrelated to cultural sophistication. We can be fairly certain that none of these images were merely decorative or ornamental. They were believed to possess power and authority, which they exerted through the rituals associated with them.

The widespread use of stone tools and weapons by *Homo sapiens*, the hominid species that evolved around 120,000–100,000 years ago, gives rise to the name of the earliest era of human development, the Paleolithic era. Carvers fashioned stone figures, both in the round and in relief, including many images of women and very few of men, suggesting that women played a central role in Paleolithic culture, exerting their influence in its ritual and spiritual life. These people were hunter-gatherers who followed herds of animals as they migrated across the continent. Slowly they began to come together in communities and build more permanent dwellings, such as the mammoth-bone houses discovered in the Ukraine.

■ **The Rise of Agriculture** As the ice that covered the Northern Hemisphere slowly melted, Mesolithic peoples began cultivating edible grasses and domesticating animals. Gradually, farming supplanted hunting as the primary means of sustaining life, especially in the great river valleys where water was abundant. The rise of agriculture is the chief characteristic of the Neolithic age. Permanent villages began to appear, including Jericho on the west bank of the Jordan River, a fortified city made of mud-brick construction that surrounded an oasis. There, skulls of the dead were preserved and buried separately, their features rebuilt in plaster and painted in the ancestor's likeness. This practice implies a sense of permanence and stability, as does the widespread use of ceramic pottery, introduced as early as 10,000 BCE in Japan. Japanese Jomon pottery is distinguished by its elaborate

flamelike rims, but Neolithic pottery in other places, such as China and the Middle East, is painted with flowing abstract designs and highly stylized images of animals, respectively. By about 3000 BCE, pottery had been introduced to Neolithic cultures as far north as Britain.

■ **The Neolithic Megaliths of Northern Europe** It was in the north—in France and England—that Neolithic peoples began constructing monumental stone architecture, or megaliths. Upright, single stone posts called menhirs were placed in the ground, either individually or in groups, as at Carnac in Brittany. Elementary post-and-lintel construction was employed to create dolmens, two posts roofed with a capstone. The most famous of the third type of monumental construction, the circular cromlech, is Stonehenge, in England. An enormous amount of human labor was required for its construction, which is oriented toward the rising sun at the summer solstice and must have served some ritual function in connection with agricultural production.

■ **Neolithic Cultures of the Americas** Neolithic culture in the Americas lasted well into the second millennium CE. The architecture of the Anasazi, in the southwestern United States, dates from about 1200 CE and bears a strong resemblance to much earlier Neolithic settlements in the Middle East. Much of our understanding of the role of myth in prehistoric cultures derives from the traditions of contemporary native American tribes that still survive in tribes such as the Hopi and Zuni, who are the direct descendents of the Anasazi. Their legends, such as the Zuni emergence tale, encapsulate the fundamental religious principles of the culture. Such stories, and the ritual practices that accompany them, reflect the general beliefs of most Neolithic peoples—that the forces of nature are inhabited by living spirits; that nature's behavior can be compared with human behavior; and that humans can communicate with these spirits, in the case of the Zuni and Hopi through kachina figures. In Neolithic cultures, ritual practices usually take place in special precincts, such as the Anasazi kiva, Stonehenge, or in the ceremonial centers of the Olmec culture of southern Mexico. By the end of the first millennium CE, the Hopewell and Mississipian cultures in North America were constructing mounds associated with religious practices connected to the sun and the corn harvest, the largest of them at Cahokia, near the juncture of the Illinois, Missouri, and Mississippi rivers.

 Glossary

animism The belief that the forces of nature are inhabited by living spirits.

anthropomorphism The practice of investing plants, animals, and natural phenomena with human form or attributes.

cairn A fully enclosed burial chamber covered with earth.

carving The act of cutting or incising stone, bone, wood, or other material into a desired form.

civilization A culture that possesses the ability to organize itself thoroughly and communicates through written language.

creation myth A story of a people's origin.

cromlech A circle of megaliths, usually surrounding a dolmen or mound.

culture The set of values, beliefs, and behaviors that governs or determines a common way of living formed by a group of people and passed on from one generation to the next.

dolmen A type of prehistoric megalithic structure made of two posts supporting a horizontal capstone.

emergence tale A type of narrative that explains beliefs about a people's origins.

hominids The earliest upright mammals, including humans, apes, and other related forms.

hunter-gatherer One whose primary method of subsistence depends on hunting animals and gathering edible plants and other foodstuffs from nature.

kiva A Pueblo ceremonial enclosure that is usually partly underground and serves as the center of village life.

lintel A horizontal architectural element.

megaliths Literally, "big stones"; large, usually rough, stones used in a monument or structure.

menhir A large single upright stone.

modeling The use of shading in a two-dimensional representation to give a sense of roundness and volume.

myth A story that a culture assumes is true. A myth also embodies the culture's views and beliefs about its world, often serving to explain otherwise mysterious natural phenomena.

naturalism In art, representations that imitate the reality in appearance of natural objects.

oral culture A culture that develops without writing and passes down stories, beliefs, values, and systems by word of mouth.

perspectival drawing The use of techniques to show the relation of objects as they appear to the eye and to convey a sense of three-dimensional space on a two-dimensional surface.

post A piece fixed firmly in an upright position.

post-and-lintel A form of construction consisting of two posts (upright members) that support a lintel (horizontal member).

prehistoric Existing in or relating to the times before writing and recorded history.

relief sculpture A three-dimensional work of art carved out of a flat background surface.

sculpture in the round A fully three-dimensional work of art.

shaman A person thought to have special ability to communicate with the spirit world.

trilithon A type of megalithic structure composed of three stones: two posts and a lintel; served in prehistory as the basic architectural unit.

 Critical Thinking Questions

1. How does a civilization differ from a culture?

2. What features of the cave paintings at Chauvet have altered the way we have traditionally thought about the development of art?

3. How does Neolithic culture differ from Paleolithic culture, and what are the primary characteristics of each?

4. What role does myth play in prehistoric cultures?

Representing the Power
of the Animal World

The two images shown here in some sense bracket the six volumes of *The Humanities*. The first (Fig. **1.22**), from the Chauvet Cave, is one of the earliest known drawings of a horse. The second (Fig. **1.23**), a drawing by contemporary American painter Susan Rothenberg (b. 1945), also represents a horse, though in many ways less realistically than the cave drawing. The body of Rothenberg's horse seems to have disappeared and, eyeless, as if blinded, it leans forward, its mouth open, choking or gagging or gasping for air.

In his catalog essay for a 1993 retrospective exhibition of Rothenberg's painting, Michael Auping, chief curator at the Albright-Knox Museum in Buffalo, New York, described Rothenberg's kind of drawing: "Relatively spontaneous, the drawings are Rothenberg's psychic energy made imminent. . . . [They] uncover realms of the psyche that are perhaps not yet fully explicable." The same could be said of the cave drawing, executed by a nameless hunter-gatherer more than 20,000 years ago. That artist's work must have seemed just as strange as Rothenberg's, lit by flickering firelight in the dark recesses of the cave, its body disappearing too into the darkness that surrounded it.

It seems certain that in some measure both drawings were the expression of a psychic need on the part of the artist—whether derived from the energy of the hunt or of nature itself—to fix upon a surface an image of the power and vulnerability of the animal world. That drive, which we will see in the art of the Bronze Age of the Middle East in the next chapter—for instance, in the haunting image of a dying lion in the palace complex of an Assyrian king at Nineveh—remains constant from the beginnings of art to the present day. It is the compulsion to express the inexpressible, to visualize the mind as well as the world. ∎

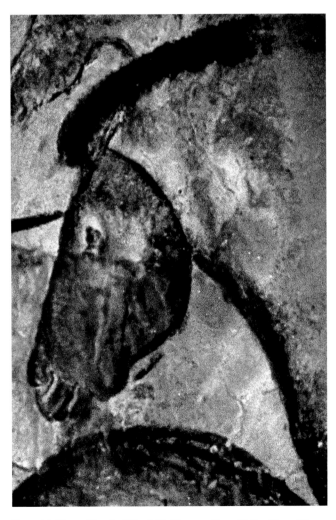

Fig. 1.22 Horse (detail of Fig. 1.3), Chauvet Cave, Vallon-Pont-d'Arc, Ardèche gorge, France. ca. 30,000 BCE. Note the realistic shading that defines the volume of the horse's head. It is a realism that artists throughout history have sometimes sought to achieve and sometimes ignored, in their efforts to express for the forces that drive them.

Fig. 1.23 Susan Rothenberg. *Untitled*. 1978. Acrylic, flashe, and pencil on paper, 20″ × 20″. Collection Walker Art Center, Minneapolis. Art Center Acquisition Fund, 1979. © 2008 Susan Rothenberg/Artist's Rights Society (ARS), NY. Part of the eeriness of this image comes from Rothenberg's use of flashe, a French vinyl-based color that is clear and so creates a misty, ghostlike surface.

2 Mesopotamia

Power and Social Order in the Fertile Crescent

Sumerian Ur

Akkad

Babylon

The Assyrian Empire

Mesopotamian Literature

The Hebrews

Neo-Babylonia

“ *Terrifying lord, in the Assembly of the gods no one equals you!* . . .
Your weapons flare in the tempest!
Your flame annihilates the steepest mountain. ”

Hymn to Marduk

◄ **Fig. 2.1 The ziggurat at Ur (modern Muqaiyir, Iraq). ca. 2100 BCE.** The best preserved and most fully restored of the ancient Sumerian temples, this ziggurat was the center of the city of Ur, in the lower plain between the Tigris and Euphrates rivers. It is symbolic of both the rise and fall of the many cultures that for three millennia dominated the region—Sumerian, Akkadian, Assyrian, and Babylonian. It was in these cultures that so many disparate things familiar to us today, including beer and the epic poem, first appeared in the Western world.

N SEPTEMBER 1922, THE BRITISH ARCHEOLOGIST, C. LEONARD

Woolley boarded a steamer, beginning a journey that would take him to southern Iraq. There, Woolley and his team would discover one of the richest treasure troves in the history of archeology—the ruins of the ancient city of Ur. During six years of

excavations, Woolley grew especially interested in a burial ground. Digging there in the winter of 1927, he unearthed a series of tombs with several rooms, many bodies, and spectacular objects. Excited by the find that he would call the "Royal Tombs," but careful to keep it secret, on January 4, 1928, Woolley telegrammed his colleagues in Latin. Translated to English it read:

> I found the intact tomb, stone built, and vaulted over with bricks of queen Shubad [later known as Puabi] adorned with a dress in which gems, flower crowns and animal figures are woven. Tomb magnificent with jewels and golden cups.
>
> —Woolley

He had found masses of golden objects—vessels, crowns, necklaces, statues, and weapons—as well as jewelry and lyres made of electrum and the deep blue stone, lapis lazuli. The find was worldwide news for years.

Archeologists and historians were especially excited by Woolley's discoveries, because they opened a window onto the larger region we call Mesopotamia [mes-uh-po-TAY-mee-uh], the land between the Tigris [TIE-gris] and Euphrates [you-FRAY-teez] rivers. Ur was one of 30 or 40 cities that arose in Sumeria, the southern portion of Mesopotamia (Map **2.1**). Its people abandoned Ur more than 2,000 years ago, when the Euphrates changed its course away from the city.

Woolley's Ur lies in the eastern half of the Fertile Crescent, a semicircle of territory that extends from the Nile River basin in Egypt, north along the Mediterranean coast to what is now Syria and Turkey, where it arches south into the Tigris and Euphrates valleys (see Map 2.1). Geologists believe that the land of Ur was largely desert, much as it is today. Rainfall was unreliable and probably too scarce to support agriculture, but the soil in the river valleys was deep and rich, especially in alluvial plains of the delta regions. All around the Fertile Crescent, the hunter-gatherers who first occupied sites such as Ur and Jericho (see chapter 1), relying for survival on the abundant wild game that thrived in the

dense growth along the riverbanks or oases, came together to form small farming communities.

Irrigation of the lands just outside the marshes on the riverbanks created the conditions necessary for more extensive and elaborate communities. People dug canals and ditches and cooperated in regulating the flow of water in them, which eventually resulted in crops that exceeded the needs of the population. These could be transformed into foodstuffs of a more elaborate kind, including beer. Evidence indicates that over half of each grain harvest went into producing beer. Excess crops were also traded by boat with nearby communities or up the great rivers to the north, where stone, wood, and metals were available in exchange. Cities such as Ur became hubs of great trading networks. And with trade came ideas, which were incorporated into local custom and spawned newer and greater ideas in turn. These are the conditions out of which centers of culture always arise.

This chapter outlines the cultural forces that came to define Mesopotamia. Among the most significant was the invention of **metallurgy**, the science of separating metals from their ores and then working or treating them to create objects. Beginning about 4000 BCE, metal began to replace stone and bone tools and weapons. The peoples of Mesopotamia may not have known they were living in a new era, but modern archeologists mark metallurgy as the end of the Stone Age and the start of the Bronze Age.

The new technology would change the culture's social organization as well. Metallurgy required the mining of ores, specialized technological training, and skilled artisans. Although the metallurgical properties of copper were widely understood, technicians discovered that by alloying it with tin they could create bronze, a material of enormous strength and durability. Bronze weapons would transform the military and the nature of warfare. Bronze created a new military social class of soldiers dedicated to protecting the competitive Sumerian **city-states** from one another. The city-states were based in the various urban centers of the Mesopotamian basin. These competing centers of culture spawned govern-

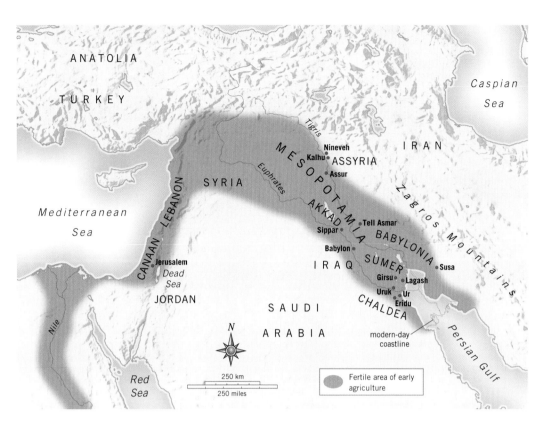

Map 2.1 Eastern Mediterranean basin and major Mesopotamian capitals, ca. 2600–2500 BCE.

ments ruled by **priest-kings**, who acted as intermediaries between the gods and the people. In their secular role, the priest-kings established laws that contributed to the social order necessary for maintaining successful agricultural societies. The arts developed largely as celebrations of the priest-kings' powers. The city-state governments demanded that records be kept, and writing, perhaps the greatest innovation of the Bronze Age, developed out of this need.

Around 2000 BCE, this social order collapsed when a nomadic tribe from the north, the Hittites, invaded the region, introducing an even stronger metal—iron—and a new means of warfare, the horse-drawn war chariot. Iron Age culture was the culture of empire, as iron weapons and armor enabled successive peoples—the Akkadians, Assyrians, Babylonians, and Persians—to control the entire Mesopotamian region. Elements of Sumerian culture lived on in these successive empires, including religious traditions, and texts such as the *Epic of Gilgamesh*.

A different set of traditions grew up around Hebrew culture in Israel. Similar in many ways to the other cultures of the region, the Hebrews are unique in their worship of a single god—monotheism—and in the authority they granted the written word as God's direct communication with their patriarch, Moses [MOH-zus]. The implications of monotheism for Western civilization were profound and enduring; we will examine the culture of the ancient Hebrews later in this chapter. We turn first to the Sumerians of Ur.

Sumerian Ur

Ur is not the oldest city to occupy the southern plains of Mesopotamia, the region known as Sumer [SOO-mur]. That distinction belongs to Uruk [oo-RUK], just to the north, and Eridu [ER-uh-doo] to the south. Surviving literary fragments suggest that Eridu was defeated by Uruk sometime after 3400 BCE. By 3100 BCE, at any rate, the people of Uruk (modern Warka [wur-KA], Iraq) had erected two large temple complexes, one dedicated to Inanna [in-NAH-nah], the goddess of fertility and heaven, and another to Anu [AH-noo], the god of the sky. But the temple structure at Ur is of particular note because it is the most fully preserved and restored.

The Ziggurat at Ur

The **ziggurat** [ZIG-uh-rat] at Ur (Figs. **2.1–2.3**) is a pyramidal temple structure consisting of successive platforms with outside staircases and a shrine at the top. It rose over the desert like a mountain. Most likely, it was designed to evoke the mountains surrounding the river valley, which were the source of the water that flowed through the two rivers and, so, the source of life. Topped by a sanctuary, the ziggurat might also have symbolized the bridge between heaven and earth. Woolley, who supervised the reconstruction of the first platform and stairway of the ziggurat at Ur, speculated that the platforms of the temple were originally not paved but covered with soil and planted with trees. The rainwater used to irrigate these trees would have flowed into the interior of the ziggurat and exited through a series of weeper-holes, venting ducts loosely filled with broken pottery, in the side of the ziggurat.

Fig. 2.2 Remains of the city of Ur (modern Muqaiyir, Iraq). ca. 2100 BCE. Public buildings and residences of the elite surrounded the ziggurat (lower left). Winding paths and alleys connected the dense housing, and certain areas were laid out in a grid plan (top of the photo). The city was walled and fortified. The desert that surrounds Ur today was once rich farmland. Barley and wheat were the principal crops, although lentils and some form of pea or bean were also plentiful. Over time, over-grazing, over-exploitation of the soils, and degradation of forests in the surrounding mountains turned the region into desert.

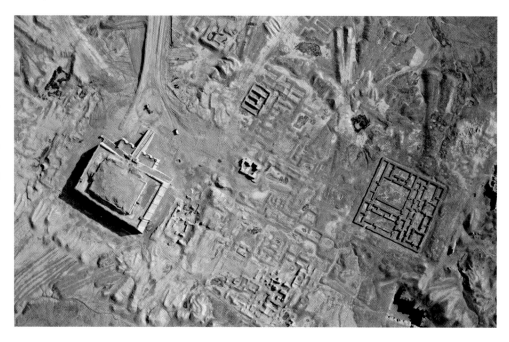

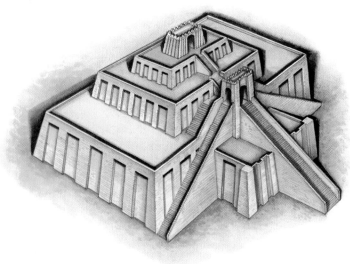

Fig. 2.3 Reconstruction drawing of the ziggurat at Ur (modern Muqaiyir, Iraq). ca. 2100 BCE. British archeologist Sir Leonard Woolley undertook reconstruction of the ziggurat in the 1930s (see Fig. 2.1). The temple on top, which was the home of the patron deity of the city, crowned a three-tiered platform, the base of which measures 140 by 200 feet. The entire structure rose to a height of 85 feet. Woolley's reconstruction was halted before the second and third platforms were completed.

Visitors—almost certainly limited to members of the priesthood—would climb their way through a series of raised forests to arrive at the temple on top. They might bring an offering of food or an animal to be sacrificed to the resident god—at Ur, it was Nanna or Sin, god of the moon. Visitors often placed in the temple a statue that represented themselves in an attitude of perpetual prayer. We know this from the inscriptions on many of the statues. One, dedicated to the goddess, protector of Girsu, a city-state across the Tigris and not far upstream from Ur, reads:

> To Bau, gracious lady, daughter of An, queen of the holy city, her mistress, for the life of Nammahani . . . has dedicated as an offering this statue of the protective goddess of Tarsirsir which she has introduced to the courtyard of Bau. May the statue, to which let my mistress turn her ear, speak my prayers.

A group of such statues, found in 1934 in the shrine room of the ziggurat at Tell Asmar, near modern Baghdad, includes ten men and two women (Fig. **2.4**). The men wear belted, fringed skirts. They have huge eyes, inlaid with lapis lazuli (a blue semiprecious stone) or shell set in bitumen. The single arching eyebrow and crimped beard (only the figure in the lower center is beardless) are typical of Sumerian sculpture. The two women wear robes, and the taller, in the middle, bares a small breast. Originally, a child stood beside her, inserted separately into the base. All figures clasp their hands in front of them, suggestive of prayer when empty and of making an offering when holding a cup. Some scholars believe that the two tallest figures represent Abu, god of vegetation, and his consort, due to their especially large eyes, but all of the figures are probably worshipers.

Religion in Ancient Mesopotamia

Although power struggles dominate Mesopotamian history, with one civilization succeeding another, and with each city-state or empire claiming its own particular divinity as chief among the Mesopotamian gods, the nature of Mesopotamian religion remained relatively constant across the centuries.

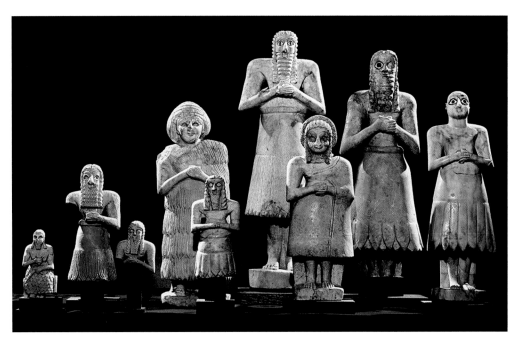

Fig. 2.4 **Dedicatory statues, from the Abu Temple, Tell Asmar, Iraq. ca. 2950–2900 BCE.** Marble, alabaster, and gypsum, height of tallest figure, approx. 30″. Excavated by the Iraq Expedition of the Oriental Institute of the University of Chicago, February 13, 1934. Courtesy of the Oriental Institute of the University of Chicago. The wide-eyed appearance of these figures is probably meant to suggest they are gazing in perpetual awe at the deity.

With the exception of the Hebrews, the religion of the Mesopotamian peoples was polytheistic, consisting of multiple gods and goddesses connected to the forces of nature—sun and sky, water and storm, earth and its fertility (see *Context*, page 40). We know many of them by two names, one in Sumerian and the other in the Semitic language of the later, conquering Akkadians. A famous Akkadian **cylinder seal**, an engraved cylinder used as a signature, a confirmation of receipt, or to identify ownership (Fig. **2.5**), represents many of the gods. The figures are recognizably gods because they wear pointed head-dresses with multiple horns, though the figure on the left, beside the lion and holding a bow, has not been definitively identified. The figure with two wings standing atop the scaly mountain is Ishtar [ISH-tar], goddess of love and war. Weapons rise from her shoulders, and she holds a bunch of figs in her hand, a symbol of fertility. Beneath her, cutting his way through the mountain so that he can rise at dawn, is the sun god, Shamash [SHAH-mash]. Standing with his foot on the mountain at the right, streams of water with fish in them flowing from his shoulders, is Ea [EE-ah], god of water, wisdom, magic, and art. Behind him is his vizier [vih-ZEER], or "burden-carrier."

To the Mesopotamians, human society was merely part of the larger society of the universe governed by these gods and a reflection of it. Anu, father of the gods, represents the authority, which the ruler emulates as lawmaker and -giver. Enlil [EN-lil], god of the air—the calming breeze as well as the violent storm—is equally powerful, but he represents force, which the ruler emulates in his role as military leader. The active principles of fertility, birth, and agricultural plenty are those of the goddess Belitili [bell-eh-TEE-lee], while water, the life force itself, the creative element, is embodied in the god Ea, or Enki [EN-kee], who is also god of the arts. Both Belitili and Ea are subject to the authority of Anu. Ishtar is subject to Enlil, ruled by his breezes (in the case of love) and by his storm (in the case of war). A host of lesser gods represented natural phenomena, or, in some cases, abstract ideas, such as truth and justice.

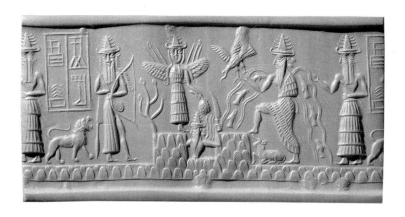

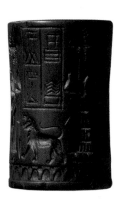

Fig. 2.5 **Cylinder seal impression from the Seal of Adda. Akkadian, ca. 2200–2159 BCE.** Greenstone, height 1 ½″. The two-line inscription at the left identifies the seal's owner as Adda, a scribe.

CULTURAL PARALLELS

Sumerian Cities and Aegean Traders

About the same time the Sumerians were building the world's first great cities, peoples living on one of the largest islands in the Aegean, Crete, were building an extensive international trade network with diverse areas such as Turkey, Cyprus, Egypt, Afghanistan, and even Scandinavia and Britain.

The Mesopotamian ruler, often represented as a "priest-king," and often believed to possess divine attributes, acts as the intermediary between the gods and humankind. His ultimate responsibility is the behavior of the gods—whether Ea blesses the crop with rains, Ishtar his armies with victory, and so on.

Royal Tombs of Ur

Religion was central to the people of Ur, and the cemetery at Ur, discovered by Sir Leonard Woolley in 1928, tells us a great deal about the nature of their beliefs. Woolley unearthed some 1,840 graves, most dating from between 2600 and 2000 BCE. The greatest number of graves were individual burials of rich and poor alike. However, some included a built burial chamber rather than just a coffin and contained more than one body, in some cases as many as eighty. These multiple burials, and the evidence of elaborate burial rituals, suggest that members of a king or queen's court accompanied the ruler to the grave. The two richest burial sites, built one behind the other, are now identified as the royal tombs of King Meskalamdug [mes-kah-LAM-doog] and Queen Puabi [poo-AH-bee].

The Golden Lyres of King Meskalamdug or Queen Puabi
In the grave of either King Meskalamdug or Queen Puabi (records are confusing on this point) were two lyres, one of which today is housed in London (Fig. **2.6**), the other in Philadelphia (Fig. **2.7**). Both are decorated with bull's heads and are fronted by a panel of **narrative scenes**, that is, scenes representing a story or event. Although originally made of wood, which rots over time, these objects were able to be saved in their original form due to an innovation of Woolley's during the excavation. He ordered his workers to tell him whenever they came upon an area that sounded hollow. He would fill such hollows (where the original wood had long since rotted away) with wax or plaster, thus preserving, in place, the decorative effects on the object's outside. It seems likely that the mix of animal and human forms that decorate these lyres represents a funerary banquet in the realm of the dead. They are related, at least thematically, to events in the Sumerian the *Epic of Gilgamesh*, which we will discuss later in the chapter. This suggests that virtually every element of the culture was tied in some way to every other.

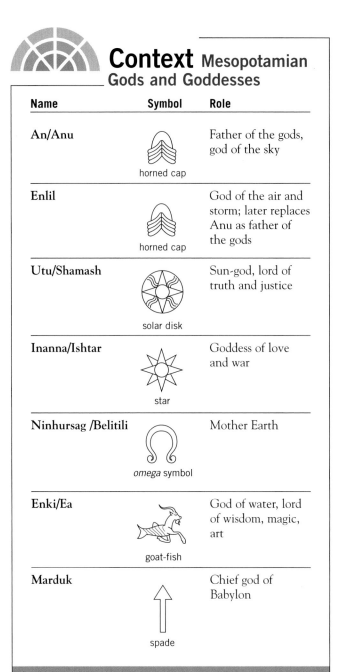

Context Mesopotamian Gods and Goddesses

Name	Symbol	Role
An/Anu	horned cap	Father of the gods, god of the sky
Enlil	horned cap	God of the air and storm; later replaces Anu as father of the gods
Utu/Shamash	solar disk	Sun-god, lord of truth and justice
Inanna/Ishtar	star	Goddess of love and war
Ninhursag /Belitili	*omega* symbol	Mother Earth
Enki/Ea	goat-fish	God of water, lord of wisdom, magic, art
Marduk	spade	Chief god of Babylon

The women whose bodies were found under the two lyres may have been singers and musicians, and the placement of the lyres over them would indicate that the lyres were put there after the celebrants died.

Such magnificent musical instruments indicate that music was important in Mesopotamian society. Surviving cuneiform documents tell us that music and song were part of the funeral ritual, and music played a role in worship at the temple, as well as in banquets and festivals. Indeed, a fragment of a poem from the middle of the third millennium BCE found at Lagash [LAY-gash] indicates that Sumerian music was anything but funereal. It is music's duty, the poet says,

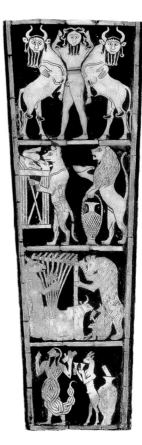

Fig. 2.7 **Soundbox panel front of the lyre from Tomb 789 (alternatively identified as Meskalamdug or Puabi's tomb), from the cemetery at Ur (modern Muqaiyir, Iraq). ca. 2600 BCE.** Wood with inlaid gold, lapis lazuli, and shell, height approx. 12 $\frac{1}{4}$". University of Pennsylvania Museum of Archaeology and Anthropology, Philadelphia. Museum object # B17694, (image #150848). The meaning of the scenes on the front of this lyre has always puzzled scholars. On the bottom, a goat holding two cups attends a man with a scorpion's body. Above that, a donkey plays a bull-headed lyre held by a bear, while a seated jackal plays a small percussion instrument. On the third level, animals walking on their hind legs carry food and drink for a feast. In the top panel, a man with long hair and beard, naked but for his belt, holds two human-headed bulls by the shoulders.

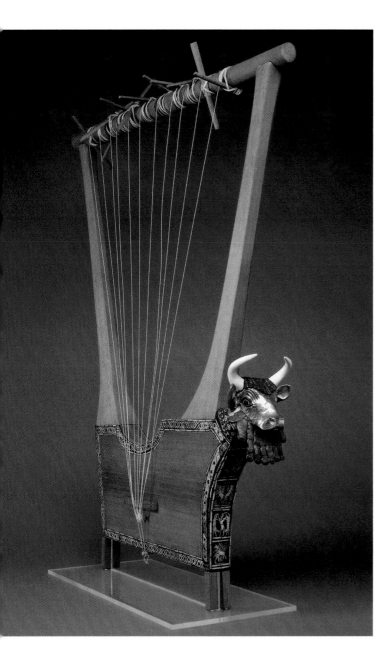

Fig. 2.6 **Lyre from Tomb 789 (alternatively identified as Meskalamdug or Puabi's tomb), from the cemetery at Ur (modern Muqaiyir, Iraq). ca. 2600 BCE.** Gold leaf and lapis lazuli over a wood core, height 44 $\frac{1}{4}$"; restored 1971–1972. © The Trustees of the British Museum.

To fill with joy the Temple court
And chase the city's gloom away
The heart to still, the passions calm,
Of weeping eyes the tears to stay.

The Royal Standard of Ur One of Woolley's most important discoveries in the Royal Cemetery was the so-called *Royal Standard of Ur* (Fig. **2.8**). Music plays a large part here too. The main panels of this rectangular box of unknown function are called "War" and "Peace," because they illustrate, on one side, a military victory and, on the other, the subsequent banquet celebrating the event or perhaps a cult ritual. Each panel is

composed of three **registers**, or self-contained horizontal bands within which the figures stand on a **ground-line**, or baseline.

At the right side of the top register of the "Peace" panel (the lower half of Fig. 2.8), a musician plays a lyre, and behind him another, apparently female, sings. The king, at the left end, is recognizable because he is taller than the others and wears a tufted skirt, his head breaking the register line on top. In this convention, known as **social perspective**, or **hierarchy of scale**, the most important figures are represented as larger than the others. In other registers on the "Peace" side of the *Standard*, servants bring cattle, goats, sheep, and fish to the celebration. These represent the bounty of the land and perhaps even delicacies from lands to the north.

Focus

Cuneiform Writing in Sumeria

Writing first appeared in the middle of the fourth millennium BCE in agricultural records as **pictograms**—pictures that represent a thing or concept—etched into clay tablets. For instance, the sign for "woman" is a pubic triangle, and the more complicated idea of "slave" is the sign for "woman" plus the sign for "mountains"—literally, a "woman from over the mountains":

woman **slave** **mountains**

Pictograms could also represent concepts. For instance, the signs for "hatred" and "friendship" are, respectively, an "X" and a set of parallel lines:

hatred
friendship

Beginning about 2900 BCE, most writing began to appear more linear, for it was difficult to draw curves in wet clay. So scribes adopted a straight-line script made with a triangle-tipped **stylus** [STY-lus], or writing tool, cut from reeds. The resulting impressions looked like wedges. **Cuneiform writing**, was named from the Latin *cuneus*, "wedge."

The size and shape of the scribe's stylus, or writing tool, could vary. Examination of surviving tablets suggests that Mesopotamian scribes used three types of stylus, as shown here.

By 2000 BCE, another significant development in the progress of writing had appeared: Signs began to represent not things but sounds. This **phonetic writing** liberated the sign from its picture, as if, in English, we represented the word *belief* with pictograms for "bee" and "leaf."

Later cuneiform pictogram of donkey

Early pictogram for donkey

In the cuneiform tablet, the sign for "donkey" (below) is everywhere apparent. It represents a later, abstracted version of the earlier pictogram (literally "picture-writing") above. Such abstracted signs come into use not long after 2400 BCE and replace the earlier pictograms.

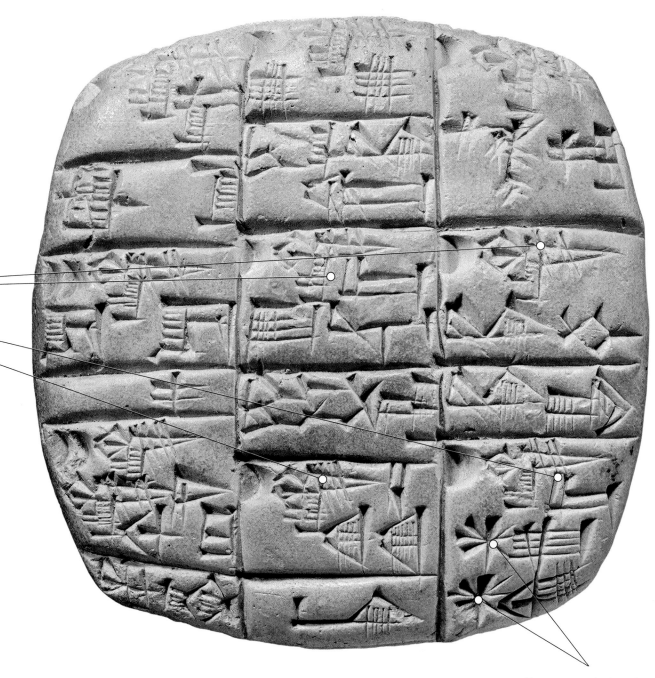

These stars are the Sumerian sign for "god." They sometimes have many more points than the eight seen here.

Sumerian tablet from Lagash, modern Tello, Iraq ca. 2360 BCE. Clay. Musée du Louvre, Paris. This tablet is an economic document detailing the loan of donkeys to, among others, a farmer, a smith, and a courier.

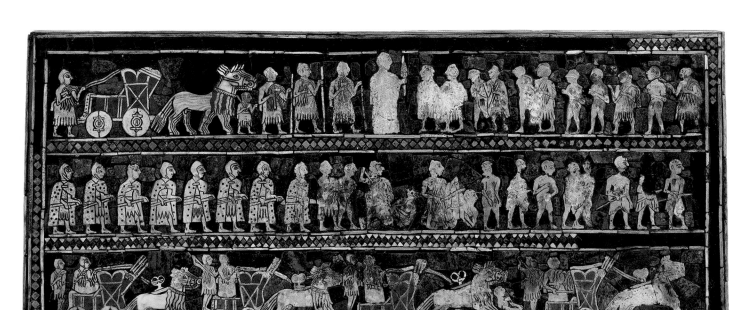

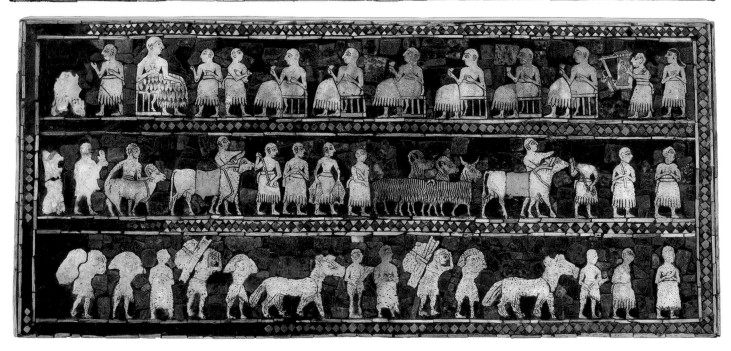

Fig. 2.8 *Royal Standard of Ur*, front ("War") and back ("Peace") sides, from tomb 779, cemetery at Ur (modern Muqaiyir, Iraq). ca. 2600 BCE. Shell, lapis lazuli, and red limestone, originally on a wooden framework, height 8″, length 19″. © The British Museum, London. For all its complexity of design, this object is not much bigger than a sheet of legal paper. Its function remains a mystery, though it may have served as a pillow or headrest. Sir Woolley's designation of it as a standard was purely conjectural.

(Notice that the costumes and hairstyles of the figures carrying sacks in the lowest register are different from those in the other two.) This display of consumption and the distribution of food may have been intended to dramatize the power of the king by showing his ability to control trade routes.

On the "War" side of the *Standard*, the king stands in the middle of the top register. War chariots trample the enemy on the bottom register. (Note that the chariots have solid wheels; spoked wheels were not invented until approximately 1800 BCE.) In the middle register, soldiers wearing leather cloaks and bronze helmets lead naked, bound prisoners to the king in the top register, who will presumably decide their fate. Many of the bodies found in the royal tombs were wearing similar military garments. The importance of the *Royal Standard of Ur* is not simply as documentary evidence of Sumerian life but as one of the earliest examples we have of historical narrative.

Akkad

At the height of the Sumerians' power in southern Mesopotamia, a people known as the Akkadians arrived from the north and settled in the area around modern Baghdad. Their capital city, Akkad [AK-ad], has never been discovered and in all likelihood lies under Baghdad itself. Under Sargon [SAR-gun] I (r. ca. 2332–2279 BCE), the Akkadians conquered virtually all other cities in Mesopotamia, including those in Sumer, to become the region's most powerful city-state. Sargon named himself "King of the Four Quarters of the World" and equated himself with the gods, a status bestowed upon Akkadian rulers from Sargon's time forward. Legends about Sargon's might and power survived in the region for thousands of years. Indeed, the legend of his birth gave rise to what amounts to a **narrative genre** (a class or category of story with a universal theme) that survives to the present day: the boy from humble origins who rises to a position of might and power, the so-called "rags-to-riches" story.

As depicted on surviving clay tablets, Sargon was an illegitimate child whose mother deposited him in the Euphrates River in a basket. There a man named Akki [AK-kee] (after whom Akkad itself is named) found him while drawing water from the river and raised him as his own son. The story antic-

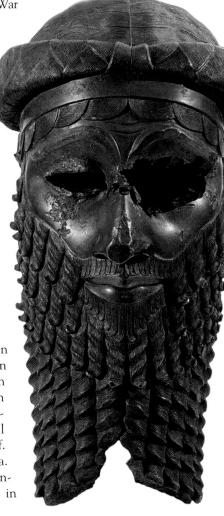

Fig. 2.9 *Head of an Akkadian Man*, **from Nineveh (modern Kuyunjik, Iraq). ca. 2300–2200 BCE.** Copper alloy, height 14 1/8″. Iraq Museum, Baghdad. Many scholars believe this to be a likeness of Sargon I.

ipates the biblical story of Moses in the bulrushes, as well as the legend of Romulus and Remus, the twin brothers who were discovered in the Tiber marshes by a she-wolf, then raised by a local farmer, and eventually founded the city of Rome.

The Akkadian language was very different from Sumerian. Nevertheless, the Akkadians adopted Sumerian culture and customs (see Fig. 2.5) and the cuneiform writing style, if not their language. In fact, many bilingual dictionaries and Sumerian texts with Akkadian translations survive. The Akkadian language was Semitic in origin, having more in common with other languages of the region, particularly Hebrew, Phoenician, and Arabic. It quickly became the common language of Mesopotamia, and peoples of the region spoke Akkadian, or dialects of it, throughout the second millennium and well into the first. The advice of an Akkadian father to his son (see *Voices*, page 47), written down over 4,000 years ago, tells us that, in some ways, not a lot has changed.

Akkadian Sculpture

Although Akkad was arguably the most influential of the Mesopotamian cultures, few Akkadian artifacts survive, perhaps because Akkad and other nearby Akkadian cities have disappeared under Baghdad and the alluvial soils of the Euphrates plain. Two impressive sculptural works do remain, however. The first is the bronze head of an Akkadian man (Fig. **2.9**), found at Nineveh [NIN-eh-vuh]. Once believed to be Sargon the Great himself, many modern scholars now think it was part of a statue of Sargon's grandson, Naramsin [nuh-RAHM-sin] (ca. 2254–2218 BCE). In either case, it is a highly realistic work, depicting a man who appears both powerful and majestic. In its damaged condition, the head is all that survives of a life-size statue that was destroyed in antiquity. Its original gemstone eyes were removed, perhaps by plundering soldiers, or possibly by a political enemy who recognized the sculpture as an emblem of absolute majesty. In the fine detail surrounding the face—in the beard and elaborate coiffure, with its braid circling the head—it testifies to the Akkadian mastery of the lost-wax casting technique, which originated in Mesopotamia as early as the third millennium BCE (see *Materials and Techniques*, page 49). It is the first existing monumental work made by that technique that we have.

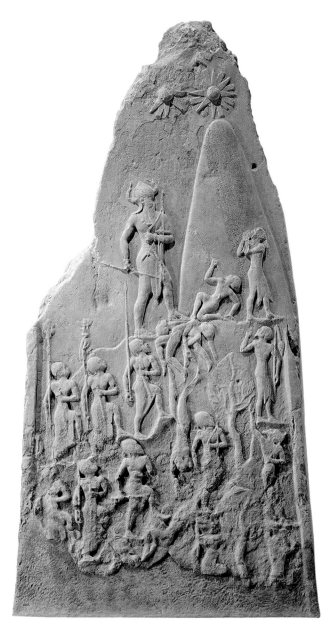

Fig. 2.10 *Stele of Naramsin*, from Susa (modern Shush, Iran).
2254–2218 BCE. Pink sandstone, height approx. 6′ 6″. Chuzeville/Musée
du Louvre, Paris, France. This work, which was stolen by invading Elamites
around 1157 BCE, as an inscription on the mountain indicates, was for
centuries one of the most influential of all artworks, copied by many rulers
to celebrate their own military feats.

The king, as usual, is larger than anyone else (another exam-
ple of social perspective or hierarchy of scale). The Akkadians
in fact believed that Naramsin became divine during the
course of his reign. In the stele, his divinity is represented by
his horned helmet and by the physical perfection of his body.
Bow and arrow in hand, he stands atop a mountain pass, dead
and wounded Lullubians beneath his feet. Another Lullubian
falls before him, a spear in his neck. Yet another seems to
plead for mercy as he flees to the right. Behind Naramsin, his
soldiers climb the wooded slopes of the mountain—here rep-
resented by actual trees native to the region.

The sculptor abandoned the traditional register system
that we saw in the *Royal Standard of Ur* and set the battle
scene on a unified landscape. The lack of registers and the use
of trees underscore the reality of the scene—and by implica-
tion, the reality of Naramsin's divinity. The divine and
human worlds are, in fact, united here, for above Naramsin
three stars (cuneiform symbols for the gods) look on, pro-
tecting both Naramsin, their representative on Earth, and his
troops. Naramsin is the earthly embodiment of the god Mar-
duk, the chief god of Akkad, whose might is celebrated in the
Akkadian *Hymn to Marduk* (**Reading 2.1**), which dates from
the end of the third millennium BCE:

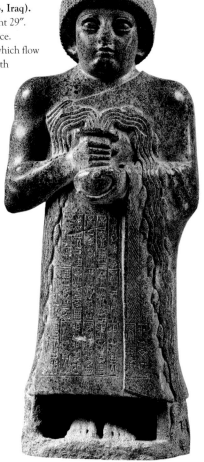

Fig. 2.11 **Votive statue of Gudea,
from Lagash (modern Tello, Iraq).**
ca. 2120 BCE. Diorite, height 29″.
Musée du Louvre, Paris, France.
Gudea holds a vessel out of which flow
two streams of water filled with
fish. The inscription on his
robe explains that Gudea
has dedicated himself,
the sculpture, and the
temple in which it
resided to Geshtinanna,
goddess of wine, poet,
singer, and interpreter
of dreams.

The second Akkadian sculpture we will look at is the *Stele
of Naramsin* (Fig. **2.10**). A **stele** [STEE-lee] is an upright stone
slab carved with a commemorative design or inscription. (The
word is derived from the Greek for "standing block.") This
particular stele celebrates the victory of Sargon's grandson
over the Lullubi [lool-LOO-bee] in the Zagros Mountains of
eastern Mesopotamia sometime between 2252 and 2218 BCE.

VOICES

An Akkadian Father Advises His Son, ca. 2200 BCE

Akkad, in northern Mesopotamia on the left bank of the Euphrates River, reached the height of its power from the 24th to 22nd centuries BCE. Along with epics such as Gilgamesh, hymns of praise to kings and gods, and lamentations related to personal or historical disaster, instructions were an important literary form, usually relating useful information from father to son, mentor to student, or craftsmen to apprentice. Here, an Akkadian father's advice to his son gives voice to an ancient civilization that disappeared more than 3,000 years ago.

Do not set out to stand around in the assembly. Do not loiter where there is a dispute, for in the dispute they will have you as an observer. Then you will be made a witness for them, and they will involve you in a lawsuit to affirm something that does not concern you. In case of a dispute, get away from it, disregard it! If a dispute involving you should flare up, calm it down. A dispute is a covered pit, a wall which can cover over its foes; it brings to mind what one has forgotten and makes an accusation against a man. Do not return evil to your adversary; requite with kindness the one who does evil to you, maintain justice for your enemy, be friendly to your enemy.

> **"Do not speak ill, speak only good. Do not say evil things, speak well of people. . . ."**

Give food to eat, beer to drink, grant what is requested, provide for and treat with honor. At this one's god takes pleasure. It is pleasing to Shamash, who will repay him with favor. Do good things, be kind all your days.

Do not honor a slave girl in your house; she should not rule your bedroom like a wife, do not give yourself over to slave girls. . . . Let this be said among your people: "The household which a slave girl rules, she disrupts." Do not marry a prostitute, whose husbands are legion, an Ishtar-woman who is dedicated to a god, . . .

Do not speak ill, speak only good. Do not say evil things, speak well of people. . . .

Worship your god every day. Sacrifice and pious utterance are the proper accompaniment of incense. Have a freewill offering for your god, for this is proper toward a god. Prayer, supplication, and prostration offer him daily, then your prayer will be granted, and you will be in harmony with god.

READING 2.1 **Hymn to Marduk (3000–2000 BCE)**

Lord Marduk, Supreme god, with
 unsurpassed wisdom. . . .
When you leave for battle the Heavens shake,
 when you raise your voice, the Sea is wild!
When you brandish your sword, the gods turn
 back.
There is none who can resist your furious blow!
Terrifying lord, in the Assembly of the gods no
 one equals you! . . .
Your weapons flare in the tempest!
Your flame annihilates the steepest mountain.

Both the copper bust of the Akkadian king and *Stele of Naramsin* testify to the role of the king in Mesopotamian culture, in general, as both hero and divinity. If the king is

not exactly the supreme god Marduk of the *Hymn*, he behaves very much like him, wielding the same awe-inspiring power.

Babylon

The Akkadians dominated Mesopotamia for just 150 years, their rule collapsing not long after 2200 BCE. For the next 400 years, various city-states thrived locally. Chief among them was Lagash on the Tigris River in the southwest. There a ruler named Gudea [goo-DEE-uh] (flourished ca. 2144–2124 BCE) built a number of temples, restored others, and celebrated his good rule by commissioning statues of himself (Fig. **2.11**), which he dedicated to the gods. Over 20 of them survive, all showing him with hands clasped (perhaps in prayer), head shaven, and wearing a long garment that leaves one shoulder and arm bare. Still, no one in Mesopotamia matched the Akkadians' power until the first decades of the eighteenth century BCE, when Hammurabi [ham-uh-RAH-bee] of Babylon [BAB-uh-lon] (r. 1792–1750 BCE) gained control of most of the region.

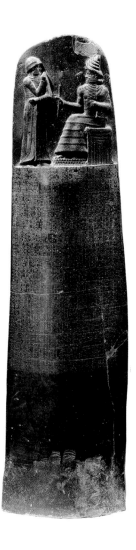

Fig. 2.12 *Stele of Hammurabi*, from Susa (modern Shush, Iran) ca. 1760 BCE. Basalt, height of stele, approx. 7′, height of relief, 28″. Musée du Louvre, Paris. Like the *Stele of Naramsin*, this stele was stolen by invading Elamites and removed to Susa, where, together with the *Stele of Naramsin*, it was excavated by the French in 1898.

eccentric, in the issues it addresses. Many of its articles seem to be "reforms" of already existing law, and as such they define new principles of justice.

Principles and Social Inequalities Chief among these is the principle of *talion* [TAL-ee-un]—an eye for an eye, a tooth for a tooth—which Hammurabi introduced to Mesopotamian law. (Sections of earlier codes from Ur compensate victims of crimes with money.) This principle punished the violence or injustice perpetuated by one free person upon another, but violence by an upper-class person on a lower-class person was penalized much less severely. Slaves (who might be either war captives or debtors) enjoyed no legal protection at all—only the protection of their owner.

The code tells us much about the daily lives of Mesopotamian peoples, including conflicts great and small. In rules governing family relations and class divisions in Mesopotamian society, inequalities are sharply drawn. Women are inferior to men, and wives, like slaves, are the personal property of their husbands (although protected from the abuse of neglectful or unjust husbands). Incest is strictly forbidden. Fathers cannot arbitrarily disinherit their sons—a son must have committed some "heavy crime" to justify such treatment. The code's strongest concern is the maintenance and protection of the family, though trade practices and property rights are also of major importance.

The following excerpts from the code, beginning with Hammurabi's assertion of his descent from the gods and his status as their favorite (**Reading 2.2**), give a sense of the code's scope. But the code is, finally, and perhaps above all, the gift of a king to his people, as Hammurabi's epilogue, at the end of the excerpt, makes clear:

The Law Code of Hammurabi

Hammurabi imposed order on Babylon where laxness and disorder, if not chaos, reigned. A giant stele, the so-called *Law Code of Hammurabi*, survives (Fig. **2.12**). By no means the first of its kind, though by far the most complete, the stele is a record of decisions and decrees made by Hammurabi over the course of some 40 years of his reign. Its purpose was to celebrate his sense of justice and the wisdom of his rule. Atop the stele, in sculptural relief, Hammurabi receives the blessing of Shamash, the sun god; notice the rays of light coming from his shoulders. The god is much larger than Hammurabi: In fact, he is to Hammurabi as Hammurabi, the patriarch, is to his people. If Hammurabi is divine, he is still subservient to the greater gods. At the same time, the phallic design of the stele, like such other Mesopotamian steles as the *Stele of Naramsin*, asserts the masculine prowess of the king.

Below the relief, 282 separate "articles" cover both sides of the basalt monument. One of the great debates of legal history is the question of whether these articles actually constitute a code of law. If by *code* we mean a comprehensive, systematic, and methodical compilation of all aspects of Mesopotamian law, then it isn't. It is instead selective, even

READING 2.2 **from the *Law Code of Hammurabi* (ca. 1792–1750 BCE)**

When Anu, the supreme, the king of the Aunnaki, and Be, the lord of heaven and earth, who fixes the destiny of the universe, had allotted the multitudes of mankind to Merodaeh, the first-born of Ea, the divine master of Law, they made him great among the Igigi; they proclaimed his august name in Babylon, exalted in the lands, they established for him within it an eternal kingdom whose foundations, like heaven and earth shall endure.

Then Anu and Bel delighted the flesh of mankind by calling me, the renowned prince, the god-fearing Hammurabi, to establish justice in the earth, to destroy the base and the wicked, and to hold back the strong from oppressing the feeble: to shine like the Sun-god upon the black-haired men, and to illuminate the land. . . .

1. If a man has laid a curse upon another man, and it is not justified, the layer of the curse shall be slain. . .

8. If a man has stolen an ox, or a sheep, or an ass, or a pig, or a boat, either from a god or a palace, he shall pay thirty-fold.

Materials & Techniques Lost-Wax Casting

At about the same time that cuneiform script was adopted, Mesopotamian culture also began to practice metallurgy, the process of mining and smelting ores. At first, copper was used almost exclusively, then later an alloy of copper and tin was melted and combined to make bronze. The resulting material was much stronger and more durable than anything previously known.

Because sources of copper and tin were mined in very different regions of the Middle East, the development of trade routes was a necessary prerequisite to the technology. While solid bronze pieces were made in simple molds as early as 4000 BCE, hollow bronze casts could produce larger pieces and were both more economical and lightweight. The technology for making hollow bronze casts was developed by the time of the Akkadians, in the second millennium BCE. Called **lost-wax casting**, the technique is illustrated below.

A positive model (1), often created with clay, is used to make a negative mold (2). The mold is coated with wax, the wax shell is filled with a cool fireclay, and the mold is removed (3). Metal rods, to hold the shell in place, and wax rods, to vent the mold, are then added (4). The whole is placed in sand, and the wax is burned out. Molten bronze is poured in where the wax used to be (5). When the bronze has hardened, the whole is removed from the sand and the rods and vents are removed (6).

If he is a plebeian, he shall render ten-fold. If the thief has nothing to pay, he shall be slain. . . .

32. If a captain or a soldier has been taken prisoner on "the way of the king," and a merchant ransoms him, and brings him back to his city; then if his house contain sufficient for his ransom, he personally shall pay for his liberation. If his house do not contain sufficient, the temple of his city shall pay. If the temple of his city have not the means, the palace shall ransom him. His field, his garden, and his house shall not be given for his ransom. . . .

143. If she has not been careful, but runs out, wastes her house and neglects her husband; then that woman shall be, thrown into the water. . . .

195. If a son has struck his father, his hands shall be cut off.

196. If a man has destroyed the eye of a free man, his own eye shall be destroyed.

197. If he has broken the bone of a free man, his bone shall be broken. . . .

229. If a builder has built a house for a man, and his work is not strong, and if the house he has built falls in and kills the householder, that builder shall be slain. . . .

282. If a slave shall say to his master, "Thou art not my master," he shall be prosecuted as a slave, and his owner shall cut off his ear. . . .

The judgments of justice which Hammurabi, the mighty king, has established, conferring upon the land a sure guidance and a gracious rule.

Hammurabi, the protecting king, am I. . .

In after days and for all time, the king who is in the land shall observe the words of justice which are written upon my pillar. He shall not alter the law of the land which I have formulated, or the statutes of the country that I have enacted: nor shall he damage my sculptures. If that man has wisdom, and desires to keep his land in order, he will heed the words which are written upon my pillar. The canon, the rule, the law of the country which I have formulated, the statutes of the country that I have enacted, this pillar shall show to him. The black-headed people he shall govern; their laws he shall pronounce, their statutes he shall decide. He shall root out of the land the perverse and the wicked; and the flesh of his people he shall delight.

Hammurabi, the king of justice, am I. . .

Consequences of the Code Even if Hammurabi meant only to assert the idea of justice as the basis for his own divine rule, the stele established what amounts to a uniform code throughout Mesopotamia. It was repeatedly copied for over a thousand years, long after it was removed to Susa in 1157 BCE with the Naramsin stele, and it established the rule of law in Mesopotamia for a millennium. From this point on, the authority and power of the ruler could no longer be capricious, subject to the whim, fancy, and subjective interpretation of his singular personality. The law was now, at least ostensibly, more objective and impartial. The ruler was required to follow certain prescribed procedures. But the law, so prescribed in writing,

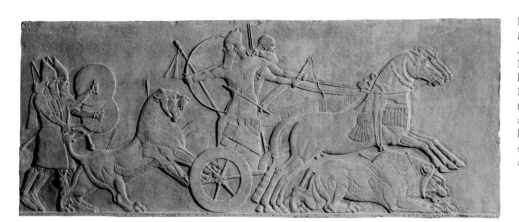

Fig. 2.13 *Ashurnasirpal II Killing Lions,* from the palace complex of Ashurnasirpal II, Kalhu (modern Nimrud, Iraq). ca. 850 BCE. Alabaster, height approx. 39″. The British Museum, London. The repetition of forms throughout this relief helps create a stunning design. Notice especially, how the two shields carried by the soldiers are echoed by the chariot wheel and the king's arched bow.

was now also much less flexible, hard to change, and much more impersonal. Exceptions to the rule were few and difficult to justify. Eventually, written law would remove justice from the discretion of the ruler and replace it by a legal establishment of learned judges charged with enacting the king's statutes.

The Assyrian Empire

With the fall of Babylon in 1595 BCE to a sudden invasion of Hittites from Turkey, the entire Middle East appears to have undergone a period of disruption and instability. Only the Assyrians, who lived around the city of Assur in the north, managed to maintain a continuing cultural identity. Over the centuries they became increasingly powerful until, beginning with the reign of Ashurnasirpal II (r. 883–859 BCE), they dominated the entire region.

Ashurnasirpal [ah-SHOORNA-zir-pahl] II built a magnificent capital at Kalhu (modern Nimrud), on the Tigris River, surrounded by nearly 5 miles of walls, 120 feet thick and 42 feet high. A surviving inscription tells us that Ashurnasirpal invited 69,574 people to celebrate the city's dedication. The entire population of the region, of all classes, probably did not exceed 100,000, and thus many guests from throughout Mesopotamia and farther away must have been invited.

Assyrian Art

Alabaster reliefs decorated many of the walls of Ashurnasirpal's palace complex, including a series of depictions of *Ashurnasirpal II Killing Lions* (Fig. **2.13**). These scenes use many of the conventions of Assyrian pictorial representation. For instance, to create a sense of deep space the sculptor used the device of overlapping, which we first encountered in prehistoric cave paintings (see Fig. 1.2). This is done convincingly where the king stands in his chariot in front of its driver, but less so in the case of the horses drawing the chariot. For instance, there are three horse heads but only six visible legs—three in front and three in back. Furthermore, Assyrian artists never hid the face of an archer (in this case,

the king himself) by realistically having him aim down the shaft of the arrow, which would have the effect of covering his eye with his hand. Instead, they drop the arrow to shoulder level and completely omit the bowstring so that it appears to pass (impossibly) behind the archer's head and back.

The scene is also a **synoptic** view, that is, it depicts several consecutive actions at once: As soldiers drive the lion toward the king from the left, he shoots it; to the right, the same lion lies dying beneath the horses' hooves. If Assyrian artists seem unconcerned about accurately portraying the animals, that is because the focus of the work is on the king himself, whose prowess in combating the lion, traditional symbol of power, underscores his own invincibility. And it is in the artists' careful balance of forms—the relationship between the positive shapes of the relief figures and the negative space between them—that we sense the importance placed on an orderly arrangement of parts. This orderliness reflects, in all probability, their sense of the orderly character of their society.

Cultural Propaganda Rulers in every culture and age have used the visual arts to broadcast their power. These reliefs were designed to celebrate and underscore for all visitors to Ashurnasirpal's palace the military prowess of the Assyrian army and their king. They are thus a form of cultural propaganda, celebrating the kingdom's achievements even as they intimidate its potential adversaries. In fact, the Assyrians were probably the most militant civilization of ancient Mesopotamia, benefactors of the invention of iron weaponry by the Hittites, a nomadic tribe that entered Asia Minor in around 2000 BCE. By 721 BCE, the Assyrians had used their iron weapons to conquer Israel, and by the middle of the seventh century BCE they controlled most of Asia Minor from the Nile Valley to the Persian Gulf.

The Assyrians also used their power to preserve Mesopotamian culture. Two hundred years after the reign of Ashurnasirpal, Ashurbanipal (r. 668–627 BCE) created the great library where, centuries later, the clay tablets containing the Sumerian *Epic of Gilgamesh*, discussed on pages 52–55, were stored. Its still partially intact collection today consists of 20,000–30,000 cuneiform tablets containing approximately 1,200 distinct texts, including a nearly complete list of ancient

Mesopotamian rulers. Each of its many rooms was dedicated to individual subjects—history and government, religion and magic, geography, science, poetry, and important government materials.

As late as Ashurbanipal's reign, reliefs of the lion hunt were still a favored form of palace decoration, but those depicted from his palace at Nineveh, in what is now northern Iraq reveal that the lions were caged and released for the king's hunt, which was now more ritual than real, taking place in an enclosed arena. The lions were sacrificed as an offering to the gods. In one section of the relief, Ashurbanipal, surrounded by musicians, pours a libation, a liquid offering to the gods, over the dead animals as servants bring more bodies to the offering table. This ritual was implicit in all kingly hunts, even Ashurnasirpal's 200 years earlier, for in his pursuit and defeat of the wild beast, the ruler masters the most elemental force of nature—the cycle of life and death itself.

The Assyrian kings represented their might and power not only through the immense size of their palaces and the decorative programs within, but also through massive gateways that greeted the visitor. Especially impressive are the gateways with giant stone monuments, such as those in Iraq at the Khorsabad [KOR-suh-bahd] palace of Sargon II (r. 721–705 BCE), who named himself after Sargon of Akkad. These monuments (Fig. **2.14**) are **composites**, part man, part bull, and part eagle, the bull signifying the king's strength and the eagle his vigilance. The king himself wears the traditional horned crown of Akkad and the beard of Sumer, thus containing within himself all Mesopotamian history. Such composites, especially in monumental size, were probably intended to amaze and terrify the visitor and to underscore the ruler's embodiment of all the forces of nature, which is to say, his embodiment of the very gods.

Mesopotamian Literature

Sumerian literature survives on nearly 100,000 clay tablets and fragments. Many deal with religious themes in the form of poems, blessings, and incantations to the gods.

The Blessing of Inanna

One particularly interesting Sumerian religious work is *The Blessing of Inanna* (**Reading 2.3**). It recounts the myth of the goddess Inanna, here depicted as a young girl from Uruk who decides to visit Enki, the god of wisdom. Inanna travels south

to Eridu, the chief seaport of Sumer, where Enki lives. Apparently taken with Inanna, Enki offers a series of toasts, each time bestowing upon her one of his special powers, including the highest powers of all:

READING 2.3 **The Blessing of Inanna**
 ca. 2300 BCE

Enki and Inanna drank beer together.
They drank more beer together.
They drank more and more beer together.
With their bronze vessels filled to overflowing,
With the vessels of Urash, Mother of the Earth
They toasted each other; they challenged each other.
Enki, swaying with drink,
 toasted Inanna: "In the name of my power!
In the name of my holy shrine!
To my daughter Inanna I shall give
The high priesthood! Godship!
The noble, enduring crown! The throne of kingship!"
Inanna replied: "I take them!"

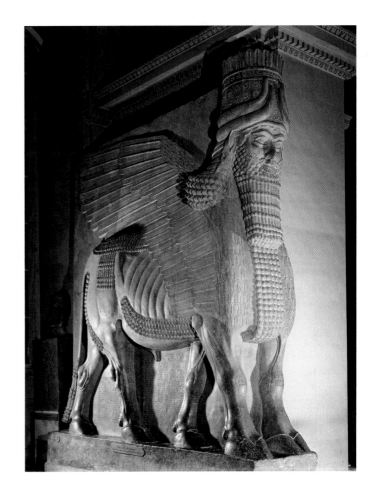

Fig. 2.14 *Human-Headed Winged Bull,* **one of a pair from the entrance to the palace of Sargon II, Khorsabad, Iraq. ca. 720 BCE.** Limestone, height approx. 13′ 10″. 02-13 Musée du Louvre, France. Seen from a three-quarter view, as here, this hybrid beast that guarded the palace entrance has five legs. He stands firmly before you when seen from the front, and seems to stride by you when seen from the side.

Having gathered all 80 of Enki's mighty powers, Inanna piles them all into her boat and sails back up river. The drunken Enki realizes what he has done and tries to recover his blessings, but Inanna fends him off. She returns to Uruk, blessed as a god, and enters the city triumphantly, bestowing now her own gifts on her people, who subsequently worship her. Enki and the people of Eridu are forced to acknowledge the glory of Inanna and her city of Uruk, assuring peace and harmony between the two competing city-states.

The Sumerians worshiped Inanna as the goddess of fertility and heaven. In this tale, she and Enki probably represent the spirits of their respective cities and the victory of Uruk over Eridu. That Inanna appears in the work first as a mere mortal is a classic example of *anthropomorphism*, endowing the gods and the forces of nature that they represent with human-like traits. The story has some basis in fact, since Uruk and Eridu are the two oldest Mesopotamian cities, and surviving literary fragments suggest that Uruk defeated Eridu sometime after 3400 BCE.

The *Epic of Gilgamesh*

One of the great surviving manuscripts of Mesopotamian culture and the oldest story ever recorded is the *Epic of Gilgamesh*. An **epic** is a long, narrative poem in elevated language that follows characters of a high position through a series of adventures, often including a visit to the world of the dead. For many literary scholars, the epic is the most exalted poetic form. The central figure is a legendary or historical figure of heroic proportion, in this case the Sumerian king Gilgamesh. Homer's *Iliad* and *Odyssey* (see chapter 5) had been considered the earliest epic, until late in the nineteenth century, when *Gilgamesh* was discovered in the library of King Ashurbanipal at Nineveh.

The scope of an epic is large. The supernatural world of gods and goddesses usually plays a role in the story, as do battles in which the hero demonstrates his strength and courage. The poem's language is suitably dignified, often consisting of many long, formal speeches. Lists of various heroes or catalogs of their achievements are frequent.

Epics are often compilations of preexisting myths and tales handed down generation to generation, often orally, and finally unified into a whole by the epic poet. Indeed, the main outline of the story is usually known to its audience. The poet's contribution is the artistry brought to the subject, demonstrated through the use of epithets, metaphors, and similes. **Epithets** are words or phrases that characterize a person (for example, "Enkidu, the protector of herdsmen," or "Enkidu, the son of the mountain"). **Metaphors** are words or phrases used in place of another to suggest a similarity between the two, as when Gilgamesh is described as a "raging flood-wave who destroys even walls of stone." **Similes** compare two unlike things by the use of the word "like" or "as" (for example, "the land shattered like a pot").

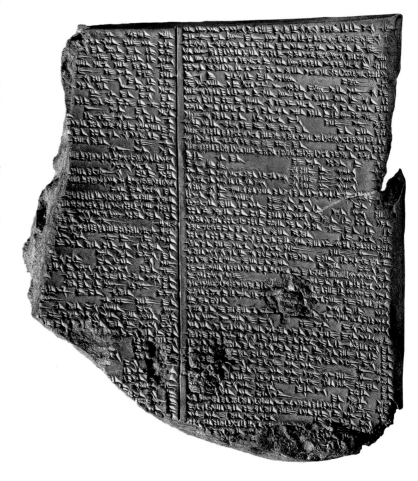

Fig. 2.15 Fragment of Tablet 11 of the *Epic of Gilgamesh*, containing the Flood Story. From the Library of Ashurbanipal, Nineveh (modern Kuyunjik, Iraq). Second millennium BCE. © The British Museum, London. Courtesy the Trustees of the British Museum. This example, which is relatively complete, shows how difficult it is to reconstruct the *Gilgamesh* epic in its entirety.

Perhaps most important, the epic illuminates the development of a nation or race. It is a national poem, describing a people's common heritage and celebrating its cultural identity. It is hardly surprising, then, that Ashurbanipal preserved the *Epic of Gilgamesh*. Just as Sargon II depicted himself at the gates of Khorsabad in the traditional horned crown of Akkad and the beard of Sumer, containing within himself all Mesopotamian history, the *Epic of Gilgamesh* preserves the historical lineage of all Mesopotamian kings—Sumerian, Akkadian, Assyrian, and Babylonian. The tale embodies their own heroic grandeur, and thus the grandeur of their peoples.

The *Epic of Gilgamesh* consists of some 2,900 lines written in Akkadian cuneiform script on eleven clay tablets, none of them completely whole (Fig. **2.15**). It was composed sometime before Ashurbanipal's reign, possibly as early as 1200 BCE, by Sinleqqiunninni [sin-lek-win-NEE-nee] a scholar-priest of Uruk. This would make Sinleqqiunninni the oldest known author. We know that Gilgamesh was the fourth king of Uruk, ruling sometime between 2700 and 2500 BCE. (The dates of his rule were recorded on a clay tablet, the *Sumerian King List*.) Recovered fragments of his story date back nearly to his actual reign, and the story we have, known as the Standard Version, is a compilation of these earlier versions.

The poem opens with a narrator guiding a visitor (the reader) around Uruk. The narrator explains that the epic was written by Gilgamesh himself and was deposited in the city's walls, where visitors can read it for themselves. Then the narrator introduces Gilgamesh as an epic hero, two parts god and one part human. The style of the following list of his deeds is the same as in hymns to the gods (**Reading 2.4a**):

READING 2.4a **from the *Epic of Gilgamesh*, Tablet I** (ca. 1200 BCE)

Supreme over other kings, lordly in appearance,
he is the hero, born of Uruk, the goring wild bull.
He walks out in front, the leader,
and walks at the rear, trusted by his companions.
Mighty net, protector of his people,
raging flood-wave who destroys even walls of stone! . . .
It was he who opened the mountain passes,
who dug wells on the flank of the mountain.
It was he who crossed ocean, the vast seas, to the rising sun,
who explored the world regions, seeking life.
It was he who reached by his own sheer strength the
 Utanapishtim, the Faraway,
who restored the cities that the Flood had destroyed! . . .
Who can compare to him in kingliness?
Who can say like Gilgamesh: "I am King!"?

After a short break in the text, Gilgamesh is described as having originally oppressed his people. Hearing the pleas of the people for relief, the gods create a rival, Enkidu [EN-kee-doo], to challenge Gilgamesh (**Reading 2.4b**):

READING 2.4b **from the *Epic of Gilgamesh*, Tablet I** (ca. 1200 BCE)

Enkidu
born of Silence, endowed with the strength of Ninurta.
His whole body was shaggy with hair,
he had a full head of hair like a woman. . . .
He knew neither people nor settled living. . . .
He ate grasses with the gazelles,
and jostled at the watering hole with the animals.

Enkidu is, in short, Gilgamesh's opposite, and their confrontation is an example of the classic struggle between nature, represented by Enkidu, and civilization, by Gilgamesh. But seduced by a harlot, Enkidu loses his ability to commune with the animals (i.e., he literally loses his innocence), and when he finally wrestles Gilgamesh, the contest ends in a draw. The two become best friends.

Gilgamesh proposes that he and Enkidu undertake a great adventure, a journey to the Cedar Forest (in present-day southern Iran), where they will kill its guardian, Humbaba [hum-BAH-buh] the Terrible, and cut down all the forest's trees. Each night on the six-day journey to the forest, Gilgamesh has a terrible dream, which Enkidu manages to interpret in a positive light. As the friends approach the forest, the god Shamash informs Gilgamesh that Humbaba is wearing only one of his seven coats of armor and is thus extremely vulnerable. When Gilgamesh and Enkidu enter the forest and begin cutting down trees, Humbaba comes roaring up to warn them off. An epic battle ensues, and Shamash intervenes to help the two heroes defeat the great guardian. Just before Gilgamesh cuts off Humbaba's head, Humbaba curses Enkidu, promising that he will find no peace in the world and will die before his friend Gilgamesh. In a gesture that clearly evokes the triumph of civilization over nature, Gilgamesh and Enkidu cut down the tallest of the cedar trees to make a great cedar gate for the city of Uruk.

At the center of the poem, in Tablet VI, Ishtar, goddess of both love and war, offers to marry Gilgamesh. Gilgamesh refuses, which unleashes Ishtar's wrath. She sends the Bull of Heaven to destroy them, but Gilgamesh and Enkidu slay it instead (see **Reading 2.4**, pages 63–64). But Gilgamesh and Enkidu cannot avoid the wrath of the gods altogether. One of them, the gods decide, must die, and so Enkidu suffers a long, painful death, attended by his friend, Gilgamesh, who is terrified (**Reading 2.4c**):

READING 2.4c from the *Epic of Gilgamesh*, Tablet X (ca. 1200 BCE)

My friend . . . Enkidu, whom I love deeply, who went
 through every hardship with me,
the fate of mankind has overtaken him.
Six days and seven nights I mourned over him
and would not allow him to be buried
until a maggot fell out of his nose.
I was terrified by his appearance,
I began to fear death, and so roam the wilderness.

The Great Flood Dismayed at the prospect of his own mortality, Gilgamesh embarks on a journey to find the secret of eternal life from the only mortal known to have attained it, Utanapishtim [ut-a-na-PISH-tim], who tells him the story of the Great Flood. Several elements of Utanapishtim's story deserve explanation. First of all, this is the earliest known version of the flood story that occurs also in the Hebrew Bible with Utanapishtim in the role of the biblical Noah. The motif of a single man and wife surviving a worldwide flood brought about by the gods occurs in several Middle Eastern cultures, suggesting a single origin or shared tradition. In the Sumerian version, Ea (Enki) warns Utanapishtim of the flood by speaking to the wall, thereby technically keeping the agreement among the gods not to warn mortals of their upcoming disaster. The passage in which Ea tells Utanapishtim how to explain his actions to his people without revealing the secret of the gods is one of extraordinary complexity and wit (**Reading 2.4d**). The word for "bread" is *kukku*, a pun on the word for "darkness," *kukkû*. Similarly, the word for "wheat," *kibtu*, also means "misfortune." Thus, when Ea says, "He will let loaves of bread shower down, / and in the evening a rain of wheat," he is also telling the truth: "He will let loaves of darkness shower down, and in the evening a rain of misfortune."

READING 2.4d from the *Epic of Gilgamesh*, Tablet XI (ca. 1200 BCE)

Utanapishtim spoke to Gilgamesh, saying:
"I will reveal to you, Gilgamesh, a thing that is hidden,
a secret of the gods I will tell you!
Shuruppak, a city that you surely know,
situated on the banks of the Euphrates,
that city was very old, and there were gods inside it.
The hearts of the Great Gods moved them to inflict the
 Flood. . . .
Ea, the Clever Prince, was under oath with them
so he repeated their talk to the reed house:
'Reed house, reed house! Wall, wall!

Hear, O reed house! Understand, O wall!
O man of Shuruppak, son of Ubartutu:
Tear down the house and build a boat!
Abandon wealth and seek living beings!
Spurn possessions and keep alive human beings!
Make all living beings go up into the boat. . . .'
I understood and spoke to my lord, Ea:
'My lord, thus is your command.
I will heed and will do it.
But what shall I answer the city, the populace, and the Elders?'
Ea spoke, commanding me, his servant:
'. . . this is what you must say to them:
"It appears that Enlil is rejecting me
so I cannot reside in your city,
nor set foot on Enlil's earth.
I will go . . . to live with my lord, Ea,
and upon you he will rain down abundance,
a profusion of fowls, myriad fishes.
He will bring you a harvest of wealth,
in the morning he will let loaves of bread shower down,
and in the evening a rain of wheat."'

Utanapishtim builds his boat, loads it with all the living creatures, and the flood strikes. For six days and seven nights the storm rages, and at its end, Utanapishtim's boat rests on the side of Mount Nimush. When the gods discover him alive, smelling his incense offering, they are outraged. They did not want a single living being to escape. But since he has, they grant him immortality and allow him to live forever in the Faraway. As a reward for Gilgamesh's own efforts, Utanapishtim tells Gilgamesh of a secret plant that will give him perpetual youth. "I will eat it," he tells the boatman who is returning him home, "and I will return to what I was in my youth." But when they stop for the night, Gilgamesh decides to bathe in a cool pool, where the scent of the plant attracts a snake who steals it away, an echo of the biblical story of Adam and Eve, whose own immortality is stolen away by the wiles of a serpent—and their own carelessness. Broken-hearted, Gilgamesh returns home empty-handed.

The *Epic of Gilgamesh* is the first known literary work to confront the idea of death, which is, in many ways, the very embodiment of the unknown. Although the hero goes to the very ends of the Earth in his quest, he ultimately leaves with nothing to show for his efforts except an understanding of his own, very human, limitations. He is the first hero in Western literature to yearn for what he can never attain, to seek to understand what must always remain a mystery. And, of course, until the death of his friend Enkidu, Gilgamesh had seemed, in his self-confident confrontation with Ishtar and in the defeat of the Bull of Heaven, as near to a god as a mortal might be. In short, he embodied the Mesopotamian hero-

king. Even as the poem asserts the hero-king's divinity—Gilgamesh is, remember, two parts god—it emphasizes his humanity and the mortality that accompanies it. By making literal the first words of the *Sumerian King List*—"After the kingship had descended from heaven"—the *Epic of Gilgamesh* acknowledges what many Mesopotamian kings were unwilling to admit, at least publicly: their own, very human, limitations, their own powerlessness in the face of the ultimate unknown—death.

The Hebrews

The Hebrews (from *Habiru*, "outcast" or "nomad") were a people forced out of their homeland in the Mesopotamian basin in about 2000 BCE. According to their tradition, it was in the delta of the Tigris and Euphrates rivers that God created Adam and Eve in the Garden of Eden. It was there that Noah survived the same great flood that Utanapishtim survived in the *Epic of Gilgamesh*. And it was out of there that Abraham of Ur led his people into Canaan [KAY-nun], in order to escape the warlike Akkadians and the increasingly powerful Babylonians. We know these stories from the Hebrew Bible—a word that derives from the Greek, *biblia*, "books"—a compilation of hymns, prophecies, and laws transcribed by its authors between 800 and 400 BCE, some 1,000 years after the events the Hebrew Bible describes. Although the archeological record in the Near East confirms some of what these scribes and priests wrote, the stories themselves were edited and collated into the stories we know today. They recount the Assyrian conquest of Israel, the Jews' later exile to Babylon after the destruction of Jerusalem by the Babylonian king Nebuchadnezzar [neb-uh-kud-NEZ-ur] in 587 BCE, and their eventual return to Jerusalem after the Persians conquered the Babylonians in 538 BCE. The stories represent the Hebrews' attempt to maintain their sense of their own history and destiny.

The Hebrews differed from other Fertile Crescent cultures in that their religion was *monotheistic*—they worshiped a single god, whereas others in the region tended to have gods for their clans and cities, among other things. According to Hebrew tradition, God made an agreement with the Hebrews, first with Noah after the flood, later renewed with Abraham and each of the subsequent **patriarchs** (scriptural fathers of the Hebrew people): "I am God Almighty; be fruitful and multiply; a nation and a company of nations shall come from you. The land which I gave to Abraham and Isaac I will give to you, and I will give the land to your descendants after you" (Genesis 35:11–12). In return for this promise, the Hebrews, the "chosen people," agreed to obey God's will. "Chosen people" means that the Jews were chosen to set an example of a higher moral standard (a light unto the nations), not chosen in the sense of favored, which is a common misunderstanding of the term.

Genesis, the first book of the Hebrew Bible, tells the story of the creation of the world out of a "formless void." It describes God's creation of the world and all its creatures and his continuing interest in the workings of the world, an interest that would lead, in the story of Noah, to God's near destruction of all things. It also posits humankind as easily tempted by evil. It documents the moment of the introduction of sin (and shame) into the cosmos, associating these with the single characteristic separating humans from animals—knowledge. And it shows, in the example of Noah, the reward for having "walked with God" the basis of the covenant. (See **Reading 2.5**, pages 64–67, for chapters 1–3 of Genesis, which narrate the Creation and story of Adam and Eve, and chapters 6–7, which tell the story of Noah.)

Moses and the Ten Commandments

The biblical story of Moses and the Ten Commandments embodies the centrality of the written word to Jewish culture. For reasons we don't know, the Hebrew people left Canaan for Egypt in about 1600 BCE and had prospered there until the Egyptians enslaved them in about 1300 BCE. Defying the rule of the pharaohs, the Jewish patriarch Moses led his people out of Egypt. According to tradition, Moses led the Jews across the Red Sea (which miraculously parted to facilitate the escape) and into the desert of the Sinai [SYE-nye] peninsula. (The event became the basis for the book of Exodus.) Most likely, they crossed a large tidal flat, called the Sea of Reeds; subsequently that body of water was misidentified as the Red Sea. Unable to return to Canaan, which was now occupied by local tribes of considerable military strength, the Jews settled in an arid region of the Sinai desert near the Dead Sea for a period of 40 years, which archeologists date to sometime between 1300 and 1150 BCE.

In the Sinai desert the Hebrews forged the principal tenets of a new religion based on worship of a single god. There, too, the Hebrew god supposedly revealed a new name for himself—YHWH, a name so sacred that it could neither be spoken nor written. The name is not known and YHWH is a cipher for it. (There are, however, many other names for God in the Hebrew Bible, among them Elohim [eh-loe-HEEM] (which is plural in Hebrew, meaning "gods, deities"), Adonai [ah-dun-EYE] ("Lord"), El Shaddai [shah-die] (literally "God of the fields" but usually translated "God Almighty.") Some scholars believe that this demonstrates the multiple authorship of the Bible. Others suggest that God has been given different names to reflect different aspects of his divinity, or the different roles that he might assume—the guardian of the flocks in the fields, or the powerful master of all. Translated into Latin as "Jehovah" [ji-HOH-vuh] in the Middle Ages, the name is now rendered in English as "Yahweh." This God also gave Moses the Ten Commandments, carved onto stone tablets, as recorded in the book of Deuteronomy (**Readings 2.5a, 2.5b**):

READING 2.5a The Ten Commandments, from the Hebrew Bible
(Deuteronomy 5:6–21)

6 I am the Lord your God, who brought you out of the land of Egypt, out of the house of slavery;

7 you shall have no other gods before[a] me.

8 You shall not make for yourself an idol, whether in the form of anything that is in heaven above, or that is on the earth beneath, or that is in the water under the earth.

9 You shall not bow down to them or worship them; for I the Lord your God am a jealous God, punishing children for the iniquity of parents, to the third and fourth generation of those who reject me,

10 but showing steadfast love to the thousandth generation[b] of those who love me and keep my commandments.

11 You shall not make wrongful use of the name of the Lord your God, for the Lord will not acquit anyone who misuses his name.

12 Observe the sabbath day and keep it holy, as the Lord your God commanded you.

13 For six days you shall labour and do all your work.

14 But the seventh day is a sabbath to the Lord your God; you shall not do any work—you, or your son or your daughter, or your male or female slave, or your ox or your donkey, or any of your livestock, or the resident alien in your towns, so that your male and female slave may rest as well as you.

15 Remember that you were a slave in the land of Egypt, and the Lord your God brought you out from there with a mighty hand and an outstretched arm; therefore the Lord your God commanded you to keep the sabbath day.

16 Honour your father and your mother, as the Lord your God commanded you, so that your days may be long and that it may go well with you in the land that the Lord your God is giving you.

17 You shall not murder.[c]

18 Neither shall you commit adultery.

19 Neither shall you steal.

20 Neither shall you bear false witness against your neighbour.

21 Neither shall you covet your neighbour's wife.

Neither shall you desire your neighbour's house, or field, or male or female slave, or ox, or donkey, or anything that belongs to your neighbour.

[a] Or *besides*
[b] Or *to thousands*
[c] Or *kill*

Subsequently, the Hebrews carried the commandments in a sacred chest, called the Ark of the Covenant (Fig. **2.16**), which was lit by seven-branched candelabras known as *menorahs* [men-OR-uhz]. The centrality to Hebrew culture of these written words is even more apparent in the words of God that follow the commandments.

READING 2.5b from the Hebrew Bible
(Deuteronomy 6:6–9)

6 Keep these words that I am commanding you today in your heart.

7 Recite them to your children and talk about them when you are at home and when you are away, when you lie down and when you rise.

8 Bind them as a sign on your hand, fix them as an emblem on your forehead,

9 and write them on the doorposts of your house and on your gates.

Whenever the Hebrews talked, wherever they looked, wherever they went, they focused on the commandments of their God. Their monotheistic religion was thus also an ethical and moral system derived from an omnipotent God. The Ten Commandments were the centerpiece of the Torah [tor-AH], or Law (literally "instructions"), consisting of the books of Genesis, Exodus, Leviticus, Numbers, and Deuteronomy. (Christians would later incorporate these books into their Bible as the first five books of the Old Testament.) The Hebrews considered these five books divinely inspired and attributed their original authorship to Moses himself, although the texts as we know them were written much later.

The body of laws outlined in the Torah is quite different from the code of Hammurabi. The code was essentially a list of punishments for offenses; it is not an *ethical* code (see Fig. 2.12 and Reading 2.2). Hebraic and Mesopotamian laws are distinctly different. Perhaps because the Hebrews were once themselves aliens and slaves, their law treats the lowest members of society as human beings. As Yahweh declares in Exodus 23:6: "You will not cheat the

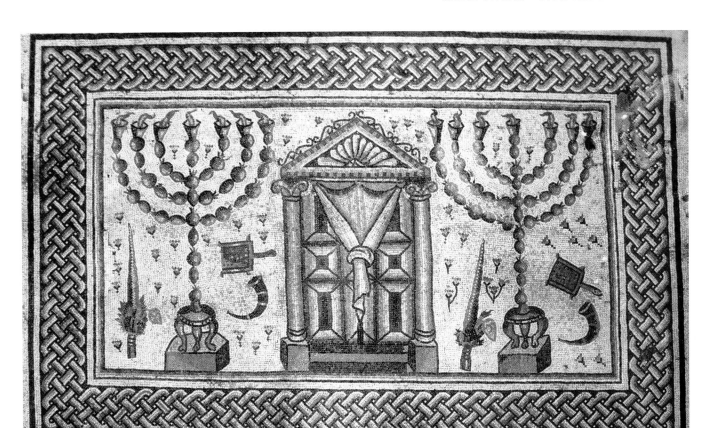

Fig. 2.16 The Ark of the Covenant and sanctuary implements, mosaic floor decorations from Hammath near Tiberias, Israel. Fourth century CE. Israel Antiquities Authority, Jerusalem. Two menorahs (seven-branched candelabras) flank each side of the Ark. The menorah is considered a symbol of the nation of Israel and its mission to be "a light unto the nations" (Isaiah 42:6). Instructions for making it are outlined in Exodus 25:31–40. Relatively little ancient Jewish art remains. Most of it was destroyed as the Jewish people were conquered, persecuted, and exiled.

Z. Radovan/www.BibleLandPictures.com

poor among you of their rights at law." At least under the law, class distinctions, with the exceptions of slaves, did not exist in Hebrew society, and punishment was levied equally. Above all else, rich and poor alike were united for the common good in a common enterprise, to follow the instructions for living as God provided.

After 40 years in the Sinai had passed, it is believed that the patriarch Joshua led the Jews back to Canaan, the Promised Land, as Yahweh had pledged in the covenant. Over the next 200 years, they gradually gained control of the region through a protracted series of wars described in the books of Joshua, Judges, and Samuel in the Bible. They named themselves the Israelites [IZ-ree-uh-lites], after Israel, the name that was given by God to Jacob. The nation consisted of 12 tribes, each descending from one of Jacob's 12 sons. By about 1000 BCE, Saul had established himself as king of Israel, followed by David, who as a boy rescued the Israelites from the Philistines [FIL-uh-steenz]

by killing the giant Goliath with a stone thrown from a sling, as described in First Samuel, and later united Israel and Judah into a single state.

Kings David and Solomon and Hebrew Society

King David reigned until 961 BCE. It was he who captured Jerusalem from the Canaanites and made it the capital of Israel (Map **2.2**). As represented in the books of Samuel, David is one of the most complex and interesting individuals in ancient literature. A poet and musician, he is author of some of the Psalms. Although he was capable of the most deceitful treachery—sending one of his soldiers, Uriah [you-RYE-uh], to certain death in battle so that he could marry his widow, Bathsheba [bath-SHE-buh]—he also suffered the greatest sorrow, being forced to endure the betrayal and death of his son Absalom. David was succeeded by his other son, Solomon, famous for his fairness in meting out justice, who ruled until 933 BCE.

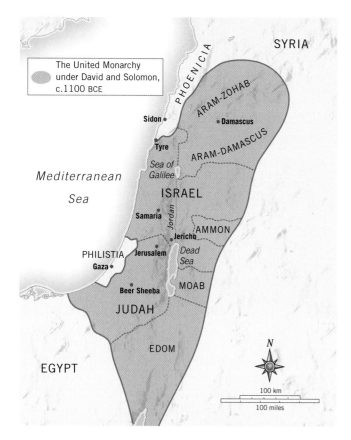

Map 2.2 The United Monarchy of Israel under David and
Solomon, ca. 1100 BCE.

22 Next he overlaid the whole house with gold, in order that
the whole house might be perfect; even the whole altar that
belonged to the inner sanctuary he overlaid with gold.

23 In the inner sanctuary he made two cherubim of olive
wood, each ten cubits high.

24 Five cubits was the length of one wing of the cherub, and
five cubits the length of the other wing of the cherub; it was
ten cubits from the tip of one wing to the tip of the other.

25 The other cherub also measured ten cubits; both cherubim
had the same measure and the same form.

26 The height of one cherub was ten cubits, and so was that
of the other cherub.

27 He put the cherubim in the innermost part of the house;
the wings of the cherubim were spread out so that a wing of
one was touching one wall, and a wing of the other cherub
was touching the other wall; their other wings towards the
centre of the house were touching wing to wing.

28 He also overlaid the cherubim with gold.

29 He carved the walls of the house all round about with
carved engravings of cherubim, palm trees, and open flowers,
in the inner and outer rooms.

Solomon's Temple Solomon undertook to complete the
building campaign begun by his father, and by the end of his
reign, Jerusalem was one of the most beautiful cities in the
Middle East. A magnificent palace and, most especially, a
splendid temple dominated the city (Fig. **2.17**). We know
the temple only through its description in First Kings
(**Reading 2.5c**):

READING 2.5c from the Hebrew Bible
(1 Kings 6:19–29)

19 The inner sanctuary he prepared in the innermost part of
the house, to set there the ark of the covenant of the Lord.

20 The interior of the inner sanctuary was twenty cubits
long, twenty cubits wide, and twenty cubits high; he over-
laid it with pure gold. He also overlaid the altar with
cedar.

21 Solomon overlaid the inside of the house with pure gold,
then he drew chains of gold across, in front of the inner sanc-
tuary, and overlaid it with gold.

We do not know how Solomon rationalized depicting
cherubim, palm trees, and open flowers, given the prohi-
bition in the Second Commandment against making "any
likeness of any thing that is in heaven, or that is on the
earth beneath," but First Kings claims that Yahweh him-
self saw the Temple and approved of it. More than a thou-
sand years later, as debates raged throughout the Middle
Ages about the appropriateness, given scriptural prohibi-
tion, of visual images in the church, the description of
Solomon's Temple in First Kings was often evoked in their
defense.

The rule of the Hebrew kings was based on the model of
the scriptural covenant between God and the Hebrews.
This covenant was the model for the relationship between
the king and his people. Each provided protection in return
for obedience and fidelity. The same relationship existed
between the family patriarch and his household. His wife
and children were his possessions, whom he protected in
return for their unerring faith in him.

The Song of Songs and the Woman's Voice Although
women were their husbands' possessions, the Hebrew Scrip-
tures provide evidence that women may have had greater
influence in Hebrew society than this patriarchal structure
would suggest. In one of the many texts later incorporated
into the Hebrew Bible and written during Solomon's
reign, the "The Song of Songs, which is Solomon's" (as
chapter 1, verse 1 of this short book reads), the woman's

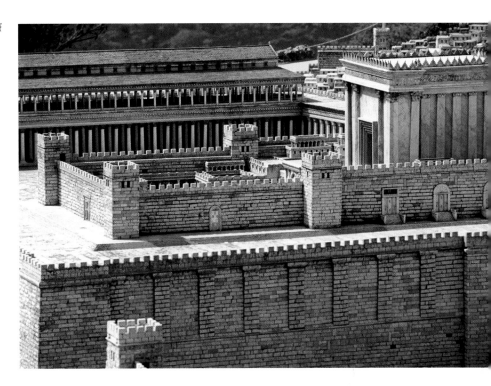

Fig. 2.17 Reconstruction drawing of the Temple of Solomon, Jerusalem. ca. 457–450 BCE. According to 1 Kings, the entire temple was covered in gold. The pillars at the front of the temple are described there as being made of brass. Their capitals were shaped like pomegranates and topped by what is described as "lily-work," all the work of Hiram of Tyre.

voice is particularly strong. It is now agreed that the book is not the work of Solomon himself, but rather a work of secular poetry, probably written during his reign. It is a love poem, a dialogue between a man (whose words are reproduced here in regular type) and a younger female lover, a Shulamite [SHOO-luh-mite], or "daughter of Jerusalem" (whose voice is in italics) (**Reading 2.5d**). This poem of sexual awakening takes place in a garden atmosphere reminiscent of Eden, but there is no Original Sin here, only fulfillment:

READING 2.5d **from the Hebrew Bible**

(Song of Solomon 4:1–6, 7:13–14)

The Song of Songs (translated by Ariel and Chana Block)

How beautiful you are, my love,
My friend! The doves of your eyes
looking out
from the thicket of your hair.

Your hair
like a flock of goats
bounding down Mount Gilead. . . .

Your breasts are two fauns
twins of a gazelle,
grazing in a field of lilies.

An enclosed garden is my sister, my bride,
A hidden well, a sealed spring. . . .

Awake, north wind! O south wind, come,
breathe upon my garden,
let its spices stream out.
Let my lover come into his garden
and taste its delicious fruit. . . .

Let us go early to the vineyards
to see if the vine has budded,
if the blossoms have opened
and the pomegranate is in flower.

There I will give you my love . . .
rare fruit of every kind, my love,
I have stored away for you.

So vivid are the poem's sexual metaphors that many people have wondered how the poem found its way into the Scriptures. But the Bible is frank enough about the attractions of sex. Consider Psalms 30:18–19: "Three things I marvel at, four I cannot fathom: the way of an eagle in the sky, the way of a snake on a rock, the way of a ship in the heart of the sea, the way of a man with a woman." The Song of Songs is full of **double entendres** [on-TAHN-druh], expressions that can be understood in two ways, one of them often sexual or risqué. Although the implications of such language are almost unavoidable, embarrassed Christian interpreters of the Bible for centuries worked hard to avoid the obvious and assert a higher purpose for the poem, reading it, especially, as a description of the relation between Christ and his "Bride," the Church.

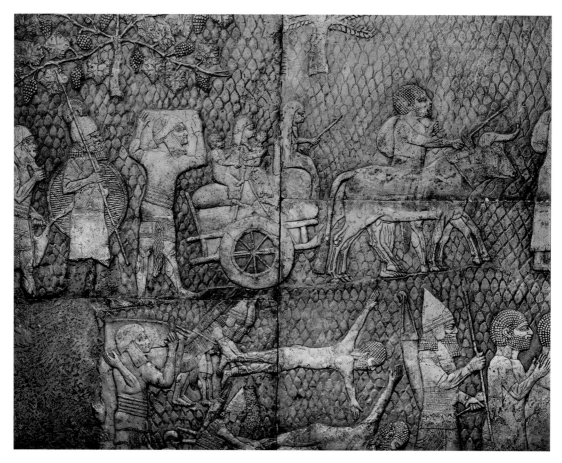

Fig. 2.18 *Exile of the Israelites,* **from the palace of Sennacherib, Ninevah, Assyria. Late eighth century** BCE. Limestone. This relief shows a family of Israelites, their cattle yoked to a cart carrying their household into exile after being defeated by the Assyrians in 722 BCE. The relief seems to depict three generations of a family: the father in front with the cattle, the son behind carrying baggage, the wife of the father seated on the front of the cart, the son's wife and children seated behind her.

Generations of translators also sought to obscure the powerful voice of the female protagonist in the poem by presenting the young woman as chaste and submissive, but of the two voices hers is the more active and authoritative. In a world in which history is traced through the patriarchs, and genealogies are generally written in the form of the father "begetting" his sons, the young woman asserts herself here in a way that suggests that if in Hebrew society the records of lineage was in the hands of its men, the traditions of love-making—and by extension, the ability to propagate the lineage itself—were controlled by its women. It is even possible that a woman composed all or large parts of the poem, since women traditionally sang songs of victory and mourning in the Bible, and the daughters of Jerusalem actually function as a chorus in the poem, asking questions of the Shulamite.

The Prophets and the Diaspora

After Solomon's death, the United Monarchy of Israel split into two separate states. To the north was Israel, with its capital in Samaria [suh-MAR-ee-uh], and to the south, Judah, with its capital in Jerusalem. In this era of the two kingdoms, Hebrew culture was dominated by **prophets**, men who were prophetic not in the sense of foretelling the future, but rather in the sense of serving as mouthpieces and interpreters of Yahweh's purposes, which they claimed to understand through visions. The prophets instructed the people in the ways of living according to the laws of the Torah, and they more or less freely confronted anyone guilty of wrongful actions, even the Hebrew kings. They attacked, particularly, the wealthy Hebrews whose commercial ventures had brought them unprecedented material comfort and who were inclined to stray from monotheism and worship Canaanite [KAY-nuh-nite] fertility gods and goddesses. The moral laxity of these wealthy Hebrews troubled the prophets, who urged the Hebrew nation to reform spiritually.

In 722 BCE, Assyrians attacked the northern kingdom of Israel and scattered its people, who were thereafter known as the Lost Tribes of Israel. The southern kingdom of Judah survived another 140 years, until Nebuchadnezzar and the Babylonians overwhelmed it in 587 BCE, destroying the Temple of Solomon in Jerusalem and deporting the Hebrews to Babylon (Fig. **2.18**). The Prophet Jeremiah

explained these events (**Reading 2.5e**) as a direct result of the Hebrews' abandonment of the scriptural covenant and their worship of the Canaanite idols. He records Yahweh's words to him:

READING 2.5e **from the Hebrew Bible**
(Jeremiah 11:11–14)

11 Therefore, thus says the Lord, assuredly I am going to bring disaster upon them that they cannot escape; though they cry out to me, I will not listen to them.

12 Then the cities of Judah and the inhabitants of Jerusalem will go and cry out to the gods to whom they make offerings, but they will never save them in the time of their trouble.

13 For your gods have become as many as your towns, O Judah; and as many as the streets of Jerusalem are the altars to shame that you have set up, altars to make offerings to Baal.

14 As for you, do not pray for this people, or lift up a cry or prayer on their behalf, for I will not listen when they call to me in the time of their trouble.

Whether or not Jeremiah actually spoke to Yahweh as he claims, his sense of catastrophic loss is unmistakable. Not only had the Hebrews lost their homeland and their temple, but the Ark of the Covenant itself disappeared. For nearly 60 years, the Hebrews endured what is known as the Babylonian Captivity. As recorded in Psalm 137: "By the rivers of Babylon, there we sat down, yea we wept, when we remembered Zion."

Finally, invading Persians, whom they believed had been sent by Yahweh, freed them from the Babylonians in 520 BCE. They returned to Judah, known now, for the first time, as the Jews (after the name of their homeland). They rebuilt a Second Temple of Jerusalem, with an empty chamber at its center, meant for the Ark of the Covenant should it ever return. And they welcomed back other Jews from around the Mediterranean, including many whose families had left the northern kingdom almost 200 years earlier. Many others, however, were by now permanently settled elsewhere, and they became known as the Jews of the Diaspora [die-AS-puh-ruh], or the "dispersion."

Symbolizing the general Jewish suffering during the Babylonian Captivity is the Book of Job [jobe], one of the first so-called **framed tales** in all of literature (see **Reading 2.6**, pages 67–68). A framed tale is a story within a story, and the story of Job takes place within the frame of the story of a bet between God and Satan. Satan bets that if Job were made to suffer, he would take the name of God in vain. God disagrees and wins the bet, but during his suffering, Job raises impor-

tant theological issues. Why, he asks, do the good suffer and the wicked prosper? If God is merciful, why does he not show mercy for his "blameless and upright" servant? God answers Job by pointing out the importance of true obedience to the Lord, whose knowledge and vision far exceed that of his faithful servants.

Hebrew Culture and the West Hebrew culture would have a profound impact on Western civilization. The Jews provided the essential ethical and moral foundation for religion in the West, including Christianity and Islam, both of which incorporate Jewish teachings into their own thought and practice. In the Torah we find the basis of the law as we understand and practice it today. So moving and universal are the stories recorded in the Torah that over the centuries they have inspired—and continue to inspire—countless works of art, music, and literature. Most important, the Hebrews introduced to the world the concept of ethical monotheism, the idea that there is only one God, and that God demands that humans behave in a certain way, and rewards and punishes accordingly. Few, if any, concepts have had a more far-reaching effect on history and culture.

Neo-Babylonia

From Ashurnasirpal's time on, the Assyrians ruled Babylon, but late in the seventh century BCE Nebuchadnezzar (r. 604–562 BCE) defeated the Assyrians at Nineveh and restored that city's palace as the center of Mesopotamian civilization. It was here that the Hebrews lived in exile for nearly 50 years (586–538 BCE) after Nebuchadnezzar captured the people of Jerusalem.

Nebuchadnezzar wished to remake Babylon as the most remarkable and beautiful city in the world. It was laid out on both sides of the Euphrates River, joined together by a single bridge. Through the middle of the older, eastern sector, ran the Processional Way, an avenue also called "May the Enemy Not Have Victory." It ran from the Euphrates bridge eastward through the temple district, past the Marduk ziggurat. (Many believe this ziggurat was the legendary Tower of Babel [BAB-ul], described in Genesis 11 as the place where God, confronted with the prospect of "one people. . . one language," chose instead to "confuse the language of all the earth," and scatter people "abroad over the face of the earth.") Then it turned north, ending at the Ishtar Gate, the northern entrance to the city. Processions honoring Marduk, the god celebrated above all others in Akkadian lore and considered the founder of Babylon itself, regularly filled the street, which was as much as 65 feet wide at some points and paved with large stone slabs.

No trace of the city's famous Hanging Gardens survives, once considered among the Seven Wonders of the World, and only the base and parts of the lower stairs of the Marduk ziggurat still remain. But in the fifth century BCE, the Greek

historian Herodotus [he-ROD-uh-tus] (ca. 484–430/420 BCE) described the ziggurat as follows:

> There was a tower of solid masonry, a furlong in length and breadth, on which was raised a second tower, and on that a third, and so on up to eight. The ascent to the top is on the outside, by a path which winds round all the towers. . . . On the topmost tower, there is a spacious temple, and inside the temple stands a couch of unusual size, richly adorned with a golden table by its side. . . . They also declare that the god comes down in person into this chamber, and sleeps on the couch, but I do not believe it.

Although the ziggurat has disappeared, we can glean some sense of the city's magnificence from the Ishtar Gate (Fig. 2.19), named after the Babylonian goddess of fertility. Today the gate is restored and reconstructed inside one of the Berlin State Museums. It was made of glazed and unglazed bricks and decorated with animal forms. The entire length of the Processional Way was similarly decorated on both sides, so the ensemble must have been a wondrous sight. The gate's striding lions are particularly interesting. They are traditional symbols of Ishtar herself. Alternating with rows of bulls with blue horns and tails, associated with deities such as Addad [AD-dad], god of the weather, are fantastic dragons with long necks, the forelegs of a lion, and the rear legs of a bird of prey, an animal form sacred to the god Marduk. Like so much other Mesopotamian art, it is at once a monument to the power of Nebuchadnezzar, an affirmation of his close relation to the gods, and a testament to his kingdom's wealth and well-being.

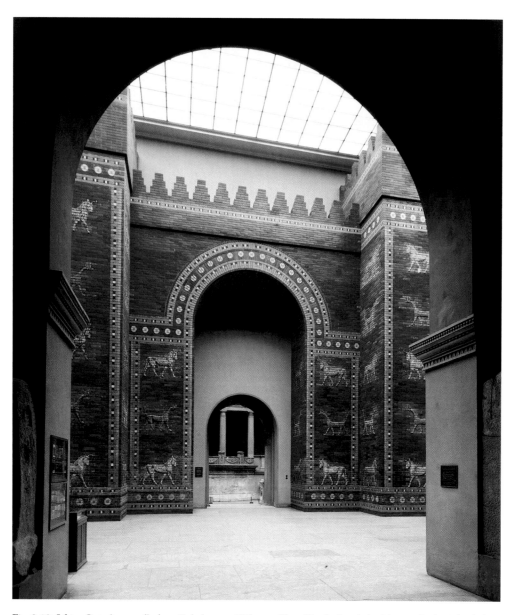

Fig. 2.19 Ishtar Gate (restored), from Babylon. ca. 575 BCE. Glazed brick. Staatliche Museen, Berlin. The dark blue bricks are glazed—that is, covered with a film of glass—and they would have shown brilliantly in the sun.

READINGS

READING 2.4

from the *Epic of Gilgamesh*, Tablet VI, Columns 1–5 (ca. 1200 BCE)
(Translated by Maureen Gallery Kovacs)

The Epic of Gilgamesh describes the exploits of the Sumerian ruler Gilgamesh and his friend Enkidu. The following passage, Tablet VI of the epic's 12 tablets, recounts the goddess Ishtar's marriage proposal to Gilgamesh, his refusal, and her subsequent wrath. In retaliation for being rebuffed, she unleashes the Bull of Heaven to destroy him, but he and Enkidu slaughter it, and then celebrate their victory. The passage describes the heroic comradeship of Enkidu and Gilgamesh and begins to address the main theme of the poem: the inevitability of death.

Tablet VI

A Woman Scorned

...When Gilgamesh placed his crown on his head Princess,
 Ishtar raised her eyes to the beauty of Gilgamesh.
 "Come along, Gilgamesh, be you my husband,
 to me grant your lusciousness.[1]
 Be you my husband, and I will be your wife.
 I will have harnessed for you a chariot of lapis lazuli and gold,
 with wheels of gold . . .
 Bowed down beneath you will be kings, lords, and princes.
 The Lullubu people[2] will bring you the produce of the moun
 tains and countryside as tribute. 10
 Your she-goats will bear triplets, your ewes twins,
 your donkey under burden will overtake the mule,
 your steed at the chariot will be bristling to gallop,
 your ox at the yoke will have no match."
Gilgamesh addressed Princess Ishtar saying:
 Do you need oil or garments for your body?
 Do you lack anything for food or drink?
 I would gladly feed you food fit for a god,
 I would gladly give you wine fit for a king . . .
 a half-door that keeps out neither breeze nor blast, 20
 a palace that crushes down valiant warriors,
 an elephant who devours its own covering,
 pitch that blackens the hands of its bearer,
 a waterskin that soaks its bearer through,
 limestone that buckles out the stone wall,
 a battering ram that attracts the enemy land,
 a shoe that bites its owner's feet!
 Where are your bridegrooms that you keep forever? . . .
 You loved the supremely mighty lion,
 yet you dug for him seven and again seven pits. 30
 You loved the stallion, famed in battle,
 yet you ordained for him the whip, the goad, and the lash,
 ordained for him to gallop for seven and seven hours,

ordained for him drinking from muddied waters,[3]
you ordained for his mother Silili to wail continually.
You loved the Shepherd, the Master Herder,
who continually presented you with bread baked in embers,
and who daily slaughtered for you a kid.
Yet you struck him, and turned him into a wolf,
so his own shepherds now chase him 40
and his own dogs snap at his shins.
You loved Ishullanu, your father's date gardener,
who continually brought you baskets of dates,
and brightened your table daily.
You raised your eyes to him, and you went to him:
 'Oh my Ishullanu, let us taste of your strength,
 stretch out your hand to me, and touch our "vulva."[4]
Ishullanu said to you:
 'Me? What is it you want from me?. . .
As you listened to these his words 50
you struck him, turning him into a dwarf(?),[5]. . .
And now me! It is me you love, and you will ordain for me as
for them!"

Her Fury

When Ishtar heard this
in a fury she went up to the heavens,
going to Anu, her father, and crying,
going to Antum, her mother, and weeping:
 "Father, Gilgamesh has insulted me over and over,
 Gilgamesh has recounted despicable deeds about me,
 despicable deeds and curses!" 60
Anu addressed Princess Ishtar, saying:
 "What is the matter? Was it not you who provoked King
 Gilgamesh?
 So Gilgamesh recounted despicable deeds about you,
 despicable deeds and curses!"
Ishtar spoke to her father, Anu, saying:
 "Father, give me the Bull of Heaven,
 so he can kill Gilgamesh in his dwelling.

[1]Literally "fruit."

[2]The Lullubu were a wild mountain people living in the area of modern-day western Iran. The meaning is that even the wildest, least controllable of peoples will recognize Gilgamesh's rule and bring tribute.

[3]Horses put their front feet in the water when drinking, churning up mud.
[4]This line probably contains a word play on *hurdatu* as "vulva" and "date palm," the latter being said (in another unrelated text) to be "like the vulva."
[5]Or "frog"?

If you do not give me the Bull of Heaven,
I will knock down the Gates of the Netherworld, 70
I will smash the door posts, and leave the doors flat down,
and will let the dead go up to eat the living!
And the dead will outnumber the living!"
Anu addressed Princess Ishtar, saying:
 "If you demand the Bull of Heaven from me,
 there will be seven years of empty husks for the land of Uruk.
 Have you collected grain for the people?
 Have you made grasses grow for the animals?"
Ishtar addressed Anu, her father, saying:
 "I have heaped grain in the granaries for the people, 80
 I made grasses grow for the animals,
 in order that they might eat in the seven years of empty
 husks.
 I have collected grain for the people,
 I have made grasses grow for the animals. . . ."
When Anu heard her words,
he placed the nose-rope of the Bull of Heaven in her hand.
Ishtar led the Bull of Heaven down to the earth.
When it reached Uruk. . .
It climbed down to the Euphrates . . . 90
At the snort of the Bull of Heaven a huge pit opened up,
and 100 Young Men of Uruk fell in.
At his second snort a huge pit opened up,
and 200 Young Men of Uruk fell in.
At his third snort a huge pit opened up,
and Enkidu fell in up to his waist.
Then Enkidu jumped out and seized the Bull of Heaven by its horns.
The Bull spewed his spittle in front of him,
with his thick tail he flung *his dung behind him* (?).
Enkidu addressed Gilgamesh, saying: 100
 "My friend, we can be bold(?) . . .
 Between the nape, the horns, and . . . thrust your sword."

Enkidu stalked and *hunted down* the Bull of Heaven.
He grasped it by the thick of its tail
and held onto it with both his hands (?),
while Gilgamesh, like an *expert butcher*,
boldly and *surely approached the Bull of Heaven.*
Between the nape, the horns, and . . . he thrust his sword. . . .
Ishtar went up onto the top of the Wall of Uruk-Haven,
cast herself into the pose of mourning, and hurled her woeful 110
curse:
 "Woe unto Gilgamesh who slandered me and killed the Bull
 of Heaven!"
When Enkidu heard this pronouncement of Ishtar,
he wrenched off the Bull's hindquarter and flung it in her face:
 "If I could only get at you I would do the same to you!
 I would drape his innards over your arms!". . .
Gilgamesh said to the palace retainers:
 "Who is the bravest of the men?
 Who is the boldest of the males? 120
 —Gilgamesh is the bravest of the men,
 the boldest of the males!
 She at whom we flung the hindquarter of the Bull of Heaven
 in anger,
 Ishtar has no one that pleases her . . ." ■

Reading Questions

The passage depicts the goddess's behavior as no better than that of humans, and probably worse than that of Gilgamesh and Enkidu. What characteristics do Ishtar and Gilgamesh share? What does this suggest about Gilgamesh's eventual fate? Can you draw a connection between the Bull of Heaven and the hero? How does the passage suggest their similarity?

READING 2.5

from the Hebrew Bible, Genesis (Chapters 1–3, 6–7)

The following excerpts from the first book of both the Hebrew Torah and the Christian Old Testament describe the Creation and the story of Adam and Eve (Chapters 1–3) and the story of Noah (Chapters 6–7). Together they demonstrate some of the characteristics of Hebrew monotheism—belief in the direct agency of their God in the workings of the world and his creation of a universe that is systematically planned and imbued with a moral order that derives from him. The passages also demonstrate the power and authority the Hebrews invested in their God.

Creation

Chapter 1

1 In the beginning when God created the heavens and the earth,

2 the earth was a formless void and darkness covered the face of the deep, while a wind from God swept over the face of the waters.

3 Then God said, "Let there be light"; and there was light.

4 And God saw that the light was good; and God separated the light from the darkness.

5 God called the light Day, and the darkness he called Night. And there was evening and there was morning, the first day.

6 And God said, "Let there be a dome in the midst of the 10
waters, and let it separate the waters from the waters."

7 So God made the dome and separated the waters that were under the dome from the waters that were above the dome.

And it was so.

8 God called the dome Sky. And there was evening and there was morning, the second day.

9 And God said, "Let the waters under the sky be gathered together into one place, and let the dry land appear." And it was so.

10 God called the dry land Earth, and the waters that were gathered together he called Seas. And God saw that it was good.

11 Then God said, "Let the earth put forth vegetation: plants yielding seed, and fruit trees of every kind on earth that bear fruit with the seed in it." And it was so.

12 The earth brought forth vegetation: plants yielding seed of every kind, and trees of every kind bearing fruit with the seed in it. And God saw that it was good.

13 And there was evening and there was morning, the third day.

14 And God said, "Let there be lights in the dome of the sky to separate the day from the night; and let them be for signs and for seasons and for days and years,

15 and let them be lights in the dome of the sky to give light upon the earth." And it was so.

16 God made the two great lights—the greater light to rule the day and the lesser light to rule the night—and the stars.

17 God set them in the dome of the sky to give light upon the earth,

18 to rule over the day and over the night, and to separate the light from the darkness. And God saw that it was good.

19 And there was evening and there was morning, the fourth day.

20 And God said, "Let the waters bring forth swarms of living creatures, and let birds fly above the earth across the dome of the sky."

21 So God created the great sea monsters and every living creature that moves, of every kind, with which the waters swarm, and every winged bird of every kind. And God saw that it was good.

22 God blessed them, saying, "Be fruitful and multiply and fill the waters in the seas, and let birds multiply on the earth."

23 And there was evening and there was morning, the fifth day.

24 And God said, "Let the earth bring forth living creatures of every kind: cattle and creeping things and wild animals of the earth of every kind." And it was so.

25 God made the wild animals of the earth of every kind, and the cattle of every kind, and everything that creeps upon the ground of every kind. And God saw that it was good.

26 Then God said, "Let us make humankind in our image, according to our likeness; and let them have dominion over the fish of the sea, and over the birds of the air, and over the cattle, and over all the wild animals of the earth, and over every creeping thing that creeps upon the earth."

27 So God created humankind in his image, in the image of God he created them; male and female he created them.

28 God blessed them, and God said to them, "Be fruitful and multiply, and fill the earth and subdue it; and have dominion over the

fish of the sea and over the birds of the air and over every living thing that moves upon the earth."

29 God said, "See, I have given you every plant yielding seed that is upon the face of all the earth, and every tree with seed in its fruit; you shall have them for food.

30 And to every beast of the earth, and to every bird of the air, and to everything that creeps on the earth, everything that has the breath of life, I have given every green plant for food." And it was so.

31 God saw everything that he had made, and indeed, it was very good. And there was evening and there was morning, the sixth day.

Chapter 2

1 Thus the heavens and the earth were finished, and all their multitude.

2 And on the seventh day God finished the work that he had done, and he rested on the seventh day from all the work that he had done.

3 So God blessed the seventh day and hallowed it, because on it God rested from all the work that he had done in creation. . .

7 then the LORD God formed man from the dust of the ground, and breathed into his nostrils the breath of life; and the man became a living being.

8 And the LORD God planted a garden in Eden, in the east; and there he put the man whom he had formed.

9 Out of the ground the LORD God made to grow every tree that is pleasant to the sight and good for food, the tree of life also in the midst of the garden, and the tree of the knowledge of good and evil.

10 A river flows out of Eden to water the garden, and from there it divides and becomes four branches.

11 The name of the first is Pishon; it is the one that flows around the whole land of Havilah, where there is gold;

12 and the gold of that land is good; odellium and onyx stone are there.

13 The name of the second river is Gihon; it is the one that flows around the whole land of Cush.

14 The name of the third river is Tigris, which flows east of Assyria. And the fourth river is the Euphrates.

15 The LORD God took the man and put him in the garden of Eden to till it and keep it.

16 And the LORD God commanded the man, "You may freely eat of every tree of the garden;

17 but of the tree of the knowledge of good and evil you shall not eat, for in the day that you eat of it you shall die."

18 Then the LORD God said, "It is not good that the man should be alone; I will make him a helper as his partner."

19 So out of the ground the LORD God formed every animal of the field and every bird of the air, and brought them to the man to see what he would call them; and whatever the man called every living creature, that was its name.

20 The man gave names to all cattle, and to the birds of the air, and to every animal of the field; but for the man there was not found a helper as his partner.

21 So the LORD God caused a deep sleep to fall upon the man, and he slept; then he took one of his ribs and closed up its place with flesh.

22 And the rib that the LORD God had taken from the man he made into a woman and brought her to the man.

23 Then the man said, "This at last is bone of my bones and flesh of my flesh; this one shall be called Woman, for out of Man this one was taken."

24 Therefore a man leaves his father and his mother and clings to his wife, and they become one flesh.

25 And the man and his wife were both naked, and were not ashamed.

The Temptation and Expulsion

Chapter 3

1 Now the serpent was more crafty than any other wild animal that the LORD God had made. He said to the woman, "Did God say, 'You shall not eat from any tree in the garden'?"

2 The woman said to the serpent, "We may eat of the fruit of the trees in the garden;

3 but God said, 'You shall not eat of the fruit of the tree that is in the middle of the garden, nor shall you touch it, or you shall die.'"

4 But the serpent said to the woman, "You will not die;

5 for God knows that when you eat of it your eyes will be opened, and you will be like God, knowing good and evil."

6 So when the woman saw that the tree was good for food, and that it was a delight to the eyes, and that the tree was to be desired to make one wise, she took of its fruit and ate; and she also gave some to her husband, who was with her, and he ate.

7 Then the eyes of both were opened, and they knew that they were naked; and they sewed fig leaves together and made loin-cloths for themselves.

8 They heard the sound of the LORD God walking in the garden at the time of the evening breeze, and the man and his wife hid themselves from the presence of the LORD God among the trees of the garden.

9 But the LORD God called to the man, and said to him, "Where are you?"

10 He said, "I heard the sound of you in the garden, and I was afraid, because I was naked; and I hid myself."

11 He said, "Who told you that you were naked? Have you eaten from the tree of which I commanded you not to eat?"

12 The man said, "The woman whom you gave to be with me, she gave me fruit from the tree, and I ate."

13 Then the LORD God said to the woman, "What is this that you have done?" The woman said, "The serpent tricked me, and I ate."

14 The LORD God said to the serpent, "Because you have done this, cursed are you among all animals and among all wild creatures; upon your belly you shall go, and dust you shall eat all the days of your life.

15 I will put enmity between you and the woman, and between your offspring and hers; he will strike your head, and you will strike his heel."

16 To the woman he said, "I will greatly increase your pangs in childbearing; in pain you shall bring forth children, yet your desire shall be for your husband, and he shall rule over you."

17 And to the man he said, "Because you have listened to the voice of your wife, and have eaten of the tree about which I commanded you, 'You shall not eat of it,' cursed is the ground because of you; in toil you shall eat of it all the days of your life;

18 thorns and thistles it shall bring forth for you; and you shall eat the plants of the field.

19 By the sweat of your face you shall eat bread until you return to the ground, for out of it you were taken; you are dust, and to dust you shall return."

20 The man named his wife Eve, because she was the mother of all living.

21 And the LORD God made garments of skins for the man and for his wife, and clothed them.

22 Then the LORD God said, "See, the man has become like one of us, knowing good and evil; and now, he might reach out his hand and take also from the tree of life, and eat, and live forever"—

23 therefore the LORD God sent him forth from the garden of Eden, to till the ground from which he was taken.

24 He drove out the man; and at the east of the garden of Eden he placed the cherubim, and a sword flaming and turning to guard the way to the tree of life.

The Story of Noah

Chapter 6

5 The LORD saw that the wickedness of humankind was great in the earth, and that every inclination of the thoughts of their hearts was only evil continually.

6 And the LORD was sorry that he had made humankind on the earth, and it grieved him to his heart.

7 So the LORD said, "I will blot out from the earth the human beings I have created—people together with animals and creeping things and birds of the air, for I am sorry that I have made them."

8 But Noah found favor in the sight of the LORD. . . .

13 And God said to Noah, "I have determined to make an end of all flesh, for the earth is filled with violence because of them; now I am going to destroy them along with the earth.

14 Make yourself an ark of cypress wood; make rooms in the ark, and cover it inside and out with pitch. . . .

120

130

140

150

160

170

180

190

200

210

17 For my part, I am going to bring a flood of waters on the earth, to destroy from under heaven all flesh in which is the breath of life; everything that is on the earth shall die.

18 But I will establish my covenant with you; and you shall come into the ark, you, your sons, your wife, and your sons' wives with you.

19 And of every living thing, of all flesh, you shall bring two of every kind into the ark, to keep them alive with you; they shall be male and female.

20 Of the birds according to their kinds, and of the animals according to their kinds, of every creeping thing of the ground according to its kind, two of every kind shall come in to you, to keep them alive.

21 Also take with you every kind of food that is eaten, and store it up; and it shall serve as food for you and for them." **22** Noah did this; he did all that God commanded him.

Chapter 7

6 Noah was six hundred years old when the flood of waters came on the earth.

7 And Noah with his sons and his wife and his sons' wives went into the ark to escape the waters of the flood.

8 Of clean animals, and of animals that are not clean, and of birds, and of everything that creeps on the ground,

9 two and two, male and female, went into the ark with Noah, as God had commanded Noah.

10 And after seven days the waters of the flood came on the earth. . . .

11 . . . on that day all the fountains of the great deep burst forth, and the windows of the heavens were opened.

12 The rain fell on the earth forty days and forty nights. . . .

18 The waters swelled and increased greatly on the earth; and the ark floated on the face of the waters.

19 The waters swelled so mightily on the earth that all the high mountains under the whole heaven were covered; . . .

21 And all flesh died that moved on the earth, birds, domestic animals, wild animals, all swarming creatures that swarm on the earth, and all human beings;

22 everything on dry land in whose nostrils was the breath of life died.

23 He blotted out every living thing that was on the face of the ground, human beings and animals and creeping things and birds of the air; they were blotted out from the earth. Only Noah was left, and those that were with him in the ark. . . . ■

Reading Questions

The story of Noah is, in some sense, a parable of the value of choosing to "walk with God." How does it reflect, then, the idea of the covenant, God's agreement with the Hebrews?

READING 2.6

from the Hebrew Bible, The Book of Job (Chapters 1–3, 38, 42)

The Book of Job is one of the great works of world literature. It is a framed tale—that is, a story within a story. Job's story, the heart of the book, is in the form of poetry, while the framing tale (the story of God's and Satan's wager on Job's faith) is told in prose. Job undergoes unjustified persecution at God's hands, losing his possessions, his family, and his health, calling into question the more general Hebraic characterization of God as merciful and benevolent.

Book of Job

Chapter 1

1 There was once a man in the land of Uz whose name was Job. That man was blameless and upright, one who feared God and turned away from evil.

2 There were born to him seven sons and three daughters.

3 He had seven thousand sheep, three thousand camels, five hundred yoke of oxen, five hundred donkeys, and very many servants; so that this man was the greatest of all the people of the east. . . .

6 One day the heavenly beings came to present themselves before the LORD, and Satan also came among them.

7 The LORD said to Satan, "Where have you come from?" Satan answered the LORD, "From going to and fro on the earth, and from walking up and down on it."

8 The LORD said to Satan, "Have you considered my servant Job? There is no one like him on the earth, a blameless and upright man who fears God and turns away from evil."

9 Then Satan answered the LORD, "Does Job fear God for nothing?

10 Have you not put a fence around him and his house and all that he has, on every side? You have blessed the work of his hands, and his possessions have increased in the land.

11 But stretch out your hand now, and touch all that he has, and he will curse you to your face."

12 The LORD said to Satan, "Very well, all that he has is in your power; only do not stretch out your hand against him!" So Satan went out from the presence of the LORD.

13 One day when his sons and daughters were eating and drinking wine in the eldest brother's house,

14 a messenger came to Job and said, "The oxen were plowing and the donkeys were feeding beside them,

15 and the Sabeans fell on them and carried them off, and killed the servants with the edge of the sword; I alone have escaped to tell you."

16 While he was still speaking, another came and said, "The fire of God fell from heaven and burned up the sheep and the servants, and consumed them; I alone have escaped to tell you."

17 While he was still speaking, another came and said, "The Chaldeans formed three columns, made a raid on the camels and carried them off, and killed the servants with the edge of the sword; I alone have escaped to tell you."

18 While he was still speaking, another came and said, "Your sons and daughters were eating and drinking wine in their eldest brother's house,

19 and suddenly a great wind came across the desert, struck the four corners of the house, and it fell on the young people, and they are dead; I alone have escaped to tell you."

20 Then Job arose, tore his robe, shaved his head, and fell on the ground and worshiped.

21 He said, "Naked I came from my mother's womb, and naked shall I return there; the LORD gave, and the LORD has taken away; blessed be the name of the LORD."

22 In all this Job did not sin or charge God with wrongdoing.

Chapter 2

7 So Satan went out from the presence of the LORD, and inflicted loathsome sores on Job from the sole of his foot to the crown of his head.

8 Job took a potsherd with which to scrape himself, and sat among the ashes.

9 Then his wife said to him, "Do you still persist in your integrity? Curse God, and die."

10 But he said to her, "You speak as any foolish woman would speak. Shall we receive the good at the hand of God, and not receive the bad?" In all this Job did not sin with his lips.

11 Now when Job's three friends heard of all these troubles that had come upon him, each of them set out from his home . . .

13 They sat with him on the ground seven days and seven nights, and no one spoke a word to him, for they saw that his suffering was very great.

Chapter 3

1 After this Job opened his mouth and cursed the day of his birth.

2 Job said:

3 "Let the day perish in which I was born, and the night that said, 'A man-child is conceived.'

4 Let that day be darkness! . . .

5 Let gloom and deep darkness claim it. Let clouds settle upon it; let the blackness of the day terrify it. . . .

20 "Why is light given to one in misery, and life to the bitter in soul,

21 who long for death, but it does not come, and dig for it more than for hidden treasures;

22 who rejoice exceedingly, and are glad when they find the grave? . . .

Chapter 38

1 Then the LORD answered Job out of the whirlwind:

2 "Who is this that darkens counsel by words without knowledge?

3 Gird up your loins like a man, I will question you, and you shall declare to me.

4 "Where were you when I laid the foundation of the earth? Tell me, if you have understanding.

5 Who determined its measurements—surely you know! Or who stretched the line upon it?

6 On what were its bases sunk, or who laid its cornerstone

7 when the morning stars sang together and all the heavenly beings shouted for joy? . . .

16 "Have you entered into the springs of the sea, or walked in the recesses of the deep?

17 Have the gates of death been revealed to you, or have you seen the gates of deep darkness?

18 Have you comprehended the expanse of the earth? Declare, if you know all this.

Chapter 42

1 Then Job answered the LORD:

2 "I know that you can do all things, and that no purpose of yours can be thwarted.

3 'Who is this that hides counsel without knowledge?' Therefore I have uttered what I did not understand, things too wonderful for me, which I did not know. . . .

5 I had heard of you by the hearing of the ear, but now my eye sees you;

6 therefore I despise myself, and repent in dust and ashes." . . . ■

Reading Questions

Modern readers often focus on Job's suffering, identifying with him and asking with him, "How can a good man's suffering be justified?" But another way to approach the Book of Job is to read it as an affirmation of the Hebrew God's absolute authority. How is that authority confirmed in these passages?

Summary

■ **Sumerian Ur** The city of Ur, unearthed by Sir Leonard Woolley in 1922, is one of the earliest powers in Mesopotamia. The tombs at Ur reveal a highly developed Bronze Age culture, based on the social order of the city-state, which was ruled by a priest-king acting as the intermediary between the gods and the people. He established law, encouraged record keeping, which in turn required the development of a system of writing—cuneiform script—and built monumental architecture dedicated to the gods. The religion of the Sumerians was polytheistic, although in each city-state one of the gods rose to prominence as the city's protector. To the Mesopotamians, human society was merely a part of the larger society of the universe governed by their god and each city-state was meant to reflect that larger order.

■ **Akkad** Around 2300 BCE, a people from the north, the Akkadians, took control of all the city-states in Sumer. The Akkadian Empire, controlling the whole of Mesopotamia, supplanted the regional city-state as the dominant power base in the region. Few Akkadian artifacts survive, but they conclusively establish the authority of the king in Akkadian culture as both hero and divinity.

■ **Babylon** Following the collapse of the Akkadian Empire, dominance of the region was achieved by Hammurabi of Babylon. Hammurabi codified Mesopotamian law, specifically in the stele that records the *Law Code of Hammurabi*. The Code tells us much about the daily life of Mesopotamian society, but perhaps equally important, it diminishes the potentially capricious rule of the king in favor of a code of law that overrides subjective feeling, creating a legal establishment of judges at the same time.

■ **The Assyrian Empire** The Assyrians were the next state to dominate the region's cultural life, especially under the leadership of Ashurnasirpal II, whose enormous palace at Kalhu on the Tigris River was decorated with alabaster reliefs celebrating the king's power. These included scenes of ritual lion hunts. Two hundred years later, during the reign of Ashurbanipal, similar scenes were still used to decorate Assyrian palaces. The Assyrian ruler embodied all the forces of nature, exercising even the cycle of life and death in his hunt of the lion, symbol of power.

■ **Mesopotamian Literature** Nearly 100,000 literary works, or fragments thereof, survive, many of which deal with religious themes and stories about the Mesopotamian gods. The *Epic of Gilgamesh*, one of the greatest of the surviving manuscripts, deals with the exploits of an early Sumerian king. The poem's artistry is most easily felt in the poet's use of epithets, metaphors, and similes, but also in the poem's profound exploration of the meaning of death. The hero Gilgamesh, having lost his friend Enkidu, seeks to discover the secret of immortality from Utanapishtim, sole survivor of the great flood, but he finally has to face his own ultimate limitation, his mortality.

■ **The Hebrews** Originating in Sumerian Ur around 2000 BCE, the Hebrews were the only peoples of Mesopotamia to practice a monotheistic religion. They consider themselves the "chosen people" of God, whom they called Yahweh. The written word is central to their culture, and it is embodied in a body of law, the Torah, and more specifically in the Ten Commandments. The Torah has much in common with the *Law Code of Hammurabi*, with the important exception that Hebraic law did not reflect most class distinctions. Under the rule of kings David and Solomon, Jerusalem became one of the most beautiful cities in the Middle East, dominated by a magnificent temple described in the Hebrew scriptures. The Hebrew state eventually fell, first to the Assyrian kings and then to the Babylonian king Nebuchadnezzar. The Jews either suffered exile to Babylonia or they scattered in what later came to be known as the Diaspora, or dispersion.

■ **Neo-Babylonia** The last of the great Mesopotamian empires was founded by King Nebuchadnezzar, who defeated the Assyrians and rebuilt the city of Babylon with the intention of making it the most beautiful city in the world.

Glossary

city-states Governments based in urban centers of the Mesopotamian basin that controlled neighboring regions; also an independent self-governing city.

composite Made up of distinct parts.

cuneiform writing A writing system composed of wedge-shaped characters.

cylinder seal An engraved piece of stone or other material used as a signature, confirmation of receipt, or identification of ownership.

double entendre A word or expression that can be understood two ways, with one often having a sexual or risqué connotation.

epic A long narrative poem in elevated language that follows characters of a high position through a series of adventures, often including a visit to the world of the dead.

epithet A word or phrase that characterizes a person.

framed tale A story set within another story.

ground-line A baseline.

hierarchy of scale A pictorial convention in which the most important figures are represented in a larger size than the others; see also *social perspective*.

lost-wax casting A sculptural process in which a figure is modeled in wax and covered in plaster or clay; firing melts away the wax and hardens the plaster or clay, which then becomes a mold for molten metal.

metallurgy The science of separating metals from their ores.

metaphor A word or phrase used in place of another to suggest a likeness.

narrative genre A class or category of story with a universal theme.

narrative scene A scene that represents a story or event.

patriarch A scriptural father of the Hebrew people.

phonetic writing A writing system in which signs represent sounds.

pictogram A picture that represents a thing or concept.

priest-kings In ancient Mesopotamia, government leaders who acted as intermediaries between gods and people and established laws.

prophet One who serves as a mouthpiece for and interpreter of Yahweh's purposes, which is understood through visions.

register A self-contained horizontal band.

simile A comparison of two unlike things using the word *like* or *as*.

social perspective A pictorial convention in which the most important figures are represented in a larger size than the others; see also *hierarchy of scale*.

stele An upright stone slab carved with a commemorative design or inscription.

stylus A writing tool.

synoptic A view that depicts several consecutive actions at once.

ziggurat A pyramidal temple structure consisting of successive platforms with outside staircases and a shrine at the top.

Critical Thinking Questions

1. What are the chief formal means employed by the anonymous Sumerian artist in creating the *Royal Standard of Ur*? How does the Akkadian *Stele of Naramsin* compare?

2. What are some of the similarities and differences between the *Law Code of Hammurabi* and the Hebrew Torah?

3. Characterize the general relationship between the Mesopotamian ruler and the gods. How does the *Epic of Gilgamesh* embody this relationship? How does what we know about the Assyrian king Sargon II inform the relationship?

4. What are the characteristics of the epic form?

Civilization in Mesopotamia developed across the last three millennia BCE almost simultaneously with civilization in Egypt, another part of the Fertile Crescent to the south and east. The two civilizations have much in common. Both formed around river systems—the Tigris and Euphrates in Mesopotamia; the Nile in Egypt. Both were agrarian societies that depended on irrigation, and their economies were hostage to the sometimes fickle, sometimes violent flow of their respective river systems. As in Mesopotamia, Egyptians learned to control the river's flow by constructing dams and irrigation canals, and it was probably the need to cooperate with one another in such endeavors that helped Mesopotamia and Egypt to create the civilization that would eventually arise in the Nile Valley.

The Mesopotamians and the Egyptians built massive architectural structures dedicated to their gods—the ziggurat in Mesopotamia (see Fig. 2.1) and the pyramid in Egypt (Fig. 2.20). Though the former appears to be dedicated, at least in part, to water and the latter to the sun, both unite earth and sky in a single architectural form. Indeed, the earliest Egyptian pyramids were stepped structures on the model of the Mesopotamian ziggurat. Both cultures developed forms of writing, although the cuneiform style of Mesopotamian culture and the hieroglyph style of Egyptian society were very different. There is ample evidence that the two civilizations traded with one another, and to a certain degree influenced one another.

What most distinguishes Mesopotamian from Egyptian culture, however, is the relative stability of the latter. Mesopotamia was rarely, if ever, united as a single entity. Whenever it was united, it was through force, the power of an army, not the free will of a people striving for the common good. In contrast, political transition in Egypt was *dynastic*—that is, rule was inherited by members of the same family, sometimes for generations. As in Mesopotamia, however, the ruler's authority was cemented by his association with divine authority. He was, indeed, the manifestation of the gods on Earth. As a result, not unlike the Lagash ruler Gudea (see Fig. 2.11), the dynastic rulers of Egypt sought to immortalize themselves through art and architecture. In fact there is clear reason to believe that the sculptural image of a ruler was believed to be, in some sense, the ruler himself. ■

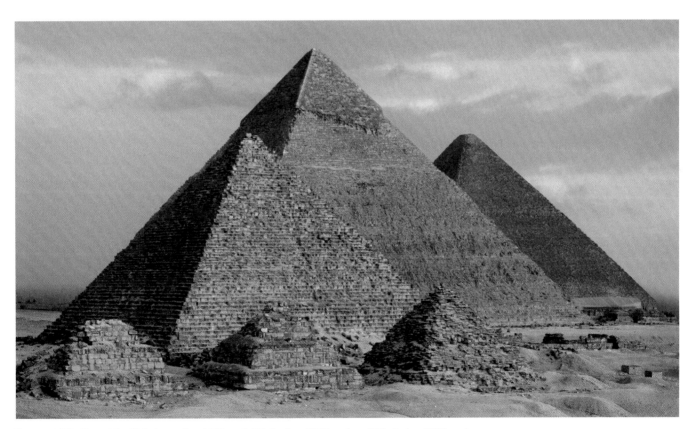

Fig. 2.20 The Pyramids of Menkaure (ca. 2470 BCE), Khafre (ca. 2500 BCE), and Khufu (ca. 2530 BCE), Giza, Egypt. Though different in form, both the ziggurat and the pyramid emphasize the importance of monumentality to their respective cultures.

3 The Stability of Ancient Egypt

Flood and Sun

I have given bread unto the hungry and water unto those who thirst, clothing unto the naked, and a boat unto the shipwrecked mariner. I have made holy offerings unto the gods; and I have given meals of the tomb to the sainted dead. O, then, deliver ye me, and protect me . . .

The Book of the Dead

◄ **Fig. 3.1 The Great Pyramids, Giza. Dynasty 4, 2573–2454 BCE.** Granite and limestone, height of pyramid of Khufu 450′. The pyramids at Giza are the only surviving works of what were known, in ancient times, as the "Seven Wonders of the World." From left to right, they are the tombs of kings Menkaure, Khafre, and Khufu, who erected them during their lifetimes. In front of the pyramids are the fertile farmlands created by the cyclical flooding of the Nile River, which together with the sun is the basis of Egyptian culture, a culture that remained stable for nearly 3,000 years.

73

"WELL, CAN YOU SEE ANYTHING?" "YES, WONDERFUL

things!" The English archeologist, Howard Carter was peering into a chamber of a tomb that had been sealed for over three thousand years. On November 26, 1922, he had pried loose a stone from the wall and inserted a candle through the hole.

"At first I could see nothing," he later wrote, ". . . , but presently, as my eyes grew accustomed to the light, details of the room within emerged slowly from the mist, strange animals, statues, and gold—everywhere the glint of gold. For the moment I was struck dumb with amazement, and when Lord Carnarvon [Carter's financial supporter] . . . inquired . . . 'Can you see anything?' It was all I could do to get out the words 'Yes, wonderful things.'"

Carter's discovery revealed the wealth that defined the Egyptian kingship, as well as the elaborate rituals surrounding the burial of the king himself, both deeply connected to the Nile River, the lifeblood and heart of Egyptian culture. Like the Tigris and Euphrates in Mesopotamia, the Nile could be said to have made Egypt possible. The river begins in Africa, one tributary in the mountains of Ethiopia and another at Lake Victoria in Uganda, from which flows north for nearly 2,000 miles. Egyptian civilization developed along the last 750 miles of the river's banks, extending from the granite cliffs at Aswan, north to the Mediterranean Sea (see Map **3.1**).

Nearly every year, torrential rains caused the river to rise dramatically. Most years, from July to November, the Egyptians could count on the Nile flooding their land. When the river receded, deep deposits of fertile silt covered the valley floor. Crops would then be planted, fields tilled, plants tended. If no flood occurred for a period of years, famine could result. The cycle of flood and sun made Egypt one of the most productive cultures in the ancient world and one of the most stable. For 3,000 years, from 3100 BCE until the defeat of Mark Antony and Cleopatra by the Roman general Octavian in 31 BCE, Egypt's institutions and culture remained remarkably unchanged. Its stability contrasted sharply with the conflicts and shifts in power that occurred in Mesopotamia. The constancy and achievements of Egypt's culture are the subject of this chapter.

The Nile and Its Culture

As a result of the Nile's annual floods, Egypt called itself *Kemet*, meaning "Black Land." In Upper Egypt, from Aswan to the Delta, the black, fertile deposits of the river covered an extremely narrow strip of land. Surrounding the river's alluvial plain were the "Red Lands," the desert environment that could not support life, but where rich deposits of minerals and stone could be mined and quarried. Lower Egypt, consisting of the Delta itself, began

some 13 miles north of Giza [GHEE-zuh], the site of the Great Pyramids, across the river from what is now modern Cairo (Fig. **3.1**).

In this land of plenty, great farms flourished, and wildlife abounded in the marshes. In fact, the Egyptians linked the marsh to the creation of the world and represented it that way in the famous hunting scene that decorates the tomb of Nebamun [NEB-ah-mun] at Thebes [theebz] (Fig. **3.2**). Nebamun is about to hurl a snake-shaped throwing stick into a flock of birds as his wife and daughter look on. The painting is a sort of visual pun, referring directly to sexual procreation. The verb "to launch a throwing stick" also means "to ejaculate," and the word "throwing stick" itself, to "create." The hieroglyphs written between Nebamun and his wife translate as "enjoying oneself, viewing the beautiful, . . . at the place of constant renewal of life."

Scholars divide Egyptian history into three main periods of achievement. Almost all of the conventions of Egyptian art were established during the first period, the *Old Kingdom*. During the *Middle Kingdom*, the "classical" literary language that would survive through the remainder of Egyptian history was first produced. The *New Kingdom* was a period of prosperity that saw a renewed interest in art and architecture. During each of these periods, successive dynasties—or royal houses—brought peace and stability to the country. Between them were "Intermediate Periods" of relative instability (see *Context*, page 80).

Egypt's continuous cultural tradition—lasting over three thousand years—is history's clearest example of how peace and prosperity go hand in hand with cultural stability. As opposed to the warring cultures of Mesopotamia, where city-state vied with city-state and empire with successive empire, Egyptian culture was predicated on unity. It was a **theocracy**, a state ruled by a god or by the god's representative—in this case a king (and very occasionally a queen), who ruled as the living representative of the sun god, Re [reh]. Egypt's government was indistinguishable from its religion, and its religion manifested itself in nature, in the flow of the Nile, the heat of the sun, and in the journey of the sun through the day and night and through the seasons. In the last judgment of the soul after death, Egyptians believed that the heart was weighed to determine whether it was "found true by trial of the Great Balance." Balance in all things—in nature, in social life, in art, and in rule—this was the constant aim of the individual, the state, and, Egyptians believed, the gods.

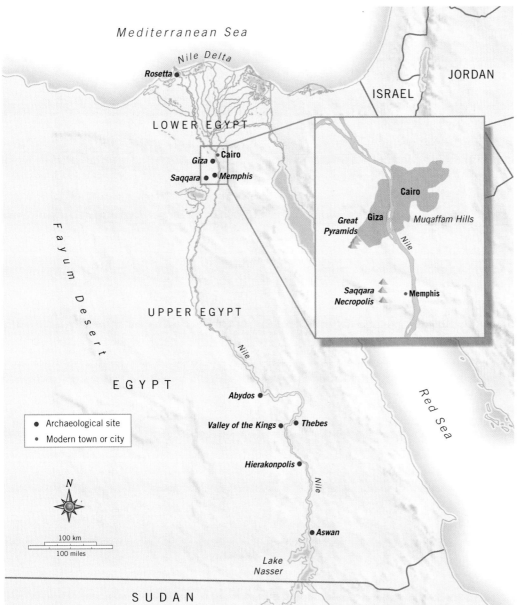

Map 3.1 Nile River Basin with Predynastic and Old Kingdom sites in relation to modern Cairo. The broad expanse of the Lower Nile Delta was crisscrossed by canals, allowing for easy transport of produce and supplies.

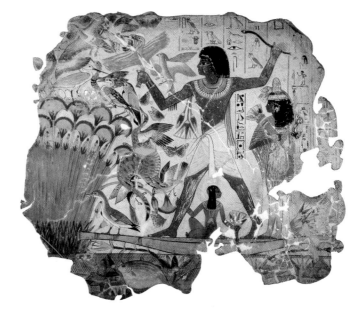

Fig. 3.2 *Nebamun Hunting Birds,* from the tomb of Nebamun, Thebes. Dynasty 18, ca. 1400 BCE. Fresco on dry plaster, approx. 2′ 8″ high. The British Museum, London. The fish and the birds, and the cat, are completely realistic, but this is not a realistic scene. It is a conventional representation of the deceased, in this case Nebamun, spearing fish or hunting fowl, almost obligatory for the decoration of a tomb. The pigments were applied directly to a dry wall, a technique that has come to be known as *fresco secco* [FRES-coh SEK-koh], dry fresco. Such paintings are extremely fragile and susceptible to moisture damage, but Egypt's arid climate has preserved them.

Whereas in Mesopotamia the flood was largely a destructive force (recall the flood in the *Epic of Gilgamesh*), in Egypt it had a more complex meaning. It could, indeed, be destructive, sometimes rising so high that great devastation resulted. But without it, the Egyptians knew, their culture could not endure. So, in Egyptian art and culture, a more complex way of thinking about nature, and about life itself, developed. Every aspect of Egyptian life is countered by an opposite and equal force, which contradicts and negates it, and every act of negation gives rise to its opposite again. As a result, events are cyclical, as abundance is born of devastation and devastation closely follows abundance. Likewise, just as the floods brought the Nile Valley back to life each year, the Egyptians believed that rebirth necessarily followed death. So their religion, which played a large part in their lives, reflected the cycle of the river itself.

Egyptian Religion: Cyclical Harmony

The religion of ancient Egypt, like that of Mesopotamia, was *polytheistic*, consisting of many gods and goddesses who were associated with natural forces and realms. When represented, gods and goddesses have human bodies and human or animal heads, and wear crowns or other headgear that identifies them by their attributes. The religion reflected an ordered universe in which the stars and planets, the various gods, and basic human activities were thought to be part of a grand and harmonious design. A person who did not disrupt this harmony did not fear death because his or her spirit would live on forever.

At the heart of this religion were creation stories that explained how the gods and the world came into being. Chief among the Egyptian gods was *Re*, god of the sun. According to these stories, at the beginning of time, the Nile created a great mound of silt, out of which Re was born. It was understood that Re had a close personal relationship with the king, who was considered the son of Re. But the king could also identify closely with other gods. The king was simultaneously believed to be the personification of the sky god, *Horus* [HOR-us], and deities associated with places like Thebes or Memphis were identified with the king when his power resided in those cities. Though not a full-fledged god, the king was *netjer nefer* [net-jer nef-er], literally, a "junior god." That made him the representative of the people to the gods, whom he contacted through statues of divine beings placed in all temples. Through these statues, Egyptians believed, the gods manifested themselves on earth. Not only did the orderly functioning of social and political events depend upon the king's successful communication with the gods, but so did events of nature—the ebb and flow of the river chief among them.

We see some indication of Re's power and place in Egyptian society in *Akhenaten's Hymn to the Sun*, which dates from the fourteenth century BCE (**Reading 3.1**). *Aten* [AH-ten] is the sun disk, a special manifestation of Re, that for a brief period was the sole official Egyptian god. At the end of each day, the sun god, having traveled across the sky, journeys into the darkness of the netherworld, leaving the world an unsure and unsafe place to be:

READING 3.1 **from *Akhenaten's Hymn to the Sun* (14th century BCE)**

Let your holy Light shine from the height of heaven,
 O living Aton, source of all life!
From eastern horizon risen and streaming,
 you have flooded the world with your beauty.
You are majestic, awesome, bedazzling, exalted,
 overlord over all earth,
 yet your rays, they touch lightly, compass the lands
 to the limits of all your creation.
There in the Sun, you reach to the farthest of those
 you would gather in for your Son,
 whom you love;
Though you are far, your light is wide upon earth;
 and you shine in the faces of all
 who turn to follow your journeying.
When you sink to rest below western horizon
 earth lies in darkness like death,
Sleepers are still in bedchambers, heads veiled,
 eye cannot spy a companion;
All their goods could be stolen away,
 heads heavy there, and they never knowing!
Lions come out from the deeps of their caves,
 snakes bite and sting;
Darkness muffles, and earth is silent:
 he who created all things lies low in his tomb.
Earth-dawning mounts the horizon,
 glows in the sun-disk as day:
You drive away darkness, offer your arrows of shining,
 and the Two Lands are lively with morningsong.
Sun's children awaken and stand,
 for you, golden light, have upraised the sleepers;
Bathed are their bodies, who dress in clean linen,
 their arms held high to praise your Return.
Across the face of the earth
 they go to their crafts and professions.
The herds are at peace in their pastures,
 trees and the vegetation grow green;
Birds start from their nests,
 wings wide spread to worship your Person;
Small beasts frisk and gambol, and all
 who mount into flight or settle to rest
 live, once you have shone upon them;
Ships float downstream or sail for the south,
 each path lies open because of your rising;
Fish in the River leap in your sight,
 and your rays strike deep in the Great Green Sea.
It is you create the new creature in Woman,
 shape the life-giving drops into Man,
Foster the son in the womb of his mother,
 soothe him, ending his tears;
Nurse through the long generations of women

to those given Air,
you ensure that your handiwork prosper.
When the new one descends from the womb
to draw breath the day of his birth,
You open his mouth, you shape his nature,
and you supply all his necessities.
vi Hark to the chick in the egg,
he who speaks in the shell!
You give him air within
to save and prosper him;
And you have allotted to him his set time
before the shell shall be broken;
Then out from the egg he comes,
from the egg to peep at his natal hour!
And up on his own two feet goes he
when at last he struts forth therefrom.

Re is clearly the life force and source of all good, identified even with the *bolti*, a species of Nile River fish that carries its eggs in its mouth, spitting out its newborn when they hatch.

Like the king, all the other Egyptian gods descend from Re, as if part of a family. As we have said, many can be traced back to local deities of predynastic times who later assumed greater significance as a given place—Thebes, for instance, gained significance. Osiris [oh-SY-ris], ruler of the underworld and god of the dead, was at first a local deity in the eastern Delta. According to myth, he was murdered by his wicked brother Seth, god of storms and violence, who chopped his brother into pieces and threw them into the Nile. But Osiris's wife and sister, Isis [EYE-zis], the goddess of fertility, collected all these parts, put the god back together, and restored him to life. Osiris was therefore identified with the Nile itself, with its annual flood and renewal. The child of Osiris and Isis was Horus, who defeated Seth and became the mythical first king of Egypt. The actual king was not only considered the earthly manifestation of Horus (as well as the son of Re) but also closely identified with Osiris, in whose kingdom he continued his existence after death.

The cyclical movement through opposing forces, embodied in both the *Akhenaten's Hymn to the Sun* and the story of Osiris and Isis, is one of the earliest instances of a system of religious and philosophic thought that survives even in contemporary thought. Life and death, flood and sun, even desert and oasis, were part of a larger harmony of nature, one that was predictable in both the diurnal cycle of day and night but also in its seasonal patterns of repetition. A good deity like Osiris was necessarily balanced by a bad deity like Seth. The fertile Nile Valley was balanced by the harsh desert surrounding it. The narrow reaches of the upper Nile were balanced by the broad marshes of the Delta. Even, at least from the Egyptian point of view, the orderly functioning of the Egyptian state was countered and balanced by the chaotic, warring factionalism of Mesopotamia. All things were predicated upon the return of their opposite, which negates them, but which in the process completes the whole and regenerates the cycle of being and becoming once again.

Pictorial Formulas in Egyptian Art

This sense of duality, of opposites, informs even the earliest Egyptian artifacts, such as the *Palette of Narmer*, found at Hierakonpolis [hy-ruh-KAHN-puh-liss], in Upper Egypt. A palette is technically an everyday object used for grinding pigments and making body or eye paint. The round circle formed by the two elongated lions' heads intertwined on the *recto*, or front, of the palette is a bowl for mixing pigments. The palette celebrates the defeat by Narmer (ruled ca. 3000 BCE) of his enemies and his unification of both Upper and Lower Egypt, which before this time had been at odds. So on the recto side, Narmer wears the red cobra crown of Lower Egypt, and on the *verso*, or back, he wears the white crown of Upper Egypt—representing his ability (and duty) to harmonize antagonistic elements.

Narmer's palette was not meant for actual use. Rather, it is a **votive**, or ritual object, a gift to a god or goddess that was placed in a temple to ensure that the king, or perhaps some temple official, would have access to a palette throughout eternity. It may or may not register actual historical events, although, in fact, Egypt marks its beginnings with the unification of its Upper and Lower territories. Subsequent kings, at any rate, presented themselves in almost identical terms, as triumphing over their enemies, mace in hand, even though they had no role in a similar military campaign. It is even possible that by the time of Narmer such conventions were already in place, although our system of numbering Egyptian dynasties begins with him. Whether or not the scene depicted is real, the **pictorial formulas**, or conventions of representation, that Egyptian culture used for the rest of its history are fully developed in this piece.

Continuity & Change
p. 44

Standard of Ur

The scenes on the *Palette of Narmer* are in low relief. Like the *Royal Standard of Ur* (see Fig. 2.8), they are arranged in registers that provide a ground-line upon which the figures stand (the two lion-tamers are an exception). The figures typically face to the right, though often, as is the case here, the design is **symmetrical**, balanced left and right. The artist represents the various parts of the human figure in what the Egyptians thought was their most characteristic view. So, the face, arms, legs, and feet are in profile, with the left foot advanced in front of the right. The eye and shoulders are in front view. The mouth, navel and hips, and knees are in three-quarter view. As a result the viewer sees each person in a **composite view**, the integration of multiple perspectives into a single unified image.

In Egyptian art, not only the figures but the scenes themselves unite two contradictory points of view into a single image. In the *Palette of Narmer*, the king approaches his dead enemies from the side, but they lie beheaded on the ground before him as seen from above. Egyptian art often represents architecture in the same terms. At the top middle of the *Palette of Narmer*, the external facade of the palace is

Focus

Reading the *Palette of Narmer*

The Egyptians created a style of writing very different from that of their northern neighbors in Mesopotamia. It consists of **hieroglyphs**, "writing of the gods," from the Greek *hieros*, meaning "holy," and *gluphein*, "to engrave." Although the number of signs increased over the centuries from about 700 to nearly 5,000, the system of symbolic communication underwent almost no major changes from its advent in the third millennium BCE until 395 CE, when Egypt was conquered by the Byzantine Empire. It consists of three kinds of signs: **pictograms**, or stylized drawings that represent objects or beings, which can be combined to express ideas; **phonograms**, which are pictograms used to represent sounds; and **determinatives**, signs used to indicate which category of objects or beings is in question. The *Palette of Narmer* is an early example of the then developing hieroglyphic style. It consists largely of pictograms, though in the top center of each side, Narmer's name is represented as a phonogram.

Hathor, the sky mother, a goddess embodying all female qualities, flanks the top of each side of the palette. Here she appears wearing cow's horns; often, though not here, a sun disk rests between her horns. Such headdresses represent the divine attributes of the figure.

The **mace** was the chief weapon used by the king to strike down enemies, and the scene here is emblematic of his power.

As on the other side of the palette, the king is here accompanied by his sandal-bearer, who stands on his own ground-line. He carries the king's sandals to indicate that the king, who is barefoot, stands on **sacred ground**, and that his acts are themselves sacred.

Narmer, wearing the white crown of Upper Egypt, strikes down his enemy, probably the embodiment of **Lower Egypt** itself, especially since he is, in size, comparable to Narmer himself, suggesting he is likewise a leader.

Two more figures represent the defeated enemy. Behind the one on the left is a small aerial view of a **fortified city;** behind the one on the right, a **gazelle trap**. Perhaps together they represent Narmer's victory over both city and countryside.

The hawk is a symbolic representation of the god **Horus**. The king was regarded as the earthly embodiment of Horus. Here, Horus has a human hand with which he holds a rope tied to a symbolic representation of a conquered land and people.

A human head grows from the same ground as six **papyrus** blossoms, symbol of Lower Egypt. Each blossom represents 1,000 prisoners held captive by the Horus/king.

This hieroglyph identifies the man that Narmer is about to kill, a name otherwise unknown.

Palette of Narmer, **verso side, from Hierakonpolis. Dynasty 1, ca. 3000** BCE. Schist, height 25 $\frac{1}{4}$". Egyptian Museum, Cairo.

These are two instances of the hieroglyphic sign for **Narmer**, consisting of a catfish above a chisel. Each individual hieroglyph is a pictogram but is utilized here for its phonetic sound. The word for "catfish" is **nar**, and the word for "chisel" is **mer**—hence "Narmer." In the lower instance, the hieroglyph identifies the king. In the instance at the top, the king's name is inside a depiction of his palace seen simultaneously from above, as a ground plan, and from the front, as a facade. This device, called a **serekh**, is traditionally used to hold the king's name.

We are able to identify **Narmer** not only from his hieroglyphic name, next to him, but by his relative size. As befits the king, he is larger than anyone else.

The hieroglyph next to this figure identifies him as the king's **vizier**, the highest official of royal administration.

The defeated **dead** lie in two rows, their decapitated heads between their feet. Narmer in sacred procession reviews them, while above them, a tiny Horus (the hawk) looks on.

Similarly positioned on the other side of the palette and identified by the accompanying hieroglyph, this is the king's **sandal-bearer**.

This is the **mixing bowl** of the palette. The lions may represent competing forces brought under control by the king. Each is held in check by one of the king's **lion-tamers**, figures that in some sense represent state authority.

The **bull** here strikes down his victim and is another representation of the king's might and power. Note that in the depictions of Narmer striking down his victim and in procession, a bull's tail hangs from his waistband.

This is a representation of a **fortified city** as seen both from above, as a floor plan, and from the front, as a facade. It is meant to represent the actual site of Narmer's victory.

Palette of Narmer, recto side, from Hierakonpolis. Dynasty 1, ca. 3000 BCE. Schist, height 25 1/4″. Egyptian Museum, Cairo.

Context Major Periods of Ancient Egyptian History

The dates of the periods of Egyptian history, as well as the kingships within them, should be regarded as approximate. Each king numbered his own regal years, and insufficient information about the reign of each king results in dates that sometimes vary, especially in the earlier periods, by as much as 100 years. Although there is general consensus on the duration of most individual reigns and dynasties, there is none concerning starting and ending points.

5500–2972 BCE	**Predynastic Period** *No formal dynasties*	Reign of Narmer and unification of Upper and Lower Egypt
2972–2647 BCE	**Early Dynastic Period** *Dynasties 1–2*	First stepped pyramids at Saqqara
2647–2124 BCE	**Old Kingdom** *Dynasties 3–8*	Pyramids at Giza
2123–2040 BCE	**First Intermediate Period** *Dynasties 9–10*	Egypt divided between a northern power center at Hierakenpolis and a southern one at Thebes
2040–1648 BCE	**Middle Kingdom** *Dynasties 11–16*	Reunification of Upper and Lower Egypt
1648–1540 BCE	**Second Intermediate Period** *Dynasty 17*	Military conflict, dominated by Thebes
1540–1069 BCE	**New Kingdom** *Dynasties 18–20*	Reunification of Egypt; an extended period of prosperity and artistic excellence
1069–715 BCE	**Third Intermediate Period** *Dynasties 21–24*	More political volatility
715–332 BCE	**Late Period** *Dynasties 25–31*	Foreign invasions, beginning with the Kushites from the south and ending with Alexander the Great from the north

depicted simultaneously from above, in a kind of ground plan, with its front columns at the bottom. The design contains Narmer's Horus-name, consisting of a catfish and a chisel (see *Focus*, pages 78–79). The hieroglyphic signs for Narmer could not be interpreted until the Rosetta Stone was discovered (see *Context*, page 83). But we now know it shows the two aspects of the king—his mortal self (the serpent or catfish) and his immortal self (his role as the gods' representative on earth), both of which are represented simultaneously. The dual role of the king—responsible to the gods for establishing order in the world and responsible to his people for maintaining the peace through force if necessary—is visually expressed as a composite view. Again we see the Egyptian tendency to regard the world as fundamentally dualistic.

The Old Kingdom

Although the *Palette of Narmer* probably commemorates an event in life, as a votive object it is devoted, like most surviving Egyptian art and architecture, to burial and the afterlife. The Egyptians buried their dead on the west side of the Nile, where the sun sets, a symbolic reference to death and rebirth since the sun always rises again. The pyramid was the first monumental royal tomb. A massive physical manifestation of the reality of the king's death, it was also the symbolic embodiment of his eternal life. It would endure for generations as, Egyptians believed, would the king's *ka* [kah]. This idea is comparable to an enduring "soul" or "life force," a concept found in many other religions. The *ka*, which all persons possessed, was created at the same time as the physical body, itself essential for the person's existence since it provided the *ka* with an individual identity in which its personality, or *ba* [bah], might also manifest itself. This meant that it was necessary to preserve the body after death so that the *ba* and *ka* might still recognize it for eternity. All the necessities of the afterlife, from food to furniture to entertainment, were placed in the pyramid's burial chamber with the king's body.

Funerary temples and grounds surrounded the temple so that priests could continuously replenish these offerings in order to guarantee the king's continued existence after death. Pyramids are the massive architectural product of what is known as the Old Kingdom, which dates from 2647 to 2124 BCE, a period of unprecedented achievement that solidified the accomplishments of the Early Dynastic Period initiated by Narmer.

The Stepped Pyramid at Saqqara

The first great pyramid was the Stepped Pyramid of Djoser [DJOH-zer] (ruled ca. 2628–2609 BCE), who ruled at Saqqara [suh-KAHR-uh], just south of modern Cairo (Figs. **3.3, 3.4**).

It predates the Ziggurat at Ur by nearly 500 years and is therefore the first great monumental architecture in human history to have survived. It consists of a series of stepped platforms rising to a height of 197 feet, but since it sits on an elevated piece of ground, it appears even taller to the approaching visitor.

Above ground level the pyramid of Djoser contains no rooms or cavities. The king's body rested below the first level of the pyramid, in a chamber some 90 feet beneath the original **mastaba** [MAS-tuh-buh]—a trapezoidal tomb structure that derives its name from the Arabic word for "bench." Such mastabas predate Djoser's pyramid but continued to be used for the burial of figures of lesser importance for centuries. The pyramid is situated in a much larger, ritual area than this earlier form of tomb. The total enclosure of this enormous complex originally measured 1,800 by 900 feet—or six football fields by three.

The idea of stacking six increasingly smaller mastabas on top of each other to create a monumental symbol of the everlasting spirit of the king was apparently the brainchild of Imhotep [IM-ho-tep], Djoser's chief architect. He is the first artist or architect whose name survives, and his reputation continued to grow for centuries

after his death. Graffiti written on the side of the pyramid a thousand years after Djoser's death praises Imhotep for a building that seems "as if heaven were within it" and as though "heaven rained myrrh and dripped incense upon it."

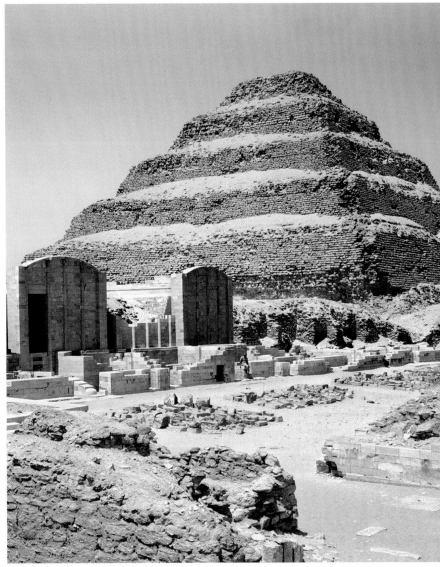

Fig. 3.3 Imhotep. Stepped pyramid and funerary complex of Djoser, Saqqara. Dynasty 3, 2610 BCE. Limestone, height of pyramid 197'. The base of this enormous structure measures 460 feet east to west, and 388 feet north to south. It is the earliest known use of cut stone for architecture. The architect, Imhotep, was Djoser's prime minister. He is the first architect in history known to us by name.

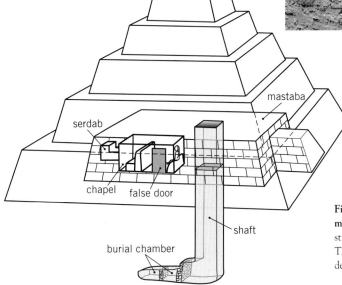

Fig. 3.4 Section and restored view of typical mastaba tombs. The mastaba is a brick or stone structure with a sloping (or "battered") wall. The *serdab* is a chamber for a statue of the deceased.

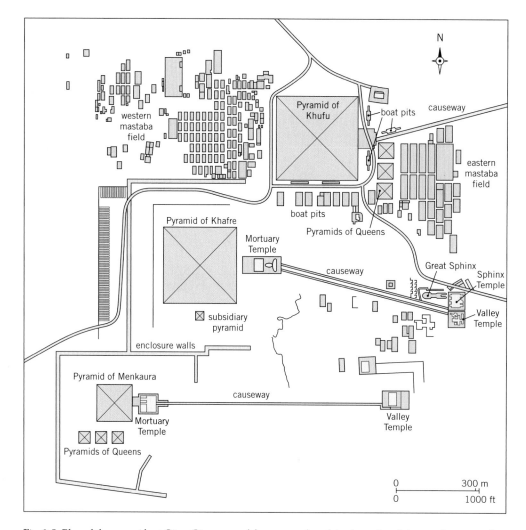

Fig. 3.5 Plan of the pyramids at Giza. Giza was an elaborate complex of ritual temples, shrines, and ceremonial causeways, all leading to one or another of the three giant pyramids. Surrounding the northernmost pyramid of Khufu were mastaba fields, a royal cemetery in which were buried various officials, priests, and nobility of the king's court. When a king died in the royal palaces on the east bank of the Nile, his body was transported across the river to a valley temple on the west bank. After a ritual ceremony, it was carried up the causeway to the temple in front of the pyramid where another ritual was performed—the "opening of the mouth," in which priests "fed" the deceased's *ka* a special meal. The body was then sealed in a relatively small tomb deep in the heart of the pyramid (see Fig. 3.6).

Three Pyramids at Giza

From Djoser's time forward, the tomb of the king was dramatically distinguished from those of other members of the royal family. But within 50 years, the stepped form of Djoser's pyramid was abandoned and replaced with a smooth-sided, starkly geometric monument consisting of four triangular sides slanting upward from a square base to an apex directly over the center of the square. The most magnificent examples of this form are found at Giza (see Fig. 3.1), just north of Djoser's tomb at Saqqara. Three great pyramids stand at Giza: Khufu's (ruled 2549–2526 BCE), Khafre's (ruled 2518–2493 BCE), and Menkaure's (ruled 2488–2460 BCE) (Fig. **3.5**).

Khufu's Pyramid Of the three pyramids at Giza, Khufu's is both the earliest and the grandest one (Fig. **3.6**), measuring 479 feet high on a base measuring 755 feet square, built from an estimated 2.3 million stone blocks, weighing between 2 and 5 tons each. Historians speculate that the stones were rolled up logs placed on inclined ramps made of packed sand. Whatever feats of engineering accomplished the transport of so much stone into such an enormous configuration, what still dazzles us is this pyramid's astronomical and mathematical precision. It is perfectly oriented to the four cardinal points of the compass (as are the other two pyramids, which were positioned later, probably using Khufu's alignment as a reference point). (See *Voices*, page 86.)

Context The Rosetta Stone

Until the nineteenth century, Egyptian hieroglyphs remained untranslated. The key to finally deciphering them was the Rosetta Stone, a discovery made by Napoleon's army in 1799 and named for the town in the Egyptian Delta near where it was found. On the stone was a decree issued in 196 BCE by the priests of Memphis honoring the ruler Ptolemy V, recorded in three separate languages—Greek, demotic Egyptian (an informal and stylized form of writing used by the people—the "*demos*"), which first came into use in the eighth century BCE, and finally hieroglyphs, the high formal communication used exclusively by priests and scribes.

The stone was almost immediately understood to be a key to deciphering hieroglyphs, but its significance wasn't fully realized until years later. The French archeologist Jean-François Champollion began an intensive study of the stone in 1808 and concluded that the pictures and symbols in hieroglyphic writing stood for specific phonetic sounds, or, as he described it, that they constituted a "phonetic alphabet." A key to unlocking the code was a

The Rosetta Stone, 196 BCE. Basalt, $46\frac{1}{2}'' \times 30\frac{1}{8}''$. © The British Museum, London. The top, parts of which have been lost, contains the formal hieroglyphs, the middle demotic Egyptian, and the bottom the Greek text of the decree.

cartouche, an ornamental and symbolic frame reserved for the names of rulers. Champollion noticed that the cartouche surrounded a name, and deciphered the phonetic symbols for P, O, L, and T—four of the letters in the name Ptolemy. In another cartouche, he found the symbols for Cleopatra's name. By 1822, he had deciphered two Egyptian texts, and gradually through the remainder of the nineteenth century, Egyptologists came to decipher the language as a whole.

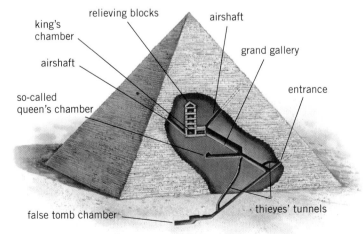

Fig. 3.6 **Cutaway elevation of the pyramid of Khufu (see Fig. 3.1).**

The two airshafts that run from the two top chambers seem oriented to specific stars, including Sirius, the brightest star in the night sky. The relationship between the various sides of the structure suggests that the Egyptians understood and made use of the mathematical value π (pi). All of this has led to considerable theorizing about "the secret of the pyramids." Most convincing is the theory that the pyramid's sides represented the descending rays of the sun god Re, whose cult was particularly powerful at the time the pyramids were built. Because they were covered in a polished limestone sheath (the only remnant survives atop Khafre's pyramid), the sun must have glistened off them. And one convincing text survives: "I have trodden these rays as ramps under my feet where I mount up to my mother Uraeus on the brow of Re."

The Great Sphinx In front of the pyramid dedicated to Khufu's son Khafre, and near the head of the causeway leading from the valley temple to the mortuary temple (see Fig. 3.5), is the Great Sphinx [sfinks], a giant sculpture carved out of an existing limestone knoll (Fig. **3.7**). A lion's body supports the head of a king wearing the royal headcloth. It probably represents Khafre protecting the approach to his own funerary complex. Its monumentality alone indicates the growing importance of sculpture to the Egyptian funerary tradition.

Monumental Royal Sculpture: Perfection and Eternity

The word for sculpture in Egyptian is the same as for giving birth. Indeed, funerary sculpture served the same purpose as the pyramids themselves—to preserve and guarantee the king's existence after death, thereby providing a kind of rebirth. The stone materials used for funerary images had to be the hardest, most durable kind, as enduring as the *ka* itself. Sandstone or limestone would not do. The materials of choice were diorite, schist, and granite, stones that can also take on a high polish and, because they are not prone to fracture, they can be finely detailed when carved. These stones were carved into three main types of male statue: (1) a seated figure, looking directly ahead, his feet side by side, one hand resting flat on the knee, the other clenched in a fist; (2) a standing figure, his gaze fixed into the distance, left foot forward, both hands alongside the body with fists clenched; and (3) a figure seated on the ground with legs crossed. The first two types were used for important officials as well as kings. The third was used for a royal scribe. Also popular were statue pairs of husband and wife, either seated or standing.

The statue of Khafre from his valley temple at Giza (see Fig. 3.5) is an example of the first type (Fig. **3.8**). The king sits rigidly upright and frontal, wearing a simple kilt and the same royal headdress as the Great Sphinx outside the valley temple. His throne is formed of the bodies of two stylized lions. Behind him, as if caressing his head, is a hawk, a manifestation of the god Horus, extending its wings in a protective gesture. In Egyptian society, the strong care for and protect the weak, so too Horus watches over Khafre as Khafre watches over his people. Because Khafre is a king and a divinity, he is shown with a perfectly smooth, proportioned face and a flawless, well-muscled body. This idealized anatomy was used in Egyptian sculpture regardless of the actual age and body of the king portrayed, its perfection mirroring the perfection of the gods themselves. Most Egyptian statues were *monolithic*, or carved out of a single piece of stone, even those depicting more than a single figure.

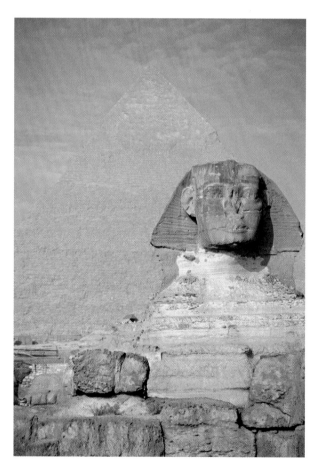

Fig. 3.7 The Great Sphinx (with the pyramid of Khafre in the background), Giza. Dynasty 4, ca. 2500 BCE. Limestone, height approx. 65′. The Great Sphinx is the largest sculpture ever made in the ancient world.

The same effect is apparent in the statue of Menkaure with a queen that was also found at his valley temple at Giza (Fig. **3.9**). Here, the deep space created by carving away the side of the stone to fully expose the king's right side seems to free him from the stone. He stands with one foot ahead of the other in the second traditional pose, the conventional depiction of a standing figure. He is not walking. Both feet are planted firmly on the ground (and so his left leg is, of necessity, slightly longer than his right). His back is firmly implanted in the stone panel behind him, but he seems to

have emerged farther from it than his wife who accompanies him, as if to underscore his power and might. Although the queen is almost the same size as her husband, her stride is markedly shorter than his. She embraces him, her arm reaching round his back, in a gesture that reminds us of Horus's protective embrace of Khafre, but suggests also the simple marital affection of husband and wife. The ultimate effect of both of these sculptures—their solidity and unity, their sense of resolute purpose—testifies finally to their purpose, which is to endure for eternity.

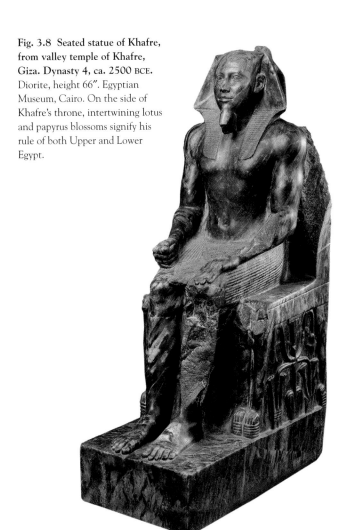

Fig. 3.8 **Seated statue of Khafre, from valley temple of Khafre, Giza. Dynasty 4, ca. 2500 BCE.** Diorite, height 66″. Egyptian Museum, Cairo. On the side of Khafre's throne, intertwining lotus and papyrus blossoms signify his rule of both Upper and Lower Egypt.

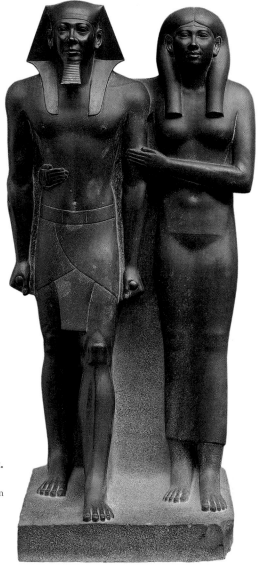

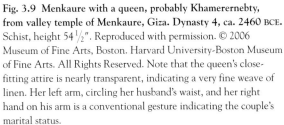

Fig. 3.9 **Menkaure with a queen, probably Khamerernebty, from valley temple of Menkaure, Giza. Dynasty 4, ca. 2460 BCE.** Schist, height 54$\frac{1}{2}$″. Reproduced with permission. © 2006 Museum of Fine Arts, Boston. Harvard University-Boston Museum of Fine Arts. All Rights Reserved. Note that the queen's close-fitting attire is nearly transparent, indicating a very fine weave of linen. Her left arm, circling her husband's waist, and her right hand on his arm is a conventional gesture indicating the couple's marital status.

VOICES

Pyramid Builders Go on Strike

This papyrus describes strikes at Deir el Medina at Thebes. The village housed the workers responsible for building royal tombs.

Year 29, second month of winter, day 10. On this day the crew passed the five guard-posts of the tomb saying: "We are hungry, for 18 days have already elapsed in this month"; and they sat down at the rear of the temple of Menkheperre. The scribe of the enclosed tomb, the two foremen, the two deputies and the two proctors came and shouted to them: "Come inside." They swore great oaths (saying): "Please come back, we have matters of Pharaoh." They spent the night in the Tomb.

Year 29, second month of winter, day 12.

They reached the temple of Wesermaatre-setepenre. They spent the night quarrelling in its entrance. They entered into its interior, and the scribe Pentaweret, the two chiefs of police, the two gatekeepers, the gatekeepers

> "We are hungry, for 18 days have already elapsed in this month'; and they sat down at the rear of the temple of Menkheperre."

of the Gatehouse of the Tomb . . . [The chief of police] Mentmose (declared that he would go) to Thebes saying: "I will fetch the mayor of Thebes. He . . ." I (Mentmose) said to him: "Those of the Tomb are (in) the temple of Wesermaatre-setepenre." . . . The two chiefs of police . . . the accounts scribe Hednakht, the god-fathers of this administration (came out) to hear their statement. They said to them: "The prospect of hunger and thirst has driven us to this; there is no clothing, there is no fish, there are no vegetables. Send to Pharaoh, our good lord, about it, and send to the vizier, our superior, that we may be supplied with provisions." The ration of the first month of winter was issued to them on this day.

The Sculpture of the Everyday

Idealized athletic physiques, austere dignity, and grand scale were for royalty only. Lesser figures were depicted more naturally, with flabby physiques or rounded shoulders, and on a more human scale. The third traditional type of male figure in Egyptian sculpture was the royal scribe, and in Figure 3.10, we can see that a soft, flabby body replaces the hardened chest of a king. The scribe's pose, seated cross-legged on the floor, diminishes him. The stone was carved out around his arms and head so that, instead of the monumental space of the kings' sculpture, which derives from its compactness and its attachment to the slab of stone behind it, the scribe seems to occupy real space. The scribe's task was important: His statue would serve the king through eternity as he had served the king in life.

Fig. 3.10 **Seated Scribe, from his mastaba, Saqqara. Dynasty 5, ca. 2400 BCE.** Painted limestone, height 21". Musée du Louvre, Paris, France. Scribes were the most educated of Egyptians—not only able to read and write but accomplished in arithmetic, algebra, religion, and law. Their *ka* statues necessarily accompanied those of their kings into the afterlife.

Statues of lesser persons were often made of less permanent materials, such as wood. Carved from separate pieces, with the arms attached to the body at the shoulders, such statues as that of the priest Ka-aper, found in his own tomb at Saqqara, could assume a more natural pose (Fig. **3.11**). The eyes, made of rock crystal, seem vital and lively. Originally, the statue was covered with plaster and painted (men were usually red-brown, like the seated scribe, and women yellow). Small statues of servants, especially those who made food, were also put in the tombs, so that the king might enjoy their services into eternity.

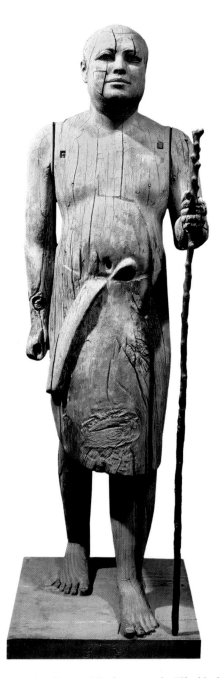

Fig. 3.11 Lector priest Ka-aper (also known as the "Sheikh el-Beled), from mastaba of Ka-aper, Saqqara. Dynasty 5, ca. 2450 BCE. Plaster and painted wood, height 3'7". This paunchy priest lacks the idealized physique reserved for more eminent nobility.

The Middle Kingdom at Thebes

The Old Kingdom collapsed for a variety of reasons—drought, a weakened kingship, greater autonomy of local administrators—all of which led to an Egypt divided between competing power centers in the north and south. After over 150 years of tension, Nebhepetre Mentuhotep II (2040–1999 BCE) assumed the rule of the southern capital at Thebes, defeated the northern kings, and reunited the country. The Middle Kingdom begins with his reign.

Thebes, on the west bank of the Nile, was the primary capital of the Middle Kingdom and included within its outer limits Karnak, Luxor, and other sites on the east bank (see Map **3.2**). Although certain traditions remained in place from the Old Kingdom, change was beginning to occur.

Middle Kingdom Literature

One of the greatest changes took place in literature. Earlier, most writing and literature served a sacred purpose. But, during the Middle Kingdom, writers produced stories, instructive literature, satires, poems, biography, history, and scientific writings. Much of the surviving writing is highly imaginative, including tales of encounters with the supernatural. Among the most interesting texts is *The Teachings of Dua-Khety* [DO-uh KEH-tee], a satiric example of instructive literature in which a scribe tries to convince his son to follow him into the profession. He begins by extolling the virtues of the scribe's life: "I shall make you love books more than your mother, and I shall place their excellence before you. It is greater than any office. There is nothing like it on earth." But he goes on to defend his own work by detailing all that is wrong with every other profession available to him:

> I have seen a coppersmith at his work at the door of his furnace. His fingers were like the claws of the crocodile, and he stank more than fish excrement. . . .
>
> I shall also describe to you the bricklayer. His kidneys are painful. When he must be outside in the wind, he lays bricks without a garment. His belt is a cord for his back, a string for his buttocks. His strength has vanished through fatigue and stiffness. . . .
>
> The sandal maker is utterly wretched carrying his tubs of oil. His stores are provided with carcasses, and what he bites is hides.

The work provides us with a broad survey of daily life in the Middle Kingdom. It ends in a series of admonitions about how a young scribe must behave—advice that parents have been giving children for millennia (see **Reading 3.2**, page 102 for more of the text).

Middle Kingdom Sculpture

Although a new brand of literature began to appear in the Middle Kingdom, sculpture remained firmly rooted in tradition. The only innovation in the traditional seated king funerary statue of Nebhepetre Mentuhotep II is that the pose has been slightly modified (Fig. **3.12**). Most noticeably, the

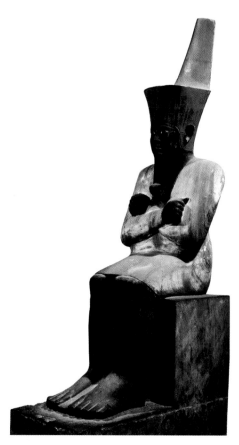

Fig. 3.12 Nebhepetre Mentuhotep II, from his funerary temple at Deir el-Bahri, Western Thebes. Dynasty 11, ca. 2000 BCE. Painted sandstone, height 72″. Egyptian Museum, Cairo. The king's dark color here may refer to the "black lands" of the Nile Valley, another symbol of the cycle of death and resurrection that is embodied in the Osiris myth.

king crosses his arms tightly across his chest. The pose is reminiscent of a **mummy**, an embalmed body wrapped for burial (see *Materials and Techniques*, page 91). The king's mummy-like pose probably refers to the growing cult of the god Osiris, discussed on page 77. By the time of the Middle Kingdom, a deceased king had come to be identified with him, rather than with the god Re. Usually depicted wrapped in white linen, as Nebhepetre Mentuhotep II is here, Osiris was god of the underworld, overseeing the judgment of souls.

In relief carvings found in the temples of the Middle Kingdom, the traditional pose of the figure, which dates back to Narmer's time, still survives. The figures in a Twelfth Dynasty relief from the White Chapel at Karnak are depicted with left foot forward, feet and face in profile, and the shoulders and hips frontal (Fig. **3.13**). But we have learned that figures were now conceived according to a *grid*. Much like a piece of graph paper, a grid is a system of regularly spaced horizontally and vertically crossed lines. Used in the initial design process, it enables the artist to transfer a design or enlarge it easily (Fig. **3.14**). In the Egyptian system, the height of the figure from the top of the forehead (where it disappears beneath the headdress) to the soles of the feet is

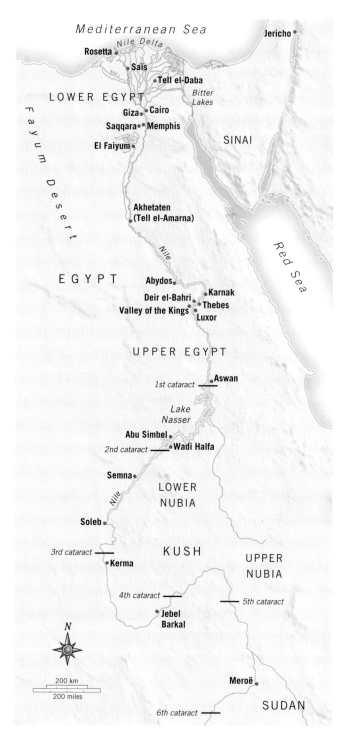

Map 3.2 Nile River Basin from the Middle Kingdom through the Late Period. During the Middle Kingdom, the seat of power moved from Lower to Upper Egypt. It returned to Lower Egypt in the Late Period.

18 squares. The top of the knee is 6 squares high, the waist, 11. The elbows are at the twelfth square, the armpits at the fourteenth, and the shoulders at the sixteenth. Each square also relates to the human body as a measure, representing the equivalent of one clenched fist.

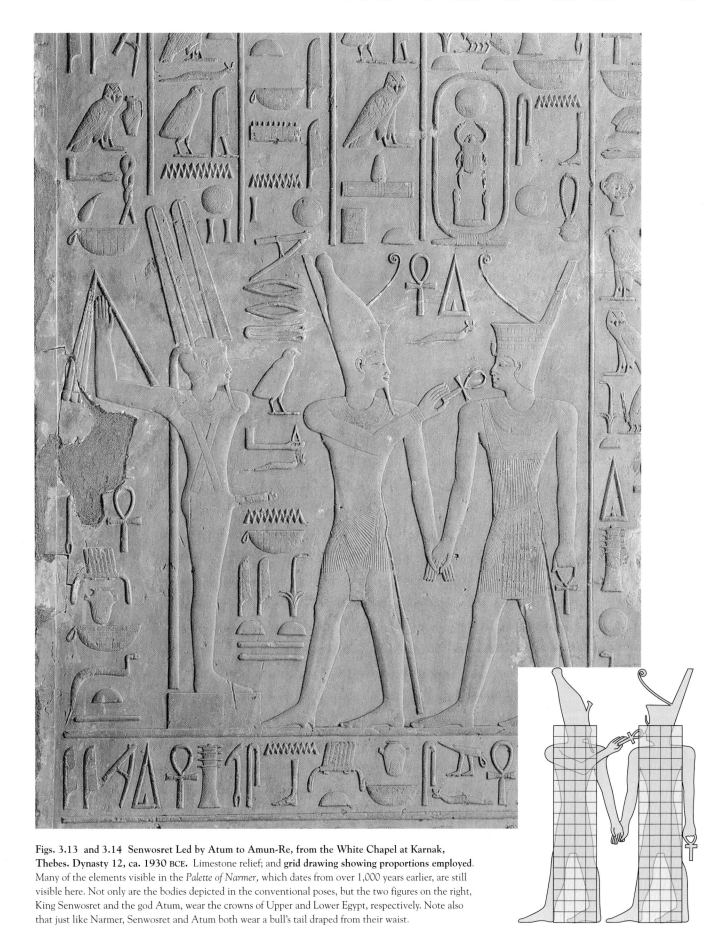

Figs. 3.13 and 3.14 Senwosret Led by Atum to Amun-Re, from the White Chapel at Karnak, Thebes. Dynasty 12, ca. 1930 BCE. Limestone relief; and **grid drawing showing proportions employed.** Many of the elements visible in the *Palette of Narmer,* which dates from over 1,000 years earlier, are still visible here. Not only are the bodies depicted in the conventional poses, but the two figures on the right, King Senwosret and the god Atum, wear the crowns of Upper and Lower Egypt, respectively. Note also that just like Narmer, Senwosret and Atum both wear a bull's tail draped from their waist.

This particular relief depicts the rise of yet another god in the Middle Kingdom—Amun, or, to associate him more closely with the sun, Amun-Re. Originally the chief god of Thebes, as the city became more prominent, Amun became the chief deity of all of Egypt. His name would appear (sometimes as "Amen") in many subsequent royal names—such as Amenhotep [ah-MEN-ho-tep] ("Amun is Satisfied") or, most famously, Tutankamun [toot-ahn-KAH-mun] ("The Living Image of Amun"). In the relief from the White Chapel, Atum, the god of the northern districts that Nebhepetre Mentuhotep II had defeated two generations earlier, leads King Senwosret [SEN-wohz-ret] I (1960–1916 BCE) to Amun, who stands at the left on a pedestal with an erect penis, sig-nifying eternal life. Atum turns to Senwosret and holds the hieroglyph ***ankh*** [ahnk], signifying life, to his nose. The king is depicted as having received the gift, since he holds it in his left hand.

The continuity and stability implied by this relief ended abruptly in 1648 BCE, when a Hyksos [HIK-sohs] king declared himself king of Egypt. The Hyksos were foreigners who had apparently lived in Egypt for some time. They made local alliances, introduced the horse-drawn chariot (which may well have helped them achieve their military domi-nance), and led Egypt into another "intermediate" period of disunity and disarray. Dissatisfaction with Hyksos rule origi-nated, once again, in Thebes, and finally, in 1540 BCE, the Theban king Ahmose [AH-moh-seh] defeated the last Hyk-sos ruler and inaugurated the New Kingdom.

The New Kingdom

The worship of Amun that developed in the Twelfth Dynasty continued though the Middle Kingdom and into the Eigh-teenth Dynasty of the New Kingdom, 500 years later. In fact, there is clear evidence that the rulers of the Eighteenth Dynasty sought to align themselves closely with the aims and aspirations of the Middle Kingdom. The funerary temple of Hatshepsut [hat-SHEP-sut] in western Thebes is an interest-ing case in point.

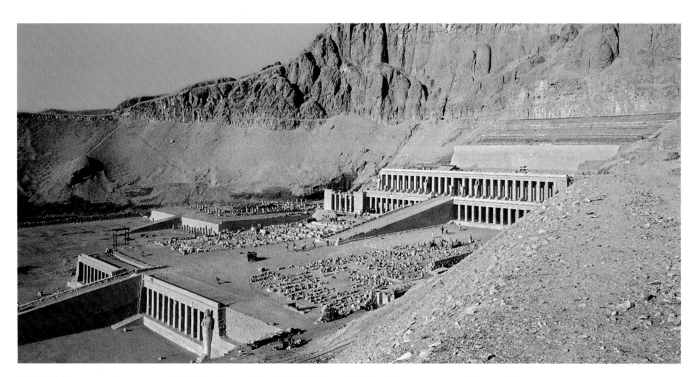

Fig. 3.15 Senenmut. Funerary temple of Hatshepsut, Deir el-Bahri, Western Thebes. Dynasty 18, ca. 1460 BCE. At the far left is the ramp and funerary temple of Nebhepetre Mentuhotep II. Dynasty 11 (Middle Kingdom), ca. 2000 BCE. We know the architect Senenmut's name because his own tomb contains biographical texts detailing his role in the project.

Materials & Techniques Mummification

In the belief that the physical body was essential to the *ka's* survival in the after-life, the Egyptians developed a sophisticated process to preserve the body, **mummification**. This was a multistaged, highly ritualized process.

The oldest evidence of mummification was recently found near Sakkara and dates from 3100 to 2890 BCE. Mummification methods changed over time, and the techniques used between 1085 and 945 BCE were the most elaborate. Upon death, the body was carried across to the west bank of the Nile, symbolically "going into the west" like the setting sun. There it was taken to "the place of purification," where it was washed with natron. (Natron is a hydrated form of sodium carbonate used to absorb the body's fluids; it also turned the body black.) After this first step in its symbolic rebirth, the body was transferred to the House of Beauty, where it was properly embalmed, its inner organs removed, dried, coated in resin, and either preserved in their own special containers, called canopic jars, or wrapped in linen and put back inside the body. The body itself was stuffed with linen and other materials in order to maintain its shape and was surrounded by bags of natron for 40 days. The entire process was overseen by an Overseer of Mysteries, God's Seal-Bearer, who served as chief surgeon, and a lector priest who recited the required texts and incantations.

After 40 days, the body was cleaned with spices and perfumes, rubbed with oils to restore some of its suppleness, and then coated with resin to waterproof it. Its nails were sewn back on and artificial eyes put into its eye sockets. Cosmetics were applied to the face, a wig put on its head. Dressed and decked out in jewels, the body was, finally, wrapped in a shroud of bandages from head to foot, along with small figurines and amulets as protection on the journey through the underworld. Finally, a mask was placed on the head and shoulders. The wrapping process involved several stages: First the head and neck were wrapped, then fingers and toes individually, and the same for the arms and legs, which were then tied together. The embalmers also placed a papyrus scroll with spells from the Book of the Dead between the wrapped hands (**a**). After sever-

al more layers of wrapping impregnated with liquid resin to glue the bandages together, the embalmers painted a picture of the god Osiris on the wrapping surface, did a final bandaging of the entire mummy with a large cloth attached by strips of linen (**b**), and then placed a board of painted wood on top. The mummy was now ready for its final ritual burial. The entire process took 70 days!

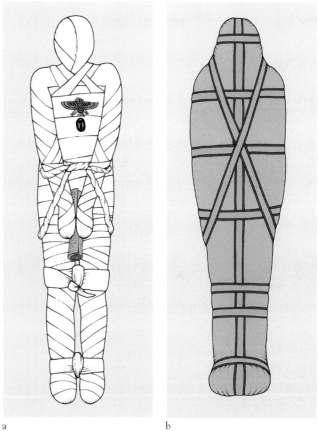

a b

Two stages in the wrapping of a mummy. © The Trustees of the British Museum.

Temple and Tomb Architecture and Their Rituals

Hatshepsut (ruled ca. 1479–1457 BCE) was the daughter of Thutmose [TOOT-mo-zeh] I (r. ca. 1504–1492 BCE) and married her half-brother Thutmose II. When her husband died, she became regent for their young son, Thutmose III, and ruled for 20 years as king (priests of Amun, in fact, declared her king).

Hatshepsut's temple, built on three levels, is modeled precisely on the single-level funerary temple of Nebhepetre Men-

tuhotep II, next to which it stands. Hatshepsut's temple is partly freestanding and partly cut into the rock cliffs of the hill (Fig. **3.15**). The first level consisted of a large open plaza backed by a long **colonnade**, a sequence or row of columns supporting a straight lintel. A long ramp led up to a second court that housed shrines to Anubis (god of embalming and agent of Osiris) and Hathor (the sky mother, probably a reference to Hatshepsut's gender). Another ramp led to another colonnade fronted with colossal royal statues, a series of chapels, and behind them, cut into the cliff, her tomb proper.

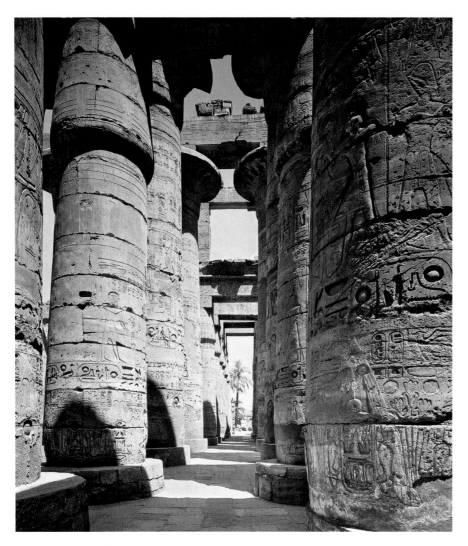

Fig. 3.16 Hypostyle hall, Great Temple of Amun, Karnak, Thebes. Dynasty 19, ca. 1294–1212 BCE. It is difficult to sense the massive scale of these columns from a photo. Dozens of people could easily stand on the top of one of them, and it takes at least eight people, holding hands, to span the circumference of a given column near its base. An average person is no taller than the first drum, or circular disk of stone, forming the column.

The Great Temple of Amun at Karnak

Directly across the valley from Hatshepsut's tomb, and aligned with it, is the Great Temple of Amun at Karnak. It is a product of the age in which the Egyptian king came to be known as **pharaoh** [FAY-roh], from Egyptian *per-aa*, "great house," meaning the palace of the king. In the same way that we refer to the presidency as "the White House," or the government of England as "10 Downing Street," so the Egyptians, beginning in the Eighteenth Dynasty, came to speak of their rulers by invoking their place of residence. (The modern practice of referring to all Egyptian kings as "pharaoh," incidentally, can probably be attributed to its use in the Hebrew Bible to refer to earlier Egyptian kings.)

The pharaohs engaged in massive building programs during the New Kingdom, lavishing as much attention on their temples as their tombs. Not only was Amun a focus of worship, but so was his wife, Mut, and their son Khonsu. Although each temple is unique, all of the New Kingdom temples share a number of common architectural premises. They were fronted by a **pylon**, or massive gateway with sloping walls, which served to separate the disorderly world of everyday existence from the orderly world of the temple.

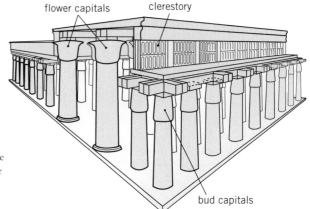

Fig. 3.17 Reconstruction drawing of the hypostyle hall, Great Temple of Amun, Karnak. Dynasty 19. ca. 1294–1212 BCE. The foreground columns have bud capitals and the third and fourth columns back are taller columns with flower capitals. The center columns are taller than the outer columns in order to admit light into the hall through windows along the upper walls.

Behind the pylon was one or more open courtyards leading to a roofed **hypostyle hall**, a vast space filled with the many massive columns required to hold up the stone slabs forming the roof. The columns in the hypostyle hall of the Great Temple of Amun at Karnak have flower and bud capitals (Figs. **3.16**, **3.17**). Behind the hypostyle hall was the **sanctuary**, in which the statue of the deity was placed. To proceed into the temple was to proceed out of the light of the outside world and into a darker and more spiritual space. The temple was therefore a metaphor for birth and creation. As the priests and kings entered the sanctuary and then returned to the world outside, they symbolically entered into the spiritual center of existence and then were reborn when they exited.

Each day, priests washed the deity statue, clothed it with a clean garment, and offered it two meals of delicious food. It was the "spirit" of the food that the gods enjoyed, and after the offering, the priests themselves ate the meals. Only kings and priests were admitted to the sanctuary, but at festival times, the cult statue of the deity was removed to lead processions—perhaps across the Nile to the funerary temples of the kings or to visit other deities in their temples (Mut regularly "visited" Amun, for instance).

The Great Temple of Amun at Karnak was the largest temple in Egypt. Although the temple was begun in the Middle Kingdom period, throughout the New Kingdom period pharaohs strove to contribute to its majesty and glory by adding to it or rebuilding its parts. The pharaohs built other temples to Amun as well. Each year, in an elaborate festival, the image of Amun from Karnak would travel south to visit his temple at Luxor. The most monumental aspects of both temples were the work of the Nineteenth Dynasty pharaoh Ramses [RAM-zez] II (1279–1213 BCE), whose 65-year rule was longer than that of any other Egyptian king. It was he who was responsible for the enormous hypostyle hall at Karnak, and it was he who built the massive pylon gate at Luxor (Fig. **3.18**).

Ramses' Pylon Gate at Luxor In front of the pylon stand two enormous statues of the king and, originally, a pair of **obelisks**—square, tapered stone columns topped by a pyramid shape (only the eastern one survives). The outside of the pylon was decorated with reliefs and texts

describing the king's victory over the Hittites, at a battle fought on the river separating modern Syria and Lebanon. The battle was not the unqualified military success depicted by the reliefs, so these may be an early example of art used as propaganda, a theme that continues up to the present. It may be better to think of these reliefs as symbolic rather than historical, as images of the king restoring order to the land. Inside the pylon, around the walls of the courtyard, were complex reliefs depicting the king, in the company of deities, together with his chief wife, 17 of his sons, and some of the nearly 100 other royal children whom he fathered with 8 other official wives.

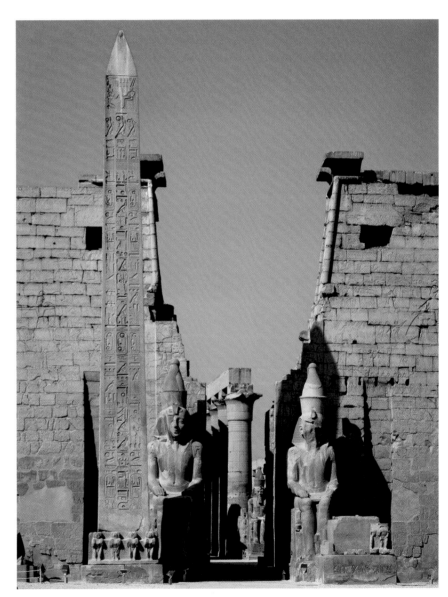

Fig. 3.18 Pylon gate of Ramses II with obelisk in the foreground, at Luxor, Thebes. Dynasty 19, ca. 1279–1212 BCE. This temple is distinctive because rather than being aligned on a single axis, it was aligned with the curving course of the Nile beside it.

Such complexity typifies New Kingdom decoration. We see it clearly in the many surviving wall paintings in the rock-cut tombs across the river from Thebes. Earlier, we discussed the variety of fish and bird life in the painting of *Nebamun Hunting Birds* (see Fig. 3.2). In a feast scene from the same tomb, the guests receive food from a servant in the top register, while below them, musicians and dancers entertain the group (Fig. **3.19**). Very little is known about how Egyptian music actually sounded. Evidently, hymns were chanted at religious festivals, and song was a popular part of daily life. As in Mesopotamia, musical instruments—flutes, harps, lyres, trumpets, and metal rattles called sistrums—were often found in Egyptian tombs. In this wall painting, the two nude dancers are posed in a complex intertwining of limbs. Furthermore, of the four seated figures on the left—one of whom plays a double flute while the others appear to be clapping and, perhaps, chanting—two are depicted frontally, a rarity in Egyptian art. The women wear cones of a scented fatty substance on their heads (as the cones melted, the women were bathed in its perfume), and the soles of their feet are turned toward us. In

this luxurious atmosphere, a new informality seems to have introduced itself into Egyptian art.

Women in the New Kingdom

The society of women depicted in the feast scene from the tomb of Nebamun suggests the growing prominence of women in the New Kingdom. Hatshepsut was one of only three women ever to govern Egypt, and she is usually pictured in male attire, wearing a royal wig and false beard, carrying the traditional accoutrements of kingship—the crook and the flail. But if she was uncommonly powerful, her ascendancy may well reflect women's improving lot. For one thing, all property was inherited through the female line. For another, whereas Middle Kingdom scribes often exhorted men to be wary of women—"Do not open your heart to your wife," warned one, "for what you say to her in private will be repeated in the street"—a growing tradition of love poetry, reminiscent of the Song of Songs in the Hebrew Bible (see chapter 2), suggests that women had become increasingly assertive, as this poem, translated by Ezra Pound and Noel Stock, attests in **Reading 3.3**:

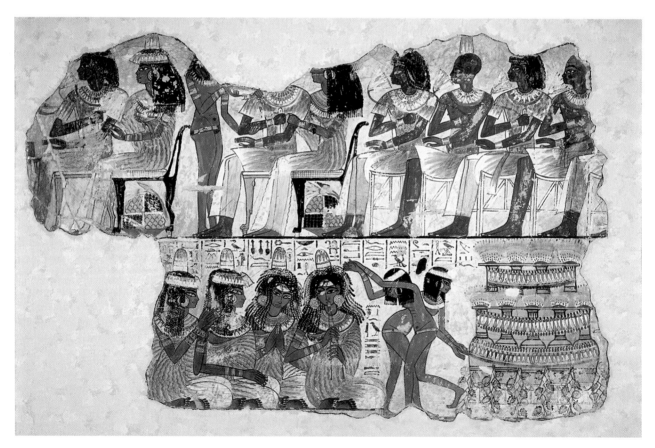

Fig. 3.19 Female musicians and dancers entertaining guests at a meal, detail of a fresco from the tomb of Nebamun, Western Thebes. Dynasty 18, ca. 1360 BCE. Paint on plaster, height of fragment 24″. The British Museum, London. Courtesy of the Trustees. The inclusion of such a scene in a tomb suggests that, in the New Kingdom, the dead demanded not only that they be accompanied by the usual necessities into the after-life, but that they be entertained there as well.

Behind the pylon was one or more open courtyards leading to a roofed **hypostyle hall**, a vast space filled with the many massive columns required to hold up the stone slabs forming the roof. The columns in the hypostyle hall of the Great Temple of Amun at Karnak have flower and bud capitals (Figs. **3.16**, **3.17**). Behind the hypostyle hall was the **sanctuary**, in which the statue of the deity was placed. To proceed into the temple was to proceed out of the light of the outside world and into a darker and more spiritual space. The temple was therefore a metaphor for birth and creation. As the priests and kings entered the sanctuary and then returned to the world outside, they symbolically entered into the spiritual center of existence and then were reborn when they exited.

Each day, priests washed the deity statue, clothed it with a clean garment, and offered it two meals of delicious food. It was the "spirit" of the food that the gods enjoyed, and after the offering, the priests themselves ate the meals. Only kings and priests were admitted to the sanctuary, but at festival times, the cult statue of the deity was removed to lead processions—perhaps across the Nile to the funerary temples of the kings or to visit other deities in their temples (Mut regularly "visited" Amun, for instance).

The Great Temple of Amun at Karnak was the largest temple in Egypt. Although the temple was begun in the Middle Kingdom period, throughout the New Kingdom period pharaohs strove to contribute to its majesty and glory by adding to it or rebuilding its parts. The pharaohs built other temples to Amun as well. Each year, in an elaborate festival, the image of Amun from Karnak would travel south to visit his temple at Luxor. The most monumental aspects of both temples were the work of the Nineteenth Dynasty pharaoh Ramses [RAM-zez] II (1279–1213 BCE), whose 65-year rule was longer than that of any other Egyptian king. It was he who was responsible for the enormous hypostyle hall at Karnak, and it was he who built the massive pylon gate at Luxor (Fig. **3.18**).

Ramses' Pylon Gate at Luxor In front of the pylon stand two enormous statues of the king and, originally, a pair of **obelisks**—square, tapered stone columns topped by a pyramid shape (only the eastern one survives). The outside of the pylon was decorated with reliefs and texts describing the king's victory over the Hittites, at a battle fought on the river separating modern Syria and Lebanon. The battle was not the unqualified military success depicted by the reliefs, so these may be an early example of art used as propaganda, a theme that continues up to the present. It may be better to think of these reliefs as symbolic rather than historical, as images of the king restoring order to the land. Inside the pylon, around the walls of the courtyard, were complex reliefs depicting the king, in the company of deities, together with his chief wife, 17 of his sons, and some of the nearly 100 other royal children whom he fathered with 8 other official wives.

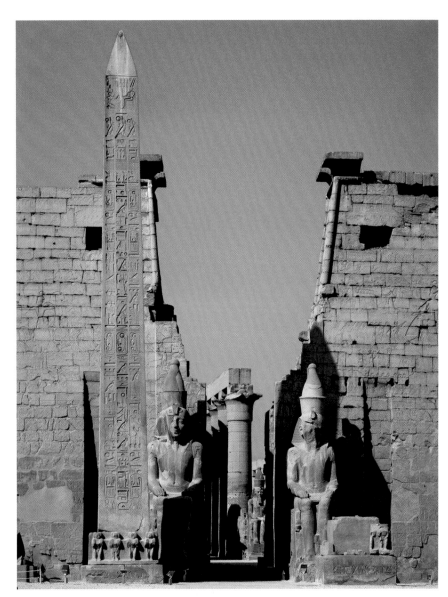

Fig. 3.18 Pylon gate of Ramses II with obelisk in the foreground, at Luxor, Thebes. Dynasty 19, ca. 1279–1212 BCE. This temple is distinctive because rather than being aligned on a single axis, it was aligned with the curving course of the Nile beside it.

Such complexity typifies New Kingdom decoration. We see it clearly in the many surviving wall paintings in the rock-cut tombs across the river from Thebes. Earlier, we discussed the variety of fish and bird life in the painting of *Nebamun Hunting Birds* (see Fig. 3.2). In a feast scene from the same tomb, the guests receive food from a servant in the top register, while below them, musicians and dancers entertain the group (Fig. **3.19**). Very little is known about how Egyptian music actually sounded. Evidently, hymns were chanted at religious festivals, and song was a popular part of daily life. As in Mesopotamia, musical instruments—flutes, harps, lyres, trumpets, and metal rattles called sistrums—were often found in Egyptian tombs. In this wall painting, the two nude dancers are posed in a complex intertwining of limbs. Furthermore, of the four seated figures on the left—one of whom plays a double flute while the others appear to be clapping and, perhaps, chanting—two are depicted frontally, a rarity in Egyptian art. The women wear cones of a scented fatty substance on their heads (as the cones melted, the women were bathed in its perfume), and the soles of their feet are turned toward us. In this luxurious atmosphere, a new informality seems to have introduced itself into Egyptian art.

Women in the New Kingdom

The society of women depicted in the feast scene from the tomb of Nebamun suggests the growing prominence of women in the New Kingdom. Hatshepsut was one of only three women ever to govern Egypt, and she is usually pictured in male attire, wearing a royal wig and false beard, carrying the traditional accoutrements of kingship—the crook and the flail. But if she was uncommonly powerful, her ascendancy may well reflect women's improving lot. For one thing, all property was inherited through the female line. For another, whereas Middle Kingdom scribes often exhorted men to be wary of women—"Do not open your heart to your wife," warned one, "for what you say to her in private will be repeated in the street"—a growing tradition of love poetry, reminiscent of the Song of Songs in the Hebrew Bible (see chapter 2), suggests that women had become increasingly assertive, as this poem, translated by Ezra Pound and Noel Stock, attests in **Reading 3.3**:

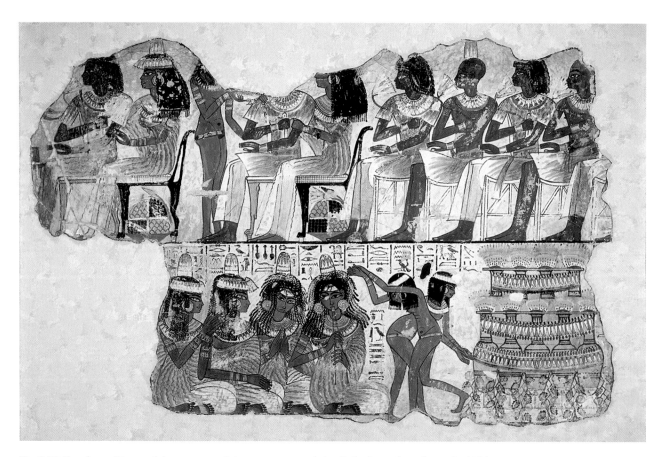

Fig. 3.19 Female musicians and dancers entertaining guests at a meal, detail of a fresco from the tomb of Nebamun, Western Thebes. Dynasty 18, ca. 1360 BCE. Paint on plaster, height of fragment 24″. The British Museum, London. Courtesy of the Trustees. The inclusion of such a scene in a tomb suggests that, in the New Kingdom, the dead demanded not only that they be accompanied by the usual necessities into the after-life, but that they be entertained there as well.

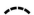

The poem is spoken, evidently, by the chief wife of a husband as if she were a pomegranate tree in his garden, and she is insisting on the preeminence of her place. Polygamy was legal, if practiced only by the wealthiest Egyptians (including, most notably, the kings themselves), and so "the garden" here is metaphorically the husband's harem. During the New Kingdom the king's harem seems to have become an important institution, as both the feast scene in Nebamun's tomb and the decorative reliefs of Ramses' giant family around the courtyard at Karnak suggest, though how it functioned remains unclear.

Akhenaten and the Politics of Religion

Toward the end of the Eighteenth Dynasty, Egypt experienced one of the few real crises of its entire history when, in 1353 BCE, Amenhotep IV (r. 1353–1337 BCE) assumed the throne of his father Amenhotep III (r. 1391–1353 BCE). It was the father who had originally begun construction of the greater (southern) part of the Temple of Amun-Mut-Khonsu at Luxor (see Fig 3.18) and who was responsible for the majority of the Temple of Amun at Karnak (see Figs. 3.16, 3.17). The great additions to these temples undertaken by Ramses II some 70 years later may have been a conscious return to the style—and traditions—of Amenhotep III. Certainly, they represent a massive, even overstated rejection of

the ways of the son, for Amenhotep IV had forsaken not only the traditional conventions of Egyptian representation but the very gods themselves.

Although previous Egyptian kings may have associated themselves with a single god whom they represented in human form, Egyptian religion supported a large number of gods. Even the Nile was worshiped as a god. Amenhotep IV abolished the pantheon of Egyptian gods and established a monotheistic religion in which the sun disk Aten was worshiped exclusively. Other gods were still acknowledged, but they were considered to be too inferior to Aten to be worth worshiping. This type of monotheism is known as *henotheism.* Amenhotep's new religion may have influenced the Hebrews, whose stay in Egypt was contemporaneous with Amenhotep's rule.

Amenhotep IV believed the sun was the creator of all life, and he may have composed *The Hymn to the Sun* (quoted earlier in this chapter), inscribed on the west wall of the tomb of the pharaoh Ay (ruled 1327–1323 BCE) at Tell el-Amarna [uh-MAHR-nuh] and in many other tombs as well. He was so dedicated to Aten that he changed his own name to Akhenaten [ah-ken-AH-ten] ("The Shining Spirit of Aten") and moved the capital of Egypt from Thebes to a site many miles north that he also named Akhetaten (modern Tell el-Amarna). This move transformed Egypt's political and cultural as well as religious life. At this new capital he presided over the worship of Aten as a divine priest and his queen as a divine priestess. Temples to Aten were open courtyards, where the altar received the sun's direct rays.

Why would Amenhotep IV/Akhenaten have substituted monotheism for Egypt's traditional polytheistic religion? Many Egyptologists argue that the switch had to do with enhancing the power of the pharaoh. With the pharaoh representing the one god that mattered, all religious justification for the power held by a priesthood dedicated to the traditional gods was gone. As we have seen, the pharaoh was traditionally associated with the sun god Re. Now in the form of the sun disk Aten, Re was the supreme deity, embodying the characteristics of all the other gods, therefore rendering them superfluous. By analogy, Amenhotep IV/Akhenaten was now supreme priest, rendering all other priests superfluous as well. Simultaneously, the temples dedicated to the other gods lost prestige and influence. These changes also converted the priests into dissidents.

A New Art: The Amarna Style Such significant changes had a powerful effect on the visual arts as well. Previously, Egyptian art had been remarkably stable because its principles were considered a gift of the gods—thus perfect and eternal. But now, the perfection of the gods was in question, and the principles of art were open to reexamination as well. A new art replaced the traditional canon of proportion—the familiar poses of king and queen—with realism, and a sense

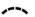

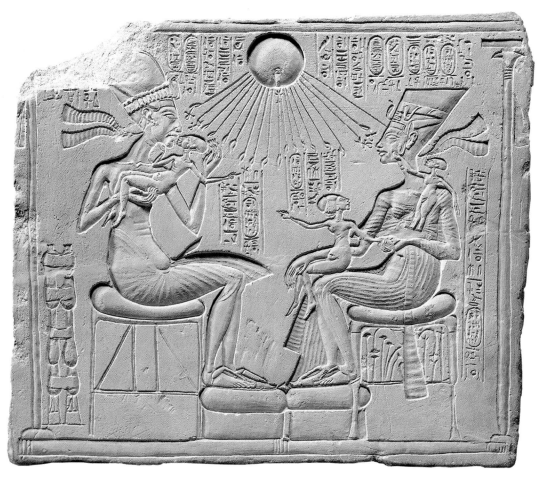

Fig. 3.20 *Akhenaten and His Family,* **from Akhetaten (modern Tell el-Amarna). Dynasty 18, ca. 1345** BCE. Painted limestone relief, $12\frac{3}{4}''$ × $14\frac{7}{8}''$. Staatliche Museen su Berlin, Preussischer Kulturbesitz, Ägyptisches Museum. Between Akhenaten and his queen Nefertiti, the sun disk Aten shines down beneficently. Its rays end in small hands, which hold the ankh symbol for life before both the king and queen.

of immediacy, even intimacy. So Akhenaten allowed himself to be portrayed with startling realism, in what has become known, from the modern name for the new capital, as the Amarna style.

For example, in a small relief from his new capital, Akhenaten has a skinny, weak upper body, and his belly protrudes over his skirt; his skull is elongated behind an extremely long, narrow facial structure; and he sits in a slumped, almost casual position (Fig. **3.20**). (One theory holds that Akhenaten had Marfan's Syndrome, a genetic disorder that leads to skeletal abnormalities.) This depiction contrasts sharply with the idealized depictions of the pharaohs in earlier periods. Akhenaten holds one of his children in his arms and seems to have just kissed her. His two other children sit with the queen across from him, one turning to speak with her mother, the other touching the

queen's cheek. The queen herself, Nefertiti [nef-er-TEE-tee], sits only slightly below her husband and appears to share his position and authority. In fact, one of the most striking features of the Amarna style is Nefertiti's prominence in the decoration of the king's temples. In one, for example, she is shown slaughtering prisoners, an image traditionally reserved for the king himself. It is likely that her prominence was part of Akhenaten's attempt to substitute the veneration of his own family (who, after all, represent Aten on earth) for the traditional Amun-Mut-Khonsu family group.

In a house in the southern part of Akhenaten's new city at Amarna, the famous bust of Queen Nefertiti was discovered along with drawings and sculptures of the royal family (Fig. **3.21**). This was the workshop of Thutmose, one of the king's royal artists. It seems likely that many other busts were mod-

buried on the west bank of the Nile at Thebes, near the tomb of Hatshepsut.

The Tomb of Tutankhamun Tutankhamun's is the only royal tomb in Egypt to have escaped the discovery of looters. When Howard Carter and Lord Carnarvon discovered it under the tomb of the Twentieth Dynasty king Ramses VI in the valley of the Kings near Dier el-Bahri, they found a coffin consisting of three separate coffins placed one inside the other (Figs. **3.22**, **3.23**). These were in turn encased in a quartzite **sarcophagus**, a rectangular stone coffin that was encased in four gilded, boxlike wooden shrines, also placed one inside the other. In their rigid formality, the coffins within, each depicting the king, hark back to the traditional Egyptian art of the Middle Kingdom. The king lies with his arms crossed over his chest, much like the Middle Kingdom king Nebhepetre Mentuhotep II in his funerary sculpture (see Fig. 3.12).

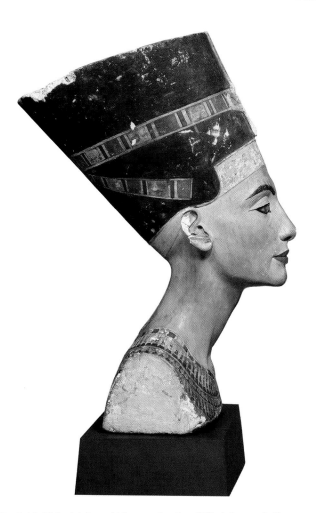

Fig. 3.21 *Nefertiti,* **from Akhetaten (modern Tell el-Amarna). Dynasty 18, ca. 1348–1336 BCE.** Painted limestone, 19″. Staatliche Museen su Berlin, Preussischer Kulturbesitz, Ägyptisches Museum. Some scholars theorize that Nefertiti's long neck may not be so much her own as a reflection of the king's—so that the reality of the king takes precedence over her own.

eled on the bust of Nefertiti, including some of the king himself. At any rate, the queen's beauty cannot be denied, and this image of her has become famous worldwide. Even in her own time, she was known by such epitaphs as "Fair of Face" and "Great in Love."

The Return to Thebes and to Tradition

Akhenaten's revolution was short-lived. Upon his death, Tutankhaten (r. 1336–1327 BCE), probably Akhenaten's son, assumed the throne and changed his name to Tutankhamun (indicating a return to the more traditional gods, in this case Amun). The new king abandoned el-Amarna, moved the royal family to Memphis in the north, and reaffirmed Thebes as the nation's religious center. He died shortly after and was

Fig. 3.22 The Tomb of Tutankhamun, antechamber, south end, Thebes, Dynasty 18. Photography by Egyptian Expedition, the Metropolitan Museum of Art, New York. This photograph shows the front chamber of King Tut's tomb as Howard Carter first saw it in 1922.

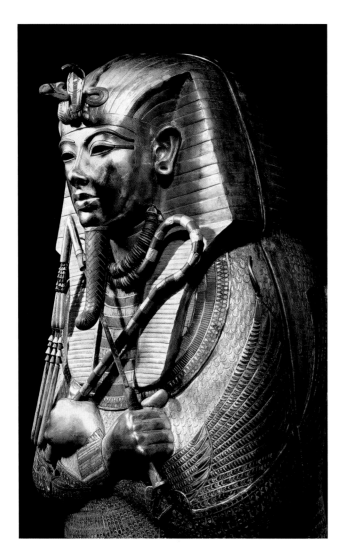

Fig. 3.23 Inner coffin of Tutankamun's sarcophagus, from his tomb, Valley of the Kings, Western Thebes. Dynasty 18, ca. 1335–1327 BCE. Gold, inlaid with glass and semiprecious stones, height 6′ 7⁄8″. Egyptian Museum, Cairo. The king's mummified body was found inside this coffin, the last of three, consisting of approximately $1.5 million worth of gold.

two-part ritual, deities first questioned the deceased about their behavior in life. Then their hearts, the seat of the *ka*, were weighed against an ostrich feather, symbol of Maat [mah-aht], the goddess of truth, justice, and order. Egyptians believed the heart contained all the emotions, intellect, and character of the individual, and so represented both the good and bad aspects of a person's life. If the heart did not balance with the feather, then the dead person was condemned to nonexistence, to be eaten by a creature called Ammit [AH-mit], the vile "Eater of the Dead," part crocodile, part lion, and part hippopotamus. Osiris, wrapped in his mummy robes, oversaw this moment of judgment. Tut himself, depicted on his sarcophagus with his crossed arms holding crook and flail, was clearly identified with Osiris.

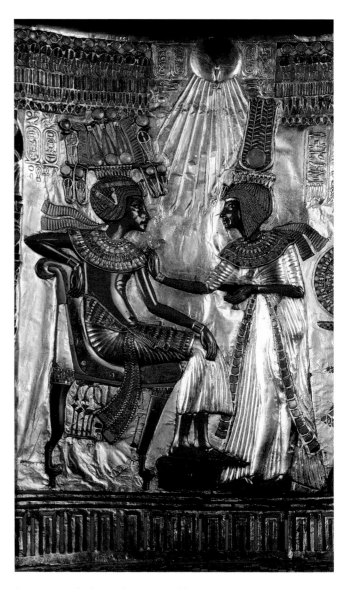

There were also vast quantities of beautiful furniture in the tomb, including a golden throne that dates from early in the king's rule and still bears the indelible stamp of the Armana style, with Aten shining down on both the king and queen (Fig. **3.24**). Jewelry of exquisite quality abounded, as did textiles—rarest of all archeological finds because they deteriorate over time. Carter and his team also found the golden *canopic* [kuh-NOPE-ik] jars which held the king's embalmed internal organs.

The Final Judgment The elaborate burial process was not meant solely to guarantee survival of the king's *ka* and *ba*. It also prepared him for a "last judgment," a belief system that would find expression in the Hebrew faith as well. In this

Fig. 3.24 Back of Tutankamun's "Golden Throne," from his tomb, Valley of the Kings, Western Thebes. Dynasty 18, ca. 1335 BCE. Wood, gold, faience, and semiprecious stones, height of entire throne 41″, height of detail approx. 12 1⁄4″. Egyptian Museum, Cairo. This throne shows that early in his life, at least, Tutankamun was still portrayed in the Armana style.

Books of the Dead Not long after Tut's death, the last judgment was routinely illustrated in Books of the Dead, collections of magical texts or spells buried with the deceased to help them survive the ritual of judgment. One such magical text was the "Negative Confession," (**Reading 3.4**) which the deceased would utter upon entering the judgment hall:

READING 3.4 from *The Book of the Dead*

I have come unto you; I have committed no faults; I have not sinned; I have done no evil; I have accused no man falsely; therefore let nothing be done against me. I live in right and truth, and I feed my heart upon right and truth. That which men have bidden I have done, and the gods are satisfied thereat. I have pacified the god, for I have done his will. I have given bread unto the hungry and water unto those who thirst, clothing unto the naked, and a boat unto the shipwrecked mariner. I have made holy offerings unto the gods; and I have given meals of the tomb to the sainted dead. 0, then, deliver ye me, and protect me; accuse me not before the great god. I am pure of mouth, and I am pure of hands. . .

I offer up prayers in the presence of the gods, knowing that which concerneth them. I have come forward to make a declaration of right and truth, and to place the balance upon its supports within the groves of amaranth. Hail, thou who art exalted upon thy resting place, thou lord of the *atef* crown[1], who declarest thy name as the lord of the winds, deliver thou me from thine angels of destruction, who make dire deeds to happen and calamities to arise, and who have no covering upon their faces, because I have done right and truth, 0 thou Lord of right and truth. I am pure, in my foreparts have I been made clean, and in my hinder parts have I been purified; my reins have been bathed in the Pool of right and truth, and no member of my body was wanting. I have been purified in the pool of the south. . .

[1] A conical headdress decorated with ostrich feathers and associated particularly with Osiris.

The following moment of judgment is depicted in one such Book of the Dead, a papyrus scroll created for an otherwise anonymous man known as Hunefer [HOO-nef-er] (Fig. **3.25**). The scene reads from left to right in a continuous pictorial narrative. To the left, Anubis [uh-NOO-bis], overseer of funerals and cemeteries, brings Hunefer into the judgment area. Hunefer's heart, represented as a pot, is being weighed against the ostrich feather. In this image, Hunefer passes the test—not surprising given that the work is dedicated to ensuring that Hunefer's *ka* survive in the afterlife. Horus brings Hunefer to Osiris, seated under a canopy, with his sisters at the right.

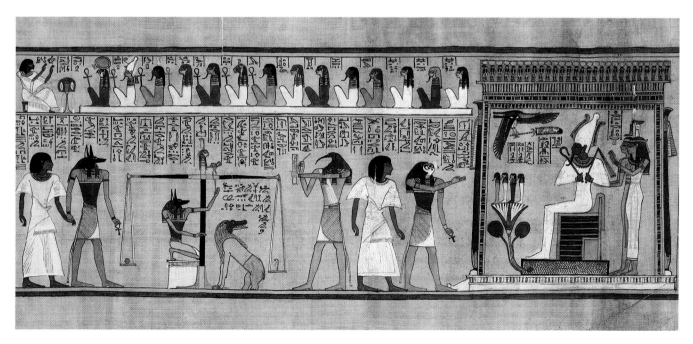

Fig. 3.25 *Last Judgment of Hunefer by Osiris*, from a Book of the Dead in his tomb at Thebes. Dynasty 19, ca. 1285 BCE. Painted papyrus scroll, height 15 ⅝". The British Museum, London. At the top, Hunefer, having passed into eternity, is shown addressing an adoring row of deities.

Fig. 3.26 *Mentuemhet*, from Karnak, Thebes. Dynasty 26, ca. 660 BCE. Granite, height 54". Egyptian Museum, Cairo. The only concession to naturalistic representation in this sculpture is in the governor's facial features.

The Late Period, the Kushites, and the Fall of Egypt

Continuity & Change
p. 85

Menkaure with a queen

From Tutankhamun's time through the Late Period (715–332 BCE) and until the fall of Egypt to the Romans in 30 BCE, the conventions of traditional representation remained in place. For example, the pose we saw in Menkaure's funeral sculpture of 2460 BCE (see Fig. 3.9) is repeated in the seventh-century BCE statue of *Mentuemhet*, the Governor (Fig. **3.26**). Mentuemhet [men-too-EM-het] strides forward into eternal life, nearly 2,000 years after that Old Kingdom pharaoh, a strong visual signal of the stability of Egyptian culture.

Mentuemhet was probably the most influential official of the Twenty-fifth Dynasty (ca. 715–656 BCE). He was appointed governor of Thebes by the Kushites [KOOSH-ites] (from Kush, the Egyptian name for the southern region of Nubia, in today's Sudan). Nubia had long been an important neighbor, appearing in Egyptian records as far back as the Old Kingdom. Nubia served as a corridor for trade between Egypt and sub-Saharan Africa and was the main means by which Egypt procured gold and incense, as well as ivory, ebony, and other valuable items. Because of its links with tropical Africa, over time, the population of Nubia became a diverse mixture of ethnicities.

Nubia had been the location of several wealthy urban centers, including Kerma, whose walls, mud brick buildings, and lavish tombs were financed and built by indigenous Nubian rulers around 1650 BCE. Napata was built during an Egyptian annexation of the area in approximately 1500 BCE, during the reign of Thutmose I. Napata became the provincial capital of southern Nubia, an area the Egyptians knew as Kush.

The Kushites

The Kushites had an immense appetite for assimilating Egyptian culture. They adopted Egyptian religion and practices, worshiping Egyptian gods, particularly Amun, the Egyptian state god. The main religious center of Kush was at Jebel Barkal [JEB-uh bar-kahl], a mountain where the Kushites believed Amun dwelled (see Map 3.2). Their adoption of Egyptian ways nevertheless retained their distinctly Nubian identity. The Kushites developed hieroglyphs to express their own language, continued to worship many of their own gods, and though they also began to erect pyramids over their royal tombs, theirs started from smaller bases and were distinctly steeper and more needle-like than their Egyptian counterparts (Fig. 3.27). There are nearly 300 of these pyramids in modern Sudan, more than in Egypt itself. Although annexed to Egypt, Kush was essentially an independent state toward the end of the New Kingdom. It built a new capital city, Meroe, farther up the Nile, as if to say it was more interested in its African neighbors than it was in maintaining convenient contact with Egypt. Egypt relied upon Kush to supply gold and other resources (including Nubian soldiers, among the most feared warriors in the region), but as Egypt struggled with its own enemies to the east, the rulers of Kush eventually found themselves in a position to take control of Egypt themselves. In the 8th century BCE, the Egyptians turned to Kush for the leadership they needed to help hold off the mounting threat of an Assyrian invasion, and the Egyptianized African rulers of Kush became the Twenty-fifth Dynasty of Pharaohs. As Pharaohs, the Kushite kings ruled an empire that stretched from the borders of Palestine possibly as far upstream as the Blue and White Niles, uniting the Nile valley from Khartoum [KAR-toom] to the Mediterranean. They were expelled from Egypt by the Assyrians after a rule of close to a hundred years.

VOICES

Everyday Life in Egypt

Herodotus, "the Father of History," visited Egypt in the mid-fifth century BCE *during the Late Period. His observations of everyday life in Egypt are valuable because of his first-hand experience traveling throughout the Mediterranean region. The detailed ethnographic, geographical, and historical information provided by Herodotus's* Histories *has elicited growing respect for his accuracy as new archeological and other scholarly findings come to light.*

" A woman cannot serve the priestly office, either for god or goddess, but men are priests to both; sons need not support their parents unless they choose, but daughters must, whether they choose or no."

Concerning Egypt itself . . . there is no country that possesses so many wonders, nor any that has such a number of works which defy description. Not only is the climate different from that of the rest of the world, and the rivers unlike any other rivers, but the people also, in most of their manners and customs, exactly reverse the common practice of mankind. . . . They eat their food out of doors in the streets, but retire for private purposes to their houses, giving as a reason that what is unseemly, but necessary, ought to be done in secret, but what has nothing unseemly about it, should be done openly. A woman cannot serve the priestly office, either for god or goddess, but men are priests to both; sons need not support their parents unless they choose, but daughters must, whether they choose or no. All other men pass their lives separate from animals, the Egyptians have animals always living with them; others make barley and wheat their food; it is a disgrace to do so in Egypt, where the grain they live on is spelt, which some call *zea*. Dough they knead with their feet; but they mix mud, and even take up dirt, with their hands. They are the only people in the world—they at least, and such as have learnt the practice from them—who use circumcision. Their men wear two garments apiece, their women but one. They put on the rings and fasten the ropes to sails inside; others put them outside. When they write or calculate, instead of going, like the Greeks, from left to right, they move their hand from right to left; and they insist, notwithstanding, that it is they who go to the right, and the Greeks who go to the left. They have two quite different kinds of writing, one of which is called sacred, the other common.

Egypt Loses Its Independence

The Assyrians left rule of Egypt to a family of local princes at Saïs [SAY-is], in the western portion of the Nile Delta, inaugurating the Twenty-sixth, or Saite [SAY-eet] Dynasty (664–525 BCE). With Memphis as their administrative center, they emphasized Mediterranean trade, which in turn produced over 100 years of economic prosperity. But Egypt was anything but secure in power struggles that dominated the larger political climate of the region. In 525 BCE, the Persians invaded from the north and made the country a mere province in its empire. For the next 200 years, Egypt enjoyed brief periods of independence, until the Persians invaded again in 343 BCE. They had ruled for not much more than a decade when the Macedonian [mass-uh-DOH-nee-un] conqueror Alexander the Great drove them out and asserted his own authority. According to legend, the god Amun spoke to Alexander through an oracle, acknowledging him as his son and therefore legitimate ruler of Egypt. Its independence as a state had come to an end. When Alexander died, the country fell to the rule of one of his generals, Ptolemy [TAHL-uh-mee], and beginning in 304 BCE the final Ptolemaic [tahl-MAY-ik] Dynasty was under way. A kingdom in the Greek constellation, Egypt would finally fall to an invading Roman army in 30

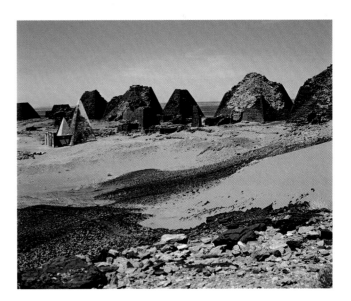

Fig. 3.27 The Ruins at Meroe show the narrower and steeper style of Kushite pyramids, as well as their solid interior construction.

BCE. But remarkably, until this moment, its artistic and religious traditions, as well as its daily customs, remained largely in place, practiced as they had been for 3,000 years. (See *Voices*, above.)

READINGS

READING 3.2

The Teachings of Dua-Khety (ca. 2040–1648 BCE)

In the following example of instructive literature, dating from the Middle Kingdom, a royal scribe tries to convince his son to follow him into the profession by debunking virtually every other career path the young man might choose to follow. The work is as instructive as it is amusing, since it presents a wonderfully complete picture of daily life in the Middle Kingdom.

The beginning of the teaching which the man of Tjel named Dua-Khety made for his son named Pepy, while he sailed southwards to the Residence to place him in the school of writings among the children of the magistrates, the most eminent men of the Residence.

So he spoke to him: Since I have seen those who have been beaten, it is to writings that you must set your mind. Observe the man who has been carried off to a work force. Behold, there is nothing that surpasses writings! They are a boat upon the water. Read then at the end of the Book of 10 Kemyet this statement in it saying:

As for a scribe in any office in the Residence, he will not suffer want in it. When he fulfills the bidding of another, he does not come forth satisfied. I do not see an office to be compared with it, to which this maxim could relate. I shall make you love books more than your mother, and I shall place their excellence before you. It is greater than any office. There is nothing like it on earth. When he began to become sturdy but was still a child, he was greeted (respectfully). When he was sent to carry out a task, before he returned he was dressed 20 in adult garments.

I do not see a stoneworker on an important errand or a goldsmith in a place to which he has been sent, but I have seen a coppersmith at his work at the door of his furnace. His fingers were like the claws of the crocodile, and he stank more than fish excrement.

Every carpenter who bears the adze is wearier than a field-hand. His field is his wood, his hoe is the axe. There is no end to his work, and he must labor excessively in his activity. At nighttime he still must light his lamp. . . . 30

The barber shaves until the end of the evening. But he must be up early, crying out, his bowl upon his arm. He takes himself from street to street to seek out someone to shave. He wears out his arms to fill his belly, like bees who eat (only) according to their work.

The reed-cutter goes downstream to the Delta to fetch himself arrows. He must work excessively in his activity. When the gnats sting him and the sand fleas bite him as well, then he is judged.

The potter is covered with earth, although his lifetime is 40 still among the living. He burrows in the field more than swine to bake his cooking vessels. His clothes being stiff with mud, his head cloth consists only of rags, so that the air which comes forth from his burning furnace enters his nose. He operates a pestle with his feet with which he himself is pounded, penetrating the courtyard of every house and driving earth into every open place.

I shall also describe to you the bricklayer. His kidneys are painful. When he must be outside in the wind, he lays bricks without a garment. His belt is a cord for his back, a string for 50 his buttocks. His strength has vanished through fatigue and stiffness, kneading all his excrement. He eats bread with his fingers, although he washes himself but once a day. . . .

The weaver inside the weaving house is more wretched than a woman. His knees are drawn up against his belly. He cannot breathe the air. If he wastes a single day without weaving, he is beaten with 50 whip lashes. He has to give food to the doorkeeper to allow him to come out to the daylight. . . .

See, there is no office free from supervisors, except the scribe's. He is the supervisor! 60

But if you understand writings, then it will be better for you than the professions which I have set before you. . . . What I have done in journeying southward to the Residence is what I have done through love of you. A day at school is advantageous to you. . . .

Be serious, and great as to your worth. Do not speak secret matters. For he who hides his innermost thoughts is one who makes a shield for himself. Do not utter thoughtless words when you sit down with an angry man.

When you come forth from school after midday recess has 70 been announced to you, go into the courtyard and discuss the last part of your lesson book.

When an official sends you as a messenger, then say what he said. Neither take away nor add to it. . . .

See, I have placed you on the path of God. . . . See, there is no scribe lacking sustenance, (or) the provisions of the royal house. . . . Honour your father and mother who have placed you on the path of the living. ■

Reading Question

Although the scribe Dua-Khety spends much time describing the shortcomings of other lines of work, he also reminds his son how he should behave at school. What do the father's words of advice tell us about the values of Egyptian society?

 ## Summary

■ **The Nile and Its Culture** The annual cycle of flood and sun, the inundation of the Nile River valley that annually deposited deep layers of silt followed by months of sun in which crops could grow in the fertile soil, helped to define Egyptian culture. This predictable cycle helped to create a cultural belief in the stability and balance of all things that lasted for over 3,000 years, across the three main periods of Egyptian history—the Old Kingdom, the Middle Kingdom, and the New Kingdom. Every aspect of Egyptian life is countered by an opposite and equal force which contradicts and negates it—the cycle of flood and sun—and every act of negation gives rise to its opposite again. This belief informed Egyptian religious practices as well. Each night the sun god Re—with whom the Egyptian kings were strongly identified—descends into the night and, as the *Great Hymn to Aten* says, "Earth is in darkness as if in death," only to be reborn each morning. Each person's soul or life force (the *ka*) as well as their personality (the *ba*) were believed to follow this same cycle. For the Egyptians, the world is therefore fundamentally dualistic in nature, a fact reflected in the composite views that can be seen even in their earliest art.

■ **The Old Kingdom** Most surviving Egyptian art and architecture was devoted to burial and the afterlife, the cycle of life, death, and rebirth. The pyramids at Saqqara and Giza are the tombs of Egyptian kings. The statuary of kings and queens were meant to preserve the king's existence after death. Sculptures of lesser figures were more natural in appearance, less stiff and formal. They were made to accompany and serve the royal family in the afterlife.

■ **The Middle Kingdom** During the Middle Kingdom, the capital of Egypt moved south to Thebes. Whereas in the Old Kingdom, writing had been used almost exclusively in a religious context, in the Middle Kingdom a vast secular literature developed. The sculptural traditions developed in the Old Kingdom remained in place, and royal artisans refined the representation of kings and queens by developing a grid system. The chief deity of Thebes, Amun-Re, a local manifestation of the traditional sun god, Re, became the chief deity of all Egypt.

■ **The New Kingdom** Seeking to associate itself with the traditions of the Middle Kingdom, the New Kingdom adopted Amun as its chief deity as well. Queen Hatshepsut, one of the few women ever to rule Egypt, dedicated her funerary temple to the god. The New Kingdom kings, now called "pharaoh," undertook massive, elaborately decorated building projects at Karnak and Thebes. Women gained a new prominence in the culture, and the king's harem seems to have become an important cultural institution. Toward the end of the Eighteenth Dynasty, Amenhotep IV forsook traditional conventions of Egyptian representation, abolished the pantheon of Egyptian gods, established a monotheistic religion in which the sun disk Aten was worshiped exclusively, and changed his own name to Akhenaten. This change was short-lived, and shortly after Amenhotep/Akhenaten's death, Egypt's traditional polytheistic religion was restored along with its long-standing artistic conventions, the most magnificent examples of which survived in the tomb of King Tutankhamun. Funeral practices soon included the incantation of texts and spells collected in Books of the Dead, which accompanied the deceased as they underwent a last judgment.

■ **The Late Period and the Fall of Egypt** After the end of the New Kingdom, traditional representational practices remained in place, even when Kushite kings from the south in modern Sudan ruled the country. Increasingly, Egypt became susceptible to invasion, and after it fell to Alexander the Great in 332 BCE, its independence as a state came to an end, even though the new Greek Ptolemaic Dynasty continued traditional Egyptian ways until Rome conquered the country in 31 BCE.

Glossary

ankh A hieroglyph of a cross whose vertical arm is topped with a loop; a symbol of life in ancient Egypt.

ba In ancient Egypt, an idea comparable to a person's personality.

cartouche In ancient Egyptian art, an ornamental and symbolic frame reserved for the names of rulers.

colonnade A sequence or row of columns supporting a lintel.

composite view A view that integrates multiple perspectives into a single unified representation.

determinative A sign used in Egyptian hieroglyphs to indicate the category of an object or being.

fresco secco Or "dry fresco"; the technique of painting on dry plaster.

hieroglyph A sign used in hieroglyphic writing, a writing system consisting mainly of pictorial characters.

hypostyle hall A vast space filled with columns supporting a roof.

ka In ancient Egypt, an idea comparable to a "soul" or "life force."

mastaba A trapezoidal tomb structure.

mummification The process of embalming, drying, and preserving a body.

mummy An embalmed body wrapped for burial.

obelisk A square, tapered stone column topped by a pyramid shape.

pharaoh A ruler of ancient Egypt.

phonogram A pictogram used to represent a sound.

pictogram A stylized drawing that represents an object or being; often combined in hieroglyphic writing to express ideas.

pictorial formula A convention of representation in art.

pylon A massive gateway with sloping walls.

sanctuary The most sacred place of a religious building.

sarcophagus A rectangular stone coffin.

serekh A hieroglyphic device representing a pharaoh's palace seen simultaneously from above and the front; used to hold the pharaoh's name.

symmetrical Balanced on the left and right sides.

theocracy A state ruled by a god or by the god's representative.

votive A ritual object.

 # Critical Thinking Questions

1. What is a "composite view"? Give an example or two. How does such a "view" reflect larger aspects of Egyptian culture?

2. How are hieroglyphs to be read? Use the *Palette of Narmer* as an example.

3. What are the three main types of Egyptian royal statuary? What purpose did these statues serve? How would you describe their ultimate effect?

4. How does Amenhotep IV's religion differ from Egyptian religion in general? What other changes to Egyptian tradition occurred during his reign?

Continuity & Change

Although Egyptian art and culture remained extraordinarily stable for over 3,000 years, it would be a mistake to assume that this was because the region was isolated. In fact, Egypt was a center of trade for the entire Mediterranean basin. Spiral and geometric designs on Egyptian pottery from as early as the Twelfth Dynasty (1980–1801 BCE) suggest the influence of Aegean civilizations, and during the reign of Hatshepsut's young son, Thutmose III, connections with Aegean cultures appear to have been extremely close. Evidence from surviving images of both cultures' ship designs—ships that would have facilitated Aegean trade—suggests a mutual influence. A small-scale model of the king's boat from the tomb of King Tut shows a stern cabin, a place of honor, where the king would sit, while his retinue traveled in the larger, central shelter (Fig. **3.28**). Ships such as this were equipped with a mast that could be raised and fitted with a sail to catch the Nile winds from astern. The ship is remarkably similar to those in a seventeenth-century BCE wall painting from the island of Thera in the Aegean Sea, north of Crete (Fig. **3.29**). Here a fleet of ships ferries passengers in what appears to be a processional celebration. Some of the ships have raised their masts above the central awning. In several, a figure of evident importance is seated in a stern cabin. Most of the ships are equipped with rear oars, as in Tut's ship.

Egypt's influence in the Mediterranean was far-flung. Archeologists escavating at Mycenae [my-SEE-nee], a center of culture that was firmly established on the Greek Peloponnesus [pel-uh-puh-NEE-sus] by 1500 BCE, have discovered Egyptian scarabs at the site, including one bearing the name of Queen Tiy [tee], mother of Akhenaten. A shipwreck discovered off the coast of southern Turkey in 1982 gives us some sense of the extent of Mediterranean trade. Carbon dating of firewood found on board suggests the ship sank in about 1316 BCE. Its cargo included gold from Egypt,

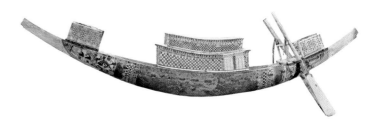

Fig. 3.28 Model of the *King's Boat*. From the tomb of Pharaoh Tutankhamun. Egypt, 18th dynasty. Egyptian Museum, Cairo, Egypt.

weapons from Greece, a scarab bearing Nefertiti's name, amber from northern Europe, hippopotamus and elephant ivory, and tin from Afghanistan. Such trade resulted not only in the transfer of goods between various regions, but in a broader cultural diffusion as well, for ideas, styles, religions, and technologies spread from one culture to another throughout the region. Much work remains to be done on the interconnections and lines of continuity and change among the peoples of the Aegean, the broader Mediterranean, Mesopotamia, and Egypt, but it is clear that they knew of one another, traded with one another, and were stimulated by one another's presence. ■

Fig. 3.29 *Flotilla* fresco. From Room 5 of West House, Akrotiri, Thera, Second Palace period, c. 1650 BCE. National Archaeological Museum, Athens, Greece.

4 China, India, and Africa

Early Civilizations

“ *Rich is the year with much millet and rice;*

And we have tall granaries

With hundreds and thousands and millions of sheaves.

We make wind and sweet spirits

And offer them to our ancestors, male and female;

Thus to fulfill all the rites

And bring down blessing in full. **”**

The Book of Songs

◄ **Fig. 4.1 The Great Wall, near Beijing, China. Begun late third century BCE.** Length approx. 4,100 miles, average height 25′. In the third century BCE, the Chinese Emperor Shihuangdi ordered his army to reconstruct, link, and augment walls on the northern frontier of China in order to form a continuous barrier protecting his young country from northern Mongol "barbarians." Its vast scale underscores the ambition, even hubris of the Chinese court, an ambition seemingly at odds with its major religious and philosophical teachings, Daoism and Confucianism.

THE NORTH CHINA PLAIN LIES IN THE LARGE, FERTILE VALLEY OF

the Yellow River (Map. **4.1**). Around 4000 BCE, when the valley's climate was much milder and the land more forested than it is today, the peoples inhabiting this fertile region began to cultivate the soil, growing primarily millet. A Neolithic

tribal people, they used stone tools, and although they domesticated animals very early on, they maintained their hunter-gatherer heritage. Later inhabitants of this region would call this area the "Central Plain" because they believed it was the center of their country. Between about 800 BCE and 480 BCE, Chinese culture in the Central Plain evolved in ways that parallel developments in the Middle East and Greece during the same period, as China transformed itself from an agricultural society into a more urban-centered state (Map. 4.1).

By the third century BCE, the government was sufficiently organized that it could build a giant wall across the hills north of the Central Plain to protect it from the menacing Central Asian Huns who lived beyond the northern borders. Some sections of the wall were already in place, built in previous centuries to protect local areas. These were rebuilt and connected to form the Great Wall of China, stretching some 4,100 miles from northeast to northwest China (Fig. **4.1**). New roads and canal systems were built linking the entire nation.

The country had realized a dream of unification symbolized by a ritual jade disc, or *Pi* [pee], made sometime in the fourth or third century BCE (Fig. **4.2**). It is decorated with both a dragon and a phoenix, today commonly found in the context of Chinese wedding ceremonies, where they hang together over the table at the wedding feast. These mythological creatures represent the ancient peoples of China—those in the west and Central Plain who worshiped the dragon and those in the east along the coast who worshiped the phoenix. The union of the two cultures, east and west, was celebrated in the representation of the phoenix and dragon. The first part of this chapter surveys the rise of the Chinese culture into a unified state responsible for such enormous undertakings as the Great Wall and its road system.

At the same time, another culture was developing in the river valleys of the Asian subcontinent of India. During this time, the importance of the individual in the workings of the state came to be understood and valued. In both China and India, national literatures arose, as did religious and philosophical practices that survive to this day and are known worldwide. But in the ancient world, East and West had not yet met. The peoples of the Mediterranean world and those living in the Yellow and Indus River valleys were unknown to one another. As trade routes stretched across the Asian continent, these cultures would eventually cross paths. Gradually, Indian thought, especially Buddhism [BOO-diz-um], would find its way into China, and Chinese goods would find their way to the West. Even more gradually, intellectual developments in ancient China and India, from the *I Jing* [ee jing] to the teachings of Confucius [kun-FYOO-shus] and Buddha [BOO-duh], would come to influence cultural practice in the Western world. But throughout the period studied in this chapter, up until roughly 200 CE, the cultures of China and India developed independently of those in the West.

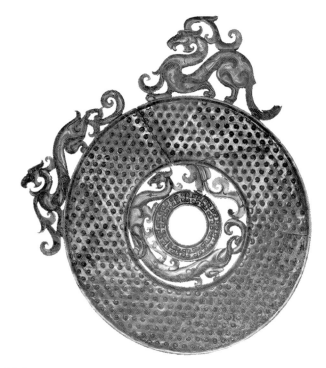

Fig. 4.2 Ritual disc *(Pi)* with dragon and phoenix motif. Eastern Zhou dynasty, Warring States period, 4th–3rd century BCE. Jade, diameter $6\frac{1}{2}''$. The Nelson-Atkins Museum of Art, Kansas City, Missouri. Purchase: Nelson Trust 33-81. This disc was discovered in a tomb, probably placed there because the Chinese believed that jade preserved the body from decay.

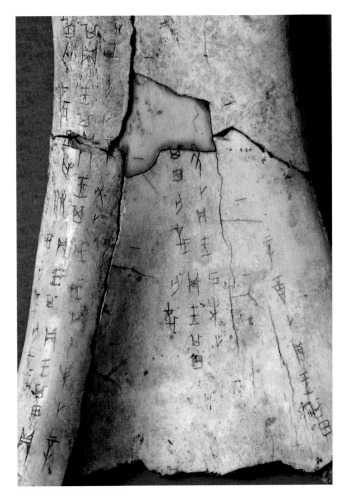

Map 4.1 Map of China, 1000–200 BCE.

flood, the course of an illness, or the wisdom of an administrative decision. To find answers, the inscribed shards were heated; the heat caused cracks to form, which the oracles then interpreted. According to Chinese legend, writing was invented by the emperor Huang Che [hwahng chuh], who lived about 2600 BCE, and who based his symbols on both constellations and bird and animal footprints. The first Chinese signs were pictograms, which, as in Mesopotamia, quickly became stylized. (See chapter 2, *Focus*, pages 42–43 for comparison.) The essence of Chinese written language is that a single sound can represent more than one object or idea, depending on how it is written. The sound "shi" [she], for instance, can mean a wide variety of things depending on the written marks with which it is combined: "to know," "to be," "power," "to love," "to see," "oath," "world," "house," and so on.

Early Chinese writing is relatively easy for scholars to interpret since it has remained remarkably constant through the ages. Traces of the earliest script survive in contemporary

Early Chinese Culture

Little remains of the earliest Chinese civilizations. We know that by the middle of the second millennium BCE Chinese leaders ruled from large capitals, rivaling those in the West in their size and splendor. Beneath present-day Zhengzhou [juhng-joe], for instance, lies an early metropolitan center with massive earthen walls. Stone was scarce in this area, but abundant forests made wood plentiful, so it was used to build cities. As impressive as they were, cities built of wood were vulnerable to fire and military attack, and no sign of them remains. Yet we know a fair amount about early Chinese culture from the remains of its written language and the tombs of its rulers. Scholars examining fragments of written scrolls found that the ancient Chinese written language is closely related to modern Chinese. And archeologists discovered that royal Chinese tombs, like Egyptian burial sites, were filled with furnishings, implements, luxury goods, and clothing—anything that the deceased might need in the next world.

Chinese Calligraphy

Like the cultures of the Middle East, sometime early in the Bronze Age, the Chinese developed a writing system, a **calligraphy**, or script written with brush and ink. The many surviving examples of writing—on oracular bones, animal bone, and tortoise-shell fragments used to predict the future—suggest that writing emerged as a means of divining the future and communicating with the gods. We know as much as we do about the day-to-day concerns of the early Chinese rulers from these oracular fragments, on which a special order of priests, or diviners, posed questions of importance and concern (Fig. **4.3**). They might ask about the harvest, the outcome of a war, the threat of

Fig. 4.3 Inscribed oracle bone. Shang period, ca. 1765–1122 BCE.
The priests inscribed the characters representing the question from top to bottom in columns.

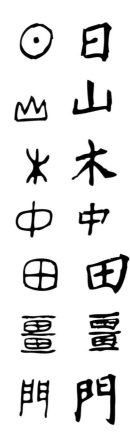

Fig. 4.4 Chinese characters. Shown are ancient characters (left) and modern ones (right). From top to bottom, they mean "sun," "mountain," "tree," "middle," "field," "frontier," and "door."

written Chinese. In the figure above, 3,000 years separate the characters on the right from those on the left (Fig. **4.4**).

The Shang Dynasty (1700–1045 BCE)

Chinese records tell of a King Tang who in 1700 BCE established the Shang dynasty. The Shang state was a linked collection of hilltop villages, each overlooking its fields in the river valleys below. It stretched across the plains of the lower Yellow River valley, but it was not a contiguous state with distinct borders; other villages separated some of the Shang villages from one another, and were frequently at war with the Shang. The royal family surrounded itself with priests, who soon developed into a kind of nobility and, in turn, created new walled urban centers focused around the nobles' palaces or temples. These were surrounded by workshop areas where bronze vessels, finely carved jades, and luxury goods were produced. The nobility organized itself into armies—surviving inscriptions describe forces as large as 13,000 men—that controlled and protected the countryside.

The Book of Changes: The First Classic Chinese Text The Shang priests were avid interpreters of oracle bones. From a modern Western perspective, interpretations of cracks in

heated bone shards were based on pure chance, but to the Shang priests, nothing was a matter of pure chance. This belief lies at the heart of Chinese culture. For the Chinese, all things in the cosmos are part of a greater logic and order. In other words, there is no such thing as chance, and nothing is insignificant, not even a crack in a bone. The challenge lies in interpreting the crack correctly.

The first classic of Chinese literature, *The Book of Changes*, or *I Jing*, which originated in the Shang era, is a guide to interpreting the workings of the universe. A person seeking to understand some aspect of his or her life or situation poses a question and tosses a set of straws or coins. The arrangement they make when they fall leads to a specific text in the *I Jing*. The text describes the conditions of the specific moment, which is, as the title suggests, always a moment of transition, a movement from one set of circumstances to the next. The *I Jing* prescribes certain behaviors appropriate to the moment. Thus, it is a book of wisdom.

This wisdom is based on a simple principle—that order derives from balance, a concept that the Chinese share with the ancient Egyptians. The Chinese believe that over time, through a series of changes, all things work toward a condition of balance. Thus, when things are out of balance, diviners might reliably predict the future by understanding that the universe tends to right itself. The image for *T'ai* [tie], or "Peace," for instance, is the unification of heaven and earth—"a time in nature when heaven seems to be on earth . . . a sign of social harmony . . . when the good elements of society occupy a central position and are in control, the evil elements coming under their influence and change for the better . . . when the spirit of heaven rules in man."

In fact, according to the Shang rulers, "the foundation of the universe" is based on the marriage of *Qian* [chee-an] (at once heaven and the creative male principle) and *Kun* (the earth, or receptive female principle), symbolized by the Chinese symbol of *yin-yang* (Fig. 4.5). *Yin* is soft, dark, moist, and cool; *yang* is hard, bright, dry, and warm. The two combine to create the endless cycles of change, from night to day, across the four seasons of the year. They balance the five elements (wood, fire, earth, metal, and water) and the five powers of creation (cold, heat, dryness, moisture, and wind). The yin-yang sign, then, is a symbol of harmonious integration, the perpetual interplay and mutual relation among all things. And note that each side contains a circle of the same values as its opposite—neither side can exist without the other.

Fig. 4.5 Yin-yang symbol.

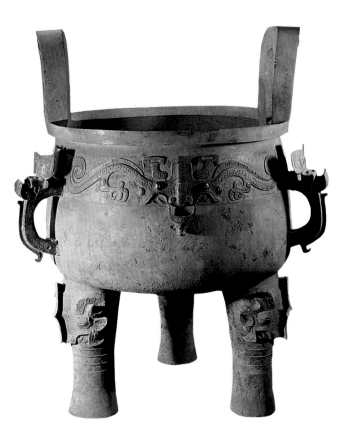

Fig. 4.6 Five-eared *ding* with dragon pattern. ca. 1200 BCE. Bronze, height 48″, diameter at mouth, 32 ³/₄″. Chinhua County Cultural Museum. One of the key features of Shang bronze decoration is the bilateral symmetry of the animal motifs, suggesting the importance of balance and order in ancient Chinese culture.

Shang Bronze The symmetry of the yin-yang motif appears in almost all Shang bronze works. The Shang developed an extremely sophisticated bronze-casting technology, as advanced as any ever used. Many of their bronze vessels—or *ding* [dee-ung]—used for storage and for wine, had explicitly religious, political, and ceremonial functions (Fig. **4.6**). Most are decorated with fantastic, supernatural creatures, especially dragons, which, for the Shang, symbolized royal authority, strength, and fertility. Their symmetry in turn symbolized the balance the Shang leadership brought to the state. The Shang-ti (or "Lord on High") granted the Shang rulers their authority, and from the "dragon throne" they ruled China with great armies, consisting primarily of archers.

At the last Shang capital and royal burial center, Yinxu [yin-shoo] (modern Anyang [ahn-yahng]), archeologists have unearthed the undisturbed royal tomb of Lady Fu Hao [foo how] (died ca. 1250 BCE), consort to the king Wu Ding. Consisting of a deep pit over which walled buildings were constructed as ritual sites to honor the dead, Lady Fu Hao's grave contained the skeletons of horses and dogs; about 440 cast and decorated

bronzes, which probably originally held food and drink; 600 jade objects; chariots; lacquered items; weapons; gold and silver ornaments; ivory inlaid with turquoise; and about 700 cowrie shells, which the Shang used as money. As in Sumerian royal burials, Lady Fu Hao was not buried alone. The decapitated skeletons of 24 women and 22 men, possibly Lady Fu Hao's servants, and the axes used to behead them, were found in the grave. Whether they submitted voluntarily to their deaths is a matter of pure conjecture.

Though geographically separate, the Bronze Age tombs of the Sumerians, Egyptians, Mycenaeans [my-suh-NEE-unz], and Shang demonstrate the widespread belief in life after death. They also testify to the enormous wealth that Bronze Age rulers were capable of accumulating.

The Zhou Dynasty (1027–256 BCE)

In 1027 BCE, a rebel tribe known as the Zhou [joe] overthrew the Shang dynasty, claiming that the Shang had lost the mandate of heaven by not ruling virtuously. It seems that the warrior culture of the Shang was incompatible with the more stable forces that drive an agricultural economy, where power resides less in military might and more in the production and trade of goods and foodstuffs. The principle of a natural order in the universe of the kind celebrated in the *Book of Changes* and embodied in the symbol of yin-yang is a manifestation of a society increasingly concerned with the agricultural cycle of planting, growing, and harvesting crops. In fact, both the *Book of Changes* and the yin-yang symbol were originated by the Shang but codified and written down by the Zhou. One of the oldest songs in the oldest collection of Chinese poetry, the *Book of Songs*, celebrates the harvest in particular (**Reading 4.1**):

READING 4.1 **from the *Book of Songs***

Abundant is the year, with much millet, much rice;
But we have tall granaries,
To hold myriads, many myriads and millions of grain.
We make wine, make sweet liquor,
We offer it to ancestor, to ancestress,
We use it to fulfil all the rites,
To bring down blessings upon each and all.

The harvest here is the sign of the family's harmony with nature, the symbol that the family's ancestors are part of the same natural cycle of life and death, planting and harvest, as the universe as a whole. It is communal in its expression, emphasizing less the importance of the individual so characteristic of Western thought, and more the good the harvest brings to the whole—a distinctly Asian worldview.

Bronze Musical Instruments Like the Shang, the Zhou were masterful bronze artisans, and they carried this mastery into the other arts as well. A magnificent set of bronze bells

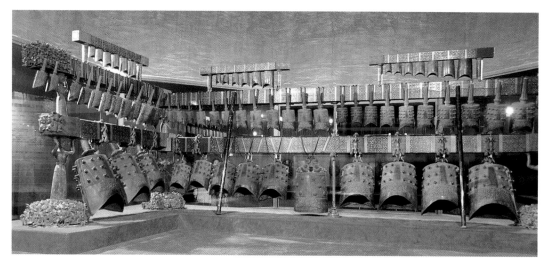

Fig. 4.7 Set of 65 bronze bells, from the tomb of Marquis Yi of Zeng, Suixian, Hubei. 433 BCE. Bronze, with bronze and timber frame, frame height 9′, length 25′. Hubei Provincial Museum, Wuhan. Each of these bells is inscribed with the names of its two notes and with a *taotie*, a masklike image combining animal and human features that is found on many ritual bronze objects. Similar half-animal half-human figures are painted on Marquis Yi's coffin, suggesting that the ancient Chinese connected the afterlife with these supernatural figures.

(Fig. **4.7**), found in the tomb of the Zhou ruler, Marquis Yi [MAR-kee yee] of Zheng [jung], in the province of Hubei [hoo-bay], gives us some feeling for the accomplishment of the Zhou in both bronze and music. The carillon consists of 65 bells, each capable of producing two distinct tones when hit either at the center or the rim. Thus, a musician playing the carillon had 130 different pitches or notes (compared to 88 on a modern piano) available in octaves of up to 10 notes. Seven zithers, two pipes, three flutes, and three drums were also found in the tomb (together with the bodies of eight young women and a dog). It is not known whether these bells and instruments were designed for ceremonial and ritual use, or whether they were played for the simple pleasure of Marquis Yi. But the skill required both to make and to play them is beyond doubt.

The Book of Songs The interest in music evidenced in the tomb of Marquis Yi was shared by the culture as a whole, which the collection known as the *Book of Songs* (*Shi jing* [she jee-ung]), cited on page 111, makes clear. The original *Book of Songs*, compiled by the Zhou in about 600 BCE, consisted of some 3,000 poems, all meant to be sung. They address almost every aspect of Zhou life. There are love poems, songs celebrating the king's rule, sacrificial hymns, and folk songs. Descriptions of nature abound—over 100 kinds of plants are mentioned, as well as 90 kinds of animals and insects. Marriage practices, family life, clothing, food, are all subjects of poems.

Spiritual Beliefs: Daoism and Confucianism The songs in the *Shi jing* are contemporary with the poems that make up the *Dao de jing* [dow duh jee-ung] (*The Way and Its Power*), the primary philosophical treatise, written in verse, of Daoism, the Chinese mystical school of thought. The *Dao*

("the way") is deeply embedded in nature, and to experience it, the individual must let go of the self through contemplation and enter into the flow of life. Contemplation of the teachings in the 5,000-word *Dao de jing* aids this process. The book consists of 81 poems believed to have been composed by Lao Zi [lou zuh] ("the Old One") in the sixth century BCE. In essence, it argues for a unifying principle in all nature, what the Chinese call *qi* [chee]. The *qi* can be understood only by those who live in total simplicity, and the Dao is the path to such a life. The Daoist engages in strict dietary practices, breathing exercises, and meditation. In considering such images as the one expressed in the following poem, the first in the volume, the Daoist finds his or her way to enlightenment (**Reading 4.2**):

READING 4.2 from the *Dao de jing*

There are ways but the Way is uncharted;
There are names but not nature in words:
Nameless indeed is the source of creation
But things have a mother and she has a name.

The secret waits for the insight
Of eyes unclouded by longing;
Those who are bound by desire
See only the outward container.

These two come paired but distinct
By their names.
Of all things profound,
Say that their pairing is deepest,
The gate to the root of the world.

The final stanza seems to be a direct reference to the principle of yin-yang, itself a symbol of the *qi*. But the chief argument here, and the argument of the Dao as a whole, is that enlightenment lies neither in the visible world nor in language, although to find the "way" one must, paradoxically, pass through or utilize both. Daoism thus represents a spiritual desire to transcend the material world.

If Daoism seeks to leave the world behind, the second great canon of teachings developed during the Zhou dynasty, Confucianism, seeks to define the proper way to behave *in* the world. For 550 years, from about 771 BCE to the final collapse of the Zhou in 221 BCE, China was subjected to ever greater political turmoil as warring political factions struggled for power. Reacting to this state of affairs was the man many consider China's greatest philosopher and teacher, Kong Fu Zi, or, as he is known in the West, Confucius.

Confucius was born to aristocratic parents in the province of Shandong in 551 BCE, the year before Peisistratos [pie-SIS-trah-tus] came to power in Athens. By his early twenties, Confucius had begun to teach a way of life, Confucianism, based on self-discipline and proper relations among people. If each individual led a virtuous life, then the family would live in harmony. If the family lived in harmony, then the village would follow its moral leadership. If the village exercised proper behavior toward its neighbor villages, then the country would live in peace and thrive.

Traditional Chinese values—values that Confucius believed had once guided the Zhou, such as self-control, propriety, and virtuous behavior—lie at the core of this system. In order to capture these values, tradition has it that Confucius compiled and edited *The Book of Changes*, *The Book of Songs* (which he edited down to 305 verses), and four other "classic" Chinese texts: *The Book of History*, containing speeches and pronouncements of historical rulers; *The Book of Rites*, which is essentially a code of conduct; *The Spring and Autumn Annals*, a history of China up to the fifth century BCE; and a lost treatise on music.

Confucius particularly valued *The Book of Songs*. "My little ones," he told his followers, "why don't you study the *Songs*? Poetry will exalt you, make you observant, enable you to mix with others, provide an outlet for your vexations; you learn from it immediately to serve your parents and ultimately to serve your prince. It also provides wide acquaintance with the names of birds, beasts, and plants."

After his death, in 479 BCE, Confucius's followers wrote down his words in a book known in English as the *Analects*. (For a selection, see **Reading 4.3** on page 126.) Where the *Dao de jing* is a spiritual work, the *Analects* is a practical one. At the heart of Confucius's teaching is the principle of *li* [lee]—civility, propriety—in short, etiquette. Politeness and good manners lead to the second principle, *jen*, or the ideal relationship that should exist among all people. Based on respect for oneself, *jen* extends this respect to all others, manifesting itself as charity, courtesy, and above all, justice. *Te* [tuh] is the power of moral example that an individual, especially a ruler, can exert through a life dedicated to the exercise of *li* and *jen*. Finally, in the ideal culture thus created, *wen*, or the arts of peace, will result. Poetry, music, painting, and the other arts will all reveal an inherent order and harmony reflecting the order and harmony of the state. Like the excellent leader, they provide a model of virtue. The Chinese moral order, like that of the Greeks (see chapter 6), did not depend upon divine decree or authority, but instead upon the people's own right actions. A scene from a painted handscroll of a later period, known as *Admonitions of the Imperial Instructress to Court Ladies* (Fig. **4.8**), illustrates a Confucian story of wifely virtue and proper behavior. As the viewer unrolled the scroll (handscrolls were not meant to be viewed all at once, as displayed in modern museums, but unrolled right to left a foot or two at a time, to savor the details), he or she would

Fig. 4.8 *Admonitions of the Imperial Instructress to Court Ladies* (detail), attributed to Gu Kaizhi. Six Dynasties period, ca. **344–464** CE. Handscroll, ink, and colors on silk, $9\frac{3}{4}'' \times 11'6''$. © The British Museum, London. This handscroll, painted nearly 900 years after the death of Confucius, shows his impact on Chinese culture.

CULTURAL PARALLELS

China and the Roman Republic Protect Their Borders

At about the time that Shihuangdi battled invaders from the north, eventually constructing the Great Wall, the early Roman Republic struggled to control its southern frontier, the Mediterranean Sea. It eventually embarked on a series of wars with its most powerful maritime competitor, the Phoenician city-state of Carthage.

observe a bear, escaped from the circus, attacking the Emperor, who cowers in fear at the right. Two panicked male attendants try to keep the bear at bay, but Lady Feng [fung] courageously steps forward to place herself between the bear and the emperor. She illustrates the fifth rule of Confucian philosophy—*yi* [yee], or duty, the obligation of the wife to her husband and of the subject to her ruler.

Its emphasis on respect for age, authority, and morality made Confucianism extremely popular among Chinese leaders and the artists they patronized. It embraced the emperor, the state, and the family in a single ethical system with a hierarchy that was believed to mirror the structure of the cosmos. As a result, the Han [hahn] dynasty (first century BCE) adopted Confucianism as the Chinese state religion, and a thorough knowledge of the Confucian classics was subsequently required of any politically ambitious person. Despite the later ascendancy among intellectuals of Daoism and Buddhism (which would begin to flourish in China after the collapse of the Han dynasty in 220 CE), Confucianism continued to be the core of civil service training in China until 1911, when the Chinese Republic ended the dynastic system. Some 6 million Chinese call themselves Confucianists today, even though Mao Zedong [mou zuh-dong], chairman of the Chinese Communist Party from 1945 until his death in 1976, conducted a virulent campaign against Confucian thought. In fact, the non-communist "Little Dragons" of East Asia—Hong Kong, Singapore, Taiwan, and South Korea—would all attribute their economic success in the 1980s to their Confucian heritage.

Imperial China

At the same time that Rome rose to dominance in the West (see chapter 8), a similar empire arose in China. But where Rome's power gradually diminished in the first centuries of the Common Era, Chinese imperial rule became stronger and stronger, until, by the second half of the first millennium, it was without equal in the world.

The Qin Dynasty (221–206 BCE): Organization and Control

The process began in 221 BCE, when China was unified for the first time in over 500 years by the Qin (or "Chin," the origin of our name for China). Under the leadership of Shihuangdi [shuh-hwang-dee] (r. 221–210 BCE), who declared himself "First Emperor," the Qin worked very quickly to achieve a stable society. To discourage disruptive invasions from the north by the Huns (a frequent occurrence in the previous centuries), they organized a workforce of 700,000 men to build a wall 1,500 miles long from the Yellow Sea east of modern Beijing far into Inner Mongolia, known today as the Great Wall of China (see Fig. 4.1).

The wall was constructed by a labor force of some 300,000 soldiers, augmented by criminals, civil servants who found themselves in disfavor, and conscripts from across the countryside. Each family was required to provide one able-bodied adult male to work on the wall each year. It was made of beaten earth, reinforced by continuous, horizontal courses of brushwood, and faced with stone. Watchtowers were built at high points, and military barracks were built in the valleys below. At the same time, the Chinese constructed nearly 4,350 miles of roads, linking even the farthest reaches of the country to the Central Plain. By the end of the second century CE, China had some 22,000 miles of roads serving a country of nearly 1.5 million square miles.

Such a massive undertaking could only have been accomplished by an administrative bureaucracy of extraordinary organizational skill. Indeed, in the 15 years that the Qin ruled China, the written language was standardized, a uniform coinage was introduced, all wagon axles were required to be the same width so that they would uniformly fit in the existing ruts on the Chinese roads (thus accommodating trade and travel), a system of weights and measures was introduced, and the country was divided into the administrative and bureaucratic provinces that exist to the present day.

Perhaps nothing tells us more about Qin organization and control than the tomb of its first emperor, Shihuangdi (see *Focus*, pages 116–117). When he died, he was buried with 8,000 life-size earthenware figures, each armed with actual swords and crossbows, all of whom would, presumably, serve him in the afterlife. Like the Great Wall, this monumental undertaking required an enormous workforce, and we know that the Qin enlisted huge numbers of workers in this and its other projects.

The Philosophy of Han-fei-tzu To maintain control, in fact, the Qin suppressed free speech, persecuted scholars, burned classical texts, and otherwise exerted an absolute power. They based their thinking on the writings of Han-fei-tzu [hahn-fay-dzuh], who had died in 233 BCE, just before the Qin took power. Orthodox Confucianism had been codified by Meng-tzu [mung dzuh], known as Mencius [men-shus] (ca. 372–289 BCE), an itinerant philosopher and sage, who argued for the innate goodness of the individual. He believed that bad character was a result of society's inability to provide a

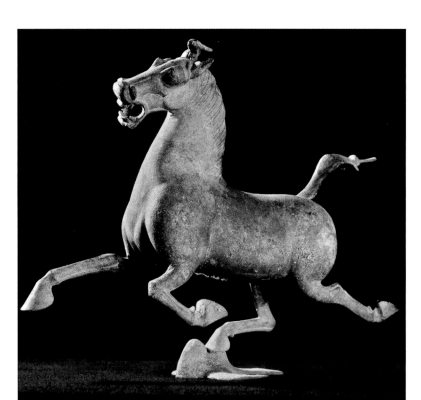

Fig. 4.9 *Flying Horse Poised on One Leg on a Swallow,* from the tomb of Governor-General Zhang at Wuswei, Gansu. Late Han dynasty, 2nd century CE. Bronze, 13 1/2″ × 17 3/4″. National Palace Museum, Beijing. According to Chinese tradition, these horses sweated blood, perhaps the result of a parasitic infection. The Chinese, incidentally, also imported grass seed to feed these horses.

positive, cultivating atmosphere in which individuals might realize their capacity for goodness. Han-fei-tzu, on the other hand, argued that human beings were inherently evil and innately selfish (exactly the opposite of Mencius's point of view). **Legalism**, as Han Fei's philosophy came to be called, required that the state exercise its power over the individual, because no agency other than the state could instill enough fear in the individual to elicit proper conduct. The Qin Legalist bureaucracy, coupled with an oppressive tax structure imposed to pay for their massive civil projects, soon led to rebellion, and after only 15 years in power, the Qin collapsed.

The Han Dynasty (206 BCE–220 CE): The Flowering of Culture

In place of the Qin, the Han dynasty came to power, inaugurating over 400 years of intellectual and cultural growth. The Han emperors restored Confucianism as the official state philosophy and established an academy to train civil servants. Where the Qin had disenfranchised scholars, the Han honored them, even going so far as to give them a role in governing the country.

Han prosperity was constantly threatened by incursions of nomadic peoples to the north, chiefly the Huns, whom the Chinese called Xiongnu [she-ong-noo], and whose impact would later be felt as far away as Rome. In 182 BCE, Emperor Wu attempted to forge military alliances with Huns, sending General Zhang Qian [jahng chee-an] with 100 of his best fighting men into the northern territories. The Huns held General Zhang captive for ten years. When he returned, he spoke of horses that were far stronger and faster than those in China. Any army using them, he believed, would be unbeatable. In fact, horses could not be bred successfully in China owing to a lack of calcium in the region's water and vegetation, and until General Zhang's report, the Chinese had known horses only as small, shaggy creatures of Mongolian origin. To meet the Huns on their own terms, with cavalry instead of infantry, China needed Western horses.

"The Heavenly Horses" A small bronze horse found in the tomb of General Zhang at Wuwei [woo-way] in Gansu [gahn-soo] represents the kind of horse to which the Chinese aspired (Fig. **4.9**). Its power is captured in the energetic lines of its composition, its flaring nostrils and barreled chest. But it is, simultaneously, perfectly, almost impossibly, balanced on one leg, as if defying gravity, having stolen the ability to fly from the bird beneath its hoof. In 101 BCE, the emperor Wu, awaiting delivery of 30 such horses in the Chinese capital of Chang'an [chahng-ahn], composed a hymn in their honor:

The Heavenly Horses are coming,
Coming from the Far West . . .
The Heavenly Horses are coming
Across the pastureless wilds
A thousand leagues at a stretch,
Following the eastern road . . .
Should they choose to soar aloft,
Who could keep pace with them?
The Heavenly Horses are coming. . .

Focus

The Tomb of Shihuangdi

One day in 1974, peasants digging a well on the flat plain 1,300 yards east of the huge Qin dynasty burial mound of the Emperor Shihuangdi in the northern Chinese province of Shaanxi [shahn-shee] unearthed parts of a life-size clay soldier—a head, hands, and body. Archeologists soon discovered an enormous subterranean pit beneath the fields containing an esti-mated 6,000 infantrymen, most standing four abreast in 11 parallel trenches paved with bricks. In 1976 and 1977, two smaller but equally spectacular sites were discovered north of the first one, containing another 1,400 individual warriors and horses, complete with metal weaponry.

Shihuangdi's actual tomb has never been excavated. It rises 140 feet above the plain. Historical records indicated that below the

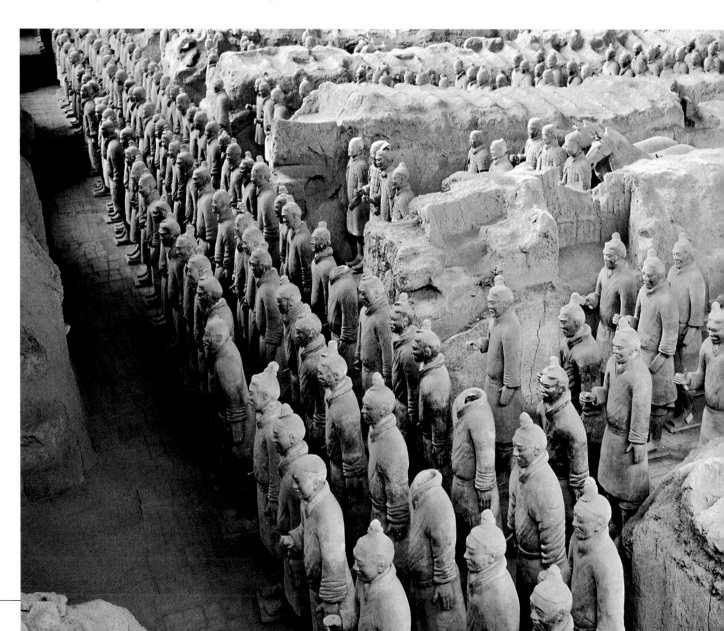

mound is a subterranean palace estimated to be about 400 feet by 525 feet. According to the *Shi Ji* [shee jee] (*Historical Records*) of Sima Qian [shee-mah chee-an], a scholar from the Han dynasty, the emperor was buried there in a bronze casket surrounded by rivers of mercury. Scientific tests conducted by Chinese archeologists confirm the presence of large quantities of mercury under the burial mound. Magnetic scans of the tomb have also revealed large numbers of coins, suggesting the emperor was buried with his treasury.

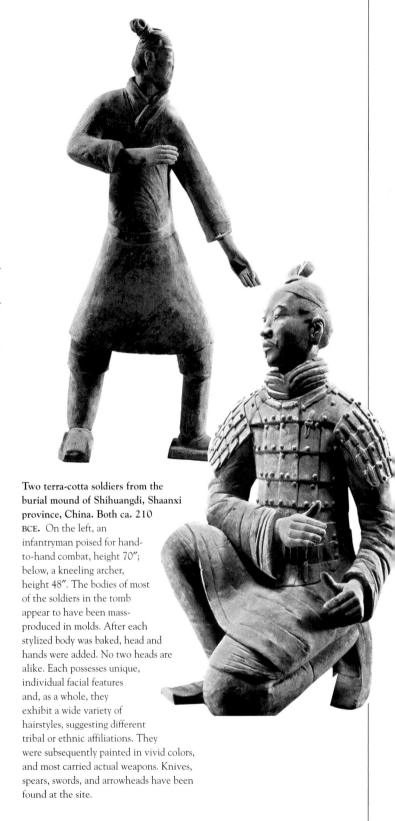

Two terra-cotta soldiers from the burial mound of Shihuangdi, Shaanxi province, China. Both ca. 210 BCE. On the left, an infantryman poised for hand-to-hand combat, height 70″; below, a kneeling archer, height 48″. The bodies of most of the soldiers in the tomb appear to have been mass-produced in molds. After each stylized body was baked, head and hands were added. No two heads are alike. Each possesses unique, individual facial features and, as a whole, they exhibit a wide variety of hairstyles, suggesting different tribal or ethnic affiliations. They were subsequently painted in vivid colors, and most carried actual weapons. Knives, spears, swords, and arrowheads have been found at the site.

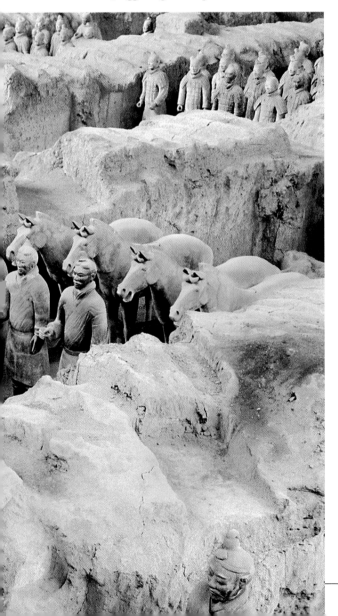

Soldiers and horses, from the tomb of Emperor Shihuangdi, Lintong, Shaanxi, China. Qin dynasty, ca. 210 BCE. Terra cotta, life-size. It is very likely that the practice of fashioning clay replicas of humans for burial at mausoleum sites replaced an earlier practice of actual human sacrifice. Over 700,000 people were employed in preparing Shihuangdi's tomb—more than the forces enlisted in building the Great Wall.

117

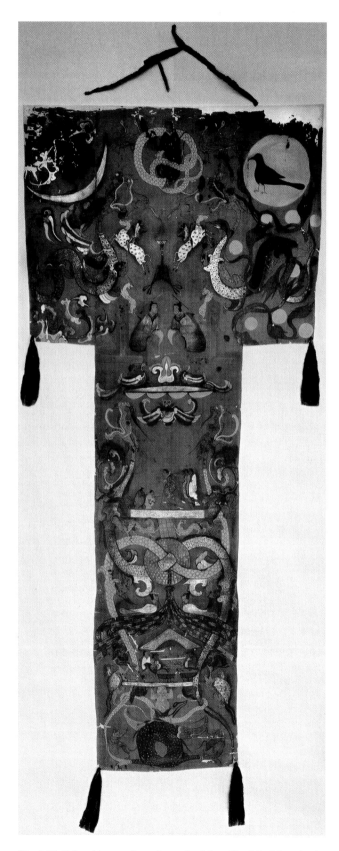

Fig. 4.10 Painted banner from the tomb of the wife of the Marquis of Dai, Mawangdui, Changsha, Hunan. Han dynasty, ca. 160 BCE. Colors on silk, height 6′ 8 1/2″. Hunan Provincial Museum. The banner was found in the innermost of the nested coffins opened in 1972.

Han Silk Aside from their military value, horses advanced the growth of trade along the Silk Road. Nearly 5,000 miles long, this trade route led from the Yellow River valley to the Mediterranean, and along it, the Chinese traded their most valuable commodity, silk. (See *Continuity and Change*, page 131.) The quality of Han silk is evident in a silk banner from the tomb of the wife of the Marquis of Dai, discovered on the outskirts of present-day Changsha [chahng-shah] in Hunan [hoo-nahn] (Fig. **4.10**). Painted with scenes representing the underworld, the earthly realm, and the heavens, it represents the Han conception of the cosmos. Long, sinuous, tendril-like lines representing dragons' tails, coiling serpents, long-tailed birds, and flowing draperies unify the three realms. In the right corner of the heavenly realm, above the crossbar of the T, is an image of the sun containing a crow, and in the other corner is a crescent moon supporting a toad. Between them is a deity entwined within his own long, red serpent tail. The deceased noblewoman herself stands on the white platform in the middle region of the banner. Three attendants stand behind her and two figures kneel before her, bearing gifts. On the white platform of the bottom realm, bronze vessels contain food and wine for the deceased.

Cartography, Paper, and Technology Motivated by trade, the Han began to make maps, becoming the world's first cartographers. They invented paper, as well as important agricultural technologies such as the wheelbarrow and horse collar. They learned to measure the magnitude of earthquakes with a crude but functional seismograph. Persistent warring with the Huns required money to support military and bureaucratic initiatives. Unable to keep up with increased taxes, many peasants were forced off the land and popular rebellion ensued. By the third century CE, the Han dynasty had collapsed.

Ancient India

Indian civilization was born along the Indus [IN-duhs] River in the northwest corner of the Indian subcontinent somewhere around 2700 BCE in an area known as Sind—from which the words *India* and *Hindu* originate (see Map **4.2**). The earliest Indian peoples lived in at least two great cities in the Indus valley, Mohenjo-daro [moh-HEN-joh-DAR-oh], on the banks of the Indus, and Harappa [huh-RAH-puh], on the river Ravi [RAH-vee], downstream from modern Lahore [luh-HORE]. By the early years of the second millennium they were adept at bronze casting, and, as the stone sculpture torso of a "priest-king" (Fig. **4.11**) from Mohenjo-daro demonstrates, they were accomplished artists. This figure, with his neatly trimmed beard, is a forceful representation of a powerful personality. The peoples of the valley even had a written language, although it remains undeciphered.

Sometime around 1500 BCE the Aryans [AIR-ee-uhnz], nomads from the north, invaded the Indus River valley and conquered its inhabitants, making them slaves. Thus began

the longest-lasting set of rigid, class-based societal divisions in world history, the Indian caste system. By the beginning of the first millennium BCE, these castes consisted of five principal groups, based on occupation: At the bottom of the ladder was a group considered "untouchable," people so scorned by society that they were not even considered a caste. Next in line were the Shudras [SHOO-druhz], unskilled workers. Then came the Vaishyas [VYSH-yuhz], artisans and merchants. They were followed by the Kshatriyas [kuh-SHAHT-ree-uhz], rulers and warriors. At the highest level were the Brahmins [BRAH-minz], priests and scholars.

Hinduism and the Vedic Tradition

The social castes were sanctioned by the religion the Aryans brought with them, a religion based on a set of sacred hymns to the Aryan gods. These hymns, called *Vedas* [VAY-duhz], were written in the Aryan language, Sanskrit, and they gave their name to an entire period of Indian civilization, the Vedic [VAY-dik] period (ca. 1500–322 BCE). From the *Vedas* in turn came the *Upanishads* [oo-PAHN-ih-shadz], a book of mystical and philosophical texts that date from sometime after 800 BCE. Taken together, the *Vedas* and the *Upanishads* form the basis of the Hindu religion, with Brahman, the universal soul, at its center. The religion has no single body of doctrine, nor any standard set of practices.

The *Upanishads* argue that all existence is a fabric of false appearances. What appears to the senses is entirely illusory. Only Brahman is real. Thus, in a famous story illustrating the point, a tiger, orphaned as a cub, is raised by goats. It learns, as a matter of course, to eat grass and make goat sounds. But one day it meets another tiger, who takes it to a pool to look at itself. There, in its reflection in the water, it discovers its true nature. The individual soul needs to discover the same truth, a truth that will free it from the endless cycle of birth, death, and rebirth and unite it with the Brahman in **nirvana** [nir-VAH-nuh], a place or state free from worry, pain, and the external world.

Fig. 4.11 Torso of a "priest-king" from Mohenjo-daro, Indus valley civilization. ca. 2000–1900 BCE. Steatite, height 7⅞". National Museum of Pakistan, Karachi, Pakistan. The look created by the figure's half-closed eyes suggests that this might be a death mask of some sort. The *trefoil*, or three-lobed decorations on the garment that crosses his chest, were originally filled with red paint.

Brahman, Vishnu, and Shiva As Hinduism [HIN-doo-iz-um] developed, the functions of Brahman, the divine source of all being, were split among three gods: Brahma, the creator; Vishnu [VISH-noo], the preserver; and Shiva [SHEE-vuh], the destroyer. Vishnu was one of the most popular of the Hindu deities. In his role as preserver he is the god of benevolence, forgiveness, and love, and like the other two main Hindu gods he was believed capable of assuming human form, which he did more often than the other gods due to his great love for humankind.

Among Vishnu's most famous incarnations is his appearance as Rama [rah-mah] in the oldest of the Hindu epics, the *Ramayana* [rah-mah-yuh-nuh] (*Way of Rama*), written by Valmiki [vahl-MIH-kee] in about 550 BCE. Like Homer in ancient Greece, Valmiki gathered together many existing legends and myths into a single story, in this case narrating the lives of Prince Rama and his queen, Sita [SEE-tuh]. The two serve as models of Hindu life. Rama is the ideal son, brother, husband, warrior, and king, and Sita loves, honors, and serves her husband with absolute and unquestioning fidelity. These characters face moral dilemmas to which they must react according to **dharma** [DAHR-muh], good and righteous conduct reflecting the cosmic moral order that underlies all existence. For Hindus, correct actions can lead to cosmic harmony, and bad actions, violating dharma, can trigger cosmic tragedies such as floods and earthquakes.

An equally important incarnation of Vishnu is as the charioteer Krishna [KRISH-nuh] in the later Indian epic the *Mahahbarata* [muh-ha-BAHR-uh-tuh], composed between 400 BCE and 400 CE. In the sixth book of the *Mahahbarata*, titled the *Bhagavad Gita* [BUH-guh-vud GHEE-tuh] (see **Reading 4.4**, page 127), Krishna comes to the aid of Arjuna [ahr-JOO-nuh], a warrior who is tormented by the

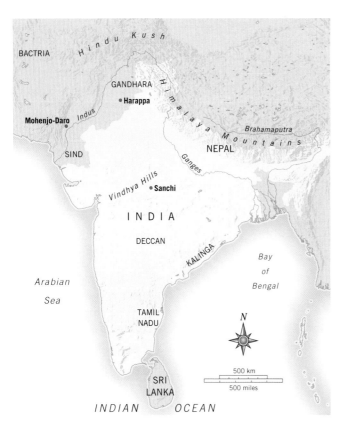

Map 4.2 India around 1500 BCE. Cut off from the rest of Asia by high mountains to the north, India was nevertheless a center of trade by virtue of its prominent maritime presence.

conflict between his duty to fight and kill his kinsmen in battle and the Hindu prohibition against killing. Krishna explains to Arjuna that as a member of the Kshatriya caste—that is, as a warrior—he is freed from the Hindu sanction against killing. In fact, by fighting well and doing his duty, he can free himself from the endless cycle of birth, death, and reincarnation, and move toward spiritual union with the Brahman.

But Vishnu's popularity is probably most attributable to his celebration of erotic love, which to Hindus symbolizes the mingling of the self and the absolute spirit of Brahman. In the *Vishnu Puranas* [poor-AH-nuhz] (the "old stories" of Vishnu), collected about 500 CE, Vishnu, in his incarnation as Krishna, is depicted as seducing one after another of his devotees. In one story of the *Vishnu Puranas*, he seduces an entire band of milkmaids: "They considered every instant without him a myriad of years; and prohibited (in vain) by husbands, fathers, brothers, they went forth at night to sport with Krishna, the object of their affection." Allowing themselves to be seduced does not suggest that the milkmaids were immoral, but shows an almost inevitable manifestation of their souls' quest for union with divinity.

If Brahma is the creator of the world, Shiva takes what Brahma has made and embodies the world's cyclic rhythms. Since in Hinduism, creation follows destruction, Shiva, though a god of destruction, is regarded as a reproductive power as well, one who restores what has been dissolved. In this reproduction mode, he is represented as the *linga* [LING-uh] (phallus), a symbol of regeneration. Shiva is also commonly portrayed as Shiva Nataraja [nah-tuh-RAH-juh], Lord of the Dance (Fig. **4.12**), framed in a circle of fire, symbolic of both creation and destruction, the endless cycle of birth, death, and reincarnation. Since Shiva embodies the rhythms of the universe, he is also a great dancer. All the gods were present when Shiva first danced, and they begged him to dance again. Shiva promised to do so in the hearts of his devotees as well as in a sacred grove in Tamil Nadu [TA-mul NAH-doo] in southern India. Artists there are responsible for many of the images of Shiva dancing, such as the one illustrated here.

Buddhism: "The Path of Truth"

Because free thought and practice mark the Hindu religion, it is hardly surprising that other religious movements drew on it and developed from it. Buddhism is one of those. Its founder, Shakyamuni [SHAHK-yuh-moo-nee] Buddha, lived from about 563 to 483 BCE. He was born Prince Siddhartha Gautama [sid-DAR-thuh gau-tah-muh], child of a ruler of the Shakya [SHAK-yuh] clan—Skakyamuni means "sage of the Shakyas"—and was raised to be a ruler himself. Troubled by what he perceived to be the suffering of all human beings, he abandoned the luxurious lifestyle of his father's palace to live in the wilderness. For six years he meditated, finally attaining complete enlightenment while sitting under a bo, or fig, tree at Bodh Gaya [bod GUY-ah]. Shortly thereafter he gave his first teaching, at the Deer Park at Sarnath, expounding the Four Noble Truths:

1. Life is suffering.
2. This suffering has a cause, which is ignorance.
3. Ignorance can be overcome and eliminated.
4. The way to overcome this ignorance is by following the Eightfold Path of right view, right resolve, right speech, right action, right livelihood, right effort, right mindfulness, and right concentration.

Living with these truths in mind, one might overcome what Buddha believed to be the source of all human suffering—the desire for material things, which is the primary form of ignorance. In doing so, one would find release from the illusions of the world, from the cycle of birth, death, and rebirth, and ultimately reach nirvana. These principles are summed up in the *Dhammapada* [dah-muh-PAH-duh], the most popular canonical text of Buddhism, which consists of 423 aphorisms, or sayings, attributed to Buddha and arranged by subject into 26 chapters (see **Reading 4.5**, page 128). Its name is a com-

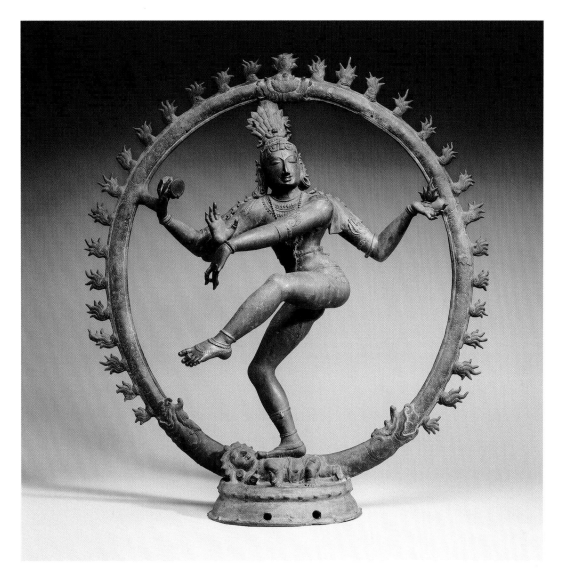

Fig. 4.12 *Shiva Nataraja, Lord of the Dance,* **from Southern India. Eleventh century** CE. Copper, height 43 ⅛″.
© The Cleveland Museum of Art. Purchase from the J. H. Wade Fund, 1930.331. Bronze and copper images of Shiva
dancing were produced in large editions by tenth- and eleventh-century artists of Tamil Nadu, in South India.

pound consisting of *dhamma,* the vernacular form of the for-mal Sanskit word *dharma,* mortal truth, and *pada,* meaning "foot" or "step"—hence it is "the path of truth." The apho-risms are widely admired for their wisdom and their some-times stunning beauty of expression.

The Buddha (which means "Enlightened One") taught for 40 years until his death at age 80. His followers preached that anyone could achieve buddhahood, the ability to see the ulti-mate nature of the world. Persons of very near total enlight-enment, but who have vowed to help others achieve buddhahood before crossing over to nirvana, came to be known as **bodhisattvas** [boh-dih-SUT-vuhz], meaning "those whose essence is wisdom." In art, bodhisattvas wear the princely garb of India, while buddhas wear a monk's robe.

Buddhism, which aims to end suffering, became the official state religion as a reaction to warfare. On a battlefield in 261 BCE, the emperor Ashoka [uh-SHOH-kuh] (r. ca. 273–232 BCE) was appalled by the carnage he had inflicted in his role as a war-rior king. As he watched a monk walking slowly among the dead, Ashoka was moved to decry violence and force of arms and to spread the teachings of Buddha. From that point Ashoka, who had been described as "the cruel Ashoka"), began to be known as "the pious Ashoka." He pursued an official pol-icy of nonviolence. The unnecessary slaughter or mutilation of animals was forbidden. Sport hunting was banned, and although the limited hunting of game for the purpose of con-sumption was tolerated, Ashoka promoted vegetarianism. He built hospitals for people and animals alike, preached the

humane treatment of all living things, and regarded all his subjects as equals, regardless of politics, religion, or caste. He also embarked on a massive Buddhist architectural campaign, erecting as many as 8,400 shrines and monuments to Buddha throughout the empire, including a series of pillars spread across the empire engraved with proclamations reflecting Buddhist teachings. Soon, Buddhism would spread beyond India, and Buddhist monks from China traveled to India to observe Buddhist practices (see *Voices*, page 123).

Buddhist Architecture: The Great Stupa Among the most famous of the Buddhist monuments that Ashoka erected is the Great Stupa [STOO-puh] at Sanchi [SAHN-chee] (Fig. **4.13**), which was enlarged in the second century BCE. A **stupa** is a kind of burial mound. The earliest eight of them were built around 483 BCE as reliquaries for Buddha's remains, which were themselves divided into eight parts. In the third century, Ashoka opened the original eight stupas and further divided Buddha's relics, scattering them among a great many other stupas, probably including Sanchi.

The stupa as a form is deeply symbolic, consisting first and foremost of a hemispheric dome, built of rubble and dirt and faced with stone, evoking the Dome of Heaven (see the plan, Fig. **4.14**). Perched on top of the dome is a small square platform, in the center of which is a mast supporting three circular discs or "umbrellas," called chatras [CHAH-truz]. These signify both the bo tree beneath which Buddha achieved enlightenment and the three levels of Buddhist consciousness—desire, form, formlessness—through which the soul ascends to enlightenment. The dome is set on a raised base, around the top of which is a circumambulatory walkway. As pilgrims to the stupa circle the walkway, they symbolically

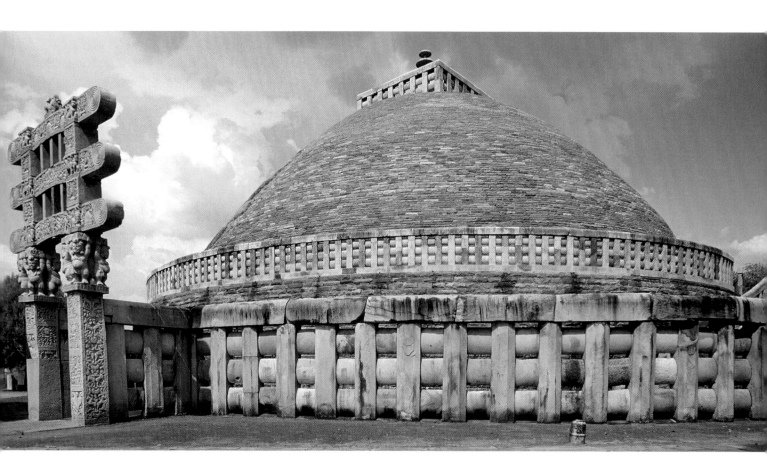

Fig. 4.13 The Great Stupa, Sanchi, Madhya Pradesh, India, view of the West Gateway. Founded 3rd century BCE, enlarged ca. 150–50 BCE. Shrine height 50′, diameter 105′. In India, the stupa is the principal monument to Buddha. The stupa symbolizes, at once, the World Mountain, the Dome of Heaven, and the Womb of the Universe.

VOICES

A Chinese Buddhist Monk Visits Indian Kingdoms

*Faxian was a Chinese Buddhist monk who traveled through-
out India, Ceylon, Sumatra, and Tibet to gather Buddhist
scriptures. When he returned to China after more than a
dozen years (399–412* CE*), he set about translating these
works. His* A Record of Buddhistic Kingdoms *offers an
account of his journey and is as enlightening for what it says
about his own society and expectations as it is about the con-
ditions of the Indian kingdoms he visited.*

> **"Criminals are simply fined, lightly or heavily,
> according to the circumstances. Even in the
> cases of repeated attempts at wicked rebellion,
> they only have their right hands cut off."**

From this place they travelled south-east, passing by
a succession of very many monasteries, with a mul-
titude of monks, who might be counted by myriads.
After passing all these places, they came to a country
named Muttra. They still followed the course of the P'oo na
river, on the banks of which, left and right, there were
twenty monasteries, which might contain three thousand
monks . . .

South from this is named the Middle Kingdom. In it
the cold and heat are finely tempered, and there is nei-
ther hoarfrost nor snow. The people are numerous and
happy; they have not to register their households, or
attend to any magistrates and their rules; only those who
cultivate the royal land have to pay (a portion of) the
gain from it. If they want to go, they go; if they want to
stay on, they stay. The king governs without decapitation
or corporal punishments. Criminals are simply fined,
lightly or heavily, according to the circumstances. Even
in the cases of repeated attempts at wicked rebellion,
they only have their right hands cut off. The king's body-
guards and attendants all have salaries. Throughout the
whole country the people do not kill any living creature,
nor drink intoxicating liquor, nor eat onions or garlic.
The only exception is that of the Chandalas [outcastes].
That is the name for those who are wicked men, and live
apart from others. When they enter the gate of a city or
a market-place, they strike a piece of wood to make
themselves known, so that men know and avoid them,
and do not come into contact with them. In that country
they do not keep pigs and fowls, and do not sell live cat-
tle; in the markets there are no butchers' shops and no
dealers in intoxicating drink . . . Only the Chandalas,
fishermen, and hunters, sell flesh meat.

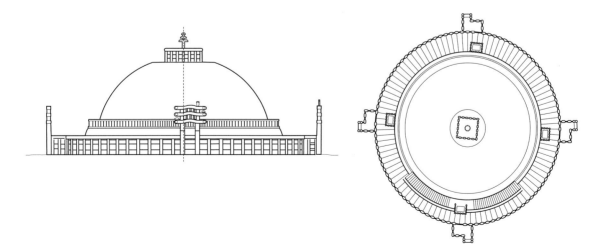

Fig. 4.14 Elevation and plan of the Great Stupa. One of the most curious aspects of the Great Stupa is that its four
gates are not aligned on an axis with the four openings in the railing. Some scholars believe that this arrangement is
derived from gates on farms, which were designed to keep cattle out of the fields.

follow Buddha's path, awakening to enlightenment. The whole is a **mandala** [MUN-duh-luh] (literally "circle"), the Buddhist diagram of the cosmos.

Leading out from the circular center of the stupa are four gates, positioned at the cardinal points, that create directional "rays," or beams of teaching, emanating from the "light" of the central mandala. They are 32 feet high and decorated with stories from the life of Buddha, as well as other sculp-tural elements including vines, lotuses, peacocks, and elephants (Fig. 4.15). Extending as a sort of bracket from the side of the east gateway is a *yakshi* [YAK-shee], a female spirit figure that probably derives from Vedic tradition. The *yakshi* symbolizes the productive forces of nature. As in Hinduism, sexuality and spirituality are visually represented here as forms of an identical cosmic energy, and the sensuous curves of the *yakshi* emphasize her deep connection to the

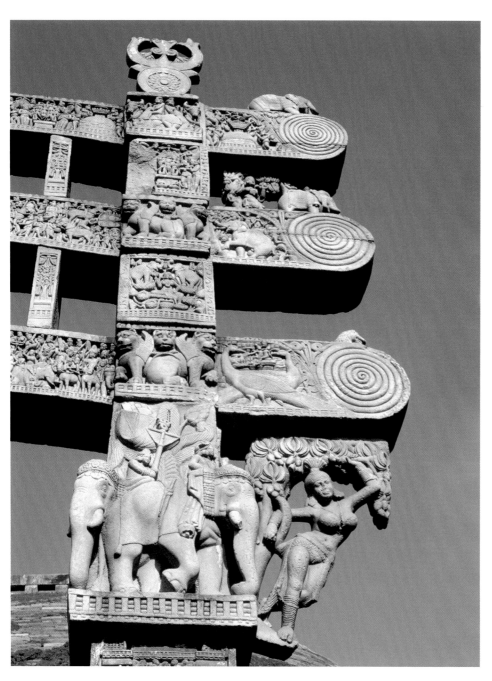

Fig. 4.15 Column capital on the East Gate of the Great Stupa, Sanchi. Stone, height of gate, 32′. The carved elephants that serve as the capital to the gateway column are traditional symbols of Buddha, signs of his authority and spiritual strength. A *yakshi* figure serves as a bracket at the right front of the elephant.

creative force. In fact, here she seems to cause the fruit in the tree above her head to ripen, as if she is the source of its nourishment.

The *yakshi* and the gate she decorates embody the distinctive sense of beauty that is characteristic of Indian art. Both are images of abundance that reflect a belief in the generosity of spirit that both Buddha and the Hindu gods share. Sensuous form, vibrant color, and a profusion of ornament dominate Indian art as a whole, and the rich textures of this art are meant to capture the very essence of the divine.

Ancient Africa

On the other side of the world, on the west coast of Africa, early societies were also developing artistic traditions. Because these cultures had no written language, and in many cases worked in materials that were not permanent, what little of their artwork that has survived is difficult to interpret. We do not know how these earliest cultures were organized, what their lives were like, or what they believed. We do not even know what they called themselves, and today they are identified instead by the contemporary names of the places where artifacts have been found.

The Nok

One such group is the Nok. In the early twentieth century near the town of Nok in modern Nigeria, fragments of fired clay were unearthed by miners over an area of approximately 100 square kilometers. Carbon 14 and other forms of dating revealed that some of these objects had been made as early as 800 BCE and others as late as 600 CE. The Nok appear to have specialized in creating approximately life-size human and animal figures for an unknown purpose. Little more than the hollow heads have survived intact, revealing an artistry based on abstract geometrical shapes (Fig. **4.16**). In some cases the heads are represented as ovals, and in others

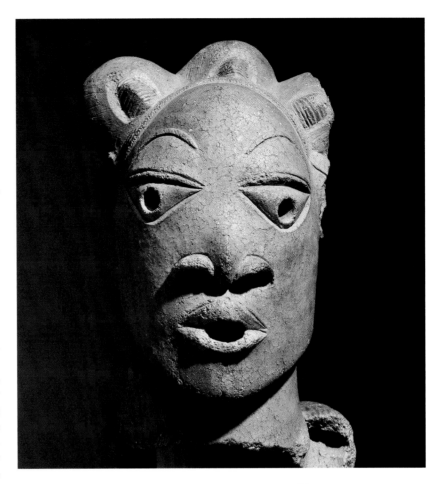

Fig. 4.16 Head, Nok ca. 500 BCE–200 CE. Terra cotta, height 14 $^{3}/_{16}$″. This slightly larger than life-size head was probably part of a complete body, and shows the Nok people's interest in abstract geometrical representations of facial features and head shape. Holes in the eyes and nose were probably used to control temperature during firing.

as cones, cylinders, or spheres. Facial features are combinations of ovals, triangles, graceful arches, and straight lines. These heads were probably shaped with wet clay and then, after firing, were finished by carving details into the hardened clay. Some scholars have argued that the technical and artistic sophistication of works by the Nok and other roughly contemporaneous groups suggests that it is likely there are older artistic traditions in Africa which have not as yet been discovered.

READINGS

READING 4.3

Confucius, from the *Analects*

The Analects *of Confucius are a collection of his dialogues and utterances, probably recorded by his disciples after his death. They reflect Confucius's dream of an ideal society of hardworking, loyal people governed by wise, benevolent, and morally upright officials—a government based on moral principles that would be reflected in the behavior of its populace.*

2-1 The Master said, "He who exercises government by means of his virtue may be compared to the north polar star, which keeps its place and all the stars turn towards it."

2-2 The Master said, "In the Book of Poetry are three hundred pieces, but the design of them all may be embraced in one sentence 'Having no depraved thoughts.'"

2-3 The Master said, "If the people be led by laws, and uniformity sought to be given them by punishments, they will try to avoid the punishment, but have no sense of shame."

"If they be led by virtue, and uniformity sought to be given them by the rules of propriety, they will have the sense of shame, and moreover will become good." . . .

4-3 The Master said, "It is only the truly virtuous man, who can love, or who can hate, others."

4-4 The Master said, "If the will be set on virtue, there will be no practice of wickedness."

4-5 The Master said, "Riches and honors are what men desire. If they cannot be obtained in the proper way, they should not be held. Poverty and meanness are what men dislike. If they cannot be avoided in the proper way, they should not be avoided." . . .

4-6 The Master said, "I have not seen a person who loved virtue, or one who hated what was not virtuous. He who loved virtue, would esteem nothing above it. He who hated what is not virtuous, would practice virtue in such a way that he would not allow anything that is not virtuous to approach his person." . . .

4-9 The Master said, "A scholar, whose mind is set on truth, and who is ashamed of bad clothes and bad food, is not fit to be discoursed with."

4-10 The Master said, "The superior man, in the world, does not set his mind either for anything, or against anything; what is right he will follow."

4-11 The Master said, "The superior man thinks of virtue; the small man thinks of comfort. The superior man thinks of the sanctions of law; the small man thinks of favors which he may receive."

4-12 The Master said, "He who acts with a constant view to his own advantage will be much murmured against." . . .

4-17 The Master said, "When we see men of worth, we should think of equaling them; when we see men of a contrary character, we should turn inwards and examine ourselves."

4-18 The Master said, "In serving his parents, a son may remonstrate with them, but gently; when he sees that they do not incline to follow his advice, he shows an increased degree of reverence, but does not abandon his purpose; and should they punish him, he does not allow himself to murmur." . . .

4-22 The Master said, "The reason why the ancients did not readily give utterance to their words, was that they feared lest their actions should not come up to them."

4-23 The Master said, "The cautious seldom err."

4-24 The Master said, "The superior man wishes to be slow in his speech and earnest in his conduct." . . . ■

Reading Question

Give two or three examples, from the previous passages, of the principle of *li* at work, and explain how *li* leads to *jen* (these terms are defined in the chapter).

READING 4.4

from "The Second Teaching" in the *Bhagavad Gita: Krishna's Counsel in Time of War*

The Bhagavad Gita *constitutes the sixth book of the first century* CE *epic Sanskrit poem, the* Mahahbarata. *It represents, in many ways, a summation of Hindu thought and philosophy. The bulk of the poem consists of the reply of Krishna, an avatar, or incarnation, of Vishnu, to Arjuna, leader of the Pandavas, who on the battlefield has decided to lay down his arms. In the following passage, Arjuna declares his unwillingness to fight. The charioteer Sanjaya, the narrator of the entire* Mahahbarata, *then introduces Krishna, who replies to Arjuna's decision and goes on to describe, at Arjuna's request, the characteristics of a man of "firm concentration and pure insight."*

from The Second Teaching

SANJAYA:

Arjuna sat dejected,
filled with pity,
his sad eyes blurred by tears.
Krishna gave him counsel.

LORD KRISHNA:

Why this cowardice
in time of crisis, Arjuna?
The coward is ignoble, shameful,
foreign to the ways of heaven.
Don't yield to impotence!
It is unnatural in you! 10
Banish this petty weakness from your heart.
Rise to the fight, Arjuna!

ARJUNA:

Krishna, how can I fight
against Bhishma and Drona
with arrows
when they deserve my worship?
It is better in this world
to beg for scraps of food
than to eat meals
smeared with the blood 20
of elders I killed
at the height of their power
while their goals
were still desires.
We don't know which weight
is worse to bear—
our conquering them
or their conquering us.
We will not want to live
if we kill 30
the sons of Dhritarashtra
assembled before us.
The flaw of pity
blights my very being
conflicting sacred duties
confound my reason.
I ask you to tell me
decisively—Which is better?

I am your pupil.
Teach me what I seek! 40
I see nothing
that could drive away
the grief
that withers my senses;
even if I won kingdoms
of unrivaled wealth
on earth
and sovereignty over gods.

SANJAYA:

Arjuna told this
To Krishna—then saying, 50
"I shall not fight,"
he fell silent.
Mocking him gently,
Krishna gave this counsel
as Arjuna sat dejected,
between the two armies.

LORD KRISHNA:

You grieve for those beyond grief,
and you speak words of insight;
but learned men do not grieve
for the dead or the living. 60
Never have I not existed,
nor you, nor these kings;
and never in the future
shall we cease to exist.
Just as the embodied self
enters childhood, youth, and old age,
so does it enter another body:
this does not confound a steadfast man.
Contacts with matter make us feel
heat and cold, pleasure and pain. 70
Arjuna, you must learn to endure
fleeting things—they come and go!
When these cannot torment a man,
when suffering and joy are equal
for him and he has courage,
he is fit for immortality.
Nothing of nonbeing comes to be,
nor does being cease to exist;
the boundary between these two

is seen by men who see reality.
Indestructible is the presence 80
that pervades all this;
no one can destroy
this unchanging reality.
Our bodies are known to end,
but the embodied self is enduring,
indestructible, and immeasurable;
therefore, Arjuna, fight the battle!
He who thinks this self a killer 90
and he who thinks it killed,
both fail to understand;
it does not kill, nor is it killed. . . .

ARJUNA:

Krishna, what defines a man
deep in contemplation whose insight
and thought are sure? How would he speak?
How would he sit? How would he move?

LORD KRISHNA:

When he gives up desires in his mind,
is content with the self within himself,
then he is said to be a man
whose insight is sure, Arjuna.

When suffering does not disturb his mind, 100
when his craving for pleasures has vanished,
when attraction, fear, and anger are gone,
he is called a sage whose thought is sure.

When he shows no preference
in fortune or misfortune
and neither exults nor hates,
his insight is sure.

When, like a tortoise retracting its limbs
he withdraws his senses 110
completely from sensuous objects,
his insight is sure.

So, Great Warrior, when withdrawal
of the senses
from sense objects is complete,
discernment is firm.

When it is night for all creatures,
a master of restraint is awake;
when they are awake, it is night
for the sage who sees reality. 120

As the mountainous depths
of the ocean
are unmoved when waters
rush into it,
so the man unmoved
when desires enter him
attains a peace that eludes
the man of many desires.

When he renounces all desires
and acts without craving, 130
possessiveness,
or individuality, he finds peace.

This is the place of the infinite spirit;
achieving it, one is freed from delusion;
abiding in it even at the time of death,
one finds the pure calm of infinity. ■

Reading Questions

What does Krishna mean when he says, "Nothing of nonbeing comes to be / nor does being cease to exist; / the boundary between these two / is seen by men who see reality"?

READING 4.5

from the *Dhammapada*

The Dhammapada, or "path of truth," consists of 423 sayings, or aphorisms, of Buddha divided by subject into 26 books. They are commonly thought to be the answers to questions put to Buddha on various occasions, and as such they constitute a summation of Buddhist thought. The following passages, consisting of different aphorisms from five different books, emphasize the Buddhist doctrine of self-denial and the wisdom inherent in pursuing the "path."

from 5. *The Fool*

. . . Should a traveler fail to find a companion
Equal or better,
Rather than suffer the company of a fool,
He should resolutely walk alone.
"I have children; I have wealth."
These are the empty claims of an unwise man.
If he cannot call himself his own,
How can he then claim children and wealth as his own?
To the extent that a fool knows his foolishness, 10
He may be deemed wise.
A fool who considers himself wise
Is indeed a fool. . . .

from 6. *The Wise*

Irrigators contain the flowing waters.
Arrowsmiths fashion arrows.
Carpenters shape wood to their design.
Wise men mold their characters. . . .

from 11. *Old Age*

Can there be joy and laughter
When always the world is ablaze?
Enshrouded in darkness
Should you not seek a light? 20
Look at the body adorned,
A mass of wounds, draped upon a heap of bones,

A sickly thing, this subject of sensual thoughts!
Neither permanent, nor enduring!
The body wears out,
A nest of disease,
Fragile, disintegrating,
Ending in death.
What delight is there in seeing the bleached bones,
Like gourds thrown away, 30
Dried and scattered in the autumn sun?
A citadel is this structure of bones,
Blood and flesh, within which dwell
Decay, death, conceit, and malice.
The royal chariots surely come to decay
Just as the body, too, comes to decay.
But the shining truth and loving kindness live on.
So speak the virtuous to the virtuous.

from 18. *Blemishes*

. . . The wise man, carefully, moment by moment,
One by one, 40
Eliminates the stains of his mind,
As a silversmith separates the dross from the silver.
Just as rust produced by iron
Corrodes the iron,
So is the violator of moral law
Destroyed by his own wrong action.
Disconnection from scripture is learning's taint,
Neglect is the taint of houses,
Uncared-for beauty withers,
Negligence is the taint of one who keeps watch. 50
A woman behaving badly loses her femininity.
A giver sharing grudgingly loses his generosity.
Deeds done from bad motives remain everlastingly tainted.
But there is nothing more tainted than ignorance.
Eliminate ignorance, O disciples,
And purity follows. . . .
Be aware, everyone, that those flawed in their nature
Have no control of themselves.
Do not let greed and anger cause you suffering
By holding you in their grasp. 60
Men give for different reasons,
Such as devotion or appreciation.
Whoever finds fault with the food or drink given by others
Will have no peace, day or night.
However, whoever gives up this habit of finding fault
With others' offerings
Will know peace, day and night.
There is no fire like lust,
No vise like hatred,
No trap like delusion, 70
And no galloping river like craving.

from 24. *Craving*

. . . Unchecked craving strangles the careless man,
Like a creeper growing in the jungle.

He leaps from lifetime to lifetime,
Like a monkey seeking fruit.
This craving, this clinging,
Overpowers the man caught in it,
And his sorrows multiply,
Like prairie grass fed by rain.
Although it is hard to gain this freedom, 80
Sorrow leaves the man who overcomes this toxic craving,
This clinging to the world,
Just as drops of water fall from a lotus leaf.
Therefore, I admonish you all who are here assembled.
You have my blessings.
Eradicate craving at the root, as you would weeds.
Find the sweet root.
Do not succumb to temptation over and over again.
The tree may be cut down but the roots remain,
Uninjured and strong, 90
And it springs up again.
Likewise, suffering returns, again and again,
If the dormant craving is not completely eradicated. . . .
Craving grows in the man aroused by worldly thoughts.
Tied to his senses, he makes his fetters strong.
Taking delight in calming sensual thoughts,
Ever mindful, meditating on the impurities of the body and so on,
One will certainly get rid of craving.
Such a one will cut off Mara's bond.
The diligent monk 100
Has reached the summit,
Fearless, free of passion.
This is the final birth of such a man.
Free of craving and grasping,
Skilled in the knowledge of the meanings within meanings,
The significance of terms, the order of things.
This great man, greatly wise,
Need return no more.
I have conquered all, I know all,
I am detached from all, I have renounced all, 110
I am freed through destruction of craving.
Having myself realized all,
Whom shall I call my teacher?
The gift of truth is the highest gift.
The taste of truth is the sweetest taste.
The joy of truth is the greatest joy.
The extinction of craving is the end of suffering. ■

Reading Questions

The *Dhammapada* is rich in metaphors, figures of speech that draw direct comparison between two seemingly unrelated things (from "Cravings," for instance, the comparison of a craving to the entangling creeper called *birana* [bir-AH-nuh]). How does Buddha's use of metaphor reflect his status as the "Enlightened One"?

Summary

■ **Early Chinese Culture** Fragments of Chinese written language, which is so closely related to modern Chinese written language that it remains legible, and tombs filled with furnishings, implements, luxury goods, and clothing, tell us much about early Chinese culture. During the Shang dynasty (1700–1045 BCE), with the production of the *The Book of Changes*, or *I Jing*, a lasting national literature began to arise, as well as a philosophy based on the principle of the balance of opposites embodied in the yin-yang symbol. During the Zhou dynasty (1027–256 BCE), these literary and philosophical traditions, which have lasted to the present day, developed further with the introduction of the *Dao de jing* (*The Way and Its Power*), the *Book of Songs*, and Confucianism.

■ **Imperial China** Under the leadership of the Emperor Shihuangdi, the Qin dynasty (221–206 BCE) unified China and undertook massive building projects, including the 4,000-mile-long Great Wall, enormous networks of roads, and the emperor's own tomb, guarded by nearly 8,000 life-size ceramic soldiers, projects that required the almost complete reorganization of Chinese society.

■ **Ancient India** The religious practice of Hinduism in India dates back to around 1500 BCE. The *Vedas* and *Upan-*
ishads were its two basic texts. Its three major gods were Brahma, the creator; Vishnu, the preserver, and god of benevolence, forgiveness, and love; and Shiva, the destroyer, who is also a great dancer, embodying the sacred rhythms of creation and destruction, birth, death, and rebirth. Vishnu was an especially popular god, who appeared in human form as Rama in the epic *Ramayana* and as Krishna in the epic *Mahahbarata*. Buddhism, a religion based on the life of Shakyamuni Buddha, born Siddhartha Gautama in about 563 BCE, is based on the belief that in giving up the desire for material things one might eventually reach nirvana. Upon his death in 483 BCE, Buddha's remains were distributed between eight reliquary stupas, symbolic mounds evoking the Dome of Heaven and the mandala, the Buddhist diagram of the cosmos. Among the most important of these is the Great Stupa at Sanchi.

■ **Ancient Africa** Artifacts from ancient African cultures, such as those found at Nok, offer evidence of artistically and technically advanced societies, but the use of less durable materials such as clay, combined with the absence of written languages, keep many of the details of these cultures shrouded in mystery.

Glossary

bodhisattva In Buddhism, a person who refrains from achieving total enlightenment in order to help others achieve buddhahood.

calligraphy A script written with brush and ink.

dharma In Hinduism, good and righteous conduct that reflects the cosmic moral order underlying all existence.

legalism A philosophy that requires the state to exercise power over the individual to elicit proper conduct.

mandala The Buddhist diagram of the cosmos.

nirvana A place or state free from worry, pain, and the external world.

stupa A type of Buddhist burial mound.

Critical Thinking Questions

1. Describe the symbolic function of the yin-yang symbol.

2. How did Confucianism contribute to the workings of the Chinese state?

3. What transformations of Chinese society can be attributed to the construction of the Great Wall and other massive building programs? What philosophy supported this transformation?

4. What are the basic tenets of the Hindu and Buddhist faiths?

The Silk Road

Continuity & Change

Under the Han, (206 BCE–220 CE), Chinese trade flourished. Western linen, wool, glass, and gold, Persian pistachios, and mustard originating in the Mediterranean, were imported in exchange for the silk, ceramics, fur, lacquered goods, and spices that made their way west along the "Silk Road" that stretched from the Yellow River across Asia to the Mediterranean (see Map **4.3**). The road followed the westernmost spur of the Great Wall to the oasis town of Dunhuang [doon-hwahng] where it split into northern and southern routes, passing through smaller oasis towns until converging again at Kashgar [KAHSH-gahr] on the western edge of the western Chinese deserts. From there traders could proceed into present-day Afghanistan, south into India, or westward through present-day Uzbekistan, Iran, and Iraq, into Syria and the port city of Antioch [AN-tee-awk]. Goods passed through many hands, trader to trader, before reaching the Mediterranean, and according to an official history of the Han dynasty compiled in the fifth century CE, it was not until 97 CE that one Gan Ying went "all the way to the Western sea and back." According to Gan Ying, there he encountered an empire with "over four hundred walled cities" to which "tens of small states are subject"—probably all outposts of the Roman Empire.

Goods and ideas spread along the Silk Road, as trade spurred the cultural interchange between East and West, India and China. As early as the first century BCE, silk from China reached Rome, where it captured the Western imagination, but the secret of its manufacture remained a mystery in the West until the sixth century CE. Between the first and third centuries CE, Buddhist missionaries from India carried their religion over the Silk Road into Southeast Asia and north into China and Korea, where it quickly became the dominant religion. By the last half of the first millennium, the Chinese capital of Chang'an, at the eastern terminus of the Silk Road, hosted Korean, Japanese, Jewish, and Christian communities, and Chinese emperors maintained diplomatic relations with Persia. Finally, the Venetian merchant Marco Polo (ca. 1254–1324), bearing a letter of introduction from Pope Gregory X, crossed the Asian continent on the Silk Road in 1275. He arrived at the new Chinese capital of Beijing, and served in the imperial court for nearly two decades. His *Travels*, written after his return to Italy in 1292, constitute the first eyewitness account of China available in Europe. ■

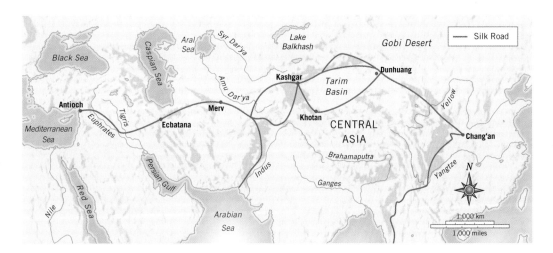

Map 4.3 The Silk Road, the trading route between the East and West and between Southeast Asia and China.

131

5 Bronze Age Culture in the Aegean World

The Great Traders

The Cyclades

Minoan Culture in Crete

Mycenaean Culture on the Peloponnese

Aegean Languages and the Phoenician Alphabet

The Homeric Epics

" *My word, how mortals take the gods to task!*

All their afflictions come from us, we hear.

And what of their own failings? Greed and folly

double the suffering in the lot of man. "

Homer, *The Odyssey*

◄ **Fig. 5.1** *Miniature Ship Fresco* (**detail from the left section**), **from Room 5, West House, Akrotiri, Thera. Before 1623 BCE.** Height 15 ³/₄″. National Archaeological Museum, Athens. The total length of this fresco is over 24 feet. Harbors such as this one provided shelter to traders who sailed between the islands of th Aegean Sea as early as 3000 BCE. In the Cycladic Islands, in Crete, and on the Greek Peloponnese, the cultures that eventually gave rise to the Greek civilization of the fourth and third centuries BCE began to take shape.

T

HE AEGEAN SEA, IN THE EASTERN MEDITERRANEAN, IS FILLED

with islands. Here, beginning in about 3000 BCE, seafaring cultures took hold.

So many were the islands, and so close to one another, that navigators were

always within sight of land. In the natural harbors where seafarers came ashore, port

communities developed and trade began to flourish. A house from approximately 1650 BCE was excavated at Akrotiri on Thera, one of these islands. The *Miniature Ship Fresco*, a frieze at the top of at least three walls, suggests a prosperous seafaring community engaged in a celebration of the sea (Fig. **5.1**). People lounge on terraces and rooftops as boats glide by, accompanied by leaping dolphins.

As trade spread throughout the islands, it was dominated by the Phoenicians [fih-NISH-unz], who lived on the eastern shores of the Mediterranean in what is now modern Lebanon (Map **5.1**). Over time, trade extended around the entire eastern Mediterranean and even farther, to Anatolia (modern Turkey), the Greek mainland, and Egypt. It also spread westward to southern Italy, and eventually to Spain and the Strait of Gibraltar. The Aegean peoples imported metal ores from Europe, the Arabian peninsula, and Anatolia, and in turn produced for export weapons and tools made of bronze, an alloy of copper and tin far superior to pure copper. It was this trade that defined the Aegean Bronze Age.

The later Greeks thought of the Bronze Age Aegean peoples as their ancestors and considered their activities and culture as part of their own prehistory. They even had a word for the way they knew them—*archaiologia* [ar-ka-ee-oh-LOH-ghee-uh], "knowing the past." They did not practice archeology as we do today, excavating ancient sites and scientifically analyzing the artifacts discovered there. Rather, they learned of their past through legends passed down, at first orally and then in writing, from generation to generation. Interestingly, the modern practice of archeology has confirmed much of what was legendary to the Greeks.

In this chapter we will consider the centers of culture in the Aegean Sea that were the first to trade with the Phoenicians and out of which the Greeks believed their own great culture sprang: the Cyclades [SIK-luh-deez], Crete [kreet], and Mycenae [my-SEE-nee]. We will look at the art these centers produced, and finally, we will consider the Greeks' own great legends about those cultures, including the Homeric epics, the *Iliad* and the *Odyssey*.

The Cyclades

The Cyclades are a group of more than 100 islands in the Aegean Sea between mainland Greece and the island of Crete (Map **5.2**). They form a roughly circular shape, giving them their name, from the Greek word *kyklos* [kih-klos], "circle" (also the origin of our word "cycle"). No written records of the early Cycladic [sih-KLAD-ik] people remain, although archeologists have found a good deal of art in and around hillside burial chambers. The most famous of these artifacts are marble figurines in a highly simplified and abstract style

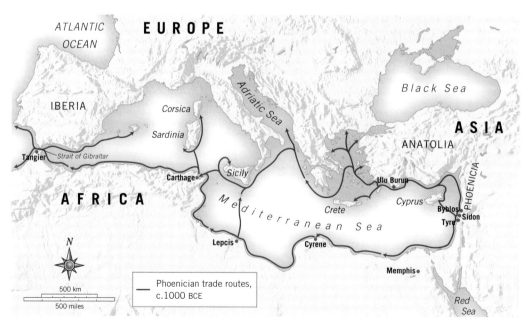

Map 5.1 Phoenician Trade Routes, ca. 1000 BCE.

134

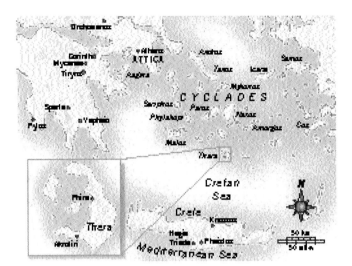

Map 5.2 Crete, the Cyclades, and the Island of Thera (modern Santorini). Thera lies just north of Crete. Evidence suggests Cretan influence here by about 2000 BCE.

land and California and in ash taken from ice core samples in Greenland. With this evidence, scientists have dated the eruption to 1623 BCE. It seems likely that when the Greek philosopher Plato [PLAY-toh] (ca. 427–347 BCE) described "the lost island of Atlantis" some 1,300 years later in the *Timaeus* [TIH-me-us] and *Critias* [KRIH-tee-us], he was describing the catastrophe at Thera. Admittedly, Plato placed his Atlantis beyond the Strait of Gibraltar, in the Atlantic Ocean, and he dated the eruption at about 9500 BCE, when nothing close to the highly developed civilization he describes is known to have existed. But Plato also describes Atlantis as "a great and wonderful empire," and we know of no people who lived as luxuriously and comfortably as the people of Thera. Not only were their homes elaborately decorated—with mural paintings such as the one shown in Fig. 5.1, made with water-based pigments on wet plaster—but they also enjoyed a level of personal hygiene unknown in Western culture until Roman times. Clay pipes led from interior toilets and baths to sewers built under winding, paved streets. Straw reinforced the walls of their homes, protecting them against earthquakes and insulating them from the heat of the Mediterranean sun.

Minoan Culture in Crete

Crete is the largest of the Aegean islands. Bronze Age civilization developed there as early as 3000 BCE. Trade routes from Crete established communication with such diverse areas as Turkey, Cyprus [SY-prus], Egypt, Afghanistan, and Scandinavia, from which the island imported copper, ivory, amethyst, lapis lazuli, carnelian, gold, and amber. From Britain, Crete imported the tin necessary to produce bronze. A distinctive culture called Minoan [mih-NO-un] flourished on Crete from about 1900 to 1375 BCE. The name comes from the legendary king Minos [MY-nos], who was said to have ruled the island's ancient capital of Knossos [NOSS-us].

that appeals to the modern eye (Fig. **5.2**). In fact, Cycladic figurines have deeply influenced modern sculptors. The Cycladic figures originally looked quite different because they were painted. Most of the figurines depict females, but male figures, including seated harpists and acrobats, also exist. The figurines range in height from a few inches to life-size, but anatomical detail in all of them is reduced to essentials. With their toes pointed down, their heads tilted back, and their arms crossed across their chests, the fully extended figures are corpselike. Their function remains unknown, but some scholars suggest they were used for home worship and then buried with their owner.

By about 2200 BCE, trade with the larger island of Crete to the south brought the Cyclades into Crete's political orbit and radically altered late Cycladic life. Evidence of this influence survives in the form of wall paintings discovered in 1967 on the island of Thera (today known as Santorini [san-tor-EE-nee]), at Akrotiri, a community that had been buried beneath one of the largest volcanic eruptions in the last 10,000 years (see Map 5.2). About 7 cubic miles of magma spewed forth, and the ash cloud that resulted during the first phase of the eruption was about 23 miles high. The enormity of the eruption caused the volcano at the center of Thera to collapse, producing a caldera, a large basin or depression that filled with seawater. The present island of Thera is actually the eastern rim of the original volcano (small volcanoes are still active in the center of Thera's crescent sea).

The eruption was so great that it left evidence worldwide—in the stunted growth of tree rings as far away as Ire-

Fig. 5.2 Figurine of a woman from the Cyclades. ca. 2500 BCE. Marble, height 15 3/4″. Nicholas P. Goulandris Foundation. Museum of Cycladic Arts, Athens. N. P. Goulandris Collection, No. 206. Larger examples of such figurines may have been objects of worship.

Minoan Painting

Many of the motifs in the frescoes at Akrotiri, in the Cyclades, also appear in the art decorating Minoan palaces on Crete, including the palace at Knossos. This suggests the mutual influence of Cycladic and Minoan cultures by the start of the second millennium BCE. Prominent in both Akrotiri and Crete are depictions of lilies, which are closely tied to religious rituals, especially those connected with Britomartis [bri-toh-MAR-tus] ("Sweet Virgin" in Minoan), the Minoan goddess of the mountains and the hunt, who took the lily as her symbol. Dolphins are also a favorite subject in both cultures (see Fig. 5.1), symbolically associated with Minoan goddess figures and thought to bring good luck to ships because they followed the vessels, sometimes for very great distances, across the sea.

Unique to Crete, however, is emphasis on the bull, the central element of one of the best-preserved frescoes at Knossos, the *Toreador Fresco* (Fig. **5.3**). Three almost nude figures appear to toy with a charging bull. (As in Egyptian art, women are traditionally depicted with light skin, men with a darker complexion.) The woman on the left holds the bull by the horns, the man vaults over its back, and the woman on the right seems to have either just finished a vault or to have positioned herself to catch the man. It is unclear whether this is a ritual activity, perhaps part of a rite of passage. What we do know is that the Minoans regularly sacrificed bulls, as well as other animals, and that the bull was at least symbolically associated with male virility and strength.

Minoan frescoes, as well as those on Thera, differ from ancient Egyptian frescoes in several ways. The most obvious is that they were painted, not in tombs, but on the walls of homes and palaces where they could be enjoyed by the living. The two kinds of frescoes were made differently as well. Rather than applying pigment to a dry wall in the *fresco secco* [FRESS-coh SEK-koh] technique of the Egyptians, Minoan artists employed a **buon fresco** [bwon FRESS-coh] technique similar to that used by Renaissance artists nearly 3,000 years later (see chapter 17). In *buon fresco*, pigment is mixed with water and then applied to a wall that has been coated with wet lime plaster. As the wall dries, the painting literally becomes part of it. *Buon fresco* is far more durable than *fresco secco*, for the paint will not flake off as easily (though all walls will eventually crumble).

Minoan Religion

The people of Thera and Crete seem to have shared the same religion as well as similar artistic motifs. Ample archeological evidence tells us that the Minoans in Crete worshiped female deities. We do not know much more than that, but some students of ancient religions have proposed that the Minoan worship of one or more female deities is evidence that in very early cultures the principal deity was a goddess rather than a god.

One Goddess or Many? It has long been believed that one of the Minoan female deities was a snake goddess, but recently, scholars have questioned the authenticity of most of the existing snake goddess figurines (see *Focus*, page 139). Sir Arthur Evans (1851–1941), who first excavated at the Palace of Minos on Crete, identified images of the Cretan goddess as "Mountain Goddess," "Snake Goddess," "Dove Goddess," "Goddess of the Caves," "Goddess of the Double Axes," "Goddess of the Sports," and "Mother Goddess." Evans saw all of these as different aspects of a single deity, or Great Goddess. Still, we cannot be certain that the principal deity of the Minoan culture was female, or that she was a snake goddess. There are no images of a snake goddess in surviving Minoan wall frescoes, engraved gems, or seals, and almost all of the statues depicting her are fakes or imaginative reconstructions.

It is likely though that Minoan female goddesses were closely associated with a cult of vegetation and fertility, and the snake is itself an almost universal symbol of rebirth and fertility. We do know that the Minoans worshiped on mountaintops, closely associated with life-giving rains, and deep in caves, another nearly universal symbol of the womb in particular and origin in general. And in early cultures the undulations of the earth itself—its hills and ravines, caves and riverbeds—were (and often still are) associated with the curves of the female body and genitalia. But until early Minoan writing is deciphered (see page 144), the exact nature of Minoan religion will remain a mystery.

The Palace of Minos

The *Snake Goddess* was discovered along with other ritual objects in a storage pit in the Palace of Minos at Knossos, which Sir Arthur Evans first unearthed in 1900. As with the *Snake Goddess*, Evans took enormous liberties in reconstructing the original palace. Among nineteenth-century archeologists, interpretations and reconstructions were often based more on hypotheses than on factual evidence.

The palace as Evans found it is enormous, covering over 6 acres. There were originally two palaces at the site—an "old palace," dating from 1900 BCE, and a "new palace," built over the old one after an enormous earthquake in 1750 BCE. This "new palace" was the focus of Evans's attention. It was one of three principal palace sites on Crete (see Map 5.2), and although Knossos is the largest, they are laid out along similar lines, with a central court surrounded by a labyrinth of rooms. They served as administrative, commercial, and religious centers ruled by a king, similar to the way palaces functioned in the civilizations of Mesopotamia and Egypt. The complexity of these unfortified palaces and the richness of the artifacts uncovered there testify to the power and prosperity of Minoan culture.

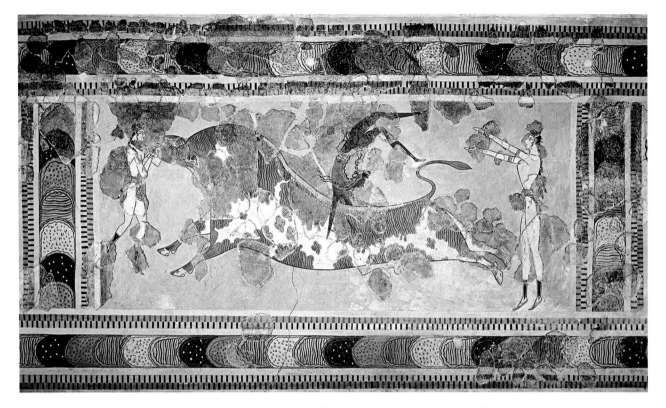

Fig. 5.3 *Bull Leaping (Toreador Fresco),* **from the palace complex at Knossos, Crete. ca. 1450–1375 BCE.** Fresco, height approx. 24 $\frac{1}{2}$″. Archaeological Museum, Iráklion, Crete. The darker patches of the fresco are original fragments. The lighter areas are modern restorations.

As its floor plan and reconstruction drawing make clear, the palace at Knossos was only loosely organized around a central, open courtyard (Fig. **5.4**). Leading from the courtyard were corridors, staircases, and passageways that connected living quarters, ritual spaces, baths, and administrative offices, in no discernable order or design. Workshops surrounded the complex, and vast storerooms could easily provide for the needs of both the palace population and the population of the surrounding countryside. In just one storeroom, excavators discovered enough ceramic jars to hold 20,000 gallons of olive oil.

Hundreds of wooden columns decorated the palace. Only fragments have survived, but we know from paintings and ceramic house models how they must have looked. Evans created concrete replicas displayed today at the West Portico and the Grand Staircase (Fig. **5.5**). The originals were made of huge timbers cut on Crete and then turned upside down so that the top of each is broader than the base. The columns were painted bright red with black **capitals**, the sculpted blocks that top them. The capitals are shaped liked pillows or cushions. (In fact, they are very close to the shape of an evergreen's root ball, as if the original design were suggested by trees felled in a storm.) Over time, as the columns rotted or were destroyed by earthquakes or possibly burned by invaders, they must have become increasingly difficult to

replace, for Minoan builders gradually deforested the island. This may be one reason why the palace complex was abandoned sometime around 1450 BCE.

Representations of double axes decorated the palace at every turn, and indeed the palace of Minos was known in Greek times as the House of the Double Axes. In fact, the Greek word for the palace was *labyrinth,* from *labrys,* "double ax." Over time, the Greeks came to associate the House of the Double Axes with its inordinately complex layout, and *labyrinth* came to mean "maze."

The Legend of Minos and the Minotaur The Greeks solidified the meaning of the labyrinth in a powerful legend. King Minos boasted that the gods would grant him anything he wished, so he prayed that a bull might emerge from the sea that he might sacrifice to the god of the sea, Poseidon [puh-SY-dun]. A white bull did emerge from the sea, one so beautiful that Minos decided to keep it for himself and sacrifice a different one from his herd instead. This angered Poseidon, who took revenge by causing Minos's queen, Pasiphae [pah-sif-eye], to fall in love with the bull. To consummate her passion, she convinced Minos's chief craftsperson, Daedalus [DEE-duh-lus], to construct a hollow wooden cow into which she might place herself and attract the bull. The result of this union was a horrid creature, half man, half bull: the Minotaur.

Fig. 5.4 Reconstruction drawing and floor plan of the new palace complex at Knossos, Crete. The complexity of the labyrinthine layout is obvious.

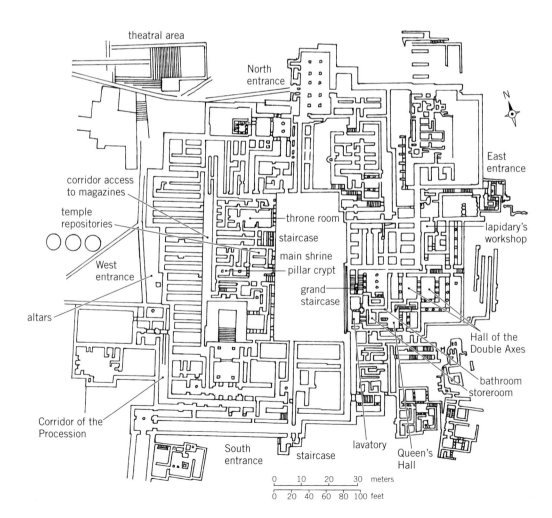

Focus

The Snake Goddess or Priestess from Crete

Arthur Evans was the archeologist responsible for the first major excavation on Crete in the early twentieth century. A century after he introduced the *Snake Goddess* to the world, scholars are still debating its authenticity.

In his book *Mysteries of the Snake Goddess* (2002), Kenneth Lapatin makes a convincing case that craftspeople employed by Evans manufactured artifacts for the antiquities market. He believes that the body of the statue is an authentic antiquity, but the form in which we see it is largely the imaginative fabrication of Evans's restorers. Many parts were missing when the figures were unearthed, and so an artist working for Evans fashioned new parts and attached them to the figure. Lapatin believes that Sir Arthur, eager to advance his own theory that Minoan religion was dedicated to the worship of a Great Goddess, never doubted the manner in which the figures were restored. As interesting as the figure is, its identity as a snake goddess is at best dubious.

When the figure was discovered, it lacked a head. This one is completely fabricated.

The crouching cat on the goddess's head is original, although it was not found with the statue.

This snake in the goddess's right hand lacked a head, leaving its identity as a snake open to question. It could just as easily have been a sheaf of grain or a necklace, both of which are depicted in the hands of other Bronze Age women or goddesses.

Most of the goddess's left arm, including the snake in her hand, was absent and later fabricated.

Snake Goddess or Priestess, **from the palace at Knossos, Crete. ca. 1500 BCE.** Faience, height $11\frac{5}{8}''$. Archaeological Museum, Iráklion, Crete. **Faience** is a kind of earthenware ceramic decorated with glazes. Modern faience is easily distinguishable from ancient because it is markedly lighter in tone.

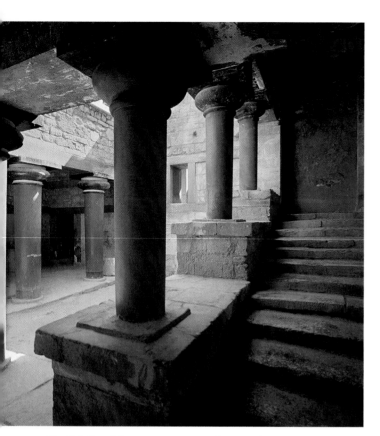

Fig. 5.5 Grand Staircase, east wing, palace complex at Knossos, Crete, as reconstructed by Sir Arthur Evans. ca. 1500 BCE. The staircase served as a light well and linked all five stories of the palace.

To appease the monster's appetite for human flesh, Minos ordered the city of Athens, which he also ruled, to send him 14 young men and women each year as sacrificial victims. Theseus, son of King Aegeus of Athens, vowed to kill the Minotaur. As he set sail for Crete with 13 others, he promised his father that he would return under white sails (instead of the black sails of the sacrificial ship) to announce his victory. At Crete, he seduced Ariadne [a-ree-AD-nee], daughter of Minos. Wishing to help Theseus, she gave him a sword with which to kill the Minotaur and a spindle of thread to lead himself out of the maze in which the Minotaur lived. Victorious, Theseus sailed home with Ariadne but abandoned her on the island of Naxos, where she was discovered by the god of wine, Dionysus, who married her and made her his queen. Theseus, sailing into the harbor at Athens, neglected to raise the white sails, perhaps intentionally. When his father, King Aegeus, saw the ship still sailing under black sails, he threw himself into the sea, which from then on took his name, the Aegean. Theseus, of course, then became king.

The story is a creation or **origin myth**, like the Zuni emergence tale (see **Reading 1.1**, page 24) or the Hebrew story of Adam and Eve in Genesis (see **Reading 2.5**, page 64). But it differs from them on one important point: Rather than narrating the origin of humankind in general, it tells the story of the birth of one culture out of another. It is the Athenian Greeks' way of knowing their past, their *archaiologia*. The tale of the labyrinth explained to the later Greeks where and how their culture came to be. It correctly suggests a close link to Crete, but it also emphasizes Greek independence from that powerful island. It tells us, furthermore, much about the emerging Greek character, for Theseus would, by the fifth century BCE, achieve the status of a national hero. The great tragedies of Greek theater represent Theseus as wily, ambitious, and strong. He stops at nothing to achieve what he thinks he must. If he is not altogether admirable, he mirrors behavior the Greeks attributed to their gods. Nevertheless, he is anything but idealized or godlike. He is, almost to a fault, completely human.

It was precisely this search for the origins of Greek culture that led Sir Arthur Evans to the discovery of the Palace of Minos in Crete. He confirmed "the truth" in the legend of the Minotaur. If there was no actual monster, there was indeed a labyrinth. And that labyrinth was the palace itself.

Mycenaean Culture on the Peloponnese

When the Minoans abandoned the palace at Knossos in about 1450 BCE, warriors from the mainland culture of Mycenae, on the Greek Peloponnese [PEL-uh-poh-neez], quickly occupied Crete (see Map 5.2). One reason for the departure from Knossos was suggested earlier—the deforestation of the island (see page 137). Another might be that Minoan culture was severely weakened in the aftermath of the volcanic eruption on Thera, and therefore susceptible to invasion. A third might be that the Mycenaean army simply overwhelmed the island. The Mycenaeans were certainly acquainted with the Minoan culture some 92 miles to their south, across the Aegean.

Minoan metalwork was prized on the mainland. Its fine quality is very evident in the *Vaphio Cup*, one of two golden cups found in the nineteenth century in a tomb at Vaphio [VAH-fee-oh], just south of Sparta, on the Peloponnese (Fig. 5.6). This cup was executed in **repoussé** [ruh-poo-SAY], a technique in which the artist hammers out the design from the inside. It depicts a man in an olive grove capturing a bull by tethering its hind legs. The bull motif is classically Minoan, and the setting suggests a religious meaning since the oil extracted from many olive groves was considered sacred. The Mycenaeans, however, could not have been more different from the Minoans. Whereas Minoan cities were unfortified, and battle scenes were virtually nonexistent in their art, the Mycenaeans lived in communities surrounding fortified hilltops, and battle and hunting scenes dominate their art.

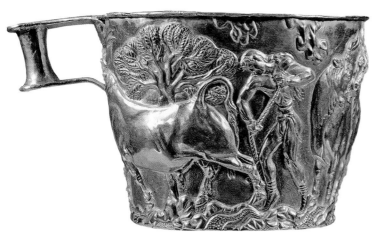

Fig. 5.6 *Vaphio Cup,* **from a tomb at Vaphio, south of Sparta, Greece. ca. 1650–1450 BCE.** Gold, height 3 1/2″. National Archaeological Museum, Iráklion, Crete. Mycenaean invaders used Crete as a base for operations for several centuries, and probably acquired the cup there.

later time. From the gate, a long, stone street wound up the hill to the citadel itself. Here, overseeing all, was the king's palace.

Mycenae was only one of several fortified cities on mainland Greece that were flourishing by 1500 BCE and that have come to be called Mycenaean. Mycenaean culture was the forerunner of ancient Greek culture and was essentially **feudal** in nature, that is, a system of political organization held together by ties of allegiance between a lord and those who relied on him for protection. Kings controlled not only their own cities but also the surrounding countryside. Merchants, farmers, and artisans owed their own prosperity to the king and paid high taxes for the privilege of living under his protection. More powerful kings, such as those at Mycenae itself, also expected the loyalty (and financial support) of other cities and nobles over whom they exercised authority. A large bureaucracy of tax collectors, civil servants, and military personnel ensured the state's continued prosperity. Like the Minoans, they engaged in trade, especially for the copper and tin required to make bronze.

Minoan culture appears to have been peaceful, while the warlike Mycenaeans lived and died by the sword.

The ancient city of Mycenae, which gave its name to the larger Mycenaean culture, was discovered by the German archeologist Heinrich Schliemann (1822–1890) in the late nineteenth century, before Sir Arthur Evans discovered Knossos. Its citadel looks down across a broad plain to the sea (Fig. **5.7**). Its walls—20 feet thick and 50 feet high—were built from huge blocks of rough-hewn stone, in a technique called **cyclopean** [sy-KLOPE-ee-un] **masonry** because it was believed by later Greeks only a race of monsters known as the Cyclopes [sy-KLOH-peez] could have managed them. Visitors to the city entered through a massive Lion Gate at the top of a steep path that led from the valley below (Fig. **5.8**) . The lions that stood above the gate's lintel were themselves 9 feet high. It is likely that their missing heads originally turned in the direction of approaching visitors, as if to humble them in their tracks, like Sargon's human-headed bull gates at Khorsabad (see Fig. 2.14). They were probably made of a different stone than the bodies and may have been plundered at a

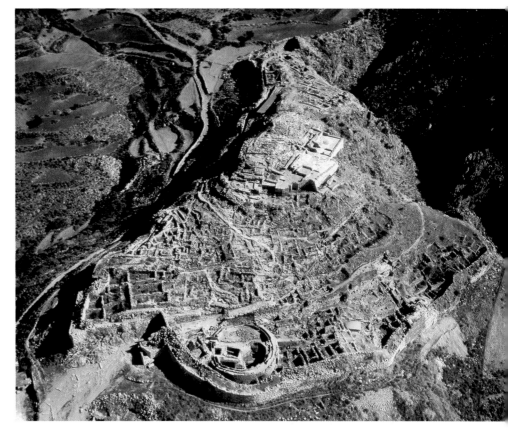

Fig. 5.7 Aerial view of Mycenae, Greece. ca. 1600–1200 BCE. The citadel at Mycenae, with its surrounding walls and massive gates, testifies to the military character of the Mycenaean state. It is very different in character from the Minoan palaces, which lack fortifications and are built on flat land.

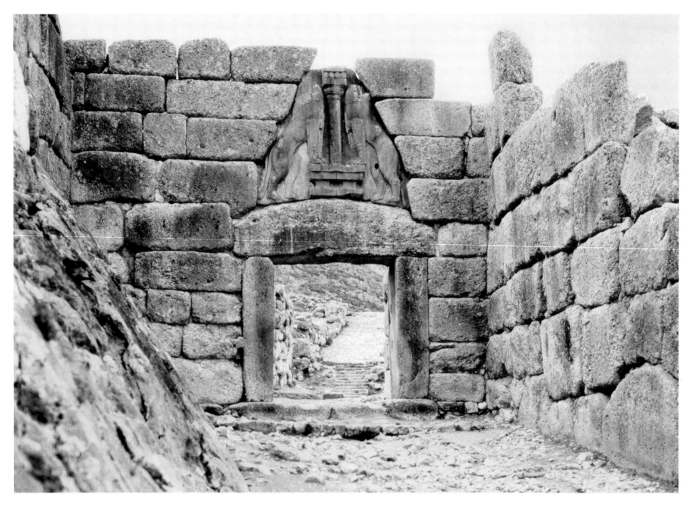

Fig. 5.8 Lion Gate, Mycenae, Greece. ca. 1300 BCE. Limestone relief, panel approx. 9′ 6″ high. The lions are carved on a triangle of stone that relieves the weight of the massive doorway from the lintel. The original heads, which have never been found, were attached to the bodies with dowels.

The feudal system allowed Mycenae's kings to amass enormous wealth, as Schliemann's excavations confirmed. He discovered gold and silver death masks of fallen heroes (Fig. **5.9**), as well as swords and daggers inlaid with imagery of events such as a royal lion hunt. He also found delicately carved ivory, from the tusks of hippopotamuses and elephants, suggesting if not the breadth of Mycenae's power, then the extent of its trade, which clearly included Africa. It seems likely, in fact, that the Mycenaean taste for war, and certainly its occupation of Crete, was motivated by the desire to control trade routes throughout the region.

Fig. 5.9 Funerary mask (*Mask of Agamemnon*), from Grave Circle A, Mycenae, Greece. ca. 1600–1550 BCE. Gold, height approx. 12″. National Archaeological Museum, Athens. When Schliemann discovered this mask, he believed it was the death mask of King Agamemnon, but it predates the Trojan War by some 300 years. Recent scholarship suggests that Schliemann may have added the handlebar mustache and large ears, perhaps to make the mask appear more "heroic."

Schliemann discovered most of this wealth in **shaft graves**, vertical pits some 20 or 25 feet deep enclosed in a circle of stone slabs. These all date from the early years of Mycenaean civilization, about 1500 BCE. Beginning in about 1300 BCE, the Mycenaeans used a new architectural form, the *tholos* [THOH-lohs] to bury their kings. A tholos is a round building often called a beehive because of its shape. The most famous of these tombs is the Treasury of Atreus [AY-tree-us], the name Schliemann attributed to it (Figs. **5.10, 5.11**). Atreus was the father of Agamemnon, an early king of Mycenae known to us from the literature of later Greeks. However, no evidence supports Schliemann's attribution except the structure's extraordinary size which was befitting of a legendary king, and the fact that it dates from approximately the time of the Trojan War. (Agamemnon led the Greeks in that 10-year war against Trojans which would form the background for Homer's epic poems, the *Iliad* and the *Odyssey*, discussed later in the chapter.) The approach to the Treasury of Atreus is by way of a long, open-air passage nearly 115 feet long and 20 feet wide leading to a 16-foot-high door. Over the door is a **relieving triangle**, a triangular-shaped opening above the lintel designed to relieve some of the weight the lintel has to bear. (See the discussions of lintels in chapter 1.) Surviving fragments reveal that a pair of green

CULTURAL PARALLELS

Mycenaeans and Egyptians Build Monumental Structures

As the Mycenaeans used huge blocks of stone to construct Cyclopean walls protecting the palace complex at Knossos around 1400 BCE, the Egyptian ruler Hatshepsut and her successors supervised the building of palaces at Karnak which were even more massive. These impressively sized dwellings served a symbolic purpose as well as a functional one.

marble columns topped by two red marble columns originally adorned the facade of the Treasury of Atreus. The columns were **engaged**—that is, they were half-columns that projected from the wall but served no structural purpose. Behind the door lay the burial chamber, a giant domed space, in which the dead would have been laid out together with gold and silver artifacts, ceremonial weapons, helmets, armor, and other items that would indicate power, wealth, and prestige.

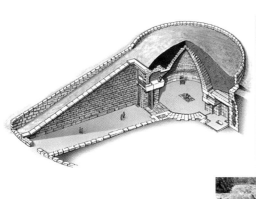

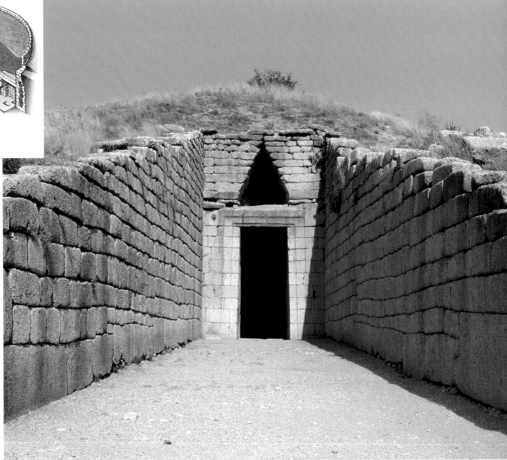

Figs. 5.10 and 5.11 Facade and sectioned view of the *tholos* of the Treasury of Atreus, Mycenae, Greece. ca. 1250 BCE. Interior vault height, 43′, diameter 47′ 6″. The interior space of this *tholos*—a small, round building—remained the largest uninterrupted space in Europe until the Pantheon was built in Rome a thousand years later. The dome is an example of corbeled construction: As the roof's squared stones curve inward toward the top, they were buttressed, or supported, on the outside by earth. Because of the conical shape of such burial chambers, they are known as beehive tombs.

Aegean Languages and the Phoenician Alphabet

One of the most fascinating aspects of the eastern Mediterranean in the Bronze Age is the development of written language. First, around the middle of the second millennium BCE, as trade increasingly flourished between and among the Greek islands and the mainland, a linear script began to appear on tablets and objects across the region. Then, 600–700 years later, the Phoenicians, the great traders of the area, began to spread a distinctly new writing system, based on an alphabet (apparently of their own invention), across the entire Mediterranean basin.

Linear A and Linear B

It was writing that most captivated Sir Arthur Evans when he excavated the Palace of Minos at Knossos. There he discovered two distinct writing systems, one of which he called Linear A and the other Linear B, since they are both written left to right on horizontally drawn lines. Linear A remains undeciphered, but in 1952, Michael Ventris, an English architect and classical scholar, deciphered Linear B. Sixteen years earlier, as a 14-year-old boy in London, Ventris had heard Evans speak about the "long forgotten civilization of ancient Crete and the mysterious writing system used by its people." He deciphered Linear B by recognizing an overall pattern in the script and the repetition of certain constants that revealed its overall structure.

Over 4,000 tablets of Linear B were found at Knossos on Crete, and it was widely believed that the Minoans had developed that language. Yet, when similar tablets turned up at Pylos on the Greek Peloponnese, and when Ventris demonstrated their connection to ancient Greek, it became clear that the Greeks as well as the Mycenaeans had adapted the Minoan Linear A to their own uses in the form of Linear B. So, as in the myth of the Minotaur, the Greeks affirmed their connection to Minoan culture, even as they asserted their independence from it.

The Phoenician Alphabet

Linear B was a cumbersome script, requiring a different sign for each spoken syllable. Sometime before 800 BCE, the Phoenicians, a people of Semitic origin in western Syria (in what is now modern Lebanon; see Map 5.1), introduced an alphabet to the Greeks.

The Phoenicians, like other Aegean cultures, were great traders who carried all manner of cargo across the region. A shipwreck that occurred sometime between 1400 and 1350 BCE at Ulu Burun [oo-loo buh-ROON] off the south coast of modern Turkey (see Map 5.1), suggests the kind of inventory Phoenician ships might have carried. On board were copper ingots used to make bronze, bronze weapons and tools; an aromatic resin used to make incense and perfume; African ebony; ivory tusks; ostrich eggs; raw blocks of blue glass; jew-elry and beads; and gold objects, including a scarab associated with Queen Nefertiti of Egypt. There were more ordinary goods as well, such as fishnets, ceramic wares, and weights for scales. But the Phoenicians were, as a result, tempting targets for pirates, and in fact the later Greek historian Thucydides (ca. 460–400) describes the early Greeks in precisely these terms (see *Voices*, page 147).

But if the Greeks plundered Phoenician traders, they also were quick to take advantage of their writing system. Their alphabet allowed the Phoenicians to keep records more easily and succinctly than their competitors. It could be quickly taught to others, which facilitated communication in the far-flung regions where their ships sailed, and, written on papyrus, it was much more portable than the clay tablets used in Mesopotamia. Along with an alphabet, the Phoenicians perfected the equipment for using it: pen, ink, papyrus, and portable wax-writing tablets, one of which was found in the shipwreck at Ulu Burun.

The Phoenician alphabet consisted only of consonants (Hebrew, too, is written without vowels). But the Greeks had many more vowel sounds than the Phoenicians. Between the alphabet's introduction in 800 BCE and the fifth century BCE, the Greeks slowly developed vowels for the alphabet—A (*alpha*), E (*epsilon* [EP-suh-lon]), O (*omicron* [OH-mih-cron]), Y (*upsilon* [OOP-suh-lon]), and I (*iota* [eye-OH-tuh]), resulting in an alphabet of 24 letters, seven of which were vowels. They also invented uppercase—that is, "capital"—letters, used largely on inscriptions, and lowercase letters, for writing on their own wax tablets. Greek writing eventually spread throughout the Mediterranean. Through its Phoenician roots, it is the source of the Latin alphabet that we use today.

The Homeric Epics

Once the ancient Greeks adopted the Phoenician alphabet in about 800 BCE, they began to write down the stories from and about their past—their *archaiologia*—that had been passed down, generation to generation, by word of mouth. The most important of these stories were composed by an author whom history calls Homer. Homer was most likely a **bard**, a singer of songs about the deeds of heroes and the ways of the gods. His stories were part of a long-standing oral tradition that dated back to the time of the Trojan War, which we believe occurred sometime between 1800 and 1300 BCE. Out of the oral materials he inherited, Homer composed two great epic poems, the *Iliad* and the *Odyssey*. The first narrates an episode in the 10-year Trojan War, which, according to Homer, began when the Greeks launched a large fleet of ships under King Agamemnon of Mycenae to bring back Helen, the wife of his brother King Menelaus of Sparta, who had eloped with Paris, son of King Priam [PRY-um] of Troy. The *Odyssey* narrates the adventures of one of the principal Greek leaders, Odysseus (also known as Ulysses), on his return home from the fighting.

Most scholars believed that these Homeric epics were pure fiction until the discovery by Heinrich Schliemann in the 1870s of the actual site of Troy, a multilayered site near modern-day Hissarlik [hih-sur-LIK], in northwestern Turkey. The Troy of Homer's epic was discovered at the sixth layer. (Schliemann also believed that the shaft graves at Mycenae, where he found so much treasure, were those of Agamemnon and his royal family, but modern dating techniques have ruled that out.) Suddenly, the *Iliad* assumed, if not the authority, then the aura of historical fact. Scholars studying both the poem and a Mycenaean vase known as the *Warrior Vase* have been struck by the similarity of many passages in the *Iliad* and scenes depicted on the vase. Those similarities testify to the accuracy of many of the poem's descriptions of Bronze Age Greece (Fig. **5.12**).

How Homer came to compose two works as long as the *Iliad* and the *Odyssey* has been the subject of much debate. Did he improvise each oral performance from memory or did he rely on written texts? There is clear evidence that **formulaic epithets**—descriptive phrases applied to a person or thing—helped him, suggesting that improvisation played an important part in the poem's composition. Common epithets in the *Iliad* include such phrases as "fleet-footed Achilles" and "bronze-armed Achaeans." (*Achaean* [uh-KEE-un] is the term Homer uses to designate the Greeks whom we associate with the Mycenaens.) These epithets appear to have been chosen to allow the performing poet to fit a given name easily into the **hexameter** structure of the verse line—what we today call "epic" meter. Each hexameter line of Homer's verse is composed of six metrical units, which can be made up of either

dactyls (a long syllable plus two short ones) or **spondees** (two long syllables). "Fleet-footed" is a dactyl; "bronze-armed" a spondee. The first four units of the line can be either dactyls or spondees; the last two must be dactyl and spondee, in that order. This regular meter, and the insertion of stock phrases into it, undoubtedly helped the poet to memorize and repeat the poem.

It seems almost certain that Homer also relied on some sort of written text in order to perform the 15,693 lines of the *Iliad*. By the sixth century BCE, it was recited every four years in Athens (without omission, according to law), and many copies of it circulated around Greece in the fifth and fourth centuries BCE. Finally, in Alexandria, Egypt, in the late fourth century BCE, scribes wrote the poem on papyrus scrolls, perhaps dividing it into the 24 manageable units we refer to today as the poem's books.

The poem was so influential that it established certain **epic conventions**, standard ways of composing an epic that were followed for centuries to come. Examples include starting the poem *in medias res* [in MEH-dee-us rays], Latin for "in the middle of things," that is, in the middle of the story; invoking the muse at the poem's outset; and stating the poem's subject at the outset.

The *Iliad*

The *Iliad* tells but a small fraction of the story of the Trojan War, which was launched by Agamemnon of Mycenae and his allies to attack Troy around 1200 BCE (Map **5.3**). The tale begins after the war is under way and narrates what is commonly called "the rage of Achilles" [uh-KIL-leez], a phrase drawn from the first line of the poem. Already encamped on the Trojan plain (Map **5.4**), Agamemnon has been forced to give up a girl that he has taken in one of his raids, but he takes the beautiful Briseis [bree-SAY-us] from Achilles as compensation. Achilles, by far the greatest of the Greek warriors, is outraged, suppresses his urge to kill Agamemnon, but withdraws from the war. He knows that the Greeks cannot succeed without him, and in his rage he believes they will deserve their fate. Indeed, Hector, the

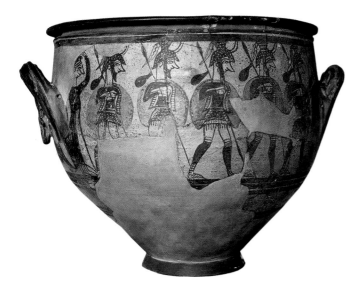

Fig. 5.12 *Warrior Vase*, **from Mycenae, Greece. ca. 1300–1100 BCE.** Ceramic, height 16″. National Archaeological Museum, Athens. Dating from the time of the Trojan War, the vase depicts a woman, on the left, waving good-bye to departing troops. The figures are crudely depicted, their profiles almost childlike in their simplicity, suggesting the relative unimportance of the arts in the militaristic Mycenaean culture.

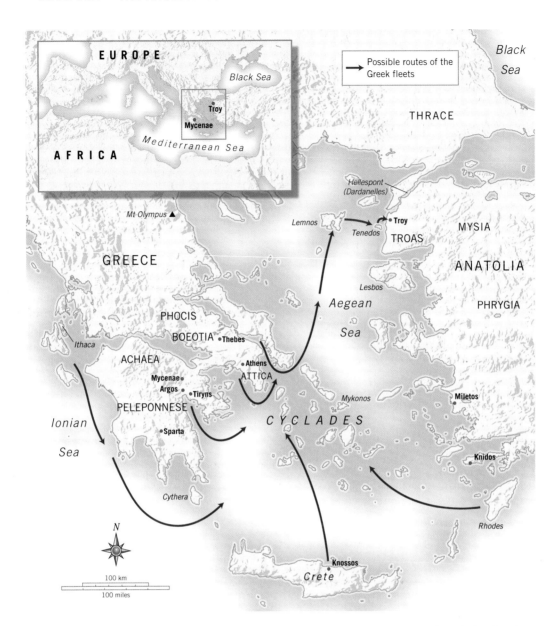

Map 5.3 Possible Routes of the Greek Fleets as They Gathered and Then Sailed to Troy. At the end of Book 2 of the *Iliad*, Homer catalogs the participating parties in the Trojan War. He lists kings and their followers from more than 150 places. It seems doubtful that the conflict was truly precipitated by the abduction of Helen from Sparta. More likely, the Greeks wanted to wrest control of the Hellespont (today known as the Dardenelles) from the Trojans, in order to gain access to trading opportunities in the Black Sea and Asia.

great Trojan prince, soon drives the Greeks back to their ships, and Agamemnon sends ambassadors to Achilles to offer him gifts and beg him to return to the battle. Achilles refuses: "His gifts, I loathe his gifts. . . . I wouldn't give you a splinter for that man! Not if he gave me ten times as much, twenty times over." When the battle resumes, things become desperate for the Greeks. Achilles partially relents, permitting Patroclus [puh-TROH-klus], his close friend and perhaps his lover, to wear his armor in order to put fear into

the Trojans. Led by Patroclus, the Achaeans, as Homer calls the Greeks, drive the Trojans back.

An excerpt from Book 16 of the *Iliad* narrates the fall of the Trojan warrior Sarpedon [sahr-PAY-dun] at the hands of Patroclus (see **Reading 5.1**, page 151). The passage opens with one of the scene's many Homeric similes: the charging Trojan forces described as "an onrush dark as autumn days / when the whole earth flattens black beneath a gale." Most notable, however, is the unflinching verbal picture Homer

VOICES

Life in Early Aegean Times

Thucydides, who lived in the fifth century BCE, *is considered one of the first true historians, basing his descriptions of events on written documents and participant interviews. The following account of earlier Aegean history comes from his introduction to* The History of the Peloponnesian War. *Just as he focuses on historical causation as a way to interpret the rush of events during the war, he employs the same technique to describe violent, nomadic habits of early settlers (and pirates) of the Aegean.*

F or in early times the Hellenes and the barbarians of the coast and islands ... were tempted to turn pirates, under the conduct of their most powerful men; the motives being to serve their own cupidity [greed] and to support the needy. They would fall upon a town unprotected by walls ... and would plunder it; indeed, this came to be the main source of their livelihood, no disgrace being yet attached to such an achievement, but even some glory ... The same rapine prevailed also by land.

... The whole of Hellas used once to carry arms, their habitations being unprotected and their communication with each other unsafe; indeed, to wear arms was as much a part of everyday life with them as with the barbarians. ... The Athenians were the first to lay aside their weapons, and to adopt an easier and more luxurious mode of life; indeed, it is only lately that their rich old men left off the luxury of wearing undergarments of linen, and fastening a knot of their hair with a tie of golden grasshop-

"The whole of Hellas used once to carry arms, their habitations being unprotected and their communication with each other unsafe; indeed, to wear arms was as much a part of everyday life with them as with the barbarians. . . ."

pers, a fashion which spread to their Ionian kindred and long prevailed ... On the contrary, a modest style of dressing, more in conformity with modern ideas, was first adopted by the Lacedaemonians [Spartans], the rich doing their best to assimilate their way of life to that of the common people. They also set the example of contending naked, publicly stripping and anointing themselves with oil in their gymnastic exercises.

With respect to their towns, later on, at an era of increased facilities of navigation and a greater supply of capital, we find the shores becoming the site of walled towns, and the isthmuses being occupied for the purposes of commerce. ... But the old towns, on account of the great prevalence of piracy, were built away from the sea, whether on the islands or the continent, and still remain in their old sites. For the pirates used to plunder one another, and indeed all coast populations, whether seafaring or not.

paints of the realities of war, not only its cowardice, panic, and brutality, but its compelling attraction as well. In this arena, the Greek soldier is able to demonstrate one of the most important values in Greek culture, his *areté* [ah-RAY-tay] often translated as "virtue," but actually meaning something closer to "being the best you can be" or "reaching your highest human potential." Homer uses the term to describe both Greek and Trojan heroes, and it refers not only to their bravery but their effectiveness in battle.

Map 5.4 Site of the Trojan War. Troy controlled the Hellespont, which connects the Aegean to the Black Sea. In Homeric times, the city of Troy was considerably closer to the straits than it is today, less than a half-mile from the shore. Many scholars believe that the Greeks may have moored their ships not in Troy Bay but in Besik Bay, 5 miles from the city at the lower left on the map.

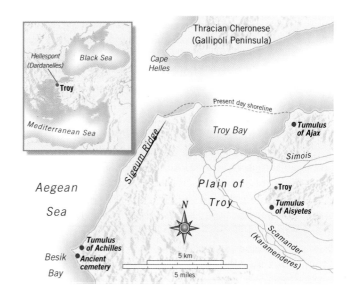

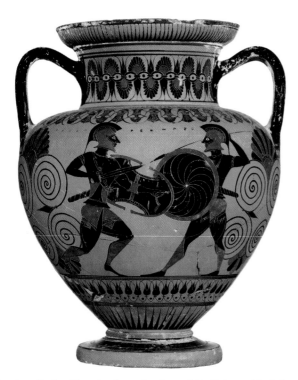

Fig. 5.13 *Botkin Class Amphora*, Greek. ca. 540–530 BCE. Black-figure decoration on ceramic, height 11 9/16″, diameter 9 1/2″. Museum of Fine Arts, Boston: Henry Lillie Pierce Fund 98.923. Photograph © 2008 Museum of Fine Arts, Boston. On the other side of this vase are two heavily armed warriors, one pursuing the other.

The sixth century BCE painting on the side of the *Botkin Class Amphora*—an **amphora** [am-FOR-uh] is a Greek jar with an egg-shaped body and two curved handles used for storing oil or wine—embodies the concept of *areté* (Fig. **5.13**). Here two warriors, one armed with a sword, the other with a spear, confront one another with unwavering determination and purpose. At one point in the *Iliad*, Homer describes two such warriors, holding their own against one another, as "rejoicing in the joy of battle." They rejoice because they find themselves in a place where they can demonstrate their *areté*.

The following passage, from Book 24, the final section of the *Iliad*, shows the other side of war and the other side of the poem, the compassion and humanity that distinguish Homer's narration (**Reading 5.1a**). Soon after Patroclus kills Sarpedon, Hector, son of the king of Troy, strikes down Patroclus with the aid of the god Apollo. On hearing the news, Achilles is devastated and finally enters the fray. Until now, fuming over Agamemnon's insult, he has sat out the battle, refusing, in effect, to demonstrate his own *areté*. But now, he redirects his rage from Agamemnon to the Trojan warrior Hector, whom he meets and kills. He then ties Hector's body to his chariot and drags it to his tent. The act is pure sacrilege, a violation of the dignity due the great Trojan warrior and an insult to his memory. Late that night, Priam, the king of Troy, steals across enemy lines to Achilles' tent and begs for the body of his son:

READING 5.1a from Homer, *Iliad*, Book 24 (ca. 750 BCE)

"Remember your own father, great godlike Achilles—
as old as I am, past the threshold of deadly old age!
No doubt the countrymen round about him plague him now,
with no one there to defend him, beat away disaster.
No one—but at least he hears you're still alive
and his old heart rejoices, hopes rising, day by day,
to see his beloved son come sailing home from Troy.
But I—dear god, my life so cursed by fate . . .
I fathered hero sons in the wide realm of Troy
and now not a single one is left, I tell you.
Fifty sons I had when the sons of Achaea came,
nineteen born to me from a single mother's womb
and the rest by other women in the palace. Many,
most of them violent Ares cut the knees from under.
But one, one was left me, to guard my wall, my people—
the one you killed the other day, defending his fatherland,
my Hector! It's all for him I've come to the ships now,
to win him back from you—I bring a priceless ransom.
Revere the gods, Achilles! Pity me in my own right,
remember your own father! I deserve more pity . . .
I have endured what no one on earth has ever done before—
I put to my lips the hands of the man who killed my son."

Those words stirred within Achilles a deep desire
to grieve for his own father. Taking the old man's hand
he gently moved him back. And overpowered by memory
both men gave way to grief. Priam wept freely
for man-killing Hector, throbbing, crouching
before Achilles' feet as Achilles wept himself,
now for his father, now for Patroclus once again,
and their sobbing rose and fell throughout the house.
Then Achilles called the serving-women out:
"Bathe and anoint the body—
bear it aside first. Priam must not see his son."
He feared that, overwhelmed by the sight of Hector,
wild with grief, Priam might let his anger flare
and Achilles might fly into fresh rage himself,
cut the old man down and break the laws of Zeus.
So when the maids had bathed and anointed the body
sleek with olive oil and wrapped it round and round
in a braided battle-shirt and handsome battle-cape,
then Achilles lifted Hector up in his own arms
and laid him down on a bier, and comrades helped him
raise the bier and body onto a sturdy wagon . . .
Then with a groan he called his dear friend by name:
"Feel no anger at me, Patroclus, if you learn—
ever there in the House of Death—I let his father
have Prince Hector back. He gave me worthy ransom
and you shall have your share from me, as always,
your fitting, lordly share."

Homer clearly recognizes the ability of these warriors to exceed their mere humanity, to raise themselves not only to a level of great military achievement, but to a state of compassion, nobility, and honor. It is this exploration of the "doubleness" of the human spirit, its cruelty and its humanity, its blindness and its insight, that perhaps best defines the power and vision of the Homeric epic.

The *Odyssey*

The fall of Troy to the Greek army after the famous ruse of the Trojan Horse (Fig **5.14**) is actually described in Book 4 of the *Odyssey*, the *Iliad*'s 24-book sequel. In **Reading 5.2a** Menelaus [me-nuh-LAY-us], now returned home with Helen, addresses her, while Telemachus [tel-uh-MOCK-us] son of the Greek commander Odysseus, listens:

READING 5.2a **from Homer, *Odyssey*, Book 4 (ca. 725 BCE)**

. . . never have I seen one like Odysseus
for steadiness and stout heart. Here, for instance,
is what he did—had the cold nerve to do—
inside the hollow horse, where we were waiting,
picked men all of us, for the Trojan slaughter,
when all of a sudden, you [Helen] came by—I dare say
drawn by some superhuman
power that planned an exploit for the Trojans;
and Deïphobos, that handsome man, came with you.
Three times you walked around it, patting it everywhere,
and called by name the flower of our fighters,
making your voice sound like their wives, calling.
Diomêdês and I crouched in the center
Along with Odysseus; we could hear you plainly;
and listening, we two were swept
by waves of longing—to reply, or go.
Odysseus fought us down, despite our craving,
and all the Akhaians kept their lips shut tight,
all but Antiklos. Desire moved his throat
to hail you, but Odysseus' great hands clamped
over his jaws, and held. So he saved us all,
till Pallas Athena led you away at last.

lope's fidelity to him. Where anger and lust drive the *Iliad*—remember Achilles' angry sulk and Helen's fickleness—love and familial affection drive the *Odyssey*. Penelope is gifted with *areté* in her own right, since for the 20 years of her husband's absence she uses all the cunning in her power to ward off the suitors who flock to marry her, convinced that Odysseus is never coming home.

A second important theme taken up by Menelaus is the role of the gods in determining the outcome of human events. Helen, he says, must have been drawn to the Trojan horse "by some superhuman / power that planned an exploit for the Trojans," some god, in other words, on the Trojans' side. And, indeed, Pallas Athena, goddess of war and wisdom and protectress of the Achaeans, leads Helen away from the horse. But in both the *Iliad* and the *Odyssey*, Homer is careful to distinguish between how people *believe* the gods exercise control over events (**Reading 5.2b**) and what control

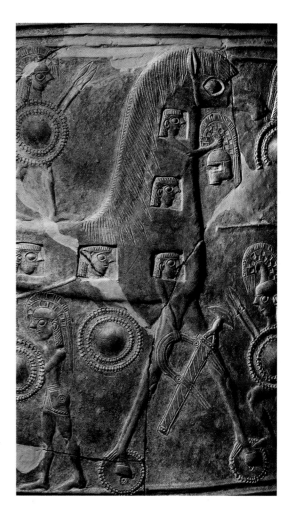

Fig. 5.14 *The Trojan Horse*, **detail from a storage jar from Chora, Mykonos. ca. 650 BCE.** Total height of jar 5″, detail as shown approx. 1″. Archaeological Museum, Mykonos. This is the earliest known depiction of the Trojan Horse, the hollow "gift" that the supposedly departing Greeks left to King Priam and his followers. The artist has opened little windows in its side, showing the Greeks hiding within, ready to attack.

Many of the themes of Homer's second epic are embedded in this short reminiscence. For although the poem narrates the adventures of Odysseus on his 20-year journey home from the war in Troy—his encounters with monsters, giants, and a seductive enchantress and a sojourn on a floating island and in the underworld—its subject is, above all, Odysseus's passionate desire to once more see his wife, Penelope, and Pene-

they actually exercise. In fact, early on in Book 1 of the *Odyssey*, Zeus, king of the gods, exclaims:

READING 5.2b **from Homer, *Odyssey*, Book 1 (ca. 725 BCE)**

My word, how mortals take the gods to task!
All their afflictions come from us, we hear.
And what of their own failings? Greed and folly
double the suffering in the lot of man.

The Greek view of the universe contrasts dramatically with that of the Hebrews. If the Greek gods exercise some authority over the lives of human beings—they do control their ultimate fate—human beings are in complete control of how they live. By exercising selflessness and wisdom, as opposed to greed and folly, they could at least halve their suffering, Zeus implies. In the *Iliad*, the crimes that Paris and Achilles commit do not violate a divine code of ethics like the Ten Commandments but, rather, a code of behavior defined by their fellow Greeks. In the Greek world, humans are ultimately responsible for their own actions.

This is the real point of the fantastic episode of Odysseus's cunning trickery of the Cyclops Polyphemus [pol-ih-FEE-mus] in Book 9 of the *Odyssey*, related by Odysseus himself to Alkinoös [ahl-ki-NOH-us] king of Phaeacia [fee-AY-shuh] (see **Reading 5.2**, page 152, for the full tale). It is Odysseus's craftiness—his wit and his intelligence—not the intervention of the gods, that saves him and his men. Compared to the stories that have come down to us from other Bronze Age cultures such as Egypt or Mesopotamia, Homer is less concerned with what happened than *how* it happened. We encounter Odysseus's trickery, his skill at making weapons, and his wordplay (Odysseus calling himself "Nobody" in anticipation of Polyphemus being asked by the other Cyclopes who has blinded him and was replying, "Nobody").

Greek artists shared this concern. They would try to refer to as many of Odysseus's talents as they could in a single work, depicting successive actions around the diameter of a vase or, as in the case of a drinking cup from Sparta, packing more than one action into a single scene (Fig. **5.15**). We saw this form of synoptic pictorial narrative in Mesopotamia, in the sculptural relief of *Ashurnasirpal II Killing Lions* (see Fig. 2.13). It is also similar to the pictorial narrative used in the *Last Judgment of Hunefer* in the Egyptian Book of the Dead, where instead of reading left to right, the actions are compounded one upon the other (see Fig. 3.25).

In later Greek culture, the *Iliad* and the *Odyssey* were the basis of Greek education. Every school child learned the two poems by heart. They were the principal vehicles through which the Greeks came to know the past, and through the past they came to know themselves. The poems embodied what might be called the Greeks' own cultural, as opposed to purely personal, *areté*, their desire to achieve a place of preeminence among all states. But in defining this larger cultural ambition, the *Iliad* and *Odyssey* laid out the individual values and responsibilities that all Greeks understood to be their personal obligations and duties if the state were ever to realize its goals.

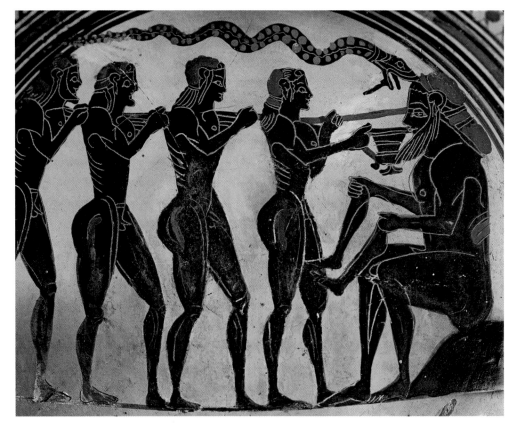

Fig. 5.15 *The Blinding of Polyphemus*, inside of drinking cup from Sparta. ca. **550 BCE.** Ceramic, diameter 8¼″. Cabinet des Médailles, Bibliothèque Nationale, Paris. At the same time that Odysseus and his companions blind Polyphemus with the pointed pole, they offer him the drink that inebriates him sufficiently to allow them to complete their task, and he finishes eating one of their companions, whose two legs he holds in his hands.

READINGS

READING 5.1

from Homer's *Iliad,* Book 16 (ca. 750 BCE)

Homer's epic poem the Iliad begins after the Trojan War has begun. It narrates, in 24 books, what it describes in the first line as "the rage of Achilles," the Greeks' greatest warrior. Achilles has withdrawn from combat in anger at the Greek leader Agamemnon for taking the beautiful Briseis from him. Finally, in Book 16, with the Greeks in desperate straits, Achilles partially relents and allows his close friend Patroclus to don his armor and lead the Greeks into combat. The following excerpts from Book 16 describe scenes from the battle in which Patroclus defeats the Trojan warrior Sarpedon. It is a stunning portrayal of the horrible realities of war.

. . . And Hector? Hector's speeding horses swept him away
armor and all, leaving his men to face their fate,
Trojans trapped but struggling on in the deep trench.
Hundreds of plunging war-teams dragging chariots down,
snapping the yoke-poles, ditched their masters' cars
and Patroclus charged them, heart afire for the kill,
shouting his Argives forward—"Slaughter Trojans!"
Cries of terror breaking as Trojans choked all roads,
their lines ripped to pieces, up from under the hoofs
a dust storm swirling into the clouds as rearing horses 10
broke into stride again and galloped back to Troy,
leaving ships and shelters in their wake. Patroclus—
wherever he saw the biggest masses dashing before him,
there he steered, plowing ahead with savage cries
and fighters tumbled out of their chariots headfirst,
crushed under their axles, war-cars crashing over, yes,
but straight across the trench went his own careering team
at a superhuman bound. Magnificent racing stallions,
gifts of the gods to Peleus, shining immortal gifts,
straining breakneck on as Patroclus' high courage 20
urged him against Prince Hector, keen for the kill
but Hector's veering horses swept him clear.
And all in an onrush dark as autumn days
when the whole earth flattens black beneath a gale,
when Zeus flings down his pelting, punishing rains—
up in arms, furious, storming against those men
who brawl in the courts and render crooked judgments,
men who throw all rights to the winds with no regard
for the vengeful eyes of the gods—so all their rivers
crest into flood spate, ravines overflowing cut the hilltops 30
off into lonely islands, the roaring flood tide rolling down
to the storm-torn sea, headlong down from the foothills
washes away the good plowed work of men—
 Rampaging so,
the gasping Trojan war-teams hurtled on.

As the battle continues, Patroclus and Sarpedon are shown to embody areté, *one of the most important values in Greek culture.*

Now as the two came closing on each other
Patroclus suddenly picked off Thrasymelus

the famous driver, the aide who flanked Sarpedon—
he speared him down the guts and loosed his limbs.
But Sarpedon hurled next with a flashing lance 40
and missed his man but he hit the horse Bold Dancer,
stabbing his right shoulder and down the stallion went,
screaming his life out, shrieking down in the dust
as his life breath winged away. And the paired horses
reared apart—a raspy creak of the yoke, the reins flying,
fouled as the trace horse thrashed the dust in death-throes.
But the fine spearman Automedon found a cure for that—
drawing his long sharp sword from his sturdy thigh
he leapt with a stroke to cut the trace horse free—
it worked. The team righted, pulled at the reins 50
and again both fighters closed with savage frenzy,
dueling now to the death.
 Again Sarpedon missed—
over Patroclus' left shoulder his spearhead streaked,
it never touched his body. Patroclus hurled next,
the bronze launched from his hand—no miss, a mortal hit.
He struck him right where the midriff packs the pounding
 heart
and down Sarpedon fell as an oak or white poplar falls
or towering pine that shipwrights up on a mountain 60
hew down with whetted axes for sturdy ship timber—
so he stretched in front of his team and chariot,
sprawled and roaring, clawing the bloody dust.
As the bull a marauding lion cuts from the herd,
tawny and greathearted among the shambling cattle,
dies bellowing under the lion's killing jaws—
so now Sarpedon, captain of Lycia's shieldsmen,
died at Patroclus' hands and died raging still,
crying out his beloved comrade's name: "Glaucus—
oh dear friend, dear fighter, soldier's soldier! 70
Now is the time to prove yourself a spearman,
a daring man of war—now, if you are brave,
make grueling battle your one consuming passion.
First find Lycia's captains, range the ranks,
spur them to fight and shield Sarpedon's body.
Then you, Glaucus, you fight for me with bronze!
You'll hang your head in shame—every day of your life—

if the Argives strip my armor here at the anchored ships
where I have gone down fighting. Hold on, full force—
spur all our men to battle!" 80
 Death cut him short.
The end closed in around him, swirling down his eyes,
choking off his breath. Patroclus planted a heel
against his chest, wrenched the spear from his wound
and the midriff came out with it—so he dragged out both
the man's life breath and the weapon's point together. ■

Reading Questions

**The scene described is full of Homeric similes. Two of the
most effective follow each other in short order directly after
Patroclus hurls his spear into Sarpedon's midriff. How do
these similes contribute to the power of the poem? How
might they either contribute to or diminish our sense of the
warriors' _areté_ ?**

READING 5.2

from Homer's *Odyssey*, Book 9 (ca. 725 BCE)

*The sequel to Homer's Iliad, the Odyssey is a second epic poem by Homer that narrates the adventures of
the Greek warrior Odysseus on his 20-year journey home from the Trojan War. The following passage
from Book 9, recounts Odysseus's confrontation with the Cyclops Polyphemus. In this confrontation
Odysseus displays the cunning and skill that make him a great leader.*

In the next land we found were Kyklopês,[1]
giants, louts, without a law to bless them.
In ignorance leaving the fruitage of the earth in mystery
to the immortal gods, they neither plow
nor sow by hand, nor till the ground, though grain—
wild wheat and barley—grows untended, and
wine-grapes, in clusters, ripen in heaven's rain.
Kyklopês have no muster and no meeting,
no consultation or old tribal ways,
but each one dwells in his own mountain cave 10
dealing out rough justice to wife and child,
indifferent to what the others do. . . .
[Camped on a desert island across from the mainland home
of the Kyklopes, Odysseus announces his intention to explore
the mainland itself.]
'Old shipmates, friends,
the rest of you stand by; I'll make the crossing
in my own ship, with my own company,
and find out what the mainland natives are—
for they may be wild savages, and lawless, 20
or hospitable and god fearing men.'
At this I went aboard, and gave the word
to cast off by the stern. My oarsmen followed,
filing in to their benches by the rowlocks,
and all in line dipped oars in the grey sea.
As we rowed on, and nearer to the mainland,

at one end of the bay, we saw a cavern
yawning above the water, screened with laurel,
and many rams and goats about the place
inside a sheepfold—made from slabs of stone 30
earthfast between tall trunks of pine and rugged
towering oak trees.
A prodigious man
slept in this cave alone, and took his flocks
to graze afield—remote from all companions,
knowing none but savage ways, a brute
so huge, he seemed no man at all of those
who eat good wheaten bread; but he seemed rather
a shaggy mountain reared in solitude.
We beached there, and I told the crew 40
to stand by and keep watch over the ship;
as for myself I took my twelve best fighters
and went ahead. I had a goatskin full
of that sweet liquor that Euanthês' son,
Maron, had given me. . . .
 No man turned away
when cups of this came round.
A wineskin full
I brought along, and victuals in a bag,
for in my bones I knew some towering brute 50
would be upon us soon—all outward power,
a wild man, ignorant of civility.
We climbed, then, briskly to the cave. But Kyklops
had gone afield, to pasture his fat sheep,
so we looked round at everything inside. . . .

[1]One-eyed giants, inhabitants of Sicily. Also spelled *Cyclops*.

My men came pressing round me, pleading:
'Why not
take these cheeses, get them stowed, come back,
throw open all the pens, and make a run for it?
We'll drive the kids and lambs aboard. We say 60
put out again on good salt water!'
Ah,
how sound that was! Yet I refused. I wished
to see the caveman, what he had to offer—
no pretty sight, it turned out, for my friends.
We lit a fire, burnt an offering,
and took some cheese to eat; then sat in silence
around the embers, waiting. When he came
he had a load of dry boughs on his shoulder
to stoke his fire at suppertime. He dumped it 70
with a great crash into that hollow cave,
and we all scattered fast to the far wall. . . .
'Strangers,' he said, 'who are you? And where from?
What brings you here by sea ways—a fair traffic?
Or are you wandering rogues, who cast your lives
like dice, and ravage other folk by sea?'
We felt a pressure on our hearts, in dread
of that deep rumble and that mighty man.
But all the same I spoke up in reply:
'We are from Troy, Akhaians, blown off course 80
by shifting gales on the Great South Sea;
homeward bound, but taking routes and ways
uncommon; so the will of Zeus would have it. . . .
It was our luck to come here; here we stand,
beholden for your help, or any gifts
you give—as custom is to honor strangers.
We would entreat you, great Sir, have a care
for the gods' courtesy; Zeus will avenge
the unoffending guest.'[2]
He answered this 90
from his brute chest, unmoved:
'You are a ninny,
or else you come from the other end of nowhere,
telling me, mind the gods! We Kyklopês
care not a whistle for your thundering Zeus
or all the gods in bliss; we have more force by far.
I would not let you go for fear of Zeus—
you or your friends—unless I had a whim to.
Tell me, where was it, now, you left your ship—
around the point, or down the shore, I wonder?' 100
He thought he'd find out, but I saw through this,
and answered with a ready lie:
'My ship?
Poseidon Lord, who sets the earth a-tremble,
broke it up on the rocks at your land's end.
A wind from seaward served him, drove us there.
We are survivors, these good men and I.'
Neither reply nor pity came from him,
but in one stride he clutched at my companions
and caught two in his hands like squirming puppies 110

to beat their brains out, spattering the floor.
Then he dismembered them and made his meal,
gaping and crunching like a mountain lion—
everything: innards, flesh, and marrow bones.
We cried aloud, lifting our hands to Zeus,
powerless, looking on at this, appalled;
but Kyklops[3] went on filling up his belly
with manflesh and great gulps of whey,
then lay down like a mast among his sheep.
My heart beat high now at the chance of action, 120
and drawing the sharp sword from my hip I went
along his flank to stab him where the midriff
holds the liver. I had touched the spot
when sudden fear stayed me: if I killed him
we perished there as well, for we could never
move his ponderous doorway slab aside.
So we were left to groan and wait for morning.
When the young Dawn with finger tips of rose
lit up the world, the Kyklops built a fire
and milked his handsome ewes, all in due order, 130
putting the sucklings to the mothers. Then,
his chores being all dispatched, he caught
another brace of men to make his breakfast,
and whisked away his great door slab
to let his sheep go through—but he, behind,
reset the stone as one would cap a quiver.
There was a din of whistling as the Kyklops
rounded his flock to higher ground, then stillness.
And now I pondered how to hurt him worst,
if but Athena granted what I prayed for. 140
Here are the means I thought would serve my turn:
a club, or staff, lay there along the fold—
an olive tree, felled green and left to season
for Kyklops' hand. And it was like a mast
a lugger of twenty oars, broad in the beam—
a deep-sea-going craft—might carry:
so long, so big around, it seemed. Now I
chopped out a six foot section of this pole
and set it down before my men, who scraped it;
and when they had it smooth, I hewed again 150
to make a stake with pointed end. I held this
in the fire's heart and turned it, toughening it,
then hid it, well back in the cavern, under
one of the dung piles in profusion there.
Now came the time to toss for it: who ventured
along with me? whose hand could bear to thrust
and grind that spike in Kyklops' eye, when mild
sleep had mastered him? As luck would have it,
the men I would have chosen won the toss—
four strong men, and I made five as captain. 160
At evening came the shepherd with his flock,
his woolly flock. The rams as well, this time,
entered the cave: by some sheep-herding whim—
or a god's bidding—none were left outside.
He hefted his great boulder into place
and sat him down to milk the bleating ewes

[2]Zeus was the protector and guarantor of the laws of hospitality.

[3]Here used as a singular; his name, we learn later, is Polyphêmos.

in proper order, put the lambs to suck,
and swiftly ran through all his evening chores.
Then he caught two more men and feasted on them.
My moment was at hand, and I went forward 170
holding an ivy bowl of my dark drink,
looking up, saying:
'Kyklops, try some wine.
Here's liquor to wash down your scraps of men.
Taste it, and see the kind of drink we carried
under our planks. I meant it for an offering
if you would help us home. But you are mad,
unbearable, a bloody monster! After this,
will any other traveller come to see you?'
He seized and drained the bowl, and it went down 180
so fiery and smooth he called for more:
'Give me another, thank you kindly. Tell me,
how are you called? I'll make a gift will please you. . . ."
I saw the fuddle and flush come over him,
then I sang out in cordial tones:
'Kyklops,
you ask my honorable name?
My name is Nohbdy: mother, father, and friends,
everyone calls me Nohbdy.'
And he said: 190
'Nohbdy's my meat, then, after I eat his friends.
Others come first. There's a noble gift, now.'
Even as he spoke, he reeled and tumbled backward,
his great head lolling to one side; and sleep
took him like any creature. Drunk, hiccuping,
he dribbled streams of liquor and bits of men.
Now, by the gods, I drove my big hand spike
deep in the embers, charring it again,
and cheered my men along with battle talk
to keep their courage up: no quitting now. 200
The pike of olive, green though it had been,
reddened and glowed as if about to catch.
I drew it from the coals and my four fellows
gave me a hand, lugging it near the Kyklops
as more than natural force nerved them; straight
forward they sprinted, lifted it, and rammed it
deep in his crater eye, and I leaned on it
turning it as a shipwright turns a drill
in planking, having men below to swing
the two-handled strap that spins it in the groove. 210
So with our brand we bored that great eye socket
while blood ran out around the red hot bar.
Eyelid and lash were seared; the pierced ball
hissed broiling, and the roots popped.
In a smithy
one sees a white-hot axehead or an adze
plunged and wrung in a cold tub, screeching steam—
the way they make soft iron hale and hard—:
just so that eyeball hissed around the spike.
The Kyklops bellowed and the rock roared round him, 220
and we fell back in fear. Clawing his face
he tugged the bloody spike out of his eye,

threw it away, and his wild hands went groping;
then he set up a howl for Kyklopês
who lived in caves on windy peaks nearby.
Some heard him; and they came by divers ways
to clump around outside and call:
'What ails you,
Polyphêmos? Why do you cry so sore
in the starry night? You will not let us sleep. 230
Sure no man's driving off your flock? No man
has tricked you, ruined you?'
Out of the cave
the mammoth Polyphêmos roared in answer:
'Nohbdy, Nohbdy's tricked me, Nohbdy's ruined me!'
To this rough shout they made a sage reply:
'Ah well, if nobody has played you foul
there in your lonely bed, we are no use in pain
given by great Zeus. Let it be your father,
Poseidon Lord, to whom you pray.' 240
So saying
they trailed away. And I was filled with laughter
to see how like a charm the name deceived them.
Now Kyklops, wheezing as the pain came on him,
fumbled to wrench away the great doorstone
and squatted in the breach with arms thrown wide
for any silly beast or man who bolted—
hoping somehow I might be such a fool.
But I kept thinking how to win the game:
death sat there huge; how could we slip away? 250
I drew on all my wits, and ran through tactics,
reasoning as a man will for dear life,
until a trick came—and it pleased me well.
The Kyklops' rams were handsome, fat, with heavy
fleeces, a dark violet.
Three abreast
I tied them silently together, twining
cords of willow from the ogre's bed;
then slung a man under each middle one
to ride there safely, shielded left and right. 260
So three sheep could convey each man. I took
the woolliest ram, the choicest of the flock,
and hung myself under his kinky belly,
pulled up tight, with fingers twisted deep
in sheepskin ringlets for an iron grip.
So, breathing hard, we waited until morning.
When Dawn spread out her finger tips of rose
the rams began to stir, moving for pasture,
and peals of bleating echoed round the pens
where dams with udders full called for a milking. 270
Blinded, and sick with pain from his head wound,
the master stroked each ram, then let it pass,
but my men riding on the pectoral fleece
the giant's blind hands blundering never found.
Last of them all my ram, the leader, came,
weighted by wool and me with my meditations.
The Kyklops patted him, and then he said:
'Sweet cousin ram, why lag behind the rest

My men came pressing round me, pleading:
'Why not
take these cheeses, get them stowed, come back,
throw open all the pens, and make a run for it?
We'll drive the kids and lambs aboard. We say 60
put out again on good salt water!'
Ah,
how sound that was! Yet I refused. I wished
to see the caveman, what he had to offer—
no pretty sight, it turned out, for my friends.
We lit a fire, burnt an offering,
and took some cheese to eat; then sat in silence
around the embers, waiting. When he came
he had a load of dry boughs on his shoulder
to stoke his fire at suppertime. He dumped it 70
with a great crash into that hollow cave,
and we all scattered fast to the far wall. . . .
'Strangers,' he said, 'who are you? And where from?
What brings you here by sea ways—a fair traffic?
Or are you wandering rogues, who cast your lives
like dice, and ravage other folk by sea?'
We felt a pressure on our hearts, in dread
of that deep rumble and that mighty man.
But all the same I spoke up in reply:
'We are from Troy, Akhaians, blown off course 80
by shifting gales on the Great South Sea;
homeward bound, but taking routes and ways
uncommon; so the will of Zeus would have it. . . .
It was our luck to come here; here we stand,
beholden for your help, or any gifts
you give—as custom is to honor strangers.
We would entreat you, great Sir, have a care
for the gods' courtesy; Zeus will avenge
the unoffending guest.'[2]
He answered this 90
from his brute chest, unmoved:
'You are a ninny,
or else you come from the other end of nowhere,
telling me, mind the gods! We Kyklopês
care not a whistle for your thundering Zeus
or all the gods in bliss; we have more force by far.
I would not let you go for fear of Zeus—
you or your friends—unless I had a whim to.
Tell me, where was it, now, you left your ship—
around the point, or down the shore, I wonder?' 100
He thought he'd find out, but I saw through this,
and answered with a ready lie:
'My ship?
Poseidon Lord, who sets the earth a-tremble,
broke it up on the rocks at your land's end.
A wind from seaward served him, drove us there.
We are survivors, these good men and I.'
Neither reply nor pity came from him,
but in one stride he clutched at my companions
and caught two in his hands like squirming puppies 110

to beat their brains out, spattering the floor.
Then he dismembered them and made his meal,
gaping and crunching like a mountain lion—
everything: innards, flesh, and marrow bones.
We cried aloud, lifting our hands to Zeus,
powerless, looking on at this, appalled;
but Kyklops[3] went on filling up his belly
with manflesh and great gulps of whey,
then lay down like a mast among his sheep.
My heart beat high now at the chance of action, 120
and drawing the sharp sword from my hip I went
along his flank to stab him where the midriff
holds the liver. I had touched the spot
when sudden fear stayed me: if I killed him
we perished there as well, for we could never
move his ponderous doorway slab aside.
So we were left to groan and wait for morning.
When the young Dawn with finger tips of rose
lit up the world, the Kyklops built a fire
and milked his handsome ewes, all in due order, 130
putting the sucklings to the mothers. Then,
his chores being all dispatched, he caught
another brace of men to make his breakfast,
and whisked away his great door slab
to let his sheep go through—but he, behind,
reset the stone as one would cap a quiver.
There was a din of whistling as the Kyklops
rounded his flock to higher ground, then stillness.
And now I pondered how to hurt him worst,
if but Athena granted what I prayed for. 140
Here are the means I thought would serve my turn:
a club, or staff, lay there along the fold—
an olive tree, felled green and left to season
for Kyklops' hand. And it was like a mast
a lugger of twenty oars, broad in the beam—
a deep-sea-going craft—might carry:
so long, so big around, it seemed. Now I
chopped out a six foot section of this pole
and set it down before my men, who scraped it;
and when they had it smooth, I hewed again 150
to make a stake with pointed end. I held this
in the fire's heart and turned it, toughening it,
then hid it, well back in the cavern, under
one of the dung piles in profusion there.
Now came the time to toss for it: who ventured
along with me? whose hand could bear to thrust
and grind that spike in Kyklops' eye, when mild
sleep had mastered him? As luck would have it,
the men I would have chosen won the toss—
four strong men, and I made five as captain. 160
At evening came the shepherd with his flock,
his woolly flock. The rams as well, this time,
entered the cave: by some sheep-herding whim—
or a god's bidding—none were left outside.
He hefted his great boulder into place
and sat him down to milk the bleating ewes

[2]Zeus was the protector and guarantor of the laws of hospitality.

[3]Here used as a singular; his name, we learn later, is Polyphêmos.

in proper order, put the lambs to suck,
and swiftly ran through all his evening chores.
Then he caught two more men and feasted on them.
My moment was at hand, and I went forward 170
holding an ivy bowl of my dark drink,
looking up, saying:
'Kyklops, try some wine.
Here's liquor to wash down your scraps of men.
Taste it, and see the kind of drink we carried
under our planks. I meant it for an offering
if you would help us home. But you are mad,
unbearable, a bloody monster! After this,
will any other traveller come to see you?'
He seized and drained the bowl, and it went down 180
so fiery and smooth he called for more:
'Give me another, thank you kindly. Tell me,
how are you called? I'll make a gift will please you. . . ."
I saw the fuddle and flush come over him,
then I sang out in cordial tones:
'Kyklops,
you ask my honorable name?
My name is Nohbdy: mother, father, and friends,
everyone calls me Nohbdy.'
And he said: 190
'Nohbdy's my meat, then, after I eat his friends.
Others come first. There's a noble gift, now.'
Even as he spoke, he reeled and tumbled backward,
his great head lolling to one side; and sleep
took him like any creature. Drunk, hiccuping,
he dribbled streams of liquor and bits of men.
Now, by the gods, I drove my big hand spike
deep in the embers, charring it again,
and cheered my men along with battle talk
to keep their courage up: no quitting now. 200
The pike of olive, green though it had been,
reddened and glowed as if about to catch.
I drew it from the coals and my four fellows
gave me a hand, lugging it near the Kyklops
as more than natural force nerved them; straight
forward they sprinted, lifted it, and rammed it
deep in his crater eye, and I leaned on it
turning it as a shipwright turns a drill
in planking, having men below to swing
the two-handled strap that spins it in the groove. 210
So with our brand we bored that great eye socket
while blood ran out around the red hot bar.
Eyelid and lash were seared; the pierced ball
hissed broiling, and the roots popped.
In a smithy
one sees a white-hot axehead or an adze
plunged and wrung in a cold tub, screeching steam—
the way they make soft iron hale and hard—:
just so that eyeball hissed around the spike.
The Kyklops bellowed and the rock roared round him, 220
and we fell back in fear. Clawing his face
he tugged the bloody spike out of his eye,

threw it away, and his wild hands went groping;
then he set up a howl for Kyklopês
who lived in caves on windy peaks nearby.
Some heard him; and they came by divers ways
to clump around outside and call:
'What ails you,
Polyphêmos? Why do you cry so sore
in the starry night? You will not let us sleep. 230
Sure no man's driving off your flock? No man
has tricked you, ruined you?'
Out of the cave
the mammoth Polyphêmos roared in answer:
'Nohbdy, Nohbdy's tricked me, Nohbdy's ruined me!'
To this rough shout they made a sage reply:
'Ah well, if nobody has played you foul
there in your lonely bed, we are no use in pain
given by great Zeus. Let it be your father,
Poseidon Lord, to whom you pray.' 240
So saying
they trailed away. And I was filled with laughter
to see how like a charm the name deceived them.
Now Kyklops, wheezing as the pain came on him,
fumbled to wrench away the great doorstone
and squatted in the breach with arms thrown wide
for any silly beast or man who bolted—
hoping somehow I might be such a fool.
But I kept thinking how to win the game:
death sat there huge; how could we slip away? 250
I drew on all my wits, and ran through tactics,
reasoning as a man will for dear life,
until a trick came—and it pleased me well.
The Kyklops' rams were handsome, fat, with heavy
fleeces, a dark violet.
Three abreast
I tied them silently together, twining
cords of willow from the ogre's bed;
then slung a man under each middle one
to ride there safely, shielded left and right. 260
So three sheep could convey each man. I took
the woolliest ram, the choicest of the flock,
and hung myself under his kinky belly,
pulled up tight, with fingers twisted deep
in sheepskin ringlets for an iron grip.
So, breathing hard, we waited until morning.
When Dawn spread out her finger tips of rose
the rams began to stir, moving for pasture,
and peals of bleating echoed round the pens
where dams with udders full called for a milking. 270
Blinded, and sick with pain from his head wound,
the master stroked each ram, then let it pass,
but my men riding on the pectoral fleece
the giant's blind hands blundering never found.
Last of them all my ram, the leader, came,
weighted by wool and me with my meditations.
The Kyklops patted him, and then he said:
'Sweet cousin ram, why lag behind the rest

in the night cave? You never linger so,
but graze before them all, and go afar 280
to crop sweet grass, and take your stately way
leading along the streams, until at evening
you run to be the first one in the fold.
Why, now, so far behind? Can you be grieving
over your Master's eye? That carrion rogue
and his accurst companions burnt it out
when he had conquered all my wits with wine.
Nohbdy will not get out alive, I swear.
Oh, had you brain and voice to tell
where he may be now, dodging all my fury! 290
Bashed by this hand and bashed on this rock wall
his brains would strew the floor, and I should have
rest from the outrage Nohbdy worked upon me.'
He sent us into the open, then. Close by,
I dropped and rolled clear of the ram's belly,
going this way and that to untie the men.
With many glances back, we rounded up
his fat, stiff-legged sheep to take aboard,
and drove them down to where the good ship lay.
We saw, as we came near, our fellows' faces 300
shining; then we saw them turn to grief
tallying those who had not fled from death.
I hushed them, jerking head and eyebrows up,
and in a low voice told them: 'Load this herd;
move fast, and put the ship's head toward the breakers.'
They all pitched in at loading, then embarked
and struck their oars into the sea. Far out,
as far off shore as shouted words would carry,
I sent a few back to the adversary:
'O Kyklops! Would you feast on my companions? 310
Puny, am I, in a Caveman's hands?
How do you like the beating that we gave you,
you damned cannibal? Eater of guests
under your roof! Zeus and the gods have paid you!'
The blind thing in his doubled fury broke
a hilltop in his hands and heaved it after us.
Ahead of our black prow it struck and sank
whelmed in a spuming geyser, a giant wave

that washed the ship stern foremost back to shore.
I got the longest boathook out and stood 320
fending us off, with furious nods to all
to put their backs into a racing stroke—
row, row, or perish. So the long oars bent
kicking the foam sternward, making head
until we drew away, and twice as far.
Now when I cupped my hands I heard the crew
in low voices protesting:
'Godsake, Captain!
Why bait the beast again? Let him alone!'
'That tidal wave he made on the first throw 330
all but beached us.'
'All but stove us in!'
'Give him our bearing with your trumpeting,
he'll get the range and lob a boulder.'
'Aye
He'll smash our timbers and our heads together!'
I would not heed them in my glorying spirit,
but let my anger flare and yelled:
'Kyklops,
if ever mortal man inquire 340
how you were put to shame and blinded, tell him
Odysseus, raider of cities, took your eye:
Laërtês' son, whose home's on Ithaka!' . . .
Now he laid hands upon a bigger stone
and wheeled around, titanic for the cast,
to let it fly in the black-prowed vessel's track.
But it fell short, just aft the steering oar,
and whelming seas rose giant above the stone
to bear us onward toward the island. . . . ∎

Reading Question

One of the features that distinguishes this particular tale in the *Odyssey* from Homer's narration in the *Iliad* is that Odysseus tells it himself, in his own voice. How does this first-person narrative technique help us to understand Homer's hero better than we might if Homer narrated the events himself?

Summary

■ **The Cyclades** The later Greeks traced their ancestry to the cultures that arose in the islands of the Aegean Sea. Their art consisted of highly simplified Neolithic figurines and, later, elaborate wall frescoes depicting everyday events. An enormous volcanic eruption on the island of Thera brought Cycladic culture to an end.

■ **Minoan Culture on Crete** Cycladic culture shares much with Minoan culture, and it is almost certain that there was close trade contact between the two before the volcanic eruption. Minoan and Cycladic frescoes have motifs in common. Unique to Crete is an emphasis on the bull, associated with the legend of King Minos and the Minotaur, and the double axe, symbol of the palace of Minos at Knossos, the complex layout of which gives rise to the word *labyrinth*. The later Greeks would trace the origin of their own culture to Minos and his heirs.

■ **Mycenaean Culture in the Peloponnese** Mycenaean warriors from the Greek mainland invaded Crete in about 1450 BCE. There is abundant archeological evidence that they had valued Minoan artistry long before and had traded with the Minoans. But from all appearances their two cultures could not have been more different. The Minoans were peace loving, building unfortified cities on the flat plains of the island. The Mycenaeans were warlike, building walled cities on highly fortified and defensible hilltops. Mycenaean culture was feudal, and its kings accumulated great wealth from control of their cities and the surrounding countryside, a wealth to which their elaborate beehive tombs bear witness.

■ **Aegean Languages and the Phoenician Alphabet** Minoan culture had a written language that remains undeciphered, Linear A. Toward the end of Minoan culture, another written language, Linear B, came into use. Sometime before 800 BCE, Phoenician traders introduced a simplified alphabet throughout the Aegean, and the Greeks quickly adopted it to their own ends.

■ **The Homeric Epics** The Phoenician alphabet was used to transcribe, around 800 BCE, Homer's great epics, the *Iliad* and the *Odyssey*. The stories had been passed down orally for generations. The *Iliad* tells of the anger of the Greek hero Achilles and its consequences during a war between Mycenae and Troy, which occurred sometime between 1800 and 1300 BCE. The *Odyssey* follows the Greek commander Odysseus on his adventure-laden journey home to his faithful wife Penelope. These stories, and legends such as the myth of the Minotaur, comprised for the Greeks their *archaiologia*, their way of knowing their past.

Glossary

amphora A Greek jar with an egg-shaped body and two curved handles that was used for storing oil or wine.

bard A singer of songs about the deeds of heroes and the ways of the gods.

buon fresco The technique of applying pigment mixed with water onto wet plaster so that the paint is absorbed by the plaster and becomes part of the wall when dry.

capital A sculpted block that forms the uppermost part of a column.

cyclopean masonry Walls made of huge blocks of rough-hewn stone; so called because of myth that a race of monsters known as the Cyclopes built them.

dactyl An element of meter in poetry consisting of one long syllable followed by two short syllables.

engaged column A half-column that projects from a wall but serves no structural purpose.

epic conventions Standard ways of composing an epic.

faience A type of earthenware ceramic decorated with glazes.

feudal A system of political organization based on ties of allegiance between a lord and those who owed their welfare to him.

formulaic epithet A descriptive phrase applied to a person or thing.

hexameter A poetic form composed of six metrical units per line.

origin myth A story that describes the birth of one culture out of another.

relieving triangle A triangular-shaped opening above a lintel that relieves some of the weight the lintel bears.

repoussé A metalworking technique of creating a design in relief by hammering or pressing on the reverse side.

shaft grave A deep vertical pit enclosed in a circle of stone slabs.

spondee An element of meter in poetry consisting of two long syllables.

tholos A small, round building.

Critical Thinking Questions

1. What is the role of trade in the spread of culture in the Aegean islands and beyond?

2. What are the major differences between the Minoan and Mycenaean cultures?

3. How did the later Greeks relate to the early Aegean cultures?

4. How do the Homeric epics, the *Iliad* and the *Odyssey*, differ from each other in their depiction of Greek culture and values?

Mycenaean culture came to an abrupt close around 1200 BCE. What precipitated this remains a mystery—plague, climate change, perhaps an invasion of the Dorians [DOR-ee-unz], a tribe from the north about whom we know nothing but vague legend. We do know that Mycenaean cities were massively fortified, as if in defense against someone, and we know as well that their collapse roughly parallels the end of the Bronze Age and the start of the Iron Age. Perhaps the invaders from the north brought with them the new, stronger iron weaponry.

A period known as the Dark Age ensued. Figurative art disappeared, as did gold metalwork and monumental architecture. Literacy was lost as well, perhaps because Linear B was reserved exclusively for the aristocratic elite, and writing died with their demise. Not until about 800 BCE—the time of Homer—when the Phoenician alphabet spread throughout the Greek world, did writing resurface. By then, Mycenaean culture was legend, its existence a matter of memory that might have been lost to Greek culture altogether had it not been for writing.

But Mycenae was the Greek past, and the Greeks saw themselves as continuing Mycenaean traditions. The vases illustrating the *Iliad* and the *Odyssey* in this chapter are the product of a Greek culture that is looking back on Mycenaean times. This, these vessels say to those who saw or owned them, is how it must have been. But, like Homer's poems, they probably tell us more about how the later Greeks saw themselves than they do about the Mycenaeans, just as our traditional understanding of the Minoan Snake Goddesses probably tells us more about ourselves than about the Minoans. We need only compare the warriors on the Myce-

naean *Warrior Vase* to those on the sixth-century BCE *Botkin Class Amphora* to understand that Mycenaean culture put far less value on craft and skill than the Greek culture that followed it (see Figs. 5.12 and 5.13).

A marble sculpture of a *Dying Warrior* from fifth-century BCE Greece highlights the military prowess that Greek culture would continue to celebrate (Fig. **5.16**). The figure was originally draped over the edge of the lintel above the door of the temple of Aphaia [uh-FIE-uh] on the island Aegina [ee-JIE-nuh]. Holes punctuate its surface to enable the island's famed bronze artisans to clothe the marble soldier in bronze weapons and armor. For centuries iron had been the metal of choice for soldiering. Therefore, decorating the Aphaia soldier in bronze was anachronistic. Perhaps the point was that it conjured up a vision of the Homeric past, as if celebrating the words of Hippolochus [hip-PAWL-uh-kus] to his son Glaucus [GLAW-kus] in Book 6 of the *Iliad*: "Always be the best, my boy, the bravest, / and hold your head up high above the others. Never disgrace the generation of your fathers." These values survived.

By the time the *Dying Warrior* was completed, "the best" referred to more than just military bravery. It also referred to philosophy, literature, and art, including the skills associated with *Dying Warrior*: the skill of bronze casting for the decoration of this sculpture, and the convincing rendering of human anatomy and emotion, the latter particularly evident in the soldier's pain and determination. Even as this sculpture celebrates the fathers of the Greeks, the Mycenaeans, it rises high above them, to the new heights that would distinguish ancient Greek culture in the Golden Age of the fifth century BCE. ■

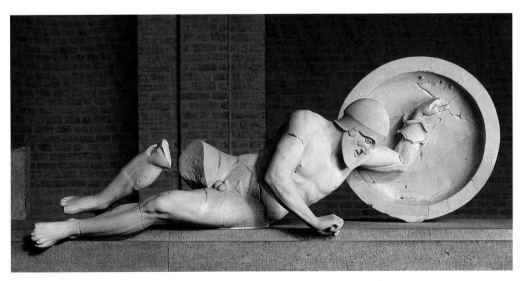

Fig. 5.16 *Dying Warrior,* **from the east pediment of the Temple of Aphaia, Aegina. ca. 480** BCE. Marble, length 6′. Staatliche Antikensammlungen und Glyptothek, Munich, Germany.

6 The Rise of Greek City-States

War and Victory

Hesiod and Rural Greek Culture

The *Polis*

The Athens of Peisistratus

Persepolis and the Persian Wars

" *But between us and Goodness the gods have placed the sweat of our brows; long and steep is the path that leads to her . . .* "

Hesiod

◄ **Fig. 6.1 The Temple of Hera I (background), ca. 560 BCE, and The Temple of Hera II (foreground), 460 BCE, Paestum, Italy.** Two of the best preserved Greek temples can be found in Italy, at Paestum, south of Naples, in a place the Greeks called Poseidonia after the god of the sea, Poseidon. Separated by one hundred years, the two temples represent the rise of the Classical Greek sense of order and proportion. These values were mirrored in the city-state as a political entity. A challenge to these values would come from Persia, and the Greeks would rally to overcome the danger that powerful empire presented.

THE GREEK CITY-STATES AROSE DURING THE NINTH CENTURY

BCE, just before the time of Homer. At about that time, colonists from the Greek mainland began migrating throughout the Mediterranean basin, as far as the Black Sea in the east and Spain in the west. They eventually established as many as 1,500

new settlements, including several large city-states in Italy (Fig. **6.1**). Since the fall of Mycenae in about 1100 BCE, some 100 years after the Trojan War, Greece had endured a long period of cultural decline that many refer to as the Dark Ages. Greek legend has it that a tribe from the North, the Dorians, overran the Greek mainland and the Peloponnese (Map **6.1**). Historical evidence suggests that the Dorians possessed iron weapons and easily defeated the bronze-armored Greeks. Scattered and in disarray, the Greek people almost forgot the rudiments of culture and reading and writing fell into disuse.

For the most part, the Greeks lived in small rural communities that often warred with one another. But despite these conditions, which hardly favored the development of art and architecture, the Greeks managed to sustain a sense of identity and even, as the survival of the Trojan War legends suggests, some idea of their cultural heritage.

In Athens, particularly, the conditions of the Dark Ages were challenging, but they did not completely stifle the arts. By the tenth century BCE, elaborate ceramic manufactures had been established at the Kerameikos [ker-AM-ay-kos] cemetery (the origin of the word *ceramics*) on the outskirts of the city. Athenian artisans invented a new, much faster potter's wheel that allowed them to more reliably control the shapes of their vases. They also created new kilns, with far greater capacity to control heat, resulting in richer, more lustrous glazes. Because the human figure is largely absent from the pots produced, which favor abstract geometric patterns, some see this work as unsophisticated, especially when compared to the great figurative tradition of later Greek art. But when we consider the Greek genius for mathematics, the abstract design and patterning of these ceramics begin to seem complex and sophisticated. Concentric circles, made with a new tool—a compass with multiple brushes—decorate even the earliest pots (Fig. **6.2**).

By the middle of the ninth century BCE, an elaborate **geometric style** dominates the pottery's surface (Fig. **6.3**), characterized by circles, rectangles, and triangles in parallel bands around the vase. This represents an extremely elaborate and highly stylized approach to decoration, one that echoes the Homeric epic in the submission of its detail to the unity of the whole. Layered band upon band, these geometric designs hint at what the Greeks believed to be the structure of the cosmos as a whole, a structure they tirelessly sought to understand. Soon, the physical philosopher Pythagoras [pie-THAG-uh-rus] (ca. 580–500 BCE), who studied the mathematical differences in the length of strings needed to produce various notes on the lyre, would develop his famous theorem. The Pythagorean theorem states that in a right triangle, the square of the hypotenuse is equal to the sum of the squares of the other two sides. And by 300 BCE, Euclid [YOU-klid], a Greek philosopher (ca. 325–250 BCE) working in Alexandria, Egypt, would formulate his definitive geometry of two- and three-dimensional space.

This chapter traces the growing sophistication of Greek culture implied by the designs of these two vases. From its early agricultural era, through the rise of the city-state as the organizing

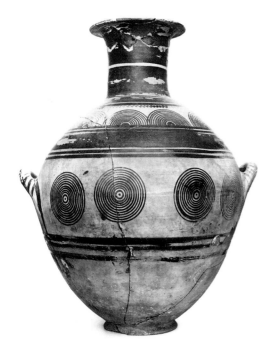

Fig. 6.2 Amphora (two-handled vase), from the Kerameikos cemetery, Athens. 10th century BCE. Height 21 3/4″. Kerameikos Museum, Athens. Though Greece is often thought to have entered a Dark Age after the fall of Mycenae, the production of ceramic wares flourished. This amphora is decorated in what is often referred to as the protogeometric style, from the Greek word *proto*, "before."

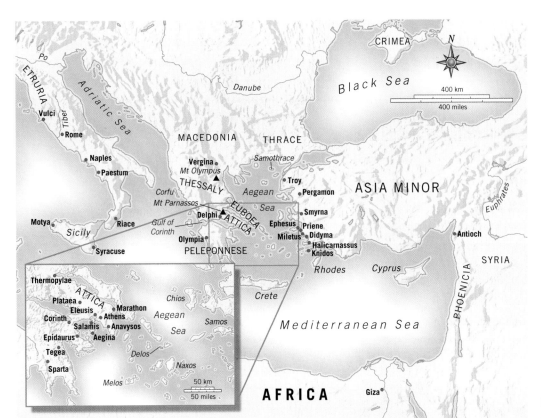

Map 6.1 The city-states of
Ancient Greece.

principle of society, to the incipient birth of democracy around 500 BCE in the city-state of Athens, a spirit of competition characterizes the culture. The gods compete with one another in the heavens; athletes compete for supremacy in the Olympic Games. The date of the first Games, in 776 BCE, marked for the Greeks the start of their history—and artists, writers, and architects all strive to be the best. This emphasis on individual achievement and accomplishment, perhaps best embodied in the growing naturalism of Greek sculpture, manifests itself politically in the movement toward democratic government. This spirit of competition extends to the city-states as well. In fact, one of the defining characteristics of the era is the tension between the Greeks' loyalty to their various city-states and their growing sense of a greater Greek identity, an identity expressed by their coming together at their common sanctuaries, in their shared architectural styles, and their sense of a common history. Athens increasingly positioned itself—both politically and culturally—as the city-state which all others looked to for leadership, but always against a background of increasing tension with Sparta, the city-state to the south that chafed at what it considered to be Athenian tyranny. Never-

theless, as the city-states faced the prospect of massive invading Persian armies, they rallied round Athens in the understanding that they shared with that city their common destiny as Greeks.

Hesiod and Rural Greek Culture

Gradually, across Greece, communities began to organize themselves and exercise authority over their own limited geographical regions, which were defined by natural boundaries—mountains, rivers, and plains. The population of even the largest communities was largely dedicated to agriculture, and agricultural values—a life of hard, honest work and self-reliance—predominated. The great pastoral poem of the poet Hesiod [HE-see-ud] (flourished ca. 800 BCE), *Works and Days* testifies to this. *Works and Days* was written at about the same time as the Homeric epics in Boeotia [be-OH-she-uh], the region of Greece dominated by the city-state of Thebes. In it Hesiod reprimands his brother, Perses [per-seez], for his laziness, inaugurating a work ethic that plays an important role in Western thought to the present day (**Reading 6.1a**):

Fig. 6.3 Amphora (two-handled vase), from the Kerameikos cemetery, Athens, 875–850 BCE. Height 28 1/2".
Kerameikos Museum, Athens. This vase is decorated in the geometric style.

READING 6.1a Hesiod, *Works and Days*

Now I'm speaking sense to you, Perses you fool.
330. It's easy to get all of Wickedness you want.
She lives just down the road a piece, and it's a smooth road too.
But the gods put Goodness where we have to sweat
To get at her. It's a long, uphill pull
And rough going at first. But once you reach the top
335. She's as easy to have as she was hard at first.
Best of all is the man who sees everything for himself,
Who looks ahead and sees what will be better in the end.
It's a good man too who knows how to take good advice.
But the man who can't see for himself nor take advice,
340. Now that kind of man is a real good-for-nothing.
So at least *listen*, Perses—you come from good stock—
And remember always to work. Work so Hunger'll
Hate you, and Demeter, the venerable crowned goddess,
Will smile on you and fill your barn with food.
345. Hunger is the lazy man's constant companion.
Gods hate him, and men do too, the loafer
Who lives like the stingless drones, wasting
The hive's honey without working themselves,
Eating free.
350. You've got to *schedule* your work
So your sheds will stay full of each season's harvest.
It's work that makes men rich in flocks and goods.
When you work you're a lot dearer to the gods
And to people too. Everybody hates a lay-about.
355. Work's no disgrace; it's idleness that's a disgrace. . . .
427. And if the spirit within you moves you to get rich,
Do as follows:
 Work, *work*, and then *work* some more.

READING 6.1b Hesiod, *Works and Days*

Autumn

Mind now, when you hear the call of the crane
Coming from the clouds, as it does year by year:
That's the sign for plowing, and the onset of winter
And the rainy season. That cry bites the heart
Of the man with no ox.
 Time then to feed your oxen
In their stall. You know it's easy to say,
"Loan me a wagon and a team of oxen."
And it's easy to answer, "Got work for my oxen."
It takes a good imagination for a man to think
He'll just peg together a wagon. Damn fool,
Doesn't realize there's a hundred timbers make up a wagon
And you have to have 'em laid up beforehand at home.
Soon as you get the first signs for plowing
Get a move on, yourself and your workers,
And plow straight through wet weather and dry,
Getting a good start at dawn, so your fields
Will full up. Work the land in spring, too,
But fallow turned in summer won't let you down.
Sow your fallow land while the soil's still light.
Fallow's the charm that keeps wee-uns well-fed.
Pray to Zeus-in-the-ground and to Demeter sacred
For Demeter's holy grain to grow thick and full.
Pray when you first start plowing, when you
Take hold of the handle and come down with your stick.
On the backs of the oxen straining at the yoke-pins.
A little behind, have a slave follow with a hoc
To make trouble for the birds by covering the seeds.
Doing things right is the best thing in the world,
Just like doing 'em wrong is the absolute worst.
This way you'll have ears of grain bending
Clear to the ground. . .

Continuity & Change Benjamin Franklin would express the same feelings, surely influenced by his own familiarity with Greek thought, 2,500 years later in his "Way to Wealth" (1757): "Dost thou love Life, then do not squander Time, for that's the Stuff Life is made of, as Poor Richard says. . . How much more than is necessary do we spend in Sleep! forgetting that the sleeping Fox catches no Poultry, and that there will be sleeping enough in the Grave, as Poor Richard says."

Even more interesting is Hesiod's narration of the duties of the farmer as the seasons progress. Here are his words regarding the farmer's obligation to plow his fields in the spring (**Reading 6.1b**):

In this extract, Hesiod gives us a clear insight not only into many of the details of Greek agricultural production, but into social conditions as well. He mentions slaves twice in this short passage, and, indeed, all landowners possessed slaves (taken in warfare), who comprised over half the population. He also mentions the Greek gods Zeus [zoos], king of the gods and master of the sky, and Demeter, goddess of agriculture and grain (see *Context*, page 163). In fact, it was Hesiod, in his *Theogony* [the-OG-uh-nee] (*The Birth of the Gods*), who first detailed the Greek **pantheon** (literally, "all the gods"). The story of the creation of the world that he tells in this work (**Reading 6.2**) resembles the origin myths of the Hebrews, as told in Genesis (see **Reading 2.5**) and even the Zuni emergence tale (see **Reading 1.1**):

[1] The Greek word is *Chaos*; but this has a misleading connotation in English.
[2] Omitting lines 118–19: "the immortals who live on the peaks of snowy Olympus, and gloomy Tartarus in a hole underneath the highways of the earth."

READING 6.2 Hesiod, *Theogeny*

First of all the Void[1] came into being, next broad-bosomed Earth, the solid and eternal home of all,[2] and Eros [Desire], the most beautiful of the immortal gods, who in every man and every god softens the sinews and overpowers the prudent purpose of the mind. Out of the Void came Darkness and black Night, and out of Night came Light and day, her children conceived after union in love with Darkness. Earth first produced starry Sky, equal in size with herself.

Behavior of the Gods

Of particular interest here—as in Homer's *Iliad*—is that the gods are as susceptible to Eros [er-oss], or Desire, as is humankind. In fact, the Greek gods are sometimes more human than humans—susceptible to every human foible. Like many a family on Earth, the father, Zeus, is an all-powerful philanderer, whose wife, Hera [hi-ruh], is watchful, jealous, and capable of

Context The Greek Gods

The religion of the Greeks informed almost every aspect of daily life. The gods watched over the individual at birth, nurtured the family, and protected the city-state. They controlled the weather, the seasons, health, marriage, longevity, and the future, which they could foresee. Each polis traced its origins to a particular founding god—Athena for Athens, Zeus for Sparta. Sacred sanctuaries were dedicated to others.

The Greeks believed that the 12 major gods lived on Mount Olympus, in northeastern Greece. There they ruled over the Greeks in a completely human fashion—they quarreled and meddled, loved and lost, exercised justice or not—and they were depicted by the Greeks in human form. There was nothing special about them except their power, which was enormous, sometimes frighteningly so. But the Greeks believed that as long as they did not overstep their bounds and try to compete with the gods—the sin of **hubris**, or pride—that the gods would protect them.

Among the major gods (with their later Roman names in parentheses) are:

Zeus (Jupiter): King of the gods, usually bearded, and associated with the eagle and thunderbolt.

Hera (Juno [JOO-no]): Wife and sister to Zeus, the goddess of marriage and maternity.

Athena (Minerva): Goddess of war, but also, through her association with Athens, of civilization; the daughter of Zeus, born from his head; often helmeted, shield and spear in hand, the owl (wisdom) and the olive tree (peace) are sacred to her.

Ares (Mars): God of war, and son of Zeus and Hera, usually armored.

Aphrodite [af-ra-DIE-tee] (Venus): Goddess of love and beauty; Hesiod says she was born when the severed genitals of Uranus, the Greek personification of the sky, were cast into the sea and his sperm mingled with sea foam to create her. Eros is her son.

Apollo (Phoebus [FEE-bus]): God of the sun, light, truth, prophecy, music, and medicine; he carries a bow and arrow, sometimes a lyre; often depicted riding a chariot across the sky.

Artemis [AR-tuh-mis] (Diana): Goddess of the hunt and the moon; Apollo's sister, she carries bow and arrow, and is accompanied by hunting dogs.

Demeter [dem-EE-ter] (Ceres [SIR-eez]): Goddess of agriculture and grain.

Dionysus [dy-uh-NY-sus] (Bacchus [BAK-us]): God of wine and inspiration, closely aligned to myths of fertility and sexuality.

Hermes (Mercury): Messenger of the gods, but also god of fertility, theft, dreams, commerce, and the marketplace; usually adorned with winged sandals and a winged hat, he carries a wand with two snakes entwined around it.

Hades [HAY-deez] (Pluto): God of the underworld, accompanied by his monstrous dog Cerberus.

Hephaestus [hif-ES-tus] (Vulcan): God of the forge and fire; son of Zeus and Hera and husband of Aphrodite; wears a blacksmith's apron and carries a hammer.

Hestia [HES-te-uh] (Vesta): Goddess of the hearth and sister of Zeus.

Poseidon [po-SI-don] (Neptune): Brother of Zeus and god of the sea; carries a trident (a three-pronged spear); the horse is sacred to him.

Persephone [per-SEF-uh-nee] (Proserpina [pro-SUR-puh-nuh]): Goddess of fertility, Demeter's daughter, carted off each winter to the underworld by her husband Hades, but released each spring to restore the world to plenty.

inflicting great pain upon rivals for her husband's affections. Their children are scheming and self-serving in their competition for their parents' attention. The gods think like humans, act like humans, and speak like humans. They sometimes seem to differ from humans only in the fact that they are immortal. Unlike the Hebrew God who is sometimes portrayed as arbitrary—consider the Book of Job—the Greek gods present humans with no clear principles of behavior, and the priests and priestesses who oversaw the rituals dedicated to them produced no scriptures or doctrines. The gods were capricious, capable of changing their minds, susceptible to argument and persuasion, alternately obstinate and malleable. If these qualities created a kind of cosmic uncertainty, they also embodied the intellectual freedom and the spirit of philosophical inquiry that would come to define the Greek state.

The *Polis*

Although Greece was an agricultural society, the *polis*, or city-state—not the farm—was the focal point of cultural life. It consisted of an urban center, small by modern standards, often surrounding some form of natural citadel which could serve as a fortification, but which usually functioned as the city-state's religious center. The Greeks called this citadel an **acropolis** [uh-KROP-uh-liss]—literally, the "top of the city." On lower ground, at the foot of the acropolis, was the **agora** [AG-uh-ruh], a large open area that served as public meeting place, marketplace, and civic center.

Athens led the way, perhaps because it was the only older Greek city that had not fallen to the Dorian invaders and thus maintained something of a civic identity. However, by 800 BCE, several hundred similar *poleis* [POL-ays] (plural of *polis* [POL-us]) were scattered throughout Greece. Gradually, the polis came to describe less a place and more a cultural and communal identity. The citizens of the polis, including the rural population of the region—the polis of Sparta, for instance, comprised some 3,000 square miles of the Peloponnese, while Athens controlled the 1,000 square miles of the region known as Attica—owed allegiance and loyalty to it. They depended upon and served in its military. They worshiped and trusted in its gods. And they asserted their identity, first of all, by participating in the affairs of the city-state, next by their family (*genos*) [jee-nus] involvement, and, probably least of all, by any sense of being Greek.

In fact, the Greek *poleis* are distinguished by their isolation from one another and their fierce independence. For the most part, Greece is a very rugged country of mountains separating small areas of arable plains. The Greek historian Thucydides [thoo-SID-ih-deez] attributed the independence of the poleis to the historical competition in earlier times for these fertile regions of the country. His *History of the Peloponnesian Wars*, written in the last decades of the fifth century and begun during the wars (he served as a general in the Athenian army), opens with an account of these earlier times, tracing the conflict in his own time to that historical situation (**Reading 6.3**):

READING 6.3 Thucydides, *History of the Peloponnesian Wars*

[I]t is evident that the country now called Hellas had in ancient times no settled population; on the contrary, migrations were of frequent occurrence, the several tribes readily abandoning their homes under the pressure of superior numbers. Without commerce, without freedom of communication either by land or sea, cultivating no more of their territory than the exigencies of life required, destitute of capital, never planting their land (for they could not tell when an invader might not come and take it all away, and when he did come they had no walls to stop him), thinking that the necessities of daily sustenance could be supplied at one place as well as another, they cared little for shifting their habitation, and consequently neither built large cities nor attained to any other form of greatness. The richest soils were always most subject to this change of masters; such as the district now called Thessaly [THES-uh-lee], Boeotia, most of the Peloponnese, Arcadia excepted, and the most fertile parts of the rest of Hellas. The goodness of the land favored the aggrandizement of particular individuals, and thus created faction which proved a fertile source of ruin. It also invited invasion.

While Greek poleis might form temporary alliances, almost always in league against other poleis, few of the invasions Thucydides speaks of resulted in the domination of one polis over another, at least not for long. Rather, each polis maintained its own identity and resisted domination.

But inevitably certain city-states became more powerful than others. During the Dark Ages, many Athenians had migrated to Ionia [eye-OH-nee-uh] in southwestern Anatolia [an-uh-TOE-lee-uh] (modern Turkey), and relations with the Near East helped Athens to flourish. Corinth, situated on the isthmus between the Greek mainland and the Peloponnese, controlled north–south trade routes from early times, but after it built a towpath to drag ships over the isthmus on rollers, it soon controlled the sea routes east and west as well.

Life in Sparta

Of all the early city-states, perhaps Sparta was the most powerful. The Spartans traced their ancestry back to the legendary Dorians, whose legacy was military might. The rule of the city-state fell to the *homoioi*, [hoh-moh-YOY] or "equals," who comprised roughly 10 percent of the population. The population consisted largely of farm laborers, or *helots* [HEE-luts], essentially slaves who worked the land held by the *homoioi*. (A third class of people, those who had inhabited

V o i c e s

Training the Boys of Sparta

As a soldier and historian, Xenophon led an adventurous life including embarking on a military campaign against the Persian king. On returning to Greece, he allied with Sparta against Athens. His experience in the wars of the fourth and fifth centuries BCE informs his histories, essays, and treatises of the era. Here, he describes the training of Sparta's boys to become obedient soldiers.

Lycurgos a Spartan law-giver of the mid-seventh century BCE . . . set over the young Spartans a public guardian—the *paidonomos*—with complete authority over them. Lycurgos further provided the guardian with a body of youths in the prime of life and bearing whips to inflict punishment when necessary, with this happy result, that in Sparta modesty and obedience ever go hand in hand . . .

Instead of softening their feet with shoe or sandal, his rule was to make them hardy through going barefoot. This habit, if practiced, would . . . enable them to scale heights more easily and clamber down precipices with

> "... Instead of softening their feet with shoe or sandal, his rule was to make them hardy through going barefoot."

less danger. In fact, with his feet so trained the young Spartan would leap and spring and run faster Instead of making them effeminate with a variety of clothes, his rule was to habituate them to a single garment the whole year through . . . so they would be better prepared to withstand the variations of heat and cold.

. . . Furthermore, and in order that the boys should not want a ruler, even in case the guardian himself were absent, he gave to any citizen who chanced to be present authority to lay upon them injunctions . . . and to chastise them for any trespass committed. By so doing he created in the boys of Sparta a most rare modesty and reverence. And indeed there is nothing which, whether as boys or men, they respect more highly than the ruler. . . .

the area before the arrival of the Spartans, enjoyed limited freedom but were subject to Spartan rule.)

Political power resided with five overseers who were elected annually by all *homoioi*—excluding women—over the age of 30. At age 7, males were taken from their parents to live under military discipline in barracks (see *Voices,* above) until age 30 (though they could marry at age 20). Men ate in the military mess until age 60. Women were given strenuous physical training so that they might bear strong sons. Weak-looking babies were left to die. The city-state, in short, controlled every aspect of the Spartans' lives. If the other Greek poleis were less militaristic, they nevertheless exercised the same authority in some fashion. They exercised power more often through political rather than militaristic means, though most could be as militaristic as Sparta when the need arose.

The Sacred Sanctuaries

Although rival city-states were often at war with one another, they also increasingly came to understand their common heritage. As early as the eighth century BCE, they created sanctuaries where they could come together to share music, religion, poetry, and athletics. The sanctuary was a large-scale reflection of another Greek invention, the **symposium**, literally a "coming together" of men (originally of the same military unit) to share poetry, food, and wine. At the sanctuaries, people from different city-states came together to honor their

gods and, by extension, to celebrate, in the presence of their rivals, their own accomplishments.

Delos and Delphi The sanctuaries were sacred religious sites. They inspired the city-states, which were always trying to outdo one another, to create the first monumental architecture since Mycenaean times. At Delphi [DEL-fie], high in the mountains above the Gulf of Corinth, and home to the Sanctuary of Apollo [uh-POLL-oh], the city-states, in their usual competitive spirit, built monuments and statues dedicated to the god, and elaborate treasuries to store offerings. Many built hostels so that pilgrims from home could gather. Delphi was an especially important site. Here, the Greeks believed, the Earth was attached to the sky by its navel. Here, too, through a deep crack in the ground, Apollo spoke, through the medium of a woman called the Pythia [PITH-ee-uh]. Priests interpreted the cryptic omens and messages she delivered. The Greek author Plutarch [PLOO-tark], writing in the first century CE, said that the Pythia entered a small chamber beneath the temple, smelled sweet-smelling fumes, and went into a trance. This story was dismissed as fiction until recently, when geologists discovered that two faults intersect directly below the Delphic temple, allowing hallucinogenic gases to rise through the fissures, specifically ethylene, which has a sweet smell and produces a narcotic effect described as a floating or disembodied euphoria.

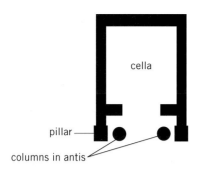

Fig. 6.4 Plan of the Siphnian Treasury, Delphi, ca. 530–525 BCE.

Greeks from the island of Siphnos [SIF-nus] built one of the most important of the treasuries at Delphi around 530 BCE in the Sanctuary of Apollo. The facade of the Treasury consisted of two columns carved in the form of female figures (such columns are called **caryatids** [kar-ee-AT-idz]), here standing *in antis* (that is, between two squared stone pillars, called **antae** [an-tie]). Behind them is the **pronaos** [pro-NAY-os], or enclosed vestibule, at the front of the building, with its doorway leading into the **cella** [SEL-uh] (or *naos* [NAY-os]), the principle interior space of the building (see the floor plan, Fig. **6.4**).

We can see the antecedents of this building type in a small ceramic model of an early Greek temple dating from the eighth century BCE and found at the Sanctuary of Hera near Argos [AR-gus] (Fig. **6.5**). Its projecting porch supported by two columns anticipates the *in antis* columns and pronaos of the Siphnian [SIF-nee-un] Treasury. The triangular area over the porch created by the pitch of the roof is not as steep in the Treasury. This area, called the **pediment**, is filled with sculptural decoration in the Siphnian Treasury, but the elaborate decoration of this later building, in which every surface

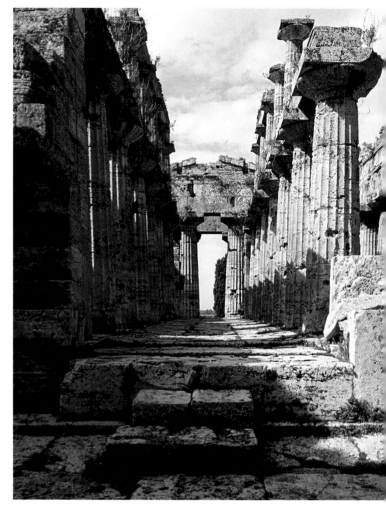

Fig. 6.6 Interior Temple of Hera II, Paestum, Italy. ca. 500 BCE. The Doric column is the oldest of the classical orders. It stands directly on the stylobate, the floor of the temple, without a base.

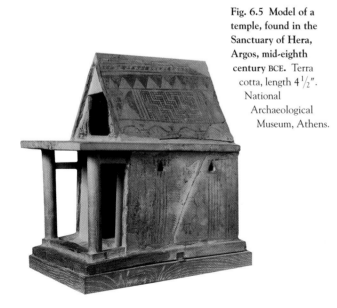

Fig. 6.5 Model of a temple, found in the Sanctuary of Hera, Argos, mid-eighth century BCE. Terra cotta, length 4 1/2″. National Archaeological Museum, Athens.

was decorated with sculpture, painted in dark blue, red, and white, and highlighted with metal additions for weaponry, seems anticipated in the geometric paintings decorating the Argos model. We do not know, however, if early temples were in fact painted like the model.

The Temples of Hera at Paestum From this basic form, surviving in the small treasuries at Delphi, the larger temples of the Greeks would develop. Two distinctive **elevations**—the arrangement, proportions, and appearance of the temple foundation, columns, and lintels—developed before 500 BCE, the **Doric order** and the **Ionic order** (see *Focus*, pages 168–169). Later, a third **Corinthian order** would emerge. The Siphnian Treasury is of the Ionic order, which employs either caryatids for columns, as here, or, more often, columns with scrolled capitals. Among earliest surviving examples of a Greek temple of the Doric order are the Temples of Hera I and II in the Sanctuary of Hera at Paestum [PES-tum], a Greek colony established in the seventh century BCE in Italy, about 50 miles south of modern Naples (Fig. **6.6**, and see

Fig. 6.1). As the plan of the Temple of Hera I makes clear (Fig. **6.7**), the earlier of the two temples was a large, rectangular structure, with a pronaos containing three (as opposed to two) columns *in antis* and an elongated cella, behind which is an **adyton** [AD-ee-tun], the innermost sanctuary housing the place where, in a temple with an oracle, the oracle's message was delivered. Surrounding this inner structure was the **peristyle** [PER-uh-style], a row of columns that stands on the **stylobate** [STY-luh-bate], the raised platform of the temple. The columns swell about one-third of the way up and contract again at the top, a characteristic known as **entasis** [EN-tuh-sis], and are topped by the two-part capital of the Doric order with its rounded **enchinus** [EN-ki-nus] and tabletlike **abacus** [AB-uh-kus].

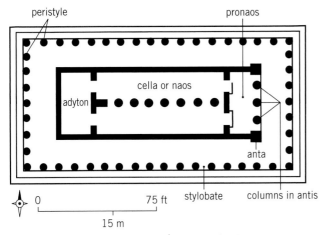

Fig. 6.7 Plan of the Temple of Hera I, Paestum, ca. 560 BCE.

Olympia and the Olympic Games The Greeks date the beginning of their history to the first formal Panhellenic ("all-Greece") athletic competition, held in 776 BCE. These first Olympic Games were held at Olympia. There, a sanctuary dedicated to Hera and Zeus also housed an elaborate athletic facility. The first contest of the first games was a 200-yard dash the length of the Olympia stadium, a race called the *stadion* (Fig. **6.8**). Over time, other events of solo performance were added, including chariot-racing, boxing, and the *pentathlon* (from Greek *penta*, "five," and *athlon*, "contest"), consisting of discus, javelin, long jump, sprinting, and wrestling. There were no second or third prizes. Winning was all. The contests were conducted every four years during the summer months and were open only to men (married women were forbidden to attend, and unmarried women probably did not attend). The Olympic Games held for more than 1,000 years, until the Christian Byzantine Emperor Theodosius [the-uh-DOH-she-us] banned them in 394 CE. The Games were revived in 1896 to promote international understanding and friendship.

The Olympic Games were only one of numerous athletic festivals held in various locations. These games comprised a defining characteristic of the developing Greek national identity. As a people the Greeks believed in *agonizesthai*, [ah-gon-ee-zus-TYE] a verb meaning "to contend for the prize." They were driven by competition. Potters bragged that their work was better than any other's. Playwrights competed for best play, poets for best recitation, athletes for best performance. As the city-states themselves competed for supremacy, they began to understand the spirit of competition as a trait shared by all.

Fig. 6.8 Euphiletos Painter (?). Detail of a black-figure amphora showing a foot-race at the Panathenaic Games in Athens. ca. 530 BCE. Terra cotta, height 24½". The Metropolitan Museum of Art, Rogers Fund, 1914 (14.130.12). Image © The Metropolitan Museum of Art. Greek athletes competed nude. In fact, our word *gymnasium* derives from the Greek word for "naked," *gymnos*.

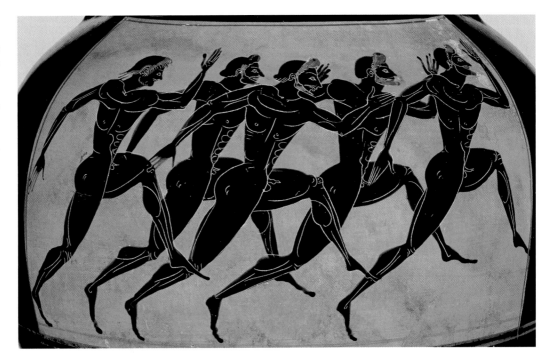

Focus

The Classical Orders

Classical **Greek architecture** is composed of three vertical elements—the **platform**, the **column**, and the **entablature**—which comprise its elevation. The relationship of these three units is referred to as the elevation's **order**. There are three orders: Doric, Ionic, and Corinthian, each distinguished by its specific design.

The classical Greek orders became the basic design elements for architecture from ancient Greek times to the present day. A major source of their power is the sense of order, predictability, and proportion that they embody. Notice how the upper elements of each order—the elements comprising the entablature—change as the column supporting them becomes narrower and taller. In the Doric order, the **architrave**, the bottom layer of the entablature, and the frieze, the flat band just above the architrave decorated with sculpture, painting, or moldings, are comparatively massive. The Doric is the heaviest of the columns (see Fig. 6.6). The Ionic is lighter and noticeably smaller. The Corinthian is smaller yet, seemingly supported by mere leaves.

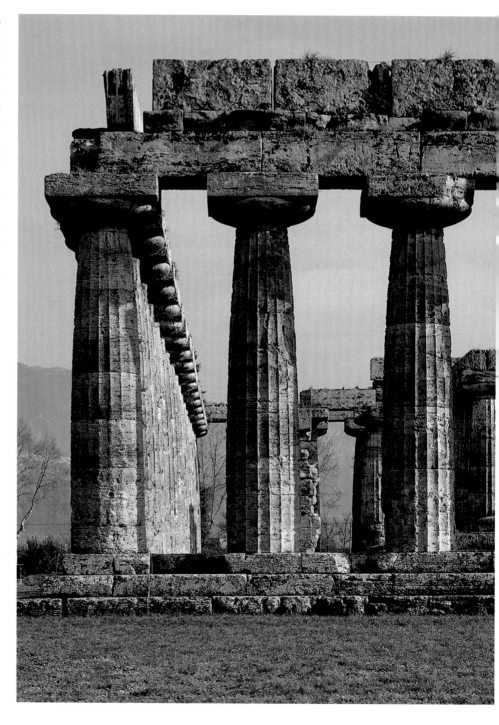

Doric columns at the Temple of Hera I, Pasteum, Italy, ca. 560.

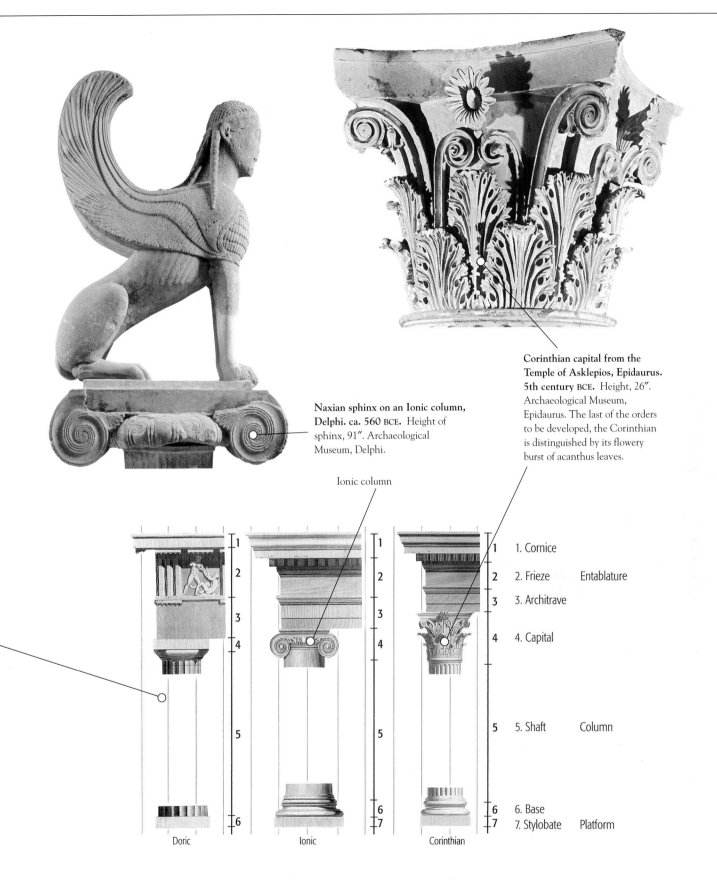

Naxian sphinx on an Ionic column, Delphi. ca. 560 BCE. Height of sphinx, 91″. Archaeological Museum, Delphi.

Corinthian capital from the Temple of Asklepios, Epidaurus. 5th century BCE. Height, 26″. Archaeological Museum, Epidaurus. The last of the orders to be developed, the Corinthian is distinguished by its flowery burst of acanthus leaves.

Ionic column

Doric

Ionic

Corinthian

1. Cornice
2. Frieze Entablature
3. Architrave
4. Capital

5. Shaft Column

6. Base
7. Stylobate Platform

The Classical Orders, from James Stuart, *The Antiquities of Athens*, London, 1794. An architectural order lends a sense of unity and structural integrity to a building as a whole. By the 6th century BCE, the Greeks had developed the Doric and the Ionic orders. The former is sturdy and simple. The latter is lighter in proportion and more elegant in detail, its capital characterized by a scroll-like motif called a **volute**. The Corinthian order, which originated in the last half of the 5th century BCE, is the most elaborate of all. It would become a favorite of the Romans.

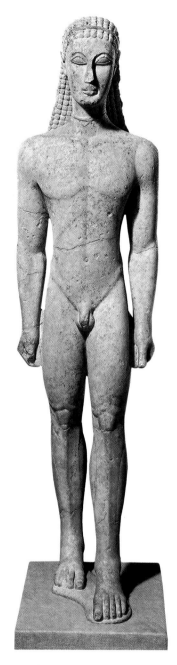

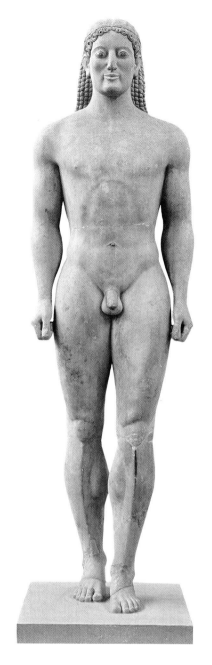

Figs. 6.9 (left) *New York Kouros.* **ca. 600** BCE. Height 6′ 4″. The Metropolitan Museum of Art, New York. Fletcher Fund, 1932 (32.11.1). Photograph © 1997 The Metropolitan Museum of Art. and **6.10 (right)** *Anavysos Kouros,* **from Anavysos cemetery, near Athens, ca. 525** BCE. Marble with remnants of paint, height 6′ 4″. National Archaeological Museum, Athens. The sculpture on the left is the earliest known life-size standing sculpture of a male in Greek art. The one on the right represents 75 years of Greek experimentation with the form. Note its closed-lip "Archaic smile," a symbol of liveliness and vitality.

Male Sculpture and the Cult of the Body

Greek athletes performed nude, so it is not surprising that athletic contests gave rise to what may be called a "cult of the body." The physically fit male not only won accolades in athletic contests, he also represented the conditioning and strength of the military forces of a particular polis. The male body was also celebrated in a widespread genre of sculpture known as the *kouros* [KOOR-os], meaning "young man" (Fig. **6.9**). This celebration of the body was uniquely Greek. No other Mediterranean culture so emphasized depiction of the male nude.

Over 20,000 *kouroi* [KOOR-oy] (plural of *kouros*) appear to have been carved in the sixth century BCE alone. They could be found in sanctuaries and cemeteries, most often serving as votive offerings to the gods or as commemorative grave markers. Their resolute features suggest their determination in their role as ever-watchful guardians.

Egyptian Influences Although we would never mistake the earlier figure for the work of an Egyptian sculptor—its nudity and much more fully realized anatomical features are clear differences—still, its Egyptian influences are obvious.

Continuity & Change
p. 85

Menkaure
with a queen

In fact, as early as 650 BCE, the Greeks were in Egypt, and by the early sixth century BCE, 12 cooperating city-states had established a trading outpost in the Nile Delta. The Greek sculpture serves the same funerary function as its Egyptian ancestors. The young man's arms drop stiffly to his side. His fists are clenched in the Egyptian manner. His left foot strides forward, though both heels remain unnaturally cemented to the ground, altogether like the Old Kingdom Egyptian *ka* statue of Menkaure with his queen (see Fig. 3.9), which is nearly 2,000 years older. The facial features of the *kouros*, with its wide, oval eyes, sharply delineated brow, and carefully knotted hair, are also reminiscent of third millennium BCE Sumerian votive statues (see Fig. 2.4).

Increasing Naturalism During the course of the sixth century, kouroi became distinguished by **naturalism**. That is, they increasingly reflect the artist's desire to represent the human body as it appears in nature. This in turn probably reflects the growing role of the individual in Greek political life.

We see more stylistic change between the first *kouros* (Fig. 6.10) and the second, a span of just 60 years, than between the first *kouros* and its Egyptian and Sumerian ancestors, created over 2,000 years earlier. The musculature of the later figure, with its highly developed thighs and calves, the naturalistic curve delineating the waist and hips, the collarbone and tendons in the neck, the muscles of the ribcage and belly, the precisely rendered feet and toes, all suggest that this is a representation of a real person. In fact, an inscription on the base of the sculpture reads, "Stop and grieve at the dead Kroisos [kroy-sos], slain by wild Ares [AR-eez] [the god of war] in the front rank of battle." This is a monument to a fallen hero, killed in the prime of youth.

Both sculptures are examples of the developing **Archaic style**, the name given to art produced from 600 to 480 BCE. We do not know why sculptors wanted to realize the human form more naturalistically, but we can surmise that the reason must be related to *agonizesthai*, the spirit of competition so dominant in Greek society. Sculptors must have competed against one another in their attempts to realize the human form. Furthermore, since it was believed that the god Apollo manifested himself as a well-endowed athlete, the more lifelike and natural the sculpture, the more nearly it could be understood to resemble the god himself.

The Athens of Peisistratus

The growing naturalism of sixth-century BCE sculpture coincides with the rise of democratic institutions in Athens and reflects this important development. Both bear witness to a growing Greek spirit of innovation and accomplishment. And both testify to a growing belief in the dignity and worth of the individual.

Toward Democracy

By the time Peisistratus [pie-SIS-truh-tus] assumed rule of Athens in 560 BCE, the city was well on the way toward establishing itself as a **democracy**—from the Greek *demokratia* [dem-oh-KRAY-te-uh], the rule (*kratia*) of the people (*demos*). Early in the sixth century BCE, a reformer statesman named Solon [SO-lun] (ca. 630–ca.560 BCE) overturned a severe code of law that had been instituted about one century earlier by an official named Draco [DRAY-koh]. Draco's law was especially hard on debtors, and from his name comes our use of the term "Draconian" [dray-KOH-nee-un] to describe particularly harsh punishments or laws. A bankrupt member of the polis could not sell or mortgage his land, but was required to mortgage the produce of the land to his debtor, effectively enslaving himself and his family to the debtor forever. Similarly, a bankrupt merchant was obliged to become the slave of his debtor.

Solon addressed the most painful of these provisions. He canceled all current debts, freed both landholders and merchants, and published a new code of law. He deemphasized the agricultural basis of the polis and encouraged trade and commerce, granting citizenship to anyone who would come and work in Athens. He also formed the Council of Four Hundred, which was comprised of landowners selected by Solon himself. This group recommended policy, which a general assembly of all citizens voted on. Only the council could formulate policy, but the citizens could veto it.

Three factions developed, representing the various regions of the city-state. Attica, the region under Athens, comprised almost 1,000 square miles, with mountains dividing the peninsula into three broad plains, and a major port, Piraeaus [pie-RE-us], on the Saronic [suh-RON-ik] Gulf (Map **6.2**).

A division between the urban and the rural was a defining characteristic of the city-state. The aristocratic landowners from the plains thought that Solon had overstepped his authority. The much poorer hill people living on the mountainsides thought he had not gone far enough, and the coastal

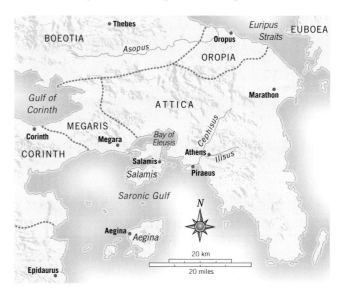

Map **6.2** Attica in the fifth century BCE.

people felt satisfied with his reforms. Peisistratus (ruled 560–527 BCE) moderated the conflict among the three factions, establishing a period of lasting peace in the polis. The hill people in particular supported him, because he advanced money to help them sustain themselves and thereby agricultural production in the polis. Two centuries later, the philosopher Aristotle [ar-uh-STOT-ul] would tell a story that reflects Peisistratus's rule (**Reading 6.4**):

READING 6.4 from Aristotle's *Athenian Constitution*

His revenues were increased by the thorough cultivation of the country, since he imposed a tax of one tenth on all the produce. For the same reasons he instituted the local justices, and often made expeditions in person into the country to inspect it and to settle disputes between individuals, that they might not come into the city and neglect their farms. It was in one of these progresses that, as the story goes, Peisistratus had his adventure with the man of Hymettus [hy-MET-us], who was cultivating the spot afterwards known as "Taxfree Farm." He saw a man digging and working at a very stony piece of ground, and being surprised he sent his attendant to ask what he got out of this plot of land. "Aches and pains," said the man; "and that's what Peisistratus ought to have his tenth of." The man spoke without knowing who his questioner was; but Peisistratus was so pleased with his frank speech and his industry that he granted him exemption from all taxes. And so in matters in general he burdened the people as little as possible with government, but always cultivated peace and kept them in all quietness.

Peisistratus was a tyrant; he ruled as a dictator, without consulting the people. But he was, by and large, a benevolent tyrant. He recognized the wisdom of Solon's economic policies and encouraged the development of trade. Perhaps most important of all, he initiated a lavish program of public works in order to provide jobs for the entire populace. He built roads and drainage systems and provided running water to most of the city. He was also a patron of the arts. Evidence suggests that in the Agora he built the first Athenian space for dramatic performances. On the Acropolis, he built several temples, though only fragmentary evidence remains.

Female Sculpture and the Worship of Athena

We know that Peisistratus emphasized the worship of Athena [uh-THEE-nuh] on the Acropolis. She was the city's protector, and from the mid-sixth century BCE on, the sculptural production of **korai** [KOR-eye], or "maidens," flourished under Peisistratus's rule. Just as the *kouros* statue seems related to Apollo, the *kore* [KOR-ee] statue appears to have been a votive offering to Athena and was apparently a gift to the goddess. Male citizens dedicated *korai* to her as a gesture of both piety and evident pleasure.

As with the *kouroi* statues, the *korai* also became more naturalistic during the century. This trend is especially obvious in their dress. In the sculpture known as the *Peplos Kore* (Fig. **6.11**), anatomical realism is suppressed by the straight lines of the sturdy garment known as a *peplos* [PEP-lus]. Usually made of wool, the *peplos* is essentially a rectangle of cloth folded down at the neck, pinned at the shoulders, and belted. Another *kore*, also remarkable for the amount of original paint on it, is the *Kore* dating from 520 BCE found on Chios [KY-os] (Fig. **6.12**), an island off the western coast of Turkey. This one wears a *chiton* [KY-ton], a garment that by the last decades of the century had become much more popular than the *peplos*. Made of linen, the *chiton* clings more closely to the body and is gathered to create pleats and folds that allow the artist to show off his virtuosity. On top of it, a gathered mantle called a *himation* [hi-MAT-ee-on] is draped diagonally from one shoulder. These sculptures, dedicated to Athena, give us some idea of the richness of decoration that adorned Peisistratus's Athens.

Athenian Pottery

By the middle of the sixth century BCE, Athens had become a major center of pottery making. Athenian potters were helped along by the extremely high quality of the clay available in Athens, which turned a deep orange color when fired. At first, the Athenian artists decorated the vases with narrative bands that encircled them in the manner of earlier pottery (see Figs. 6.2, 6.3). Eventually, as with Athenian sculpture, the decorations on these vases grew increasingly naturalistic and detailed until, generally, only one scene filled each side of the vase.

Many pots depict gods and heroes, including representations of the *Iliad* and *Odyssey* (see Figs. 5.13 and 5.15). An example of this tendency is a krater [KRAY-tur], or vessel in which wine and water are mixed, that shows the *Death of Sarpedon* [sar-PE-dun], painted by Euphronius [you-FRO-ne-us] and made by the potter Euxitheos [you-ZI-thee-us (soft th as in think)] by 515 BCE (Fig. **6.13**). Euphronius was praised especially for his ability to accurately render human anatomy. Here Sarpedon has just been killed by Patroclus (see **Reading 5.1**), Blood pours from his leg, shoulder, and carefully drawn abdomen. The winged figures of Hypnos [HIP-nos] (Sleep) and Thanatos [THAN-uh-tohs] (Death) are about to carry off his body as Hermes [HER-meez], messenger of the gods who guides the dead to the underworld, looks on. But the naturalism of the scene is not the source

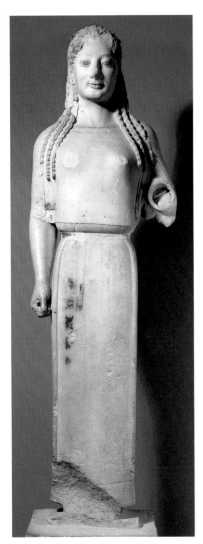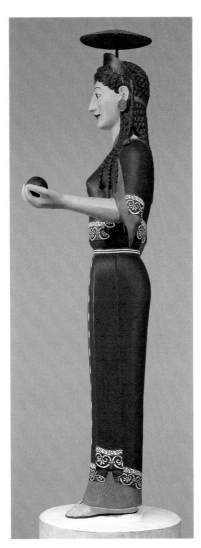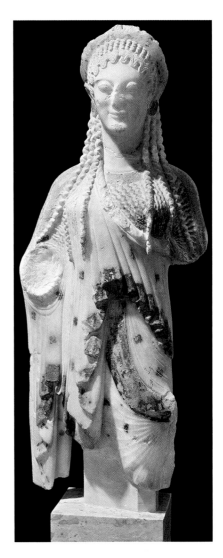

Fig. 6.11 *Peplos Kore* **and cast reconstruction of the original, from the Acropolis, Athens. Dedicated 530 BCE.** Polychromed marble, height 47 ¹⁄₂″. Acropolis Museum, Athens (original) and Museum of Classical Archaeology, Cambridge, England (cast). The extended arm, probably bearing a gift, was originally a separate piece, inserted in the round socket at her elbow. Note the small size of this sculpture, more than two feet shorter than the male *kouros* sculptures (Figs. 6.9, 6.10).

Fig. 6.12 *Kore*, **from Chios (?). ca. 520 BCE.** Polychromed marble, height 21″. Acropolis Museum, Athens. Although missing half its height, the sculpture gives us a clear example of the elaborate dress of the last years of the sixth century BCE.

of its appeal. Rather, its perfectly balanced composition transforms the tragedy into a rare depiction of death as an instance of dignity and order. The spears of the two warriors left and right mirror the edge of the vase, the design formed by Sarpedon's stomach muscles is echoed in the decorative bands both top and bottom, and the handles of the vase mirror the arching backs of Hypnos and Thanatos.

The *Death of Sarpedon* is an example of a **red-figure** vase. To decorate such vases, Greek artists used special "slips," mixtures of clay and water, which they painted over the background around the figures. Using the same slip, they also drew

details on the figure (such as Sarpedon's abdomen) with a brush. The vase was then fired in three stages, each one varying the amount of oxygen allowed into the kiln. In the first stage, oxygen was allowed into the kiln, which "fixed" the whole vase in one overall shade of red. Then, oxygen in the kiln was reduced to the absolute minimum, turning the vessel black. At this point, as the temperature rose, the slip became vitrified, or glassy. Finally, oxygen entered the kiln again, turning the unslipped areas—in this case, the red figures— back into a shade of red. The areas painted with the vitrified slip were not exposed to oxygen, so that they remained black.

Black-figure vases are the reverse of the red-figure variety. The figures on these vases are painted with the slip, so after firing they remain black against an unslipped red background. *Women at a Fountain House* (Fig. **6.14**) is an example. Here the artist, whom scholars have dubbed the Priam [PRY-um] painter, has added touches of white by mixing white pigment into the slip. By the second half of the sixth century, new motifs, showing scenes of everyday life, became increasingly popular. This hydria [HY-dree-uh], or water jug, shows women carrying similar jugs as they chat at a fountain house of the kind built by Peisistratus at the ends of the aqueducts that brought water into the city. Such fountain houses were extremely popular spots, offering women, who were for the most part confined to their homes, a rare opportunity to gather socially. Water flows from animal-head spigots at both the sides and across the back of the scene. The composition's strong vertical and horizontal framework, with its Doric columns, is softened by the rounded contours of the women's bodies and the vases they carry. This vase underscores the growing Greek taste for realistic scenes and naturalistic representation.

Fig. 6.13 Euphronius (painter) and Euxitheos (potter), *Death of Sarpedon*, ca. 515 BCE. Red-figure decoration on a calyx krater. Ceramic, height of krater 18″. The Metropolitan Museum of Art, New York. Purchase, Gift of Darius Ogden Mills, Gift of J. Pierpont Morgan, and Bequest of Joseph H. Durkee, by exchange, 1972 (1972.11.10). This type of krater is called a *calyx krater* because its handles curve up like the calyx flower.

The Poetry of Sappho

The poet Sappho (ca. 610–ca. 580 BCE) was hailed throughout antiquity as "the tenth Muse" and her poetry celebrated as a shining example of female creativity. We know little of Sappho's somewhat extraordinary life. She was the daughter of an aristocrat, married, had a daughter of her own, and then, apparently, left all behind to settle on the island of Lesbos. There she surrounded herself with a group of young women and engaged in the worship of Aphrodite—the Lesbian cult. Most of her circle shared their lives with one another only for a brief period before marriage. As we will see later, Plato's *Symposium* suggests that homoeroticism was institutionalized for young men at this stage of life; it may have been institutionalized for young women as well.

Sappho produced nine books of **lyric poems**—poems to be sung to the accompaniment of a lyre—on themes of love and personal relationships, often with other women. Sappho's poetry was revered throughout the Classical world, but only fragments have survived. It is impossible to convey the subtlety and beauty of her poems in translation, but their astonishing economy of feeling does come across. In the following poem (**Reading 6.5a**) one of the longest surviving fragments, she expresses her love for a married woman:

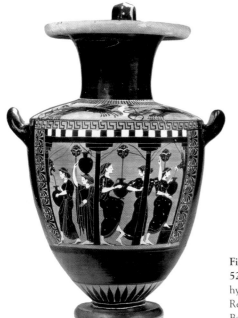

Fig. 6.14 The Priam Painter, *Women at a Fountain House*, 520–510 BCE. Black-figure decoration on a hydria vase, height of hydria 20⅞″. Courtesy, Museum of Fine Arts, Boston. Reproduced with permission. © 2005 Museum of Fine Arts, Boston. All Rights Reserved. The convention of depicting women's skin as white is also found in Egyptian and Minoan art.

READING 6.5a Sappho, lyric poetry

He is more than a hero
He is a god in my eyes
the man who is allowed
to sit beside you—he
who listens intimately
to the sweet murmur of
your voice, the enticing
laughter that makes my own
heart beat fast. If I meet
you suddenly, I can't
speak—my tongue is broken;
a thin flame runs under
my skin; seeing nothing
hearing only my ears
drumming, I drip with sweat;
trembling shakes my body
and I turn paler than
dry grass. At such times
death isn't far from me.

Sappho's talent is the ability to condense the intensity of her feelings into a single breath, a breath that, as the following poem suggests, lives on (**Reading 6.5b**):

READING 6.5b Sappho, lyric poetry

Although they are
only breath, words
which I command
are immortal

Even in so short a poem, Sappho realizes concretely the Greek belief that we can achieve immortality through our words and deeds.

The First Athenian Democracy

Peisistratus's son Hippias [HIP-ee-us] became the ruler of Athens in 527 BCE. Peisistratus had been a tyrant, exiling aristocrats who didn't support him, and often keeping a son of a noble family as a personal hostage to guarantee the family's loyalty. Hippias was harsher still, exiling more nobles and executing many others. In 510 the exiled nobles led a revolt, with aid from Sparta, and Hippias escaped to Persia.

In 508 BCE, Kleisthenes [KLEYE-sthuh-neez] instituted the first Athenian democracy, an innovation in self-government that might not have been possible until the Athenians had experienced the tyranny of Hippias. Kleisthenes reorga-

nized the Athenian political system into **demes** [deemz], small local areas comparable to precincts or wards in a modern city. Because all citizens—remember, only males were citizens—registered in their given *deme*, landowners and merchants had equal political rights. Kleisthenes then grouped the *demes* into ten political "tribes," whose membership cut across all family, class, and regional lines, thus effectively diminishing the power and influence of the noble families. Each tribe appointed 50 of its members to a Council of Five Hundred, which served for 36 days. There were thus ten separate councils per year, and no citizen could serve on the council more than twice in his lifetime. With so many citizens serving on the council for such short times, it is likely that nearly every Athenian citizen participated in the government at some point during his lifetime.

Persepolis and the Persian Wars

The new Greek democracy was immediately threatened by the rise of the Persian Empire in the east. These were the same Persians, formerly a minor nomadic tribe, who had defeated the Babylonians and freed the Jews in 520 BCE (see chapter 2). As early as 530 BCE, the Persians had taken control of the Greek cities in Ionia on the west coast of Anatolia. Under King Darius [duh-RY-us] (ruled 522–486 BCE), they soon ruled a vast empire that stretched from Egypt in the south, around Asia Minor, to the Ukraine [you-KRAIN] in the north. The capital of the empire was Parsa, which the Greeks called Persepolis [per-SEP-uh-lis], or city of the Persians, located in the Zagros [ZAG-rus] highlands of present-day Iran (Fig. **6.15**). Built by artisans and workers from all over the Persian Empire, including Greeks from Ionia, it reflected Darius's multicultural ambitions. If he was, as he said, "King of King, King of countries, King of the earth," his palace should reflect the diversity of his peoples.

The columns reflect Egyptian influence, and, especially in their Ionian **fluting**, the vertical channels that exaggerate their height and lend them a feeling of lightness, they reflect the influence of the Greeks. Rulers are depicted in relief sculptures with Assyrian beards and headdresses. In typical Mesopotamian fashion, they are larger than other people in the works. Huge winged bulls with the heads of bearded kings, reminiscent of the human-headed winged bulls that guard the Khorsabad palace of Assyrian king Sargon II (see Fig. 2.14), dominate the approach to the south gateway. Thus Mesopotamian, Assyrian, Egyptian, and Greek styles all intermingle in the palace's architecture and decoration.

In 499 BCE, probably aware of the newfound political freedoms in Athens and certainly chafing at the tyrannical rule of the Persians, the Ionian cities rebelled, burning down the city of Sardis, the Persian headquarters in Asia Minor. In 495

Continuity & Change
p. 51

Human-Headed
Winged Bull

CULTURAL PARALLELS

Historical Records in Fifth-Century BCE Greece and China

In the same period that Herodotus composed his *Histories,* in the middle of the fifth century BCE, Chinese philosopher Confucius compiled and edited documentary records of ancient China to create the *Book of History* (*Shu jing*).

BCE, Darius struck back. He burned down the most important Ionian city, Miletus [my-LEET-us], slaughtering the men and taking its women and children into slavery. Then, probably influenced by Hippias, who lived in exile in his court, Darius turned his sights on Athens, which had sent a force to Ionia to aid the rebellion.

In 490 BCE, a huge Persian army, estimated at 90,000, landed at Marathon, on the northern plains of Attica. They were met by a mere 10,000 Greeks, led by a professional soldier named Miltiades [mil-TIE-uh-deez] who had once served under Darius in Persia, and who understood the weakness of Darius's military strategy. Miltiades struck Darius's forces at dawn, killing 6,000 Persians and suffering minimal losses himself. The Persians were routed. The anxious citizens of Athens heard news of the victory from Phidippides [fih-DIP-uh-deez] who ran the 26 miles between Marathon and Athens, thus completing the original marathon, a run that the Greeks would soon incorporate into their Olympic Games. (Contrary to popular belief, Phidippides did not die in the effort.)

Darius may have been defeated, but the Persians were not done. Even as the Greeks basked in victory, Darius and his son Xerxes [ZURK-seez] were once again solidifying their power at Persepolis. The decorations at the palace during this time reflect their sense that all the peoples of the region owed them allegiance. The front steps rising up to the palace platform were covered with images of Darius's subjects bringing gifts to the palace—23 subject nations in all—Ionian, Babylonian, Syrian, Susian, and so on—each culture recognizable by its beards and costumes. On the wall of the audience hall, Darius receives tribute as Xerxes stands behind him (Fig. **6.16**), as if waiting to take his place as the Persian ruler.

In 486 BCE, Darius died fighting in Egypt, and Xerxes (ruled 486–465 BCE) assumed the throne. By 481 BCE, it was apparent that Xerxes was preparing to attack Greece once again. Themistocles [thuh-MIS-tuh-kleez] (ca. 524–ca. 460 BCE), an Athenian statesman and general, had been anticipating the invasion for a decade. He convinced the Athenians to unite with the other Greek poleis under the direction of the Spartans, the strongest military power. When a large

supply of silver was discovered in 483 BCE, Themistocles, convinced that the Persians could not be defeated on land, persuaded Athens to use its new-found wealth to build a fleet.

Finally, in 480 BCE, Xerxes led a huge army into Greece. In his *Persian Wars* (430 BCE), written 50 years after the events, Herodotus [hih-ROD-uh-tus], the first Greek historian, says that Xerxes's army numbered 5 million men and that whole rivers were dried when the army stopped to drink. These are doubtless exaggerations, but Xerxes's army was probably the largest ever assembled until that time. Modern estimates suggest it was composed of at least 150,000 men. Herodotus also tells us that the Delphic oracle had prophesied that Athens would be destroyed and advised the Athenians to put their trust in "wooden walls" (see **Reading 6.6,** page 180). Themistocles knew that the Persians had to be delayed so that the Athenians would have time to abandon the city and take to sea. At a narrow pass between the sea and the mountains called Thermopylae [ther-MOP-uh-lee], a band of 300 Spartans, led by their king, Leonidas [lee-ON-ih-dus], gave their lives so that the Athenians could escape. Herodotus tells the story (**Reading 6.6a**):

READING 6.6a **from Book VII of Herodotus,** ***The Histories***

The Lacedaemonians* fought a memorable battle; they made it quite clear that they were the experts, and that they were fighting against amateurs. This was particularly evident every time they turned tail and pretended to run away *en masse*; the Persians raised a great cry of triumph at the sight of the retreat and pressed forward after them, but the Lacedaemonians let them catch up and then suddenly turned and faced them—and cut the Persians down in untold numbers. However, a few Spartiates would be lost as well during this manoeuvre. Once their attempt on the pass had proved a complete failure and they had not gained the slightest foothold in it, whether they sent in regiment after regiment or whatever tactics they used for their attack, the Persians withdrew.

212 During this phase of the battle, as he watched his men attacking the Greek positions, it is said that fear for his army made the king leap up from his seat three times. The next day, after the first day of fighting had passed as described, the conflict went no better for the Persians. They went into battle in the expectation that the Greeks would no longer be capable of fighting back, given that there were so few of them and that they had already taken so many casualties. But the Greeks formed themselves into units based on nationality which took turns to fight, except for the Phocians who were posted on the heights above to guard the path. On finding that things had not changed from their experiences of the previous day, the Persians pulled back.

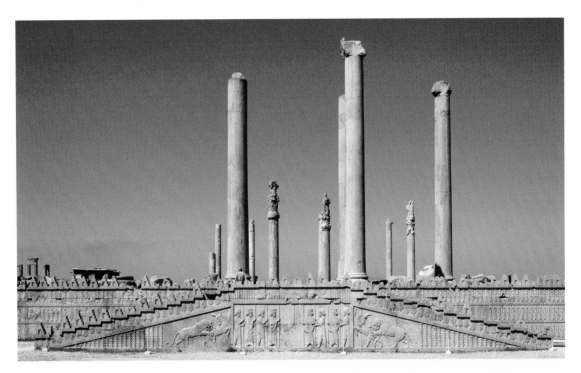

Fig. 6.15 Palace of Darius and Xerxes, Persepolis, Iran. 518–ca. 460 BCE. The palace stands on a rock terrace 545 yards deep and 330 yards wide. Approached by a broad staircase decorated with men carrying gifts, its centerpiece was the Hall of One Hundred Columns, a forest of stone comprised of ten rows of ten columns, each rising to a height of 40 feet.

213 Xerxes did not know how to cope with the situation, but then a Malian called Ephialtes the son of Eurydemus arranged a meeting with him, with information for which he hoped the king would pay him handsomely. Ephialtes told him about the mountain path to Thermopylae, and so caused the deaths of the Greeks who had taken their stand there.

* Lacedaemon was the name of Sparta's city-state. Today, "Sparta" may refer to both the city and its broader city-state.

Ephialtes's treachery came too late, for by then the Athenians had abandoned Athens. At Salamis, off the Athenian coast, the Greeks won a stunning victory, led by Themistocles. The Persian fleet, numbering about 800 galleys, faced the Greek fleet of about 370 smaller and more maneuverable *triremes* [TRY-reemz], galleys with three tiers of oars on each side. Themistocles lured the Persian fleet into the narrow waters of the strait at Salamis. The Greek triremes then attacked the crowded Persian fleet and used the great curved prows of their galleys to ram and sink about 300 Persian vessels. The Greeks lost only about 40 of their own fleet, and Xerxes was forced to retreat, never to threaten the Greek mainland again.

Fig. 6.16 *Darius and Xerxes Receiving Tribute,* **detail of a relief from a stairway leading to the Apadana, ceremonial complex, Persepolis, Iran, 491–486 BCE.** Limestone, height 8′ 4″. Iranbastan Museum, Teheran. This panel was originally painted in blue, scarlet, green, purple, and turquoise. Objects such as Darius's necklace and crown were covered in gold. Note that Darius stands behind Xerxes, indicating that power has been passed from father to son.

The *Histories* of Herodotus

We know the story of the Persian Wars so well thanks largely to Herodotus's nine-volume *History of the Persian Wars*. Herodotus is the first writer in the Western tradition who devoted himself to historical writing. If he is not yet a fully scientific and objective historian—he quotes speech after speech at length, 50 years after the fact, literally putting words into his characters' mouths—he is remarkably nonpartisan and objective. He presents his reader with every piece of evidence at his disposal and weighs the merits of their sometimes contradictory implications. He pays extraordinary attention to detail, even if he is sometimes prone to exaggeration. He is, above all, a great storyteller, including digressions and anecdotes in his narrative that make history come alive, even today. An example is his description of the Egyptians in *The Histories* (**Reading 6.7**)—perhaps the earliest travel narrative, one which remains one of our most detailed sources for information about Egyptian cultural practices.

READING 6.7 **from Book II of Herodotus, *The Histories***

35 I am going to talk at some length about Egypt, because it has very many remarkable features and has produced more monuments which beggar description than anywhere else in the world. That is why more will be said about it. In keeping with the idiosyncratic climate which prevails there and the fact that their river behaves differently from any other river, almost all Egyptian customs and practices are the opposite of those of everywhere else. For instance, women go out to the town square and retail goods, while men stay at home and do the weaving; and whereas everyone else weaves by pushing the weft upwards, the Egyptians push it downwards. Or again, men carry loads on their heads, while women do so on their shoulders. Women urinate standing up, while men do so squatting. They relieve themselves indoors, but eat outside on the streets; the reason for this, they say, is that things that are embarrassing but unavoidable should be done in private, while things which are not embarrassing should be done out in the open. There are no female priestesses of any god or goddess; all their gods, and goddesses too, are served in this capacity by men. Sons do not have to look after their parents if they do not want to, but daughters must even if they are reluctant.

36 Everywhere else in the world, priests have long hair, but in Egypt they shave their heads. In times of mourning, it is the norm elsewhere for those most affected by the bereavement to crop their hair; in Egypt, however, in the period following a death, they let both their hair and their beards grow, when they had previously been shaved. Everywhere else in the world people live separately from their animals, but animals and humans live together in Egypt. Other people live off barley and ordinary wheat, but Egyptians regard it as demeaning to make those grains one's staple diet; their staple is hulled wheat, or 'emmer' as it is sometimes known. They knead dough with their feet and clay with their hands, and they pick up dung with their hands too. Other people, unless they have been influenced by the Egyptians, leave their genitals in their natural state, but the Egyptians practise circumcision. Men have two cloaks each, but women have only one. In other countries rings and reefing-ropes are attached to the outside of the sail, but in Egypt they are on the inside. As Greeks write and do their sums they move their hands from left to right, but Egyptians move from right to left; although this is their actual practice, they say that they are doing it right, while the Greeks are left-handed.

As Herodotus compares Egyptian cultural practice to his own, he reveals an even more important aspect of his writing. Though he identifies himself in the opening sentence of his *Persian Wars* as Herodotus of Halicarnassus [hal-ih-kar-NAS-us], a Greek town in southwestern Anatolia (Halicarnassus is present-day Bodrum, Turkey)—"Herodotus of Halicarnassus hereby publishes the results of his inquiries, hoping to do two things: to preserve the memory of the past by putting on record the astonishing achievements both of the Greek and the non-Greek peoples; and more particularly, to show how the two races came into conflict." He is, above all, Greek, and exploring his identity as a Greek may have been the true aim of his *History*. His unsentimental and matter-of-fact description of the ultimate defeat of the Spartans at Thermopylae—"by which disclosure he [Ephialtes] brought destruction on the band of Greeks who had there withstood the barbarians"—not only subtly distinguishes the Greeks from non-Greek peoples ("barbarians"), but refers to Leonidas and his men not as Spartans but as Greeks. In Herodotus's writing, a Greek national identity begins to take shape, a national character above and beyond any personal identification with the city-state.

Aeschylus and *The Persians*

Among the soldiers at both Marathon and Salamis was the playwright Aeschylus [ES-kuh-lus] (525–456 BCE). Since the time of Hesiod and Homer, the Greeks had performed religious rites in honor of Dionysius [dy-uh-NY-se-us], god of wine and inspiration. These rites featured a dialogue between two **choruses** (groups of worshipers or ritual participants who recited in unison) or a chorus and a lead voice (perhaps a priest). By the late sixth century BCE, these rituals had evolved into two distinct forms: **tragedy**, which probably evolved from rites associated with the harvest and the end of the growing season, and **comedy**, which was associated with

the coming of spring. (Both will be discussed more fully in chapter 7.) Each fall and spring, at festivals dedicated to Dionysius, playwrights would compete for supremacy in contests that were as hard fought—and at least as important—as the Olympic Games.

Greek tradition has it that, as a boy, Aeschylus worked in the vineyards, where one day he fell asleep and was visited by Dionysus, who exhorted him to turn his attention to the art of tragedy. When he awoke, he tried his hand at writing and discovered his considerable talent. Only a handful of his 97 plays survive. Greek dramatists were economical in the number of events and characters they portrayed, concentrating on the psychological and ethical aspects of characterization. The major dramatic innovation attributed to Aeschylus is the introduction of a second actor. His first play was performed in 499 BCE, but he would not win the prize for tragedy until 484 BCE. In the meantime, he prided himself on his military career, and *The Persians* is the only surviving play from a trilogy that celebrated the Persian wars.

The play is set in Susa [SOO-suh], the capital of Persia. It is a tragedy in which the ghost of Darius laments the defeat of his son Xerxes. Darius finds the cause of his son's death within Xerxes himself. His own **hubris** caused his defeat. This quality, an exaggerated pride and self-confidence, often brought retribution from the gods. Xerxes's does not himself recognize his fault when, at the play's end, he returns to Susa, defeated and ashamed. The play opens with a messenger returning to Persepolis to inform Xerxes's queen, Attosa [ah-TOE-zuh] of the defeat at Salamis. The messenger claims that "these mine eyes/Beheld the ruin which my tongue would utter," as, in fact, Aeschylus's eyes had witnessed the battle (see **Reading 6.8**, pages 181–182). In this opening dialogue the Persians refer to themselves as "barbarians," a subtle but forceful reminder of Greek superiority and national identity. (Interestingly, the first revival of a Greek play since antiquity was an Italian adaptation of *The Persians*, performed on the Greek island of Zakynthos in 1571.) So enduring are the play's themes, that it is still performed throughout the world (Fig. **6.17**).

Aeschylus shows both deep compassion for the defeated Persians and great pride in the Greek victory. But the play also has political overtones. By the time it was first performed, in 472 BCE, the great Themistocles, Aeschylus's commander at Salamis and leader of the most democratic of Athens's political factions, was in deep trouble. Not long after the play's performance, in fact, he was formally ostracized by a vote of the citizens. Each year, citizens would write on broken pieces of pottery the name of the leader they most disliked. Any politician who received a majority, amounting to at least 6,000 votes, was exiled for ten years. Aeschylus was no doubt troubled by the prospect of this happening to Themistocles. In fact, Pericles [PER-uh-kleez], the democratic king who would guide Athens in the Golden Age to follow, served as producer of Aeschylus's play. Perhaps this plum job was offered to a powerful politician in an unsuccessful attempt to forestall Themistocles's downfall.

The contest between national identity and allegiance to the city-state was still deeply at play in Greek consciousness, and the play comments on current controversies. As *The Persians* was being produced in 472 BCE, the Delian League, the alliance of Greek city-states formed for mutual protection after the Battle of Salamis, used force against another city-state to compel it to join the League. Aeschylus may well have seen the hubris in such actions, and, in fact, the League soon became more aggressive, forcing other city-states to join. By 454 BCE, the League's treasury was transferred from Delos to the Acropolis at Athens, and all pretense of it being a voluntary and democratic alliance came to end. Athens was a naval empire, and the members of the League were its subject states. By assuming this position of preeminence among the city-states, Athens positioned itself to define the larger Greek identity in its own terms. This is just what it did in the era that came to be known as the Golden Age of Greece, the subject of the next chapter.

Fig. 6.17 Modern performance of Aeschylus's *The Persians*. 2004. Performed by the Aurora Theater in Berkeley, California.

READINGS

from Book VII of Herodotus, *The Histories*

Herodotus's account of the Persian Wars in The Histories *chronicles the Greek war with Persia that lasted from 500* BCE *to 449* BCE*. It is generally considered the first example of historical writing. In the following passage, Herodotus relates the prophecy of the Delphic oracle, which warned the Athenians to put their trust in "wooden walls." Themistocles interprets this to mean that the Greeks should trust in their fleet, believing that the oracle's statement that the isle of Salamis "will slay many children of women" refers to the Persians, not the Greeks.*

140 For when some emissaries sent from Athens to Delphi entered the temple and took their places (after having performed the prescribed rites in the sanctuary and generally prepared themselves to consult the oracle), the Pythia, whose name was Aristonice, gave them the following prophecy:

Fools, why sit you here? Fly to the ends of the earth,
Leave your homes and the lofty heights girded by your city.
The head is unstable, the trunk totters; nothing—
Not the feet below, nor the hands, nor anything in
 between— 10
Nothing endures; all is doomed. Fire will bring it down,
Fire and bitter War, hastening in a Syrian chariot.
Many are the strongholds he will destroy, nor yours alone;
Many the temples of the gods he will gift with raging fire,
Temples which even now stand streaming with sweat
And quivering with fear, and down from the roof-tops
Dark blood pours, foreseeing the straits of woe.
Go! Leave my temple! Shroud your hearts in misery!

141 These words completely disheartened the Athenian emissaries. The doom foretold for them plunged them into utter 20
despair, but then Timon the son of Androbulus, who was one of the most distinguished men in Delphi, suggested that they should go back, this time with branches of supplication, and consult the oracle again, as suppliants. The Athenians took his advice and said to the god, 'Lord, please respect these branches with which we come before you as suppliants, and grant us a more favorable prediction for our country. Otherwise we will never leave your temple, but will stay right here until we die.' At this request of theirs the oracle's prophetess gave them a second prophecy, which went as follows: 30

No, Pallas Athena cannot placate Olympian Zeus,
Though she begs him with many words and cunning argu-
 ments.
I shall tell you once more, and endue my words with adamant:
While all else that lies within the borders of Cecrops' land
And the vale of holy Cithaeron is falling to the enemy,
Far-seeing Zeus gives you, Tritogeneia, a wall of wood,
Only this will stand intact and help you and your children.
You should not abide and await the advance of the vast host

Of horse and foot from the mainland, but turn your back 40
And yield. The time will come for you to confront them.
Blessed Salamis, you will be the death of mothers' sons
Either when the seed is scattered or when it is gathered in.

142 This oracle was less harsh than the previous one, and that is certainly what the emissaries thought, so they had it written down and then returned to Athens. Back in Athens, they gave their report to the people, and various interpretations of the meaning of the oracle were proposed. The two which clashed most strongly were as follows. Some of the more elderly citizens argued for the view that the god was 50
predicting the survival of the Acropolis; in times past the Athenian Acropolis had been surrounded by a defensive stockade, so they came to the conclusion that the "wall of wood" referred to this stockade. Others, however, maintained that the god was talking about ships, and tried to get the Athenian people to abandon everything else and concentrate on preparing a fleet. But those who claimed that the "wall of wood" meant ships failed to make sense of the last two lines of the Pythia's prophecy:

Blessed Salamis, you will be the death of mothers' sons 60
Either when the seed is scattered or when it is gathered in.

The view that the "wall of wood" was a fleet was confounded by these words, because the official interpreters of oracles took them in mean that if the Athenians took steps to engage the enemy at sea off Salamis, they were bound to lose.

143 Now, there was in Athens a man called Themistocles the son of Neocles who had just recently risen to a position of prominence. He claimed that the conclusion the interpreters had come to was not quite right. His argument was that if the oracle had really been directed against Athens it 70
would have been phrased in harsher terms; rather than "Blessed Salamis", it would have said "Cruel Salamis" if the inhabitants were doomed to die there. No, the true interpretation of the oracle, he argued, was that the Persians, not the Athenians, were the target of the god's words. So he advised them to get the fleet ready for a battle at sea, on the grounds that the "wall of wood" referred to the fleet. The Athenians decided that Themistocles' explanation of the oracle was

preferable to that of the official interpreters who would rather they did not prepare for battle—whose advice, in fact, was 80 that the Athenians should not resist at all, but should abandon Attica and find somewhere else to live. ■

Reading Question

As a historian, Herodotus is renowned for his attempt to report history in as non-partisan and objective a manner as possible. How does this passage reflect that approach?

READING 6.8

Aeschylus, from *The Persians*

The following is the opening scene of Aeschylus's tragedy The Persians. *The play is set in Susa, capital of Persia, and the action begins with a messenger reporting the complete defeat of the Persian forces at Salamis to the chorus (which represents the general public) and the Persian queen, Attosa. Aeschylus shows both deep compassion for the defeated Persians and great pride in the Greek victory.*

A Messenger enters.

MESSENGER:

Woe to the towns through Asia's peopled realms!
Woe to the land of Persia, once the port
Of boundless wealth, how is thy glorious state
Vanish'd at once, and all thy spreading honours
Fall'n, lost! Ah me! unhappy is his task
That bears unhappy tidings: but constraint
Compels me to relate this tale of woe.
Persians, the whole barbaric host is fall'n.

CHORUS CHANTING:

O horror, horror! What a baleful train
Of recent ills! Ah, Persians, as he speaks 10
Of ruin, let your tears stream to the earth.

MESSENGER:

It is ev'n so, all ruin; and myself,
Beyond all hope returning, view this light....
I speak not from report; but these mine eyes
Beheld the ruin which my tongue would utter....
In heaps the unhappy dead lie on the strand
Of Salamis, and all the neighbouring shores.

CHORUS CHANTING:

Unhappy friends, sunk, perish'd in the sea;
Their bodies, mid the wreck of shatter'd ships,
Mangled, and rolling on the encumber'd waves! 20

MESSENGER:

O Salamis, how hateful is thy name!
And groans burst from me when I think of Athens....
Know then, in numbers the barbaric fleet
Was far superior: in ten squadrons, each
Of thirty ships, Greece plough'd the deep; of these
One held a distant station. Xerxes led

A thousand ships; their number well I know;
Two hundred more, and seven, that swept the seas
With speediest sail: this was their full amount.
And in the engagement seem'd we not secure 30
Of victory? But unequal fortune sunk
Our scale in fight, discomfiting our host....
The morn, all beauteous to behold,
Drawn by white steeds bounds o'er the enlighten'd earth;
At once from ev'ry Greek with glad acclaim
Burst forth the song of war, whose lofty notes
The echo of the island rocks return'd,
Spreading dismay through Persia's hosts, thus fallen
From their high hopes; no flight this solemn strain
Portended, but deliberate valour bent 40
On daring battle; while the trumpet's sound
Kindled the flames of war....
and now distinct we heard
From ev'ry part this voice of exhortation:—
"Advance, ye sons of Greece, from thraldom save
Your country, save your wives, your children save,
The temples of your gods, the sacred tomb
Where rest your honour'd ancestors; this day
The common cause of all demands your valour."...
The deep array 50
Of Persia at the first sustain'd the encounter;
But their throng'd numbers, in the narrow seas
Confined, want room for action; and, deprived
Of mutual aid, beaks clash with beaks, and each
Breaks all the other's oars: with skill disposed
The Grecian navy circled them around
With fierce assault; and rushing from its height
The inverted vessel sinks: the sea no more
Wears its accustomed aspect, with foul wrecks

And blood disfigured; floating carcasses
Roll on the rocky shores: the poor remains
Of the barbaric armament to flight
Ply every oar inglorious: onward rush
The Greeks amid the ruins of the fleet,
As through a shoal of fish caught in the net,
Spreading destruction: the wide ocean o'er
Wailings are heard, and loud laments, till night
With darkness on her brow brought grateful truce.
Should I recount each circumstance of woe,

60

Ten times on my unfinished tale the sun
Would set; for be assured that not one day
Could close the ruin of so vast a host.

ATOSSA:
Ah, what a boundless sea of woe hath burst
On Persia, and the whole barbaric race! ◼

70

Reading Question

What is the significance of the messenger's initial reference to the Persian fleet as "the whole barbaric host"?

Summary

■ **Hesiod and Rural Greek Culture** During the so-called Dark Ages of Greek history, lasting from about 1100 BCE until roughly the ninth century BCE, Greece endured a period of cultural decline. The population was rural and dedicated to agriculture, and its values—hard work and self-reliance—were celebrated by the poet Hesiod in his *Works and Days* (ca. 800 BCE). In his *Theogony*, Hesiod also detailed the pantheon of Greek gods. Toward the end of the period, highly sophisticated ceramic art, decorated with geometric designs, appeared.

■ **The *Polis*** Each of the rural areas of Greece, separated from one another by mountainous geography, gradually began to form into a community—the polis, or city-state—that exercised authority over its region. Inevitably, certain of these poleis became more powerful than the others. Corinth's central location allowed it to control sea, and trade with the Near East inspired its thriving pottery industry. Sparta was the most powerful of the early Greek city-states, and it exercised extreme authoritarian rule over its people.

■ **The Sacred Sanctuaries** At Delos, Delphi, Olympia, and even in colonies such as Paestum on the Italian peninsula, the city-states came together to honor their gods and, by extension, to celebrate, in the presence of their rivals, their own accomplishments. The oracle at Delphi, known as the Pythia, was believed to foretell the future, though the interpretation of her words was always problematic. In the Sanctuary of Apollo at Delphi, the city-states competed with one another in building elaborate treasuries in which they stored their offerings. Some of the best preserved temples of the era can be found at the Sanctuary of Hera at Paestum. At Olympia, on the Peloponnese, the Greeks came together every four years, beginning in 776 BCE, to celebrate their athletic prowess at a sanctuary dedicated to Hera and Zeus. These games were one of the defining characteristics of the developing Greek national identity. As a people the Greeks believed in *agonizesthai*, a verb meaning "to contend for the prize." They were driven by competition, both individual competition and competition between the city-states.

■ **Male Sculpture and the Cult of the Body** The Greeks were unique among Mediterranean cultures in portraying the male nude, especially in the widespread genre of *kouros* sculpture, which could be found in sanctuaries and cemeteries, most often serving as votive offerings to the gods or as commemorative grave markers. These sculptures became increasingly naturalistic during the sixth century BCE, as the Greeks gradually abandoned the inspiration of Egyptian funerary sculpture.

■ **The Athens of Peisistratus** Coinciding with the increasing naturalism of Greek sculpture was the rise of democratic institutions in Athens. This transformation was inspired in no small part in reaction to the tyranny of Peisistratus and his successor, his son Hippias. Peisistratus was by and large a benevolent tyrant who championed the arts, while Hippias was almost his opposite. After Hippias was overthrown, Kleisthenes instituted the first Athenian democracy in 508 BCE. The power and influence of noble families was diminished under the rule of the Council of Five Hundred, the membership of which changed every 36 days.

■ **Persepolis and the Persian Wars** The new Greek democracy was immediately threatened by Persian king Darius. The diverse decorative styles of his palace at the Persian capital Persepolis reflected Darius's sense of himself as king of all peoples and cultures. Darius attacked Greece in 490 BCE but was defeated at Marathon by a much smaller Greek army led by Miltiades. Darius's son Xerxes attacked once again in 480 BCE, and after a small band of Spartans held him off at Thermopylae, the Greek navy destroyed his fleet in the straits of Salamis. *The Persian Wars* of Herodotus, the first history every written, narrates these events. Their aftermath in Persia is the subject of Aeschylus's tragedy, *The Persians*, in which Xerxes's hubris is seen as the ultimate cause of the Persian defeat.

 ## Glossary

abacus The tabletlike slab that forms the uppermost part of a capital.

acropolis Literally, "top of the city"; the natural citadel of a Greek city that served as a fortification or religious center.

adyton The innermost sanctuary of a building housing the place where, in a temple with an oracle, the oracle's message was delivered.

agora A large open area in ancient Greek cities that served as public meeting place, marketplace, and civic center.

antae Squared stone pillars.

Archaic style A style in early Greek art (about 660–480 BCE) marked by increased naturalism, seen especially in the period's two predominant sculptural types, *kouros* and *kore*.

architrave The bottom layer of an entablature.

black figure A style in Greek pottery decoration composed of black figures against a red background.

caryatids Columns carved in the form of female figures.

cella The principal interior space of a Greek building, especially a temple; also called a *naos*.

chorus A groups of worshipers or ritual participants who recited in unison.

column A vertical element that serves as an architectural support, usually consisting of a capital, shaft, and base.

comedy A form of the religious rites associated with Dionysius that probably evolved from rites associated with the harvest and the end of the growing season.

Corinthian order The most elaborate of the Greek architectural orders distinguished by a capital decorated with acanthus leaves.

deme A division of the Athenian political system composed of small local areas comparable to modern-day precincts or wards.

democracy Rule by the people.

Doric order The oldest and simplest of the Greek architectural orders characterized by a heavy column that stands directly on a temple's stylobate.

elevation The arrangement, proportions, and appearance of a temple foundation, columns, and lintels.

enchinus The rounded part of a capital.

entablature The uppermost horizontal elements of an order composed of the cornice, frieze, and architrave.

entasis A swelling of the shaft of a column.

fluting The vertical channels in a column shaft.

geometric style A style of early Greek ceramics characterized by circles, rectangles, and triangles arranged in parallel bands.

hubris Exaggerated pride and self-confidence.

Ionic order One of the Greek architectural orders characterized by columns either of caryatids or with scrolled capitals.

kore (pl. korai) A freestanding sculpture of a standing maiden.

kouros (kouroi) A freestanding sculpture of a nude male youth.

lyric poem Poetry generally written to be accompanied by a lyre.

naturalism A style in art that seeks to represent the human body as it appears in nature.

order In Classical Greek architecture, the relationship of an elevation's three vertical elements: platform, column, and entablature; see *Doric*, *Ionic*, and *Corinthian*.

pantheon All the gods as a group.

pediment The triangular area over a porch.

peristyle A row of columns.

platform A raised horizontal surface.

polis The Greek city-state that formed the center of cultural life.

pronaos The enclosed vestibule at the front of a Greek building, especially a temple.

red figure A style in Greek pottery decoration composed of red figures against a black background.

stylobate The raised platform of the temple.

symposium In ancient Greece, a gathering of men initially for the purpose of sharing poetry, food, and wine.

tragedy A form of the religious rites associated with Dionysius associated with the coming of spring.

volute A scroll-like motif on a column's capital.

 ## Critical Thinking Questions

1. What is a polis? How is it central to Greek culture and history?

2. What role did the sanctuaries play in the development of Greek culture?

3. How would you describe the evolution of the *kouros* in the sixth century BCE?

4. How do the histories of Herodotus contribute to the growing sense of Greek national identity?

Egyptian and Greek Sculpture

Continuity & Change

Freestanding Greek sculpture of the Archaic period—that is, sculpture dating from about 600–480 BCE—is notable for its stylistic connections to 2,000 years of Egyptian tradition. The Late Period statue of *Mentuemhet* [men-too-em-het] (Fig. **6.18**), from Thebes, dating from around 2500 BCE, differs hardly at all from Old Kingdom sculpture at Giza (see Figs. 3.8–3.9), and even though the *Anavysos* [ah-NAH-vee-sus] *Kouros* (Fig. **6.19**), from a cemetery near Athens, represents a significant advance in relative naturalism over the Greek sculpture of just a few years before, it still resembles its Egyptian ancestors. Remarkably, since it follows upon the *Anavysos Kouros* by only 75 years, the *Doryphoros* [dor-IF-uh-ros] (*Spear Bearer*) (Fig. **6.20**) is significantly more naturalistic. Although this is a

Roman copy of a lost fifth-century BCE bronze Greek statue, we can assume it reflects the original's naturalism, since the original's sculptor, Polyclitus [pol-ih-KLY-tus], was renowned for his ability to render the human body realistically. But this advance, characteristic of Golden Age Athens, represents more than just a cultural taste for naturalism. As we will see in the next chapter, it also represents a heightened cultural sensitivity to the worth of the individual, a belief that as much as we value what we have in common with one another—the bond that creates the city-state—our *individual* contributions are at least of equal value. By the fifth century BCE, the Greeks clearly understood that individual genius and achievement could be a matter of civic pride. ■

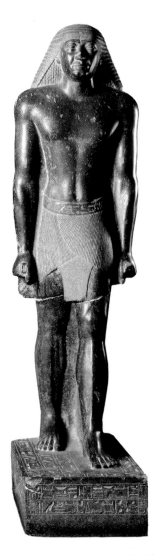 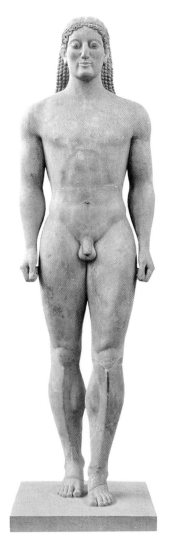 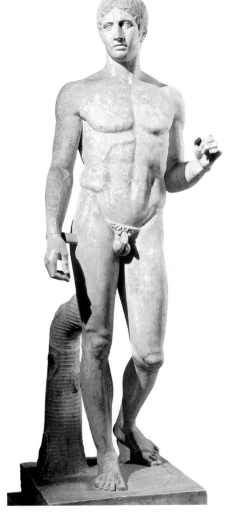

Fig. 6.18 *Montuemhet*, **from Karnak, Thebes. ca. 660 BCE.** Granite, height 54″. Egyptian Museum, Cairo.

Fig. 6.19 *Anavysos Kouros*, **perhaps young Kroisos, from a cemetery at Anavysos [ah-NAH-vee-sus], near Athens. ca. 525 BCE.** Marble with remnants of paint, height 6′ 4″. National Archaeological Museum, Athens; **Fig. 6.20** *Doryphoros (Spear Bearer)*, **Roman copy after the original bronze by Polyclitus of ca. 450–440 BCE.** Marble, height 6′ 6″. Museo Archeològico Nazionale, Naples.

7 Golden Age Athens

The School of Hellas

The Politics of Athens

Rebuilding the Acropolis

Socrates: Philosophy and the *Polis*

The Theater of the People

The Hellenistic World

> **"** *I say that Athens is the school of Hellas, and that the individual Athenian in his own person seems to have the power of adapting himself to the most varied forms of action with the utmost versatility and grace. This is no passing and idle word, but truth and fact; and the assertion is verified by the position to which these qualities have raised the state.* **"**

Pericles's Funeral Speech

◄ **Fig. 7.1 The Acropolis, Athens, Greece. Originally constructed in the second half of the 4th century BCE.** After the Persians destroyed Athens in 479 BCE, the entire city, including the Acropolis, had to be rebuilt. This afforded the Athenians a unique opportunity to create one of the greatest monumental spaces in the history of Western architecture. At the same time, they created a culture in pursuit of the "good life." In this culture the theater thrived as an art form, and a spirit of inquiry led to ideas and discoveries that would form the foundations of modern science and philosophy.

T HE ATHENIAN *POLIS*, LIKE EACH OF THE GREEK *POLEIS* AT

the start of the fifth century BCE, was predominantly rural and agricultural. The

city of Athens (Fig. **7.1**, Map **7.1**) was four miles inland from its port at Piraeus,

but the actual *polis* comprised all of Attica, a region of nearly 1,060 square miles dotted

with small rural villages, olive orchards, and vineyards.

The Greek philosopher Aristotle (384–322 BCE) described the Athenian polis in his *Politics* like this: "The partnership finally composed of several villages is the *polis*; it has at last attained the limit of virtually complete self-sufficiency, and thus while it comes into existence for the sake of mere life, it exists for the sake of the good life." For Aristotle, the essential purpose of the polis was to guarantee, barring catastrophe, that each of its citizens may flourish. Writing in the fourth century BCE, Aristotle is thinking back to the Athens of the fifth century BCE, the so-called Golden Age. During these years the pursuit of what Aristotle called *eudaimonia* [yoo-day-MOE-nee-uh], "the good or flourishing life," resulted in a culture of astonishing sophistication and diversity. For *eudaimonia* is not simply a happy or pleasurable existence; rather, the *polis* provides the conditions in which each individual may pursue an "activity of soul in accordance with complete excellence." For Aristotle, this striving to "complete excellence" defines Athens in the Golden Age. The polis produced a body of philosophical thought so penetrating and insightful that the questions it posed—the relationship between individual freedom and civic responsibility, the nature of the beautiful, the ideal harmony between the natural world and the intellectual or spiritual realm, to name a few—and the conclusions it reached dominated Western inquiry for centuries to come.

The writings of Herodotus and Thucydides during this period contributed to the development of history as a systematic and critical discipline. Golden Age Athens developed a theater, both comedic and tragic, that to this day influences stage actors and the methods dramatists use to reveal human psychology. In architecture, the Athenians achieved such a level of distinction that the stylistic traits they employed—the clarity of the parts, the harmony and balance among them, and the proportion and apparent simplicity of the whole—are imitated down to the present day. We have come to call this style **Classical**. The word typically refers to anything of the highest class. For scholars it refers specifically to the art and architecture of the Greeks in the fifth century BCE Greece.

Above all, the Athenian pursuit of the good life fostered a *politics*—that is, a dedication to the well-being of the polis through discussion, consensus, and united action, as well as the creation of institutions to foster this process. This chapter traces the rise and fall of Athens as a political power from the time of its victory over the Persians at Salamis in 480 BCE until its defeat by Sparta in the Peloponnesian Wars in 404 BCE, the years of Athens' Golden Age.

The chapter continues by surveying the subsequent **Hellenistic** period of Greek history, which begins with the rise to power of Alexander the Great (356–323 BCE) and extends to the Roman defeat of Cleopatra in Egypt in 30 BCE. (*Hellenes* is the name the Greeks called, and still call, themselves, and Alexander was understood to have made the world over in the image of Greece.) In the Hellenistic age, as Alexander conquered region after region, cities were built on the model of the Athenian polis, many of which became great centers of culture and learning in their own right. Soon the accomplishments of Greek culture had spread throughout the Mediterranean, across North Africa and the Middle East, even into the Indian subcontinent.

The Politics of Athens

"Nothing is worse for a city than a tyrant," wrote Euripides in his play, *The Suppliant Women*. "One man rules, and frames the

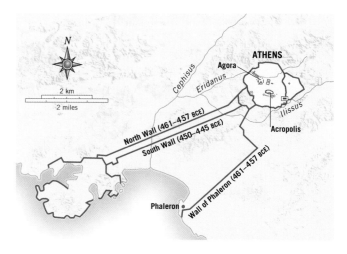

Map 7.1 The polis of Athens and its port at Piraeus, 5th century BCE.
The map shows the heights of the mountains in the area. Notice that Athens itself is built on a hilly site.

Map 7.2

- ■ Temple
- ■ Baths
- ● Theater or Stadium
- ■ Important building
- ⊣⊢ City walls
- ▮ City gate

Themistocles' Wall

Pompeion
Dipylon
Sacred Gate
Sacred Way

Hill of Theseion

Painted Stoa
Stoa of Poikele
Temple of Ares

Eridanus

Stoa of Zeus
Metreon
Bouleuterion
Tholos
AGORA

Hadrian's Library
Roman Agora

Hadrian's Wall

Lyceum

Middle Stoa
Stoa of Attalos

Pantheon

AREOPAGUS
Erechtheion
Parthenon
ACROPOLIS
Sanctuary of Zeus Poleus
Sanctuary of Pandon

N. Long Wall
Pnyx
Propylaia
Temple of Athena Nike

Wall of Cimmon

Hill of the Nymphs

Hadrian's Gate

Odeon of Herodes Atticus
Stoa of Eumenes
Sanctuary of Asclepius
Theater of Dionysos
Odeon of Pericles

Hill of the Muses

Temple of Olympieion

Ilisus

S. Long Wall

500 meters
500 yards

Map 7.2 Athens as it appeared in the late 5th century BCE. The map shows a modern artist's rendering of the city.

law himself. Equality doesn't exist. But when laws are written down, both rich and poor have the same right to justice. This is freedom's rallying cry: 'What man has good advice to give the city? Make it public, and earn a reputation. . . . For the city's sake, what could be better than that? When the people are the pilots of the city, they control their own destiny.'" In other words, a politics—a dedication to the well-being of the polis through discussion, consensus, and united action— depends upon democracy. In a tyranny, there can be no politics because there can be no debate. Whatever their diverging views, the citizens of the polis were free to debate the issues, to speak their minds. They spoke as individuals, and they cherished the freedom to think as they pleased. But they spoke out of a concern for the common good, for the good of the polis, which, after all, gave them the freedom to speak in the first place. When Aristotle says, in his *Politics*, that "man is a political animal," he means that man is a creature of the polis,

bound to it, dedicated to it, determined by it, and, somewhat paradoxically, liberated by it as well.

The Agora and the Good Life

When the Athenians returned to an Athens that had been devastated by the Persians in 480 BCE (see chapter 6), they rebuilt the city (Map **7.2**). They turned their attention first to the **agora**, an open place used for congregating or as a market. The principal architectural feature of the agora was the **stoa** (Fig. **7.2**), a long, open arcade supported by **colonnades**, rows of columns. While Athenians could shop for grapes, figs, flowers, and lambs in the agora, it was far more than just a shopping center. It was the place where citizens congregated, debated the issues of the day, argued points of law, settled disputes, and presented philosophical discourse. In short, it was the place where they practiced their politics.

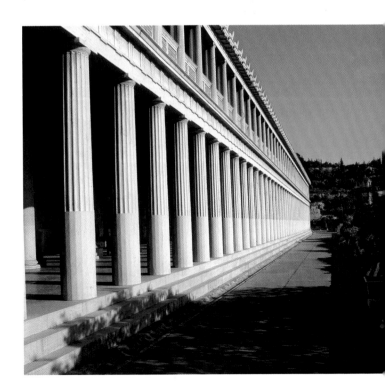

Fig. 7.2 The Stoa of Attalos, Athens, Greece. 150 BCE. This stoa, reconstructed at the eastern edge of the modern agora retains traditional form. The broad causeway on the right was the Panathenaic Way, the route of the ritual processions to the Acropolis in the distance. The original agora buildings lie farther to the right and overlook the Panathenaic Way.

CULTURAL PARALLELS

Early Democracies Differ in Greece and Rome

Even as the Athenians perfected early democracy in the fifth century BCE, the city of Rome had expelled the last of its Etruscan kings and decided to rule themselves without a monarch. However, in Rome, although every free male was a citizen, not all citizens shared equal privileges.

The City Council of 500 citizens, elected annually, met in the Bouleuterion [boo-loo-TER-ee-un] in the agora, and its executive committee dined, at public expense, in the nearby Tholos, a small round building with six columns supporting a conical roof. In the Metreon [MET-ree-un], the polis housed its weights and measures as well as its official archives. A special place honored the laws of Solon. Carved into the hill in the southwestern part of the city was a giant bowl, the Pynx, where as many as 10,000 citizens could gather. Here the polis convened four times each month (the Greek calendar consisted of ten months), to vote on the resolutions of its governing council.

The chief occupation of Athenian citizens was to gather in the agora to exercise their political duties. This purpose explains several seemingly contradictory aspects of the Athenian polis. Most citizens lived in relatively poor circumstances. Homes were tiny and hygiene practically nonexistent. Furniture was basic and minimal. Bread was the staple of life, eaten with olives or relish made from fish (though wine, at least, was plentiful). Wood for fire and heat was scarce, and the water supply was inadequate. This is not to say that the Athenians had no wealth. They simply chose not to buy material things. Instead, they acquired leisure, the free time necessary to perform the responsibilities of citizenship. (See *Voices*, page 191.)

Slaves and Metics

The Athenian democracy was based on its citizens' ability to have others do its manual work. This marks a radical departure from the culture of Hesiod's *Works and Days*, in which one advanced oneself by "work with work upon work." To the Athenian citizen, work was something to be avoided. (See chapter 6.) Typically it fell to slaves or to *metics* [MET-iks], free men who were not citizens because they came from some other polis in Greece or from a Greek colony.

By the middle of the Golden Age, the population of Athens was approximately 275,000, of which only 40,000 were citizens. Between 80,000 and 100,000 residents of Athens were slaves. The rest were metics and women. The practice of slavery came naturally to the Greeks, since most slaves were "barbarians" (the word Greeks used to describe non–Greek-speaking people) and hence by definition inferi-

or. Almost every citizen had at least one slave attendant and a female domestic servant. As for the metics, one contemporary reported that "They do everything. . . . [They] do the removal of rubbish, mason's work, and plastering, they capture the wood trade, timber construction, and rough carpentry, metal work and all subsidiary occupations are in their hands, and they hold the clothing industries, the sale of colors and varnishes, and in short every small trade."

Metics were equally central to the development of the arts and philosophy in the Golden Age. Most of the sculptors, potters, and painters came from abroad and thus were metics. Almost all of the city's philosophers—except, most notably, Socrates and Plato—were also metics. By the fourth century, so were all the leading comic playwrights, with the important exception of Aristophanes.

The Women of Athens

Like the metics, the women of Athens were not citizens and did not enjoy any of the privileges of citizenship. In 431 BCE, the playwright Euripides put these words into the mouth of Medea, a woman believed to be of divine origin who punished the mortal Jason for abandoning her. Medea kills Jason's new bride as well as her own children (**Reading 7.1**):

READING 7.1 from Euripides, *Medea*

Of all things which are living and can form a judgment
We women are the most unfortunate creatures.
Firstly, with an excess of wealth it is required
For us to buy a husband and take for our bodies
A master; for not to take one is even worse. . . .
A man, when he's tired of the company in his home,
Goes out of the house and puts an end to his boredom
And turns to a friend or companion of his own age.
But we are forced to keep our eyes on one alone [i.e., the husband].
What they say of us is that we have a peaceful time
Living at home, while they do the fighting in war.
How wrong they are! I would very much rather stand
Three times in front of battle than bear one child.

As Medea suggests, women in Athens were excluded from most aspects of social life. In general they married before they were 15 years old, at an age when they were considered to be still educable by husbands who averaged about 30 years of age. Athenian women were not educated. Near the beginning of the third century BCE, the comic playwright Menander explained the reason this way: "Teach a woman to read and write? What a terrible thing to do! Like feeding a vile snake on more poison." Neither were women expected to participate in conversation, which was the male's prerogative. Their role was largely domestic, even though their household obligations were sometimes minimal given the number of slaves and maids. Above all,

Voices

Rich and Poor in Athens

Xenophon took a critical view of Athenian society and democracy as a result of his alliance with Sparta and subsequent banishment from Athens.

As for. . . the Athenians, their choice of this type of constitution I do not approve, for in choosing thus they choose that thieves should fare better than the elite. . . at Athens the poor and the commons seem justly to have the advantage over the well-born and the wealthy; for it is the poor which mans the fleet and has brought the state her power. . .

People are surprised that. . . they [the Athenians] give the advantage to thieves, the poor, and the radical elements rather than to the elite. This is just where they will be seen to be preserving democracy. For if the poor and the common people and the worse elements are treated well, the growth of these classes will exalt the democracy; whereas if the rich and the elite are treated well the democrats strengthen their own opponents. In every land the elite are opposed to democracy. Among the elite there is very little license and injustice, very great discrimination as to what is worthy, while among the poor there is very great ignorance, disorderliness, and thievery;

> **"For if the poor and the common people and the worse elements are treated well, the growth of these classes will exalt the democracy."**

for poverty tends to lead them to what is disgraceful as does lack of education. . .

The license allowed to slaves and foreigners at Athens is extreme, and a blow to them is forbidden there, nor will a slave make way for you!

As regards sacrifices and temples and festivals. . . it is not possible for every poor citizen to do sacrifice and hold festival, or to set up temples. . . But it has hit upon a means of meeting the difficulty. They sacrifice—that is, the whole state sacrifices—at the public cost a large number of victims; but it is the [common] People that keeps holiday and distributes the victims by lot amongst its members. Rich men have in some cases private gymnasia and baths. . . but the People takes care to have built at the public cost a number of palaestras, dressing-rooms, and bathing establishments for its own special use, and the mob gets the benefit of the majority of these. . .

the wife's primary duty was to produce male offspring for her husband's household.

Women did, in fact, serve another important role in Athenian social life—they took part in religious rituals and public festivals. They were also, as Euripides' *Medea* suggests, central figures in much of Greek culture, from its mythology, to its painting and sculpture, and, perhaps above all, its theater. Plays such as Euripides' *Medea* and Sophocles' *Antigone*, and especially Aristophanes' comedy *Lysistrata*, in which the women of Athens and Sparta unite to withhold sexual favors from their husbands until they agree to make peace, suggest that Athenian society was deeply torn by the tension between the reality of female power and the insistence on male authority.

Nevertheless, we know that some women exerted real power in Greek culture. A particularly powerful woman was Aspasia (ca. 469–ca. 406 BCE), mistress of the statesman and leader Pericles (whose rule is discussed later in the chapter). Aspasia was a *hetaira* [heh-TYE-ruh], one of a class of Greek courtesans distinguished by their beauty and, as opposed to most women in Athenian society, their often high level of education. After Pericles divorced his wife around 445 BCE, Aspasia lived with him openly as if they were married. (Since she was both foreign-born and a *hetaira*, actual mar-

riage was forbidden by Athenian law.) She is said to have taught rhetoric to students such as Socrates and Plato, with such skill that some scholars believe it was actually she who invented the "dialectic method" (see page 203). And she evidently exerted enough political influence on Pericles that their relationship was the target of attacks and jokes in Greek comedy.

Some Hellenic city-states treated their women better than the Athenians. Spartan women were taught to read and write, and they were encouraged to develop the same physical prowess as Spartan men, participating in athletic events such as javelin, discus, and foot races, as well as fighting in staged battles. Spartan women met with their husbands only for procreative purposes and had little to do with raising their children. A woman's property was her own to keep and manage, and if her husband was away too long at war, she was free to remarry.

Pericles and the School of Hellas

No person dominated Athenian political life during the Golden Age more than the statesman Pericles (ca. 495–429 BCE), who served on the Board of Ten Generals for nearly 30 years. An aristocrat by birth, he was nonetheless democracy's strongest advocate. Late in his career, in 431 BCE, he delivered a speech

honoring soldiers who had fallen in early battles of the Peloponnesian War, a struggle for power between Sparta and Athens that would eventually result in Athens's defeat in 404 BCE, long after Pericles's own death. Although Athens and Sparta had united to form the Delian League in the face of the Persian threat in 478 BCE, by 450 BCE Persia was no longer a threat, and Sparta sought to foment a large-scale revolt against Athenian control of the Delian League. Sparta formed its own Peloponnesian League, motivated at least partly by Athens's use of Delian League funds to rebuild its acropolis. Pericles resisted the rebellion vigorously, as Athenian preeminence among the Greeks was at stake. The Greek historian Thucydides recorded Pericles's speech in honor of his soldiers in its entirety in his *History of the Peloponnesian Wars* (**Readings 7.2a, b, c**). Although Thucydides, considered the greatest historian of antiquity, tried to achieve objectivity—to the point that he claimed, rather too humbly, that he was so true to the facts that the reader might find him boring—he did admit that he had substituted his own phrasings when he could not remember the exact words of his subjects. Thus, Pericles's speech may be more Thucydides than Pericles. Furthermore, gossip at the time suggests that the speech was in large part the work of Aspasia, Pericles's mistress and partner. So the speech may, in fact, be more Aspasia than Pericles, and more Thucydides than Aspasia. Nevertheless, it reflects what the Athenians thought of themselves.

Pericles begins his speech by saying that, in order to properly honor the dead, he would like "to point out by what principles of action we rose to power, and under what institutions and through what manner of life our empire became great." First and foremost in his mind is Athenian democracy:

READING 7.2a Thucydides, *History of the Peloponnesian Wars*, Pericles's Funeral Speech

Our form of government does not enter into rivalry with the institutions of others. We do not copy our neighbors, but are an example to them. It is true that we are called a democracy, for the administration is in the hands of the many not the few. But while the law secures equal justice to all alike in their private disputes, the claim of excellence is also recognized; and when a citizen is in any way distinguished, he is preferred to the public service, not as a matter of privilege, but as the reward of merit.

This "claim of excellence" defines Athenian political, social, and cultural life. It is the hallmark not only of their political system but also of their military might. It explains their spirited competitions in the arts and in their athletic contests, which the citizens regularly enjoyed. All true Athenians, Pericles suggests, seek excellence through the conscientious pursuit of the public good:

READING 7.2b Thucydides, *History of the Peloponnesian Wars*, Pericles's Funeral Speech

A spirit of reverence pervades our public acts. . . . We alone regard a man who takes no interest in public affairs, not as a harmless, but as a useless character; and if few of us are originators, we are all sound judges of policy. The great impediment to action is, in our opinion, not discussion, but the want of that knowledge which is gained by discussion preparatory to action. For we have a peculiar power of thinking before we act and of acting too, whereas other men are courageous from ignorance but hesitate upon reflection.

Pericles is not concerned with politics alone. He praises the Athenians' "many relaxations from toil." He acknowledges that life in Athens is as good as it is because "the fruits of the whole earth flow in upon us." And, he insists, Athenians are "lovers of the beautiful" who seek to "cultivate the mind." "To sum up," he concludes:

READING 7.2c Thucydides, *History of the Peloponnesian Wars*, Pericles's Funeral Speech

I say that Athens is the school of Hellas, and that the individual Athenian in his own person seems to have the power of adapting himself to the most varied forms of action with the utmost versatility and grace. This is no passing and idle word, but truth and fact; and the assertion is verified by the position to which these qualities have raised the state. . . . I have dwelt upon the greatness of Athens because I want to show you that we are contending for a higher prize than those who enjoy none of these privileges, and to establish by manifest proof the merit of these men whom I am now commemorating. Their loftiest praise has been already spoken. For in magnifying the city, I magnify them, and men like them whose virtues made her glorious.

When Pericles says that Athens is "the school of Hellas," he means that it teaches all of Greece by its example. He insists that the greatness of the state is a function of the greatness of its individuals. The quality of Athenian life depends upon this link between individual freedom and civic responsibility—which most of us in the Western world recognize as the foundation of our own political idealism (if, too often, not our political reality).

Beautiful Mind, Beautiful Body

One of the most interesting aspects of Pericles's oration is his sense that the greatness of the Athenians is expressed in both the love of beauty and the cultivation of intellectual inquiry. We find this particularly in the development of scientific inquiry. In fact, one of the more remarkable features of fifth-century Greek culture is that it spawned a way of thinking that transformed the way human beings see themselves in relation to the natural world. Most people in the ancient world saw themselves at the mercy of flood and sun, subject to the wiles of gods beyond their control. They faced the unknown through the agency of priests, shamans, kings, mythologies, and rituals.

In contrast, the Greeks argued that the forces that governed the natural world were knowable. The causes of natural disasters—flood, earthquake, drought—could be understood as something other than the punishment of an angry god. As early as 600 BCE, for instance, Thales of Miletes (ca. 625?–547? BCE) accurately described the causes of a solar eclipse—an event that had periodically terrorized ancient peoples. His conclusions came from objective observation and rigorous analysis of the facts. Observing that water could change from solid to liquid to gas, Thales also argued that water was the primary substance of the universe. Many disagreed, opting for air or fire as the fundamental substance. Nevertheless, the debate inaugurated a tradition of dialogue that fostered increasingly sophisticated thinking. Intellectuals challenged one another to ever more demonstrable and reasonable explanations of natural phenomena.

In this light, the cult of the human body developed in the Golden Age. The writings attributed to Hippocrates (ca. 470–390 BCE), the so-called father of medicine, insist on the relationship between cause and effect in physical illness, the mind's ability to influence the physical body for good or ill, and the influence of diet and environment on physical health. In fact, in the Golden Age, the beautiful body comes to reflect, not only physical but also mental superiority.

In a pile of debris on the Acropolis, pushed aside by Athenians cleaning up after the Persian sack of Athens in 479 BCE, a sculpture of a nude young man, markedly more naturalistic than its kouros predecessors was uncovered in 1865 (its head was discovered 23 years later, in a separate location). Attributed by those who found it to the sculptor Kritios, the so-called *Kritios Boy* (Fig. **7.3**) demonstrates the increasing naturalism of Greek sculpture during the first 20 years of fifth century BCE.

Compare the *Kritios Boy* with the earlier stiff-looking kouros figures (see Figs 6.9 and 6.10). The boy's head is turned slightly to the side. His weight rests on the left leg and the right leg extends forward, bent slightly at the knee. The figure seems to twist around its **axis**, or imaginary central line, the natural result of balancing the body over one supporting leg. The term for this stance, coined during the Italian Renaissance, is **contrapposto** ("counterpoise"), or weight-shift. The inspiration for this development seems to have been a

Continuity & Change
p. 178

Anavysos Kouros

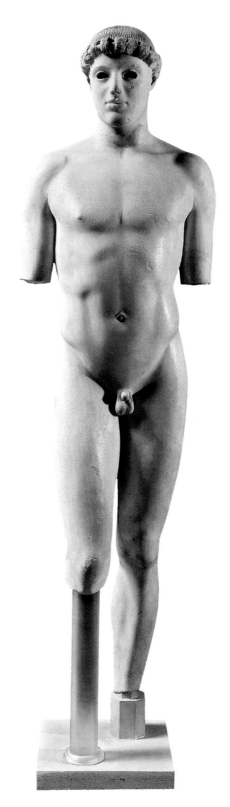

Fig. 7.3 *Kritios Boy,* **from Acropolis, Athens. ca. 480** BCE. Marble, height 46″. Acropolis Museum, Athens. The growing naturalism of Greek sculpture is clear when one compares the *Kritios Boy* to the earlier *kouros* figures discussed in chapter 6. Sculptures such as this one mark a transition from the votive function of the *kouros* figures to the more decorative use of figurative sculpture in later Greek art.

growing desire by Greek sculptors to dramatize the stories nar-rated in the decorative programs of temples and sanctuaries. Liveliness of posture and gesture and a sense of capturing the body in action became their primary sculptural aim and the very definition of classical beauty.

An even more developed version of the *contrapposto* pose can be seen in the *Doryphoros*, or *Spear Bearer* (Fig. **7.4**), whose weight falls on the forward right leg. An idealized por-trait of an athlete or warrior, originally done in bronze, the *Doryphoros* is a Roman copy of the work of Polyclitus, one of the great artists of the Golden Age. The sculpture was famous throughout the ancient world as a demonstration of Polycli-tus's treatise on proportion known as *The Canon* (from the Greek *kanon,* meaning "measure" or "rule"). In Polyclitus's system, the ideal human form was determined by the height of the head from the crown to the chin. The head was one-eighth the total height, the width of the shoulders was one-quarter the total height, and so on, each measurement reflecting these ideal proportions. For Polyclitus, these rela-tions resulted in the work's *symmetria,* the origin of our word "symmetry," but meaning, in Polyclitus's usage, "commensu-rability," or "having a common measure." Thus the figure, beautifully realized in great detail, right down to the veins on the back of the hand, reflects a higher mathematical order and embodies the ideal harmony between the natural world and the intellectual or spiritual realm.

Rebuilding the Acropolis

After the Persian invasion of Greece in 480 BCE (see chapter 6), the Athenians had initially vowed to keep the Acropolis in a state of ruin as a reminder of the horrible price of war; however, Pericles convinced them to rebuild it. Richly deco-rated with elaborate architecture and sculpture, it would become, Pericles argued, a fitting memorial not only to the war but especially to Athena's role in protecting the Athen-ian people. Furthermore, at Persepolis, the defeated Xerxes and then his son and successor Artaxerxes [ar-tuh-ZERK-seez] I (r. 465–424 BCE), were busy expanding their palace, and Athens was not about to be outdone.

Pericles placed the sculptor, Phidias, in charge of the sculp-tural program for the new buildings on the Acropolis, and Phidias may have been responsible for the architectural project as well. The centerpiece of the project was the Parthenon, a temple to honor Athena, which was completed in 432 BCE after 15 years of construction. The monumental entryway to the complex, the Propylaia, was completed the same year. Two other temples, completed later, the Erechtheion (430s–406 BCE) and the Temple of Athena Nike (420s BCE), also may have been part of the original scheme. The chief architects of the Acropolis project were Ictinus, Callicrates, and Mnesicles. (See *Focus,* pages 196–197.)

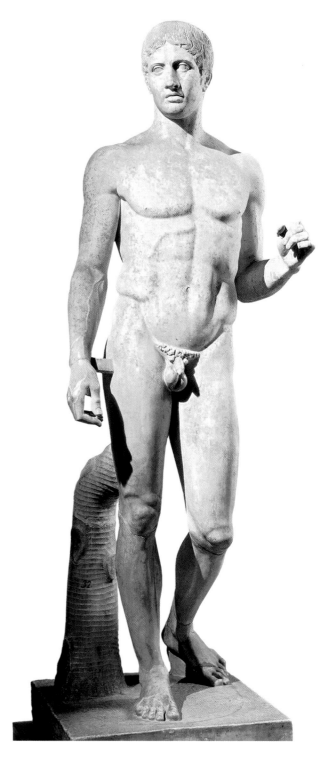

Fig. 7.4 *Doryphoros (Spear Bearer)*, Roman copy after the original bronze by Polyclitus of ca. 450–440 BCE. Marble, height 6′ 6″. Museo Archeològico Nazionale, Naples. There is some debate about just what "measure" Polyclitus employed to achieve his ideal figure. Some argue that his system of proportions is based on the length of the figure's index finger or the width of the figure's hand across the knuckles. The idea that it is based on the distance between the chin and hairline derives from a much later discussion of proportion by the Roman writer Vitruvius, who lived in the first century CE. It is possible that Vitruvius had first-hand knowledge of Polyclitus's *Canon,* which was lost long ago.

The Sculpture Program at the Parthenon

If Phidias's hand is not directly involved in carving the sculpture decorating the Parthenon, most of the decoration is probably his design. We know for certain that he designed the giant statue of Athena Parthenos housed in the Parthenon (Fig. **7.5**). Though long since destroyed, we know its general characteristics through literary descriptions and miniature souvenir copies. It stood 40 feet high and was supported by a ship's mast. Its skin was made of ivory and its dress and armor of gold. Its spectacular presence was meant to celebrate not only the goddess's religious power but also the political power of the city she protected. She is at once a warrior, with spear and shield, and the model of Greek womanhood, the *parthenos,* or maiden, dressed in the standard Doric peplos. And since the gold that formed the surface of the statue was removable, she was, in essence, an actual treasury.

Something of the quality of Phidias's work might be seen in a bronze sculpture recovered off the Italian coast near Riace (Fig. **7.6**). There is some reason to believe that this piece was once part of an ensemble of thirteen bronzes commissioned by Kimon, son of the great general at Marathon, Miltiades, to honor his father. Sculpted by Phidias, they stood near the Athenian Treasury at Delphi. This particular bronze might represent Miltiades himself, since the figure wears a helmet pushed back on his head, the usual manner of depicting generals. Whatever the case, the bronze evidences an advanced *contrapposto* pose, a high degree of naturalism, and, at nearly six-and-a-half feet tall, an imposing monumentality. Bronze was, in fact, the material of choice for Greek sculptors. Marble was difficult to work with, susceptible to cracking during the sculpting process, and hard to fix if a mistake were made. But in sculpting the clay model for a bronze, artists could easily rework any part again and again. They could thus achieve a degree of perfection often unattainable in stone. Greek sculptors employed the lost-wax technique that had originated in the Middle East (see chapter 2), and they soon learned to create a variety of surface textures—for hair and skin, for instance. As here, they were able to embellish the works with copper-colored lips, ivory and glass-paste eyes, and teeth made of silver. Each eyelash on the Riace warrior is individually cast.

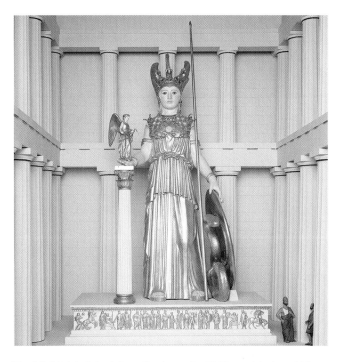

Fig. 7.5 Model of the *Athena Parthenos,* by Phidias, original ca. 440 BCE. Royal Ontario Museum, Toronto. Surviving "souvenir" copies of Phidias's original give us some idea of how it must have originally appeared, and this model is based on those.

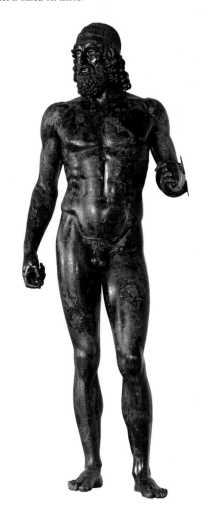

Fig. 7.6 *Riace Warrior* A, found in the sea of Riace, Italy, perhaps the work of Phidias, ca. 450 BCE. Bronze, height 6′ 8″. Reggio/Museo Archeologico Nazionale di Napoli, Naples, Italy. This is one of two sculptures discovered in 1972 by scuba divers who saw an arm protruding out of the sand in about 25 feet of water.

Focus

The Parthenon

The Parthenon is famous both for its architectural perfection and for the sculptural decoration that is so carefully integrated into the structure. In the clarity of its parts, the harmony among them, and its overall sense of proportion and balance, it represents the epitome of classical architecture. This classical sense of beauty manifests itself in the architects' use of the **Golden Section**, believed by the Greeks to be the most beautiful of all proportions. It represents a ratio of approximately 8:5, or, more precisely, 1.618:1. That is, given a line of a certain length, the whole length ($a + b$) is to the longer section a as 8 is to 5. The Greeks, with their great affinity for geometry, quickly realized that a rectangle based on these proportions could easily be divided and subdivided into sections, or *Golden Rectangles*. The east and west facades of the Parthenon are such rectangles—the width of the building is 1.618 times the height, a ratio of 8:5. Furthermore, the ground plan of the structure is laid out in similar proportions. The mathematical regularity of the temple is particularly suited to the worship of Athena, who is not only goddess of war but also goddess of wisdom, or rationality.

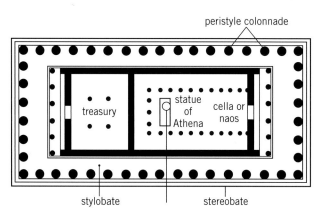

The giant 40-foot high sculpture of Athena Parthenos was located in the Parthenon's *cella* or *naos*, the central interior room of a temple in which the cult statue was traditionally housed.

The Golden Rectangle (left) and Golden Section (right).

The Sculpture Program at the Parthenon

If Phidias's hand is not directly involved in carving the sculpture decorating the Parthenon, most of the decoration is probably his design. We know for certain that he designed the giant statue of Athena Parthenos housed in the Parthenon (Fig. **7.5**). Though long since destroyed, we know its general characteristics through literary descriptions and miniature souvenir copies. It stood 40 feet high and was supported by a ship's mast. Its skin was made of ivory and its dress and armor of gold. Its spectacular presence was meant to celebrate not only the goddess's religious power but also the political power of the city she protected. She is at once a warrior, with spear and shield, and the model of Greek womanhood, the *parthenos,* or maiden, dressed in the standard Doric peplos. And since the gold that formed the surface of the statue was removable, she was, in essence, an actual treasury.

Something of the quality of Phidias's work might be seen in a bronze sculpture recovered off the Italian coast near Riace (Fig. **7.6**). There is some reason to believe that this piece was once part of an ensemble of thirteen bronzes commissioned by Kimon, son of the great general at Marathon, Miltiades, to honor his father. Sculpted by Phidias, they stood near the Athenian Treasury at Delphi. This particular bronze might represent Miltiades himself, since the figure wears a helmet pushed back on his head, the usual manner of depicting generals. Whatever the case, the bronze evidences an advanced *contrapposto* pose, a high degree of naturalism, and, at nearly six-and-a-half feet tall, an imposing monumentality. Bronze was, in fact, the material of choice for Greek sculptors. Marble was difficult to work with, susceptible to cracking during the sculpting process, and hard to fix if a mistake were made. But in sculpting the clay model for a bronze, artists could easily rework any part again and again. They could thus achieve a degree of perfection often unattainable in stone. Greek sculptors employed the lost-wax technique that had originated in the Middle East (see chapter 2), and they soon learned to create a variety of surface textures—for hair and skin, for instance. As here, they were able to embellish the works with copper-colored lips, ivory and glass-paste eyes, and teeth made of silver. Each eyelash on the Riace warrior is individually cast.

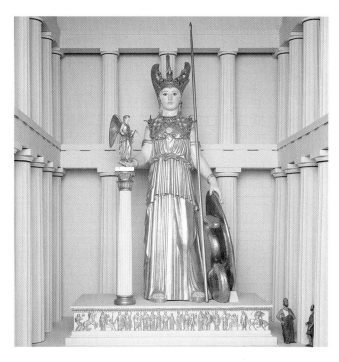

Fig. 7.5 Model of the *Athena Parthenos,* by Phidias, original ca. 440 BCE. Royal Ontario Museum, Toronto. Surviving "souvenir" copies of Phidias's original give us some idea of how it must have originally appeared, and this model is based on those.

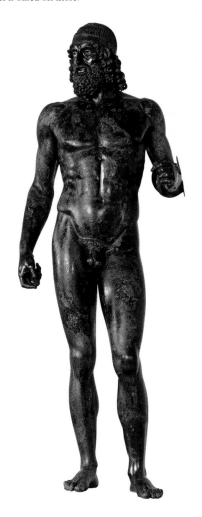

Fig. 7.6 *Riace Warrior* A, found in the sea of Riace, Italy, perhaps the work of Phidias, ca. 450 BCE. Bronze, height 6′ 8″. Reggio/Museo Archeologico Nazionale di Napoli, Naples, Italy. This is one of two sculptures discovered in 1972 by scuba divers who saw an arm protruding out of the sand in about 25 feet of water.

Focus

The Parthenon

The Parthenon is famous both for its architectural perfection and for the sculptural decoration that is so carefully integrated into the structure. In the clarity of its parts, the harmony among them, and its overall sense of proportion and balance, it represents the epitome of classical architecture. This classical sense of beauty manifests itself in the architects' use of the **Golden Section**, believed by the Greeks to be the most beautiful of all proportions. It represents a ratio of approximately 8:5, or, more precisely, 1.618:1. That is, given a line of a certain length, the whole length (*a* + *b*) is to the longer section *a* as 8 is to 5. The Greeks, with their great affinity for geometry, quickly realized that a rectangle based on these proportions could easily be divided and subdivided into sections, or *Golden Rectangles*. The east and west facades of the Parthenon are such rectangles—the width of the building is 1.618 times the height, a ratio of 8:5. Furthermore, the ground plan of the structure is laid out in similar proportions. The mathematical regularity of the temple is particularly suited to the worship of Athena, who is not only goddess of war but also goddess of wisdom, or rationality.

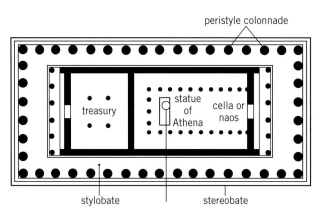

The giant 40-foot high sculpture of Athena Parthenos was located in the Parthenon's *cella* or *naos*, the central interior room of a temple in which the cult statue was traditionally housed.

The Golden Rectangle (left) and Golden Section (right).

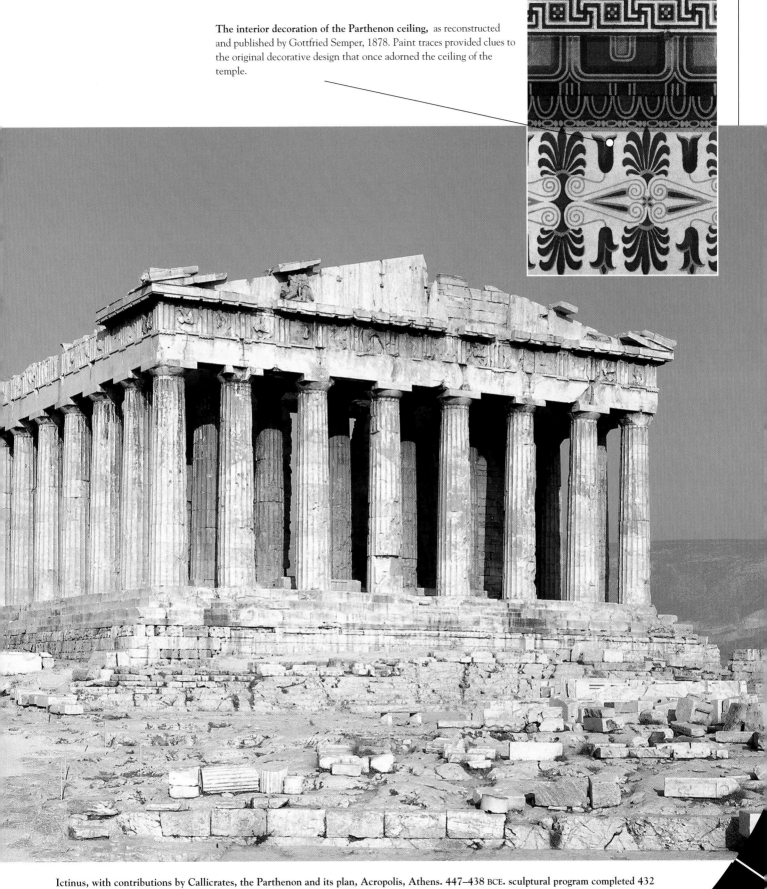

The interior decoration of the Parthenon ceiling, as reconstructed and published by Gottfried Semper, 1878. Paint traces provided clues to the original decorative design that once adorned the ceiling of the temple.

Ictinus, with contributions by Callicrates, the Parthenon and its plan, Acropolis, Athens. 447–438 BCE. sculptural program completed 432 BCE. The temple measures about 228′ × 101′ on the top step. The temple remained almost wholly intact (though it served variously as a church and then a mosque) until 1687, when the attacking Venetians exploded a Turkish powder magazine housed in it.

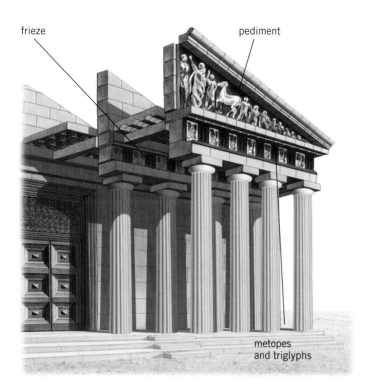

frieze

pediment

metopes
and triglyphs

Fig. 7.7 Cutaway drawing of the Parthenon porch showing friezes, metopes, and pediment. Evident here is the architect Ictinus's juxtaposition of the Doric order, used for the columns with their capitals and the entablature on the outside, with the lighter Ionic order, with its continuous frieze, used for the entablature inside the colonnade.

The decorative sculptures were in three main areas (Fig. **7.7**)—in the pediments at each end of the building, on the **metopes**, or the square panels between the beam ends under the roof, and on the frieze that runs across the top of the outer wall of the cella. Brightly painted, these sculptures must have appeared strikingly lifelike. The west pediment depicts Athena battling with Poseidon to determine who was to be patron saint of Athens. Scholars debate the identity of the figures in the east pediment, but it seems certain that overall it portrays the birth of Athena with gods and goddesses in attendance (Fig. **7.8**). The three-foot-high frieze depicts a ceremonial procession (Fig. **7.9**) and originally ran at a height of nearly 27 feet around the central block of the building. Traditionally, the frieze has been interpreted as a depiction of the Panathenaic procession, an annual civic festival honoring Athena, but a recent interpretation, discussed below in connection with the Erechtheion, suggests a mythological reading. The 92 metopes on the four sides of the temple narrate battles between the Greeks and four enemies—the Trojans on one side, and on the other three, giants, Amazons (perhaps symbolizing the recently defeated Persians), and centaurs, mythological beasts with the legs and bodies of horses and the trunks and heads of humans. Executed in high relief (Fig. **7.10**), these metopes represent the clash between the forces of civilization—the Greeks—and their barbarian, even bestial opponents. The male nude reflects not only physical but mental superiority, a theme particularly appropriate for a temple to Athena, goddess of both war and wisdom.

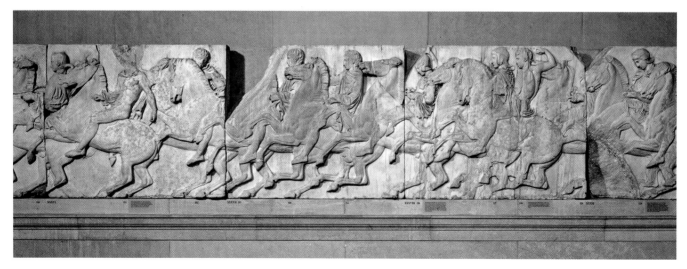

Fig. 7.8 *Young Men on Horseback*, segment of the north frieze, Parthenon. ca. 440 BCE. Marble, height 41″.
© The Trustees of the British Museum. This is just a small section of the entire procession, which extends completely around the Parthenon.

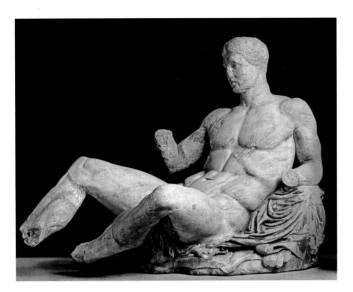

Fig. 7.9 A recumbent god or hero, east pediment of the Parthenon, ca. 435 BCE. © Copyright The British Museum. In 1801, Thomas Bruce, earl of Elgin and British ambassador to Constantinople, brought the marbles from the east pediment back to England to decorate his mansion—the source of their name, the *Elgin Marbles*. The identities of the figures are much disputed, but the greatness of their execution is not. Now exhibited in the round, in their original position on the pediment, they were carved in high relief. As the sun passed over the three-dimensional relief on the east and west pediments, the sculptures would have appeared almost animated by the changing light and the movement of their cast shadows.

The Architectural Program at the Parthenon

The cost of rebuilding the Acropolis was enormous, but despite the reservations expressed by many over such an extravagant expenditure—financed mostly by tributes that Athens assessed upon its allies in the Delian League—the project (Fig. **7.11**) had the virtue of employing thousands of Athenians—citizens, metics, and slaves alike—thus guaranteeing its general popularity. Writing a *Life of Pericles* five centuries later, the Greek-born biographer Plutarch (ca. 46–after 119 CE) gives us some idea of the scope of the rebuilding project and its effects (**Reading 7.3**):

READING 7.3 **Plutarch, *Life of Pericles***

The raw materials were stone, bronze, ivory, gold, ebony, and cypress wood. To fashion them were a host of craftsmen: carpenters, moulders, coppersmiths, stonemasons, goldsmiths, ivory-specialists, painters, textile-designers, and sculptors in relief. Then there were the men detailed for transport and haulage: merchants, sailors, and helmsmen at sea; on land, cartwrights, drovers, and keepers of traction animals. There were also the rope-makers, the flax-workers, cobblers, roadmakers, and miners. Each craft, like a commander with his own army, had its own attachments of hired labourers and individual specialists organized like a machine for the service required. So it was that the various commissions spread a ripple of prosperity throughout the citizen body.

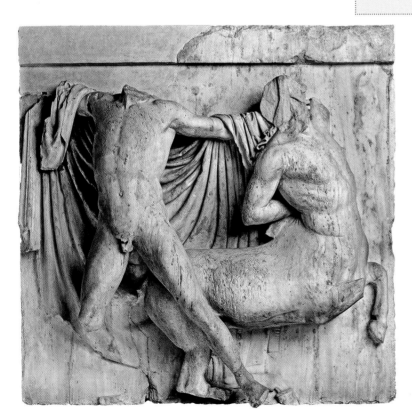

Fig. 7.10 Lapith Overcoming a Centaur, south metope 27, Parthenon, Athens, 447–438 BCE. Marble relief, height 4′ 5″. © Trustees of the British Museum, London. The Lapiths are a people in Greek myth who were defeated in a war provoked by drunken centaurs at the wedding of their king, Pirtihous. The Greeks identified themselves with the Lapiths after they were defeated by the Persians, whom they considered centaur-like.

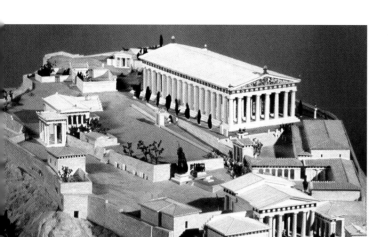

Fig. 7.11 Model of the Acropolis, ca. 400 BCE. American School of Classical Studies, Athens.

the towering mass of the Propylaia was the far more delicate Temple of Athena Nike (Fig. 7.12), situated on the promontory just to the west and overlooking the entrance way. Graced by slender Ionic columns, the diminutive structure (it measures a mere 27 by 19 feet) was designed by Callicrates and built in 425 BCE, not long after the death of Pericles. It was probably meant to celebrate what the Athenians hoped would be their victory in the Peloponnesian Wars, as *nike* is Greek for "victory." Before the end of the wars, between 410 and 407 BCE, it was surrounded by a **parapet**, or low wall, faced with panels depicting Athena together with her winged companions, the Victories.

After passing through the Propylaia into the sacred precinct at the top of the Acropolis, the visitor would confront, not only the massive spectacle of the Parthenon, but also an imposing statue of Athena Promachus [PROM-uh-kus], Athena the Defender, executed by Phidias between 465 and 455 BCE. Twenty feet high, it was tall enough that sailors landing at the port of Piraeus several miles away could see the sun

The Parthenon was of course the centerpiece of the project. Built to give thanks to Athena for the salvation of Athens and Greece in the Persian Wars, it was a tangible sign of the power and might of the Athenian state, designed to impress all who visited the city. It was built on the foundations and platform of an earlier structure, but the architects Ictinus and Callicrates clearly intended it to represent the Doric order in its most perfect form. It has eight columns at the ends and seventeen on the sides. Each column swells out about one-third of the way up, a device called **entasis**, to counter the eye's tendency to see the uninterrupted parallel columns as narrowing as they rise and to give a sense of "breath" or liveliness to the stone. The columns also slant slightly inward, so that they appear to the eye to rise straight up. And since horizontal lines appear to sink in the middle, the platform beneath them rises nearly five inches from each corner to the middle. There are no true verticals or horizontals in the building, a fact that lends its apparently rigid geometry a sense of liveliness and animation.

One of the architects employed in the project, Mnesicles [NES-ih-kleez], was charged with designing the **propylon**, or large entryway, where the Panathenaic Way approached the Acropolis from below. Instead of a single gate, he created five, an architectural tour de force named the Propylaia [prop-uh-LAY-uh] (the plural of *propylon*), flanked with porches and colonnades of Doric columns. The north wing included a picture gallery featuring paintings of Greek history and myth, none of which survive. Contrasting with

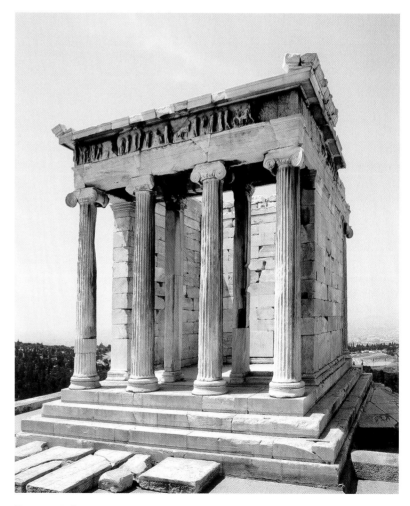

Fig. 7.12 Callicrates. Temple of Athena Nike, Acropolis, Athens. ca. 425 BCE. Overlooking the approach to the Propylaia, the lighter Ionic columns of the temple contrast dramatically with the heavier, more robust Doric columns of the gateway.

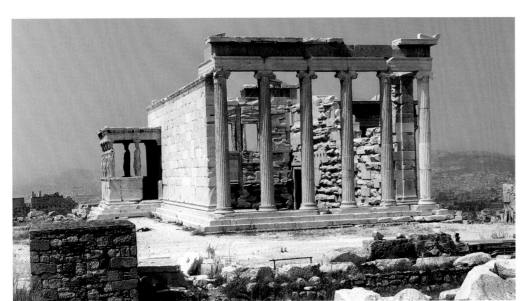

Fig. 7.13 Erechtheion, Acropolis, Athens. 430s–405 BCE. The Erechtheion, with its irregular and asymmetrical design, slender Ionic columns, and delicate Porch of the Maidens, contrasts dramatically and purposefully with the more orthodox and highly regular Parthenon across the Acropolis to the south.

reflected off Athena's helmet. And just to the left of the statue they would have seen the Erechtheion (Fig. **7.13**). Like the Propylaia, it was designed by Mnesicles, but its asymmetrical and multi-leveled structure is unique, resulting from the rocky site on which it is situated. Flatter areas were available on the Acropolis, so its demanding position is clearly intentional. The building surrounds a sacred spring dedicated to Erechtheus, the first legendary king of Athens, after whom the building is named. Work on the building began after the completion of the Parthenon, in the 430s BCE, and took 25 years. Among its unique characteristics is the famous Porch of the Maidens, facing the Parthenon. It is supported by six **caryatids**, female figures serving as columns (visible on the far left in Fig. 7.13). These figures literalize the sense of animation created by the entasis of the Parthenon's columns. All assume a classic *contrapposto* pose, the three on the left with their weight over the right leg, the three on the right with their weight over the left. Although all six figures are unique—the folds on their chitons fall differently, and their breasts are different sizes and shapes—together they create a sense of balance and harmony.

The Relation of the Erechtheion to the Parthenon The importance of Erechtheus to the entire plan of the Acropolis, including the Parthenon, has recently been enforced by a new reading of a frieze panel that originally stood immediately over the main entrance to the Parthenon (Fig. **7.14**). According to surviving lines from an otherwise lost play by Euripides, the *Erechtheus*, Athena's victory over Poseidon in their combat for the patronage of Athens (depicted on the west pediment of the Parthenon and traditionally believed to have occurred at the site of the Erechtheion) so angered Poseidon's son Eumolpos [yoo-MOL-pos] that he threatened to destroy the city. The oracle at Delphi told King Erechtheus that in order to protect the city from Eumolpos's wrath, one of his three daughters must be sacrificed. Unknown to him, the three swore an oath that, if one died, the others would die as well. Praxithea, Erechtheus's wife, knew of the oath, and when she was told the news, she accepted her daughters' sacrifice, choosing the

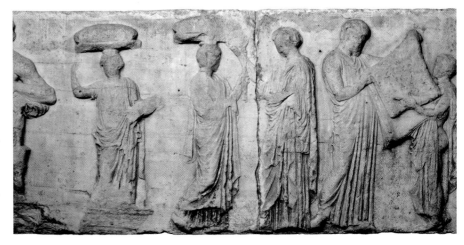

Fig. 7.14 *Erechtheus, Praxithea, and Their Daughters,* from the Parthenon frieze. ca. 440 BCE.
© The British Museum. These figures are among the least dynamic of the entire frieze, partially because they are much eroded by the elements. Their position above the main entrance to the Parthenon always seemed at least a little odd, until they were identified with the central figures of Euripides' play the *Erechtheus.*

good of the state over the well-being of her family. In the Parthenon frieze, she can be seen watching two of her daughters as they arrive with their funerary robes balanced on their heads, ready for their sacrifice. Behind her, Erechtheus, dressed as a priest, hands the funerary robes to the third daughter. After their sacrifice, Erechtheus is killed by Poseidon, who strikes the Acropolis rock with his trident, opening a chasm into which he pulls Erechtheus. The room on the west side of the Erechtheion known as "the Salt Sea of Erechtheus" apparently marks this spot. In a fragment of the *Erechtheus* discovered in 1962 in Egypt (**Reading 7.4**), Athena addresses the mourning Praxithea [prax-ITH-ee-uh]:

READING 7.4 **Euripides,** *Erechtheus*

And first I shall tell you about the girl whom your husband sacrificed for this land: bury her where she breathed out her pitiful life, and these sisters in the same tomb of the land, on account of their nobility. . . . To my fellow townsmen I say not to forget them in time but with annual sacrifices and bull-slaying slaughters to honor them, celebrating them with holy maiden-dances.

This fragment of text has important implications for our understanding of the Parthenon. The Greek word *parthenoi* [PAR-thuh-noy] means "place of the maidens or girls," and the Parthenon may well rest over the tombs of the three daughters of Erechtheus. We have never understood how or why Athena came to be called Athena Parthenos—it is a fourth century BCE phenomenon—but perhaps it is through her identification with the virgin daughters of Erechtheus, who, like Athena during the Persian Wars, came to the rescue of their city. And perhaps the Parthenon frieze does not represent the Panathenaic procession, as we have long thought, but the celebration of the virgins' sacrifice that Athena directs the people of Athens to undertake annually in the Erechtheus.

Philosophy and the *Polis*

The extraordinary architectural achievement of the Acropolis is matched by the philosophical achievement of the great Athenian philosopher Socrates, born in 469 BCE, a decade after the Greek defeat of the Persians. His death in 399 BCE arguably marks the end of Athens's Golden Age. Socrates' death was not a natural one. His execution was ordered by a polis in turmoil after its defeat by the Spartans in 404 BCE. The city had submitted to the rule of the oligarchic government installed by the victorious Spartans, the so-called Thirty Tyrants, whose power was ensured by a gang of "whip-bearers." They deprived the courts of their power and initiated a set of trials against rich men, especially metics, and democrats who opposed their tyranny. Over 1,500 Athenians were subsequently executed. Socrates was brought to trial, accused of subversive behavior, corrupting young men, and introducing new gods, though these charges may have been politically motivated. He antagonized his jury of citizens by insisting that his life had been as good as anyone's and that far from committing any wrongs, he had greatly benefited Athens. He was convicted by a narrow majority and condemned to death by drinking poisonous hemlock. His refusal to flee and his willingness to submit to the will of the polis and drink the potion testify to his belief in the very polis that condemned him. His eloquent defense of his decision to submit is recorded in the *Crito* [KRIH-toh] (see **Reading 7.5** on pages 220–221), a dialogue between Socrates and his friend Crito, actually written by Plato, Socrates' student and fellow philosopher. Although the Athenians would continue to enjoy relative freedom for many years to come, the death of Socrates marks the end of their great experiment with democracy. Socrates would become the model of good citizenship and right thinking for centuries to come.

The Philosophical Context

To understand Socrates' position, it is important to recognize that the crisis confronting Athens in 404 BCE was not merely political, but deeply philosophical. And furthermore, a deep division existed between the philosophers and the polis. Plato, Socrates' student, through whose writings we know Socrates' teachings, believed good government was unattainable "unless either philosophers become kings in our cities or those whom we now call kings and rulers take to the pursuit of philosophy." He well understood that neither was likely to happen, and good government was, therefore, something of a dream. To further complicate matters, there were two distinct traditions of Greek *philosophia*—literally, "love of wisdom"—pre-Socratic and Sophist.

The Pre-Socratic Tradition The oldest philosophical tradition, that of the **pre-Socratics**, referring to Greek philosophers who preceded Socrates, was chiefly concerned with describing the natural universe—the tradition inaugurated by Thales of Miletus. "What," the pre-Socratics asked, "lies behind the world of appearance? What is everything made of? How does it work? Is there an essential truth or core at the heart of the physical universe?" In some sense, then, they were scientists who investigated the nature of things, and they arrived at some extraordinary insights. Pythagoras, whom we have discussed in terms of his contributions to music and geometry (see chapter 6), was one such pre-Socratic thinker. Leucippus (fifth century BCE) was another.

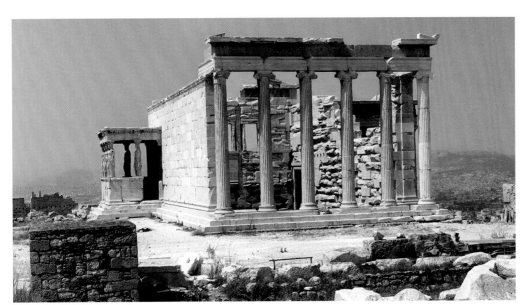

Fig. 7.13 **Erechtheion, Acropolis, Athens. 430s–405 BCE.** The Erechtheion, with its irregular and asymmetrical design, slender Ionic columns, and delicate Porch of the Maidens, contrasts dramatically and purposefully with the more orthodox and highly regular Parthenon across the Acropolis to the south.

reflected off Athena's helmet. And just to the left of the statue they would have seen the Erechtheion (Fig. **7.13**). Like the Propylaia, it was designed by Mnesicles, but its asymmetrical and multi-leveled structure is unique, resulting from the rocky site on which it is situated. Flatter areas were available on the Acropolis, so its demanding position is clearly intentional. The building surrounds a sacred spring dedicated to Erechtheus, the first legendary king of Athens, after whom the building is named. Work on the building began after the completion of the Parthenon, in the 430s BCE, and took 25 years. Among its unique characteristics is the famous Porch of the Maidens, facing the Parthenon. It is supported by six **caryatids**, female figures serving as columns (visible on the far left in Fig. 7.13). These figures literalize the sense of animation created by the entasis of the Parthenon's columns. All assume a classic *contrapposto* pose, the three on the left with their weight over the right leg, the three on the right with their weight over the left. Although all six figures are unique—the folds on their chitons fall differently, and their breasts are different sizes and shapes—together they create a sense of balance and harmony.

The Relation of the Erechtheion to the Parthenon The importance of Erechtheus to the entire plan of the Acropolis, including the Parthenon, has recently been enforced by a new reading of a frieze panel that originally stood immediately over the main entrance to the Parthenon (Fig. **7.14**). According to surviving lines from an otherwise lost play by Euripides, the *Erechtheus*, Athena's victory over Poseidon in their combat for the patronage of Athens (depicted on the west pediment of the Parthenon and traditionally believed to have occurred at the site of the Erechtheion) so angered Poseidon's son Eumolpos [yoo-MOL-pos] that he threatened to destroy the city. The oracle at Delphi told King Erechtheus that in order to protect the city from Eumolpos's wrath, one of his three daughters must be sacrificed. Unknown to him, the three swore an oath that, if one died, the others would die as well. Praxithea, Erechtheus's wife, knew of the oath, and when she was told the news, she accepted her daughters' sacrifice, choosing the

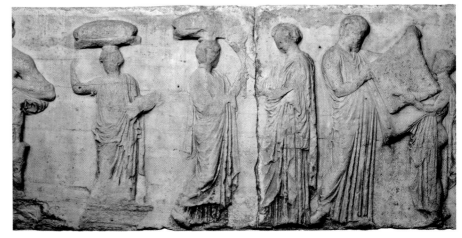

Fig. 7.14 *Erechtheus, Praxithea, and Their Daughters,* **from the Parthenon frieze. ca. 440 BCE.**
© The British Museum. These figures are among the least dynamic of the entire frieze, partially because they are much eroded by the elements. Their position above the main entrance to the Parthenon always seemed at least a little odd, until they were identified with the central figures of Euripides' play the *Erechtheus.*

good of the state over the well-being of her family. In the Parthenon frieze, she can be seen watching two of her daughters as they arrive with their funerary robes balanced on their heads, ready for their sacrifice. Behind her, Erechtheus, dressed as a priest, hands the funerary robes to the third daughter. After their sacrifice, Erechtheus is killed by Poseidon, who strikes the Acropolis rock with his trident, opening a chasm into which he pulls Erechtheus. The room on the west side of the Erechtheion known as "the Salt Sea of Erechtheus" apparently marks this spot. In a fragment of the *Erechtheus* discovered in 1962 in Egypt (**Reading 7.4**), Athena addresses the mourning Praxithea [prax-ITH-ee-uh]:

READING 7.4　　Euripides, *Erechtheus*

And first I shall tell you about the girl whom your husband sacrificed for this land: bury her where she breathed out her pitiful life, and these sisters in the same tomb of the land, on account of their nobility. . . . To my fellow townsmen I say not to forget them in time but with annual sacrifices and bull-slaying slaughters to honor them, celebrating them with holy maiden-dances.

This fragment of text has important implications for our understanding of the Parthenon. The Greek word *parthenoi* [PAR-thuh-noy] means "place of the maidens or girls," and the Parthenon may well rest over the tombs of the three daughters of Erechtheus. We have never understood how or why Athena came to be called Athena Parthenos—it is a fourth century BCE phenomenon—but perhaps it is through her identification with the virgin daughters of Erechtheus, who, like Athena during the Persian Wars, came to the rescue of their city. And perhaps the Parthenon frieze does not represent the Panathenaic procession, as we have long thought, but the celebration of the virgins' sacrifice that Athena directs the people of Athens to undertake annually in the Erechtheus.

Philosophy and the *Polis*

The extraordinary architectural achievement of the Acropolis is matched by the philosophical achievement of the great Athenian philosopher Socrates, born in 469 BCE, a decade after the Greek defeat of the Persians. His death in 399 BCE arguably marks the end of Athens's Golden Age. Socrates' death was not a natural one. His execution was ordered by a polis in turmoil after its defeat by the Spartans in 404 BCE. The city had submitted to the rule of the oligarchic government installed by the victorious Spartans, the so-called Thirty Tyrants, whose power was ensured by a gang of "whip-bearers." They deprived the courts of their power and initiated a set of trials against rich men, especially metics, and democrats who opposed their tyranny. Over 1,500 Athenians were subsequently executed. Socrates was brought to trial, accused of subversive behavior, corrupting young men, and introducing new gods, though these charges may have been politically motivated. He antagonized his jury of citizens by insisting that his life had been as good as anyone's and that far from committing any wrongs, he had greatly benefited Athens. He was convicted by a narrow majority and condemned to death by drinking poisonous hemlock. His refusal to flee and his willingness to submit to the will of the polis and drink the potion testify to his belief in the very polis that condemned him. His eloquent defense of his decision to submit is recorded in the *Crito* [KRIH-toh] (see **Reading 7.5** on pages 220–221), a dialogue between Socrates and his friend Crito, actually written by Plato, Socrates' student and fellow philosopher. Although the Athenians would continue to enjoy relative freedom for many years to come, the death of Socrates marks the end of their great experiment with democracy. Socrates would become the model of good citizenship and right thinking for centuries to come.

The Philosophical Context

To understand Socrates' position, it is important to recognize that the crisis confronting Athens in 404 BCE was not merely political, but deeply philosophical. And furthermore, a deep division existed between the philosophers and the polis. Plato, Socrates' student, through whose writings we know Socrates' teachings, believed good government was unattainable "unless either philosophers become kings in our cities or those whom we now call kings and rulers take to the pursuit of philosophy." He well understood that neither was likely to happen, and good government was, therefore, something of a dream. To further complicate matters, there were two distinct traditions of Greek *philosophia*—literally, "love of wisdom"—pre-Socratic and Sophist.

The Pre-Socratic Tradition The oldest philosophical tradition, that of the **pre-Socratics**, referring to Greek philosophers who preceded Socrates, was chiefly concerned with describing the natural universe—the tradition inaugurated by Thales of Miletus. "What," the pre-Socratics asked, "lies behind the world of appearance? What is everything made of? How does it work? Is there an essential truth or core at the heart of the physical universe?" In some sense, then, they were scientists who investigated the nature of things, and they arrived at some extraordinary insights. Pythagoras, whom we have discussed in terms of his contributions to music and geometry (see chapter 6), was one such pre-Socratic thinker. Leucippus (fifth century BCE) was another.

He conceived of an atomic theory in which everything is made up of small, indivisible particles and the empty space, or void, between them (the Greek word for "indivisible" is *atom*). Democritus of Thrace (ca. 460–ca. 370? BCE) furthered the theory by applying it to the mind. Democritus taught that everything from feelings and ideas to the physical sensations of taste, sight, and smell could be explained by the movements of atoms in the brain. Heraclitus of Ephesus (ca. 540–ca. 480 BCE) argued for the impermanence of all things. Change, or flux, he said, is the basis of reality, although an underlying Form or Guiding Force (*logos*) guides the process, a concept that later informs the Gospel of John in the Christian Bible, where *logos* is often mistranslated as "word."

The Sophist Tradition Socrates was heir to the second tradition of Greek philosophy, that of the **Sophists**, literally "wise men." The Sophists no longer asked, "What do we know?" but, instead, "How do we know what we think we know?" and, crucially, "How can we trust what we think we know?" In other words, the Sophists concentrated not on the natural world but on the human mind, fully acknowledging the mind's many weaknesses. The Sophists were committed to what we have come to call **humanism**—that is, a focus on the actions of human beings, political action being one of the most important.

Protagoras (ca. 485–410 BCE), a leading Sophist, was responsible for one of the most famous of all Greek dictums: "Man is the measure of all things." By this he meant that each individual human, not the gods, not some divine or all-encompassing force, defines reality. All sensory appearances and all beliefs are true for the person whose appearance or belief they are. The Sophists believed that there were two sides to every argument. Protagoras's attitude about the gods is typical: "I do not know that they exist or that they do not exist."

The Sophists were teachers who traveled about, imparting their wisdom for pay. Pericles championed them, encouraging the best to come to Athens, where they enjoyed considerable prestige despite their status as metics. Their ultimate aim was to teach political virtue—*areté* [ah-RAY-tay]—emphasizing skills useful in political life, especially rhetorical persuasion, the art of speaking eloquently and persuasively. Their emphasis on rhetoric—their apparent willingness to assume either side of any argument merely for the sake of debate—as well as their critical examination of myths, traditions, and conventions, gave them a reputation for cynicism. Thus, their brand of argumentation came to be known as *sophistry*—subtle, tricky, superficially plausible, but ultimately false and deceitful reasoning.

Socrates and the Sophists Socrates despised everything the Sophists stood for, except their penchant for rhetorical debate, which was his chief occupation. He roamed the streets of Athens, engaging his fellow citizens in dialogue, wittily and often bitingly attacking them for the illogic of their positions. He employed the **dialectic method**—a process of inquiry and instruction characterized by continuous question and answer dialogue designed to elicit a clear statement of the knowledge supposed to be held implicitly by all reasonable beings. Unlike the Sophists, he refused to

demand payment for his teaching, but like them, he urged his fellow men not to mistake their personal opinions for truth. Our beliefs, he knew, are built mostly on a foundation of prejudice and historical conditioning. He differed from the Sophists most crucially in his emphasis on virtuous behavior. For the Sophists, the true, the good, and the just were relative things. Depending on the situation or one's point of view, anything might be true, good, or just—the point, as will become evident in the next section, of many a Greek tragedy.

For Socrates, understanding the true meaning of the good, the true, and the just was prerequisite for acting virtuously, and the meaning of these things was not relative. Rather, true meaning resided in the **psyche**, the seat of both intelligence and character. Through **inductive reasoning**—moving from specific instances to general principles, and from particular to universal truths—it was possible, he believed, to understand the ideals to which human endeavor should aspire. Neither Socrates nor the Sophists could have existed without the democracy of the polis and the freedom of speech that accompanied it. Even during the reign of Pericles, Athenian conservatives had charged the Sophists with the crime of impiety. In questioning everything, from the authority of the gods to the rule of law, they challenged the stability of the very democracy that protected them. It is thus easy to understand how, when democracy ended, Athens condemned Socrates. He was democracy's greatest defender, and if he believed that the polis had forsaken its greatest invention, he himself could never betray it. Thus he chose to die.

Plato's *Republic* and Idealism

So far as we know, Socrates himself never wrote a single word. We know his thinking only through the writings of his greatest student, Plato (ca. 428–347 BCE). Thus, it may be true that the Socrates we know is the one Plato wanted us to have, and that when we read Socrates' words, we are encountering Plato's thought more than Socrates'.

As Plato presents Socrates to us, the two philosophers, master and pupil, have much in common. They share the premise that the psyche is immortal and immutable. They also share the notion that we are all capable of remembering the psyche's pure state. But Plato advances Socrates' thought in several important ways. Plato's philosophy is a brand of **idealism**—it seeks the eternal perfection of pure ideas, untainted by material reality. He believes that there is an invisible world of eternal Forms, or Ideas, beyond everyday experience, and that the psyche, trapped in the material world and the physical body, can only catch glimpses of this higher order. Through a series of mental exercises, beginning with the study of mathematics and then moving on to the contemplation of the Forms of Justice, Beauty, and Love, the student can arrive at a level of understanding that amounts to superior knowledge.

Socrates' death deeply troubled Plato—not because he disagreed with Socrates' decision, but because of the injustice of his condemnation. The result of Plato's thinking is *The Republic*. In

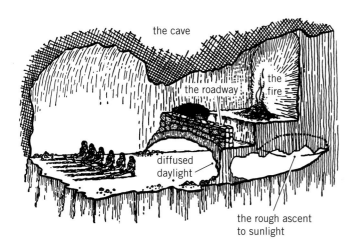

the cave

the roadway

the fire

diffused daylight

the rough ascent to sunlight

Fig. 7.15 "Allegory of the Cave," from *The Great Dialogues of Plato*, **trans. W.H.D. Rouse.** Translation © 1956, renewed 1984 by J.C.G. Rouse. Used by permission of Dutton Signet, a division of Penguin Books USA Inc.

this treatise, Plato outlines his model of the ideal state. Only an elite cadre of the most highly educated men were to rule—those who had glimpsed Plato's ultimate Form, or Idea—the Good. In *The Republic*, in a section known as the "Allegory of the Cave" (Fig. **7.15**), Socrates addresses Plato's older brother, Glaucon [GLAW-kon], in an attempt to describe the difficulties the psyche encounters in its attempt to understand the higher Forms (see **Reading 7.6** on pages 221–223). The Form of Goodness, Socrates says, is "the universal author of all things beautiful and right, parent of light and of the lord of light in this visible world, and the immediate source of reason and truth in the intellectual; and . . . this is the power upon which he who would act rationally, either in public or private life must have his eye fixed." The Form of Goodness, then, is something akin to God (though not God, from whom imperfect objects such as human beings descended, but more like an aspect of the Ideal, of which, one supposes, God must have some superior knowledge). The difficulty is that, once having attained an understanding of the Good, the wise individual will appear foolish to the people, who understand not at all. And yet, as Plato argues, it is precisely these individuals, blessed with wisdom, who must rule the commonwealth.

In many ways, Plato's ideal state is reactionary—it certainly opposes the individualistic and self-aggrandizing world of the Sophists. Plato is indifferent to the fact that his wise souls will find themselves ruling what amounts to a totalitarian regime. He believes their own sense of Goodness will prevail over their potentially despotic position. Moreover, rule by an intellectual philosopher king is superior to rule by any person whose chief desire is to satisfy his own material appetites.

To live in Plato's *Republic* would have been dreary indeed. Sex was to be permitted only for purposes of procreation. Everyone would undergo physical and mental training reminiscent of Sparta in the sixth century BCE. Although he believed in the intellectual pursuit of the Form or Idea of Beauty, Plato did not champion the arts. He condemned cer-

tain kinds of lively music because they affected not the reasonable mind of their audience but the emotional and sensory tendencies of the body. (But even for Plato, a man who did not know how to dance was uneducated—Plato simply preferred more restrained forms of music.) He also condemned sculptors and painters, whose works, he believed, were mere representations of representations—for if an actual bed is one remove from the Idea of Bed, a painting of a bed is twice removed, the faintest shadow. Furthermore, the images created by painters and sculptors appealed only to the senses. Thus he banished them from his ideal republic. Because they gave voice to tensions within the state, poets were banned as well.

Plato's *Symposium*

If Plato banned sex in his *Republic*, he did not ban it in his life. Indeed, one of the most remarkable of his dialogues is *The Symposium*. A symposium is literally a drinking party, exclusively for men, except for a few slaves and a nude female flute player or two. Dinner was served first, followed by ritualized drinking. Wine was poured to honor the "good spirit," hymns were sung, a member of the group was elected to decide the strength of the wine, which was mixed with water (usually five parts water to two of wine), and then host and guests, seated usually two to a couch around a square room, took turns in song or speech, one after another around the room.

Plato's *Symposium* recounts just such an evening. At the outset, the female flute player provided by the host is sent away, indicating the special nature of the event, which turns out to be a series of speeches on the nature of love, homoerotic love in particular. It should be remembered that the idea that homosexual behavior is atypical is a modern one. To the Greeks, it was considered normal for males to direct their sexual appetites toward both males and females, generally without particular preference for one or the other. Since the symposium was an all-male environment (Fig. **7.16**), it is hardly surprising that homoerotic behavior was commonplace, or at least commonly discussed.

In *The Symposium*, each member of the party makes a speech about the nature of Love—or more precisely Eros, the god of love *and* desire—culminating with Socrates, whose presentation is by far the most sophisticated. Phaedrus makes clear, and all agree, that the loved one becomes virtuous by being loved. Pausanius [paw-ZAY-nee-us] contributes an important distinction between Common Love, which is simply physical, and Heavenly Love, which is also physical but is generated only in those who are capable of rational and ethical development. Thus, he suggests, an older man contributes to the ethical education of a youth through his love for him. No one disagrees, though the question remains whether *physical* love is necessary to the relationship.

Since Plato was himself a bachelor who led an essentially monastic existence, it is hardly surprising that by the time Socrates contributes to this discussion, Eros comes to be defined as more than just interpersonal love; it is also desire, desire for something it *lacks*. What Eros lacks and needs is

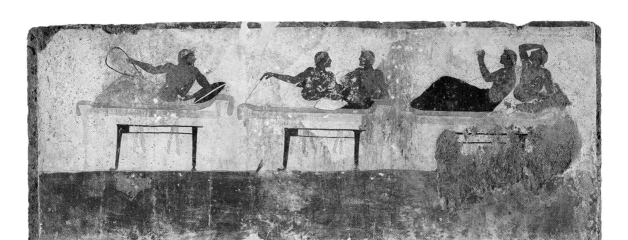

Fig. 7.16 *Banqueting Scene*, panel from the Tomb of the Diver, Paestum, Italy. Early 5th century BCE. Fresco, Museo Archeològico Nazionale, Paestum. Scala, Florence. Part of a painted tomb, this is a rare surviving example of Greek painting.

beauty. The purpose of love, then, according to Socrates, and by extension Plato, is to give birth to beauty "in both body and mind," and, finally, to attain insight into the ultimate Form of Beauty. These are lessons, Socrates claims, that he learned from a woman named Diotama [dye-oh-TAY-ma], who "was wise about this and many other things," a character many believe to be modeled on Aspasia, Pericles's mistress and partner. In our excerpt, Socrates quotes Diotama at length (see **Reading 7.7** on pages 223–224).

The high philosophical tone of Socrates' speech comes to an abrupt end when the drunken politician Alcibiades crashes the party, regaling all with a speech in praise of Socrates, including an account of his own physical attraction to the older philosopher, his desire for an erotic-educational relationship with him, and the surprising denouement, a description of a time when he succeeded in getting into bed with him (**Reading 7.7a**).

READING 7.7a **Plato,** *The Symposium*

I threw my arms round this really god-like and amazing man, and lay there with him all night long. And you can't say this is a lie, Socrates. After I'd done all this he completely triumphed over my good looks—and despised, scorned and insulted them—although I placed a very high value on these looks, gentlemen of the jury. . . . I swear to you by the gods, and by the goddesses, that when I got up the next morning I had no more slept with Socrates than if I'd been sleeping with my father or elder brother.

Socrates, Plato finally shows us, knows a higher form of Love than the physical and is an example to all present at the symposium.

The Theater of the People

The Dionysian aspects of the symposium—the drinking, the philosophical dialogue, and sexual license—tell us something about the origins of Greek drama. The drama was originally a participatory ritual, tied to the cult of Dionysus. A chorus of people participating in the ritual would address and respond to another chorus or to a leader, such as a priest, perhaps representing (thus "acting the part" of) Dionysus. These dialogues usually occurred in the context of riotous dance and song—befitting revels dedicated to the god of wine. By the sixth century BCE, groups of men regularly celebrated Dionysus, coming together for the enjoyment of dance, music, and wine. Sexual license was the rule of the day. On a mid-sixth-century amphora used as a wine container (Fig. **7.17**) we see five **satyrs**, minor deities with characteristics of goats or horses, making wine, including one playing pipes. Depicted in the band across the top is Dionysus himself, sitting in the midst of a rollicking band of satyrs and **maenads**—the frenzied women with whom he cavorted.

This kind of behavior gave rise to one of the three major forms of Greek drama, the **satyr play**. Always the last event of the day-long performances, the satyr-play was **farce**, that is, broadly satirical comedy, in which actors disguised themselves as satyrs, replete with extravagant genitalia, and generally honored the "lord of misrule," Dionysus, by misbehaving themselves. One whole satyr play survives, the *Cyclops* of Euripides, and half of another, Sophocles' *Trackers*. The spirit of these plays can perhaps be summed up best by Odysseus's first words in the *Cyclops* as he comes ashore on the island of Polyphemus (recall Reading 5.2, page 152, and Fig. 5.15): "What? Do I see right? We must have come to the city of Bacchus. These are satyrs I see around the cave." The play, in

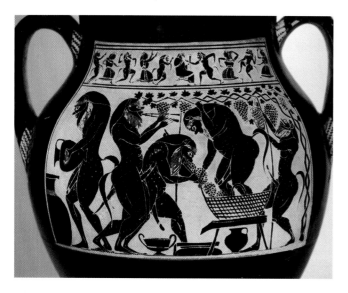

Fig. 7.17 Amasis Painter (?) *Satyrs Making Wine,* **detail of Athenian black-figure amphora. ca. 540–530 BCE.** Martin von Wagner Museum, University of Würzburg, Germany. The entire ritual of wine production is depicted here, from harvesting the grapes, to stomping them to render their juice, to pouring the juice into large vats for fermentation. All lead to the state of ecstacy (*ekstasis*) painted across the top band.

other words, spoofs or lampoons traditional Greek legend by setting it in a world turned topsy-turvy, a world in which Polyphemus is stronger than Zeus because his farts are louder than Zeus's thunder.

Comedy

Closely related to the satyr-plays was **comedy**, an amusing or lighthearted play designed to make its audience laugh. The word itself is derived from the *komos,* [KO-mus] a phallic dance, and nothing is sacred to comedy.
It freely slandered, buffooned, and ridiculed politicians, generals, public figures, and especially the gods. Foreigners, as always in Greek culture, are subject to particular abuse, as are women; in fact, by our standards, the plays are racist and sexist. Most of what we know about Greek comedies comes from two sources: vase painting and the plays of the playwright Aristophanes.

Comedic action was a favorite subject of vase painters working at Paestum in Italy in the fourth century BCE. They depict actors wearing masks and grotesque costumes distinguished by padded bellies, buttocks, and enlarged genitalia. These vases show a theater of burlesque and slapstick that relied heavily on visual gags (Fig. **7.18**).

Fig. 7.18 Red-figure krater depicting a comedy by Assteas, from Paestum, Italy. ca. 350 BCE. Staatliche Museen, Berlin. On a stage supported by columns, with a scenic backdrop to the left, robbers try to separate a man from his strongbox.

The works of Aristophanes (ca. 445–388 BCE) are the only comedies to have survived, and only 11 of his 44 plays have come down to us. *Lysistrata* is the most famous. Sexually explicit to a degree that can still shock a modern audience, it takes place during the Peloponnesian Wars and tells the story of an Athenian matron who convinces the women of Athens and Sparta to withhold sex from their husbands until they sign a peace treaty. First performed in 411 BCE, seven years before Sparta's victory over Athens, it has its serious side, begging both Athenians and Spartans to remember their common traditions and put down their arms. Against this dark background, the play's action must have seemed absurd and hilarious to its Athenian audience, ignorant of what the future would hold for them.

Tragedy

It was at **tragedy** that the Greek playwrights truly excelled. As with comedy, the basis for tragedy is conflict, but the tensions at work in tragedy—murder and revenge, crime and retribution, pride and humility, courage and cowardice—have far more serious consequences. Tragedies often explore the physical and moral depths to which human life can descend. The form also has it origins in the Dionysian rites—the name itself derives from *tragoidos* [trah-GOY-dus], the "goat song" of the half-goat, half-man satyrs, and tragedy's seriousness of purpose is not at odds with its origins. Dionysus was also the god of immortality, and an important aspect of his cult's influence is that he promised his followers life after death, just as the grapevine regenerates itself year after year. If tragedy can be said to have a subject, it is death—and the lessons the living can learn from the dead.

The original chorus structure of the Dionysian rites survives as an important element in tragedy. Thespis, a playwright from whom we derive the word *thespian,* "actor," first assumed the conscious role of an actor in the mid-sixth century BCE and apparently redefined the role of the **chorus**. At first, the actor asked questions of the chorus, perhaps of the "tell me what happened next" variety, but when two, three, and sometimes four actors were introduced to the stage, the chorus began to comment on their interaction. In this way the chorus assumed its classic function as an intermediary between actors and audience. Although the chorus's role diminished noticeably in the fourth century BCE, it remained the symbolic voice of the people, asserting the importance of the action to the community as a whole.

Greek tragedy often focused on the friction between the individual and his or her community, and, at a higher level,

between the community and the will of the gods. This conflict manifests itself in the weakness or "tragic flaw" of the play's **protagonist**, or leading character, which brings the character into conflict with the community, the gods, or some **antagonist** who represents an opposing will. The action occurs in a single day, the result of a single incident that precipitates the unfolding crisis. Thus the audience feels that it is experiencing the action in real time, that it is directly involved in and affected by the play's action.

During the reign of the tyrant Peisistratus (see chapter 6), the performance of all plays was regularized. An annual competitive festival for the performance of tragedies called the City Dionysia was celebrated for a week every March as the vines came back to life, and a separate festival for comedies occurred in January. At the City Dionysia, plays were performed in sets of four—**tetralogies**—all by the same author, three of which were tragedies, performed during the day, and the fourth a satyr play, performed in the evening. The audiences were as large as 14,000, and audience response determined which plays were awarded prizes. Slaves, metics, and women judged the performances alongside citizens.

Aeschylus Although many Greek playwrights composed tragedies, only those of Aeschylus, Sophocles, and Euripides have come down to us. Aeschylus (ca. 525–ca. 456 BCE), the oldest of the three, and author of *The Persians*, which we encountered in chapter 6, is reputed to have served in the Athenian armies during the Persian Wars and fought in the battles at Marathon and Salamis. He won the City Dionysia 13 times. It was Aeschylus who introduced a third actor to the tragic stage, and his chorus plays a substantial role in drawing attention to the underlying moral principles that define or determine the action. He also was a master of the visual presentation of his drama, taking full advantage of stage design and costume. Three of his plays, known as the *Oresteia* [oh-ray-STYE-ee-uh], form the only complete set of tragedies from a tetralogy that we have.

The plays narrate the story of the Mycenaean king Agamemnon, murdered by his adulterous wife Clytemnestra and mourned and revenged by their children, Orestes and Electra. In the first play, *Agamemnon*, Clytemnestra murders her husband, partly in revenge for his having sacrificed their daughter Iphigenia to ensure good weather for the invasion of Troy, and partly to marry her lover, Aegisthus. In the second play, *The Libation Bearers*, Orestes murders Aegisthus and Clytemnestra, his mother, to avenge his father's death. Orestes is subsequently pursued by the Furies, a band of *chthonian gods* (literally "gods of the earth," a branch of the Greek pantheon that is distinguished from the Olympian, or "heavenly" gods), whose function is to seek retribution for wrongs and blood-guilt among family members. The Furies form the Chorus of the last play in the cycle, the *Eumenides*, in which the seemingly endless cycle of murder comes to an end. In this play, Athens institutes a court to hear Orestes' case. The court absolves him of the crime of matricide, with Athena herself casting the deciding vote.

None of the violence in the plays occurs on stage—either the chorus or a messenger describes it. And in fact, the ethical dimension of Aeschylus's trilogy is underscored by the triumph of civilization and law, mirrored by the transformation of the Furies—the blind forces of revenge—into the Eumenides, or "Kindly Ones," whose dark powers have been neutralized.

Sophocles Playwright, treasurer for the Athenian polis, a general under Pericles, and advisor to Athens on financial matters during the Peloponnesian Wars, Sophocles (ca. 496–406 BCE) was an almost legendary figure in fifth century BCE Athens. He wrote over 125 plays, of which only seven survive, and he won the City Dionysia 18 times. In *Oedipus the King*, Sophocles dramatizes how the king of Thebes, a polis in east central Greece, mistakenly kills his father and marries his mother, then finally blinds himself to atone for his crimes of patricide and incest. In *Antigone*, he dramatizes the struggle of Oedipus's daughter Antigone with her uncle Creon, the tyrannical king who inherited Oedipus's throne. Antigone struggles for what amounts to her democratic rights as an individual to fulfill her familial duties, even when this opposes what Creon argues is the interest of the polis. Her predicament is doubly complicated by her status as a woman.

As the play opens, Antigone's brothers, Polynices and Eteocles, have killed each other in a dispute over their father's throne. Creon, Oedipus's brother-in-law, who has inherited the throne, has forbidden the burial of Polynices, believing Eteocles to have been the rightful heir. Antigone, in the opening scene, defends her right to bury her brother, and this willful act, which she then performs in defiance of Creon's authority, leads to the tragedy that follows. She considers the burial her duty, since no unburied body can enjoy an afterlife. The play begins as Antigone explains her action to her sister, Ismene (see **Reading 7.8**, page 224), who thoroughly disapproves of what she has done.

The conflict between Antigone and Creon is exacerbated by their gender difference. The Greek male would expect a female to submit to his will. But it is, in the end, Antigone's "rush to extremes" that forces the play's action—that, and Creon's refusal to give in. Creon's "fatal flaw"—his pride (hubris)—leads to the destruction of all whom he loves, and Antigone herself is blindly dedicated to her duty to honor her family. Her actions in the play have been the subject of endless debate. Some readers feel that she is far too hard on Ismene, and certainly a Greek audience would have found her defiance of male authority shocking. Nevertheless, her strength of conviction seems to many—especially modern audiences—wholly admirable.

But beyond the complexities of Antigone's personality, one of Sophocles' greatest achievements, the play really pits two forms of idealism against one another: Antigone's uncompromising belief in herself plays off Creon's equally uncompromising infatuation with his own power and his dedication to his political duty, which he puts above devotion even to family.

The philosophical basis of the play is clearly evident in the essentially Sophist debate between Creon and his son Haemon [HEE-mun], as Haemon attempts to point out the wrong in his father's action. Finally, the play demonstrates the extreme difficulty of reconciling the private and public spheres—one of Greek philosophy's most troubling and troubled themes—even as it cries out for the rational action and sound judgment that might have spared its characters their tragedy.

Euripides The youngest of the three playwrights, Euripides (ca. 480–406 BCE), writing during the Peloponnesian Wars, brought a level of measured skepticism to the stage. Eighteen of his ninety works survive, but Euripides won the City Dionysia only four times. His plays probably angered more conservative Athenians, which may be why he moved from Athens to Macedonia in 408 BCE. In *The Trojan Women*, for instance, performed in 415 BCE, he describes, disapprovingly, the Greek enslavement of the women of Troy, drawing an unmistakable analogy to the contemporary Athenian victory at Melos, where women were subjected to Athenian abuse.

His darkest play, and his masterpiece, is *The Bacchae*, which describes the introduction to Thebes of the worship of Dionysus by the god himself, disguised as a mortal. Pentheus, the young king of the city, opposes the Dionysian rites both because all the city's women have given themselves up to Dionysian ecstasy and because the new religion disturbs the larger social order. Performed at a festival honoring Dionysus, the play warns of the dangers of Dionysian excess as the fren-

zied celebrants, including Pentheus's own mother, mistake their king for a wild animal and murder him. Euripides' play underscores the fact that the rational mind is unable to comprehend, let alone control, all human impulses. Greek theater itself, particularly the tragedies of Aeschylus, Sophocles, and Euripides, would become the object of study in the fourth century BCE, when the philosopher Aristotle, Plato's student, attempted to account for tragedy's power in his *Poetics*. And despite the fact that the tragedies were largely forgotten in the Western world until the sixteenth century, they have had a lasting impact upon Western literature, deeply influencing

the works of William Shakespeare (see chapter 24), the seventeenth-century French dramatists Pierre Corneille and Jean Racine (see chapter 27), and even modern novelists such as the American William Faulkner (see chapter 42).

The Performance Space

During the tyranny of Peisistratos (see chapter 6), plays were performed in an open area of the Agora called the **orchestra**, or "dancing space." Spectators sat on wooden planks laid on portable scaffolding. Sometime in the fifth century BCE, the scaffolding collapsed, and many people were injured. The Athenians built a new theater (*theatron*, meaning "viewing space"), dedicated to Dionysus, into the hillside on the side of the Acropolis away from the Agora

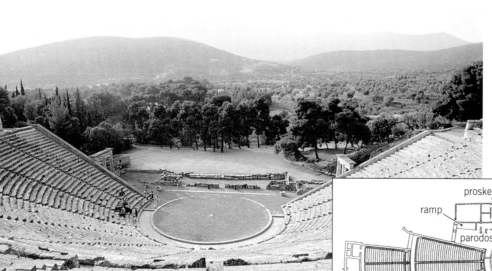

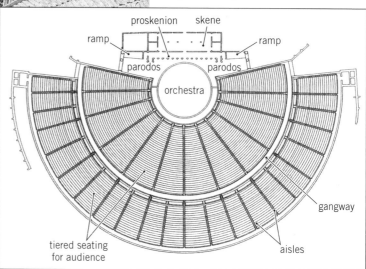

Fig. 7.19 Theater, Epidaurus. Early 3rd century BCE. This theater is renowned for its democratic design—not only is every viewer equally well situated, but the acoustics of the space are unparalleled. A person sitting in the very top row can hear a pin drop on the *orchestra* floor.

Fig. 7.20 Plan of the theater at Epidaurus. Early 3rd century BCE.

and below the Parthenon. Architecturally, it was very similar to the best preserved of all Greek theaters, the one at Epidaurus (Figs. **7.19**, **7.20**), built in the early third century BCE. The *orchestra* has been transformed into a circular performance space, approached on each side by an entryway called a **parados,** through which the chorus would enter the *orchestra* area. Behind this was an elevated platform, the **proscenium**, the stage on which the actors performed and where painted backdrops could be hung. Behind the proscenium was the **skene**, literally a "tent," and originally a changing room for the actors. Over time, it was transformed into a building, often two stories tall. Actors on the roof could portray the gods, looking down on the action below. By the time of Euripides, it housed a rolling or rotating platform that could suddenly reveal an interior space.

Artists were regularly employed to paint stage sets, and evidence suggests that they had at least a basic knowledge of perspective (although the geometry necessary for a fully realized perspectival space would not be developed until around 300 BCE, in Euclid's *Optics*). Their aim was, as in sculpture, to approximate reality as closely as possible. We know from literary sources that the painter Zeuxis "invented" ways to shade or model the figure in the fifth century BCE. Legend also had it that he once painted grapes so realistically that birds tried to eat them. The theatrical sets would have at least aimed at this degree of naturalism.

Music and Dance

Music and dance appear to have been central elements in the performance of plays. For the Greeks, music was divinely inspired by Euterpe, one of the nine **muses** (hence the word "music"), the nine sister goddesses who presided over song, poetry, and the arts and sciences (see *Context* on this page). The only complete work of music to have survived from ancient Greece is a *skolion* [SKO-lee-un], or drinking song, by Seikolos [SYE-kuh-lus], found chiseled on the first-century BCE gravestone of his wife Euterpe **(CD-Track 6.1)**. We do, however, know something of the theory upon which Greek music was based. In chapter 6, we discussed the Greek interest in geometry, and it was Pythagoras who, in seeking to understand the relationship of a string's length to the note it produced, created the Greek scale of eight notes, each one determined by its numerical ratio to the lowest tone. For Pythagoras, these ratios reflected the **cosmos**—meaning the harmonious and beautiful order of the universe. The movement of the planets, Pythagoras believed, produced a special harmony, called the *music of the spheres*.

Over time, musical **modes** evolved in which different pitches were believed to evoke different emotions. Each of the modes was thought to have a different emotional and ethical impact. The *Dorian mode*—favored by Plato for

Context The Greek Muses

The nine Greek muses were goddesses upon whom poets—and later other artists—depended to inspire their works. Their names probably originated with Hesiod in his *Theogony* (see chapter 5).

Calliope—epic poetry
Melpomene—tragedy
Clio—history
Thalia—comedy
Euterpe—flute-playing
Polyhymnia—hymns and pantomime
Terpsichore—lyric poetry and dancing
Urania—astronomy
Erato—lyric poetry

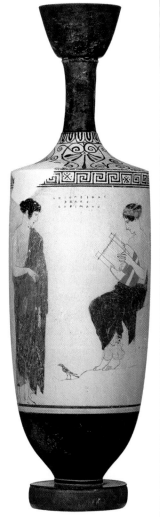

Achilles Painter. *Muse and Maiden*. ca. 445–430 BCE. White-ground and black-figure decoration on a *lekythos*. Terra cotta, with additional painting in tempera, height 16″. Staatliche Antikensammlungen, Munich. A *lekythos* is a narrow, cylindrical vase with a single handle used for oil. Written below the muse's seat is the word *Helikon*, referring to Mount Helikon, the home of the muses. This vase is a funerary offering, depicting a blissful afterlife.

its restraint—was formal and dignified, and promoted virtue in its audience. The *Lydian mode* was sentimental and weak. And the *Phrygian mode*—condemned by Plato as irrational and overly emotional—was the mode of the satyrs—wild and frenzied.

The Greeks had a system for writing musical notation, apparently borrowed from the Phoenicians, though only a few traces survive. It was designed for the two types of harp used by the Greeks, the *lyre* (with a U-shaped frame; see illustration in *Context, The Greek Muses*) and the *kithara* [kee-TAH-rah] (larger than the lyre and having a box-shaped resonator), and marked the position of the fingers on the string. It was later adapted for both the *aulos* [AWE-lus], the double flute or pipes, and for the voice. Much of Greek poetry was accompanied by music, including, in the theater, the choric interludes, during which the chorus also danced. Many poems, including the works of Sappho, as noted in chapter 6, were written to be sung, accompanied, as the word *lyric* suggests, by the lyre. That said, we have very little knowledge of what Greek music actually sounded like.

For the Greeks, music was a sensory reflection of the higher order that pervades all things. Its highest forms were believed to affect the moral character in a positive way, but, as Plato insisted, music of the wrong sort could be morally and socially destructive. Ultimately, all music had the power to mold people's souls in its own image. Ideally, Plato felt, it should reflect the Classicism that distinguished the art and architecture of fifth-century Athens. It should be balanced, harmonious, and dignified.

The Hellenistic World

Both the emotional drama of Greek theater and the sensory appeal of its music reveal a growing tendency in the culture to value emotional expression at least as much, and sometimes more, than the balanced harmonies of classical art. During the **Hellenistic** age in the fourth and third centuries BCE, the truths that the culture increasingly sought to understand were less idealistic and universal and more and more empirical and personal. This shift is especially evident in the new empirical philosophy of Aristotle (384–322 BCE), whose investigation into the workings of the real world supplanted, or at least challenged, Plato's idealism. In many ways, however, the ascendancy of this new aesthetic standard can be attributed to the daring, the audacity, and the sheer awe-inspiring power of a single figure, Alexander of Macedonia, known as Alexander the Great (356–323 BCE) (Fig. **7.21**). Alexander aroused the emotions and captured the imagination of not just a theatrical audience, but an entire people—perhaps even the entire Western world—and created a legacy that established Hellenic Greece as the model against which all cultures in the West had to measure themselves.

The Empire of Alexander the Great

Alexander was the son of Philip II (382–336 BCE) of Macedonia, a relatively undeveloped northern Greek state whose inhabitants spoke a Greek dialect unintelligible to Athenians. Macedonia was ruled loosely by a king whose power was checked by a council of nobles. Philip had been a hostage in the polis of Thebes early in his life, and while there he had learned to love Greek civilization, but he also recognized that, after the Peloponnesian Wars, the Greek *poleis* were in disarray. In 338 BCE, at the battle of Chaeronea, on the plains near Delphi, he defeated the combined forces of Athens and Thebes and unified all of Greece, with the exception of Sparta, in the League of Corinth.

In the process of mounting a military campaign to subdue the Persians, Philip was assassinated in 336 BCE, possibly ordered by Alexander himself. (Philip had just divorced the 19-year-old's mother and removed him from any role in the government.) Although the Thebans immediately revolted, Alexander quickly took control, burning Thebes to the ground and selling its entire population into slavery. He then turned his sights on the rest of the world.

Within two years Alexander had crossed the Hellespont into Asia and defeated Darius III of Persia at the battle of Issus (just north of modern Iskenderon, Turkey). The victory continued Philip's plan to repay the Persians for their role in the Peloponnesian Wars and to conquer Asia as well. By 332 BCE, Alexander had conquered Egypt, founding the great city of Alexandria (named, of course, after himself) in the Nile Delta (Map **7.3**). Then he marched back into Mesopotamia, where he again defeated Darius III and then marched into both Babylon and Susa without resistance. After making the proper sacrifices to the Akkadian god Marduk (see chapter 2)—and thus gaining the admiration of the locals—he advanced on Persepolis, the Persian capital, which he burned after seizing its royal treasures. Then he entered present-day Pakistan.

Alexander's object was India, which he believed was relatively small. He thought if he crossed it, he would find what he called Ocean, and an easy sea route home. Finally, in 326 BCE his army reached the Indian Punjab. Under Alexander's leadership it had marched over 11,000 miles without a defeat. It had destroyed ancient empires, founded many cities (in the 320s BCE, Alexandrias proliferated across the world), and created the largest empire the world had ever known.

When Alexander and his army reached the banks of the Indus River in 326 BCE, he encountered a culture that had long fascinated him. His teacher Aristotle had described it, wholly on hearsay, as had Herodotus before him, as the farthest land mass to the east, beyond which lay an Endless Ocean that encircled the world. Alexander stopped first at Taxila (20 miles north of modern Islamabad, Pakistan; see Map 4.2), where King Omphis [OHM-fis] greeted him with a gift of 200 silver talents, 3,000 oxen, 10,000 sheep, 30 elephants, and bolstered Alexander's army by giving him 700 Indian cavalry and 5,000 infantry.

While Alexander was in Taxila, he became acquainted with the Hindu philosopher Calanus [kuh-LAY-nus]. Alexander recognized in Calanus and his fellow Hindu philosophers a level of wisdom and learning that he valued highly, one clearly reminiscent of Greek philosophy, and his encounters with them represent the first steps in a long history of the cross-fertilization of Eastern and Western cultures.

But in India the army encountered elephants, whose formidable size proved problematic. East of Taxila, Alexander's troops managed to defeat King Porus [PAW-rus] (Fig. **7.22**), whose army was equipped with 200 elephants. Rumor had it that farther to the east, the kingdom of the Ganges, their next logical opponent, had a force of 5,000 elephants. Alexander pleaded with his troops: "Dionysus, divine from birth, faced terrible tasks—and we have outstripped him! . . . Onward, then: let us add to our empire the rest of Asia!" The army refused to budge. His conquests thus concluded, Alexander himself sailed down the Indus River, founding the city that would later become Karachi. As he returned home, he contracted fever in

Fig. 7.21 *Alexander the Great,* **head from a Pergamene copy (ca. 200 BCE) of a statue, possibly after a 4th-century BCE original by Lysippus.** Marble, height 16 1/8″. Archaeological Museum, Istanbul, Turkey. Alexander is traditionally portrayed as if looking beyond his present circumstances to greater things.

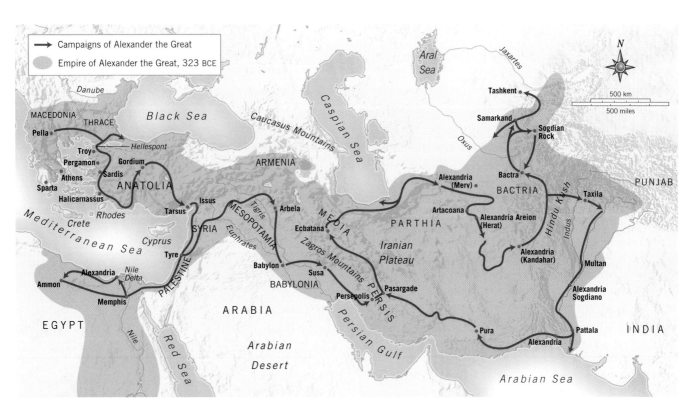

MAP 7.3 Alexander's empire as of his death in 323 BCE and the route of his conquests. Alexander founded over 70 cities throughout his empire, naming many after himself.

Fig. 7.22 Commemorative silver *decadrachm* [DAY-ka-drakm] celebrating Alexander's victory over King Porus, 326 BCE. On one side of the coin, Alexander is pictured as "King of Asia," wearing a helmet modeled on the Persian royal headdress. On the other, Alexander, wearing the same helmet, is pictured mounted on his famous horse, Bucephalus, chasing after the retreating Porus astride his elephant.

Babylon and died in 323 BCE. Alexander's life was brief, but his influence on the arts was long-lasting.

Toward Hellenistic Art: Sculpture in the Late Classical Period

During Alexander's time, sculpture flourished. Ever since the fall of Athens to Sparta in 404 BCE, Greek artists had continued to develop the Classical style of Phidias and Polyclitus, but they modified it in subtle yet innovative ways. Especially notable was a growing taste for images of men and women in quiet, sometimes dreamy and contemplative moods, which increasingly replaced the sense of nobility and detachment characteristic of fifth-century Classicism and found its way even into depictions of the gods. The most admired sculptors of the day were Lyssipus, Praxiteles, and Skopas. Very little of the latter's work has survived, though he was noted for high relief sculpture featuring highly energized and emotional scenes. The work of the first two is far better known.

The Heroic Sculpture of Lysippus Alexander hired the sculptor Lysippus (flourished fourth century BCE) to do all his portraits. Despite his cruel treatment of the Thebans early in his career, Alexander was widely admired by the Greeks. Even during his lifetime, but especially after his death, sculptures celebrating the youthful hero abounded, almost all of them modeled on Lyssipus's originals. Alexander is easily recognizable—his disheveled hair long and flowing, his gaze

intense and melting, his mouth slightly open, his head alertly turned on a slightly tilted neck (see Fig. 7.21).

Lysippus dramatized his hero. That is, he did not merely represent Alexander as naturalistically as possible, he also animated him, showing him in the midst of action. In all likelihood, he idealized him as well. The creation of Alexander's likeness was a conscious act of propaganda. Early in his conquests the young hero referred to himself as "Alexander the Great," and Lysippus's job was to embody that greatness. Lysippus challenged the Classical *kanon* of proportion created by Polyclitus—smaller heads and slenderer bodies lent his heroic sculptures a sense of greater height. In fact, he transformed the Classical tradition in sculpture and began to explore new possibilities that, eventually, would define Hellenistic art, with its sense of animation, drama, and psychological complexity. In a Roman copy of a lost original by Lysippus known as the *Apoxyomenos* [uh-pox-ee-oh-MAY-nus] (Fig. **7.23**), or *The Scraper*, an athlete removes oil and dirt from his body with an instrument called a strigil. Compared to the *Doryphorus (Spear Bearer)* of Polyclitus (see Fig. 7.4), the *Scraper* is much slenderer, his legs much longer, his torso shorter. *The Scraper* seems much taller, though, in fact, the sculptures are very nearly the same height. The arms of *The Scraper* break free of his frontal form and invite the viewer to look at the sculpture from the sides as well as the front. He seems detached from his circumstances, as if recalling his athletic performance. All in all, he seems both physically and mentally uncontained by the space in which he stands.

gest that her original pose was far less modest than that of the Roman copy, her right hand not shielding her genitals.) The statue made Knidos famous, and many people traveled there to see it. She was enshrined in a circular temple, easily viewed from every angle, the Roman scholar Pliny the Elder (23–79 CE) tells us, and she quickly became an object of religious attention—and openly sexual adoration. The reason for this is

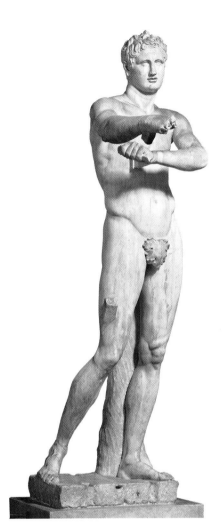

Fig. 7.23 Lysippus, *Apoxyomenos (The Scraper),* Roman copy of an original Greek bronze of ca. 350–325 BCE. Museo Pio Clementino, Vatican Museums, Vatican State. Marble, height 6′ 8″. According to the Roman Pliny the Younger, writing in his *Natural History* in the first century CE, the ratio of the head size to the body in Lysippus's sculpture is 1:9, as compared to Polyclitus's Classical proportions of 1:8.

The Sensuous Sculpture of Praxiteles Competing with Lysippus for the title of greatest sculptor of the fourth century BCE was the Athenian Praxiteles (flourished 370–330 BCE). Praxiteles was one of the 300 wealthiest men in Athens, thanks to his skill, but he also had a reputation as a womanizer. The people of the port city of Knidos [ku-NEE-dus], a Spartan colony in Asia Minor, asked him to provide them with an image of their patron goddess, Aphrodite, in her role as the protectress of sailors and merchants. Praxiteles responded with a sculpture of Aphrodite as the goddess of love, here reproduced in a later Roman copy (Fig. **7.24**). She stands at her bath, holding her cloak in her left hand, and she was displayed in the middle of a large garden in a colonnaded, circular shrine, the remains of which have been discovered. The sculpture is a frank celebration of the body—reflecting in the female form the humanistic appreciation for the dignity of the human body in its own right. (Images of it on local coins sug-

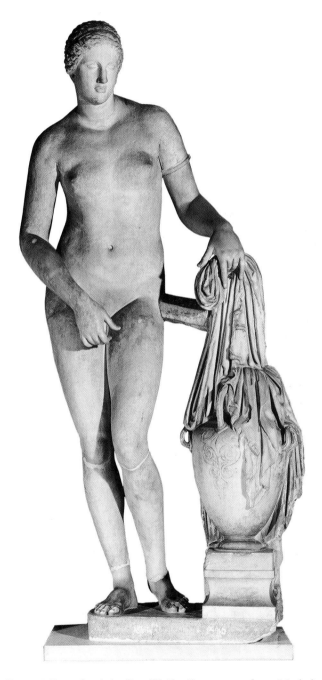

Fig. 7.24 Praxiteles, *Aphrodite of Knidos,* Roman copy of an original of ca. 350 BCE. P. Zigrossi/Vatican Museums, Rome, Italy. Marble, height 6′ 8″. The head of this figure is from one Roman copy, the body from another. The right forearm and hand, the left arm, and the lower legs of the *Aphrodite* are all seventeenth- and eighteenth-century restorations. There is reason to believe that her hand was not so modestly positioned in the original.

difficult to assess in the rather mechanical Roman copies of the lost original.

Praxiteles' *Aphrodite of Knidos* may be the first fully nude depiction of a woman in Greek sculpture, which may be why it caused such a sensation. Its fame elevated female nudity from a sign of low moral character to the embodiment of beauty, even truth itself. Paradoxically, it is also one of the earliest examples of artwork designed to appeal to what some art historians describe as the **male gaze** that regards woman as its sexual object. Praxiteles' canon for depicting the female nude—wide hips, small breasts, oval face, and centrally parted hair—remained the standard throughout antiquity.

Aristotle: Observing the Natural World

We can only guess what motivated Lysippus and Praxiteles to so dramatize and humanize their sculptures, but it is likely that the aesthetic philosophy of Aristotle (384–322 BCE) played a role. Aristotle was a student of Plato's. Recall that, for Plato, all reality is a mere reflection of a higher, spiritual truth, a higher dimension of Ideal Forms that we glimpse only through philosophical contemplation (see Fig. 7.15).

Aristotle disagreed. Reality was not a reflection of an ideal form, but existed in the material world itself, and by observing the material world, one could come to know universal truths. So Aristotle observed and described all aspects of the world in order to arrive at the essence of things. His methods of observation came to be known as *empirical investigation*. And though he did not create a formal **scientific method**, he and other early empiricists did create procedures for testing their theories about the nature of the world that, over time, would lead to the great scientific discoveries of Bacon, Galileo, and Newton. Aristotle studied biology, zoology, physics, astronomy, politics, logic, ethics, and the various genres of literary expression. Based on his observations of lunar eclipses, he concluded as early as 350 BCE that the Earth was spherical, an observation that may have motivated Alexander to cross India in order to sail back to Greece. He described over 500 animals in his *Historia Animalium*, including many that he dissected himself. In fact, Aristotle's observations of marine biology were unequaled until the seventeenth century and were still much admired by Charles Darwin in the nineteenth.

He also understood the importance of formulating a reasonable hypothesis to explain phenomena. His *Physics* is an attempt to define the first principles governing the behavior of matter—the nature of weight, motion, physical existence, and variety in nature. But Aristotle was often too hasty in extending his experiments to general principles or laws. For instance, he claimed to have proved by testing that seawater becomes fresh water when it evaporates, but then goes on to claim that the same is true of wine.

At the heart of Aristotle's philosophy is a question about the relation of *identity* and *change* (not far removed, incidentally, from one of the governing principles of this text, the idea of continuity and change in the humanities).

To discuss the world coherently, we must be able to say what it is about a thing that makes it the thing it is, that separates it from all the other things in the world. In other words, what is the attribute that we would call its material identity or *essence*? What it means to be human, for instance, does not depend on whether one's hair turns gray. Such "accidental" changes matter not at all. At the same time, our experience of the natural world suggests that any coherent account requires us to acknowledge process and change—the change of seasons, the changes in our understanding associated with gaining knowledge in the process of aging, and so on. For Aristotle, any account of a thing must accommodate both aspects: We must be able to say what changes a thing undergoes while still retaining its essential nature, and Aristotle thus approached all manner of things—from politics to the human condition—with an eye toward determining what constituted its essence.

Aristotle's *Poetics*　What constitutes the essential nature of literary art, and the theater in particular, especially fascinated him. Like all Greeks, Aristotle was well acquainted with the theater of Aeschylus, Euripides, and Sophocles, and in his *Poetics* he defined their literary art as "the imitation of an action that is complete and whole." Including a whole action, or a series of events that ends with a crisis, gives the play a sense of unity. Furthermore, he argued (against Plato, who regarded imitation as inevitably degrading and diminishing) that such imitation elevates the mind ever closer to the universal.

One of the most important ideas that Aristotle expressed in the *Poetics* is **catharsis,** the cleansing, purification, or purgation of the soul (see **Reading 7.9** on pages 225–226). As applied to drama, it is not the tragic hero who undergoes catharsis, but the audience. The audience's experience of catharsis is an experience of change, just as change always accompanies understanding. In the theater, what moves the audience to change is its experience of the universality of the human condition—what it is that makes us human, our weaknesses as well as our strengths. At the sight of the action onstage they are struck with "fear and pity." Plato believed that both of these emotions were pernicious. But Aristotle argued that the audience's emotional response to the plight of the characters on stage clarified for them the fragility and mutability of human life. What happens in tragedy is universal—the audience understands that the action could happen to anyone at any time. Often, in fact, the themes of the fifth-century tragedies reflected the discourse, debates, and decision-making of contemporary Athenian society, with speeches aimed at juries in the city's courts of law. Thus, tragedy presents the audience with the opportunity to recognize its own and its city's shortcomings and, through catharsis, to learn from them.

Aristotle's emphasis on arousing the emotions of the audience was among his greatest contributions to the art of the next three centuries. But in the *Poetics*, Aristotle is concerned with the structure of the play as well as the audience's

emotional response to it. And that structure was decidedly classical. The plot should be composed of a plausible beginning, middle, and end; it should be a coherent action, more or less beautiful depending upon the orderly arrangement of its parts.

The Golden Mean In Aristotle's philosophy, such Classical aesthetic elements as unity of action and time, orderly arrangement of the parts, and proper proportion all have ethical ramifications. He argued for them by means of a philosophical method based on the **syllogism**, two premises from which a conclusion can be drawn. The most famous of all syllogisms is this:

> All men are mortal;
> Socrates is a man;
> Therefore, Socrates is mortal.

In the *Nicomachean Ethics*, written for and edited by his son Nicomachus [nee-koh-MAH-kus], Aristotle attempts to define, once and for all, what Greek society had striven for since the beginning of the polis—the good life. The operative syllogism goes something like this:

> The way to happiness is through the pursuit of moral virtue;
> The pursuit of the good life is the way to happiness;
> Therefore, the good life consists in the pursuit of moral virtue.

The good life, Aristotle argued, is attainable only through balanced action. Tradition has come to call this the **Golden Mean**—not Aristotle's phrase but that of the Roman poet Horace—the middle ground between any two extremes of behavior. Thus, in a formulation that was particularly applicable to his student Alexander the Great, the Golden Mean between cowardice and recklessness is courage. Like the arts, which imitate an action, human beings are defined by their actions: "As with a flute-player, a statuary, or any artisan, or in fact anybody who has a definite function, so it would seem to be with humans. . . . The function of humans is an *activity* of soul in accordance with reason." This activity of soul seeks out the moral mean, just as "good artists . . . have an eye to the mean in their works" (see **Reading 7.10**, on pages 226–227).

The state is a creation of this same sensibility. In his *Politics,* Aristotle collected over 150 state constitutions, compared and contrasted their virtues, and concluded that a constitutional regime ruled by the middle class was the perfect form of government. The middle class is a "mean" group, exciting neither the envy of the poor nor the contempt of the wealthy. Furthermore, the primary function of the polis is the exercise of justice, which epitomizes the Golden Mean: "For man, when perfected, is the best of animals, but, when separated from law and justice, he is the worst of all. . . . Justice is the bond of men in states, for the administration of justice, which is the determination of what is just, is the principle of order in political society."

Despite the measure and moderation of Aristotle's thinking, Greek culture did not necessarily reflect the balanced approach of its leading philosopher. Alexander's imperial adventuring was defined by his hubris rather than by his courage, and increasingly after Aristotle's death, Greek culture would come to value the emotional and the dramatic above the measured and proportioned. In his emphasis on catharsis—the value of experiencing "fear and pity," the emotions that move us to change—Aristotle introduced the values that would define the age of Hellenism, the period lasting from 323 to 31 BCE, that is, from the death of Alexander to the Battle of Actium, the event that marks in the minds of many the beginning of the Roman Empire.

Pergamon: Capital of Hellenistic Greece

Upon his death, Alexander left no designated successor, and his three chief generals divided his empire into three successor states: the kingdom of Macedonia (including all of Greece), the kingdom of the Ptolemies (Egypt), and the kingdom of the Seleucids (Syria and what is now Iraq). But a fourth, smaller kingdom in western Anatolia, Pergamon (modern-day Bergama, Turkey), soon rose to prominence and became a center of Hellenistic culture. Ruled by the Attalids [ATT-uh-lidz]—descendants of a Macedonian general named Attalus [ATT-uh-lus]—Pergamon was founded as a sort of treasury for the huge fortunes Alexander had accumulated in his conquests. It was technically under the control of the Seleucid kingdom. However, under the leadership of Eumenes [YOU-mee-neez] I (r. 263–241 BCE), Pergamon achieved virtual independence.

The Library at Pergamon The Attalids created a huge library filled with over 200,000 Classical Athenian texts. These were copied onto parchment, a word that derives from the Greek *pergamene*, meaning "from Pergamon" and refers to sheets of tanned leather. (See *Materials and Techniques*, page 217.) Pergamon's vast treasury allowed the Attalids the luxury of investing enormous sums of money in decorating their acropolis with art and architecture. Especially under the rule of Eumenes II (r. 197–160 BCE), the building program flourished. It was Eumenes II who built the library, as well as the theater and a gymnasium. And he was probably responsible for the Altar of Zeus (Fig. **7.25**), which is today housed in Berlin.

A New Sculptural Style The altar is decorated with the most ambitious sculptural program since the Parthenon, but unlike the Parthenon, its frieze is at eye level and is $7\frac{1}{2}$ feet high. Its subject is the mythical battle of the gods and the giants for control of the world. The giants are depicted with snakelike bodies that coil beneath the feet

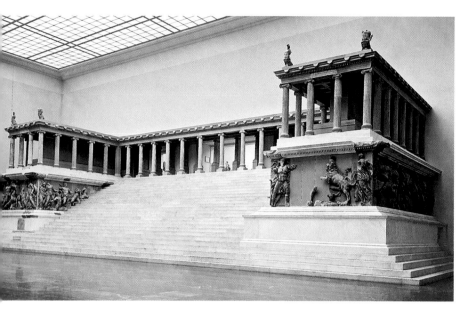

Fig. 7.25 Reconstructed west front of the Altar of Zeus, from Pergamon. ca. 165 BCE. Marble, Staatliche Museen zu Berlin, Antikensammlung, Pergamonmuseum. The staircase entrance to the altar is 68 feet wide and nearly 30 feet deep. It rises to an Ionic colonnade. As opposed to the Parthenon, where the frieze is elevated above the colonnade, the first thing the viewer confronts at the Altar of Zeus is the frieze itself, a placement that draws attention to its interlace of nearly 200 separate twisted, turning, and animated figures. Notice how, as the frieze narrows and rises up the stairs, the figures seem to break free of the architectural space that confines them and crawl out onto the steps of the altar. As the figures come to occupy real space, they simultaneously gain a theatrical reality, as if they were live stage presences in the visitor's space.

of the triumphant gods (Fig. **7.26**). These figures represent one of the greatest examples of the Hellenized style of sculpture that depends for its effects on its **expressionism**, that is, the attempt to elicit an emotional response in the viewer. The theatrical effects of Lysippus (see Fig. 7.23) are magnified into a heightened sense of drama. Where Classical artists sought balance, order, and proportion, this frieze, with its figures twisting, thrusting, and striding in motion, stresses diagonal forces that seem to pull each other apart. Swirling bodies and draperies weave in and out of the sculpture's space, and the relief is so three-dimensional that contrasts of light and shade add to the dramatic effects. Above all, the frieze is an attempt to evoke the emotions of fear and pity that Aristotle argued led to catharsis in his *Poetics* (see pages 224–225), not the intellectual order of Classical tradition.

Most authorities agree that the actual subject of the relief is the Attalid victory over the Gauls, a group of non–Greek speaking and therefore "barbarian" central European Celts who had begun to migrate south through Macedonia as early as 300 BCE, and who had eventually settled in Galatia, just east of Pergamon. Sometime around 240–230 BCE, Attalos I (r. 241–197 BCE) defeated the Gauls in battle. Just as the Athenians had alluded to the battle between the forces of civilization and inhuman, barbarian aggressors in the metopes of the Parthenon (see Fig. 7.10), so too the Pergamenes [PUR-guh-meen] suggested the nonhumanity of the Gauls by depicting

Fig. 7.26 Details of the east frieze of the Altar of Zeus, from Pergamon. ca. 165 BCE. In this image, Athena grabs the hair of a winged, serpent-tailed monster, who is identified on the base of the monument as Alkyoneos, son of the earth goddess Ge. Ge herself rises up from the ground on the right to avenge her son. Behind Ge, a winged Nike flies to Athena's rescue.

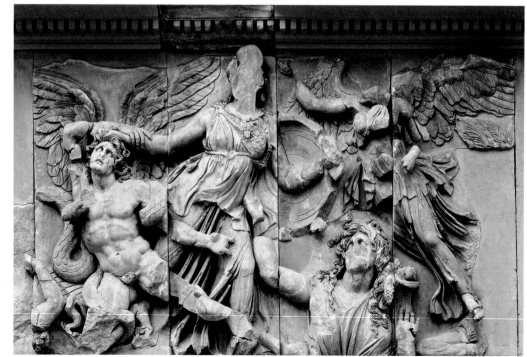

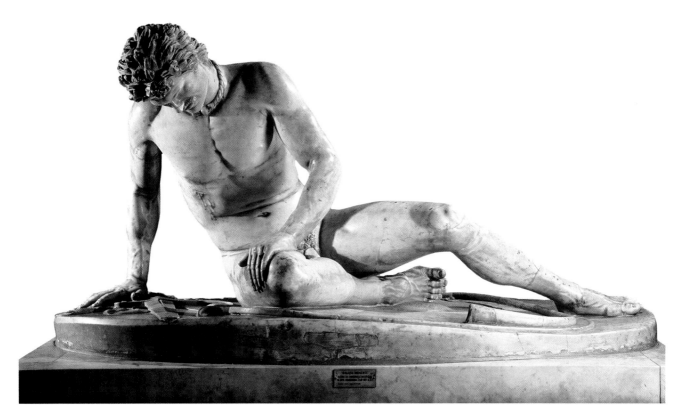

Fig. 7.27 Epigonos (?). *Dying Gaul,* **Roman copy of an original bronze of ca. 220 BCE. Marble, height 37".** Museo Capitolino, Rome. The Gaul seems both resigned to his fate—pressing against the ground to support himself as if pushing futilely against death—and also determined to show his valor and strength to the end—holding himself up as long as he can. Such emotional ambiguity is an integral aspect of Hellenistic art.

the giants as snakelike and legless, unable to even begin to rise to the level of the Attalid victors.

When Attalus I defeated the Gauls, he commissioned a group of three life-size figures to decorate the sanctuary of Athena Nikephoros [nee-KAY-for-us] (the "Victory-bringer") on the acropolis. The original bronze versions of these sculptures, which represent the vanquished Gauls, no longer exist, and how they related to each other is not clear. Nevertheless, the drama of their presentation and their appeal to the emotions of the viewer is unmistakable.

One of the three figures, which depicts a wounded Gallic trumpeter (Fig. 7.27), is possibly by the sculptor Epigonos. The Gaul's identity is established by his tousled hair and moustache (uncharacteristic of Greeks) and by his golden Celtic torque, or choker, the only item of clothing the Gauls wore in combat. He is dying from a chest wound that bleeds profusely below his right breast. The brutal realism together with the nobility and heroism of the defeated Gaul places this work among the earliest examples of Hellenistic expressionism.

Materials & Techniques Parchment Books

Pergamon scribes resorted to parchment when the rival kingdom of the Ptolemies in Egypt refused to provide them with papyrus for writing. They prepared hides—sheepskin, calfskin, or goatskin, and sometimes even gazelle, antelope, and ostrich—by soaking them in a lime bath, then scrubbing them free of flesh and hair with knife and pumice stone. This tanning process resulted in a smooth, lightly grained surface that would absorb ink without allowing it to spread. Far superior to

papyrus, which was very fragile, parchment would revolutionize the art of writing. As scribes learned to write on both sides of it and bind successive sheets together, the book as we know it in the West was born. For the first time, it became possible to transmit ideas in a long-lasting written form, not in fragile fragments. An individual's body of thought—what we have come to call a *corpus*, a Latin word literally meaning "body"—might long survive the body itself.

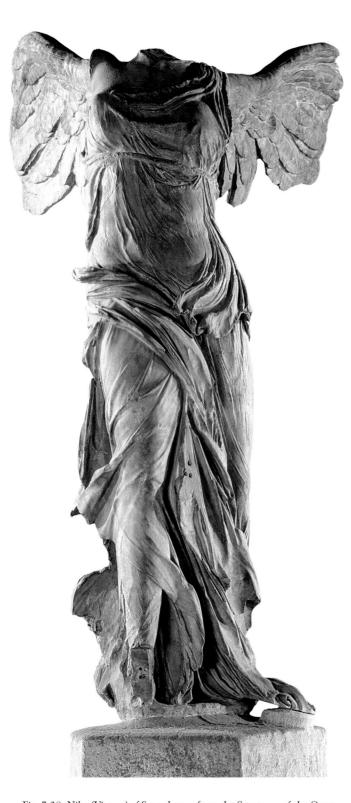

Fig. 7.28 *Nike (Victory) of Samothrace,* from the Sanctuary of the Great Gods, Samothrace. ca. 300–190 BCE. Musée du Louvre, Paris. Marble, height 8′ 1″. Discovered by French explorers in 1863, the Nike appears so immediate and alive that the viewer can almost feel the gust of wind that blows across her body.

Other Hellenistic sculptures deserve particular attention: the *Nike of Samothrace* and the *Aphrodite of Melos.* Convincing arguments date the *Nike of Samothrace* (Fig. **7.28**) anywhere from 300 BCE to as late as 31 BCE, though most agree that it was probably commissioned to celebrate a naval victory. It originally stood (with head and arms that have not survived, except for a single hand) upon the sculpted prow of a ship that was dramatically set in a pool of water at the top of a cliff on the island of Samothrace in the north Aegean. The dynamic forward movement of the striding figure is balanced dramatically by the open gesture of her extended wings and the powerful directional lines of her windblown gown across her body. When light rakes across the deeply sculpted forms of this figure, it emphasizes the contrasting textures of feathers, fabric, and flesh. With the *Altar of Zeus* and the *Dying Gaul,* this sculpture reflects a new direction in art. Not only is this new art more interested in non-Greek subjects (Gauls and Trojans, for instance), but the calm and restraint of Classical art have disappeared, replaced by the freedom to explore the emotional extremes of the human experience.

Alexandria

If Pergamon was a spectacular Hellenistic city, it paled beside Alexandria in Egypt. Alexander had conceived of all the cities he founded as centers of culture. They would be hubs of trade and learning, and Greek culture would radiate out from them to the surrounding countryside. But Alexandria exceeded even Alexander's expectations.

The city's ruling family, the Ptolomies (heirs of Alexander's close friend and general, Ptolomy I), built the world's first museum—from the Greek *mouseion* [moo-ZAY-on], literally, "temple to the muses"—conceived as a meeting place for scholars and students. Nearby was the largest library in the world, exceeding even Pergamon's. It contained over 700,000 volumes when it was destroyed in 47 BCE, after Julius Caesar ordered his troops to set fire to the Ptolemaic fleet and winds spread the flames to warehouses and dockyards. Here were collected the great works of Greek civilization, the writings of Plato and Aristotle, the plays of the great tragedians Aeschylus, Sophocles, and Euripides, as well as the comedies of Aristophanes. Stimulated by the intellectual activity in the city, the great mathematician Euclid formulated the theorems of plane and solid geometry here. And, when Ptolomy I (r. 323–285 BCE) diverted the funeral train of Alexander the Great from its Macedonian destination to Egypt, burying him either in Memphis or Alexandria (his tomb has never been found), the city was inevitably associated with the cult of Alexander himself. Tomb decorations at Luxor depict Alexander in the traditional role and style of an Egyptian pharaoh.

The city was designed by Alexander's personal architect, Dinocrates [dye-NOK-rah-teez] of Rhodes (flourished fourth

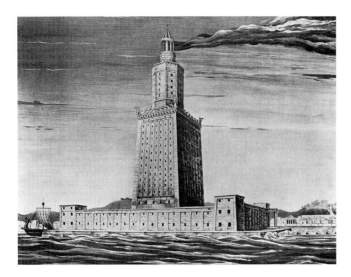

century BCE), laid out in a grid, enclosed by a wall, and accessible by four gates at the ends of its major avenues. It was blessed by three extraordinary harbors. One was connected to the Nile, allowing for the transfer of the Nile's enormous agricultural wealth. Two others opened onto the Mediterranean, the Western Port and the Great Port, both protected by the island of Pharos, upon which was erected a giant lighthouse (Fig. **7.29**). Atop its 440-foot structure, a beam of light from a lantern was magnified by a system of reflectors so that approaching sailors could see the harbor from far off at sea. With the Hanging Gardens of Babylon and the Pyramids at Giza, the lighthouse at Pharos was considered one of the Seven Wonders of the World. (Its remains have been discovered in the harbor.)

Alexandria was a cosmopolitan city, exceeding even Golden Age Athens in the diversity of its inhabitants. As its population approached 1 million at the end of the first century BCE, commerce was its primary activity. Banks did transactions. Markets bustled. Inhabitants traded with others from all parts of the known world. Peoples of different ethnic backgrounds—Jews, black Africans, Greeks, Egyptians, various races and tribes from Asia Minor—all came together with the single purpose of making money. Gradually, Hellenistic and Egyptian cultures merged. The most striking evidence of this are the large number of mummy coffins decorated with startlingly realistic portraits of the deceased (Fig. **7.30**). These give us some idea of Hellenistic portrait painting, almost none of which otherwise survives. They are **encaustic**, done with pigment mixed with heated wax, and the artists, in keeping with the Hellenistic style, were evidently intent on conveying something of the deceased's personality and emotional makeup. No more dramatic or moving approach to coffin decoration could be conceived, nor one more traditional in terms of preserving the tradition of the Egyptian *ka*.

Fig. 7.30 Youth from Hawarra, from Egypt. ca. 100 BCE. Encaustic on wood, height of entire coffin, 52″. © The Trustees of the British Museum, London. Mummy portraits were executed in encaustic, a medium composed of beeswax and pigment. Applied in molten form, it fuses to the surface to create a lustrous enamel effect of intense color. It is the most durable of all artists' paints, since wax is impervious to moisture. As the Egyptian mummy portraits attest, over time encaustic retains all the freshness of a newly finished work.

READINGS

READING 7.5

from Plato, *Crito*

The Crito is a dialogue between Socrates and his friend, the rich Athenian citizen Crito, about the source and nature of political obligation. Crito tries to persuade Socrates to escape his imprisonment and go into exile after he is sentenced to death on the charges of impiety and corrupting the youth of Athens. But Socrates counters each of Crito's arguments.

SOCRATES Why have you come at this hour, Crito? Is it not still early?

CRITO. Yes, very early.

SOCR. About what time is it?

CRITO. It is just daybreak.

SOCR. I wonder that the jailer was willing to let you in.

CRITO. He knows me now, Socrates; I come here so often, and besides, I have given him a tip.

SOCR. Have you been here long?

CRITO. Yes, some time. 10

SOCR. Then why did you sit down without speaking? Why did you not wake me at once?

CRITO. Indeed, Socrates, I wish that I myself were not so sleepless and sorrowful. But I have been wondering to see how soundly you sleep. And I purposely did not wake you, for I was anxious not to disturb your repose. Often before, all through your life, I have thought that your temperament was a happy one; and I think so more than ever now when I see how easily and calmly you bear the calamity that has come to you. . . But, O my good Socrates, I beg you for the last time 20
to listen to me and save yourself. For to me your death will be more than a single disaster; not only shall I lose a friend the like of whom I shall never find again, but many persons who do not know you and me well will think that I might have saved you if I had been willing to spend money, but that I neglected to do so. And what reputation could be more disgraceful than the reputation of caring more for money than for one's friends? The public will never believe that we were anxious to save you, but that you yourself refused to escape.

SOCR. But, my dear Crito, why should we care so much about 30
public opinion? Reasonable men, of whose opinion it is worth our while to think, will believe that we acted as we really did.

CRITO. But you see, Socrates, that it is necessary to care about public opinion, too. This very thing that has happened to you proves that the multitude can do a man not the least, but almost the greatest harm, if he is falsely accused to them.

SOCR. I wish that the multitude were able to do a man the greatest harm, Crito, for then they would be able to do him the greatest good, too. That would have been fine. But, as it is, they can do neither. They cannot make a man either wise 40
or foolish: they act wholly at random. . . Consider it in this way. Suppose the laws and the commonwealth were to come and appear to me as I was preparing to run away (if that is the right phrase to describe my escape) and were to ask, "Tell us, Socrates, what have you in your mind to do? What do you mean by trying to escape but to destroy us, the laws and the whole state, so far as you are able? Do you think that a state can exist and not be overthrown, in which the decisions of law are of no force, and are disregarded and undermined by private individuals?" How shall we answer questions like 50
that, Crito? Much might be said, especially by an orator, in defense of the law which makes judicial decisions supreme. Shall I reply, "But the state has injured me by judging my case unjustly?" Shall we say that?

CRITO. Certainly we will, Socrates.

SOCR. And suppose the laws were to reply, "Was that our agreement? Or was it that you would abide by whatever judgments the state should pronounce?" And if we were surprised by their words, perhaps they would say, "Socrates, don't be surprised by our words, but answer us; you yourself are accus- 60
tomed to ask questions and to answer them. What complaint have you against us and the state, that you are trying to destroy us? Are we not, first of all, your parents? Through us your father took your mother and brought you into the world. Tell us, have you any fault to find with those of us that are the laws of marriage?" "I have none," I should reply. "Or have you any fault to find with those of us that regulate the raising of the child and the education which you, like others, received? Did we not do well in telling your father to educate you in music and athletics?" "You did," I should say. "Well, then, 70
since you were brought into the world and raised and educated by us, how, in the first place, can you deny that you are our child and our slave, as your fathers were before you? And if this be so, do you think that your rights are on a level with ours? Do you think that you have a right to retaliate if we should try to do anything to you? You had not the same rights that your father had, or that your master would have had if you had been a slave. You had no right to retaliate if they ill-treated you, or to answer them if they scolded you, or to strike them back if they struck you, or to repay them evil with evil 80
in any way. And do you think that you may retaliate in the case of your country and its laws? If we try to destroy you, because we think it just, will you in return do all that you can to destroy us, the laws, and your country, and say that in so doing you are acting justly—you, the man who really thinks

so much of excellence? Or are you too wise to see that your country is worthier, more to be revered, more sacred, and held in higher honor both by the gods and by all men of understanding, than your father and your mother and all your other ancestors; and that you ought to reverence it, and to submit to it, and to approach it more humbly when it is angry with you than you would approach your father; and either to do whatever it tells you to do or to persuade it to excuse you; and to obey in silence if it orders you to endure flogging or imprisonment, or if it sends you to battle to be wounded or to die? That is just. You must not give way, nor retreat, nor desert your station. In war, and in the court of justice, and everywhere, you must do whatever your state and your country tell you to do, or you must persuade them that their commands are unjust. But it is impious to use violence against your father or your mother; and much more impious to use violence against your country." What answer shall we make, Crito? Shall we say that the laws speak the truth, or not?

CRITO. I think that they do.

SOCR. "Then consider, Socrates," perhaps they would say, "if we are right in saying that by attempting to escape you are attempting an injustice. We brought you into the world, we raised you, we educated you, we gave you and every other citizen a share of all the good things we could. Yet we proclaim that if any man of the Athenians is dissatisfied with us, he may take his goods and go away wherever he pleases; we give that privilege to every man who chooses to avail himself of it, so soon as he has reached manhood, and sees us, the laws, and the administration of our state. No one of us stands in his way or forbids him to take his goods and go wherever he likes, whether it be to an Athenian colony or to any foreign country, if he is dissatisfied with us and with the state. But we say that every man of you who remains here, seeing how we administer justice, and how we govern the state in other matters, has agreed, by the very fact of remaining here, to do whatsoever we tell him. And, we say, he who disobeys us acts unjustly on three counts: he disobeys us who are his parents, and he disobeys us who reared him, and he disobeys us after he has agreed to obey us, without persuading us that we are wrong. Yet we did not tell him sternly to do whatever we told him. We offered him an alternative; we gave him his choice either to obey us or to convince us that we were wrong; but he does neither.

"These are the charges, Socrates, to which we say that you will expose yourself if you do what you intend; and you are more exposed to these charges than other Athenians." And if I were to ask, "Why?" they might retort with justice that I have bound myself by the agreement with them more than other Athenians. They would say, "Socrates, we have very strong evidence that you were satisfied with us and with the state. You would not have been content to stay at home in it more than other Athenians unless you had been satisfied with it more than they. You never went away from Athens to the festivals, nor elsewhere except on military service; you never made other journeys like other men; you had no desire to see other states or other laws; you were contented with us and our state; so strongly did you prefer us, and agree to be governed by us. And what is more, you had children in this city, you found it so satisfactory. Besides, if you had wished, you might at your trial have offered to go into exile. At that time you could have done with the state's consent what you are trying now to do without it. But then you gloried in being willing to die. You said that you preferred death to exile. And now you do not honor those words: you do not respect us, the laws, for you are trying to destroy us; and you are acting just as a miserable slave would act, trying to run away, and breaking the contracts and agreement which you made to live as our citizen. First, therefore, answer this question. Are we right, or are we wrong, in saying that you have agreed not in mere words, but in your actions, to live under our government?" What are we to say, Crito? Must we not admit that it is true?

CRITO. We must, Socrates. ■

Reading Question

What is the "implicit contract" Socrates speaks about, and why does It follow that having entered this contract Socrates must accept his punishment?

READING 7.6

Plato, "Allegory of the Cave," from *The Republic*

The Republic is an inquiry into the nature of justice, which in turn leads logically to a discussion about the nature of the ideal state (where justice would, naturally, be meted out to perfection). The work takes the form of a dialogue between Socrates and six other speakers. The passage here is from Book VII, the famous "Allegory of the Cave," in which Socrates addresses an older brother of Plato named Glaucon. Socrates distinguishes between unenlightened people and enlightened philosophers such as himself, even as he demonstrates how difficult it is for the enlightened to re-enter the sphere of everyday affairs—which they must, of course, since it is their duty to rule.

And now, I [Socrates] said, let me show in a figure how far our nature is enlightened or unenlightened:— Behold! human beings living in an underground den, which has a mouth open towards the light and reaching all along the den; here they have been from their childhood, and have their legs and necks chained so that they cannot move,

and can only see before them, being prevented by the chains from turning round their heads. Above and behind them a fire is blazing at a distance, and between the fire and the prisoners there is a raised way; and you will see, if you look, a low wall built along the way, like the screen which marionette players have in front of them, over which they show the puppets.

I see [replied Glaucon].

And do you see, I said, men passing along the wall carrying all sorts of vessels, and statues and figures of animals made of wood and stone and various materials, which appear over the wall? Some of them are talking, others silent.

You have shown me a strange image, and they are strange prisoners.

Like ourselves, I replied; and they see only their own shadows, or the shadows of one another, which the fire throws on the opposite wall of the cave?

True, he said; how could they see anything but the shadows if they were never allowed to move their heads?

And of the objects which are being carried in like manner they would only see the shadows?

Yes, he said.

And if they were able to converse with one another, would they not suppose that they were naming what was actually before them?

Very true.

And suppose further that the prison had an echo which came from the other side, would they not be sure to fancy when one of the passers-by spoke that the voice which they heard came from the passing shadow?

No question, he replied.

To them, I said, the truth would be literally nothing but the shadows of the images.

That is certain.

And now look again, and see what will naturally follow it: the prisoners are released and disabused of their error. At first, when any of them is liberated and compelled suddenly to stand up and turn his neck round and walk and look towards the light, he will suffer sharp pains; the glare will distress him, and he will be unable to see the realities of which in his former state he had seen the shadows; and then conceive some one saying to him, that what he saw before was an illusion, but that now, when he is approaching nearer to being and his eye is turned towards more real existence, he has a clearer vision—what will be his reply? And you may further imagine that his instructor is pointing to the objects as they pass and requiring him to name them—will he not be perplexed? Will he not fancy that the shadows which he formerly saw are truer than the objects which are now shown to him?

Far truer.

And if he is compelled to look straight at the light, will he not have a pain in his eyes which will make him turn away to

take and take in the objects of vision which he can see, and which he will conceive to be in reality clearer than the things which are now being shown to him?

True.

And suppose once more, that he is reluctantly dragged up a steep and rugged ascent, and held fast until he's forced into the presence of the sun himself, is he not likely to be pained and irritated? When he approaches the light his eyes will be dazzled, and he will not be able to see anything at all of what are now called realities.

Not all in a moment, he said.

He will require to grow accustomed to the sight of the upper world. And first he will see the shadows best, next the reflections of men and other objects in the water, and then the objects themselves; then he will gaze upon the light of the moon and the stars and the spangled heaven; and he will see the sky and the stars by night better than the sun or the light of the sun by day?

Certainly.

Last of all he will be able to see the sun, and not mere reflections of him in the water, but he will see him in his own proper place, and not in another; and he will contemplate him as he is. . . And when he remembered his old habitation, and the wisdom of the den and his fellow-prisoners, do you not suppose that he would felicitate himself on the change, and pity them?

Certainly, he would. . .

Would he not say with Homer, Better to be the poor servant of a poor master, and to endure anything, rather than think as they do and live after their manner?

Yes, he said, I think that he would rather suffer anything than entertain these false notions and live in this miserable manner.

Imagine once more, I said, such an one coming suddenly out of the sun to be replaced in his old situation; would he not be certain to have his eyes full of darkness?

To be sure, he said. . .

This entire allegory, I said, you may now append, dear Glaucon, to the previous argument; the prison-house is the world of sight, the light of the fire is the sun, and you will not misapprehend me if you interpret the journey upwards to be the ascent of the soul into the intellectual world according to my poor belief, which, at your desire, I have expressed whether rightly or wrongly God knows. But, whether true or false, my opinion is that in the world of knowledge the idea of good appears last of all, and is seen only with an effort; and, when seen, is also inferred to be the universal author of all things beautiful and right, parent of light and of the lord of light in this visible world, and the immediate source of reason and truth in the intellectual; and that this is the power upon which he who would act rationally, either in public or private life must have his eye fixed.

I agree, he said, as far as I am able to understand you.

Moreover, I said, you must not wonder that those who attain

to this beatific vision are unwilling to descend to human affairs; for their souls are ever hastening into the upper world where they desire to dwell; which desire of theirs is very natural, if our allegory may be trusted. . .

[A]nd there is another thing which is likely, or rather a necessary inference from what has preceded, that neither the uneducated and uninformed of the truth, nor yet those who never make an end of their education, will be able ministers of State; not the former, because they have no single aim of duty which is the rule of all their actions, private as well as public; nor the latter, because they will not act at all except upon compulsion, fancying that they are already dwelling apart in the islands of the blest.

Very true, he replied.

Then, I said, the business of us who are the founders of the State will be to compel the best minds to attain that knowledge which we have already shown to be the greatest of all—they must continue to ascend until they arrive at the good; but when they have ascended and seen enough we must not allow them to do as they do now.

What do you mean?

I mean that they remain in the upper world: but this must not be allowed; they must be made to descend again among the prisoners in the den, and partake of their labours and honours, whether they are worth having or not.

But is not this unjust? he said; ought we to give them a worse life, when they might have a better? . . .

Observe, Glaucon, that there will be no injustice in compelling our philosophers to have a care and providence of others; we shall explain to them that in other States, men of their class are not obliged to share in the toils of politics: and this is reasonable, for they grow up at their own sweet will, and the government would rather not have them. Being self-taught, they cannot be expected to show any gratitude for a culture which they have never received. But we have brought you into the world to be rulers of the hive, kings of yourselves and of the other citizens, and have educated you far better and more perfectly than they have been educated, and you are better able to share in the double duty. Wherefore each of you, when his turn comes, must go down to the general underground abode, and get the habit of seeing in the dark. When you have acquired the habit, you will see ten thousand times better than the inhabitants of the den, and you will know what the several images are, and what they represent, because you have seen the beautiful and just and good in their truth. And thus our State which is also yours will be a reality, and not a dream only, and will be administered in a spirit unlike that of other States, in which men fight with one another about shadows only and are distracted in the struggle for power, which in their eyes is a great good. Whereas the truth is that the State in which the rulers are most reluctant to govern is always the best and most quietly governed, and the State in which they are most eager, the worst. . . . ■

Reading Question

In what way does Glaucon's experience, as Socrates' student, mirror Socrates' allegory?

READING 7.7

Plato, from *The Symposium*

The Symposium recounts a discussion about the nature of Love among members of a drinking party in Athens at which Plato and Socrates were in attendance. Their homosexual love for young boys, commonplace in Athens, is the starting point, but the essay quickly moves beyond discussion of mere physical love. In the excerpt below, Socrates quotes a woman named Diotama who has taught him, he says, that the purpose of love is to give birth to beauty, which in turn allows the philosopher to attain insight into the ultimate Form of Beauty. His speech is addressed to one Phaedrus, who has already made an important distinction between common physical love and a higher heavenly love.

"Even you, Socrates, could perhaps be initiated in the rites of love I've described so far. But the purpose of these rites, if they are performed correctly, is to reach the final vision of the mysteries; and I'm not sure you could manage this. But I'll tell you about them," she said, "and make every effort in doing so; try to follow, as far as you can."

"'The correct way," she said, "for someone to approach this business is to begin when he's young by being drawn towards beautiful bodies. At first, if his guide leads him correctly, he should love just one body and in that relationship produce beautiful discourses. Next he should realize that the beauty of any one body is closely related to that of another, and that, if he is to pursue beauty of form, it's very foolish not to regard the beauty of all bodies as one and the same. Once he's seen this, he'll become a lover of all beautiful bodies, and will relax his intense passion for just one body, despising this passion and regarding it as petty. After this, he should regard the beauty of minds as more valuable than that of the body, so that, if someone has goodness of mind even if he has little of the bloom of beauty, he will be content with him, and will love and care for him, and give birth to the kinds of discourse that help young men to become better. As a result, he will be forced to observe the beauty in practices and laws and to see that every type of beauty is closely related to every other, so that he will regard beauty of body as something petty. After practices, the guide must lead him towards forms of knowledge, so that he sees their

beauty too. Looking now at beauty in general and not just at individual instances, he will no longer be slavishly attached to the beauty of a boy, or of any particular person at all, or of a specific practice. Instead of this low and small-minded slavery, he will be turned towards the great sea of beauty and gazing on it he'll give birth, through a boundless love of knowledge, to many beautiful and magnificent discourses and ideas. At last, when he has been developed and strengthened in this way, he catches sight of one special type of knowledge, whose object is the kind of beauty I shall now describe.

"'Now try,' she said, "to concentrate as hard as you can. Anyone who has been educated this far in the ways of love, viewing beautiful things in the right order and way, will now reach the goal of love's ways. He will suddenly catch sight of something amazingly beautiful in its nature; this, Socrates, is the ultimate objective of all the previous efforts. First, this beauty always *is*, and doesn't come into being or cease; it doesn't increase or diminish. Second, it's not beautiful in one respect but ugly in another, or beautiful at one time but not at another, or beautiful in relation to this but ugly in relation to that; nor beautiful here and ugly there because it is beautiful for some people but ugly for others. Nor will beauty appear to him in the form of a face or hands or any part of the body; or as a specific account or piece of knowledge; or as being anywhere in something else, for instance in a living creature or earth or heaven or anything else. It will appear as in itself and by itself, always single in form; all other beautiful things share its character, but do so in such a way that, when other things come to be or cease, it is not increased or decreased in any way nor does it undergo any change...." ■

Reading Question

How does the process of coming to a higher understanding of the nature of love compare to Socrates' description of arriving at enlightenment in "Allegory of the Cave"?

READING 7.8

Sophocles, from *Antigone*

Sophocles' Antigone *dramatizes the struggle of Oedipus's daughter Antigone with her uncle Creon, the tyrannical king who has inherited Oedipus's throne after Antigone's brothers, Polynices and Eteocles, have killed one another. At the heart of the conflict is Creon's refusal to allow Antigone to bury Polynices, since, he believes, Eteocles was the rightful heir. Antigone defies Creon's authority. In the following passage, opening the play, she explains her actions to her sister Ismene.*

Ismene
Oh my sister, think—
think how our own father died, hated,
his reputation in ruins, driven on
by the crimes he brought to light himself
to gouge out his eyes with his own hands—
then mother. . . his mother and wife, both in one,
mutilating her life in the twisted noose—
and last, our two brothers dead in a single day,
both shedding their own blood, poor suffering boys,
battling out their common destiny hand-to-hand.
Now look at the two of us, left so alone. . .
think what a death we'll die, the worst of all

if we violate the laws and override
the fixed decree of the throne, its power—
we must be sensible. Remember we are women,
we're not born to contend with men. Then too,
we're underlings, ruled by much stronger hands,
so we must submit in this, and things still worse.
I, for one, I'll beg the dead to forgive me—
I'm forced, I have no choice—I must obey
the ones who stand in power. Why rush to extremes?
It's madness, madness. ■

Reading Question

How would the Socrates of the *Crito* regard Antigone's actions?

READING 7.9

Aristotle, from *Poetics*

Aristotle's Poetics *is an attempt to account for the power of tragedy by defining the chief attributes of Greek theater. In it, Aristotle contributed a number of key ideas to literary criticism, most especially the idea of the imitation of an action, the definition of plot as "an arrangement of incidents," and the concept of* catharsis, *translated in the first passage below, from Book VI of the* Poetics, *as "purification." Catharsis is an effect of the "feat and pity" aroused in the spectator, discussed by Aristotle in the second passage quoted below, from Book XIV.*

Book VI

Tragedy, then, is an imitation of an action that is serious, complete, and of a certain magnitude; in language embellished with every kind of artistic ornament, the several kinds being found in separate parts of the play; in the form of dramatic action, not of narrative; through pity and fear effecting the proper purification of these emotions[1] By "language embellished," I mean language into which rhythm, harmony, and song enter. By "the several kinds in separate parts," I mean that some parts are rendered through the medium of verse alone, others again with the aid of song.

Now as tragic imitation implies persons acting, it necessarily follows, in the first place, that spectacular equipment will be a part of tragedy. Next, song and diction, for these are the medium of imitation. By diction, I mean the metrical arrangement of the words: as for song, it is a term whose sense everyone understands.

Again, tragedy is the imitation of an action, and an action implies personal actors, who necessarily possess certain distinctive qualities of character and thought; for it is by these that we form our estimate of their actions and these two—thought and character—are the natural causes from which their actions spring, and on their actions all success or failure depends. Now, the imitation of the action is the plot; by plot I here mean the arrangement of the incidents. By character I mean that because of which we ascribe certain qualities to the actors. Thought is needed whenever they speak to prove a statement or declare a general truth. Every tragedy, therefore, must have six parts, which parts determine its quality—namely, plot, character, diction, thought, spectacle, song. . . .

But most important of all is the structure of the incidents. For tragedy is an imitation, not of men, but of action and life, of happiness and misery. And life consists of action, and its end is a mode of activity, not a quality. Now character determines men's qualities, but it is their actions that make them happy or wretched. The purpose of action in the tragedy, therefore, is not the representation of character: character comes in as contributing to the action. Hence the incidents and the plot are the end of the tragedy; and the end is the chief thing of all. So without action there cannot be a tragedy; there may be one without character. . . .

Again, you may string together a set of speeches expressive of character, and well finished in point of diction and thought, and not produce the essential tragic effect nearly so well as with a play which, however deficient in these respects, yet has a plot and artistically constructed incidents. Besides which, the most powerful elements of emotional interest in tragedy—reversal of the situation and recognition scenes —are parts of the plot. A further proof is that novices in the art attain to finish of diction and precision of portraiture before they can construct the plot. It is the same with almost all the early poets.

The plot, then, is the first principle, and, as it were, the soul of a tragedy: character holds the second place. A similar statement is true of painting. The most beautiful colors, laid on confusedly, will not give as much pleasure as a simple chalk outline of a portrait. Thus tragedy is the imitation of an action, and of actors mainly with a view to the action. . . .

The spectacle is, indeed, an attraction in itself, but of all the parts it is the least artistic, and connected least with the art of poetry. For the power of tragedy is felt even apart from representation and actors. Besides, the production of scenic effects is more a matter for the property man than for the poet.

Book XIV

Fear and pity may be aroused by spectacular means; but they may also result from the inner structure of the piece, which is the better way, and indicates a superior poet. For the plot ought to be so constructed that, even without the aid of the eye, he who hears the tale told will thrill with horror and melt to pity at what takes place. This is the impression we should receive from hearing the story of Oedipus. But to produce this effect by the mere spectacle is a less artistic method, and dependent on extraneous aids. Those who employ spectacular means to create a sense not of the terrible but of the merely monstrous are strangers to the purpose of tragedy; for we must not demand of tragedy any and every kind of pleasure, but only that which is proper to it. And since the pleasure the tragic poet should offer is that which comes from pity and fear through imitation, it is evident that this quality must be impressed on the incidents.

Let us then determine what circumstances strike us as terrible or pitiful.

Actions of this sort must happen between persons who are either friends or enemies or indifferent to one another. If an enemy kills an enemy, there is nothing to excite pity either in the act or the intention—except in so far as the suffering itself is pitiful. So too with indifferent persons. But when the tragic incident occurs between those who are near or dear to one another—if, for example, a brother kills, or intends to kill, a brother, a son his father, a mother her son, a son his mother, or any other deed of the kind is done—these are situations to be looked for by the poet. He may not indeed destroy the framework of the received legends—the fact, for instance, that Clytemnestra was slain by Orestes . . . but he ought to show invention of his own, and skillfully handle the traditional material. . . .

Enough has now been said concerning the structure of the incidents and the right kind of plot. ■

Reading Question

Can you say what actions in Sophocles' *Antigone* might lead, in Aristotle's view, to the catharsis of the play's audience?

[1] Note that an unhappy or what we call a tragic ending was not one of the Greek requirements for a tragedy, though Aristotle thought it the perfect ending. Many tragedies ended with a solemn reconciliation after a conflict or quiet after pain, to please the audience, Aristotle says.

READING 7.10

Aristotle, from the *Nicomachean* [nee-koh-muh-KEE-un] *Ethics*

Aristotle's Nicomachean Ethics *was not intended for publication, but was a series of notes for teaching written for, and probably edited by, his son Nicomachus (hence the work's title). It is Aristotle's attempt to define once and for all what Athenian society meant by the "good life," achieved by the doctrines of moderation in all things and balanced action.*

Every art and every inquiry, and similarly every action and pursuit, is thought to aim at some good; and for this reason the good has rightly been declared to be that at which all things aim. But a certain difference is found among ends; some are activities, others are products apart from the activities that produce them. Where there are ends apart from the actions, it is the nature of the products to be better than the activities. . . .

If, then, there is some end of the things we do, which we desire for its own sake (everything else being desired for the sake of this), and if we do not choose everything for the sake of something else (for at that rate the process would go on to infinity, so that our desire would be empty and vain), clearly this must be the good and the chief good. Will not the knowledge of it, then, have a great influence on life? Shall we not, like archers who have a mark to aim at, be more likely to hit upon what is right? If so, we must try, in outline at least, to determine what it is, and of which of the sciences or capacities it is the object. It would seem to belong to the most authoritative art and that which is most truly the master art. And politics appears to be of this nature; for it is this that ordains which of the sciences should be studied in a state, and which each class of citizens should learn and up to what point they should learn them; and we see even the most highly esteemed of capacities to fall under this, e.g. strategy, economics, rhetoric; now, since politics uses the rest of the sciences, and since, again, it legislates as to what we are to do and what we are to abstain from, the end of this science must include those of the others, so that this end must be the good for man. For even if the end is the same for a single man and for a state, that of the state seems at all events something greater and more complete whether to attain or to preserve; though it is worth while to attain the end merely for one man, it is finer and more godlike to attain it for a nation or for city-states. These, then, are the ends at which our inquiry aims, since it is political science, in one sense of that term. . . .

To judge from the lives that men lead, most men, and men of the most vulgar type, seem (not without some ground) to identify the good, or happiness, with pleasure; which is the reason why they love the life of enjoyment. For there are, we may say, three prominent types of life—that just mentioned, the political, and thirdly the contemplative life. Now the mass of mankind are evidently quite slavish in their tastes, preferring a life suitable to beasts, but they get some ground for their view from the fact that many of those in high places share the tastes of Sardanapallus. A consideration of the prominent types of life shows that people of superior refinement and of active disposition identify happiness with honour; for this is, roughly speaking, the end of the political life. But it seems too superficial to be what we are looking for, since it is thought to depend on those who bestow honour rather than on him who receives it, but the good we divine to be something proper to a man and not easily taken from him. Further, men seem to pursue honour in order that they may be assured of their goodness; at least it is by men of practical wisdom that they seek to be honoured, and among those who know them, and on the ground of their virtue; clearly, then, according to them, at any rate, virtue is better. And perhaps one might even suppose this to be, rather than honour, the end of the political life. . . .

Next we must consider what virtue is. Since things that are found in the soul are of three kinds—passions, faculties, states of character, virtue must be one of these. By passions I mean appetite, anger, fear, confidence, envy, joy, friendly feeling, hatred, longing, emulation, pity, and in general the feelings that are accompanied by pleasure or pain; by faculties the things in virtue of which we are said to be capable of feeling these, e.g. of becoming angry or being pained or feeling pity; by states of character the things in virtue of which we stand well or badly with reference to the passions, e.g. with reference to anger we stand badly if we feel it violently or too weakly, and well if we feel it moderately; and similarly with reference to the other passions.

Now neither the virtues nor the vices are passions, because we are not called good or bad on the ground of our passions, but are so called on the ground of our virtues and our vices, and because we are neither praised nor blamed for our passions (for the man who feels fear or anger is not praised, nor is the man who simply feels anger blamed, but the man who feels it in a certain way), but for our virtues and our vices we are praised or blamed.

Again, we feel anger and fear without choice, but the virtues are modes of choice or involve choice. Further, in respect of the passions we are said to be moved, but in respect of the virtues and the vices we are said not to be moved but to be disposed in a particular way.

For these reasons also they are not faculties; for we are neither called good nor bad, nor praised nor blamed, for the simple capacity of feeling the passions; again, we have the faculties by nature, but we are not made good or bad by nature; we have spoken of this before. If, then, the virtues are neither passions nor faculties, all that remains is that they should be states of character.

Thus we have stated what virtue is in respect of its genus. We must, however, not only describe virtue as a state of character, but also say what sort of state it is. We may remark, then, that every virtue or excellence both brings into good condition the thing of which it is the excellence and makes the work of that thing be done well; e.g. the excellence of the eye makes both the eye and its work good; for it is by the excellence of the eye that we see well. Similarly the excellence of the horse makes a horse both good in itself and good at running and at carrying its rider and at awaiting the attack of the enemy. Therefore, if this is true in every case, the virtue of man also will be the state of character which makes a man good and which makes him do his own work well.

How this is to happen we have stated already, but it will be made plain also by the following consideration of the specific nature of virtue. In everything that is continuous and divisible it is possible to take more, less, or an equal amount, and that either in terms of the thing itself or relatively to us; and the equal is an intermediate between excess and defect. By the intermediate in the object I mean that which is equidistant from each of the extremes, which is one and the same for all men; by the intermediate relatively to us that which is neither too much nor too little and this is not one, nor the same for all. For instance, if ten is many and two is few, six is the intermediate, taken in terms of the object; for it exceeds and is exceeded by an equal amount; this is intermediate according to arithmetical proportion. But the intermediate relatively to us is not to be taken so; if ten pounds are too much for a particular person to eat and two too little, it does not follow that the trainer will order six pounds; for this also is perhaps too much for the person who is to take it, or too little—too little for Milo, too much for the beginner in athletic exercises. The same is true of running and wrestling. Thus a master of any art avoids excess and defect, but seeks the intermediate and chooses this—the intermediate not in the object but relatively to us.

If it is thus, then, that every art does its work well—by looking to the intermediate and judging its works by this standard (so that we often say of good works of art that it is not possible either to take away or to add anything, implying that excess and defect destroy the goodness of works of art, while the mean preserves it; and good artists, as we say, look to this in their work), and if, further, virtue is more exact and better than any art, as nature also is, then virtue must have the quality of aiming at the intermediate. I mean moral virtue; for it is this that is concerned with passions and actions, and in these there is excess, defect, and the intermediate. For instance, both fear and confidence and appetite and anger and pity and in general pleasure and pain may be felt both too much and too little, and in both cases not well; but to feel them at the right times, with reference to the right objects, towards the right people, with the right motive, and in the right way, is what is both intermediate and best, and this is characteristic of virtue. Similarly with regard to actions also there is excess, defect, and the intermediate. Now virtue is concerned with passions and actions, in which excess is a form of failure, and so is defect, while the intermediate is praised and is a form of success; and being praised and being successful are both characteristics of virtue. Therefore virtue is a kind of mean, since, as we have seen, it aims at what is intermediate. . . . ■

Reading Question

Explain Aristotle's statement that "virtue is a kind of mean."

Summary

■ **The Politics of Athens** In their politics, the Athenians sought to strike a balance between the rights of the individual and the needs of the state. They collectively pursued what Aristotle called *eudaimonia*, "the good or flourishing life" in the agora, the secular center of the city. Slaves and metics, as well as women, were excluded from governance. Women were, however, given greater privileges in other city-states, particularly in Sparta, and the woman poet Sappho of Lesbos became one of Greece's leading literary figures.

■ **Pericles and the "School of Hellas"** In the fifth century, the statesman Pericles dominated Athenian political life. In his funeral speech honoring the dead, delivered early in the Peloponnesian Wars, he claimed "excellence" for Athenians in all aspects of endeavor, leading Greece by its example. The Athenians realized this excellence in their sculpture of male nudes, which became increasingly naturalistic even as they embodied an increasingly perfect sense of proportion. They realized it even more dramatically on the Acropolis, where Pericles instituted a massive architectural program that included what is perhaps the highest expression of the Doric order, the Parthenon. The sculptor Phidias was in charge of the sculptural program of the Parthenon, creating a giant sculpture of Athena for the temple's interior, as well as complex sculptural groups for the building's metopes, its pediments, and the frieze encircling its central block, the last a ritual procession that has been interpreted in ways that connect it to one of the other great buildings on the Acropolis, the Erechtheion. We have come to call the style of art and architecture created in fifth-century Athens Classical, a term referring to the clarity of each part, the harmony and balance among them, and the proportion and apparent simplicity of the whole.

■ **Socrates: Philosophy and the Polis** Pericles also championed the practice of philosophy in Athens. His Athens inherited two distinct philosophical traditions, that of the Pre-Socratics, who were chiefly concerned with describing the natural universe, and that of the Sophists, who were primarily concerned with understanding the nature of human "knowing" itself. Pericles was particularly interested in the Sophists, whose emphasis on rhetoric and the consequences of human action were particularly applicable to political life. However, their practice was rejected by Socrates, who emphasized virtuous behavior instead of the pragmatism of the Sophists, a position that would cost him his life. Socrates never wrote a word himself, but his student Plato recorded his thoughts. In the *Republic*, Plato advocated the search for ideal forms of Goodness, Justice, Beauty, and Love. In the *Symposium*, he outlined the ways in which a higher ideal love can be discovered through the lesser homoerotic love of young boys, a practice common among Greek intellectuals.

■ **The Theater of the People** The sexual license implied in Plato's *Symposium* gave rise to Greek theatrical practice, which arose out of rites connected with Dionysus, god of wine. Greek comedy was by and large a satiric medium. Tragedy was directed more at pointing out the consequences of misguided personal action upon the well-being of the polis. This is the point of Sophocles' great play, *Antigone*, in which both the protagonist heroine, Antigone, and her antagonist adversary, the king Creon, bring tragedy upon themselves and the state through their own blind self-interest. Euripides' *Bacchae* challenges the wisdom of Dionysian rites themselves. But the plays celebrated the Dioynsian principle annually, in increasingly elaborate theaters such as the one at Epidaurus, incorporating through the Chorus and their music and dance an ideal of harmony and perfection given right human action.

■ **The Hellenistic World** Alexander's Greek influence extended across North Africa and Egypt, the Middle East, as far as the Indian subcontinent, creating the largest empire the world had ever known. During his reign, sculpture flourished as a medium. Lyssipus redefined the Classical canon of beauty even as his chief competitor, Praxiteles, created what may well be the first nude female figure in Greek sculpture, defining a new canon for the female form as well. Alexander's tutor, the philosopher Aristotle, emphasized the importance of empirical observation in understanding the world, distinguishing between a thing's identity, its essence, and the changes that inevitably occur to it over time. Great cities also sprang up in the wake of Alexander's victories, Pergamon and Alexandria chief among them. In Pergamon, a new Hellenistic sculpture is designed to evoke a strong emotional response in the viewer.

Glossary

agora An open place used for gathering or as a market.

antagonist One who represents an opposing will; an adversary or opponent.

axis An imaginary central line.

caryatid A female figure that serves as a column.

catharsis Cleansing, purification, or purgation of the soul.

chorus The company of actors who comment on the action in a Greek tragedy.

Classical Refers specifically to the art of the Greeks in the fifth century BCE; also commonly used to refer to anything of the first or highest class.

colonnade A row of columns.

comedy An amusing or lighthearted play designed to evoke laughter in an audience.

contrapposto Italian for "counterpoise"; a term used to describe the weight-shift stance developed by the ancient Greeks in which the sculpted figure seems to twist around its axis as a result of balancing the body over one supporting leg.

cosmos To the ancient Greeks, the harmonious and beautiful order of the universe.

dialectic method A process of inquiry and instruction characterized by continuous question and answer dialogue designed to elicit a clear statement of knowledge supposed to be held implicitly by all reasonable beings.

encaustic A paint medium composed of beeswax and pigment.

entasis A swelling of the shaft of a column.

expressionism The attempt to elicit an emotional response in a viewer.

farce A broadly satirical comedy.

Golden Mean Philosophically, the middle ground between any two extremes of behavior.

Golden Section Mathematically, the most beautiful of all proportions, a ratio of approximately 8:5, or, more precisely, 1.618:1.

Hellenistic A period of Greek history that begins with the rise to power of Alexander the Great (356–323 BCE) and extends to the Roman defeat of Cleopatra in Egypt in 30 BCE.

humanism A focus on the actions of human beings, especially political action.

idealism The eternal perfection of pure ideas untainted by material reality.

inductive reasoning A type of reasoning that moves from specific instances to general principles and from particular truths to universal ones.

maenad In ancient Greek literature, the frenzied women with whom Dionysus cavorted.

male gaze A term used especially in art to describe the chauvinistic glance that regards woman as its sexual object.

metope A square panel between the beam ends under a roof and on a frieze.

mode An aspect of musical performance in which, the Greeks believed, different pitches evoked different emotions.

muse One of the nine sister goddesses in Greek mythology who presided over song, poetry, and the arts and sciences.

orchestra The "dancing space" on which ancient Greek plays were performed.

parados An entranceway through which the chorus entered the *orchestra* area.

parapet A low wall.

pre-Socratic Greek philosophy that preceded Socrates, chiefly concerned with describing the natural world.

propylon A large entryway.

proscenium The stage on which actors perform and where painted backdrops can be hung.

protagonist The leading character in a play or literary work.

psyche The seat of both intelligence and character.

satyr A woodland deity part human and part goat and noted for its lasciviousness.

satyr play A comic play that was one of the three major forms of Greek drama; see *farce*.

scientific method The effort to construct an accurate (that is, reliable, consistent, and non-arbitrary) representation of the world.

skene Literally, "tent"; originally a changing room for Greek actors that, over time, was transformed into a building, often two stories tall.

Sophist Literally, "wise man"; an ancient Greek teacher or philosopher who was committed to humanism and primarily concerned with understanding the nature of human "knowing" itself.

stoa A long, open arcade supported by colonnades.

syllogism A type of deductive reasoning consisting of two premises from which a conclusion can be drawn.

tetralogy A set of four related plays.

tragedy A type of drama whose basis is conflict; it often explores the physical and moral depths to which human life can descend.

 Critical Thinking Questions

1. How would you summarize the contributions of Pericles to the Greeks' sense of themselves?

2. How would you define the Idea of Beauty (a Platonic notion) as reflected in Greek sculpture? in Greek architecture as exemplified by the Parthenon?

3. In what ways does the philosophy of Socrates differ from that of the Sophists?

4. How does Sophocles' play *Antigone* mirror the conflict between the Athenian self and that self's responsibility to the state?

5. How does Hellenistic sculpture differ from Classical and Late Classical sculpture?

Golden Age Athens as an Ideal in Western Thought

Continuity & Change

Let there be light! said Liberty,
And like sunrise from the sea,
Athens arose!

So wrote the English poet Percy Bysshe Shelley in 1822 in the first act of his verse play *Hellas*. It was in Athens, Shelley believed, that democracy was born. It was from Athens that his own art had sprung (*Hellas* was modeled on *The Persians* by Aeschylus). It was to Athens that Western culture owed everything. "We are all Greeks," Shelley declared. "Our laws, our literature, our religion, our arts, have their roots in Greece." Thus, in 1822, as Greece fought Turkey for its independence, Shelley dreamed of a new Golden Age:

Another Athens shall arise,
And to remoter time
Bequeath, like sunset to the skies,
The splendour of its prime.

If we have never quite realized Shelley's dream, the image of Golden Age Athens remains an ideal for many people and nations in the Western world.

When the city of Athens, Georgia, was incorporated in 1805, it chose its name to reflect the fact that it was a center of culture, home to the University of Georgia, which had been founded there four years earlier. And Athens, Ohio, likewise named itself after its Greek forbearer because it was home to Ohio University, founded in 1804. When in 1914 Henry Bacon revealed his plans for the Lincoln Memorial in Washington, DC (Fig. **7.31**), he chose the design of a classical Greek temple to reflect Lincoln's steadfast belief in the Greek principles of democracy and liberty. The Memorial, completed in 1922, is composed of 36 massive columns, one for each state in the Union during Lincoln's presidency. They are Doric, the earliest, sturdiest, and most steadfast of the Greek orders, and each is an imposing 44 feet high and 23 feet in circumference. This massiveness was meant to signify the enduring strength of democracy as an idea. These are but a few examples that illustrate how Golden Age Greece remains a reference point and model for Western culture down to the present day. ■

Fig. 7.31 Henry Bacon. Lincoln Memorial, Washington, DC. Completed 1922. It was on the steps of the Lincoln Memorial that Martin Luther King Jr., delivered his "I Have a Dream" speech in 1963.

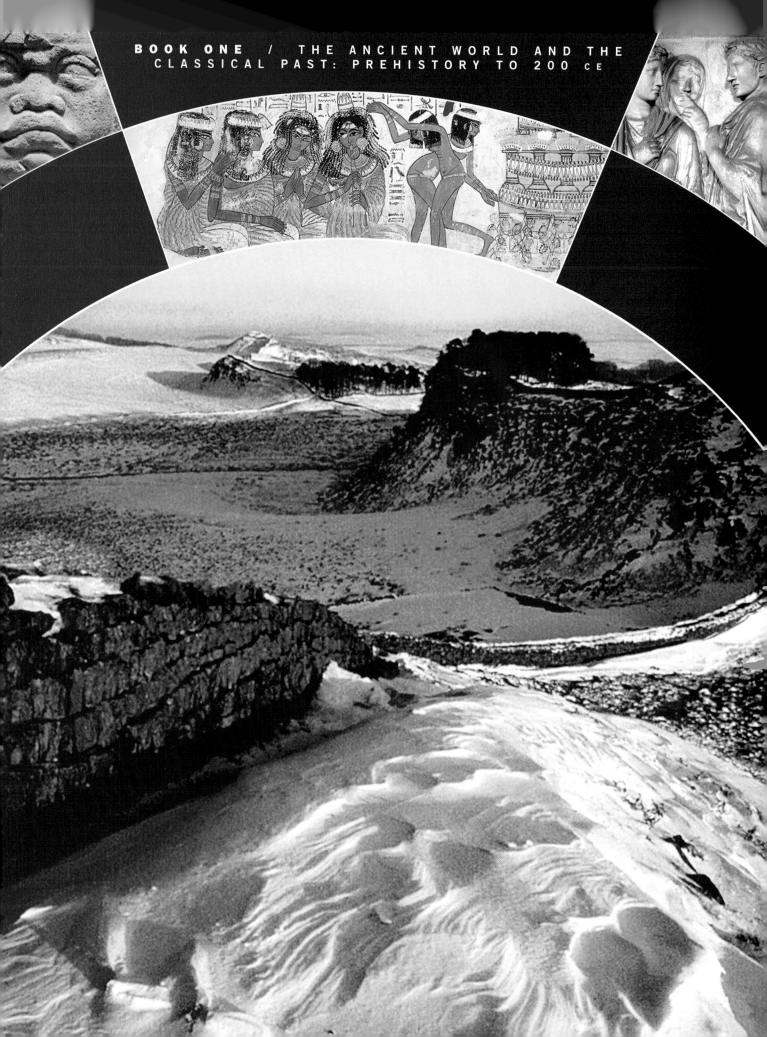

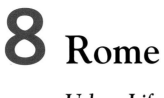

8 Rome

Urban Life and Imperial Majesty

> **"** *Others [namely Greeks], no doubt, will better mould*
> *the bronze*
> *To the semblance of soft breathing, draw, from marble*
> *The living countenance;. . .*
> *remember, Roman,*
> *To rule the people under law, to establish*
> *The way of peace, to battle down the haughty,*
> *To spare the meek. Our fine arts, these, forever.* **"**
>
> Virgil, *Aeneid*

◄ **Fig. 8.1 Hadrian's Wall, seen from near Housesteads, England. 2nd century CE.** Built by the emperor Hadrian (r. 117–138 CE) to protect the northern frontier of the Roman Empire from the Picts and Scots to the north, the wall stretched 73 miles and was 20 feet high and 8 to 10 feet thick. Forts were inserted at 5-mile intervals, and troops were stationed in turrets every mile along its length. The wall epitomizes the imperial reach of the empire, its military power, and its bureaucratic skill.

ROME, OF ALL THE CULTURES TO ARISE IN THE MEDITERRANEAN, would become the most powerful, the political center of a vast empire. At the height of its power, the Roman Empire stretched from Scotland in the north (Fig. **8.1**) to the oases of the Sahara Desert in the south, from the Iberian Peninsula in the

west to Asia Minor as far as the Tigris River in the east (Map **8.1**). Rome saw itself as the model for all other cities in its empire. The building program that distinguished the imperial city— its amphitheaters, theaters, racetracks, and baths, its forums, temples, triumphal arches, broad avenues, and aqueducts—all these amenities were replicated in the territories the Romans conquered. Whether in Gaul or North Africa, Anatolia or Spain, the Roman citizen deserved to live like a Roman. Rome admired Greece for its cultural achievements, from its philosophy to its sculpture, and, as we have seen, its own art developed from Hellenistic models. But Rome admired its own achievements as well, and its art differed from that of its Hellenic predecessors in certain key respects. Instead of depicting mythological events and heroes, Roman artists depicted current events and real people, from generals and their military exploits to portraits of their leaders and recently deceased citizens. They celebrated the achievements of a state that was their chief patron so that all the world might stand in awe of the state's accomplishments.

Nowhere was this identity more fully expressed than in Roman architecture. Though the structural principles of the arch had long been known, the Romans mastered the form, allowing for the construction of larger, more open spaces than ever before. They invented concrete, which provided the structural strength to support such expansive spaces. The Romans were great engineers, and public works were fundamental to the Roman sense of identity, propagandistic tools that symbolized Roman power.

This chapter traces the rise of Roman civilization from its Greek and Etruscan origins in the sixth century BCE to about 180 CE, when the empire began its slow decline. Based on values developed in Republican Rome and extended to the Imperial state, the Roman citizen owed the state dutiful respect. As the rhetorician and orator Marcus Tullius Cicero put it in his first-century BCE essay, *On Duty*, "It is our duty, then, to be more ready to endanger our own than the public welfare." This sense of duty was mirrored in family life, where reverence for one's ancestors was reflected in the profusion of portrait busts that decorated Roman households. One was obliged to honor one's father as one honored Rome itself. The family became one of the focuses of the first Roman emperor, Augustus, and his dedication to it was reflected in his public works and statuary, and

in the work of the artists and writers he supported. But the lasting legacy of Augustus was his transformation of Rome into what he called "a city of marble." Subsequent emperors in the first two centuries CE would continue to transform Rome until it was arguably the most magnificent center of culture ever built.

Origins of Roman Culture

The origins of Roman culture are twofold. On the one hand, there were the Greeks, who as early as the eighth century BCE colonized the southern coastal regions of the Italian peninsula and Sicily and whose Hellenic culture the Romans adopted for their own. On the other hand, there were the Etruscans. Scholars continue to debate whether the Etruscans were indigenous to Italy or whether they migrated from the near East. In the ninth and eighth centuries BCE, the Etruscans became known to the outside world for their mineral resources, and by the seventh and sixth centuries they were major exporters of fine painted pottery, a black ceramic ware known as *bucchero*, bronze-work, jewelry, oil, and wine. By the fifth century BCE, they were known throughout the Mediterranean for their skill as sculptors in both bronze and terra cotta.

Greek and Etruscan Roots

The Etruscan homeland, Etruria, occupied the part of the Italian peninsula that is roughly the same as modern-day Tuscany (see Map **8.1**). It was bordered by the Arno River to the north (which runs through Florence) and the Tiber River to the south (which runs through Rome). No Etruscan literature survives, although around 9,000 epigrammatic texts do, enough to make clear that even though the alphabet was related to Greek, the language itself was unrelated to any other in Europe. Scholars know how to pronounce most of its words, although they do not understand the words themselves. Most of what we know about the Etruscans comes from their art, which has survived particularly in burial tombs decorated with vases, sculptures, and paintings, including large numbers of Attic vases that not only demonstrate the extent of Etruscan trade but contribute much to our understanding of Greek art.

Map 8.1 The Roman Empire at its greatest extent, ca. 180 CE. By 180 CE the Roman Empire extended from the Atlantic Ocean in the west to Asia Minor, Syria, and Palestine in the east, and from Scotland in the north to the Sahara Desert in North Africa.

Tombs: Clues to Etruscan Life The Etruscans buried their dead in cemeteries removed from their cities. The tombs were arranged in neat rows along a network of streets. They used a type of tomb called a **tumulus**, a round structure partially below and partially above ground and covered with earth. Inside, the burial chambers are rectangular and resemble domestic architecture. In fact, they may resemble actual Etruscan homes—only the foundations of their homes survive so we cannot be sure—since entire families were buried together. Plaster reliefs on the walls include kitchen implements, tools, and, in general, the

necessities for everyday life, suggesting that the Etruscan sense of the afterlife was in some ways similar to that of the Egyptians, with whom, incidentally, they traded.

Most of what we know about the Etruscans comes from the sculptures and paintings that have survived in tombs. Women evidently played a far more important role in Etruscan culture than in Greece, and Roman culture would later reflect the Etruscan sense of women's equality. On Etruscan **sarcophagi**, or coffins, many of which are made of terra cotta, there are many examples of husbands and wives reclining together. One

Continuity & Change
p. 170

Anavysos Kouros

of the most famous examples comes from Cerveteri, on the coast north of Rome (Fig. **8.2**). Husband and wife are depicted reclining on a dining couch, and they are given equal status. Their hands are animated, their smiles full, and they seem engaged in a lively dinner conversation. Their smiles, in fact, are reminiscent of the Greek Archaic smiles found on sculptures such as the nearly contemporary *Anavysos Kouros* (see Fig. 6.10), suggesting that the Etruscans were acquainted with Greek art.

Architectural Influences Because of their mud-brick wall and wooden column construction, only the foundations of Etruscan temples (Figs. **8.3**, **8.4**) survive, but we know something of what they looked like from surviving votive terra-cotta models and from written descriptions. The first-century BCE Roman architect Vitruvius described Etruscan temples in writings that date from between 46 and 39 BCE, 700 years after the Etruscans built them. They were constructed on a platform, or **podium** with a single set of steps up to a front porch or portico. The ground plan was almost square and the space was divided about equally between the porch and three interior rooms that probably housed cult statues (Figs. **8.3** and **8.4**).

The Etruscans also adapted the Greek Doric order to their own ends, creating what Vitruvius called the **Tuscan order** (Fig. **8.5**). The Tuscan order utilized an unfluted, or smooth, shaft and a pedestal base. Overall, the Tuscan order shares with the Doric a sense of geometric simplicity. But the

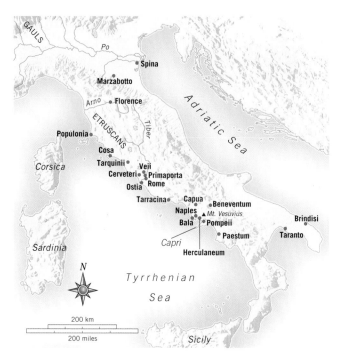

Map 8.2 Italy in the third–second centuries BCE, including earlier Etruscan cities and Greek colonies.

Etruscan temples were also heavily decorated with brightly colored paintings, probably similar to those that survive in the tombs, and their roofs were decorated with sculptural groups. Both of these features must have lent them an air of visual richness and complexity.

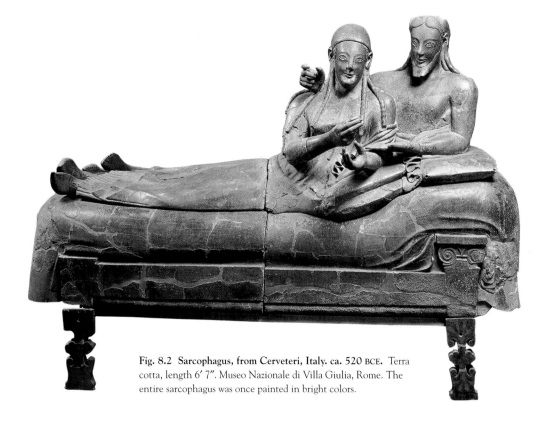

Fig. 8.2 Sarcophagus, from Cerveteri, Italy. ca. 520 BCE. Terra cotta, length 6′ 7″. Museo Nazionale di Villa Giulia, Rome. The entire sarcophagus was once painted in bright colors.

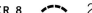

Map 8.1 The Roman Empire at its greatest extent, ca. 180 CE. By 180 CE the Roman Empire extended from the Atlantic Ocean in the west to Asia Minor, Syria, and Palestine in the east, and from Scotland in the north to the Sahara Desert in North Africa.

Tombs: Clues to Etruscan Life The Etruscans buried their dead in cemeteries removed from their cities. The tombs were arranged in neat rows along a network of streets. They used a type of tomb called a **tumulus**, a round structure partially below and partially above ground and covered with earth. Inside, the burial chambers are rectangular and resemble domestic architecture. In fact, they may resemble actual Etruscan homes—only the foundations of their homes survive so we cannot be sure—since entire families were buried together. Plaster reliefs on the walls include kitchen implements, tools, and, in general, the

necessities for everyday life, suggesting that the Etruscan sense of the afterlife was in some ways similar to that of the Egyptians, with whom, incidentally, they traded.

Most of what we know about the Etruscans comes from the sculptures and paintings that have survived in tombs. Women evidently played a far more important role in Etruscan culture than in Greece, and Roman culture would later reflect the Etruscan sense of women's equality. On Etruscan **sarcophagi**, or coffins, many of which are made of terra cotta, there are many examples of husbands and wives reclining together. One

Continuity & Change
p. 170

Anavysos Kouros

of the most famous examples comes from Cerveteri, on the coast north of Rome (Fig. **8.2**). Husband and wife are depicted reclining on a dining couch, and they are given equal status. Their hands are animated, their smiles full, and they seem engaged in a lively dinner conversation. Their smiles, in fact, are reminiscent of the Greek Archaic smiles found on sculptures such as the nearly contemporary *Anavysos Kouros* (see Fig. 6.10), suggesting that the Etruscans were acquainted with Greek art.

Architectural Influences Because of their mud-brick wall and wooden column construction, only the foundations of Etruscan temples (Figs. **8.3**, **8.4**) survive, but we know something of what they looked like from surviving votive terracotta models and from written descriptions. The first-century BCE Roman architect Vitruvius described Etruscan temples in writings that date from between 46 and 39 BCE, 700 years after the Etruscans built them. They were constructed on a platform, or **podium** with a single set of steps up to a front porch or portico. The ground plan was almost square and the space was divided about equally between the porch and three interior rooms that probably housed cult statues (Figs. **8.3** and **8.4**).

The Etruscans also adapted the Greek Doric order to their own ends, creating what Vitruvius called the **Tuscan order** (Fig. **8.5**). The Tuscan order utilized an unfluted, or smooth, shaft and a pedestal base. Overall, the Tuscan order shares with the Doric a sense of geometric simplicity. But the

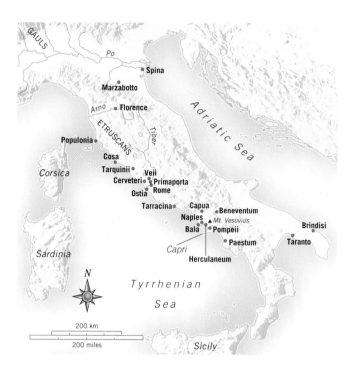

Map 8.2 Italy in the third–second centuries BCE, including earlier Etruscan cities and Greek colonies.

Etruscan temples were also heavily decorated with brightly colored paintings, probably similar to those that survive in the tombs, and their roofs were decorated with sculptural groups. Both of these features must have lent them an air of visual richness and complexity.

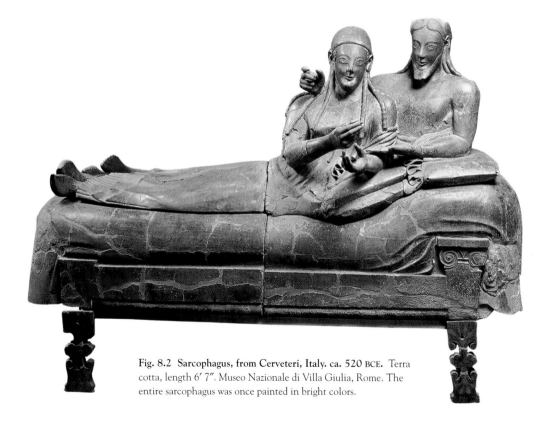

Fig. 8.2 Sarcophagus, from Cerveteri, Italy. ca. 520 BCE. Terra cotta, length 6′ 7″. Museo Nazionale di Villa Giulia, Rome. The entire sarcophagus was once painted in bright colors.

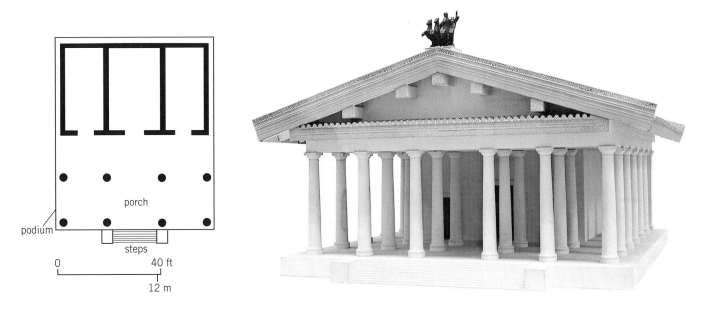

Figs. 8.3 and 8.4 Plan and reconstruction model of an Etruscan temple. Instituto di Etruscologia e Antichità Italiche, University of Rome. Note the sculptures adorning the roof, an innovation in Etruscan architecture very different from the relief sculptures decorating the pediments and entablatures of the Greek temple.

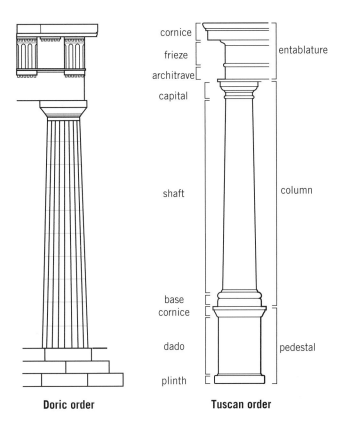

Doric order **Tuscan order**

The later Romans modified the Tuscan order by adding a much more elaborate pedestal, but their debt to Etruscan temples is especially evident if we compare the Etruscan model and its plan to a Roman temple from the late second century BCE (Figs. **8.6**, **8.7**), the Temple of Portunus [por-TOO-nus], (also known as the Temple of Fortuna Virilis [for-TOO-nuh vee-RIL-is]). Dedicated to Portunus, the god of harbors and ports, the temple stands beside the Tiber River and represents a mixture of Etruscan and Greek influences. Like the Etruscan temple, it is elevated on a podium and approached by a set of stairs at the front. Although more rectangular than its Etruscan ancestor, its floor plan is similarly divided between exterior porch and interior space. But it utilizes the Greek Ionic order and its interior consists of a single room, or cella. The Ionic columns represent a new direction in exterior design.

Fig. 8.5 Doric and Tuscan orders. The Tuscan order illustrated here is a later Roman version of the early Tuscan order. The simple base of the column, evident in the temple model in Figure 8.7 but never found in the Doric order, was elaborated by the Romans into a pedestal composed of a plinth, a dado, and a base cornice.

Though freestanding on the porch, they are *engaged* around the cella. That is, they serve no real support function, but rather are decorative additions that give the effect of a continuous colonnade surrounding the cella.

The double ancestry of the Temple of Portunus, both Etruscan and Greek, is reflected in almost every aspect of early Roman culture. Even geographically, Rome lies between the two cultures, with the Greek colonies to the south and the Etruscan settlements to the north. Its situation, in fact, is geographically improbable. Rome was built on a hilly site (seven hills to be precise) on the east bank of the Tiber. Its low-lying areas were swampy and subject to flooding, while the higher elevations of the hillsides did not easily lend themselves to building. The river Tiber itself provides a sensible explanation for the city's original siting, since it gave the city a trade route to the north and access to the sea at its port of Ostia to the south. And so does Tiber Island, next to the Temple of Portunus, which was one of the river's primary crossings from the earliest times. Thus, Rome was physically and literally the crossing place of Etruscan and Greek cultures (see Map 8.2).

The Etruscan Founding Myth The city also had competing foundation myths. One was Etruscan. Legend had it that twin infants named Romulus and Remus were left to die on the banks of the Tiber but were rescued by a she-wolf who suckled them (Fig. **8.8**). Raised by a shepherd, the twins decided to build a city on the Palatine Hill above the spot where they had been saved (accounting, in the manner of foundation myths, for the unlikely location of the city). Soon, the two boys feuded over who would rule the new city. In his *History of Rome*, the Roman historian Livy (59 BCE–17 CE) briefly describes the ensuing conflict:

> Then followed an angry altercation; heated passions led to bloodshed; in the tumult Remus was killed. The more common report is that Remus contemptuously jumped over the newly raised walls and was forthwith killed by the enraged Romulus, who exclaimed, "So shall it be henceforth with every one who leaps over my walls." Romulus thus became sole ruler, and the city was called after him, its founder.

The date, legend has it, was 753 BCE.

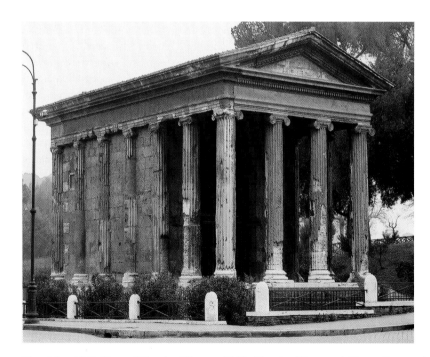

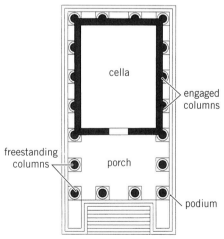

cella

engaged columns

freestanding columns

porch

podium

Figs. 8.6 and 8.7 Plan and Temple of Fortuna Virilis (Temple of Portunus), Forum Boarium (cattle market), Rome. Late 2nd century BCE. This temple stood next to the Bridge of Amelius, remnants of which still survive. The bridge crossed the Tiber River just below Tiber Island.

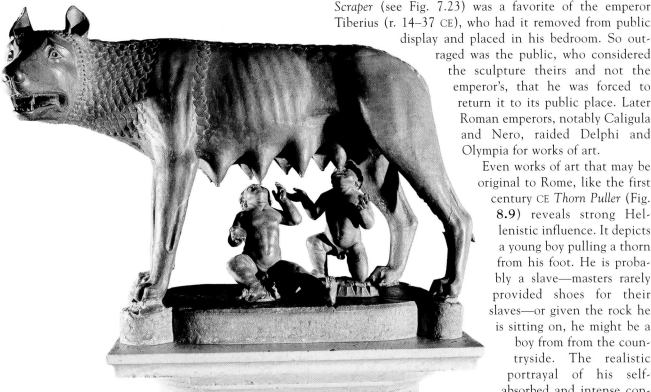

Scraper (see Fig. 7.23) was a favorite of the emperor Tiberius (r. 14–37 CE), who had it removed from public display and placed in his bedroom. So outraged was the public, who considered the sculpture theirs and not the emperor's, that he was forced to return it to its public place. Later Roman emperors, notably Caligula and Nero, raided Delphi and Olympia for works of art.

Even works of art that may be original to Rome, like the first century CE *Thorn Puller* (Fig. 8.9) reveals strong Hellenistic influence. It depicts a young boy pulling a thorn from his foot. He is probably a slave—masters rarely provided shoes for their slaves—or given the rock he is sitting on, he might be a boy from from the countryside. The realistic portrayal of his self-absorbed and intense concentration combined with the beauty of his physique both suggest the Roman attraction to Hellenistic precedents.

Fig. 8.8 *She-Wolf.* **ca. 500–480 BCE.** Bronze, with glass-paste eyes, height 33″. Museo Capitolino, Rome. The two suckling figures representing Romulus and Remus are Renaissance additions. This Etruscan bronze, which became a symbol of Rome, combines a ferocious realism with the stylized portrayal of, for instance, the wolf's geometrically regular mane.

Hellenized Rome The second founding myth, as told by the poet Virgil (70–19 BCE) in his epic poem the *Aeneid,* was Greek. By the second and first centuries BCE, Rome had achieved political control of the entire Mediterranean. But even after Rome conquered Greece in 146 BCE, Greece could be said to "rule" Rome, at least culturally. Rome was a fully Hellenized culture—it fashioned itself in the image of Greece almost from its beginnings. Indeed, many of the works of Greek art reproduced in this book are not Greek at all but later Roman copies of Greek originals. The Romans loved Greek art. Julius Caesar would set up the Pergamene *Dying Gaul* (see Fig. 7.27) as a symbol of his own triumph over the Gauls of France from 58 to 51 BCE. Augustus (r. 27 BCE–14 CE), sought to transform Rome into the image of Pericles's Athens. Lysippus's

Continuity & Change
p. 217

Dying Gaul

No sculpture speaks to the Hellenization of Rome more powerfully than *Laocoön and His Sons* (Fig. 8.10). The Roman writer Pliny the Elder attributed it to three sculptors from Rhodes, who were clearly inspired by the Altar of Zeus at Pergamon (see Figs. 7.25, 7.26). It is made of Italian marble, and some scholars believe it to be an original, others a brilliant copy. It dates from the very early years of the first century CE and was found in the ruins of the emperor Titus's (r. 79–81 CE) palace, exactly where Pliny had originally seen it. Its subject is the punishment of the Trojan priest Laocoön, who warned his countrymen against accepting the "gift" of a wooden horse from the Greeks.

Rome traced its origins back to the Trojan warrior Aeneas, who at the end of the Trojan War sailed off to found a new homeland for his people. Aeneas's story is recounted by the poet Virgil (70–19 BCE) in the *Aeneid,* an epic

Fig. 8.9 *Thorn-Puller.* **Late 1st century BCE.** Bronze, height 33″. Capitoline Museums, Rome, Italy. The statue is one of the few large-scale bronze sculptures to survive from antiquity.

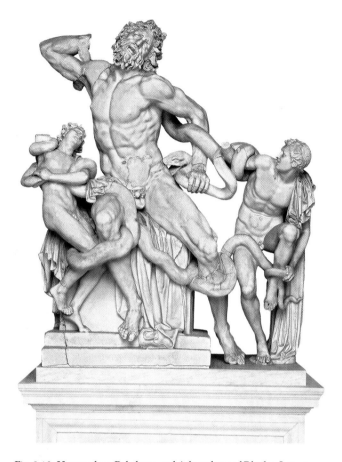

Fig. 8.10 Hagesandros, Polydoros, and Athanadoros of Rhodes. *Laocoön and His Sons*, marble copy of an original bronze probably made at Pergamon, **ca. 150** BCE. Marble, height 8′ 1/2″. Museo Pio Clementino, Vatican Museums, Vatican State. Pliny the Elder attributes the sculpture to the three artists from Rhodes. It is possible that Virgil knew of the original when he composed his poem that so fully describes this moment. It seems likely that the copy was inspired by the success of Virgil's poem.

poem written around 30–19 BCE. In Book II, Virgil recounts Laocoön's protest (**Reading 8.1**):

READING 8.1a **Virgil, *Aeneid*, Book II**

"Are you crazy wretched people?
Do you think they have gone, the foe? Do you think that any
Gifts of the Greeks lack treachery? Ulysses,[1]—
What was his reputation? Let me tell you,
Either the Greeks are hiding in this monster,
Or it's some trick of war, a spy, or engine,
To come down on the city. Tricky business
Is hiding in it. Do not trust it, Trojans,
Do not believe this horse. Whatever it may be,
I fear the Greeks even when bringing presents."
With that, he hurled the great spear at the side
With all the strength he had. I hastened, trembling,
And the struck womb rang hollow, a moaning sound.

[1] **Ulysses:** The Roman name for Odysseus.

But Laocoön's warning is ignored, and a few pages later Aeneas describes how the gods (probably Athena) who supported the Greeks punished Laocoön:

READING 8.1b **Virgil, *Aeneid*, Book II**

I shudder even now,
Recalling it—there came a pair of serpents
With monstrous coils, breasting the sea, and aiming
Together for the shore. Their heads and shoulders
Rose over the waves, upright, with bloody crests,
The rest of them trailing along the water,
Looping in giant spirals; the foaming sea
Hissed under their motion. And they reached the land,
Their burning eyes suffused with blood and fire,
Their darting tongues licking the hissing mouths.
Pale at the sight, we fled. But they went on
Straight toward Laocoön, and first each serpent
Seized in its coils his two young sons, and fastened
The fangs in those poor bodies. And the priest
Struggled to help them, weapons in his hand.
They seized him, bound him with their mighty coils,
Twice round his waist, twice round his neck, they squeezed
With scaly pressure, and still towered above him.
Straining his hands to tear the knots apart,
His chaplets[1] stained with blood and the black poison,
He uttered horrible cries, not even human,
More like the bellowing of a bull when, wounded,
It flees the altar, shaking from the shoulder
The ill-aimed axe.

[1] **chaplets:** Garlands for the head.

Hopelessly entangled in the coiled snakes, crushed by them together with his sons, the sculptured Laocoön appears to be caught in the middle of his cry, a cry that is almost audible to the viewer. The drama and expressionism of the sculpture are pure Hellenism. So too are its complex interweaving of elements and diagonal movements, reminiscent of Athena's struggle with the giants on the frieze of the Altar of Zeus at Pergamon (see Fig. 7.26). In the tradition of the *Dying Gaul*—and, for that matter, the *Iliad*—it embodies the heroism and nobility of a righteous death.

And yet Virgil's poem Romanizes the scene. Virgil incorporates Greek culture as part and parcel of Roman tradition even as he rejects it, a fact that becomes apparent in comparing Virgil's version to Homer's description of the same scene in the *Odyssey*. At the end of Book 8, Odysseus asks a minstrel to sing the story of the wooden horse:

The minstrel stirred, murmuring to the god, and soon
clear words and notes came one by one, a vision
of the Akhaians in their graceful ships

drawing away from shore: the torches flung
and shelters flaring: Argive soldiers crouched
in the close dark around Odysseus: and
the horse, tall on the assembly ground of Troy.
For when the Trojans pulled it in, themselves,
up to the citadel, they say nearby
with long-drawn-out and hapless argument—
favoring, in the end, one course of three:
either to stave the vault with brazen axes,
or to haul it to a cliff and pitch it down,
or else to save it for the gods, a votive glory—
the plan that could not but prevail.
For Troy must perish, as ordained, that day. . . .

Though Laocoön's position on the wooden horse is articulated, no mention is made of him—nor in the entire *Odyssey*—let alone his terrible fate. Virgil's debt to Homer is clear. In fact, the first six books of the *Aeneid,* in which Aeneas's wanderings through the Mediterranean are narrated, could be said to mirror the *Odyssey,* while the last six books are a war story similar to the *Iliad.* But Laocoön is not an Homeric character (Virgil probably knew him through a Greek epic cycle dating from the seventh and sixth centuries BCE of which only a few fragments survive). He is, by and large, a Roman invention.

If the Romans trace their origins to the Trojans, Laocoön functions in Virgil's poem as almost the sole embodiment of wisdom among their ancestors and as Rome's first martyr, sacrificed together with his children to the gods. Both the Laocoön sculpture and Virgil's poem celebrate this martyrdom. But Laocoön's warning against Greeks bearing gifts had clear cultural implications for Virgil. In Book 6, the ghost of Aeneas's father Anchises tells his son:

Others, no doubt, will better mould the bronze
To the semblance of soft breathing, draw, from marble,
The living countenance; and other plead
With greater eloquence, or learn to measure,
Better than we, the pathways of the heaven,
The risings of the stars: remember, Roman,
To rule the people under law, to establish
The way of peace, to battle down the haughty,
To spare the meek. Our fine arts, these, forever.

If the Greeks brought to Rome the gifts of art, rhetoric, and scientific knowledge, it remained for Rome to rule wisely—this was the art they practiced best. Good governance would become, Virgil's *Aeneid* argued, Rome's historical destiny.

Republican Rome

By the time of Virgil, the Greek and Etruscan myths had merged. Accordingly, Aeneas's son founded the city of Alba Longa, just to the south of Rome, which was ruled by a succession of kings until Romulus brought it under Roman control.

According to legend, Romulus inaugurated the traditional Roman distinction between **patricians**, the land-owning aristocrats who served as priests, magistrates, lawyers, and judges, and **plebians**, the poorer class who were craftspeople, merchants, and laborers. When, in 510 BCE, the Romans expelled the last of the Etruscan kings and decided to rule themselves without a monarch, the patrician/plebian distinction became very similar to the situation in fifth-century BCE Athens. There, a small aristocracy who owned the good land and large estates shared citizenship with a much larger working class (see chapter 6).

In Rome, as in the Greek model, every free male was a citizen, but in the Etruscan manner, not every citizen enjoyed equal privileges. The Senate, the political assembly in charge of creating law, was exclusively patrician. In reaction, the plebians formed their own legislative assembly, the Consilium Plebis (Council of Plebians), to protect themselves from the patricians, but the patricians were immune from any laws the plebians passed, known as *plebiscites.* Finally, in 287 BCE, the plebiscite became binding law on all citizens, and something resembling equality of citizenship was assured.

The expulsion of the Etruscan kings and the dedication of the Temple of Jupiter on the Capitoline Hill in 509 BCE mark the beginning of actual historical records documenting the development of Rome. They also mark the beginning of the Roman Republic, a state whose political organization rested on the principle that the citizens were the ultimate source of legitimacy and sovereignty. Many people believe that the Etruscan bronze head of a man (Fig. **8.11**) is a portrait of Lucius Junius Brutus, the founder and first consul of the Roman Republic. However, it dates from approximately 100–200 years after Brutus's life, and it more likely represents a noble "type," an imaginary portrait of a Roman founding father, or *pater,* the root of the word *patrician.* This role is conveyed through the figure's strong character and strength of purpose.

In republican Rome every plebian chose a patrician as his patron, whose duty it was to represent the plebian in any matter of law. This paternalistic relationship—which we call *patronage*—reflected the family's central role in Roman culture. The *pater,* "father," protected not only his wife and family but also his clients, who submitted to his patronage. In return for the pater's protection, family and client equally owed the *pater* their total obedience—which the Romans referred to as *pietas,* "dutifulness." So embedded was this attitude that when toward the end of the first century BCE the Republic declared itself an empire, the emperor was called *pater patriae,* "father of the fatherland."

Roman Rule

By the middle of the third century BCE, the Republic had embarked on a series of military exploits that recall Alexander's imperial adventuring of the century before. For over 100 years, beginning in 264 BCE, the Republic advanced against Carthage, the Phoenician state in present-day Tunisia (see Map 8.1). Carthage controlled most of the wealth of the

western Mediterranean, including the vast agricultural and commercial resources of Sicily, Sardinia, Corsica, and the eastern portion of the Iberian peninsula.

In his *History of Rome*, Livy immortalized the Carthaginian general Hannibal's march, from what is now Spain, over the Pyrenees, across the Rhône River, and through the Alps with his army of nearly 100,000 men—including a contingent of elephants. (Perhaps this was meant to imitate the armies of India that had terrorized Alexander's troops.) Hannibal laid waste to most of northern Italy, defeating an army of 80,000 men in 216 BCE, the worst defeat in Roman history. But Rome eventually defeated him by adopting a policy "always to fight him where he is not," cutting off supplies from the Iberian Peninsula, and counterattacking back home in Carthage. When Hannibal returned to defend his homeland, in 202 BCE, without ever having lost a battle to the Romans in Italy, he was defeated by the general Scipio [SEE-pee-oh] Africanus (236–ca. 184 BCE) in northern Africa. Despite the fact that Hannibal had occupied Italy for 15 years, marching to the very gates of Rome in 211, his eventual defeat led the Romans (and their potential adversaries) to believe Rome was invincible.

Meanwhile, in the eastern Mediterranean, Philip V of Macedonia (r. 221–179 BCE), Alexander's heir, had made an alliance with Hannibal and threatened to overrun the Greek peninsula. With Greek help, the Romans defeated him in the northern Greek region of Thessaly in 197 BCE, then pressed on into Asia Minor, which they controlled by 189 BCE. (Just over 50 years later, in 133 BCE, Attalos III of Pergamon would deed his city and all its wealth to Rome.) Finally, in the Third Punic War (149–146 BCE), the Romans took advantage of a weakened Carthage and destroyed the city, plowing it under and sprinkling salt in the furrows to symbolize the city's permanent demise. Its citizens were sold into slavery. When all was said and done, Rome controlled almost the entire Mediterranean world (see Map 8.1).

The Aftermath of Conquest Whenever Rome conquered a region, it established permanent colonies of veteran soldiers who received allotments of land, virtually guaranteeing them a certain level of wealth and status. These soldiers were citizens. If the conquered people proved loyal to Rome, they could gain full Roman citizenship. Furthermore, when not involved in combat, the local Roman soldiery transformed themselves into engineers, building roads, bridges, and civic projects of all types, significantly improving the region. In this way, the Republic diminished the adversarial status of its colonies and gained their loyalty.

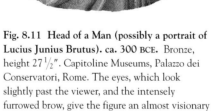

Fig. 8.11 Head of a Man (possibly a portrait of Lucius Junius Brutus). ca. 300 BCE. Bronze, height 27½″. Capitoline Museums, Palazzo dei Conservatori, Rome. The eyes, which look slightly past the viewer, and the intensely furrowed brow, give the figure an almost visionary force and suggest the influence of Lysippus (compare Fig. 7.21).

The prosperity brought about by Roman expansion soon created a new kind of citizen. They called themselves *equites* ("equestrians") to connect them to the cavalry, the elite part of the military, since only the wealthy could afford the necessary horses. The *equites* were wealthy businessmen, but not often landowners and therefore not patricians. The patricians considered the commercial exploits of the *equites* crass and their wealth ill-gotten. Soon the two groups were in open conflict, the *equites* joining ranks with the plebians.

The Senate was the patrician stronghold, and it feared any loss of power and authority. When the general Pompey the Great (106–48 BCE), returned from a victorious campaign against rebels in Asia Minor in 62 BCE, the Senate refused to ratify the treaties he had made in the region and refused to grant the land allotments he had given his soldiers. Outraged, Pompey joined forces with two other successful military leaders. One had put down the slave revolt of Spartacus in 71 BCE. The other was Gaius Julius Caesar (100–44 BCE), a military leader from a prestigious patrician family that claimed descent from Aeneas and Venus. The union of the three leaders became known as the First Triumvirate.

A Divided Empire Wielding the threat of civil war, the First Triumvirate soon dominated the Republic's political life, but theirs was a fragile relationship. Caesar accepted a five-year appointment as governor of Gaul, present-day France. By 49 BCE, he had brought all of Gaul under his control. He summed up this conquest in his *Commentaries* in the famous phrase "Veni, vidi, vinci"—"I came, I saw, I conquered"—a statement that captures, perhaps better than any other, the militaristic nature of the Roman state as a whole. He was preparing to return home when Pompey joined forces with the Senate. They reminded him of a long-standing tradition that required a returning commander to leave his army behind, in this case on the Gallic side of the Rubicon River, but he refused. Pompey fled to Greece, where Caesar defeated him a year later. Again Pompey fled, this time to Egypt, where he was murdered. The third member of the Triumvirate had been captured and executed several years earlier.

Now unimpeded, Caesar assumed dictatorial control over Rome. Caesar treated the Senate with disdain, and most of its membership counted themselves as his enemies. On March 15, 44 BCE, the Ides of March, he was stabbed 23 times by a group of 60 senators at the foot of a sculpture honoring Pompey on the floor of the Senate. This scene was memorialized in English by Shakespeare's great play *Julius Caesar* and Caesar's famous line, as he sees his ally Marcus Junius Brutus (85–42 BCE) among the assassins, "Et tu, Brute?"—"You also, Brutus?" Brutus and the others believed they had freed Rome

of a tyrant, but the people were outraged, the Senate disgraced, and Caesar martyred.

Caesar had recognized that his position was precarious, and he had prepared a member of his own family to assume power in his place, his grandnephew, Gaius Octavius, known as Octavian (63 BCE–14 CE), whom he adopted as son and heir. Although only 18 years old when Caesar died, Octavian quickly defeated his main rival, Marcus Antonius (ca. 82–30 BCE), known as Mark Antony. He then adroitly formed an alliance with Mark Antony and Marcus Emilius Lepidus (died ca. 12 BCE), another of Caesar's officers, known as the Second Triumvirate. Octavian and Antony pursued Cassius and Brutus into Macedonia and defeated them at the battle of Philippi. Octavian, Antony, and Lepidus then divided up the empire, which was larger than any one person could control and govern: Lepidus got Africa, Antony the eastern provinces including Egypt, and Octavian the west, including Rome. Lepidus soon plotted against the young dictator, but Octavian persuaded Lepidus's troops to desert him. Antony, meanwhile, had formed an alliance with Cleopatra VII, the queen of Egypt (ruled 51–31 BCE). When Octavian defeated Antony at the battle of Actium in 31 BCE, Antony and Cleopatra committed suicide. Octavian was left the sole ruler of the empire. He assumed power as a monarch in everything but actual title.

Cicero and the Politics of Rhetoric

In times of such political upheaval, it is not surprising that one of the most powerful figures of the day would be someone who specialized in the art of political persuasion. In pre-Augustan Rome that person was the **rhetorician** (writer and public speaker, or orator) Marcus Tullius Cicero (106–43 BCE). First and foremost, Cicero recognized the power of the Latin language to communicate with the people. Although originally used almost exclusively as the language of commerce, Latin, by the first century CE, was understood to be potentially a more powerful tool of persuasion than Greek, still the literary language of the upper classes. The clarity and eloquence of Cicero's style can be quickly discerned, even in translation, as an excerpt (**Reading 8.2**) from his essay *On Duty* demonstrates.

READING 8.2 **Cicero, *On Duty***

That moral goodness which we look for in a lofty, high-minded spirit is secured, of course, by moral, not physical strength. And yet the body must be trained and so disciplined that it can obey the dictates of judgment and reason in attending to business and in enduring toil. But that moral goodness which is our theme depends wholly upon the thought and attention

given to it by the mind. And, in this way, the men who in a civil capacity direct the affairs of the nation render no less important service than they who conduct its wars: by their statesmanship oftentimes wars are either averted or terminated; sometimes also they are declared. Upon Marcus Cato's counsel, for example, the Third Punic War was undertaken, and in its conduct his influence was dominant, even after he was dead. And so diplomacy in the friendly settlement of controversies is more desirable than courage in settling them on the battlefield; but we must be careful not to take that course merely for the sake of avoiding war rather than for the sake of public expediency. War, however, should be undertaken in such a way as to make it evident that it has no other object than to secure peace.

But it takes a brave and resolute spirit not to be disconcerted in times of difficulty or ruffled and thrown off one's feet, as the saying is, but to keep one's presence of mind and one's self-possession and not to swerve from the path of reason.

Now all this requires great personal courage; but it also calls for great intellectual ability by reflection to anticipate the future, to discover some time in advance what may happen whether for good or for ill, and what must be done in any possible event, and never to be reduced to having to say "I had not thought of that."

These are the activities that mark the spirit strong, high, and self-reliant in its prudence and wisdom. But to mix rashly in the fray and to fight hand to hand with the enemy is but a barbarous and brutish kind of business. Yet when the stress of circumstances demands it, we must gird on the sword and prefer death to slavery and disgrace. . . .

We must, of course, never be guilty of seeming cowardly and craven in our avoidance of danger; but we must also beware of exposing ourselves to danger needlessly. Nothing can be more foolhardy than that. . . .

The dangers attending great affairs of state fall sometimes on those who undertake them, sometimes upon the state. In carrying out such enterprises, some run the risk of losing their lives, others their reputation and the good-will of their fellow-citizens. It is our duty, then, to be more ready to endanger our own than the public welfare and to hazard honor and glory more readily than other advantages. . . .

Philosophically, Cicero's argument extends back to Plato and Aristotle, even Hesiod (see chapter 6), but rhetorically—that is, in the structure of its argument—it is purely Roman. It is purposefully deliberative in tone—that is, its chief concern is to give sage advice rather than to engage in a Socratic dialogue to evolve that advice.

In his speeches and his letters Cicero was particularly effective. His speeches were notoriously powerful. He understood, as he wrote in *De Oratore* (Concerning Oratory), that "Nature has assigned to each emotion a particular look and tone of voice and bearing of its own; and the whole of a person's frame and every look on his face and utterance of his voice are like strings of a harp, and sound according as they are struck by each successive emotion." In his letters, he could be disarmingly frank. After having invited Julius Caesar to dinner—in the struggle between Pompey and Caesar, Cicero had backed Pompey, and he hardly trusted the new dictator—he described the great man in a letter to his friend Atticus (**Reading 8.3**):

READING 8.3 Cicero, *Letters to Atticus*

Quite a guest, although I have no regrets and everything went very well indeed. . . . He was taking medicine for his digestion, so he ate and drank without worrying and seemed perfectly at ease. It was a lavish dinner, excellently served and in addition well prepared and seasoned with good conversation, very agreeable, you know. What can I say? We were human beings together. But he's not the kind of guest to whom you'd say "it's been fun, come again on the way back." Once is enough! We talked about nothing serious, a lot about literature: he seemed to enjoy it and have a good time. So now you know about how I entertained him—or rather had him billeted on me. It was a nuisance, as I said, but not unpleasant.

His ambivalence about Caesar notwithstanding, the "dangers attending great affairs of state" that concerned Cicero in his *On Duty* would come back to haunt him. Fearing Cicero's power, and angry that he had called Antony a tyrant in his speeches, the Second Triumvirate sent troops to hunt him down at his country estate in 43 BCE. Laena, their leader, severed Cicero's head, then presented it, in Rome, to Antony himself.

Portrait Busts, *Pietas*, and Politics

This historical context helps us understand a major Roman art form of the second and first centuries BCE, the portrait bust. These are generally portraits of patricians (and upper-middle-class citizens wishing to emulate them) rather than *equites*. Roman portrait busts share with their Greek ancestors an affinity for naturalistic representation, but they are even more realistic, revealing their subjects' every wrinkle and wart (Fig. **8.12**). This form of realism is known as **verism** (from the Latin *veritas*, "truth"). Indeed, the high level of naturalism, similar to the rebuilt plaster skulls found in Neolithic Jericho (see Fig. 1.9), may have resulted from their original form, wax death masks, called *imagines*, which were then transferred to stone.

◂━━
Continuity & Change
p. 211 ━▸

Alexander the Great

Compared to the Greek Hellenistic portrait bust—recall Lysippus's portrait of Alexander (see Fig. 7.21), copies of which proliferated throughout the Mediterranean in the third century BCE—the Roman portrait differs particularly in the age of the sitter. Both the Greek and Roman busts are essentially propagandistic in intent, designed to extol the virtues of the sitter, but where Alexander is portrayed as a young man at the height of his powers, the usual Roman portrait bust depicts its subject at or near the end of life. The Greek portrait bust, in other words, signifies youthful possibility and ambition, while the Roman version claims for its subject the wisdom and experience of age. These images celebrate *pietas*, the deep-seated Roman virtue of dutiful respect toward the gods, fatherland, and parents. To respect one's parents was tantamount, for the Romans, to respecting one's moral obligations to the gods. The respect one owed one's parents was, in effect, a religious obligation.

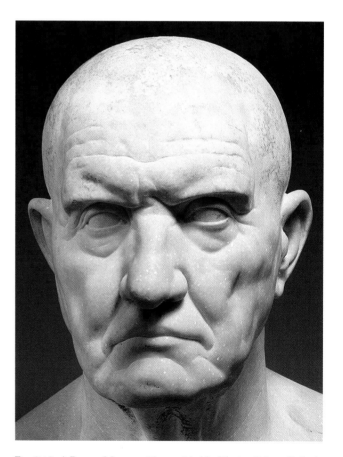

Fig. 8.12 *A Roman Man*. ca. 80 BCE. Marble, life-size. Palazzo Torlonia, Rome. The Metropolitan Museum of Art, Rogers Fund, 1912 (12.233). Image © The Metropolitan Museum of Art. His face creased by the wrinkles of age, this man is the very image of the *pater*, the man of *gravitas* (literally "weight," but also, "presence" or "influence"), *dignitas* ("dignity," "worth," and "character"), and *fides* ("honesty" and "conscientiousness").

If the connection to Alexander—especially the emphasis in both on the power of the gaze—is worth considering, the Roman portrait busts depict a class under attack, a class whose virtues and leadership were being threatened by upstart generals and *equites*. They are, in other words, the very picture of conservative politics. Their furrowed brows represent their wisdom, their wrinkles their experience, their extraordinarily naturalistic representation their character. They represent the Senate itself, which should be honored, not disdained.

Imperial Rome

On January 13, 27 BCE, Octavian came before the Senate and gave up all his powers and provinces. It was a rehearsed event. The Senate begged him to reconsider and take Syria, Gaul, and the Iberian Peninsula for his own (these provinces just happened to contain 20 of the 26 Roman legions, guaranteeing him military support). They also asked him to retain his title as consul of Rome, with the supreme authority of *imperium*, the power to give orders and exact obedience, over all of Italy and subsequently all Roman-controlled territory. He agreed "reluctantly" to these terms, and the Senate, in gratitude, granted him the semidivine title Augustus, "the revered one." Augustus (r. 27 BCE–14 CE) thereafter portrayed himself as a near-deity. The *Augustus of Primaporta* (Fig. **8.13**) is the slightly larger than life-size sculpture named for its location at the home of Augustus's wife, Livia, at Primaporta, on the outskirts of Rome. Augustus is represented as the embodiment of an admonition given to Aeneas by his dead father (*Aeneid*, Book 6):

> Others [namely Greeks], no doubt, will better mould the bronze
> To the semblance of soft breathing, draw, from marble
> The living countenance; . . .
> remember, Roman,
> To rule the people under law, to establish
> The way of peace, to battle down the haughty,
> To spare the meek. Our fine arts, these, forever.

Augustus, like Aeneas, is duty bound to exhibit *pietas*, the obligation to his ancestor "to rule earth's peoples."

The sculpture, though recognizably Augustus, is nevertheless idealized. It adopts the pose and ideal proportions of Polyclitus's *Doryphorus* (see Fig. 7.4). The gaze, reminiscent of the look of Alexander the Great, purposefully recalls the visionary hero of Greece who died 300 years earlier. The extended arm points toward an unknown, but presumably greater, future. The military garb announces his role as commander-in-chief. Riding a dolphin at his feet is a small Cupid, son

Continuity & Change
p. 194

Doryphorus

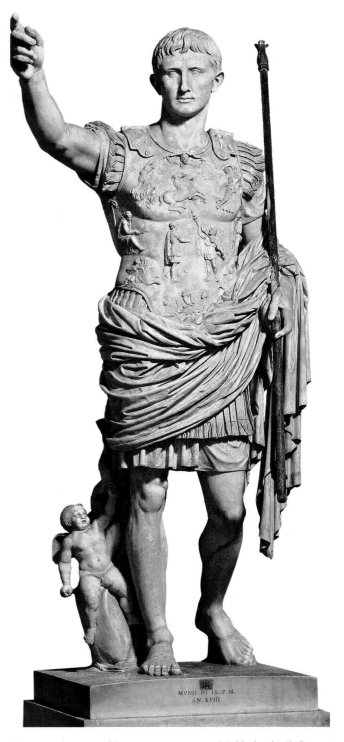

Fig. 8.13 *Augustus of Primaporta.* **ca. 20 BCE.** Marble, height 6′ 8″. Vatican Museums, Rome. On the breastplate a bearded Parthian from Asia Minor hands over Roman standards that had been lost in a battle of 53 BCE. In 20 BCE, when this statue was carved, Augustus had won them back.

of the goddess Venus, laying claim to the Julian family's divine descent from Venus and Aeneas. Though Augustus was over 70 years old when he died, he was always depicted as young and vigorous, choosing to portray himself, apparently, as the ideal leader rather than the wise, older *pater*.

Augustus was careful to maintain at least the trappings of the Republic. The Senate stayed in place, but Augustus soon eliminated the distinction between patricians and *equites* and fostered the careers of all capable individuals, whatever their origin. Some he made provincial governors, others administrators in the city, and he encouraged still others to enter political life. Soon the Senate was populated with many men who had never dreamed of political power. All of them—governors, administrators, and politicians—owed everything to Augustus. Their loyalty further solidified his power.

Family Life

Augustus also quickly addressed what he considered to be another crisis in Roman society—the demise of family life. Adultery and divorce were commonplace. There were more slaves and freed slaves in the city than citizens, let alone aristocrats. And family size, given the cost of living in the city, was diminishing. He reacted by criminalizing adultery and passed several other laws to promote family life. Men between the ages of 20 and 60 and women between the ages of 20 and 50 were required to marry. A divorced woman was required to remarry within six months, a widow within a year. Childless adults were punished with high taxes or deprived of inheritance. The larger an aristocrat's family, the greater his

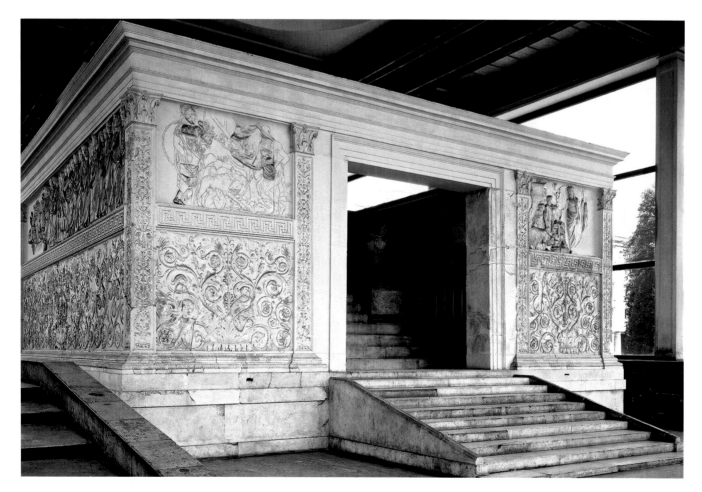

Fig. 8.14 *Ara Pacis Augustae*, west side.

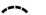

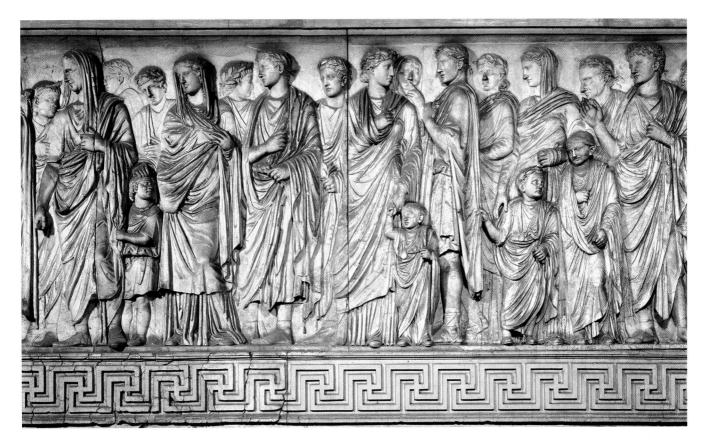

Fig. **8.15** *Ara Pacis Augustae*, **detail of Imperial Procession, south frieze, Rome. 13–9** BCE. Marble, width approx. 35′.
At the left is Marcus Agrippa, Augustus's son-in-law, married to his daughter Julia. Augustus's grandson, Gaius Caesar, who
with his brother Lucius often traveled with their grandfather and whom Augustus taught to imitate his own handwriting,
clings to his father's robe and looks backward and up at his grandmother, Augustus's wife, Livia, one of the most powerful
people in Rome. Behind Livia is her son by an earlier marriage, Tiberius, who would succeed Augustus as emperor.

political advantage. It is no coincidence that when Augustus commissioned a large monument to commemorate his triumphal return after establishing Roman rule in Gaul and restoring peace to Rome, the *Ara Pacis Augustae* (Altar of Augustan Peace), he had its exterior walls on the south decorated with a retinue of his own large family, a model for all Roman citizens, in a procession of lictors, priests, magistrates, senators, and other representatives of the Roman people (Figs. **8.14**, **8.15**).

Art historians believe that the *Ara Pacis Augustae* (Altar of Peace) represents a real event, perhaps a public rejoicing for Augustus's reign (it was begun in 13 BCE when he was 50), or the dedication of the altar itself, which occurred on Livia's fiftieth birthday in 9 BCE. The realism of the scene is typically Roman. A sense of spatial depth is created by depicting figures farther away from us in low relief and those closest to us in high relief, so high in fact that the feet of the nearest figures project over the architectural frame into our space (visible in the detail, Fig. 8.15). This technique would have encouraged viewers—the Roman public—to feel that they

were part of the same space as the figures in the sculpture itself. The Augustan peace is the peace enjoyed by the average Roman citizen, the Augustan family a metaphor for the larger family of Roman citizens.

The *Ara Pacis Augustae* is preeminently a celebration of family. Three generations of Augustus's family are depicted in the relief. It also demonstrates the growing prominence of women in Roman society. Augustus's wife Livia is depicted holding Augustus's family together, standing between her stepson, Marcus Agrippa, and her own sons, Tiberius and Drusus.

Livia became a figure of idealized womanhood in Rome. She was the "female leader," of Augustus's programs of reform, a sponsor of architectural projects and a trusted advisor to both her husband and son. While Livia enjoyed greater power and influence than most, Roman women possessed the rights of citizenship, although they could not vote or hold public office. Still, married women retained their legal identity. They controlled their own property and managed their own legal affairs. Elite women modeled themselves after Livia, wielding power through their husbands and sons.

Fig. 8.16 *Young Woman Writing,* **detail of a wall painting from Pompeii. Late first century CE.** Diameter 14⅝″. Museo Archeològico Nazionale, Naples. Women at all levels of society, except the very poorest, apparently learned to read and write.

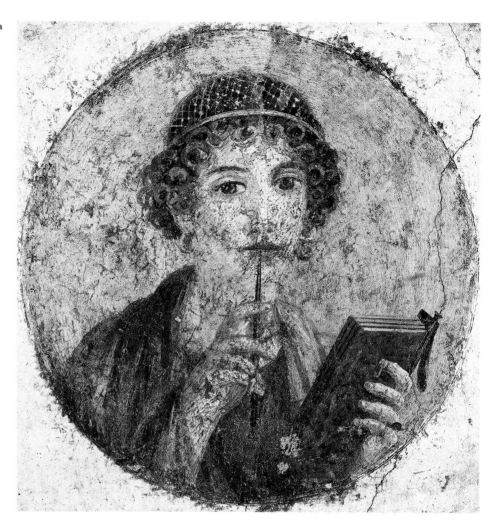

Education of the Sexes

The Romans educated their girls like their boys. Patricians probably hired tutors for their daughters, but the middle classes sent both their boys and girls to school until they were 12 years old, where they learned to read, write, and calculate. In a wall painting from Pompeii (Fig. **8.16**), a young woman bites on her stylus, as if contemplating her next words. Perhaps she is a poet. There were notable examples in Roman times, including Julia Balbilla [bal-BIL-uh] and Sulpicia [sul-PEE-see-uh], an elegist who was accepted into male literary circles. Women were, at any rate, sufficiently well educated that the satirist Juvenal would complain about it in his *Satires,* written in the early second century CE (**Reading 8.4**).

READING 8.4 **Juvenal,** *Satires*

Exasperating is the woman who begs as soon as she sits down to dinner to discourse on poets and poetry. . . . She rattles on at such a pitch that you'd think that all the pots and pans in the kitchen were crashing to the floor and that every bell in town was clanging. . . . She should learn the philosopher's lesson: "moderation is necessary even for intellectuals." And if she still wants to appear educated and eloquent, let her dress as a man, sacrifice to men's gods, and bathe in men's baths. Wives shouldn't try to be public speakers; they shouldn't use rhetorical devices; they shouldn't read the classics—there should be some things women don't understand. I myself cannot understand a woman who can quote the rules of grammar and never make a mistake and cite obscure, long-forgotten poets—as if men cared for such things.

For all the misogyny in Juvenal's diatribe, one thing is clear: women understand most everything that men do—and maybe better. His is a world in which women have attained an education at least comparable to that of men.

Education as a whole was left largely to Greeks, who came to Rome in Republican times to teach language, literature, and philosophy, as well as what the Romans called *humanitas*. *Humanitas* was considered the equivalent of the Greek *paideia* [pie-DAY-uh], the process of educating a person into his or her true and genuine form. It developed from Plato's insistence on the four sciences—arithmetic, geometry, astronomy, and music—as well as grammar and rhetoric. Both formed the core of the curriculum during the Middle Ages. Through the study of Classical Greek literature, a student possessing true *humanitas* should be able to find beauty in the equilibrium and harmony of a work of art, which should in turn inspire the student to search for such beauty in his or her own way of life.

Most Romans learned Greek from a teacher called a *grammaticus*, who taught not only rhetoric and grammar but also Greek literature, especially Homer. As a result, most Romans were bilingual. As Latin began to establish a literature of its own—it was initially the language of politics, law, and commerce—translation became a course of study, and the great Greek classics were soon available in Latin.

The Philosophy of the City: Chance and Reason

Many wealthier Romans hired Greek philosophers to teach their children in their own homes, and as a result Roman philosophy is almost wholly borrowed from the Greeks. Two of the most attractive philosophical systems to the Romans were Epicureanism and Stoicism.

Epicureanism Epicurus (341–270 BCE) was a Greek philosopher who taught in Athens. His ideas were promoted in Rome, particularly by the poet Lucretius (ca. 99–ca. 55 BCE), in his treatise *On the Nature of the Things*. **Epicureanism** is based on the theory of Epicurus, who believed that fear, particularly fear of death, was responsible for all human misery, and that the gods played no part in human affairs. All things, he argued, are driven by the random movement of atoms swirling through space. There are no first causes or final explanations, only chance. Thus, life can be enjoyed with complete serenity, and pleasure is the object of human life. At death, he concluded, our atoms simply disperse. Epicurus's philosophy might seem hedonistic, but, in fact, he argued that pleasure of the soul, attained through the quiet contemplation of philosophy, was far preferable to bodily pleasure. He stressed clarity and simplicity of thought, and "sober reasoning." In Lucretius's version of the philosophy, love is but a mental delusion.

Stoicism Most Romans rejected Epicureanism because they associated it with self-indulgence and debauchery, despite Lucretius's efforts to emphasize its more moderate and intellectual aspects. **Stoicism**, a hard-headed, practical philosophy that had developed in the Athenian *stoa* during the late fourth and early third century BCE, was far more popular. In the first century CE, as the population of Rome approached one million and the empire expanded almost unimaginably, the rational detachment and practical common-sense principles of Stoicism appealed to a citizenry confronting a host of problems related to the sheer size of city and empire. By submitting one's emotions to the practice of reason, one could achieve what the playwright and essayist Lucius Annaeus Seneca (ca. 8 BCE–65 CE) called tranquility of mind. In his most famous essay, *Tranquility of Mind*, Seneca argues that the best way to achieve peace of mind is to avoid responsibilities, especially those associated with excessive wealth (**Reading 8.5**):

READING 8.5 Seneca, *Tranquility of Mind*

Our question, then, is how the mind can maintain a consistent and advantageous course, be kind to itself and take pleasure in its attributes, never interrupt this satisfaction but abide in its serenity, without excitement or depression. This amounts to tranquility. We shall inquire how it may be attained. . . .

A correct estimate of self is prerequisite, for we are generally inclined to overrate our capacities. One man is tripped by confidence in his eloquence, another makes greater demands upon his estate than it can stand, another burdens a frail body with an exhausting office. Some are too bashful for politics, which require aggressiveness; some are too headstrong for court; some do not control their temper and break into unguarded language at the slightest provocation; some cannot restrain their wit or resist making risky jokes. For all such people retirement is better than a career; an assertive and intolerant temperament should avoid incitements to outspokenness that will prove harmful. . . .

We pass now to property, the greatest source of affliction to humanity. If you balance all our other troubles—deaths, diseases, fears, longings, subjection to labor and pain—with the miseries in which our money involves us, the latter will far weigh the former. Reflect, then, how much less a grief it is not to have money than to lose it, and then you will realize that poverty has less to torment us with in the degree that it has less to lose. If you suppose that rich men take their losses with greater equanimity you are mistaken; a wound hurts a big man as much as it does a little. . . .

All life is bondage. Man must therefore habituate himself to his condition, complain of it as little as possible, and grasp whatever good lies with his reach. No situation is so harsh that a dispassionate mind cannot find some consolation in it. If a man lays even a very small area out skillfully it will provide ample space for many uses, and even a foothold can be made livable by deft arrangement. Apply good sense to your problems; the hard can be softened, the narrow widened, and the heavy made lighter by the skillful bearer. . . .

Seneca's message was especially appealing to many Romans who were struggling for survival in the city. If we are all slaves to our situation, he seemed to argue, then like slaves, we must make of life the best we can. Tragically, Seneca would get the opportunity to practice what he preached. When his student, the emperor Nero, ordered him to commit suicide, a practice sanctioned by his Stoic philosophy, Seneca obliged.

Literary Rome: Virgil, Horace, and Ovid

When Augustus took control of Rome, he arranged for all artistic patronage to pass through his office. During the civil wars, the two major poets of the day, Virgil and Horace, had lost all their property, but Augustus's patronage allowed them to keep on with their writings. Because the themes they pursued were subject to Augustus's approval, they tended to glorify both the emperor and his causes. He was far less supportive of the poet Ovid, whom he permanently banished from Rome.

Virgil and the *Aeneid* After Augustus's triumph over Antony and Cleopatra at the battle of Actium in 31 BCE, Virgil retired to Naples, where he began work on an epic poem designed to

Continuity & Change
p. 162

Works and Days

rival Homer's *Iliad* and to provide the Roman state—and Augustus in particular—with a suitably grand founding myth. Previously he had been engaged with two series of pastoral idylls, the *Eclogues* (or *Bucolics*) and the *Georgics*. The latter poems (**Reading 8.6**) are modeled after Hesiod's *Works and Days* (see chapter 4). They extol the importance of hard work, the necessity of forging order in the face of a hostile natural world, and, perhaps above all, the virtues of agrarian life.

READING 8.6 **from Virgil, *Georgics***

In early spring-tide, when the icy drip
Melts from the mountains hoar, and Zephyr's breath
Unbinds the crumbling clod, even then 'tis time;
Press deep your plough behind the groaning ox,
And teach the furrow-burnished share to shine.
That land the craving farmer's prayer fulfils,
Which twice the sunshine, twice the frost has felt;
Ay, that's the land whose boundless harvest-crops
Burst, see! the barns.

The political point of the *Georgics* was to celebrate Augustus's gift of farmlands to veterans of the civil wars, but in its exaltation of the myths and traditions of Italy, it served as a precursor to the *Aeneid*. It was written in **dactylic hexameter**, the verse form that Homer had used in the *Iliad* and *Odyssey* (the metrical form of the translation above, however, is iambic pentameter—five rhythmic units, each short long, as in *dee-dum*—a meter much more natural to English than the Latin dactylic hexameter). In dactylic hexameter each line consists of six rhythmic units, or **feet**, and each foot is either

a **dactyl** (long, short, short, as in *dum-diddy*) or a **spondee** (long, long, as in *dum-dum*).

Virgil reportedly wrote the *Georgics* at a pace of less than one line a day, perfecting his understanding of the metrical scheme in preparation for the longer poem.

The *Aeneid* opens in Carthage, where, after the Trojan War, Aeneas and his men have been driven by a storm, and where they are hosted by the Phoenician Queen Dido. During a rainstorm Aeneas and Dido take refuge in a cave, where the queen, having fallen in love with the Trojan hero, gives herself willingly to him. She now assumes that she is married, but Aeneas, reminded by his father's ghost of his duty to accomplish what the gods have predetermined—a classic instance of *pietas*—knows he must resume his destined journey (see **Reading 8.7** on page 266). An angry and accusing Dido begs him to stay. When Aeneas rejects her pleas, Dido vows to haunt him after her death and to bring enmity between Carthage and his descendants forever (a direct reference on Virgil's part to the Punic Wars). As his boat sails away, she commits suicide by climbing a funeral pyre and falling upon a sword. The goddesses of the underworld are surprised to see her. Her death, in their eyes, is neither deserved nor destined, but simply tragic. Virgil's point is almost coldly hard-hearted: All personal feelings and desires must be sacrificed to one's responsibilities to the state. Civic duty takes precedence over private life.

The poem is, on one level, an account of Rome's founding by Aeneas, but it is also a profoundly moving essay on human destiny and the great cost involved in achieving and sustaining the values and principles upon which culture—Roman culture in particular, but all cultures by extension—must be based. Augustus, as Virgil well knew, claimed direct descent from Aeneas, and it is particularly important that the poem presents war, at which Augustus excelled, as a moral tragedy, however necessary.

In Book 7, Venus gives Aeneas a shield made by the god Vulcan. The shield displays the important events in the future history of Rome, including Augustus at the Battle of Actium. Aeneas is, Virgil writes, "without understanding. . . proud and happy . . . [at] the fame and glory of his children's children." But in the senseless slaughter that ends the poem, as Aeneas and the Trojans battle Turnus and the Italians, Virgil demonstrates that the only thing worse than not avenging the death of one's friends and family is, perhaps, avenging them. In this sense the poem is a profound plea for peace, a peace that Augustus would dedicate himself to pursuing.

The Horatian Odes Quintus Horatius Flaccus [KWIN-tus hor-AY-she-us FLAK-us], known as Horace (65–8 BCE), was a close friend of Virgil. Impressed by Augustus's reforms, and probably moved by his patronage, Horace was won over to the emperor's cause, which he celebrated directly in two of his many **odes**, lyric poems of elaborate and irregular meter. Horace's odes imitated Greek precedents. The following lines open the fifth ode of Book Three of the collected poems, known simply as the *Odes*:

Jove [the Roman Zeus, also called Jupiter] rules in heaven, his thunder shows;

Henceforth Augustus earth shall own
Her present god, now Briton foes
And Persians bow before his throne.

The subject matter of the *Odes* ranges from these patriotic pronouncements to private incidents in the poet's own life, the joys of the countryside (Fig. **8.17**), the pleasures of wine, and so on. His villa offered him an escape from the trials of daily life in Rome itself. In Ode 13 of Book Two, for instance, Horace addresses a tree that had unexpectedly crashed down, nearly killing him (see **Reading 8.8** on pages 267–268). He begins by cursing the man who planted the tree but then concludes that we all fail to pay attention to the real dangers in life. Apparently lost in thought, he begins to imagine the Underworld, the abode of departed souls, where he sees the love poet Sappho (see chapter 6) and the political poet Alcaeus both writing poetry. Their lyrics give comfort to the dead, just as Horace's own poem has comforted him and allowed him to forget his near-death experience. No Roman poet more gracefully harmonized the Greek reverence for beauty with the Roman concern with duty and obligation.

Ovid's *Art of Love* and *Metamorphoses* Augustus's support for poets did not extend to Publius Ovidius Naso [POO-ble-us ov-ID-ee-us NAY-so], known as Ovid (43 BCE–17 CE). Ovid's talent was for love songs designed to satisfy the notoriously loose sexual mores of the Roman aristocrats, who lived in somewhat open disregard of Augustus and Livia's family-centered lifestyle. His *Ars Amatoria* [ahrs ah-mah-TOR-ee-uh] (Art of Love) angered Augustus, as did some indiscretion by Ovid. As punishment, Augustus permanently exiled him to the town of Tomis [TOE-mus] on the Black Sea, the remotest part of the empire, famous for its wretched weather. The *Metamorphoses,* composed in the years just before his exile, is a collection of stories describing or revolving around one sort of supernatural change of shape or another, from the divine to the human, the animate to the inanimate, from the human to the vegetal.

In the *Ars Amatoria* the poet describes his desire for the fictional Corinna. Ovid outlines the kinds of places in Rome where one can meet women, from porticoes to gaming houses, from horse races to parties, and especially anywhere wine, that great banisher of inhibition, can be had. Women, he says, love clandestine affairs as much as men; they simply don't chase after men, "as a mousetrap does not chase after mice." Become friends with the husband of a woman you desire, he advises. Lie to her—tell her that you only want to be her friend. Nevertheless, he says, "If you want a woman to love you, be a lovable man."

Ovid probably aspired to Virgil's fame, though he could admit, "My life is respectable, but my Muse is full of jesting." His earliest major work, the *Amores* [ah-MOHR-eez] (Loves), begins with many self-deprecating references to Virgil's epic, which begins with the famous phrase, "Arms and the man I sing":

Arms, warfare, violence—I was winding up to produce
A regular epic, with verse-form to match—

Fig. 8.17 *Idyllic Landscape,* **wall painting from a villa at Boscotrecase, near Pompeii. 1st century** BCE. Museo Nazionale, Naples. This landscape depicts the love of country life and the idealizing of nature that is characteristic of the Horatian *Odes.* It contrasts dramatically with urban life in Rome.

Hexameters, naturally. But Cupid (they say) with a snicker
Lopped off one foot from each alternate line.
"Nasty young brat," I told him, "who made *you* Inspector
of Metres?"

Nevertheless, Ovid uses dactylic hexameter for the *Metamorphoses* and stakes out an epic scope for the poem in its opening lines:

My intention is to tell of bodies changed
To different forms; the gods, who made the changes,
Will help me—or I hope so—with a poem
That runs from the world's beginning to our own days!

If the *Metamorphoses* is superficially more a collection of stories than an epic, few poems in any language have contributed so importantly to later literature. It is so complete in its survey of the best-known classical myths, plus stories from Egypt, Persia, and Italy, that it remains a standard reference work. At the same time, it tells its stories in an utterly moving and memorable way. The story of Actaeon, for instance, is a cautionary tale about the power of the gods. Actaeon happens to see the virgin goddess Diana bathing one day when he is out hunting with his dogs. She turns him into a

stag to prevent him from ever telling what he has seen. As his own dogs turn on him and savagely tear him apart, his friends call out for him, lamenting his absence from the kill. But he is all too present:

> Well might he wish not to be there, but he was there,
> and well might he wish to see
> And not to feel the cruel deeds of his dogs.

In the story of Narcissus, Echo falls in love with the beautiful youth Narcissus, but when Narcissus spurns her, she fades away. He in turn is doomed to fall in love with his own image reflected in a pool, according to Ovid, the spring at Clitumnus [clye-TOOM-nus]. So consumed, he finally dies beside the pool, his body transformed into the narcissus flower. In such stories, the duality of identity and change, Aristotle's definition of the essence of a thing, becomes deeply problematic. Ovid seems to deny that any human characteristic is essential, that all is susceptible to change. To subsequent generations of readers, from Shakespeare to Freud, Ovid's versions of myths would raise the fundamental questions that lie at the heart of human identity and psychology.

Augustus and the City of Marble

Of all the problems facing Augustus when he assumed power, the most overwhelming was the infrastructure of Rome. The city was, quite simply, a mess. Seneca reacted by preaching Stoicism. He argued that it was what it was, and one should move on as best one can. Augustus reacted by calling for a series of public works, which would serve the people of Rome and, he well understood, himself. The grand civic improvements Augustus planned would be a kind of imperial propaganda, underscoring not only his power but also his care for the people in his role as *pater patriae*. Public works could—and indeed did—elicit the public's loyalty.

Rome had developed haphazardly, without any central plan, spilling down the seven hills it originally occupied into the valleys along the Tiber. By contrast, all of the empire's provincial capitals were conceived on a strict grid plan, with colonnaded main roads leading to an administrative center, and adorned with public works like baths, theaters, and triumphal arches. In comparison, Rome was pitiable. Housing conditions were dreadful, water was scarce, food was in short supply. Because the city was confined by geography to a small area, space was at a premium.

Urban Housing: The Apartment At least as early as the third century BCE, the ancient Romans created a new type of living space in response to overcrowding—the multistoried apartment block, or *insula* [IN-soo-luh] (Fig. **8.18**). In Augustus's time, the city was increasingly composed of such *insulae* [IN-soo-lye], in which 90 percent of the population of Rome lived.

The typical apartment consisted of two private rooms—a bedroom and a living room—that opened onto a shared central space. The poor lived in kitchenless apartments, cooking and eating in the shared space.

The *insulae* were essentially tenements, with shops on the ground floor and living quarters above. They rose to a height of 60 or 70 feet (five or six stories), were built with inadequate wood frames, and often collapsed. Fire was an even greater danger. Richer apartment dwellers—and there were many, buildable land being scarce—often employed slaves as their own private fire brigades. In 6 CE, Augustus introduced *vigils* [VI-juls] to the city, professional firefighters (and policemen) who patrolled the city at night.

In the *insulae*, noise was a constant problem, and hygiene an even worse issue (see *Voices*, page 253). Occupants of the upper stories typically dumped the contents of their chamber pots into the streets rather than carry them down to the cesspool. As the satirist Juvenal described the situation: "You can suffer as many deaths as there are open windows to pass under. So offer up a prayer that people will be content with just emptying out their slop bowls."

Augustus could not do much about the housing situation, although he did build aqueducts to bring more water into the city. He created a far larger administrative bureaucracy than before and oversaw it closely, guaranteeing its efficiency. But most of all he implemented an ambitious building program designed to provide elegant public spaces where city dwellers could escape from their cramped apartments. He once claimed that he had restored 82 temples in one year. But if he could boast, "I found a city of brick, and left it a city of marble," that was largely because he had put a lot of marble veneer over brick wall. By the second century CE, the city would be one of the most beautiful in the world, but the beauty was only skin deep. The housing situation that Augustus inherited had barely improved.

Fig. 8.18 Reconstruction model of a Roman apartment, or *insula*, **ruins of which survive at Ostia, Rome's port. ca. 150 CE.** The ground floor of this *insula* contained shops. Above these were many apartments. There were also single-room living quarters behind the shops.

Voices

Coping with Life in Ancient Rome

City-dwellers have always complained about noise, crowds, and their fellow citizens. Always, too, they have longed for a country escape. In this passage, the poet Martial (Marcus Valerius Martialis), describes his difficulties as a less-than-wealthy resident of Rome during the late first century, during the reigns of Domitian, Nerva, and Trajan.

Do you ask why I often resort to my small fields in arid Nomentum [a country town near Rome], and the unkempt household of my villa? Neither for thought, . . . nor for quiet is there any place in Rome for a poor man. Schoolmasters in the morning do not let you live; before daybreak, bakers; the hammers of the coppersmiths all day. On this side the money-changer idly rattles on his dirty table Nero's coins, or that the hammerer of Spanish gold dust beats his well-worn stone with burnished mallet; and Bellona's raving throng does not rest, nor the canting shipwrecked seaman with his swathed body [pretending he had lost a limb], . . . nor the blear-eyed huckster of sulphur [ceramic] wares. He who can count the losses lazy sleep must bear will say how many brass pots and pans city

> "... as for me, the laughter of the passing throng wakes me and Rome is at my bed's head. Whenever worn out with worry and I wish to sleep, I go to my villa."

hands clash when the eclipsed moon is being assailed by the Colchian magic wheel. [Eclipses were attributed to witches, and the Romans believed that the clashing of brass vessels drove away evil demons.]

You Sparsus, know nothing of these things and cannot know, luxurious as you are in your [palace] domain whose ground floor looks down on the hill tops and where you have country in the town, and a Roman for your vine-dresser [cultivator of grapes].

. . . as for me, the laughter of the passing throng wakes me and Rome is at my bed's head. Whenever worn out with worry and I wish to sleep, I go to my villa.

Public Works and Monuments Augustus inaugurated what amounted to an ongoing competition among the emperors to outdo their predecessors in the construction of public works and monuments. His ambitions are reflected in the work of the architect Vitruvius (flourished late first century BCE to early first century CE). A military engineer for Julius Caesar, under Augustus's patronage, Vitruvius wrote the ten-volume *On Architecture*. The only work of its kind to have survived from antiquity, it would become extremely influential over 1,000 years later, when Renaissance artists became interested in classical design. In its large scale, the work matches its patron's architectural ambitions, dealing with town planning, building materials and construction methods, the construction of temples, the classical orders, and the rules of proportion. Vitruvius also wrote extensively about one of Rome's most pressing needs—how to satisfy the city's needs for water. In fact, one of the most significant contributions of the Julio-Claudian dynasty, which extends from Augustus through Nero (r. 54–68 CE), was an enormous aqueduct, the Aqua Claudia. These aqueducts depended on Roman ingenuity in perfecting the arch and vault so that river gorges could be successfully spanned to carry the pipes bringing water to a city miles away. The Aqua Claudia delivered water from 40 miles away into the very heart of the city, not so much for

private use as for the fountains, pools, and public baths. (See *Materials and Techniques*, page 255.)

The Colosseum Nero was succeeded by one of his own generals, Vespasian (r. 69–79 CE), the former commander in Palestine. Vespasian built the Colosseum (Fig. **8.19**) across from Nero's Golden House. He named it after the Colossus, a 120-foot high statue of Nero as sun god that stood in front of it. A giant oval, 615 feet long, 510 feet wide, and 159 feet high, audiences, estimated at 50,000, entered and exited through its 76 vaulted arcades in a matter of a few minutes.

These vaults were made possible by the invention of concrete, which the Romans had increasingly utilized in their buildings since the second century BCE. Mixed with volcanic aggregate from nearby Naples and Pompeii, it set faster and was stronger than any building material yet known. The Colosseum's wooden floor, laid over a maze of rooms and tunnels that housed gladiators, athletes, and wild animals that entertained the masses, was sturdy enough that the *arena* (Latin for "sand," which covered the floor) could be flooded for mock sea battles. The top story of the building housed an awning system that could be extended on a system of pulleys and ropes to shield part of the audience

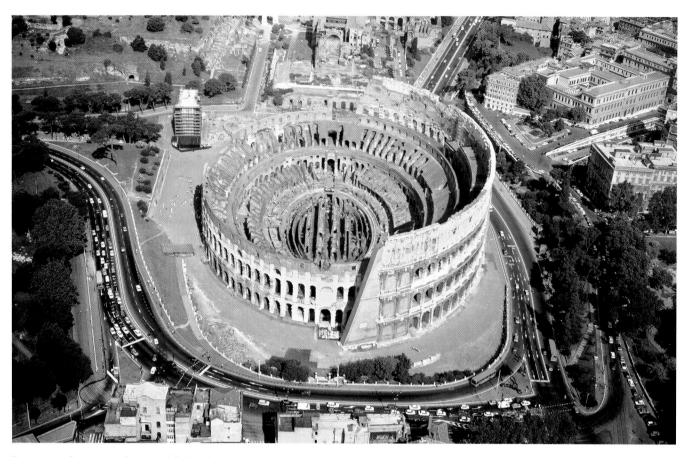

Figs. 8.19 and 8.20 Aerial view and, below, detail of outer wall of Colosseum, Rome. 72–80 CE. The opening performance at the Colosseum in 80 CE lasted 100 days. During that time, 9,000 wild animals—lions, bears, snakes, boars, even elephants, imported from all over the empire—were killed, and so were 2,000 gladiators.

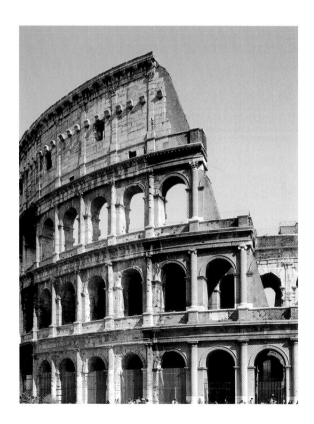

from the hot Roman sun. Each level employed a different architectural order: the Tuscan order on the ground floor, the Ionic on the second, and the Corinthian, the Romans' favorite, on the third (Fig. **8.20**). All of the columns are engaged and purely decorative, serving no structural purpose. The facade—originally covered with marble, most of which was removed for use in later buildings—thus moves from the heaviest and sturdiest elements at the base to the lightest, most decorative at the top, a logic that seems both structurally and visually satisfying.

Voices

Coping with Life in Ancient Rome

City-dwellers have always complained about noise, crowds, and their fellow citizens. Always, too, they have longed for a country escape. In this passage, the poet Martial (Marcus Valerius Martialis), describes his difficulties as a less-than-wealthy resident of Rome during the late first century, during the reigns of Domitian, Nerva, and Trajan.

Do you ask why I often resort to my small fields in arid Nomentum [a country town near Rome], and the unkempt household of my villa? Neither for thought, . . . nor for quiet is there any place in Rome for a poor man. Schoolmasters in the morning do not let you live; before daybreak, bakers; the hammers of the coppersmiths all day. On this side the money-changer idly rattles on his dirty table Nero's coins, or that the hammerer of Spanish gold dust beats his well-worn stone with burnished mallet; and Bellona's raving throng does not rest, nor the canting shipwrecked seaman with his swathed body [pretending he had lost a limb], . . . nor the blear-eyed huckster of sulphur [ceramic] wares. He who can count the losses lazy sleep must bear will say how many brass pots and pans city

> **". . . as for me, the laughter of the passing throng wakes me and Rome is at my bed's head. Whenever worn out with worry and I wish to sleep, I go to my villa."**

hands clash when the eclipsed moon is being assailed by the Colchian magic wheel. [Eclipses were attributed to witches, and the Romans believed that the clashing of brass vessels drove away evil demons.]

You Sparsus, know nothing of these things and cannot know, luxurious as you are in your [palace] domain whose ground floor looks down on the hill tops and where you have country in the town, and a Roman for your vine-dresser [cultivator of grapes].

. . . as for me, the laughter of the passing throng wakes me and Rome is at my bed's head. Whenever worn out with worry and I wish to sleep, I go to my villa.

Public Works and Monuments Augustus inaugurated what amounted to an ongoing competition among the emperors to outdo their predecessors in the construction of public works and monuments. His ambitions are reflected in the work of the architect Vitruvius (flourished late first century BCE to early first century CE). A military engineer for Julius Caesar, under Augustus's patronage, Vitruvius wrote the ten-volume *On Architecture*. The only work of its kind to have survived from antiquity, it would become extremely influential over 1,000 years later, when Renaissance artists became interested in classical design. In its large scale, the work matches its patron's architectural ambitions, dealing with town planning, building materials and construction methods, the construction of temples, the classical orders, and the rules of proportion. Vitruvius also wrote extensively about one of Rome's most pressing needs—how to satisfy the city's needs for water. In fact, one of the most significant contributions of the Julio-Claudian dynasty, which extends from Augustus through Nero (r. 54–68 CE), was an enormous aqueduct, the Aqua Claudia. These aqueducts depended on Roman ingenuity in perfecting the arch and vault so that river gorges could be successfully spanned to carry the pipes bringing water to a city miles away. The Aqua Claudia delivered water from 40 miles away into the very heart of the city, not so much for

private use as for the fountains, pools, and public baths. (See *Materials and Techniques*, page 255.)

The Colosseum Nero was succeeded by one of his own generals, Vespasian (r. 69–79 CE), the former commander in Palestine. Vespasian built the Colosseum (Fig. **8.19**) across from Nero's Golden House. He named it after the Colossus, a 120-foot high statue of Nero as sun god that stood in front of it. A giant oval, 615 feet long, 510 feet wide, and 159 feet high, audiences, estimated at 50,000, entered and exited through its 76 vaulted arcades in a matter of a few minutes.

These vaults were made possible by the invention of concrete, which the Romans had increasingly utilized in their buildings since the second century BCE. Mixed with volcanic aggregate from nearby Naples and Pompeii, it set faster and was stronger than any building material yet known. The Colosseum's wooden floor, laid over a maze of rooms and tunnels that housed gladiators, athletes, and wild animals that entertained the masses, was sturdy enough that the *arena* (Latin for "sand," which covered the floor) could be flooded for mock sea battles. The top story of the building housed an awning system that could be extended on a system of pulleys and ropes to shield part of the audience

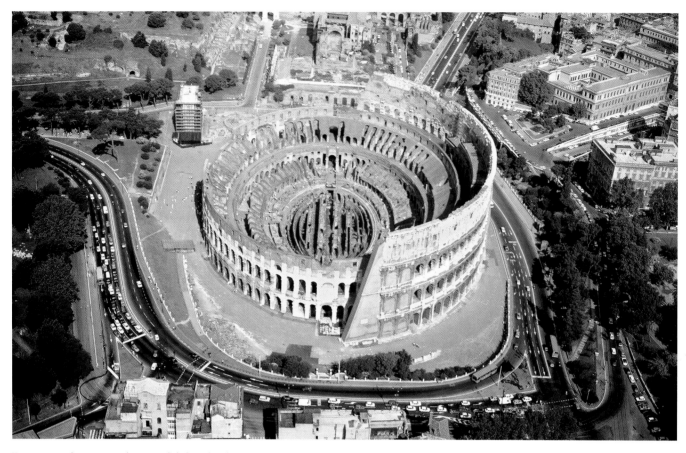

Figs. 8.19 and 8.20 Aerial view and, below, detail of outer wall of Colosseum, Rome. 72–80 CE. The opening
performance at the Colosseum in 80 CE lasted 100 days. During that time, 9,000 wild animals—lions, bears, snakes, boars,
even elephants, imported from all over the empire—were killed, and so were 2,000 gladiators.

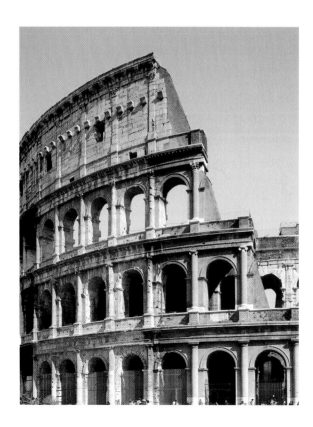

from the hot Roman sun. Each level employed a different
architectural order: the Tuscan order on the ground floor,
the Ionic on the second, and the Corinthian, the Romans'
favorite, on the third (Fig. 8.20). All of the columns are
engaged and purely decorative, serving no structural pur-
pose. The facade—originally covered with marble, most of
which was removed for use in later buildings—thus moves
from the heaviest and sturdiest elements at the base to the
lightest, most decorative at the top, a logic that seems both
structurally and visually satisfying.

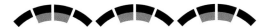

Materials & Techniques Arches and Vaults

While the arch was known to cultures such as the Mesopotamians, the Egyptians, and the Greeks, it was the Romans who perfected it, evidently learning its principles from the Etruscans but developing those principles further. The Pont du Gard, a beautiful Roman aqueduct in southern France near the city of Nîmes, is a good example.

The Romans understood that much wider spans than the Etruscans had bridged could be achieved with the **round arch** than with post-and-lintel construction. The weight of the masonry above the arch is displaced to the supporting upright elements (**piers** or **jambs**). The arch is constructed with a supporting scaffolding that is formed with wedge-shaped blocks, called **voussoirs** [voo-swarrs], and capped with a

large, wedge-shaped stone, called the **keystone**, the last element put in place. The space inside the arch is called a **bay**. And the wall areas between the arches of an **arcade** (a succession of arches, such as seen on the Pont du Gard) are called **spandrels**.

When a round arch is extended, it forms a **barrel vault**. To ensure that the downward pressure from the arches does not collapse the walls, a **buttress** support is often added. When two barrel vaults meet one another at a right angle, they form a **groin vault**. The interior corridors of the Colosseum in Rome utilize both barrel and groin vaulting. Since all the stones in a vault must be in place to support the arched structure, the vault cannot be penetrated by windows.

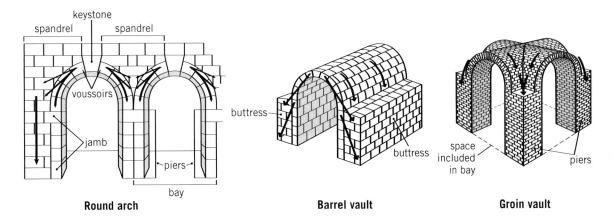

Round arch **Barrel vault** **Groin vault**

Pont du Gard, near Nîmes, France, late 1st century BCE**–early 1st century** CE**.** Height 180′. The Roman city of Nîmes received 8,000–12,000 gallons of water a day from this aqueduct.

Figs. 8.21 and 8.22 Arch of Titus, Rome, ca. 81 CE and *Spoils from the Temple in Jerusalem,* a detail of the interior relief of the arch. Height of relief, approx. 7′ 10″. The figures in the relief are nearly life-size. The relief has been badly damaged, largely because in the Middle Ages, a Roman family used the arch as a fortress, constructing a second story in the vault. Holes for the floor beams appear at the top of the relief.

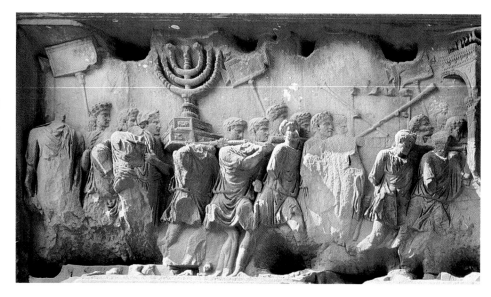

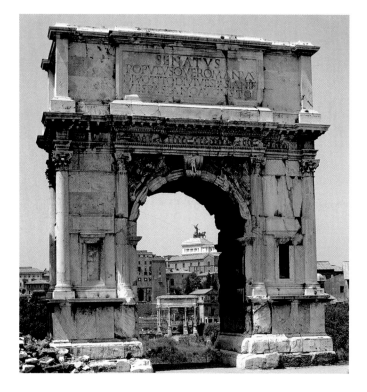

Triumphal Arches and Columns During Vespasian's reign, his son Titus (r. 79–81 CE) defeated the Jews in Palestine, who were rebelling against Roman interference with their religious practices. Titus's army sacked the Second Temple of Jerusalem in 70 CE. To honor this victory and the death of Titus 11 years later, a memorial arch was constructed on the Sacred Way. Originally the Arch of Titus was topped by a statue of a four-horse chariot and driver. Such arches, known as *triumphal arches* because triumphant armies marched through them, were composed of a simple barrel vault enclosed within a rectangle, and enlivened with sculpture and decorative engaged columns (Fig. 8.21). They would deeply influence later architecture, especially the facades of

Renaissance cathedrals. Hundreds of triumphal arches were built throughout the Roman Empire. Like all Roman monumental architecture, they were intended to symbolize Rome's political power and military might.

The Arch of Titus was constructed of concrete and faced with marble, its inside walls decorated with narrative reliefs. One of them shows Titus's soldiers marching with the treasures of the Second Temple in Jerusalem (Fig. 8.22). In the foreground the soldiers carry the golden Ark of the Covenant, and behind that a *menorah,* the sacred Jewish candelabrum, also made of gold. They bend under the weight of the gold and stride forward convincingly. The carving is extremely deep, with nearer figures and elements rendered with undercutting and in higher relief than more distant ones. This creates a sense of real space and, when light and shadow play over the sculptural relief, even a sense of real movement.

Another type of monument favored by the Romans and with similar symbolic meaning—suggestive not only of power but also of male virility—is the ceremonial column. Like the triumphal arch it was a masonry and concrete platform for narrative reliefs. Two of the so-called Five Good Emperors who ruled Rome after the Flavian dynasty—Trajan and Marcus Aurelius—built columns to celebrate their military victories. Trajan's Column, perhaps the most complete artistic statement of Rome's militaristic character, consists of a spiral of 150 separate scenes from his military campaign in Dacia, across the Danube River in what is now Hungary and Romania. If laid out end to end, the complete narrative would be 625 feet long (Fig. 8.23). At the bottom of the column the band is 36 inches wide, at the top 50 inches, so that the higher elements might be more readily visible. In order to eliminate shadow and increase the legibility of the whole, the carving is very low relief. At the bottom of the column, the story begins with Roman troops crossing the Danube on a pontoon bridge (Fig. 8.24). A river god looks on with some interest. To the left of

the second band and at the right side of the fourth band, Trajan addresses his troops. Battle scenes constitute less than a quarter of the entire narrative. Instead, we witness the Romans building fortifications, harvesting crops, participating in religious rituals. All in all, the column's 2,500 figures are carrying out what Romans believed to be their destiny—they are bringing the fruits of civilization to the world.

The Imperial Roman Forum Trajan's Column stands in what was once the Forum of Trajan. This vast building project was among the most ambitious undertaken in Rome by the Five Good Emperors. (See *Focus*, pages 258–259.)

Rome thrived under the rule of the Five Good Emperors: Nerva (r. 96–98 CE), Trajan (r. 98–117 CE), Hadrian (r. 117–138 CE), Antonius Pius (r. 138–161 CE), and Marcus Aurelius (r. 161–180 CE). The stability and prosperity of the city was due, at least in part, to the fact that none of these men except Marcus Aurelius had a son to whom he could pass on the empire. Thus, each was handpicked by his predecessor from among the ablest men in the Senate. When, in 180 CE, Marcus Aurelius's decadent and probably insane son, Commodus (r. 180–192 CE), took control, the empire quickly learned that the transfer of power from father to son was not necessarily a good thing.

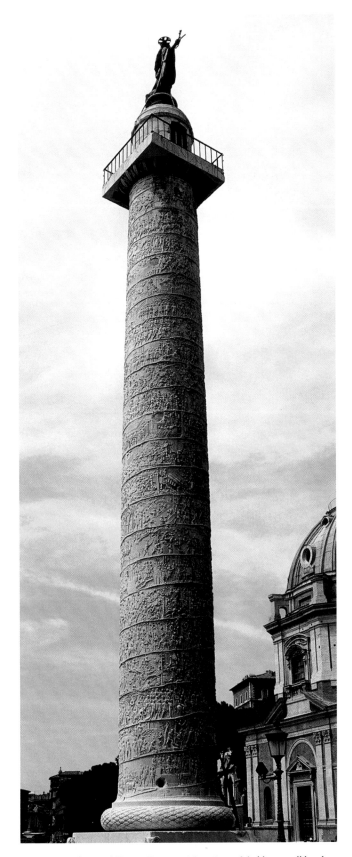

Fig. 8.23 Column of Trajan, Rome, 106–113 CE. Marble, overall height with base, 125′.

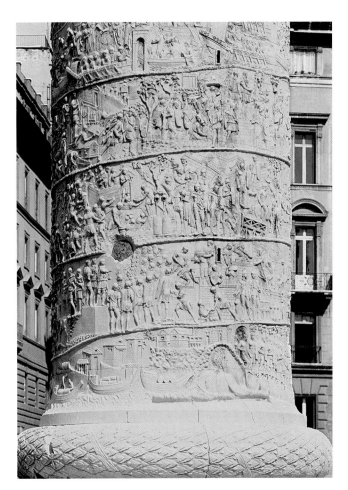

Fig. 8.24 Lower portion of the Column of Trajan, Forum of Trajan, Rome. 106–113 CE.

Focus

The *Forum Romanum* and Imperial Forums

The *Forum Romanum*, or Roman Forum, was the chief public square of Rome, the center of Roman religious, ceremonial, political, and commercial life. Originally, a Roman forum was comparable to a Greek *agora*, a meeting place in the heart of the city. But gradually the forum took on a symbolic function as well, becoming a symbol of imperial power that testified to the prosperity—and peace—that the emperor bestowed upon Rome's citizenry. Julius Caesar was the first to build a forum of his own in 46 BCE, just to the north of the *Forum Romanum*. Augustus subsequently paved it over, restored its Temple of Venus, and proceeded to build his own forum with its Temple of Mars the Avenger. Thus began what amounted to a competition among successive emperors to outdo their predecessors by creating their own more spectacular forums. These imperial forums lined up north of and parallel to the great Roman Forum, which over the years was itself subjected to new construction. Stretched out along the Via dei Fori Imperiali (Street of Imperial Forums) were Vespasian's Forum of Peace (laid out after the Jewish War in 70 CE), the Forum of Nerva (completed in 97 CE), the Forum of Augustus, the Forum of Caesar, and the Forum of Trajan (completed by Hadrian, ca. 117 CE). The result was an extremely densely built city center. Trajan's was the last, largest, and most splendid forum. It sheltered the Column of Trajan, Trajan's Market, and the Basilica Ulpia)—the largest basilica in the empire (see the discussion of the basilica in chapter 9 page 294).

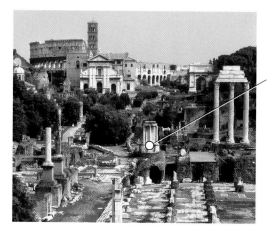

Contemporary view of the *Forum Romanum*. Little remains of the Roman forums but a field of ruins in the heart of the city. The rounded white columns are the ruins of the Temple of Vesta, one of the earliest buildings erected there.

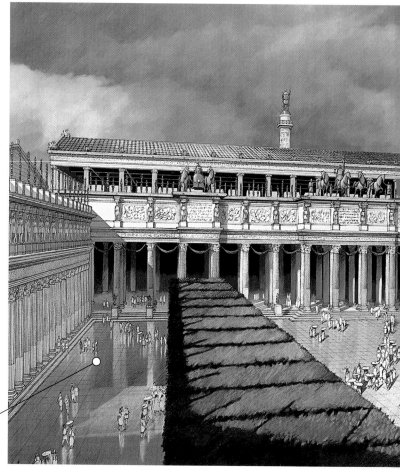

Forum of Trajan, Rome. 110–112 CE. Restored view by Gilbert Gorski. To make up for the destruction of a major commercial district that was required to construct his forum, Trajan commissioned a large marketplace. Like a contemporary mall, the market had 150 different shops on several levels.

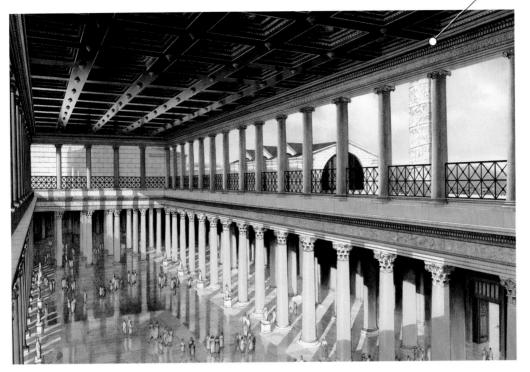

Reconstruction drawing of the central hall, Basilica Ulpia, Forum of Trajan, Rome 113 CE. A **basilica** is a large rectangular building with a rounded extension, called an **apse**, at one or both ends, and easy access in and out. It was a general-purpose building that could be adapted to many uses. Designed by Trajan's favorite architect, the Greek Apollodorus of Damascus, the Basilica Ulpia was 200 feet wide and 400 feet long. In a courtyard outside a door in the middle of the colonnade to the right stood the Column of Trajan. Relatively plain and massive on the outside, the basilica is distinguished by its vast interior space, which would later serve as the model for some Christian churches.

Model of the Roman Forum and the Imperial Forums, Rome. ca. 46 CE–117 BCE. This model emphasizes the dense building plan of ancient Rome.

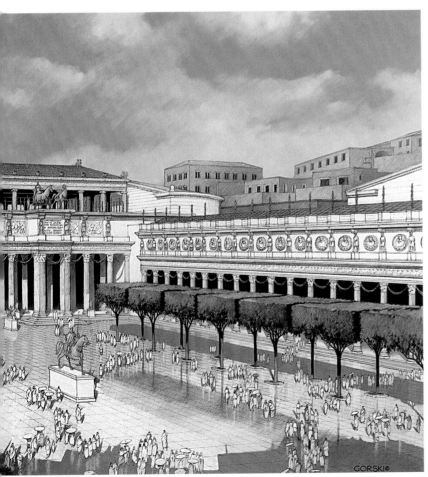

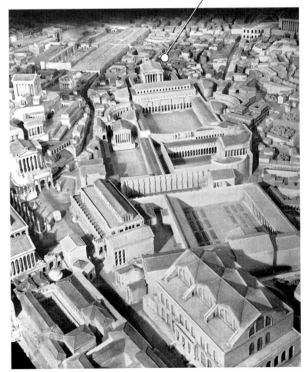

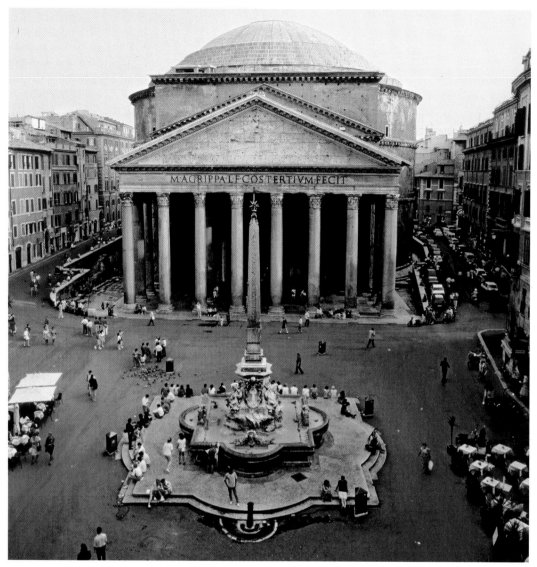

Fig. 8.25 The Pantheon, Rome. 118–125 CE. The Pantheon is an impressive feat of architectural engineering, and it would inspire architects for centuries to come. However, Hadrian humbly (and politically) refused to accept credit for it. He passed off the building as a "restoration" of a temple constructed on the same site by Augustus's original heir, Marcus Agrippa, in 27–25 BCE. Across the architrave (the bottom element in an entablature above the columns) of the facade is an inscription that serves both propagandistic and decorative purposes: "Marcus Agrippa, son of Lucius, three times consul, made this."

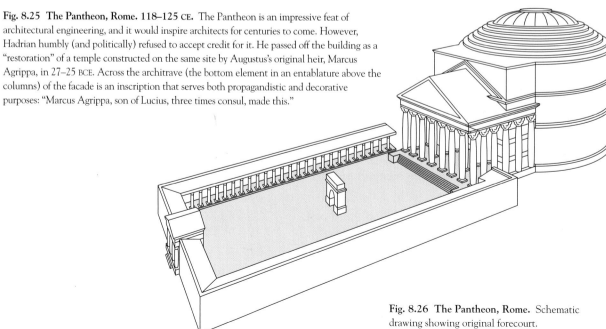

Fig. 8.26 The Pantheon, Rome. Schematic drawing showing original forecourt.

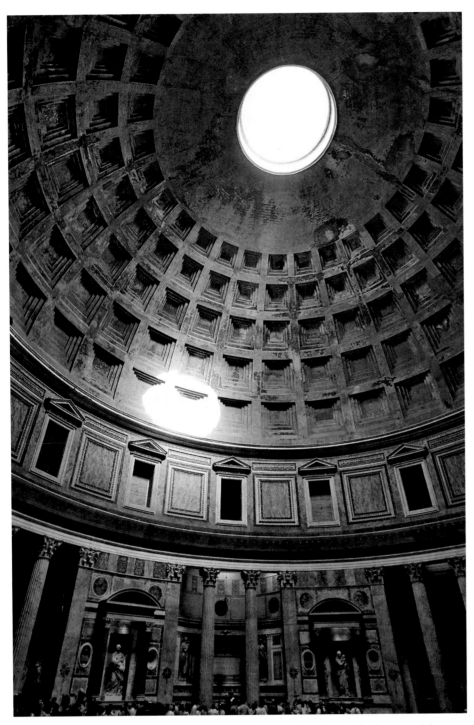

Fig. 8.27 The Pantheon, Rome. Interior. The sun's rays entering through the *oculus* form a spotlight on the Pantheon's interior, moving and changing intensity with the time of day.

which are massive bronze doors (Fig. 8.25). Contemporary photographs give little evidence of its monumental presence, elevated above its long forecourt (Fig. 8.26). Today both the forecourt and the elevation have disappeared beneath the streets of modern Rome. Figure 8.25 shows the Pantheon as it looks today.

The facade gives no hint of what lies beyond the doors. The interior of the Pantheon consists of a cylindrical space topped by a dome, the largest built in Europe before the twentieth century (Fig. 8.27). The whole is a perfect hemisphere—the diameter of the rotunda is 144 feet, as is the height from floor to ceiling. The weight of the dome rests on eight massive supports, each more than 20 feet thick. The dome itself is 20 feet thick at the bottom but narrows to only 6 feet thick at the **oculus**, the circular opening at the top, which Hadrian conceived of as the "Eye of Jupiter." The *oculus* is 30 feet in diameter. Recessed panels, called **coffers**, further lighten the weight of the roof. The *oculus*, or "eye," admits light, which forms a round spotlight that moves around the building during the course of a day (it admits rain as well, which is drained out by small openings in the floor). For the Romans, this light symbolized Jupiter's ever-watchful eye cast over the affairs of state, illuminating the way.

In the vast openness of its interior, the Pantheon mirrors the cosmos, the vault of the heavens. Mesopotamian and Egyptian architecture had created monuments with exterior mass. Greek architecture was a kind of sculptural event, built up of parts that harmonized. But the Romans concentrated on sheer size, including the vastness of interior space. Like the Basilica Ulpia (see *Focus,* page 258) in the Forum of Trajan, the Pantheon is concerned primarily with realizing a single, whole, uninterrupted interior space.

In this sense, the Pantheon mirrors the empire. It too was a single, uninterrupted space, stretching from Hadrian's Wall in the north of England (see Fig. 8.1 and Map 8.1) to the Rocks of Gibraltar in the south, across north Africa and Asia

The Pantheon Hadrian's Pantheon ranks with the Forum of Trajan as one of the most ambitious building projects undertaken by the Good Emperors. The Pantheon (from the Greek *pan,* "all," and *theos,* "gods") is a temple to "all the gods," and sculptures representing all the Roman gods were set in recesses around its interior. The facade imitates a Greek temple, with its eight massive Corinthian columns and deep portico, behind

Minor, and encompassing all of Europe except what is now northern Germany and Scandinavia. Like Roman architecture, the empire was built up of parts that were meant to harmonize in a unified whole, governed by rules of proportion and order. And if the monuments the empire built to celebrate itself were grand, the empire was grander still.

Pompeii

In 79 CE, during the rule of the Emperor Titus, the volcano Vesuvius erupted southeast of Naples, burying the seaside town of Pompeii in 13 feet of volcanic ash and rock. Its neighbor city Herculaneum was covered in 75 feet of a ground-hugging avalanche of hot ash that later solidified. Stationed nearby was Pliny the Elder, a commander in the Roman navy and the author of *The Natural History*, an encyclopedia of all contemporary knowledge. At the time of the eruption, his nephew, Pliny the Younger (ca. 61–ca. 113 CE), was staying with him. This is his eyewitness account (**Reading 8.9**):

READING 8.9 from *Letters of Pliny the Younger*

On 24 August, in the early afternoon, my mother drew his attention to a cloud of unusual size and appearance. He had been out in the sun, had taken a cold bath, and lunched while lying down, and was then working at his books. He called for his shoes and climbed up to a place which would give him the best view of the phenomenon. It was not clear at that distance from which mountain the cloud was rising (it was afterwards known to be Vesuvius); its general appearance can best be expressed as being like an umbrella pine, for it rose to a great height on a sort of trunk and then split off into branches, I imagine because it was thrust upwards by the first blast and then left unsupported as the pressure subsided, or else it was borne down by its own weight so that it spread out and gradually dispersed. . . .

They debated whether to stay indoors or take their chance in the open, for the buildings were now shaking with violent shocks, and seemed to be swaying to and fro as if they were torn from their foundations. Outside on the other hand, there was the danger of falling pumice-stones, even though these were light and porous; however, after comparing the risks they chose the latter. In my uncle's case one reason outweighed the other, but for the others it was a choice of fears. As a protection against falling objects they put pillows on their heads tied down with cloths. . . .

We also saw the sea sucked away and apparently forced back by the earthquake: at any rate it receded from the shore so that quantities of sea creatures were left stranded on dry sand. On the landward side a fearful black cloud was rent by forked and quivering bursts of flame, and parted to reveal great tongues of fire, like flashes of lightning magnified in size. . . .

You could hear the shrieks of women, the wailing of infants, and the shouting of men; some were calling their parents, others their children or their wives, trying to recognize them by their voices. People bewailed their own fate or that of their relatives, and there were some who prayed for death in their terror of dying. Many besought the aid of the gods, but still more imagined there were no gods left, and that the universe was plunged into eternal darkness for evermore. . . .

Pliny's uncle, Pliny the Elder, interested in what was happening, made his way toward Vesuvius, where he died, suffocated by the poisonous fumes. Pliny the Younger, together with his mother, survived. Of the 20,000 inhabitants of Pompeii, 2,000 died, mostly slaves and the poor left behind by the rich who escaped the city after early warning shocks.

Much of what we know today about everyday Roman life is the direct result of the Vesuvius eruption. Those who survived left their homes in a hurry, and were unable to recover anything they left behind. Buried under the ashes were not only homes and buildings but also food and paintings, furniture and garden statuary, even pornography and graffiti. The latter include the expected—"Successus was here," "Marcus loves Spendusa"—but also the unexpected and perceptive—"I am amazed, O wall, that you have not collapsed and fallen, since you must bear the tedious stupidities of so many scrawlers." When Pompeii was excavated, beginning in the eighteenth century, many of the homes and artifacts were found to be relatively well preserved. The hardened lava and ash had protected them from the ravages of time. But eighteenth-century excavators also discovered something unexpected. By filling the hollows where the bodies of those caught in the eruption had decomposed, they captured images of horrific death.

Domestic Architecture: The *Domus* Although by no means the most prosperous town in Roman Italy, Pompeii was something of a resort, and, together with villas from other nearby towns, the surviving architecture gives us a good sense of the Roman ***domus***—the townhouse of the wealthier class of citizen. The *domus* was oriented to the street along a central axis that extended from the front entrance to the rear of the house. The House of the Silver Wedding at Pompeii is typical in its design (Figs. **8.28, 8.29**). An **atrium**, a large space with a shallow pool for catching rainwater below its open roof, extends directly behind the vestibule. Behind the atrium and opening onto it is a reception area, often decorated with portrait busts of the family's ancestors. These busts were also housed in the reception rooms just off the main one, which in turn opens onto a central **peristyle courtyard**, surrounded by a colonnaded walkway. The dining room faces into the courtyard, as do a number of *cubicula*, small general-purpose rooms often used

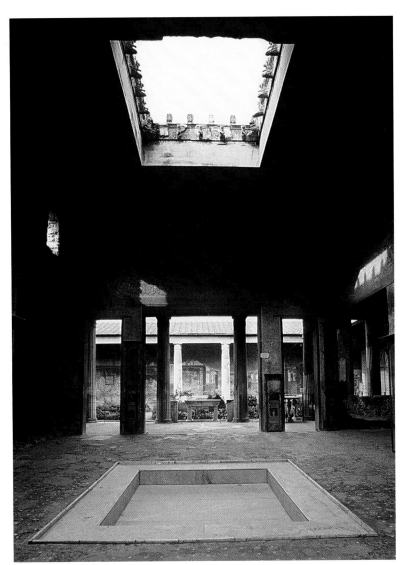

Fig. 8.28 Atrium, House of the Silver Wedding, Pompeii. 1st century BCE. This view looks through the atrium to the main reception area and the peristyle court. The house gets its name from the silver wedding anniversary of Italy's King Humbert and his queen, Margaret of Savoy, in 1893, the year it was excavated. They actively supported archeological fieldwork at Pompeii, which began in the mid-eighteenth century.

for sleeping quarters. At the back of the house, facing into the courtyard, is a hall furnished with seats for discussion. Servants probably lived upstairs at the rear of the house.

The *domus* was a measure of a Roman's social standing, as the vast majority lived in an apartment block or *insulae*. The house itself was designed to underscore the owner's reputation. Each morning, the front door was opened and left open. Gradually, the house would fill with clients—remember, the head of a Roman household was patron to many—who came to show their respect in a ritual known as the *salutatio* [sah-loo-TAH-tee-oh]. Passersby could look in to see the crowded atrium, and the patron himself was generally seated in the reception area, silhouetted by the light from the peristyle court behind. Surrounded by the busts of his ancestors, the symbol of his social position and prestige, he watched over all who entrusted themselves to his patronage.

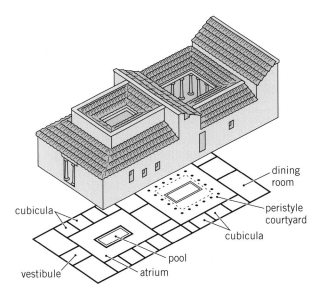

Fig. 8.29 Plan of the House of the Silver Wedding, Pompeii. 1st century CE.

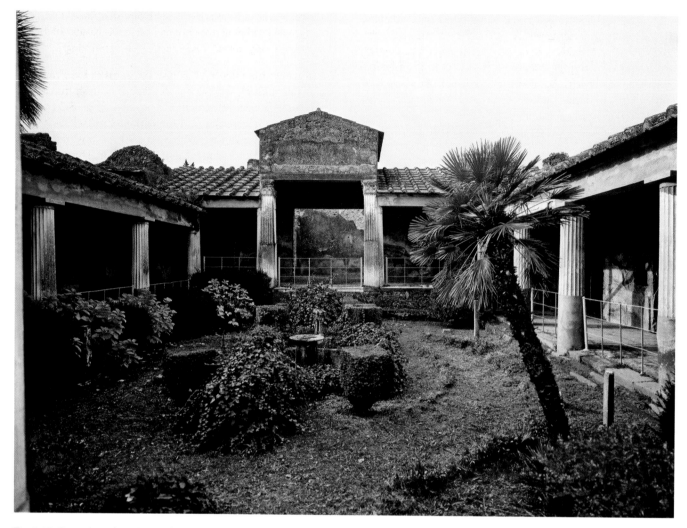

Fig. 8.30 Peristyle garden, House of the Golden Cupids, Pompeii. 62–79 CE. Built just before the eruption of Vesuvius, this house dispensed with the atrium; all its rooms are built around the peristyle garden. The dining room was entered through the pedimented portal at the rear of the garden, a dramatic setting for the *domus*'s primary social space.

At the center of the Roman *domus* was the garden of the peristyle courtyard, with a fountain or pond in the middle (Fig. **8.30**). Thanks to the long-term research of the archeologist Wilhelmina Jashemski, we know a great deal about these courtyard gardens. At the House of G. Polybius [poe-LEE-bee-us] in Pompeii, excavators carefully removed ash down to the level of the soil on the summer day of the eruption in 79 CE, when the garden would have been in full bloom. They were able to collect pollen, seeds, and other evidence, including root systems (obtained by pouring plaster into the surviving cavities) and thus determine what plants and trees were cultivated in it. Polybius's garden was lined, at one end, with lemon trees in pots, which were apparently trained and pruned to cover the wall in an *espalier*—a geo-metric trellis. Cherry, pear, and fig trees filled the rest of the space. Gardens at other villas suggest that most were planted with nut- and fruit-bearing trees, including olive, which would provide the family with a summer harvest. Vegetable gardens are often found at the rear of the *domus*, a source of more fresh produce.

The garden also provided visual pleasure for the family. In the relatively temperate Roman climate the garden was in bloom for almost three-quarters of the year. It was the focus of many rooms in the domus, which opened onto the garden. And it was evidently a symbol for the fertility, fecundity, and plenty of the household itself, for many a Roman garden was decorated with statuary referencing the cult of Dionysus.

Wall Painting Mosaics decorated many floors of the *domus*, and paintings adorned the walls of the atrium, the hall, the dining room, and other reception rooms throughout the villa. Artists worked with pigments in a solution of lime and soap, sometimes mixed with a little wax, polished with a special metal or glass, and then buffed with a cloth. Even the *cubicula* bedrooms were richly painted.

Writing in the second century CE, the satirist and rhetorician Lucian (ca. 120–after 180 CE) describes what he takes to be the perfect house—"lavish, but only in such degree as would suffice a modest and beautiful woman to set off her beauty." He continues, describing the wall paintings:

> The . . . decoration—the frescoes on the walls, the beauty of their colors, and the beauty, exactitude and truth of each detail—might well be compared with the face of spring and with a flowery field, except that those things fade and wither and change and cast their beauty, while this is spring eternal, field unfading, bloom undying.

In Rome, at the villa of Livia and Augustus at the Primaporta, a wall painting depicting a garden full of fresh fruit, songbirds, and flowers reflects this sensibility (Fig. **8.31**). It is rendered as if it were an extension of the room itself, as if Livia and Augustus and their visitors could, at any time, step through the wall into their "undying" garden. Thus, although naturalistically rendered, it is an idealistic representation. As we shall discuss in chapter 9, Jesus was born in Palestine during Augustus's reign and Christianity was just beginning to take hold during Lucian's career. Lucian's essay and this painting suggest that the desire for enduring life promised by the Christian faith was already a central tenet of Roman culture.

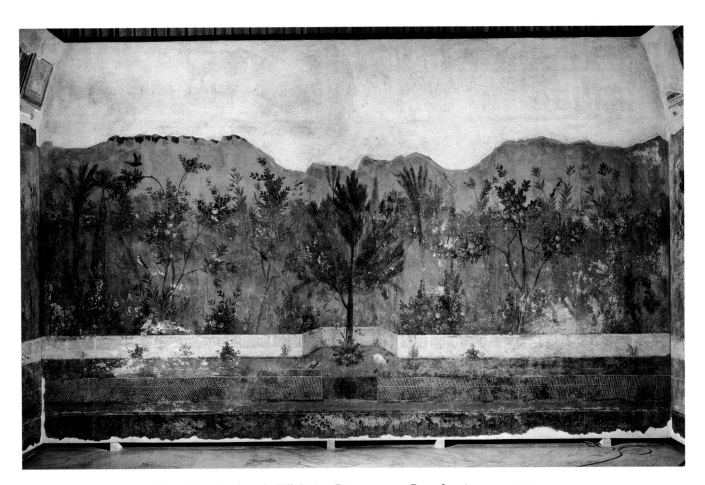

Fig. 8.31 *Garden Scene*, detail of a wall painting from the **Villa Livia at Primaporta, near Rome. Late 1st century** BCE. Museo Nazionale Romano, Rome. The artist created a sense of depth by setting a wall behind a fence with its open gate.

READINGS

Virgil, from the *Aeneid*, Book IV

Modeled on the epics of Homer, Virgil's Aeneid was intended to provide the Emperor Augustus, the author's patron, with a grand myth of the origins of the Roman state. It narrates the travails of the Trojan Aeneas, who after the fall of Troy sails the Mediterranean predestined to found Rome. The poem opens in Carthage, where Aeneas and his men have been the guests of the Phoenician Queen Dido. She has fallen in love with Aeneas, but he must, he knows, forge ahead to meet his destiny. The following passage opens as Dido begins to realize that he is preparing to desert her. As compassionate as Virgil is in presenting Dido and Aeneas's mutual tragedy, his sympathy for them both is tempered—or perhaps made even more compelling—by the fact that Aeneas must renounce her in the name of duty.

He is more than eager
To flee that pleasant land, awed by the warning
Of the divine command. But how to do it?
How get around that passionate queen? What opening
Try first? His mind runs out in all directions,
Shifting and veering. Finally, he has it,
Or thinks he has: he calls his comrades to him,
The leaders, bids them quietly prepare
The fleet for voyage, meanwhile saying nothing
About the new activity; since Dido 10
Is unaware, has no idea that passion
As strong as theirs is on the verge of breaking,
He will see what he can do, find the right moment
To let her know, all in good time. Rejoicing,
The captains move to carry out the orders.
Who can deceive a woman in love? The queen
Anticipates each move, is fearful even
While everything is safe, foresees this cunning,
And the same trouble-making goddess, Rumor,
Tells her the fleet is being armed, made ready 20
For voyaging. She rages through the city
Like a woman mad. . . .
She waits no explanation from Aeneas;
She is the first to speak: "And so, betrayer,
You hoped to hide your wickedness, go sneaking
Out of my land without a word? Our love
Means nothing to you, our exchange of vows,
And even the death of Dido could not hold you.
The season is dead of winter, and you labor
Over the fleet; the northern gales are nothing— 30
You must be cruel, must you not? Why, even,
If ancient Troy remained, and you were seeking
Not unknown homes and lands, but Troy again,
Would you be venturing Troyward in this weather?
I am the one you flee from: true? I beg you
By my own tears, and your right hand—(I have nothing
Else left my wretchedness)—by the beginnings
Of marriage, wedlock, what we had, if ever
I served you well, if anything of mine
Was ever sweet to you, I beg you, pity 40
A falling house; if there is room for pleading

As late as this, I plead, put off that purpose. . . ."
There was nothing he could say. Jove bade him keep
Affection from his eyes, and grief in his heart
With never a sign. At last, he managed something:—
"Never, O Queen, will I deny you merit
Whatever you have strength to claim; I will not
Regret remembering Dido, while I have
Breath in my body, or consciousness of spirit.
I have a point or two to make. I did not, 50
Believe me, hope to hide my flight by cunning;
I did not, ever, claim to be a husband,
Made no such vows. If I had fate's permission
To live my life my way, to settle my troubles
At my own will, I would be watching over
The city of Troy, and caring for my people,
Those whom the Greeks had spared, and Priam's palace
Would still be standing; for the vanquished people
I would have built the town again. But now
It is Italy I must seek, great Italy, 60
Apollo orders, and his oracles
Call me to Italy. There is my love,
There is my country. . . ."
Out of the corner of her eye she watched him
During the first of this, and her gaze was turning
Now here, now there; and then, in bitter silence,
She looked him up and down; then blazed out at him:—
"You treacherous liar! No goddess was your mother,
No Dardanus the founder of your tribe,
Son of the stony mountain-crags, begotten 70
On cruel rocks, with a tigress for a wet-nurse!
Why fool myself, why make pretense? what is there
To save myself for now? When I was weeping
Did he so much as sigh? Did he turn his eyes,
Ever so little, toward me? Did he break at all,
Or weep, or give his lover a word of pity?
What first, what next? Neither Jupiter nor Juno
Looks at these things with any sense of fairness.
Faith has no haven anywhere in the world.
He was an outcast on my shore, a beggar, 80
I took him in, and, like a fool, I gave him
Part of my kingdom; his fleet was lost, I found it,

His comrades dying, I brought them back to life.
I am maddened, burning, burning: now Apollo
The prophesying god, the oracles
Of Lycia, and Jove's herald, sent from heaven,
Come flying through the air with fearful orders,—
Fine business for the gods, the kind of trouble
That keeps them from their sleep. I do not hold you,
I do not argue, either. Go. And follow 90
Italy on the wind, and seek the kingdom
Across the water. But if any gods
Who care for decency have any power,
They will land you on the rocks; I hope for vengeance,
I hope to hear you calling the name of Dido
Over and over, in vain. Oh, I will follow
In blackest fire, and when cold death has taken
Spirit from body, I will be there to haunt you,
A shade, all over the world. I will have vengeance,
And hear about it; the news will be my comfort 100
In the deep world below." She broke it off,
Leaving the words unfinished; even light
Was unendurable; sick at heart, she turned
And left him, stammering, afraid, attempting
To make some kind of answer. And her servants
Support her to her room, that bower of marble,
A marriage-chamber once; here they attend her,
Help her lie down.
And good Aeneas, longing
To ease her grief with comfort, to say something 110
To turn her pain and hurt away, sighs often,
His heart being moved by this great love, most deeply,
And still—the gods give orders, he obeys them;
He goes back to the fleet. And then the Trojans
Bend, really, to their work, launching the vessels
All down the shore. The tarred keel swims in the water,
The green wood comes from the forest, the poles are lopped
For oars, with leaves still on them. All are eager
For flight; all over the city you see them streaming,
Bustling about their business, a black line moving 120
The way ants do when they remember winter
And raid a hill of grain, to haul and store it
At home, across the plain, the column moving
In thin black line through grass, part of them shoving
Great seeds on little shoulders, and part bossing
The job, rebuking laggards, and all the pathway
Hot with the stream of work.
And Dido saw them
With who knows what emotion: there she stood
On the high citadel, and saw, below her, 130
The whole beach boiling, and the water littered
With one ship after another, and men yelling,
Excited over their work, and there was nothing
For her to do but sob or choke with anguish.
There is nothing to which the hearts of men and women
Cannot be driven by love. Break into tears,
Try prayers again, humble the pride, leave nothing
Untried, and die in vain. . . . ■

Reading Questions

The tragedy here lies in the conflict between personal desire and civic duty. What metaphor does Virgil use to underscore the power of civic duty and responsibility to overcome the demands of human love? What does Dido do that demonstrates the opposite? How, for Virgil, do these alternatives seem to be driven by gender?

READING 8.8

Horace, Ode 13 from the *Odes*

Horace's Odes are lyric poems of elaborate and complex meter. Although they often extol the virtues of life on his rural estate outside Rome, in the following example Horace curses a tree that has unexpectedly crashed down, nearly killing him. It is an instance, among many others that he mentions, of the unanticipated but nevertheless real dangers of life. In the last half of the poem he imagines that he has been killed, finding himself in the Underworld with other lyric poets who give comfort to the dead with their verses.

The man who first planted thee did it upon an
evil day and reared thee with a sacrilegious
hand, O tree, for the destruction of posterity
and the countryside's disgrace.
I could believe that he actually strangled his
own father and spattered his hearthstone with
a guest's blood at dead of night; he too has
dabbled in Colchic poisons
and whatever crime is anywhere
conceived—the man that set thee out on my 10
estate, thou miserable stump, to fall upon the
head of thy unoffending master.
Man never heeds enough from hour to hour
what he should shun. The Punic sailor dreads
the Bosphorus,[1] but fears not the unseen fates
beyond that threaten from other quarters.
The soldier dreads the arrows of the Parthians and their swift
retreat; the Parthian fears the chains and rugged strength of
Italy; but the fatal violence that has snatched away, and again

[1]Punic sailor dreads the Bosphorus, etc. (lines 14–19): each person fears the danger near at hand.

will snatch away, the tribes of men, is something unforeseen. 20
How narrowly did I escape beholding the realms
of dusky Proserpine[2] and Aeacus[3] on his
judgment-seat, and the abodes set apart
for the righteous,
and Sappho complaining on Aeolian lyre of her
countrywomen, and thee, Aleaeus, rehearsing in fuller
strain with golden plectrum[4] the woes of seaman's
life, the cruel woes of exile, and the woes of war.
The shades[5] marvel at both as they utter words worthy
of reverent silence; but the dense throng, shoulder 30
to shoulder packed, drinks in more eagerly with
listening ear stories of battles and of tyrants banished.

What wonder, when lulled by such strains,
the hundred-headed monster lowers his
black ears, and the serpents writhing in the
locks of the Furies stop for rest!
Yea, even Prometheus and Pelops' sire[6] are
beguiled of their sufferings by the soothing
sound, nor does Orion[7] care to chase the lions
or the wary lynxes. ■ 40

Reading Question

Why do you suppose this poem has been described as "a defense of poetry"?

[2]**Proserpine:** wife of Pluto and queen of the Underworld.
[3]**Aeacus:** A righteous king who, after his death, judges the souls who arrive in the Underworld.
[4]**plectrum:** a device for plucking a stringed instrument, such as a lyre.
[5]**shades:** souls of the dead in the Underworld.

[6]**Prometheus and Pelops' sire:** Prometheus and Tantalus, both of whom received especially terrible punishments.
[7]**Orion:** a mighty hunter.

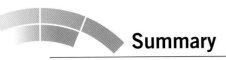

Summary

■ **Origins of Roman Culture** Roman culture developed out of both Greek and indigenous Etruscan roots. Most of what we know of the Etruscans comes from sculptures and paintings that survive in tombs. Their temples employed the Tuscan order, a modified version of the Greek Doric order, and the Romans later adapted their floor plans to their own temples, adding a new feature, the engaged column. The Romans also learned the principles of the architectural arch from the Etruscans. The Etruscans also provided the Greeks with one of their founding myths, the legend of Romulus and Remus (Virgil's *Aeneid* was the other). According to legend, it was Romulus who inaugurated the traditional Roman distinction between patricians and plebians with its system of patronage and *pietas*.

■ **Republican Rome** During the Republic, Rome embarked on a series of military exploits culminating in the Punic Wars, which began in 264 BCE and lasted for over 100 years. The Roman victory over Hannibal and the Carthaginians helped to establish the feeling that Rome was invincible. Whenever Rome conquered a region, it established permanent colonies and gave land to the victorious citizen-soldiers. In the first century BCE, power swayed back and forth between the *equites*, Rome's military elite, and the Senate, dominated by patricians, and between the generals themselves. Julius Caesar eventually assumed dictatorial control of Rome until his assassination in 44 BCE. After several years of discord, he was succeeded by his grandnephew, Octavian, who assumed full control of Rome after his victory at the Battle of Actium in 31 BCE. During the first century, the powerfully eloquent and persuasive writing of the rhetorician Cicero helped to make Latin the chief language of the empire. His essay *On Duty* helped to define *pietas* as a Roman value, a value evidenced in the portrait busts of the era with their veristic realism.

■ **Imperial Rome** In 27 BCE, the Senate granted Octavian the imperial name Augustus and the authority of *imperium* over all the empire. Augustus idealized himself in the monumental statues dedicated to him and presented his family as the ideal Roman family in the sculptural program of the *Ara Pacis Augustae*. His wife, Livia, became the ideal figure for womanhood in the Roman state, which educated both sexes equally until at least 12 years of age. Many Romans brought Greek philosophers into their homes to educate their children, and two Greek philosophical systems gained considerable Roman following—Epicureanism and, especially, Stoicism. Virgil's epic poem the *Aeneid* is consciously inspired by the example of Homer, but it leaves its Greek sources behind in its profound examination of the values on which the Roman state was founded. Horace's *Odes* were likewise inspired by Greek precedents, blending the Greek love of beauty with a distinctly Roman sense of duty. Augustus's literary patronage extended to both Virgil and Horace, but not to Ovid, whose *Art of Love* offended him. Nevertheless, Ovid's *Metamorphoses* constitutes one of the most moving works of the era in its exploration of human identity and transformation.

But Augustus's greatest achievement, and that of the emperors to follow him, was the transformation of Rome into, in Augustus's words, "a city of marble." In Rome itself citizens lived in the crowded conditions of the apartment block, or *insula*, but in rural and resort communities such as Pompeii, buried by ash in the eruption of Mt. Vesuvius in 79 CE, the more spacious Roman *domus* was more common, its rooms surrounding a courtyard and the walls of its *cubiculae* decorated with paintings. In Rome itself, life was largely lived in the open spaces of the avenues, in its wide forums and spacious basilicas. In the seemingly endless spaces of the Imperial Forums, in the throngs that filled the Colosseum, in the vast interior of the Pantheon, Roman architecture mirrored the empire, each a vast unified whole, governed by rules of proportion and order.

Glossary

apse A rounded extension at the end of a basilica.

arcade A succession of arches.

atrium An unroofed interior courtyard.

barrel vault A rounded vault formed when a round arch is extended.

basilica A large, rectangular building with an apse at one or both ends.

bay The space inside an arch.

buttress An architectural support usually formed by a projecting masonry structure.

coffer A recessed panel in a ceiling or dome.

dactyl An element of meter in poetry consisting of one long syllable followed by two short syllables.

dactylic hexameter A poetic verse consisting of six rhythmic units, or feet, and each foot is either a dactyl or a spondee.

domus A traditional Roman house or villa.

Epicureanism A philosophy founded by Epicurus (341–270 BCE), who stressed clarity and simplicity of thought and believed that fear was responsible for all human misery.

foot A rhythmic unit in poetry.

groin The projecting line formed when two barrel vaults meet one another at a right angle.

jamb An upright structural support.

keystone A wedge-shaped stone at the top of an arch.

oculus A circular opening at the top of a dome.

ode A lyric poem of elaborate and irregular meter.

patrician A land-owning aristocrat.

peristyle courtyard A courtyard surrounded by a colonnaded walkway.

pier An upright structural support.

plebian A member of the poorer classes of ancient Rome.

podium An elevated platform.

rhetorician A writer or orator.

round arch A curved architectural support element that spans an opening.

sarcophagus (pl. sarchophagi) A coffin, usually of stone.

spandrel The areas between the arches of an arcade.

spondee An element of meter in poetry consisting of two long syllables.

Stoicism A practical philosophy that developed in the Athenian *stoa* and stressed rational detachment and practical common-sense principles.

tumulus A round structure partially excavated and partly above ground and covered with earth.

Tuscan order A Classical architectural order composed of columns with unfluted shafts and a pedestal base.

verism A form of realism in art or literature.

voussoir A wedge-shaped block used to form an arch or vault.

Critical Thinking Questions

1. In what ways does a Roman temple, such as the Temple of Fortuna Virilis, differ from a Greek temple, such as the Parthenon?

2. Describe *pietas* and explain how it is reflected in Roman portrait sculpture.

3. Why did the Roman emperors build so many public works? What did they symbolize or represent?

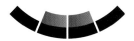

During the period we call the Middle Ages, the naturalism in art that we associate with the classical traditions of Greece and Rome faded away. Christianity began, like both Judaism and Islam, as a religion not of images but of scriptures. Even as images came to play a role in the Christian tradition—in Byzantium, for instance, where the Virgin and Child became a standard motif—they served to tell sacred stories that Christians understood and appreciated emotionally for the events they symbolized. Not until the Renaissance, nearly a thousand years later, would the individual portrait, so commonplace in Rome, gain popular favor once again.

It would be a mistake to see a decline of artistic ability or sensitivity in the abandonment of naturalism. The forces in the Middle Ages that resulted in flat surfaces, schematic or diagram-like figuration, and an almost total disregard for depicting real space were, rather, manifestations of a desire to reveal truths higher than those readily visible to the naked eye. Such truths were to be understood through the mind and heart instead, as expressions of faith.

For nearly a millennium after Rome's official acceptance of Christianity under the emperor Constantine in 313 CE, sight served a role of secondary importance to faith. Insofar as sight served the Christian faith, inspiring the faithful in the light of a stained glass window or the illuminated image in a manuscript, it was deemed acceptable, even desirable, by the clergy. But one could never see—at least not in this lifetime—the God in which they believed, and, as the faithful were constantly reminded, that ultimate vision is what mattered most of all.

Nevertheless, Roman traditions did live on in the Middle Ages, particularly in architecture. The Roman basilica would become the model for the Christian basilica-plan church, and certain aspects of Roman villa architecture would also come to inform Christian designs for the "house of God." Both the Romans and the Christians understood the power of grand architectural space to enthrall visitors and capture their imaginations. By the first years of the second millennium, even the Roman triumphal arch would find its way into the architecture of Christian churches—compare, for instance, the Arch of Constantine (Fig. 8.32) with the portal of the Church of Sainte-Marie-Madeleine in Vézeley, France (Fig. 8.33). This similarity is one of many that account for the designation "Romanesque," or "Roman-like," to describe the style of early medieval architecture. Features that had once celebrated

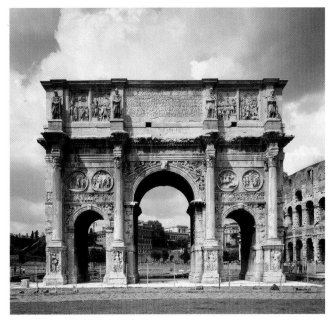

Fig. 8.32 Arch of Constantine, Rome. 315 CE. The monumental effects produced by this triumphal arch would find their way to the portals of Christian churches, such as Old St. Peter's Basilica, built in Rome shortly after this arch in 320–327 CE.

Fig. 8.33 Church of Sainte-Marie-Madeleine, Vézeley, France. ca. 1089–1206 CE. As we shall see in Book 2, the architectural style of this facade is so clearly indebted to Roman precedents that it has been labeled Romanesque.

the glory of the emperor now celebrated the glory of God.

Later, during the Renaissance, individual genius would once again be valued, and classical naturalism would be restored. Architects like Brunelleschi, Alberti, and Michelangelo would visit Rome to study and learn from its ruins. Playwrights like Shakespeare would study Roman history and retell it on the stage. Long-lost manuscripts by Tacitus, Cicero, Propertius, and Petronius would all be unearthed as Rome was excavated, and these would influence writers and teachers. By the eighteenth century, when Pompeii and Herculaneum were excavated, a kind of Roman fever gripped the West. In America, John Adams and Thomas Jefferson, both well read in classical literature, would model their new nation on the Roman Republic, remembering, among other things, their Cicero: "The people's good is the highest law." Napoleon, in France, would model his new civil code on Roman law (and his imperial aspirations on Roman history). These are stories that subsequent volumes will tell, all Roman in inspiration. ■

Index

Photo Credits

Chapter 1

Book Opener Siegfried Tauquer, eStock Photography LLC, © Siegfried Tauquer/eStock Photo; **1-1** French Minstry of Culture & Communication; **1-2** Jean Clottes, Ministere de la Culture et des Communications, Ministere de la Culture et de la Communication. Direction Regionale des affaires Culturelles de Rhone-Alpes. Service Regional de l'Archeologie; **1-3** Corbis/Sygma; **1-4** Yvonne Vertut; **1-5** Image © The Metropolitan Museum of Art / Art Resource, NY; **1-6** Erich Lessing, Art Resource, NY, Naturhistorisches Museum, Vienna, Austria. © Photography by Erich Lessing/Art Resource, NY; **1-8** Zev Radovan, Z. Radovan/www.BibleLandPictures.com; **1-9** Archaeological Museum; **1-10** P. Pleynet, © Réunion des Musées Nationaux/Art Resource, NY; **1-11** Dorling Kindersley Media Library, © Judith Miller / Dorling Kindersley / Wallis and Wallis; **1-12** Art Resource/Musée du Louvre; **1-13** Yan Arthus-Bertrand, Photo Researchers, Inc.; **1-14** Chris Hellier, CORBIS–NY, © Chris Hellier / CORBIS All Rights Reserved; **1-15** Aerofilms; **1-16** John Deeks, Photo Researchers, Inc.; **1-17** Peabody Museum, Harvard University, © 2006 Peabody Museum, Harvard University 64-19-10/42483 T180; **1-18** Millicent Rogers Museum, Zuni. © Millicent Rogers Museum; **1-19** Suzanne Murphy, Getty Images Inc.–Stone Allstock; **1-20** Tony Linck, SuperStock, Inc.; **1-21** Cahokia Mounds State Historic Site; **1-22** Corbis/Sygma; **1-23** © 2008 Susan Rothenberg/Artist's Rights Society (ARS), NY; page 11, The Bridgeman Art Library International, Musée des Antiquites Nationales, St. Germain-en-Laye, France/The Bridgeman Art Library; pages 20–21, Dorling Kindersley Media Library, Christian Hook © Dorling Kindersley.

Chapter 2

2-1 Nik Wheeler; **2-2** Georg Gerster, Photo Researchers, Inc.; **2-3** The Oriental Institute Museum, Courtesy of the Oriental Institute of the University of Chicago; **2-4** HIP, Art Resource, NY; **2-06** Art Resource/The British Museum Great Court Ltd; **2-7** University of Pennsylvania Museum of Archaeology and Anthropology, Mythological figures, Detail of the sound box of *The Bull-headed Lyre* from Ur. University of Pennsylvania Museum object #B17694, (image #150848); **2-8** Art Resource/The British Museum Great Court Ltd; **2-9** SCALA, Art Resource, NY; **2-10** Chuzeville, Art Resource/Musée du Louvre, Chuzeville/ Musée du Louvre/RMN Réunion des Musées Nationaux, France. Art Resource, NY; **2-11** D. Arnaudet/Louvre, Paris France/RMN, Art Resource/Musée du Louvre, D. Arnaudet/Louvre, Paris France/Réunion des Musées Nationaux/Art Resource, NY; **2-12** page Herve Lewandowski, RMN/Réunion des Musées Nationaux/Art Resource, NY; **2-13** British Museum, London, Art Resource, NY; **2-14** MN Réunion des Musées Nationaux, France. SCALA/Art Resource, NY; **2-15** Art Resource/The British Museum Great Court Ltd, © Copyright The British Museum; **2-17** ALAN ODDIE, PhotoEdit Inc.; **2-18** Erich Lessing, Art Resource, NY; **2-19** Bildarchiv Preussischer Kulturbesitz, Art Resource/Bildarchiv Preussischer Kulturbesitz; **2-20** Staffan Widstrand, Nature Picture Library; page 41 (right), RMN Réunion des Musées Nationaux, France. SCALA/Art Resource, NY.

Chapter 3

3-1 Alistair Duncan, Dorling Kindersley Media Library, Alistair Duncan © Dorling Kindersley; **3-2** Werner Forman, Art Resource, NY; **3-3** Dagli Orti, Picture Desk, Inc./Kobal Collection; **3-7** Vanni, Art Resource, NY; **3-8** Araldo de Luca/The Egyptian Museum, Cairo, Index Ricerca Iconografica; **3-9** Reproduced with permission. © 2006 Museum of Fine Arts, Boston. Harvard University-Boston Museum of Fine Arts. All Rights Reserved.; **3-10** Herve Lewandowski, RMN Réunion des Musées Nationaux, France. Art Resource, NY; **3-11** Picture Desk, Inc./Kobal Collection; **3-12** Dagli Orti/Egyptian Museum, Cairo, Picture Desk, Inc./Kobal Collection; **3-13** SCALA, Art Resource, NY; **3-15** Petera A. Clayton; **3-16** Yvonne Vertut; **3-18** AKG-Images; **3-19** Art Resource/The British Museum Great Court Ltd; **3-20** Bildarchiv Preussischer Kulturbesitz, Berlin, Germany, Art Resource/Bildarchiv Preussischer Kulturbesitz; **3-21** Art Resource/Bildarchiv Preussischer Kulturbesitz; **3-22** Art Resource/The Metropolitan Museum of Art, Photography by Egyptian Expedition, The Metropolitan Museum of Art; **3-23** Juergen Liepe, Jurgen Liepe Photo Archive; **3-24** SCALA, Art Resource, NY; **3-25** Art Resource/The British Museum Great Court Ltd; **3-26** SCALA, Art Resource, NY; **3-27** Silvio Fiore, SuperStock, Inc., Silvio Fiore/SuperStock; **3-28** SCALA, Art Resource, NY; **3-29** Nimatallah/National Archeological Museum, Athens, Art Resource, NY; page 78, Art Resource, NY; page 79, Art Resource, NY; page 83, Art Resource/The British Museum Great Court Ltd, © Copyright The British Museum; page 91 (left), Art Resource/The British Museum Great Court Ltd, © The Trustees of the British Museum; page 91 (right), Art Resource/The British Museum Great Court Ltd, © The Trustees of the British Museum.

Chapter 4

4-1 D. E. Cox, Getty Images Inc.–Stone Allstock, D. E. Cox/Stone/Getty Images; **4-2** The Nelson-Atkins Museum of Art, Kansas City, Missouri. (Purchase: Nelson Trust) 33-81; **4-3** Lowell Georgia, CORBIS–NY, © Lowell Georgia / CORBIS All Rights Reserved; **4-6** Chunhua County Cultural Museum, Art Resource, NY; **4-7** Liu Liqun, ChinaStock Photo Library; **4-8** page 000, Art Resource/The British Museum Great Court Ltd, © Copyright The British Museum; **4-9** The Art Archive, Picture Desk, Inc./Kobal Collection; **4-10** Marshall Wu, Hunan Provincial Museum; **4-11** SCALA, Art Resource, NY; **4-12** The Cleveland Museum of Art, "Shiva Nataraja, Lord of the Dance". South India. Chola period, 11th Century. Bronze. 111.5 × 101.65 cm. © The Cleveland Museum of Art, Purchase from the J.H. Wade Fund 1930.331.; **4-13** Massimo Borchi/Atlantide Phototravel, CORBIS–NY, © Massimo Borchi/© Atlantide Phototravel / CORBIS All Rights Reserved; **4-15** Adam Woolfitt, CORBIS–NY, © Adam Woolfitt / CORBIS All Rights Reserved; **4-16** © Werner Forman/Art Resource, NY; page 116, Art Resource, NY; page 117 (top), Wang Lu, ChinaStock Photo Library; page 117 (bottom), The Bridgeman Art Library International.

Chapter 5

5-1 Nimatallah/National Archeological Museum, Athens, Art Resource, NY; **5-2** Nicholas P. Goulandris Foundation. Museum of Cycladic Art.; **5-3** Archeological Museum, Iraklion, Crete, Studio Kontos Photostock; **5-4 (top)** McRae Books Srl; **5-4 (bottom)** Pearson Education/PH College, From John Griffiths Pedley, "Greek Art and Archaeology, 2/e' Prentice Hall, 1998, fig. 3.1, p. 65.; **5-5** Roger Wood, CORBIS–NY, © Roger Wood / CORBIS All Rights Reserved; **5-6** National Archaeological Museum, National Archaeological Museum, © Hellenic Ministry of Culture, Archaeological Receipts Fund; **5-7** Studio Kontos Photostock; **5-8** Studio Kontos Photostock; **5-9** National Archaeological Museum, Athens, Hirmer Fotoarchiv, National Archaeological Museum, Athens/Hirmer Fotoarchiv, Munich, Germany; **5-10** Vanni Archive, CORBIS–NY, © Vanni Archive / CORBIS All Rights Reserved; **5-11** Dorling Kindersley Media Library, Maltings Partnership © Dorling Kindersley; **5-12** Studio Kontos Photostock; **5-13** Museum of Fine Arts, Boston, Photograph © 2008 Museum of Fine Arts, Boston.; **5-14** Erich Lessing/Archaeological Museum, Mykonos, Greece, Art Resource, NY; **5-15** Bibliotheque Nationale/Erich Lessing, Art Resource, NY; **5-16** Staatliche Antikensammlungen und Glyptothek Munich, Staatliche Antikensammlungen und Glyptothek, Munich, Germany; page 139, Erich Lessing, Art Resource, NY

Chapter 6

6-1 Marco Cristofori, CORBIS–NY; 6-2 Seraph, The German Archaeological Institute - ROME, Seraph, DAI, Neg. No. D-DAI-ATH-Kerameikos 7750; 6-3 Zeiler, The German Archaeological Institute–ROME, Zeiler, DAI, Neg. No. D-DAI-ATH-Kerameikos 8036; 6-5 Nimatellah, Art Resource, NY; 6-6 John Heseltine, CORBIS–NY, © John Heseltine / CORBIS All Rights Reserved; 6-8 Art Resource/The Metropolitan Museum of Art, Image © The Metropolitan Museum of Art / Art Resource, NY; 6-9 Art Resource/The Metropolitan Museum of Art, Photograph © 1997 The Metropolitan Museum of Art.; 6-10 SCALA, Art Resource, NY; 6-11 (left) Akropolis Museum, Athens, Studio Kontos Photostock; 6-11 (right) Cambridge University Museum of Archaeology and Anthropology, Museum of Classical Archaeology, University of Cambridge, UK; 6-12 Dagli Orti/Acropolis Museum Athens, Picture Desk, Inc./Kobal Collection; 6-13 Art Resource/The Metropolitan Museum of Art, NY; 6-14 Courtesy, Museum of Fine Arts, Boston. Reproduced with permission. © 2005 Museum of Fine Arts, Boston. All Rights Reserved.; 6-15 Gerard Degeorge, CORBIS–NY, © Gerard Degeorge/ CORBIS All Rights Reserved; 6-16 Art Resource/The British Museum Great Court Ltd; 6-17 David Allen Studio, DavidAllenStudio.com; 6-18 SCALA, Art Resource, NY; 6-19 SCALA, Art Resource, NY; 6-20 Dagli Orti/Archaeological Museum, Naples, Picture Desk, Inc./Kobal Collection; page 168, Canali Photobank; page 169 (top left), Nimatellah, Art Resource, NY; page 169 (top right), John Decopoulos; page 169 (bottom), Library of Congress, Courtesy of the Library of Congress.

Chapter 7

7-1 Studio Kontos Photostock; 7-2 Sonia Halliday Photographs; 7-2 Map AKG-Images; 7-3 Nimatallah, Art Resource, NY, Acropolis Museum, Athens, Greece. Nimtallah/Art Resource, NY; 7-4 Dagli Orti/Archaeological Museum, Naples, Picture Desk, Inc./Kobal Collection; 7-5 Royal Ontario Museum ROM, With permission of the Royal Ontario Museum © ROM; 7-6 Reggio, Museo Archeologico Nazionale di Napoli, Reggio/Museo Archeologico Nazionale di Napoli, Naples, Italy; 7-8 Art Resource/The British Museum Great Court Ltd, © The Trustees of the British Museum; 7-9 Art Resource/The British Museum Great Court Ltd, © Copyright The British Museum; 7-10 Baghdad Museum, Art Resource/The British Museum Great Court Ltd, © The Trustees of the British Museum; 7-11 Royal Ontario Museum ROM, With permission of the Royal Ontario Museum © ROM; 7-12 Studio Kontos Photostock; 7-13 Studio Kontos Photostock; 7-14 Art Resource/The British Museum Great Court Ltd, © Copyright The British Museum; 7-15 Penguin Group USA, Inc.; 7-16 SCALA, Art Resource, NY; 7-17 Martin von Wagner Museum der Universitat Wurzburg/Antikensammlung, Martin von Wagner Museum, University of Wurzburg, Wurzburg, Germany; 7-18 Ingrid Geske/Antikensammlung, Staatliche Muséen zu Berlin, Art Resource/Bildarchiv Preussischer Kulturbesitz; 7-19 Ruggero Vanni, CORBIS–NY; 7-21 Erich Lessing, Art Resource, NY; 7-22 (right) Picture Desk, Inc./Kobal Collection; 7-22 (left) Picture Desk, Inc./Kobal Collection; 7-23 SCALA, Art Resource, NY; 7-24 P Zigrossi, Musei Vaticani, P. Zigrossi/Vatican Museums, Rome, Italy; 7-25 Tourist Organization of Greece; 7-26 Art Resource, NY; 7-27 SCALA, Art Resource, NY; 7-28 Art Resource/Musée du Louvre, RMN Réunion des Musées Nationaux, France. SCALA/Art Resource, NY; 7-29 AKG-Images; 7-30 Art Resource/The British Museum Great Court Ltd, © The Trustees of the British Museum; 7-31 Adam Woolfitt, CORBIS–NY, © Adam Woolfitt / CORBIS All Rights Reserved; page 197 (top), Phaidon Press Limited; page 197 (bottom), Studio Kontos Photostock; page 196 (bottom), Staatliche Antikensammlungen und Glyptothek, Staatliche Antikensammlungen und Glyptothek, Munich, Germany.

Chapter 8

8-1 Biran Brake, John Hillelson Agency; 8-2 Villa Giulia; 8-4 Penelope Davies; 8-7 Canali Photobank; 8-8 Erich Lessing, Art Resource, NY, Museo Capitolino, Rome, Italy. © Photography by Erich Lessing/Art Resource, NY; 8-9 Timothy McCarthy, Art Resource, NY; 8-10 M. Sari/Musei Vaticani/SCALA, Art Resource, NY; 8-11 Araldo de Luca, CORBIS–NY; 8-12 Art Resource/The Metropolitan Museum of Art; 8-13 SuperStock, Inc., Vatican Museums & Galleries, Vatican City/Superstock; 8-14 Foto Vasari, Index Ricerca Iconografica; 8-15 SCALA, Art Resource, NY; 8-16 Museo Archeologico Nazionale, Naples, Gemeinnutzige Stiftung Leonard von Matt, Gemeinnutzige Stiftung Leonard von Matt, Buochs, Switzerland; 8-17 Dagli Orti/Archaeological Museum, Naples, Italy, Picture Desk, Inc./Kobal Collection; 8-18 SCALA, Art Resource, NY; 8-19 Pubbli Aer Foto; 8-20 Canali Photobank; 8-21 Michael Larvey, Canali Photobank; 8-22 Werner Forman, Art Resource, NY; 8-23 Robert Frerck, Woodfin Camp & Associates; 8-24 SCALA, Art Resource, NY; 8-25 Canali Photobank; 8-27 Hemera Technolgies, Alamy Images Royalty Free; 8-28 Henri Stierlin; 8-29 Cambridge University Press. Reprinted with the permission of Cambridge University Press; 8-30 Fotografica Foglia; 8-31 Canali Photobank; 8-32 Araldo de Luca Archives, Index Ricerca Iconografica; 8-33 Bildarchiv Monheim, AKG-Images; page 255 (bottom), Danita Delimont Photography; pages 258–259, Gilbert Gorski; page 258 (top), Vanni, Art Resource, NY; page 259 (top), Dr. James E. Packer; page 259 (bottom right), Fototeca Unione, American Academy in Rome.

Text Credits

Chapter 1

Reading 1.1, page 24: Zuni Emergence Tale, THE HEATH ANTHOLOGY OF AMERICAN LITERATURE, Fifth Edition, Volume A, edited by Paul Lauter. Copyright © 2006 by Houghton Mifflin Company. Used with permission.

Chapter 2

Reading 2.1, page 47: Hymn to Marduk, BOTTERO, MESOPOTAMIA. "Hymn to Marduck", trans. By Zainab Bahrani and Marc Van de Mieroop. Copyright © 1992 by the University of Chicago Press. Reprinted by permission. Reading 2.3, page 51: The Blessing of Inanna, BOTTERO, MESOPOTAMIA. "The Blessing of Inanna", trans. By Zainab Bahrani and Marc Van de Mieroop. Copyright © 1992 by the University of Chicago Press. Reprinted by permission. Readings 2.4 (a, b, c, d), pages 53–54: from the Epic of Gilgamesh, Reprinted with permission from © 1997 The Epic of Gilgamesh, 2nd Edition by Danny P. Jackson, published by Bolchazy-Carducci Publishers, Inc., Wauconda, IL 60084. Reading 2.4, page 63: from The Epic of Gilgamesh (Tablet VI), From Kovacs, Maureen Gallery, translator. THE EPIC OF GILGAMESH, with an Introduction and Notes. Copyright © 1985, 1989 by the Board of Trustees of the Leland Stanford Junior University. All rights reserved. Used with the permission of Stanford University Press, www.sup.org Reading 2.5, page 64: from the Hebrew Bible (Chapters 1–3, 6–7), "New Revised Version Bible, copyright 1989, Division of Christian Education of the National Council of the Churches of Christ in the United States of America. Used by permission. All rights reserved." Reading 2.5a, page 56: The Ten Commandments, from the Hebrew Bible (Dt. 5:6–21), "New Revised Standard Version Bible, copyright 1989, Division of Christian Education of the National Council of the Churches of Christ in the United States of America. Used by permission. All rights reserved." Reading 2.5b, page 56: from The Hebrew Bible (Dt. 6:6–9), "New Revised Standard Version Bible, copyright 1989, Division of Christian Education of the National Council of the Churches of Christ in the United States of America. Used by permission. All rights reserved." Reading 2.5c,

page 58: from the Hebrew Bible (1 Kings 6:19–29), "New Revised Standard Version Bible, copyright 1989, Division of Christian Education of the National Council of the Churches of Christ in the United States of America. Used by permission. All rights reserved." Reading 2.5d, page 59: from The Hebrew Bible (Song of Solomon 4:1–6, 7:13–14), THE SONG OF SONGS: A NEW TRANSLATION AND COMMENTARY by Ariel Bloch and Chana Bloch. Copyright © 1995 by Ariel Bloch and Chana Bloch. Reprinted by permission of Georges Borchardt, Inc., on behalf of the translators. Reading 2.5e, page 61: from the Hebrew Bible (Jer. 11:11–14), "New Revised Standard Version Bible, copyright 1989, Division of Christian Education of the National Council of the Churches of Christ in the United States of America. Used by permission. All rights reserved." Reading 2.6, page 67: from The Hebrew Bible The Book of Job (Chapters 1–3, 38, 42), "New Revised Standard Version Bible, copyright 1989, Division of Christian Education of the National Council of the Churches of Christ in the United States of America. Used by permission. All rights reserved."

Chapter 3

Reading 3.1, page 76: from Akhenaten's Hymn to the Sun, From ANCIENT EGYPTIAN LITERATURE: AN ANTHOLOGY translated by John L. Foster, Copyright © 2001. By permission of University of Texas Press. Reading 3.3, page 95: from "Garden Songs", Edited by Ezra Pound, Translated by Noel Stock, from LOVE POEMS OF ANCIENT EGYPT, copyright © 1962 by Noel Stock. Reprinted by permission of New Directions Publishing Corp.

Chapter 4

Reading 4.1, page 111: from the Book of Songs, Song 156 from THE BOOK OF SONGS translated by Arthur Waley. Published by Houghton in 1937. Reprinted by permission of The Arthur Waley Estate. Reading 4.2, page 112: from the Dao de jing, From THE WAY OF LIFE by Lao Tzu, translated by Raymond B. Blakney, copyright ©